陳澄波全集
CHEN CHENG-PO CORPUS
第三卷・淡彩速寫
Volume 3・Watercolor Sketch

策劃／財團法人陳澄波文化基金會
發行／財團法人陳澄波文化基金會
中央研究院台灣史研究所
出版／藝術家出版社

感　謝
APPRECIATE

行政院文化建設委員會 Council for Cultural Affairs

嘉義市政府 Chiayi City Government

臺北市立美術館 Taipei Fine Arts Museum

高雄市立美術館 Kaohsiung Museum of Fine Arts

台灣創價學會 Taiwan Soka Association

尊彩藝術中心 Liang Gallery

吳慧姬女士 Ms. WU HUI-CHI

陳澄波全集
CHEN CHENG-PO CORPUS

第三卷・淡彩速寫
Volume 3・Watercolor Sketch

目　錄

Contents

董事長 序

　　家父陳澄波先生生於台灣割讓給日本的乙未（1895）之年，罹難於戰後動亂的二二八事件（1947）之際。可以說：家父的生和死，都和歷史的事件有關；他本人也成了歷史的人物。

　　家父的不幸罹難，或許是一樁歷史的悲劇；但家父的一生，熱烈而精采，應該是一齣藝術的大戲。他是台灣日治時期第一個油畫作品入選「帝展」的重要藝術家；他的一生，足跡跨越台灣、日本、中國等地，居留上海期間，也榮膺多項要職與榮譽，可說是一位生活得極其精彩的成功藝術家。

　　個人幼年時期，曾和家母、家姊共赴上海，與父親團聚，度過一段相當愉快、難忘的時光。父親的榮光，對當時尚屬童稚的我，雖不能完全理解，但隨著年歲的增長，即使家父辭世多年，每每思及，仍覺益發同感驕傲。

　　父親的不幸罹難，伴隨而來的是政治的戒嚴與社會疑慮的眼光，但母親以她超凡的意志與勇氣，完好地保存了父親所有的文件、史料與畫作。即使隻紙片字，今日看來，都是如此地珍貴、難得。

　　感謝中央研究院翁啟惠院長和台灣史研究所謝國興所長的應允共同出版，讓這些珍貴的史料、畫作，能夠從家族的手中，交付給社會，成為全民共有共享的資產；也感謝基金會所有董事的支持，尤其是總主編蕭瓊瑞教授和所有參與編輯撰文的學者們辛勞的付出。

　　期待家父的努力和家母的守成，都能夠透過這套《全集》的出版，讓社會大眾看到，給予他們應有的定位，也讓家父的成果成為下一代持續努力精進的基石。

　　我が父陳澄波は、台湾が日本に割譲された乙未（1895）の年に生まれ、戦後の騒乱の228事件（1947）の際に、乱に遭われて不審判で処刑されました。父の生と死は謂わば、歴史事件と関ったことだけではなく、その本人も歴史的な人物に成りました。

　　父の不幸な遭難は、一つの歴史の悲劇であるに違いません。だが、彼の生涯は、激しくて素晴らしいもので、一つの芸術の偉大なドラマであることとも言えよう。彼は、台湾の殖民時代に、初めで日本の「帝国美術展覧会」に入選した重要な芸術家です。彼の生涯のうちに、台湾は勿論、日本、中国各地を踏みました。上海に滞在していたうちに、要職と名誉が与えられました。それらの面から見れば、彼は、極めて成功した芸術家であるに違いません。

　　幼い時期、私は、家父との団欒のために、母と姉と一緒に上海に行き、すごく楽しくて忘れられない歳月を過ごしました。その時、尚幼い私にとって、父の輝き仕事が、完全に理解できなっかものです。だが、歳月の経つに連れて、父が亡くなった長い歳月を経たさえも、それらのことを思い出すと、彼の仕事が益々感心するようになりました。

　　父の政治上の不幸な非命の死のせいで、その後の戒厳令による厳しい状況と社会からの疑わしい眼差しの下で、母は非凡な意志と勇気をもって、父に関するあらゆる文献、資料と作品を完璧に保存しました。その中での僅かな資料であるさえも、今から見れば、貴重且大切なものになれるでしょう。

　　この度は、中央研究院長翁啟恵と台湾史研究所所長謝国興のお合意の上で、これらの貴重な文献、作品を共同に出版させました。終に、それらが家族の手から社会に渡され、我が文化の共同的な資源になりました。基金会の理事全員の支持を得ることを感謝するとともに、特に総編集者である蕭瓊瑞教授とあらゆる編輯作者たちのご苦労に心より謝意を申し上げます。

　　この《全集》の出版を通して、父の努力と母による父の遺物の守りということを皆さんに見せ、評価が下させられることを期待します。また、父の成果がその後の世代の精力的に努力し続ける基盤になれるものを深く望んでおります。

<div style="text-align: right">

財團法人陳澄波文化基金會
董事長　陳重光

</div>

Foreword from the Chairman

My father was born in the year Taiwan was ceded to Japan (1895) and died in the turbulent post-war period when the 228 Incident took place (1947). His life and death were closely related to historical events, and today, he himself has become a historical figure.

The death of my father may have been a part of a tragic event in history, but his life was a great repertoire in the world of art. One of his many oil paintings was the first by a Taiwanese artist featured in the Empire Art Exhibition in Japan. His life spanned Taiwan, Japan and China and during his residency in Shanghai, he held important positions in the art scene and obtained numerous honors. It can be said that he was a truly successful artist who lived an extremely colorful life.

When I was a child, I joined my father in Shanghai with my mother and elder sister where we spent some of the most pleasant and unforgettable days of our lives. Although I could not fully appreciate how venerated my father was at the time, as years passed and even after he left this world a long time ago, whenever I think of him, I am proud of him.

The unfortunate death of my father was followed by a period of martial law in Taiwan which led to suspicion and distrust by others towards our family. But with unrelenting will and courage, my mother managed to preserve my father's paintings, personal documents, and related historical references. Today, even a small piece of information has become a precious resource.

I would like to express gratitude to Wong Chi-huey, president of Academia Sinica, and Hsieh Kuo-hsing, director of the Institute of Taiwan History, for agreeing to publish the *Chen Cheng-po Corpus* together. It is through their effort that all the precious historical references and paintings are delivered from our hands to society and shared by all. I am also grateful for the generous support given by the Board of Directors of our foundation. Finally, I would like to give special thanks to Professor Hsiao Chong-ruy, our editor-in-chief, and all the scholars who participated in the editing and writing of the *Chen Cheng-po Corpus*.

Through the publication of the *Chen Cheng-po Corpus*, I hope the public will see how my father dedicated himself to painting, and how my mother protected his achievements. They deserve recognition from the society of Taiwan, and I believe my father's works can lay a solid foundation for the next generation of Taiwan artists.

Chairman and Founder, Chen Cheng-po Cultural Foundation
Chen Chung-kuang *Chen, Tsung-kuang*

9

院長 序

　　嘉義鄉賢陳澄波先生，是日治時期台灣最具代表性的本土畫家之一，1926年他以西洋畫作〔嘉義街外〕入選日本畫壇最高榮譽的「日本帝國美術展覽會」，是當時台灣籍畫家中的第一人；翌年再度以〔夏日街景〕入選「帝展」，奠定他在台灣畫壇的先驅地位。1929年陳澄波完成在日本的專業繪畫教育，隨即應聘前往上海擔任藝術專校西畫教席，當時也是台灣畫家第一人。然而陳澄波先生不僅僅是一位傑出的畫家而已，更重要的是他作為一個台灣知識份子與文化人，在當時台灣人面對中國、台灣、日本之間複雜的民族、國家意識與文化認同問題上，反映在他的工作、經歷、思想等各方面的代表性，包括對傳統中華文化的繼承、台灣地方文化與生活價值的重視（以及對台灣土地與人民的熱愛）、日本近代性文化（以及透過日本而來的西方近代化）之吸收，加上戰後特殊時局下的不幸遭遇等，已使陳澄波先生成為近代台灣史上的重要人物，我們今天要研究陳澄波，應該從台灣歷史的整體宏觀角度切入，才能深入理解。

　　中央研究院台灣史研究所此次受邀參與《陳澄波全集》的資料整輯與出版事宜，十分榮幸。台史所近幾年在收集整理台灣民間資料方面累積了不少成果，台史所檔案館所收藏的台灣各種官方與民間文書資料，包括實物與數位檔案，也相當具有特色，與各界合作將資料數位化整理保存的專業經驗十分豐富，在這個領域可說居於領導地位。我們相信台灣歷史研究的深化需要多元的觀點與重層的探討，這一次台史所有機會與財團法人陳澄波文化基金會合作共同出版陳澄波全集，以及後續協助建立數位資料庫，一方面有助於將陳澄波先生的相關資料以多元方式整體呈現，另一方面也代表在研究與建構台灣歷史發展的主體性目標上，多了一項有力的材料與工具，值得大家珍惜善用。

<div style="text-align: right;">
台北南港／中央研究院

院長　翁啟惠
</div>

Foreword from the President of the Academia Sinica

Mr. Chen Cheng-po, a notable citizen of Chiayi, was among the most representative painters of Taiwan during Japanese rule. In 1926, his oil painting "Chiayi Suburb" was featured in Empire Art Exhibition in Japan (i.e. the Imperial Exhibition). This made him the first Taiwanese painter to ever attend the top-honor painting event. In the next year, his work "Summer Street" was selected again to the Imperial Exhibition, which secured a pioneering status for him in the local painting scene. In 1929, as soon as Chen completed his painting education in Japan, he headed for Shanghai under invitation to be an instructor of Western painting at an art academy. Such cordial treatment was unprecedented for Taiwanese painters. Chen was not just an excellent painter. As an intellectual his work, experience and thoughts in the face of the political turmoil in China, Taiwan and Japan, reflected the pivotal issues of national consciousness and cultural identification of all Taiwanese people. The issues included the passing on of Chinese cultural traditions, the respect for the local culture and values (and the love for the island and its people), and the acceptance of modern Japanese culture. Together with these elements and his unfortunate death in the post-war era, Chen became an important figure in the modern history of Taiwan. If we are to study the artist, we would definitely have to take a macroscopic view to fully understand him.

It is an honor for the Institute of Taiwan History of the Academia Sinica to participate in the editing and publishing of the *Chen Cheng-po Corpus*. The institute has achieved substantial results in collecting and archiving folk materials of Taiwan in recent years, the result an impressive archive of various official and folk documents, including objects and digital files. The institute has taken a pivotal role in digital archiving while working with professionals in different fields. We believe that varied views and multi-faceted discussion are needed to further the study of Taiwan history. By publishing the corpus with the Chen Cheng-po Cultural Foundation and providing assistance in building a digital database, the institute is given a wonderful chance to present the artist's literature in a diversified yet comprehensive way. In terms of developing and studying the subjectivity of Taiwan history, such a strong reference should always be cherished and utilized by all.

President of the Academia Sinica
Nangang, Taipei
Wong Chi-huey

總主編 序

作為台灣第一代西畫家，陳澄波幾乎可以和「台灣美術」劃上等號。這原因，不僅僅因為他是台灣畫家中入選「帝國美術展覽會」（簡稱「帝展」）的第一人，更由於他對藝術創作的投入與堅持，以及對台灣美術運動的推進與貢獻。

出生於乙未割台之年（1895）的陳澄波，父親陳守愚先生是一位精通漢學的清末秀才；儘管童年的生活，主要是由祖母照顧，但陳澄波仍從父親身上傳承了深厚的漢學基礎與強烈的祖國意識。這些養分，日後都成為他藝術生命重要的動力。

1918年台北國語學校畢業後，陳澄波便與同鄉的張捷女士結縭，並分發母校嘉義第一公學校服務，後調往郊區的水上公學校。未久，便因對藝術創作的強烈慾望，在夫人的全力支持下，於1924年，服完六年義務教學後，毅然辭去人人稱羨的安定教職，前往日本留學，考入東京美術學校圖畫師範科，也參與創立台灣重要的繪畫團體「七星畫壇」。

1926年，東京美校三年級，便以〔嘉義街外〕一作，入選第七回「帝展」，為台灣油畫家入選之第一人，震動全島。1927年，又以〔夏日街景〕再度入選。同年，本科結業，再入研究科深造。

1928年，作品〔龍山寺〕也獲第二屆「台灣美術展覽會」（簡稱「台展」）「特選」。隔年，東美畢業，即在日本文部省推薦及留日中國畫家王濟遠（1893-1975）邀請下，前往上海任教，先後擔任「新華藝專」西畫科主任教授，及「昌明藝專」、「藝苑研究所」等校西畫教授及主任等職。此外，又任上海市全國訓政紀念綜合藝展審查員、國民政府日本工藝考察團委員、上海市紀念訓政全國美展審查委員等職；作品〔清流〕亦代表中華民國參加芝加哥世界博覽會，同時入選全國十二代表畫家等。其間，作品持續多次入選「帝展」及「台展」特選，並於1932年獲「台展」無鑑查展出資格。

居滬期間，陳澄波教學相長、奮力創作，留下許多大幅力作，均呈現特殊的現代主義思維。同時，他也積極參與新派畫家活動，如「決瀾社」的多次籌備會議。他生性活潑、熱力四射，與傳統國畫家和新派畫家均有深厚交誼。

唯1932年，爆發「一二八」上海事件，中日衝突，這位熱愛祖國的台灣畫家，竟被以「日僑」身份，遭受排擠，險遭不測，並被迫於1933年離滬返台。

返台後的陳澄波，將全生命奉獻給故鄉，邀集同好，組成「台陽美術協會」，每年舉辦年展及全島巡迴展，全力推動美術提升及普及的工作，影響深遠。個人創作亦於此時邁入高峰，色彩濃郁活潑，充份展現台灣林木蓊鬱、地貌豐美、人群和善的特色。

1945年，二次大戰終了，台灣重回中國統治，他以興奮的心情，號召眾人學說「國語」，並加入「三民主義青年團」，同時膺任第一屆嘉義市參議會議員。1947年年初，爆發「二二八事件」，他代表市民前往水上機場協商、慰問，卻遭扣留羈押；並於3月25日上午，被押往嘉義火車站前廣場，槍決示眾，熱血流入他日夜描繪的故鄉黃泥土地，留給後人無限懷思。

陳澄波的遇難，成為戰後台灣歷史中的一項禁忌，有關他的生平、作品，也在許多後輩的心中逐漸模糊淡忘。儘管隨著政治的逐漸解嚴，部份作品開始重新出土，並在國際拍賣場上屢創新高；但學界對他的生平、創作之理解，仍停留在有限的資料及作品上，對其獨特的思維與風格，也難以一窺全貌，更遑論一般社會大眾。

以「政治受難者」的角色來認識陳澄波，對這位一生奉獻給藝術的畫家而言，顯然是不公平的。歷經三代人的含冤、忍辱、保存，陳澄波大量的資料、畫作，首次披露在社會大眾的面前，這當中還不包括那些因白蟻蛀蝕而毀壞的許多作品。

個人有幸在1994年，陳澄波百年誕辰的「陳澄波・嘉義人學術研討會」中，首次以「視覺恆常性」的角度，試圖詮釋陳氏那種極具個人獨特風格的作品；也得識陳澄波的長公子陳重光老師，得悉陳澄波的作品、資料，如何一路從夫人張捷女士的手中，交到重光老師的手上，那是一段滄桑而艱辛的歷史。大約兩年前（2010），重光老師的長子立栢先生，從職場退休，在東南亞成功的企業經營經驗，讓他面對祖父的這批文件、史料及作品時，迅速地知覺這是一批不僅屬於家族，也是台灣社會，乃至近代歷史的珍貴文化資產，必須要有一些積極的作為，進行永久性的保存與安置。於是大規模作品修復的工作迅速展開；2011年至2012年之際，兩個大型的紀念展：「切切故鄉情」與「行過江南」，也在高雄市立美術館、台北市立美術館先後且重疊地推出。眾人才驚訝這位生命不幸中斷的藝術家，竟然留下如此大批精采的畫作，顯然真正的「陳澄波研究」才剛要展開。

　　基於為藝術家留下儘可能完整的生命記錄，也基於為台灣歷史文化保留一份長久被壓縮、忽略的珍貴資產，《陳澄波全集》在眾人的努力下，正式啟動。這套全集，合計十八卷，前十卷為大八開的巨型精裝圖版畫冊，分別為：第一卷的油畫，搜羅包括僅存黑白圖版的作品，約近400幅；第二卷為炭筆素描、水彩畫、膠彩畫、水墨畫及書法等，合計約211件；第三卷為淡彩速寫，約400餘件，其中淡彩裸女占最大部份，也是最具特色的精采力作；第四卷為速寫（Ｉ），包括單張的鉛筆速寫95件和鉛筆素描954件；第5卷為速寫（ＩＩ），分別出自36本速描簿中的約1170餘幅作品；第六、七卷為個人史料（Ｉ）、（ＩＩ），分別包括陳氏家族照片、個人照片、書信、文書、史料等；第八、九卷為陳氏收藏，包括相當完整的「帝展」明信片，以及各式畫冊、圖書；第十卷為相關文獻資料，即他人對陳氏的研究、介紹、展覽及相關周邊產品。

　　至於第十一至十八卷，為十六開本的軟精裝，以文字為主，分別包括：第十一卷的陳氏文稿及筆記；第十二、十三卷的評論集，即歷來對陳氏作品研究的文章彙集；第十四卷的二二八相關史料，以和陳氏相關者為主；第十五至十七卷，為陳氏作品歷年來的修復報告及材料分析；第十八卷則為陳氏年譜，試圖立體化地呈現藝術家生命史。

　　對台灣歷史而言，陳澄波不只是個傑出且重要的畫家，同時他也是一個影響台灣深遠（不論他的生或他的死）的歷史人物。《陳澄波全集》由財團法人陳澄波文化基金會和中央研究院台灣史研究所共同發行出版，正是名實合一地呈現了這樣的意義。

　　感謝為《全集》各冊盡心分勞的學界朋友們，也感謝執行編輯何冠儀、賴鈴如兩位小姐的辛勞；同時要謝謝藝術家出版社何政廣社長，尤其他的得力助手美編柯美麗小姐不厭其煩的付出。當然《全集》的出版，背後最重要的推手，還是陳重光老師和他的長公子立栢夫婦，以及整個家族的支持。這件歷史性的工程，將為台灣歷史增添無限光采與榮耀。

<div align="right">
《陳澄波全集》總主編

國立成功大學歷史系所教授　蕭瓊瑞
</div>

Foreword from the Editor-in-Chief

As an important first-generation painter, the name Chen Cheng-po is virtually synonymous with Taiwan fine arts. Not only was Chen the first Taiwanese artist featured in the Empire Art Exhibition in Japan, but he also dedicated his life toward artistic creation and the advocacy of art in Taiwan.

Chen Cheng-po was born in 1895, the year Qing Dynasty China ceded Taiwan to Imperial Japan. His father, Chen Shou-yu, was a Chinese imperial scholar proficient in Sinology. Although Chen's childhood years were spent mostly with his grandmother, a solid foundation of Sinology and a strong sense of patriotism were fostered by his father. Both became Chen's impetus for pursuing an artistic career later on.

In 1918, Chen Cheng-po graduated from the Taipei Language Grammar School and married his hometown sweetheart Chang Chie. He was assigned a teaching post at his alma mater, the Chiayi First Public Elementary School and later transferred to the suburban Shueishang Public Elementary School. Chen resigned from the much envied post in 1924 after six years of compulsory teaching service. With the full support of his wife, he began to explore his strong desire for artistic creation. He then travelled to Japan and was admitted to the Tokyo University of the Arts where he majored in Western Painting. During that period, he became a founding member of an important painter's group in Taiwan called the Seven Stars Painting Society.

In 1926, during his junior year, Chen's oil painting "Chiayi Suburb" was featured in the seventh Empire Art Exhibition. His selection caused a sensation in Taiwan as it was the first time a local oil painter was included in the exhibition. Chen was featured at the exhibition again in 1927 with "Summer Street". That same year, he completed his undergraduate studies and entered the graduate program at Tokyo University of the Arts.

In 1928, Chen's painting "Longshan Temple" was awarded the Special Selection prize at the second Taiwan Fine Arts Exhibition (Taiwan Exhibition). After he graduated the next year, Chen was invited by the Chinese painter Wang Chi-yuan (1893-1975) and recommended by the Japanese Ministry of Education to teach in Shanghai. There, Chen taught as a Professor and Dean of the Western Painting Departments of the Xinhua Art School, Changming Art School, and Yiyuan Painting Institute. During this period, Chen had many great accomplishments — he was a committee member of the Shanghai National Political Tutelage Commemoration Comprehensive Art Exhibition and Shanghai National Political Tutelage Art Exhibition, and an Inspector of the Republic of China for Japanese Crafts. His painting "Fresh Flow" represented the Republic of China at the Chicago World Fair, and he was selected to the list of Top Twelve National Painters. Chen's works also featured in the Empire Art Exhibition and the Special Selection Category of the Taiwan Exhibition many more times, and in 1932 he gained audit exemption from the Taiwan Exhibition .

During his residency in Shanghai, Chen Cheng-po spared no effort toward the creation of art, completing several large-sized paintings that manifested distinct modernist thinking of the time. He also actively participated in modernist painting events, such as the many preparatory meetings of the Strom Art Society. Chen's outgoing and enthusiastic personality helped him form deep bonds with both traditional and modernist Chinese painters.

Yet in 1932, with the outbreak of the 128 Incident in Shanghai, the local Chinese and Japanese communities clashed. Chen was outcast by locals because of his Japanese expatriate status and nearly lost his life amidst the chaos. Ultimately, he was forced to return to Taiwan in 1933.

On his return, Chen devoted himself to his homeland. He invited like-minded enthusiasts to found the Taiyang Fine Arts Association, which held annual exhibitions and tours to promote art to the general public. The association was immensely successful and had a profound influence on the development and advocacy for fine arts in Taiwan. It was during this period that Chen's creative expression climaxed — his use of strong and lively colors fully expressed the verdant forests, breathtaking landscape and friendly people of Taiwan.

When the Second World War ended in 1945, Taiwan returned to Chinese control. Chen eagerly called on everyone around him to adopt the new national language, Mandarin. He also joined the Three Principles of the People Youth Corps, and served as a councilor of the Chiayi City Council in its first term. Not long after, the 228 Incident broke out in early 1947. On behalf of the Chiayi citizens, he went to the Shueishang Airport to negotiate with and appease Kuomintang troops, but instead was detained and imprisoned without trial. On the morning of March 25, he was publicly executed at the Chiayi Train Station Plaza. His warm blood flowed down onto the land which he had painted day and night, leaving only his works and memories for future generations.

The unjust execution of Chen Cheng-po became a taboo topic in postwar Taiwan's history. His life and works were gradually lost to the minds of the younger generation. It was not until martial law was lifted that some of Chen's works re-emerged and were sold at record-breaking

prices at international auctions. Even so, the academia had little to go on about his life and works due to scarce resources. It was a difficult task for most scholars to research and develop a comprehensive view of Chen's unique philosophy and style given the limited resources available, let alone for the general public.

Clearly, it is unjust to perceive Chen, a painter who dedicated his whole life to art, as a mere political victim. After three generations of suffering from injustice and humiliation, along with difficulties in the preservation of his works, the time has come for his descendants to finally reveal a large quantity of Chen's paintings and related materials to the public. Many other works have been damaged by termites.

I was honored to have participated in the "A Soul of Chiayi: A Centennial Exhibition of Chen Cheng-po" symposium in celebration of the artist's hundredth birthday in 1994. At that time, I analyzed Chen's unique style using the concept of visual constancy. It was also at the seminar that I met Chen Chung-kuang, Chen Cheng-po's eldest son. I learned how the artist's works and documents had been painstakingly preserved by his wife Chang Chie before they were passed down to their son. About two years ago, in 2010, Chen Chung-kuang's eldest son, Chen Li-bo, retired. As a successful entrepreneur in Southeast Asia, he quickly realized that the paintings and documents were precious cultural assets not only to his own family, but also to Taiwan society and its modern history. Actions were soon taken for the permanent preservation of Chen Cheng-po's works, beginning with a massive restoration project. At the turn of 2011 and 2012, two large-scale commemorative exhibitions that featured Chen Cheng-po's works launched with overlapping exhibition periods — "Nostalgia in the Vast Universe" at the Kaohsiung Museum of Fine Arts and "Journey through Jiangnan" at the Taipei Fine Arts Museum. Both exhibits surprised the general public with the sheer number of his works that had never seen the light of day. From the warm reception of viewers, it is fair to say that the Chen Cheng-po research effort has truly begun.

In order to keep a complete record of the artist's life, and to preserve these long-repressed cultural assets of Taiwan, we publish the *Chen Cheng-po Corpus* in joint effort with coworkers and friends. The works are presented in 18 volumes, the first 10 of which come in hardcover octavo deluxe form. The first volume features nearly 400 oil paintings, including those for which only black-and-white images exist. The second volume consists of 211 charcoal drawings, watercolor paintings, gouache paintings, ink-and-wash paintings, and calligraphy works. The third volume contains more than 400 watercolor sketches most powerfully delivered works that feature female nudes. The fourth volume is made up of sketches and drawings, including 95 croquis drawings and 954 pencil sketches. The fifth volume comprises 1,170 sketches selected from Chen's 36 sketchbooks. The artist's personal historic materials are included in the sixth and seventh volumes. The materials include his family photos, individual photo shots, letters, and paper documents. The eighth and ninth volumes contain a complete collection of Empire Art Exhibition postcards, relevant collections, literature, and resources. The tenth volume consists of research done on Chen Cheng-po, exhibition material, and other related information.

Volumes eleven to eighteen are paperback decimo-sexto copies mainly consisting of Chen's writings and notes. The eleventh volume comprises articles and notes written by Chen. The twelfth and thirteenth volumes contain studies on Chen. The historical materials on the 228 Incident included in the fourteenth volumes are mostly focused on Chen. The fifteen to seventeen volumes focus on restoration reports and materials analysis of Chen's artworks. The eighteenth volume features Chen's chronology, so as to more vividly present the artist's life.

Chen Cheng-po was more than a painting master to Taiwan — his life and death cast lasting influence on the Island's history. The *Chen Cheng-po Corpus*, jointly published by the Chen Cheng-po Cultural Foundation and the Institute of Taiwan History of Academia Sinica, manifests Chen's importance both in form and in content.

I am grateful to the scholar friends who went out of their way to share the burden of compiling the corpus; to executive editors Ho Kuan-yi and Lai Ling-ju for their great support; and Ho Cheng-kuang, president of Artist Publishing co. and his capable art editor Ke Mei-li for their patience and support. For sure, I owe the most gratitude to Chen Chung-kuang; his eldest son Li-bo and his wife Hui-ling; and the entire Chen family for their support and encouragement in the course of publication. This historic project will bring unlimited glamour and glory to the history of Taiwan.

Editor-in-Chief, *Chen Cheng-po Corpus*
Professor, Department of History, National Cheng Kung University
Hsiao Chong-ray

Chong-ray Hsiao

筆墨輕抹詩意濃
——陳澄波「淡彩裸女」的風格探討

　　陳澄波畫於1931-1932年間的淡彩[1]人物畫，與一般印象中的陳澄波畫風大異其趣，也提供了另一個解讀陳澄波藝術的切面。1929-1933年間，陳澄波旅居上海，任教於「新華藝專」與「昌明藝專」；這批作品多數為課堂中所畫，部分可能是示範教學之作。相較於他厚重的人體油畫，淡彩人物則即興揮灑，似乎都是信筆撚來，特別顯得靈動輕快。

　　陳澄波的淡彩人物是一個值得探討的課題。論者都認為陳澄波上海時期畫風受到中國文人畫的影響而有明顯的轉變，這批淡彩人物是否也能用此一論點來觀察？1930年前後的上海文化界的氛圍及陳澄波與上海文化界的互動情形，是否可以為這批獨特的畫作增添一些註解？與當代上海畫家的關係如何？此外，這種簡淡的人體風格，也讓人想起興起於兩次大戰期間的「巴黎畫派」畫風，如：莫迪里亞尼、史丁、尤特里羅等人的風格，尤其是與常玉、潘玉良兩位那個年代中國旅法畫家是否也有所關聯？

　　本文依循這些線索，以「淡彩裸女」為主要目標，探討陳澄波這批「淡彩」作品的風格意涵，試圖揭開陳澄波藝術的另一種面向。

一、風雲際會上海灘

　　1929年陳澄波在黎明暉的《毛毛雨》[2]的歌聲中來到上海，也一腳踩進了這個藝術界的十里洋場。

　　1920年代以來的上海可謂風起雲湧，成為近代中國最「進步」的都會。上海不是由傳統的中心城市逐漸演變成近代大都市，而是在1840年代租界開闢後，由中外移民共同締造的現代都市。「租界」，為西方文化輸入上海，提供了便利條件。同時由於上海社會移民人口的特點，傳統士紳角色缺位，使得近代上海文化呈現無霸權狀態，有利於異質文化的交流與融合。近代上海不中不西、亦中亦西，是中西不同文化共存、交流、融合的狀態，也是上海被稱為「文化熔爐」的原因所在。[3]

　　1920、30年代，上海乃是整個亞洲最繁華和國際化的大都會。這個被譽為「十里洋場」的上海，除了繁榮的經貿之外，在藝術和文化方面，也是一個融合薈萃之地。這個時期，陳澄波因緣際會的來到上海，親眼見證了上海的繁榮與多樣，也以藝術創作回應了上海的繁華。

海上畫派與揚州八怪

　　19世紀中葉上海開港之後，便取代了揚州的地位，成為南方最繁榮的城市。清代中葉以來，揚州因鹽業興盛，成為培育「揚州八怪」的溫床；而上海也因為商業興起，富商巨賈雲集，各地文人名流彙聚，在繪畫上形成了「海上畫派」。

　　「海上畫派」大約形成於19世紀中葉，與上海開港同時。「海上畫派」延續「揚州八怪」大膽創新之風，都各自在某些方面受「揚州八怪」的影響。「海上畫派」名家眾多，1920年代仍活躍一時的，包括有：吳昌碩、王夢白、王雪濤、唐雲、王一亭、陳師曾、黃賓虹、潘天壽等。他們的畫風瀟灑放縱，又富雄厚古樸的特色；此外，「海上畫派」多為高產量畫家，這與上海的商業化特色，以及他們賣畫為生的身分相吻合。

　　「海上畫派」畫家除了周旋於富商巨賈間，風雅酬酢，也在學術殿堂中位居要津。在上海文化圈的是：吳昌碩是藝壇風範；潘天壽任教於上海美專、新華藝專；黃賓虹任上海美專國畫理論與詩文教授，又兼新華藝術大學教席；陳師曾活躍於北京，任教於北京高等師範學校、北大畫法研究會中國畫導師、北京的多所美術專門學校任國畫教授；王一亭在政壇與藝壇兩棲。都名噪一時。此外，徐悲鴻任北平藝術學院院長、南國藝術學院美術系主任和南京中央大學藝術系教

授、蘇州美專校長，雖非屬「海上畫派」，卻與上海關係密切且深具影響力。

「海上畫派」中的黃賓虹、王一亭、潘天壽等，都與陳澄波在上海有所交集。

劉海粟與裸體畫風波

海上畫派的畫風與傳統社會的習性相符，在上海可謂如魚得水；但某些與傳統社會相悖的新觀念之傳播，則掀起滔天巨浪，引發社會的一陣騷動，如1920年代，上海有所謂的「三大文妖」。[4]不論在生活層面或文化層面，這是一個新舊交會、中西雜陳的地方，在各種衝突與融會中，整個社會像起了化學變化一般，一切都在快速變動中激盪著，上海灘也不斷的質變。

1920年代在美術上掀起軒然大波的是三大文妖之一的劉海粟。

1917年上海美專展覽人體畫，校長劉海粟被抨擊為：「藝術叛徒，教育界之蟊賊」，此後劉海粟自號「藝術叛徒」；1920年，劉海粟聘用女模陳曉君，裸體少女第一次出現在學校畫室，「上海出了三大文妖」之傳言，不脛而走；1925年再加封「名教叛徒」；1926年政府正式禁止上海美專以人體寫生，孫傳芳函令解僱模特兒；1927年劉海粟被以「學閥」罪名通緝，避居日本，政府交涉封鎖上海美專，所幸該校位於法國租界內，未受實質影響。

1920年代的人體模特兒事件轟動一時，成了熱門話題。把裸體畫與當代思潮畫上等號，或許太過簡單，但從裸體畫事件可以窺見：在一個新舊交替、中西混雜的社會裡，上海的燈紅酒綠不只呈現在生活上，也顯現在文化上藝術上；上海在「海上派」光環之外，無疑也隱藏著許多將要一一被引爆的文化能量，準備開出一朵朵光燦的「上海花」。劉海粟在美術上掀起的波瀾，毋寧為上海藝壇注入了一股活力，在以傳統文人為根底的「海上」風尚中，吹入了不同的氣息，也豐富了上海文化的多樣性。

裸體畫風波終究使「模特兒」成為學院美術教學的常態，讓陳澄波可以放心一搏，也為他日後為數可觀的「淡彩裸女」系列創作埋下伏筆。

潘玉良風情

1928年潘玉良自歐返國。潘玉良（1895-1977）身世坎坷，被視為傳奇人物，是電影《畫魂》裡的主人翁。1918年，潘玉良考取上海美專，從王濟遠、朱屺瞻等人學畫。1921年上海美專畢業後，又考取安徽省公費津貼留法的資格。在歐洲她先後就讀於里昂國立美術專門學校、巴黎國立美術學院，和義大利羅馬國立美術學院等。1928年應劉海粟之邀回國任教於母校上海美專，並在上海舉辦個展，中華書局還出版了一本《潘玉良畫冊》，被譽為中國第一位女性西畫家。此外，也兼任新華藝專，並擔任中央大學和南京師範大學教授，而校長正是在法國結識的徐悲鴻。

潘玉良留學巴黎期間，雖然莫迪里亞尼（Modigliani, 1884-1920）已經過世，但仍是「巴黎畫派」活躍的期間，各國畫家雲集。「巴黎畫派」以扭曲誇張的手法，以一種獨特而且具豐富色彩的畫風詮釋悲劇性的生命孤寂。潘玉良與巴黎畫派畫家同住巴黎蒙帕那斯區（Montparnasse），畫風也沾染了該派色彩。

她的回到上海，除了帶來個人的爭議外，也帶回了巴黎的味道。潘玉良的畫風有著「巴黎畫派」孤寂、鄉愁的風味，此種異樣的風味也適時注入了上海的空氣中。此外，與潘玉良同時在巴黎的常玉雖然這段期間不曾回國，但1929年幾乎已在法國成名，他那淒美而帶著濃厚鄉愁與東方情調的畫風，也應為當時上海美術界所熟悉。

潘玉良也是上海文化圈的一個話題，與周璇、張愛玲、阮玲玉、蝴蝶等被列為舊上海「十大名媛」之一，成為那年

代上海灘重要的風情與別致[5]；而其先妓後妾的身世，及「裸體畫」都令她不容於當時社會，風波不斷，但也造成風潮。多番掙扎後，再次於1937年離開上海到法國，定居巴黎直至終老。

潘玉良回國與陳澄波在上海的時間重疊，且相互交往；嘉義市文化局仍保存有潘氏夫婦寄來的明信片[6]，可以為他們之間這一段上海情誼作註。

二、《毛毛雨》中上海行

陳澄波在《毛毛雨》歌聲中來到上海後，先後任教於新華藝專、昌明藝專及藝苑繪畫研究所，也積極參與畫會活動，開拓自己的人際網路與藝術空間。

陳澄波在上海的活動情形，可從目前由陳氏家屬保存的一幅水墨瓜果條幅窺見一斑[7]；此畫保留陳澄波在上海活動的跡痕。根據黃冬富教授的描述：

畫中由張大千畫荷花（菡萏），張善子寫藕，俞劍華畫菱角，楊清磐畫西瓜，並由王濟遠題字，款識如下（標點符號為筆者（黃冬富）所加）：

「己巳小暑，大千、劍華將東渡，藝苑全（同）人設宴為之餞別，乘酒興發為豪墨，合作多幀，皆雋逸有深趣，特以此幅贈　澄波兄　紀念　濟遠題。」[8]

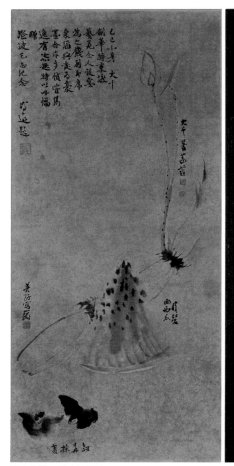

五人合筆　81.1×36.1cm

款識中提到的張大千、張善子、俞劍華、楊清磐皆屬「藝苑」會員，而題款者王濟遠為「藝苑」主持人，亦為陳澄波到上海教書的引薦人。此作雖屬文人酬酢，卻鮮活地保存了陳澄波在上海活動的實況。黃冬富〈陳澄波畫風中的華夏意識——上海任教時期的發展契機〉一文，對陳澄波在新華藝專的人際網路也有清楚的陳述：

「陳氏任教新華藝專時期，同事當中，除了有留日的俞寄凡、汪亞塵，留法的汪敬浪（日章）、潘玉良，以及海上派書畫名家潘天授、諸樂三、諸聞韻、熊松泉（庚昌），中國美術史學者俞劍華……等人，這些不同專長背景的同事，對陳澄波視野之拓展，應該會有相當程度之助益。剛任教新華藝專不久（1929年），陳澄波即奉教育部派遣，陪同潘玉良（上海美專西畫科主任）、王濟遠、金敢靜（上海美專教授）等人赴日本考察工藝美術。或許由於同行出國之機緣，潘玉良於翌（1929）年也應邀至新華藝專和藝苑繪畫研究所兼課。數年之後，潘玉良返歐發展，仍然常以書信與陳氏聯繫……」[9]

而在談及昌明藝專時，也提到：

「……由海上派書畫名家王震（一亭）擔任校長，教務長為諸聞韻，國畫系主任是王賢（個簃），前述三人皆為吳昌碩（1844-1927）之弟子，副校長兼總務主任吳邁（東邁）則為吳昌碩三子，顯示出該校校務體系與吳昌碩之淵源極深。此外西畫系主任為汪荻波（日章），藝教系國畫組主任為潘天授（天壽），西畫組主任則為陳澄波……」[10]

吉田千鶴子在〈陳澄波與東京美術學校的教育〉一文[11]中提到：陳澄波在新華藝專時，寄給東京美術大學繪畫師範科教官的信，對其在上海的活動也頗具參考價值。該信除了介紹當年上海藝壇的狀況外，也清楚交代上海美術界接待母校（東京美術學校）校長正木先生的情況，參與的畫家包括：國畫家王一亭、張大千、李秋君、馬望容，西洋畫家陳抱一、汪亞塵、江小鶼、許達、王道源等。其中東京美術大學的校友除了陳澄波外，尚有江小鶼、陳抱一、汪亞塵、王道源、許達等。這是陳澄波在上海人際網路的另一面。

此外，陳澄波也熱心參與各項展覽與社團活動，黃冬富指出：

「成為新華藝專等校教授兼西畫科主任以後，陳氏也迅速躋身上海畫壇高層之地位。1929年4月10日起，上海舉行第一屆全國美術展覽會，當時陳澄波剛任教新華藝專不久，年僅35歲的他很幸運地應邀參與評審員……」

「1929年上海舉辦的第一屆全國美展，與劉海粟關係密切的上海美專以及天馬和藝苑會員參與此展覽事務頗為深入，其中與陳澄波頗為深交的王濟遠也擔任籌備會的會場組主任，對於陳氏剛到上海不久隨即能擔任評審員應該有推薦之作用，此外陳氏亮眼的參展資歷和學經歷也是促成這項推薦的主要條件。」[12]

1931年，陳澄波在上海也因緣際會參與了中國近代最重要的畫會—「決瀾社」的創立活動，成為重要的五位發起人之一。「決瀾社」的成員與會友有：龐薰琹、倪貽德、王濟遠、周多、段平右、梁白波、陳澄波、陽太陽、楊秋人、曾志良、周糜、鄧雲梯、周真太、張弦、丘堤、關良、梁錫鴻、李仲生、周碧初、曾志良、李寶泉等，都是當代畫壇的一時俊秀。[13]

租界的上海相對於東京或台北，是一個更為開放性的國際型都會，雜揉了各種異質文化，也匯聚了各路英雄豪傑；縱浪上海灘，陳澄波打開了眼界，也敞開了胸懷。他在上海似乎一點都不寂寞，依舊熱情如昔，除了認真於學校的教學，也積極的介入畫壇活動。從這個時期留存的眾多作品來看，陳澄波雖然身在異地，仍舊創作若狂；而從留下的文物及畫於1931年的〔我的家庭〕中陳澄波面前擺放著一本永田一脩所著的《プロレタリア繪畫論》（普羅主義繪畫論）[14]來看，都在在證明他也求知若渴。他一頭埋進這個新的環境中，努力吸收、盡情揮灑，使他的畫風起了質變。論者對他的上海時期畫風或有定論，咸認為受到「華夏美學」的影響。他在抵達上海的第三年（1931）開始，創作出令人耳目一新的淡彩人物，似乎正是他在這個十里洋場因緣際會下思維的呈現。

三、淡彩揮灑畫裸女

陳澄波的淡彩畫總數約為408件，其中「裸女」325件，約佔總數的八成。標示日期最早為1931年10月，最晚為

1932年5月；而標示為1932年1月的多達194件；其次是1932年5月底之前的31件；有79件未標日期。目前沒有資料顯示1932年1月陳澄波在怎樣的機緣或心情下畫出大量的「淡彩裸女」，但畫裸女是在他1929年3月到上海兩年半之後才開始的，這一點卻頗堪玩味。

「淡彩裸女」創作期間很短，從有標示日期的作品看，1931年10月到1932年5月前後僅有八個月時間；而未標示日期的79件，大部分手法上較接近1931年的作品；再檢視其他非「裸女畫」的「頭像」、「畫室」、「群像」、「人物」等，也都有相同情形，即所標的日期都在1931年10月之後。就此推論，未標日期之作可能以早期的作品為多。為了方便敘述，本文僅對其標示日期者，依創作時間略作區分，即1931年、1932年1月，及1932年5月三個階段，就其畫風加以分析，藉以觀察這批畫作的創作手法及其創作思維的脈絡。

1931

標示1931年的作品只有15件，在此僅列舉四件，作為此一階段「淡彩裸女」的觀察取樣。〔坐姿裸女-31.10.8（1）〕（頁38）是標示日期最早的一件，時間是1931年10月8日。鉛筆隨著人體肌膚起伏，也跟著肢體遊走，線條有起落、轉接，略去許多細節；以簡潔的線條勾劃出細緻多變的身軀，形象鮮活生動，充分展現陳澄波敏銳的觀察力與卓越的表現力；薄薄的施上一層淡彩，則增添了畫意與韻味。〔立姿裸女-31.11.18（1）〕（頁40）勾勒模特兒的正面姿態，線條則更為簡練，也更加輕盈有緻，表達出一個豐腴自在的人體。〔坐姿裸女-31.12.7（6）〕（頁46）線條轉為流暢，在鉛筆的自由遊走間，身軀似乎逐漸轉化為線條；線條與對象之間呈現些許落差，軀體卻飽含詩意，意蘊深遠朦朧。〔立姿裸女-31.12.28（4）〕（頁49）畫於12月28日，是1931年的最後一件。本作在鉛筆線上再以彩筆描過，整體看來，少了柔順感，卻多了幾分拙澀味；色淡則以斜向筆觸在人體上皴擦，但不受侷限而越出人體之外，即興、自由，部分筆觸呈現「飛白」狀態，為人體增添不同的姿色。

從1931年的作品中可以看出陳澄波在這個階段「淡彩裸女」兩點發展的趨向。一、從重視模特兒的寫實性開始，線條的起落、斷續是隨著肌膚的起伏與人體的結構而來，如〔坐姿裸女-31.10.8（1）〕（頁38）、〔立姿裸女-31.11.18（1）〕（頁40）。而稍後的〔坐姿裸女-31.12.7（6）〕（頁46）、〔立姿裸女-31.12.28（4）〕（頁49）線條則變得較為獨立，鉛筆在線條與對象之間自由遊走，但在形象上卻更顯得生動，更有韻味。二、淡彩的塗繪也逐漸脫離「明暗」的考量，而與形體脫鉤，轉向更具「繪畫性」的平面塗抹，畫意更濃。

線描著色的「淡彩畫」大多是作為畫家的草圖，這在西洋美術史上屢見不鮮，例如魯本斯（Peter Paul Rubens, 1577-1640）、華鐸（Antoine Watteau, 1684-1721）、哥雅（Francisco Goya, 1746-1828）都留下許多類似草圖。從作品的意涵與作畫的意圖來看，陳波的「淡彩裸女」並不是一般草圖，而是一種頗具野心的美學追尋。

1932.1

1932年1月，陳澄波在短短一個月之間一口氣畫了194件「淡彩裸女」，這種狀況確實深堪玩味。檢視這批畫作，線條遠遠超越身體的侷限，飛龍走蛇，自在地抒發伸展；色彩的塗抹也更為自由，幾乎與形體脫離，隨意點染揮灑，小小的尺幅成了一片任由奔馳的天地。他似乎完全沉浸在一種創造的樂趣中，也顯出某種強烈的企圖心。

〔臥姿裸女-32.1（13）〕（頁89）畫一個趴伏著的裸女，線條輕盈流轉，與女體相互對應；淡彩超越形體，把女體渲染進一片空無之中。肉體味道全然消失，轉化為一片朦朧的詩意，抒情優美。〔坐姿裸女-32.1（19）〕（頁72）

則明快流暢，當女體被提煉為韻味雋永的線條時，陳澄波的美學意味也呼之欲出。我們暫時忘卻世俗的紛擾，二〇年代以來的裸體風波在此完全止歇；裸體的世界原來也是藝術的世界，無關情慾，也無關道德，而是一個讓人忘機的處所，讓人留連的所在。其他如〔坐姿裸女-32.1（31）〕（頁93）、〔坐姿裸女-32.1（46）〕（頁127）等風味稍異，但體現的美學意涵並無二致。這段期間，陳澄波也畫了一些「雙人畫」的作品，如〔坐姿裸女-32.1（41）〕（頁438）、〔坐姿裸女-32.1（38）〕（頁106）、〔立姿裸女-32.1（23）〕（頁155），這些「雙人畫」多為同一模特兒姿態的兩種不同角度；他在畫意的經營上力求變化，希望創造更豐盈的審美世界。

　　畫於1931年1月的作品數量大，陳澄波忘情的畫，其中也可以看到他的許多嘗試與探索；嘗試各種繪畫的手法，也探索藝術的種種可能性。〔坐姿裸女-32.1（55）〕（頁153）以幾乎「任意」的線條勾勒女體，用少見的鮮豔顏色塗抹渲染，沿著身軀畫上深黑色墨線，再畫上斜向、縱向並排筆觸，在所有的作品中顯得特別突出，這是他用力試探的一個典型例子。其中，我們似乎可以看到某些藝術胚芽正在滋長，這或許可以藉以說明陳澄波何以在短期間畫出大量的作品；他似乎在探討一個美學課題。寓居上海將近三年了，一向熱情的他，接觸面廣，也看的很多，對藝術課題的思考應該更多，他想在「裸女」中實踐某種對藝術的想法。果真如此，則「淡彩裸女」，可能是一把鑰匙，可用以試著解開陳澄波藝術中的某些奧秘。

1932.5

　　畫於1932年5月的作品共有31件，畫風與前兩個階段又有不同；沿著人體一邊輪廓所畫的墨線，最為引人注目。這一條墨線通常濃重粗黑，在畫面中顯得特別醒目，也成為這個階段畫風中最顯著的特徵。〔坐姿裸女-32.5.22（111）〕（頁289）女體前身的鉛筆線依稀可見，沿著身體背部則畫上重重的墨線，再以重色枯筆乾擦，藉以烘托人體。〔臥姿裸女-32.5.23（58）〕（頁293）畫橫躺的女體，以濕筆用反覆的斜線畫背部，其渲染的效果有很濃的「筆墨」味道。〔臥姿裸女-32.5.29（69）〕（頁314）畫於5月29日，這是標示日期的最後一天。圖中兩個橫躺的人體均以黃綠色的寬粗線條強調背部的輪廓線；這兩條黃綠色的寬粗線，其視覺效果已凌駕了輕柔的鉛筆線，躍升為畫中的主角。這是一個值得觀察的現象。

　　在「淡彩裸女」的最後階段，陳澄波幾乎要跳脫「裸女」的框架，大玩其「筆墨」遊戲。〔坐姿裸女-32（121）〕（頁317）是極為特殊的一件：僅標記1932，未註明月日，卻寫上「閘北」，是唯一記明地點的作品；而其繪畫手法上可謂「恣意而為」，一點不受人體形態或其固有章法的羈絆，「筆墨」味道十足，而在所有「淡彩裸女」中特別顯得醒目耀眼。

　　「淡彩裸女」止於1932年5月29日，原因目前並不清楚；但陳澄波這一趟「淡彩裸女」的探索之旅，雖然僅有短短八個月，卻行囊充滿，成為藝術生涯中另一個亮眼的篇章。從寫實到寫意、從「裸女」到「筆墨」，進程中身形不斷轉換，質地一再進化，標示出一條創作思維的軸線。

四、筆情墨韻文人氣

　　〔坐禪〕創作於1933年，畫幅很小，畫一棵枯樹，樹下有一僧人在打坐，以重色枯筆隨意點染，用筆簡練，筆觸卻奔放粗獷；這不是陳澄波一向常用的題材，畫風也很獨特，不論題材或畫意，都與「海上畫派」的文人風味相呼應。

〔坐禪〕在陳澄波的油畫中，唯無僅有，與「淡彩裸女」為同一時期之創作。兩者之間的關係不言可喻。

「海上畫派」的概況如本文前揭，是近代中國最重要的畫派之一，從十九世紀中葉就在上海美術獨領風騷，20年代仍然興盛一時，活躍於上海文化圈。陳澄波在與「海上畫派」有近距離的接觸，黃賓虹、王一亭、潘天壽等均有交集；此外，他也對當時引領風騷的中國畫派有相當的熱情。依據林玉山的回憶，陳澄波每年暑假必定從上海返台，也會帶回中國近代名家之畫集。他說：

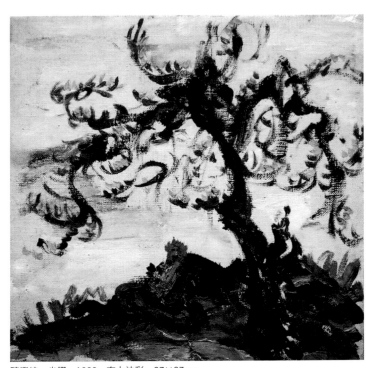

陳澄波 坐禪 1933 布上油彩 27×27cm

「陳先生帶回來的中國近代、現代畫家之畫集，大部分是以上海為中心，如任伯年、胡公壽、吳昌碩、王一亭（震）、張大千、劉海粟、潘天壽（授）、王濟遠、林風眠、徐悲鴻、謝公展等，就中有古派又有新派之國畫。新派者如劉海粟、王濟遠、林風眠、徐悲鴻等，於傳統畫風之中均融有西畫之長處，當時我對他們的作品感覺很新鮮。」[15]

陳澄波來到上海，除了工作，也另有一份對文化的嚮往。據陳重光先生的回憶，老師石川欽一郎曾鼓勵他說，到上海可以接觸到中國的藝術文化。[16]那個年代，許多台灣的知識分子都對「祖國」存著一份景仰之心；陳澄波在上海，對活躍一時的海上派尤其關注。海上派屬揚州八怪一脈相承的文人畫脈絡，因此剖析文人畫的美學內涵，是探討陳澄波「淡彩裸女」風格的重要參照。

對於文人畫的美學特點，近代名家陳師曾[17]的分析頗為精闢，表達了他對文人畫的理解和評價，及其所追求的藝術理想。他寫道：

「文人畫首貴精神，不貴形式，故形式有所欠缺而精神優美者，仍不失為文人畫。文人畫中固亦有醜怪荒率者，所謂寧樸毋華，寧拙毋巧，寧醜怪毋妖好，寧荒率毋工整；純任天真，不假修飾，正足以發揮個性，振起獨立之精神，力矯軟美取姿，塗脂抹粉之態，以保其可遠觀不可近玩之品格。」

「蓋藝術之為物，以人感人，以精神相應者也。有此感想，有此精神，然後能感人而能自感也。」[18]

陳澄波在1937年的〈製作隨感〉中談及文化認知的問題時曾提到倪瓚、八大山人、梵谷、雷諾瓦等中西畫家。至於對繪畫的觀念則認為：

「將實物理智性地、說明性地描繪出來的作品沒有什麼趣味。即使畫得很好也缺乏震撼人心的偉大力量。任純真的感受運筆而行、盡力作畫的結果更好。」

兩者的說法如出一轍，可見陳澄波受文人畫美學的感染極深。由於淡彩畫與水墨畫的媒材特性接近，因此，文人美學觀點的呈現——筆墨韻味的追求——在「淡彩裸女」中比在他的油畫中要來的清晰可辨。

　　作為中國畫核心技法的筆墨，在近代文人畫中，既是形式，也是內容；所謂「逸筆草草」、「胸中逸氣」，最後都體現在筆墨韻味中。「淡彩裸女」突破細枝末節的束縛，強調「神似」而非「形似」；由形體的輪廓線轉化為輕盈流轉的逸氣書寫，由表現人物量體的明暗著色轉化成詩意橫溢的皴擦渲染。以〔坐姿裸女-32（121）〕（頁317）為例，這件疑似畫於最後階段的作品來看，其對自然形體的不在意與恣意揮灑的筆墨，正是對著重筆情墨韻之文人畫美學的體悟與表現。

伍、淡淡的波希米亞風

　　〔臥姿裸女（71）〕（頁327）畫一個半俯靠在床上的裸女，窗簾及物件刻畫較為詳細，且全幅著色，雖然仍屬淡彩，但趣味上與其他畫作完全不同，而在「淡彩裸女」系列中顯得極為獨特。本作充滿陽光的溫馨感，給人舒緩平和的感受，卻嗅不到一絲文人氣。這件作品讓人聯想到的是1920年代馬諦斯（Henri Matisse, 1869-1954）在尼斯所畫的許多裸女畫。由於未標明時間，難以判斷其在系列畫作中創作的先後順序，但陳澄波裸女畫與西洋裸女畫傳統的淵源，則不待贅言。

　　西方裸女畫自馬內（Edouard Manet, 1832-1883）以來，已完全拋棄學院規範的箝制，也擺脫了社會道德的制約，而且不排除隱藏其中的情慾意涵。〔躺著的裸體〕是莫迪里亞尼1917年的作品，在淒美中散發出異樣的情色味道；莫迪里亞尼是「巴黎畫派」的代表性畫家，他的裸女畫獨樹一幟，在二十世紀早期顯得特別亮眼。

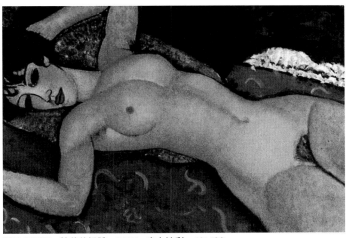

莫迪里亞尼　躺著的裸體　1917　布上油彩　60×92cm

　　「巴黎畫派」畫家多為異鄉客，帶有波希米亞主義的傾向；他們一般寄身在閣樓與小屋中，貧窮、病痛與消沉是他們生活的寫照；沈溺於酒精與麻藥中，創作內涵充滿著悲傷、回憶與夢想；他們生活浪漫不羈，藝術中帶著濃濃的異國腔調，生命中有著悲劇性的孤寂感。

　　廣義的巴黎畫派其實範圍廣闊，泛指1910至1940年間，由約一百多位外國畫家在巴黎蒙帕那斯區（Montparnasse）所引發的一種畫風。畢卡索（Pablo Picasso, 1881-1973）、凡東榮（Kees Van Dongen, 1877-1968）以及一些法國畫家，德朗（Derain, 1880-1954）、弗拉曼克（Maurice de Vlaminck,1876-1958）、尤特里羅（Maurice Utrillo, 1883-1995），甚至是馬諦斯都曾被歸類到這個畫派中，幾乎涵蓋了那個年代在巴黎創作的所有畫家。這個畫派中的著名畫家，如夏卡爾（Marc Chagall, 1887-1985）、莫迪里亞尼、史丁（Soutine, 1894-1943）、奇斯林（Moïse Kisling, 1891-1953）以及帕散（Julius Pascin, 1885-1930），他們都是猶太人。而潘玉良、常玉與藤田嗣治三位來自東方的畫家也可以歸入其中。

　　在這些藝術家的作品中，往往混雜著許多異質元素，有憂傷、有鄉愁，也有詩意般的美麗。他們都歷經過戰爭的殘酷，也想在作品中表達他們的情緒、渴望、熱情與痛苦，並企圖以女性裸體，滿足他們亟想捕捉美好片刻的渴望。莫迪

里亞尼是巴黎畫派中最重要的成員，他生活在貧困之中，既執著地追求藝術，又沉迷於女人、酒精和毒品，處在絕望的孤獨裡，使他的裸女畫風即使情色飄盪，卻總帶有一股浪漫哀傷的情調，創造了一種特殊的裸女畫類型，把第一次大戰之後巴黎社會的不安與藝術家的內心世界給形象化了。

作為一個異鄉人，潘玉良與同一時期都在巴黎的同胞畫家常玉與日本畫家藤田嗣治，都在「巴黎畫派」強烈氣流的籠罩之下，畫風都呈現出一種具東方情調的淡淡鄉愁。十九世紀末以來，巴黎就是藝術之都，全世界藝術家的仰望之地，「巴黎風格」其實也是世界風格；在同一個時期寓居北京的台籍畫家王悅之（原名劉錦堂，1894-1937）也呈現類似的風味。

潘玉良1928年回到上海，也帶回了這種巴黎色彩──波希米亞味，並與20年代的上海的裸體風波形成共振；陳澄波的「淡彩裸女」似乎就是這場共振下的產物。我們難以論斷陳澄波畫中淡淡的波希米亞味與潘玉良的關係，卻無法否認作為國際都會的上海也處在這種國際風潮的吹拂下，而潘玉良無疑是這種風潮適時的觸媒。

十里洋場在醉人的歌舞昇平中，也潛藏著不安的因子；發生在東北九一八事件、上海的一二八事件都在陳澄波的心中投下陰影。獨在異鄉為異客，日本人的陳澄波、台灣人的陳澄波與「祖國」的陳澄波，三種身分彼此交纏，他內心深處那份孤寂，也許正如「淡彩裸女」所散發的波希米亞風一般，飄蕩著一股幽幽鄉愁。

六、結語

陳澄波在《毛毛雨》的歌聲中走入上海；1934年6月6日，在周璇《何日君再來》[19]的歌聲尚未響起之前，就打包返台，準備投入另一階段的藝術人生。縱浪上海灘，他一本對藝術的狂熱，不僅化身為油彩，也隱身入淡彩中，一探文人美學的「虛實」；另一方面，也赤裸的暴露在世界性思潮下，沾滿一身波希米亞的味道。「淡彩裸女」的寫意風格，是一種詩意體現；把現實中的五光十色、身分的糾結與對藝術的思維，都鎔鑄其中，呈現為一片詩意幽遠的筆墨韻味。

陳澄波的上海時期是一趟藝術探索的旅程。除了豐富的油彩創作，1931-1932年間的淡彩人物速寫，尤其是其「淡彩裸女」，開展了他繪畫的另一個面向；跳脫「南國色彩」的侷限，也以豐富的人文思維擴張了他的藝術內涵。

「淡彩」作品保存不易，在長期塵封之下，今天仍能以完整面貌出現，本文最後要向用心呵護這些作品的家屬，表達最高的敬意。

撰文／陳水財*

【註釋】

＊ 陳水財教授，原任教國立成功大學建築系所、台南應用科技大學美術系所，為國內知名畫家及藝術評論家，曾主編《炎黃藝術》、《山藝術》，並獲2011年高雄文化獎。

1. 「淡彩畫」，是指先用鉛筆等工具畫出對象輪廓或明暗，再以透明水彩著色的一種畫法。

2. 《毛毛雨》是黎錦暉在1927年創作、1929年由女兒黎明暉演唱並錄製成唱片的歌曲，後來被公認為中國第一首流行歌曲。

3. 參見熊月之〈上海租界與文化融合〉http://www.lw23.com/paper_61650841/ 2012.2.20 15:00。

4. 「三大文妖」指的是：編纂《性史》的張競生，主張在美術課堂中公開使用人體模特兒的劉海粟，以及譜寫「靡靡之音」《毛毛雨》的黎錦暉。

5. 舊上海「十大名媛」包括：潘玉良、周璇、張愛玲、阮玲玉、王人美、秦怡、蝴蝶、上關雲珠、黎莉莉、龔秋霞等。參見 http://www.hudong.com/wiki/%E6%BD%98%E7%8E%89%E8%89%AF 2012.2.26 14:00。

6. 明信片上以毛筆寫上：「萬國開畫展 此口在雪黎 澳南春正好 聊以祝新禧 讚化 玉良 同賀 元旦」

7. 此畫曾刊印在正修藝術中心出版（2011），《民族到土地——陳澄波作品中的文化意涵》的封底。

8. 參見黃冬富〈陳澄波畫風中的華夏意識——上海任教時期的發展契機〉，收入嘉義市政府文化局發行（2011）《檔案・顯像・新「視」界——陳澄波文物資料特展暨學術論壇論文集》，頁27-44。

9. 同註8。

10. 同上註。

11. 參見吉田千鶴子撰，石垣美幸譯〈陳澄波與東京美術學校的教育〉，收入嘉義市政府文化局發行（2011）《檔案・顯像・新「視」界——陳澄波文物資料特展暨學術論壇論文集》，頁21-25。

12. 同註8。

13. 參見謝佩霓〈「決瀾社」與陳澄波〉，收入正修藝術中心出版（2011）《民族到土地—陳澄波作品中的文化意涵》，頁9-10。

14. 永田一脩（1903-1988），是日本二戰之前的前衛藝術家，提倡普羅藝術；プロレタリア為Proletariat之日譯，中文譯為「普羅」，即平民大眾之意。

15. 參見林玉山〈與陳澄波交由之回憶〉《雄獅美術》106期，頁60-65。另參同註8。

16. 參見《台灣百年人物誌——陳澄波》，財團法人公共電視文化事業基金會發行，2005。

17. 陳師曾（1876-1923），又名衡恪，號朽道人、槐堂，江西義甯（今修水）人。曾留學日本，善詩文、書法，尤長於繪畫、篆刻；著有《中國繪畫史》、《中國文人畫之研究》、《染蒼室印存》等。

18. 參見陳師曾〈文人畫之價值〉http://www.douban.com/group/topic/1423995 2012.2.20.16:30。

19. 《何日君再來》劉雪庵（1905-1985）作曲，貝林黃加謨作詞，1937年由名歌星周璇唱紅；優美中帶著傷感，成為1930年代上海情調的最佳寫照。

Light Brushstrokes, Strong Poetic Sense:
The Style of Chen Cheng-po´s Watercolor Nude Sketch

The watercolor sketch[1] that Chen Cheng-po created in 1931 and 1932 differ greatly from his other works, suggesting an alternative aspect of his art. From 1929 to 1933, Chen sojourned in Shanghai as an instructor at Xinhua Art School and Changming Art School. Most of these works may have been used to demonstrate drawing techniques to students in class. Compared to his heavily-layered figure paintings, the watercolor sketchs seem to have been improvised, and therefore look particularly lively.

Chen's watercolor sketches are worth studying. Most believe that Chen's painting style changed a great deal while in Shanghai, under the influence of the Chinese literati painting. Is it possible to analyze his watercolor sketch from this perspective too ? Can the special aura of Shanghai's cultural scene around 1930, as well as the artist's relationship with the Shanghai literati, be factors affecting these unique works ? How was Chen's relationship to other contemporary Shanghai painters ? The artist's simple drawing style resembles the School of Paris strand of French art between the two world wars. Amedeo Modigliani, Chaim Soutine and Maurice Utrillo were among the representative artists of the school. More specifically, were the drawings related to Chang Yu and Pan Yu-liang, two Chinese painters residing in France at the time ?

Following these leads, this article aims to reveal a different aspect to Chen's art by discussing the style and meaning of the watercolor sketches on female nudes by Chen Cheng-po.

I. Shanghai in an opportune time

In 1929, Chen Cheng-po arrived in Shanghai when "Drizzling Rain"[2] was heard throughout the city. By setting foot in Shanghai, the artist also entered the concession area of art.

Shanghai was the most advanced metropolis as plenty of fashion trends had been introduced to the city since the 1920s. In fact, it had not developed into an international hub from a traditional central city. It was created by domestic and overseas immigrants as concessions were made in the 1840s, which also provided easy access for the import of Western culture to the city. It is because Shanghai's population was mainly composed of immigrants that it lacked a traditional literati class — and a hegemonic power — which in turn facilitated the exchange and mingling of heterogenic cultures. Modern Shanghai was neither completely a Chinese nor Western city, but a fantastical mix of cultures. It was where the East and the West coexisted, mingled, and integrated into each another. That was why Shanghai was called a "cultural melting pot." [3]

Shanghai was truly the most prosperous and internationalized metropolis in Asia during the 1920s and 1930s. A city praised as the "Tantalizing Ten-Chinese-Mile Foreign Concession Area," in addition to ongoing business activities, arts and culture at their best also congregated here. In an opportune time, Chen came to Shanghai and witnessed its prosperity and diversity. Inspired by the glamorous city, he created plenteous collection of artwork.

The Haishang Painting School and the Eight Eccentrics of Yangzhou

Not long after its port was opened, Shanghai replaced Yangzhou as the most prosperous city in southern China in the mid 19th century. Just as Yangzhou, which flourished on salt trade and cradled the Eight Eccentrics of Yangzhou in the mid-Ching Dynasty, Shanghai, with its burgeoning trade, affluent patrons and literati, and artists from around the country, bred the Haishang Painting School.

The Haishang Painting School was formed around the same time when Shanghai Harbor was inaugurated. Most Haishang painters, influenced by the Eight Eccentrics of Yangzhou, expressed certain provocative tone of creativity. There were many noted Haishang painters in the 1920s — Wu Chang-shuo, Wang Meng-bai, Wang Xue-tao, Tang Yun, Wag Yi-ting, Chen Shi-tseng, Huang Pin-hung, and Pan Tien-shou. Their paintings were expressive and unrestrained with a tinge of old-time simplicity. Most of them were highly productive because they made a living by painting. This corresponds with the fact that Shanghai was a commercial city.

In addition to socializing with wealthy merchants in a refined way, the Haishang painters also gained important posts in the academia.

In the cultural circle of Shanghai, Wu Chang-shuo was an exemplary predecessor. Pan Tien-shou held a teaching position at the Shanghai Art School ad Xinhua Art School. Huang Pin-hung was a professor of the Shanghai Art School specializing in traditional Chinese painting theory, poetry and prose. He was also an instructor at the Xinhua Art University. Chen Shi-tseng was active in Beijing. He was an instructor at the Beijing Normal College and the Chinese Painting Group of the Beijing University Painting Society, and a professor in Chinese painting at various art schools. Wang Yi-ting was a luminous artist and a politician of the time. On a relevant note, Hsu Pei-hung was the dean of the Beiping Art School, head of the Department of Fine Arts of Nanguo Art College, professor of the National Central University in Nanjing, and dean of the Suzhou Art School. Although he did not belong to the Haishang Painting School, he was closely involved and profoundly influenced the art circle in Shanghai.

Of the noted Haishang painters, Chen Cheng-po especially socialized with Huang Pin-hung, Wang Yi-ting and Pan Tien-shou during his stay in Shanghai.

Liu Hai-su and the nude painting scandal

Most Haishang painters shared similar values with the traditional society and enjoyed life in the city like fish swimming in water. However, some challenged tradition, resulting in waves of controversy in the society. A famous example was the "Three Literati Demons of Shanghai" in the 1920s. 4 Nevertheless, in terms of life or culture, Shanghai was a place where the new met the old, and the orient paralleled with the occident. Amidst the clashes and integration, the Shanghai society continued to incur drastic changes and metamorphosized swiftly along an inspiring path.

As one of the "Three Literati Demons," Liu Hai-su was the one that aroused tempestuous disturbance in the Shanghai art scene in the 1920s.

In 1917, nude paintings were displayed at the Shanghai Art School, for which the school dean Liu Hai-sui was criticized as a traitor of art and a pest to the educators' community. Soon after, Liu started calling himself the traitor of art. In 1920, Liu hired a female nude model named Chen Hsiao-chun, to pose for hisstudents. It was the first time a nude model appeared in class, and a rumor that the "Three Literati Demons have emerged in Shanghai" spread like wildfire. In 1925, Liu was further branded a traitor of ethical principles and manners. A year later, the government banned teachers and students of the Shanghai Art School from making nude paintings and the general Sun Chuan-fan issued an order to dismiss all nude models. In 1927, Liu became a wanted criminal for being a "scholar-tyrant". While Liu escaped to Japan, the government attempted to clamp down on the school. Luckily, the school was located in the French concession which made it free from Chinese laws and was not affected substantially.

The nude model incident was a huge scandal and hot topic in the 1920s. While it may be overly simple to relate the nude painting scandal to the conservative thought and trends of the time. But the topic gave a glimpse to how Shanghai's social transformation from old to new, mixture of eastern and western elements, in its glaring complexity, also manifested in culture and art. Other than the prominent Haishang Painting School, pent up cultural energy was on the verge of explosion and would soon transform into the stunning "flowers of Shanghai." The waves of controversy that Liu raised in Shanghai undoubtedly injected refreshing vigor into the veins of Shanghai's art community. Other than the traditional Haishang literati, alternative paths were integrated into the rich cultural diversity in Shanghai.

Eventually, nude painting became commonplace in art academies, and Chen was rendered a scandal-free environment to create nude paintings. Consequently, Liu's story can be seen as a foreshadowing event to Chen's considerable creations of line-and-wash female nudes later on.

The many faces of Pan Yu-liang

Pan Yu-liang (1895-1977) endured a painful life before she became a prominent painter. She was such a legend that a film *Painting Soul*

(1994) was made to pay tribute to her accomplishments. In 1918, Pan was admitted to the Shanghai Art School and studied painting from Wang Chi-yuan and Chu Chi-chan. Upon graduation in 1921, she gained sponsorship from the Anhui Provincial Government to study in France. During her stay in Europe, she studied at Ecole Nationale Supérieure des Beaux-Arts de Lyon, Ecole Nationale Supérieure des Beaux-Arts in Paris, and Accademia di Belle Arte di Roma. In 1928, on invitation from Liu Hai-su, Pan began to teach at her alma mater, the Shanghai Art School. She also held a solo exhibition in town which led to the publication of the *Pan Yu-liang Catalogue* by the Zhonghua Book Company, for which she was praised as the first female modern painter in China. In addition, she gave lectures at the Xinhua Art School and served as a professor at the National Central University and Nangjing Normal University. During that time, Hsu Pei-hung, whom she befriended in France, was the dean of the NCU.

Although one of the pioneers of the School of Paris, Amedeo Modigliani (1885-1920) had passed away during her stay in Paris, the school continued to attract followers from around the world. Painters of the school adopted an exaggerated approach, often using distorted forms and strong colors to portray the tragic loneliness of life. Like many of them, Pan lived in the Montparnasse district of Paris. As a result, her works carry some elements from the School of Paris.

Upon her return to Shanghai, Pan caused a stir not only because of her personal background, but because she introduced the aura of Paris to Shanghai. The paintings of Pan, in the lonesome, nostalgic style derived from the School of Paris, infused the scent of the French city into Shanghai's atmosphere. Chang Yu, a fellow painter of Pan while in Paris, had not returned to China but chose to remain in France. In 1929, he was already a prominent figure and known to the art community of Shanghai for oriental paintings that induced strong feelings of poignance and nostalgia.

Pan was a much discussed subject among the Shanghai literati. Like singer-star Chou Hsuan, writer Eileen Chang, and actresses Ruan Ling-yu and Hu Tie, she was praised as one of the "Ten Female Celebrities" of old Shanghai.[5] However, her prostitute then concubine-turned-painter past and nude paintings were not accepted by society of the time. She was constantly trapped in public disputes despite that she also led the trends. After much struggle, Pan left Shanghai for France again in 1937. She settled down in Paris and lived there until herdeath.

Pan and Chen befriended one another as their stays in Shanghai overlapped. The postcard from Pan and her husband to Chen, kept at the Cultural Affairs Bureau of Chiayi City[6] is solid proof of their friendship.

II. A trip to Shanghai in dazzling rain

Chen arrived in Shanghai accompanied by the song "Drizzling Rain," to teach at Xinhua Art School, Changming Art School, and Yiyuan Painting Institute successively. He actively participated in events held by local painting societies as he hoped to expand his personal network and artistic horizon.

One can get a glance of Chen's social life through an ink fruits painting kept by the Chen family.[7] Traces of the artist's social activities are well kept in this picture. According to Professor Huang Tung-fu,

In the picture, Chang Ta-chien portrayed lotus flowers (water lilies), Chang Shan-tsi depicted lotus roots, Yu Chien-hua painted water chestnuts, and Yang Ching-pan illustrated water melons. Wang Chi-yuan wrote an inscription for it as follows (the punctuation marks are added by the writer (Huang Tung-fu),

"It is the time of Hsiaoshu (moderate heat) in the year of Yisi (1929). As Ta-chien and Chien-hua are traveling eastward, the members of Yihuan hold a farewell banquet for them. Inspired by drinks, we decided to create ink-and-wash paintings together, all of which are enjoyable and inspiring. We hereby give this painting to Cheng-Po as a memorial gift. Chi-yuan." [8]

Chang Ta-chien, Chang Shan-tsi, Yu Chien-hua and Yang Ching-pan as mentioned in the inscription were members of Yiyuan. And Wang Chi-yuan, the artist who wrote the inscription was the head of the painting institute and recommender of Chen for his teaching opportunity in Shanghai. Although this painting was casually made while socializing, it vividly portrays Chen's social activities in Shanghai. In "Huaxia Consciousness in Chen Chen-po's works: opportunities for the artist during his teaching years in Shanghai," Professor Huang gave a clear account of Chen's personal network at Xinhua Art School:

"When Chen taught at the Xinhua Art School, the faculty staff included Yu Chi-fan and Wang Ya-chen who had studied in Japan, Wang Ching-lan (Ji-chang) and Pan Yu-liang who had studied in France, renowned Haishang School painters Pan Tien-shou, Chu Le-san, Chu Wen-yun and Hsiung Sung-chuan (Keng-chang), and Chinese art historian Yu Chien-hua. His colleagues, from different backgrounds and with various specializations, helped Chen expand his horizons. Not long after he started teaching at the Xinhua Art School (1929), Chen took a trip to Japan with Pan Yu-liang (head of the Western Painting Department, Shanghai Art School), Wan Chi-yuan and Chin Kan-ching (professor of the Shanghai Art School) as assigned by the Ministry of Education to see how art and crafts were developed there. It is perhaps because of the trip that Pan had befriended Chen and invited him to give lectures at the Xinhua Art School and Yiyuan Painting Institute the following year. Even after Pan returned to Europe years later, she still kept in touch with Chen by mail."[9]

And on the subject of the Changming Art School, Huang said,

"[…] Famed Haishang painter and calligrapher Wang Chen (Yi-ting) was the school principal, Chu Wen-yun served as the head of academic affairs, and Wan Hsien (Ke-yi) was the head of the Chinese Painting Department. All of them were students of Wu Chang-shuo (1844-1927). In addition, the deputy principal and administration officer Wu Mai (Tung-mai) was Wu Chang-shuo's third son. This shows how the school was strongly related to Wu. What's more, Wang Ti-po (Ji-chang) was the head of the Western Painting Department, Pan Tien-shou served as the leader of the Chinese painting group of the Art Education Department, and Chen Cheng-po was the leader of the western painting group of the same department…"[10]

In "Chen Cheng-Po and Education at the Tokyo School of Fine Arts,"[11] Yoshida Chizuko noted that, while Chen taught at the Xinhua Art School, he wrote a letter to an officer at the painting teacher's department of Tokyo University of the Arts (formerly Tokyo School of Fine Arts). The letter serves as a good reference to Chen's social life in Shanghai, too. In the letter, Chen not only introduced the art community of Shanghai, but also gave a clear account of how the community received Masaki Naohiko, the principal of Chen's alma mater (i.e., Tokyo School of Fine Arts). Painters welcoming Masaki included traditional Chinese painters Wang Yi-ting, Chan Ta-chien, Li Chiu-chun, and Ma Wang-jung, as well as oil painters Chen Pao-yi, Wang Ya-chen, Chiang Hsiao-chian, Hsu Ta, and Wang Tao-yuan. Other than Chen, Chiang Hsiao-chien, Chen Pao-yi, Wang Ya-chen, Wang Tao-yuan and Hsu Ta also graduated from Tokyo University of the Arts. This reveals another aspect of Chen's personal network in Shanghai.

In addition, Chen was an active participant in various exhibitions and club gatherings. According to Huang,

"Ever since he began giving lectures at various schools such as the Xinhua Art School and served as the dean of the Western Painting Department, Chen quickly became a prominent figure in the painting community of Shanghai. The first national fine art exhibition kicked off on April 10, 1929 in Shanghai. That was not long after Chen gained a teaching post at Xinhua. At a young age of 35, it was an honor for him to be invited to be a review committee member of the exhibition……"

"At the first national fine arts exhibition in Shanghai, 1929, faculty staff from the Shanghai Art School, which had a close relationship with Liu Hai-su, as well as members of Tienma and Yiyuan, devoted themselves to the exhibition affairs. Wang Chi-yuan, who was a close friend of Chen Cheng-po, also served as the founding committee's arrangement leader. They may have recommended Chen to be a review committee member despite his relatively recent arrival to Shanghai. Chen's experience with fine arts exhibitions, his degrees and work experiences also made him an popular candidate." [12]

In 1931, out of chance, Chen became one of the five founding members of the Storm Society, the most important painting society in modern China. Members and affiliated friends of the society included Pan Shun-chin, Ni Yi-te, Wang Chi-yuan, Chou Tuo, Chia Ping-you, Liang Pai-po, Chen Cheng-po, Yang Tai-yang, Yang Chiu-jen, Tseng Chi-liang, Chou-mi, Teng Yun-ti, Chou Chen-tai, Chang Hsuan, Chiu Ti, Kuan Liang, Liang Hsi-hung, Li Chung-sheng, Chou Pi-chu, Tseng Chi-liang, and Li Pao-chuang. They were all excellent painters of the time.[13]

The concession territories of Shanghai, compared to Tokyo and Taipei, was a much more accommodating and international environment. It not only took in many different cultures, but also attracted great talents from around the world. While riding cultural waves along the Shanghai Bund, Chen had his horizons expanded and his mind opened. He did not seem to be lonely at all. He remained a passionate artist, and dedicated his time to teaching and participating in art-related activities. Judging from the considerable amount of paintings he made during this time and although Chen lived in a foreign land, his crave for artistic creation continued fiercely. The objects that he left behind and his painting "My Family" (1931), which featured Nagata Isshu's *Theory of Proletariat Art*[14] book placed in front of himself illustrates that Chen was hungry for knowledge. He plunged himself into the new environment, trying to learn and paint as much as he could. As a result, his painting style was transformed. It was generally believed that he was under the influence of "Huaxia (Chinese) aesthetics" during the Shanghai period. From the third year on (1931) in Shanghai, Chen started creating refreshing line-and-wash figure drawings. The drawings seem to embody the artist's thoughts during his opportune stay in Shanghai.

III. Female nudes, in expressive watercolor sketch

Chen created around 408 watercolor sketches during his lifetime, 325 or 80 percent of which are female nudes. As marked on the canvas, the earliest one was made in October 1931, and the latest one on May 1932. As many as 194 of them were made in January 1932; 31 were created before the end of May in the same year; and 79 were undated. At present, no literature suggests why or how Chen created so many watercolor female nude sketches in January 1932. Interestingly, the artist only started painting female nudes in March 1929, two and a half years after he arrived in Shanghai.

The creative period of Chen's 1 watercolor sketches spanned a mere eight months between October 1931 and May 1932. The 79 undated drawings were probably made in 1931 according to the techniques used. The same applied to Chen's other paintings, such as portraits, studio paintings, group portraits and figure paintings: they were all made after October 1931. Thus, undated works were mostly likely made at an earlier time. To provide a clearer account, only the drawings marked with dates, namely, those made in 1931, January of 1932, and May of 1932, are discussed in this article. In the following paragraphs, their creative approaches and backgrounds are analyzed.

1931

In this corpus, only 15 watercolor nude sketches were made in 1931. I will only examine four of them in this section. "Seated Nude-31.10.8 (1)" (p.38), made in October 8, 1931, is the earliest of all. The pencil lines, closely following the wrinkles of human skin and the contours of the human body, are pithy and right to the point. Using simple lines, the artist managed to depict the minute movements of the

human body. The nude, vividly portrayed, manifests the artist's detailed observations and excellent drawing skills. The lightly-painted colors, moreover, create additional charm for the drawing. "Standing Nude-31.11.18 (1)" (p.40) depicts a model from the front. The lines in this drawing are even more simple, light and succinct. Together they form a carefree, well-rounded human body. "Seated Nude-31.12.7 (6)" (p.46) is composed of flowing lines. They are so flowing that the human body seem to become part of the lines. While the lines and the human body do not match as perfectly, the human body exudes a poetic sense. The drawing seems to carry a profound though obscure meaning. "Standing Nude-31.12.28 (4)" (p.49) was painted on December 28. It was also the last one painted in 1931. The artist used colors to cover the pencil lines. Overall, the drawing is more rough than smooth. The slanting texture strokes make up the human body, and they are not confined by it. In this improvisational, free-flowing work, "hollow strokes" were also used to add extra texture to the human body.

The 1931 works suggest two key developments in Chen's watercolor sketches. In terms of lines, Chen closely followed the lines of human skin and body, hoping to portray his models as realistically as possible, as shown in "Seated Nude-31.10.8 (1)" (p.38) and "Standing Nude-31.11.18 (1)" (p.40). It was not until later that he began to draw more expressive pencil lines, as shown in "Seated Nude-31.12.7 (6)" (p.46) and "Standing Nude-31.12.28 (4)" (p.49). Interestingly enough, this approach make the subjects livelier and more unique. Likewise, Chen also learned to break away from the concern of shading, using it as a pictorial method to express his thoughts.

Watercolor sketches, mostly used as drafts, are nothing new in the history of Western art. Renowned painters, such as Peter Paul Rubens (1577-1640), Antoine Watteau (1684-1721) and Francisco Goya (1746-1828), had all left works of this sort to the world. However, judging from the artist's motivation and the message delivered, Chen's watercolor nude sketches are not just drafts. They manifest the artist's ambitious pursuit of utmost beauty.

January 1932

In January 1932, Chen painted 194 watercolor nude sketches in just a month — a feat worth paying extra attention to. In these drawings, the lines go far beyond the human body. Expressive, they seem to move like flying dragons or winding snakes on the paper. In addition, the painted colors look much more liberating than before. With improvised dots and wash, the artist expanded the small drawings into a vast world where his heart ran wild. Chen seemed to not only enjoy creativity; he manifested a strong artistic ambition.

In "Lying Nude-32.1 (13)" (p.89), a female nude lies with her face facing the ground. The flowing lines complement the graceful female body, while the colors wash away the boundary between the body and the empty background. The human flesh is thus transformed into a lyrical, poetic space. The lines in "Seated Nude-32.1 (19)" (p.72) are brisk and bright. When the female body is refined into meaningful lines, the aesthetic ideal seems to come out at the artist's call. Upon seeing the drawings, all worldly disturbances seem to be gone, and the nude model scandal of the 1920s also comes to an end. As it turns out, the world of nude is also the world of art. Nudity has nothing to do with sexuality or morality. It makes people forget about schemes. It makes people linger and stay. The drawings as shown in "Seated Nude-32.1 (31)" (p.93) and "Seated Nude-32.1 (46)" (p.127) are slightly different in style, but manifest the same ideal. During this time, Chen also created some "double portraits" like "Seated Nude-32.1 (41)" (p.438), "Seated Nude-32.1 (38)" (p.106), and "Standing Nude-32.1 (23)" (p.155). Most of them show the same model from two different angles. It can be seen that Chen strove to make changes to drawings, creating a more diversified world of art.

Chen indulged himself in drawing so fully that he created many of them in January 1931. One can see that he experimented and explored different approaches in these works. In "Seated Nude-32.1 (55)" (p.153), the artist used almost "random" lines to depict the female body. He even used bright colors — something hard to find in his other works. He applied dark black ink to draw the contour of the body, and then used slanting and vertical brushstrokes to add more details. This makes it a unique drawing and a good example of how the artist explored different techniques. It seems that, during this period, some of the artist's ideas began to sprout. This may explain why he created so many works in such a short time — Chen might have been studying a certain artistic theme. When he started painting female nudes, he

had sojourned in Shanghai for nearly three years. As an enthusiastic artist, Chen explored and tried many things. It would make sense that he delved more deeply into art, and that he wanted to practice his ideas through the nudes. If this is true, the watercolor sketchs on female nudes may be a key to unlock the secrets of the artist's works.

May 1932

There are a total of 31 nude drawings made in May 1932. Their style, again, is different. In most cases, there is a heavy, dark line drawn with ink along one side of the female nude. This is also the most prominent feature in these drawings. In "Seated Nude-32.5.22 (111)" (p.289), some of the pencil lines can still be detected on the front side of the female body. The artist used heavy ink to mark out the woman's back before using a dry brush to accentuate the human flesh. In "Lying Nude-32.5.23 (58)" (p.293), a woman lies horizontally. The artist used a wet brush and slanting lines to draw the woman's back, creating a strong "wash effect" found in ink painting. "Lying Nude-32.5.29 (69)" (p.314), which is dated May 29, was also the last dated drawing of ink-and-wash female nudes that the artist made. He used thick yellow-green lines to accentuate the two lying figures' backs. The two thick yellow-green lines create such an overwhelming visual impact that they (and not the soft pencil lines) become the center of attention. This approach is worth further observation.

Near the end of this period, Chen attempted to break away from the confines of nude drawings with his playful brushstroke. "Seated Nude-32 (121)" (p.317) is a special drawing. It is only marked with its year of creation, 1932, and not the exact date. In addition, the words "Zhabei" were written on the margin, making it the only drawing marked with a location. The artist seemed to draw willfully. He was not restrained by the shape of human body or any existing rules. Reminiscent of ink painting, it is especially eye-catching among all of Chen's female nude drawings.

Chen stopped painting line-and-wash female nudes on May 29, 1932 for unknown reasons. Although the exploration lasted only eight months, Chen gained fruitful results which led to a brilliant new chapter in his artistic life. From the realistic to the expressive, and from female nudes to ink paintings, Chen's paintings continued to evolve in form and content, marking an axis of aesthetic thinking for his career.

IV. Heartfelt brushstrokes and literati temperament

"Meditation" was made in 1933. In this rather small painting, a monk meditates under a withered tree. The artist used heavy colors and a dry brush to make dots and washes. Not only was the theme uncommon to Chen's paintings, the simple yet wild brushstrokes are hard to find in his works. In fact, "Meditation" is reminiscent to the style of the Haishang School. This is theonly oil painting made by Chen during the "female nude" period. It goes without saying that the two are subtly related to each other.

Previously mentioned, the Haishang School was one of the most important painting schools in modern China. As a leading trendsetter during the mid 19th century in the art community of Shanghai, it continued as the mainstream in the 1920s. Closely related to the school, Chen Cheng-po acquainted himself with Huang Pin-hung, Wang Yi-ting, and Pan Tien-shou. In fact, he was genuinely interested in the mainstream Chinese painting school. According to contemporary painter Lin Yu-shan, whenever Chen returned to Taiwan every summer, he brought along painting albums of renowned modern Chinese painters. Lin noted,

"The painting albums of modern Chinese painters that Chen brought to Taiwan are mostly the painters in Shanghai, such as Jen Po-nien, Hu Kung-shou, Wu Chang-shuo, Wang Yi-ting (Chen), Chang Ta-chien, Liu Hai-su, Pan Tien-shou, Wang Chi-yuan, Lin Feng-mien, Hsu Pei-hung, and Hsieh Kung-chan. Some of them were traditional painters, and some of them were progressive painters. Those who integrated traditional techniques with a modern style include Liu Hai-su, Wan Chi-yuan, Lin Feng-mien, and Hsu Pei-hung. Their works were new to me at the time."[15]

Chen went to Shanghai not only for work, but also for its cultural atmosphere. According to the artist's son, Chen Tsung-kuang, Chen Cheng-po's instructor, Ishikawa Kinichiro, had encouraged him to learn the Chinese art and culture in Shanghai.[16] During that time, many Taiwanese intellectuals revered China as their motherland. Therefore, when Chen was in Shanghai, he paid particular attention to the much active Haishang Painting School. Because the school developed from the tradition of the literati painting of the Eight Eccentrics of Yangzhou, it is essential to analyze the aesthetics of literati painting in discussing Chen's watercolor nude sketches .

In an insightful analysis of the aesthetic characteristics of literati painting by the illuminated painter Chen Shi-tseng[17], he expressed his understanding and comments of this painting category, as well as the ideals and pursuits of literati painters:

"Literati painting is about content, not form. Even when it is not very gracefully painted, as long as there is good content, it can be listed as a literati painting. In fact, some of the literati paintings are ugly, weird, and even carelessly made. This is because, in literati painting, plainness is preferred over sumptuousness, clumsiness over swiftness, ugliness over superfluous refinement, and sloppiness over rigidness. It is through a natural and unsophisticated approach that a literati painter can freely express himself, break away from conventions, and correct the pretentious mannerisms of today. In this way the painter will be respected, not profaned."

"The essence of art lies in its impact on the human mind. That is, a painter should be able to feel for the viewer, and express his feelings through paintings. Bearing this in mind, he will be able to move both himself and his viewer."[18]

In the 1937 article "Random Thoughts on Painting", Chen mentioned Chinese and European painters such as Ni Tsan, Bada Shanren (Chu Ta), Vincent van Gough, and Pierre-Auguste Renoir in regards to cultural identity. As for painting, he believed,

"There is not much fun for painters to represent the physical world realistically. Even when a painting truthfully depicts a subject in form, it will never bring an impact on people. Just follow your heart and express your feelings as much as you can with a paint brush. This will render a much better result."

The two artists' comments are almost the same. Thus, it can be said that Chen Cheng-po was profoundly influenced by the aesthetics of literati painting. In terms of the performance of medium, line-and-wash drawing is similar to ink painting. This also helps manifest Chen's pursuit after literati brushworks in his drawings on female nudes (and not in oil painting).

Ink and pen is the key to Chinese painting. In modern literati painting, it is both content and form. The so-called "free-flowing brushstrokes" and "unearthly temperament," which traditionally are part of the content, are eventually embodied through brushworks. Likewise, Chen's watercolor sketchs on female nudes break away from the convention of meticulous depiction, focusing on the "spiritual content," rather than "realistic form." In Chen's nude drawings, contours are used to express temperament, and colors and shades gave way to poetic expressions. The drawing in "Seated Nude-32 (121)" (p.317) is considered to be made on one of the last days of this period. The carefree-looking figures and lighthearted brushstrokes perfectly embodied the artist's view of literati painting which valued content more than form.

V. A Bohemian sentiment

In "Lying Nude (71)" (p.327), a female nude leans against her bed, with window curtains and other objects delineated in detail. Fully colored, it is also considered a watercolor sketch. However, the pleasure that it offers is totally unique, making it special among all other watercolor sketches on female nudes. Lit with bright colors of sunshine and infused with a sense of peace, it does not look like a literati

painting at all. Rather, it reminds one of the many female nudes painted by Henri Matisse (1869-1954) during the 1920s in Nice, France. Because no dates are marked on the drawing, it is hard to place it alongside other nude drawings in a time order. However, this drawing is still important in that it manifests the strong connection between Chen's nude drawings and the Western tradition of female nudes.

Since Edouard Manet (1832-1883), the Western painters have completely walked away from academy rules and social morality when painting nudes. They even dared to include erotic connotations in their works. Take Modigliani's 1917 painting "Lying Nude" as an example, an erotic element is pitted against the sorrowful beauty of the woman. As one of the representative artists of the School of Paris, Modigliani's female nudes stood out amongst others in the early 20th century.

Most of the painters of the School of Paris were Bohemian foreigners. They stayed in shattered attics and huts, with their lives characterized by poverty, sickness and despair. More often, they indulged in alcohol and drugs, and painted about sorrow, memories and dreams. The romantic and carefree artists were able to create extremely exotic works, but their lives were filled with tragedy and loneliness.

The School of Paris, in a broader term, refers to a trend initiated by more than a hundred resident painters in Montparnasse, Paris, from the 1910s to 1940s. Non-French painters like Pablo Picasso (1881-1973) and Kees Van Dongen (1877-1968), as well as French painters, like André Derain (1880-1954), Maurice de Vlaminck (1876-1958) and Maurice Utrillo (1883-1995), and even Matisse, are included in the category. Marc Chagall (1887-1985), Modigliani, Chaim Soutine (1894-1943), Moïse Kisling (1891-1953) and Julius Pascin (1885-1930) are among the famous Jewish painters of the school. The three oriental painters — Pan Yu-liang, Chang Yu and Léonard Tsugouharu Foujita also belong to the School of Paris. In fact, the school encompasses almost all of the painters residing in Paris at the time.

Many heterogenic elements are mingled in their paintings. There are themes of sorrow, nostalgia, and poetic beauty. Having lived through the cruelty of war, they were eager to express their mood, longings, passion and pain, and attempted to quench their own hope of capturing some moments of happiness by painting female nudes. For instance, Modigliani is one of the most prominent members of the School of Paris. Although he was dedicated to art, he often found himself in financial despair giving in to women, alcohol and drugs. Hence the coquettish female nudes he painted always carried a sense of romantic sorrow. These unique nude paintings not only manifested the inner world of the artist, but embodied the social unrest of post-war Paris.

As outsiders of the Parisian society, Pan Yu-liang, Chang Yu and the Japanese artist Léonard Tsugouharu Foujita created paintings with a touch of oriental nostalgia under the strong influence of the School of Paris. In fact, since the late 19th century, Paris had been the world capital of art, a much aspired place for artists around the globe. The Parisian style was also the style of the world. For instance, Taiwanese painter Wang Yue-Zhi (originally known as Liu Jin-Tang, 1894-1937), who resided in Beijing at the time, expressed a similar aura in his paintings.

Pan introduced Bohemianism to Shanghai upon her return in 1928, which resonated with the nudity scandal of the time. It seems that Chen's watercolor nude sketches are an outcome of the resonation. It may be hard to explicate whether the Bohemian touch in Chen's nude drawings has anything to do with Pan, but there is no doubt that Pan was a catalyst of the trend in the international city of Shanghai.

At the Ten-Chinese-Mile Foreign Concession Territories of Shanghai, unrest seeped into peace and prosperity. Not long after, the 918 Incident in northeastern China and the 128 Incident in Shanghai took place, casting shadows on Chen's mind. As a lone resident on a foreign land, a Japanese, a Taiwanese and a Chinese longing to be embraced by the motherland, Chen felt desolate. His Bohemian-style watercolor nude sketches conveyed his loneliness and homesickness.

VI. Conclusion

With the song of "Drizzling Rain" resonating in the air, Chen Cheng-po set foot on Shanghai. On June 6, 1934, before the debut of "When Will Your Return"[19] by singer-star Chou Hsuan, he packed up and returned to Taiwan, ready to turn a new page in his artistic career. During his stay in the metropolis, Chen rode the cultural waves along the Shanghai Beach, transforming his passion for art into oil paintings

and watercolor sketches while delving into the world of the Shanghai literati. There, fully exposed to the latest trends, he became almost like a Bohemian. Chen's expressive female nudes are a manifestation of artistic poetry. With his resplendent life, complicated identity, and thoughts on art etched on drawing paper, Chen's nudes become so poetic that they are worth being savored time and again.

Chen's journey to Shanghai was an artistic exploration. Other than his numerous oil paintings, in 1931 and 1932, the artist created plenty of watercolor figure sketches. In particular, the female nudes opened a new gate for his artistic career. He was able to break away from the confines of local color, and expand the idea of humanistic depth in his works.

It is not an easy task to preserve the watercolor sketches. I would like to express my utmost respect to the Chen family, who carefully looked after the drawings for many years. It is through their effort that the drawings can be presented in good condition today.

 *

∗ Professor Chen Shui-tsai used to teach at the Department of Architecture at National Cheng Kung University and the Department of Fine Arts at Tainan University of Technology. A renowned painter and an art critic, Chen is the former editor-in-chief for *Dragon Art Monthly* and *Mountain Art*. Chen was awarded the Kaohsiung Awards in 2011.

1. Watercolor sketches are outlined by tools such as pencil and then colored with diluted ink or watercolor.
2. "Drizzling Rain" was composed by Li Ching-hui in 1927. It was sung by his daughter Li Ming-hui, recorded, and released in 1929. The song is considered to be the first pop song in China.
3. Xong Yue, "Concession Territories in Shanghai and Cultural Integration." http://www.lw23.com/paper_61650841/ 2012.2.20 15:00.
4. "The Three Literati Demons" refer to Chang Ching-sheng, who compiled and edited the book *The History of Sex*; Liu Hai-su, who proposed that nude models should be used in painting class; and Li Ching-hui, who wrote the "decadent" song of "Drizzling Rain."
5. The "Ten Female Celebrities" of the old Shanghai include Pan Yu-liang, Chou Hsuan, Eileen Chang, Ruan Ling-yu, Wan Ren-mei, Chin Yi, Hu Tie, Shangkuan Yun-chu, Li Li-li, and Kung Chiu-hsia. http://www.hudong.com/wiki/%E6%BD%98%E7%8E%89%E8%89%AF. 2012.2.26 14:00.
6. On the postcard, it writes in calligraphy, "My paintings are being displayed at the world's fair in Sydney. The spring is wonderful here. Wish you a happy New Year. Tsan-hua and Yu-liang on New Year's Eve."
7. This painting was printed on the back cover of *From People to Land: the cultural messages delivered through Chen Cheng-po's works*. Cheng Shiu University Art center. 2011.
8. According to "Huaxia Consciousness in Chen Cheng-po's works: opportunities for the artist during his teaching years in Shanghai," by Huang Tung-fu, included in *Documents, Imagery and a New Vision: Chen Cheng-po Archives Exhibition and Seminar*, published by the Cultural Affairs Bureau, Chiayi City in 2011. pp. 27-44.
9. Ibid.
10. Ibid.
11. See "Chen Cheng-po and Education at the Tokyo School of Fine Arts," by Yoshida Chizuko, included in *Documents, Imagery and a New Vision: Chen Cheng-po Archives Exhibition and Seminar*, published by the Cultural Affairs Bureau, Chiayi City Government in 2011. pp. 21-25.
12. See note 8.
13. According to "The Storm Society and Chen Cheng-po" by Hsieh Pei-Hsia, included in *From the Nation to the Land: the cultural connotations in Chen Cheng-po's works*. Cheng Shiu University Art Center. 2011. pp. 9-10.
14. Nagata Isshu (1903-1988), an avant-garde artist prior to World War II in Japan, was dedicated to promoting pop art. "プロレタリア" was a Japanese translation of "proletariat." In Chinese, the term is translated as "pu-luo," meaning "the populace."
15. See Lin Yu-shan, "Recalling My Friendship with Chen Cheng-po," *The Lion Art Monthly*, No. 106, pp. 60-65. See also note 8.
16. See A Centennial Record of Celebrities in Taiwan: Chen Cheng-po, Public Television Service Foundation, Taiwan, 2005.
17. Chen Shi-tseng (1876-1923), a.k.a. Heng-ke, assumed names Xiu Tao-jen and Huai-tang, was born in Yining (known as Xiushui today), Jiangxi Province, China. The Japan-educated painter excelled in poetry, prose and calligraphy, and particularly in painting and seal carving. His published books include *The History of Chinese Painting*, *A Study on Chinese Literati Painting*, and *Seal Collection of the Jantsang Room*.
18. See Chen Shi-tseng, "The Values of Literati Painting". http://www.douban.com/group/topic/142399. 2012.2.20.16:30.
19. "When Will You Return" was composed by Liu Hsue-an (1905-1985). Beilin (Huang Chia-mo) wrote the lyrics. The song became a huge hit as it was sung by the famous singer Chou Hsuan in 1937. Graceful and sorrowful, it was the best embodiment of Shanghai in the 1930s.

淡彩速寫
Watercolor Sketch

1931

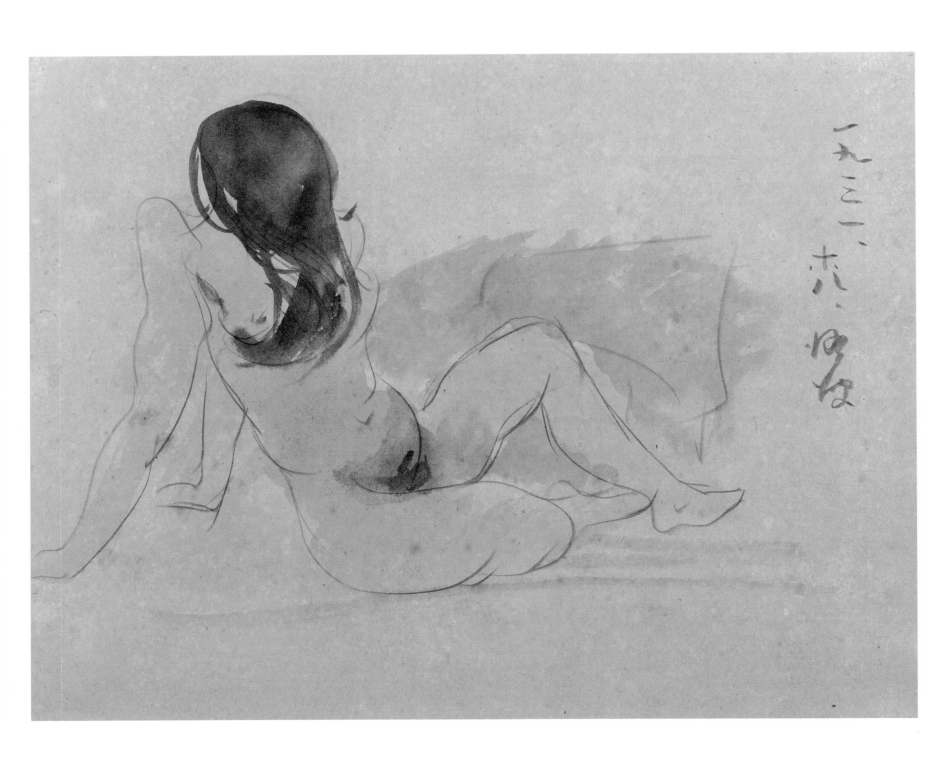

坐姿裸女-31.10.8（1）Seated Nude-31.10.8 (1)

1931　紙本淡彩鉛筆　27.5×36cm

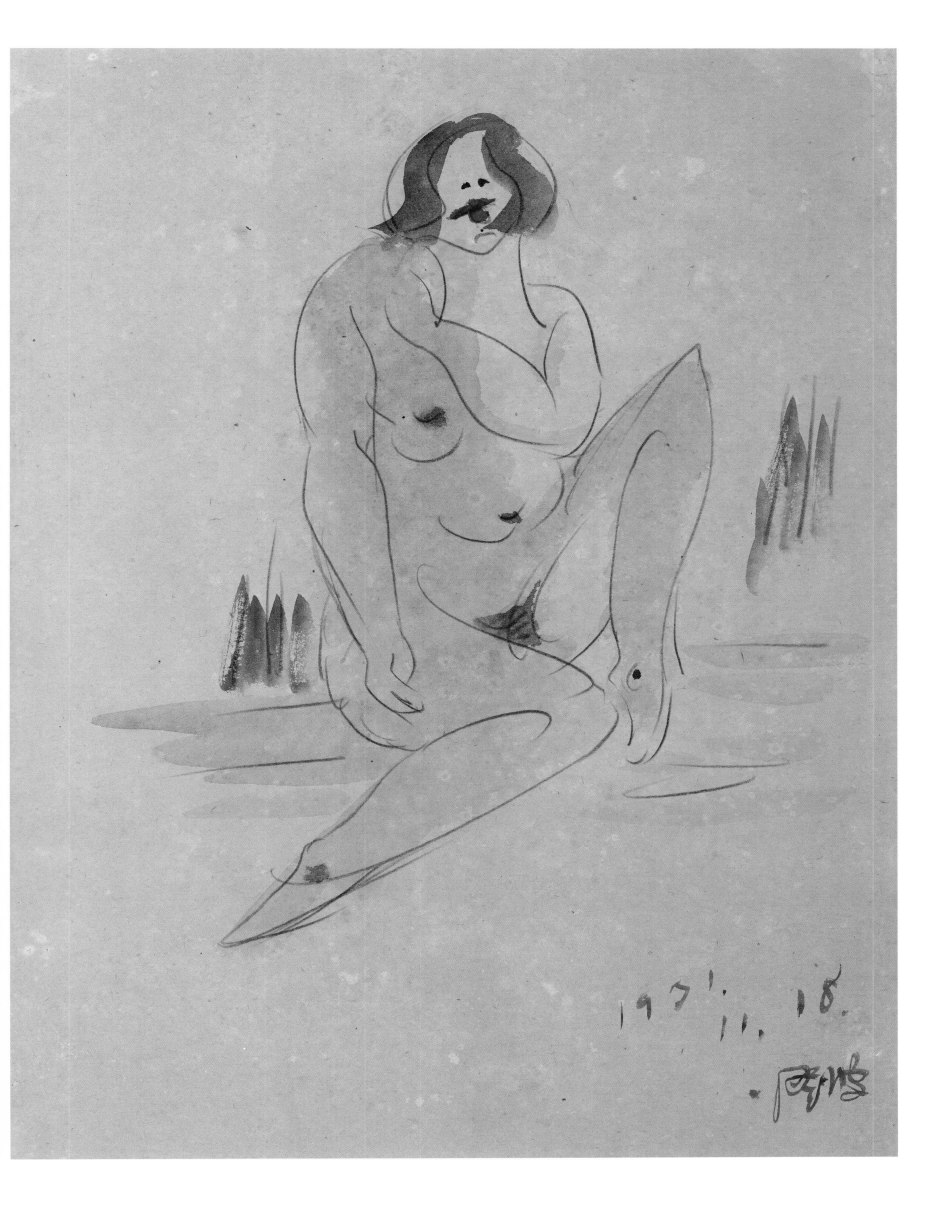

坐姿裸女-31.11.18（2）Seated Nude-31.11.18 (2)

1931　紙本淡彩鉛筆　36×28cm

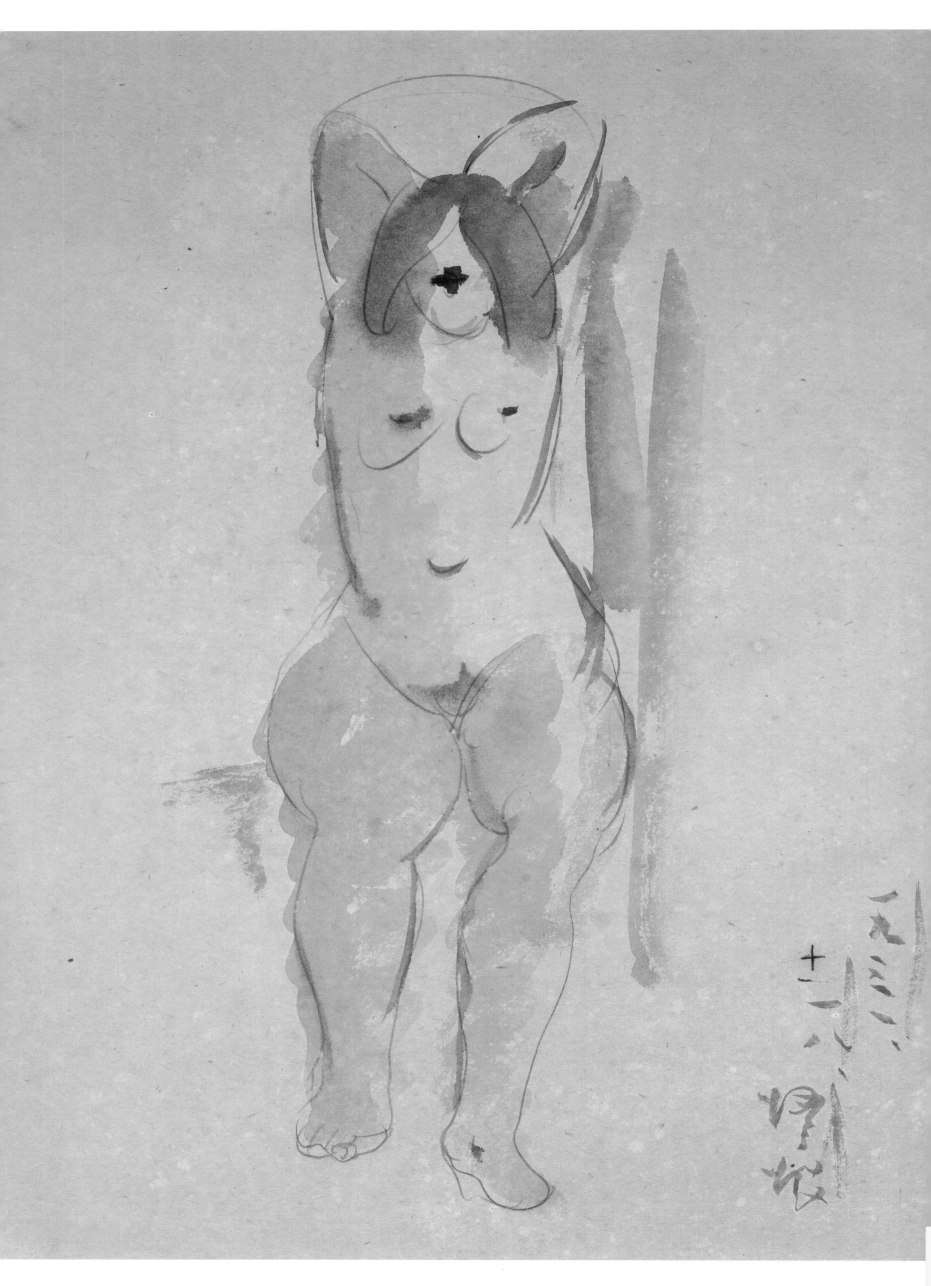

40

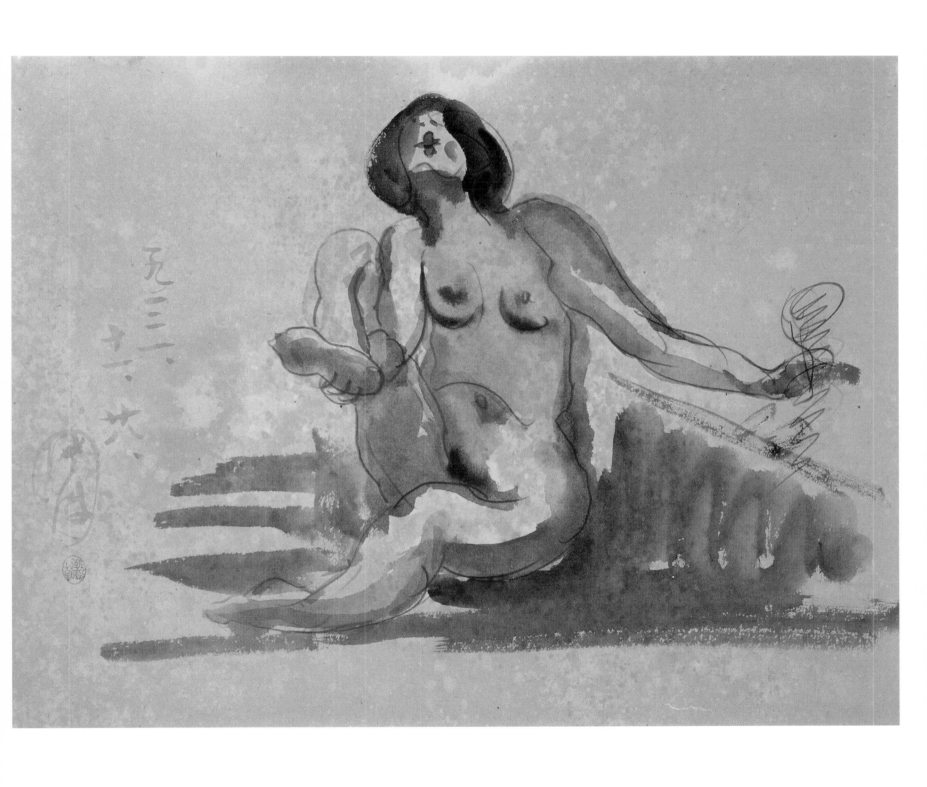

坐姿裸女-31.11.28（3） Seated Nude-31.11.28 (3)

1931　紙本淡彩鉛筆　29×37cm

[左頁圖]

立姿裸女-31.11.18（1） Standing Nude-31.11.18 (1)

1931　紙本淡彩鉛筆　36.5×28cm

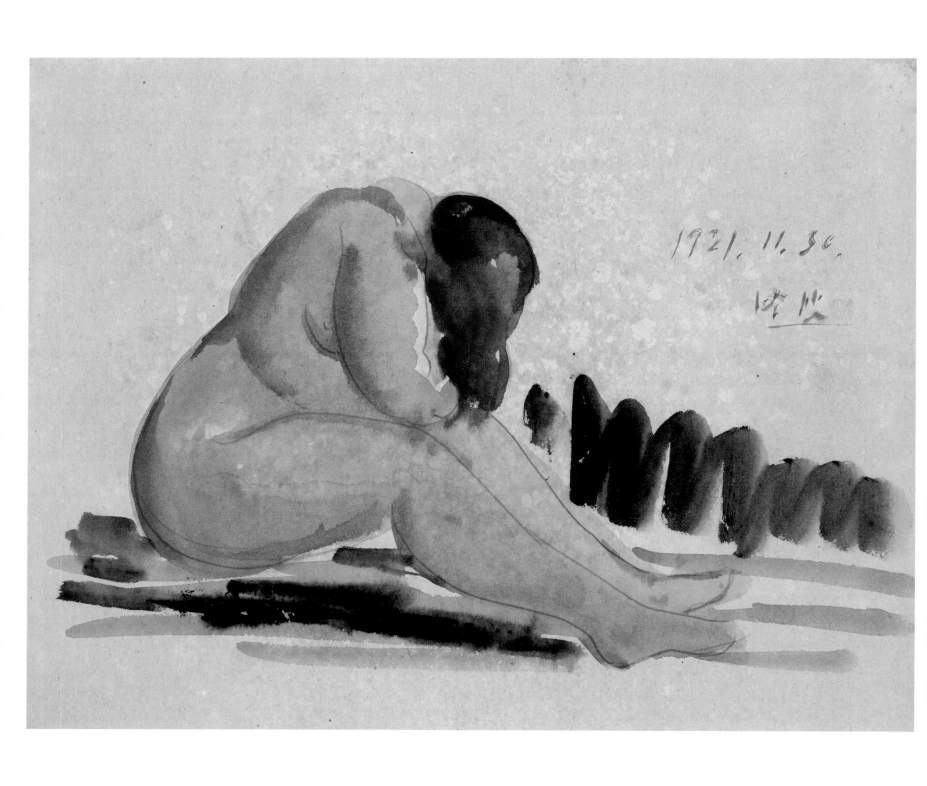

坐姿裸女-31.11.30（4）Seated Nude-31.11.30 (4)

1931　紙本淡彩鉛筆　28×37cm

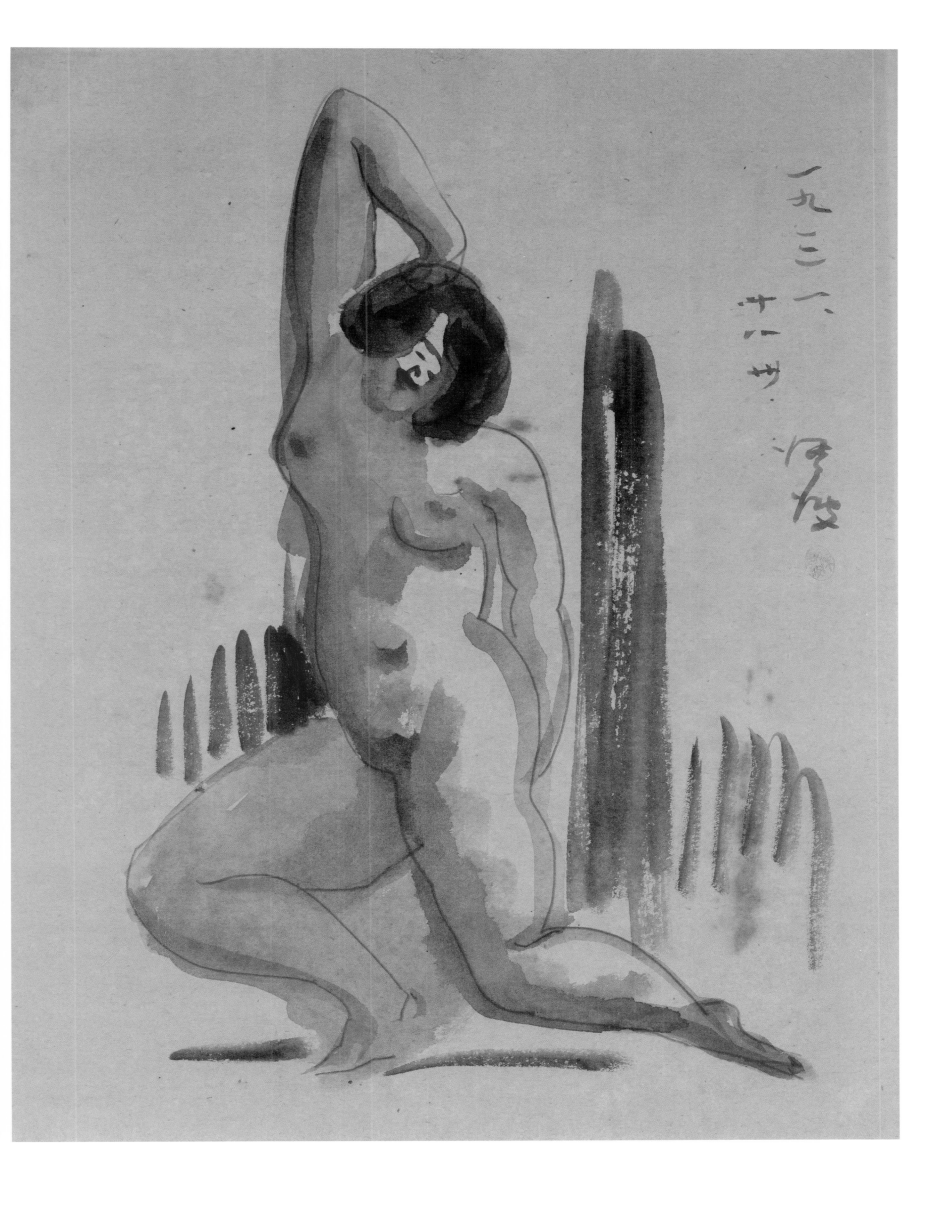

立姿裸女-31.11.30（2） Standing Nude-31.11.30 (2)

1931　紙本淡彩鉛筆　36.5×28cm

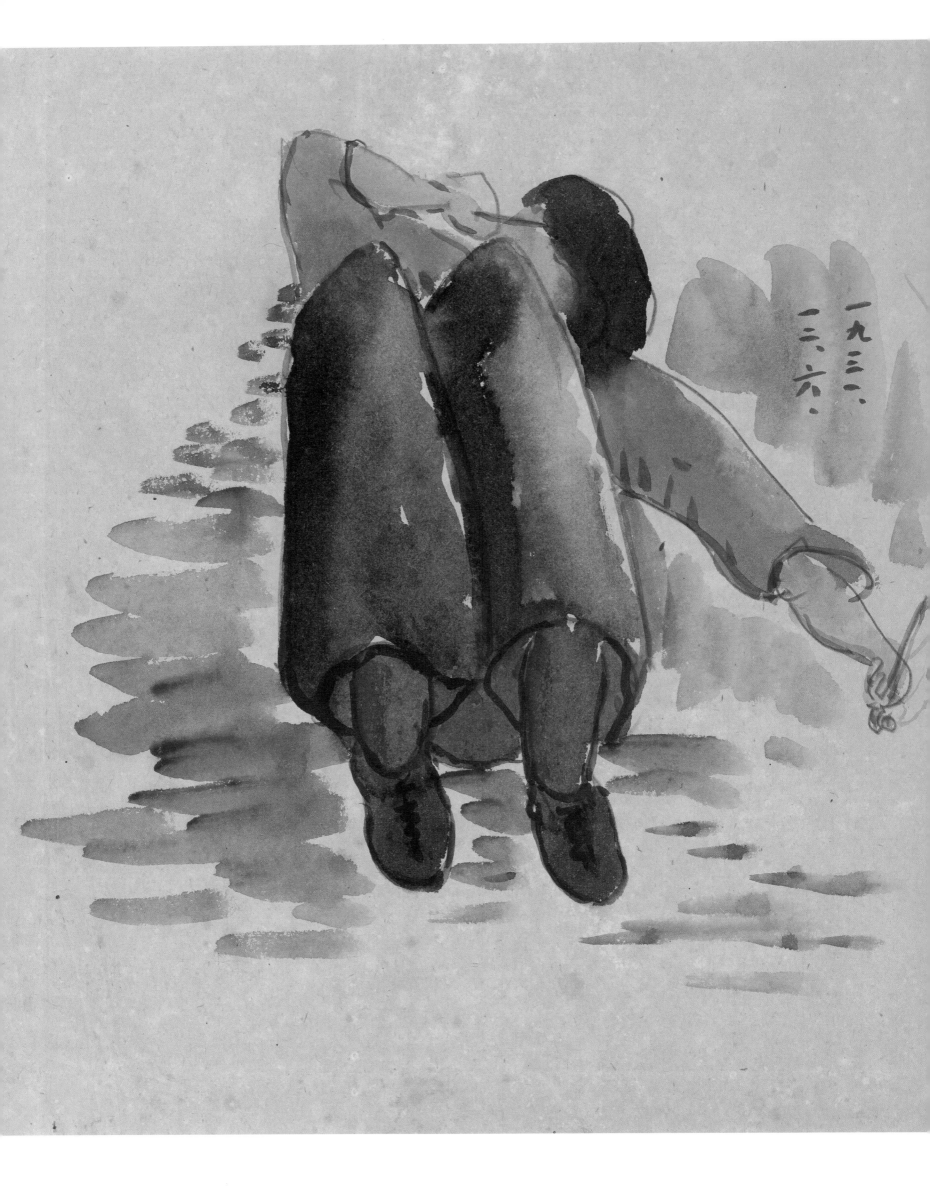

人物-31.12.6（１）Figure-31.12.6（1）

1931　紙本淡彩鉛筆　30.5×27cm

坐姿裸女-31.12.7（5）Seated Nude-31.12.7 (5)

1931　紙本淡彩鉛筆　28×36cm

坐姿裸女-31.12.7（6）Seated Nude-31.12.7 (6)

1931　紙本淡彩鉛筆　29.5×36.5cm

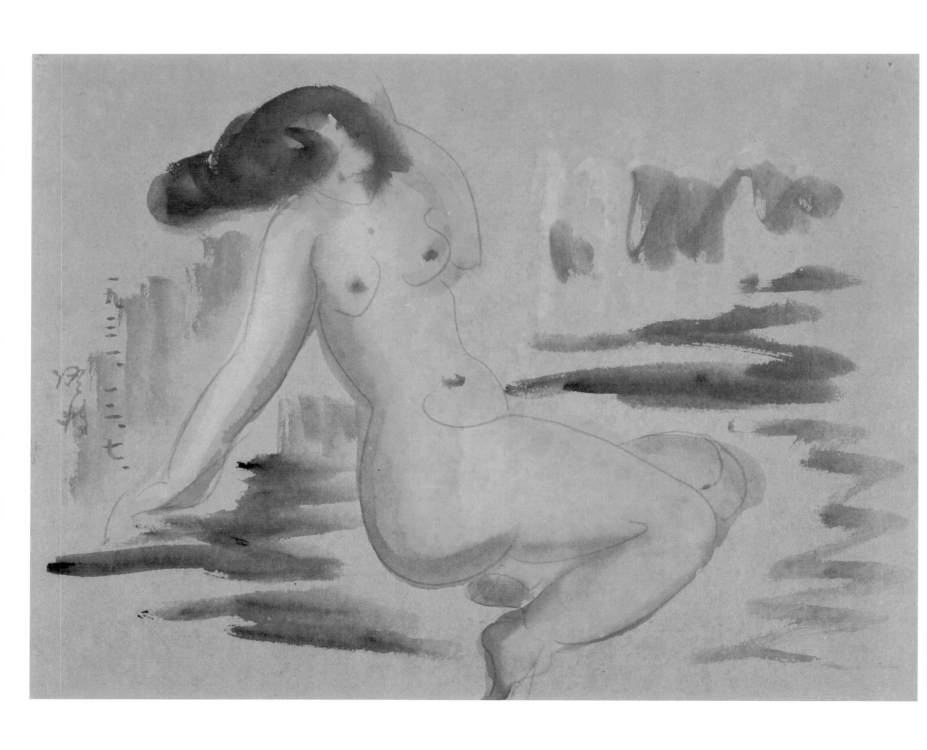

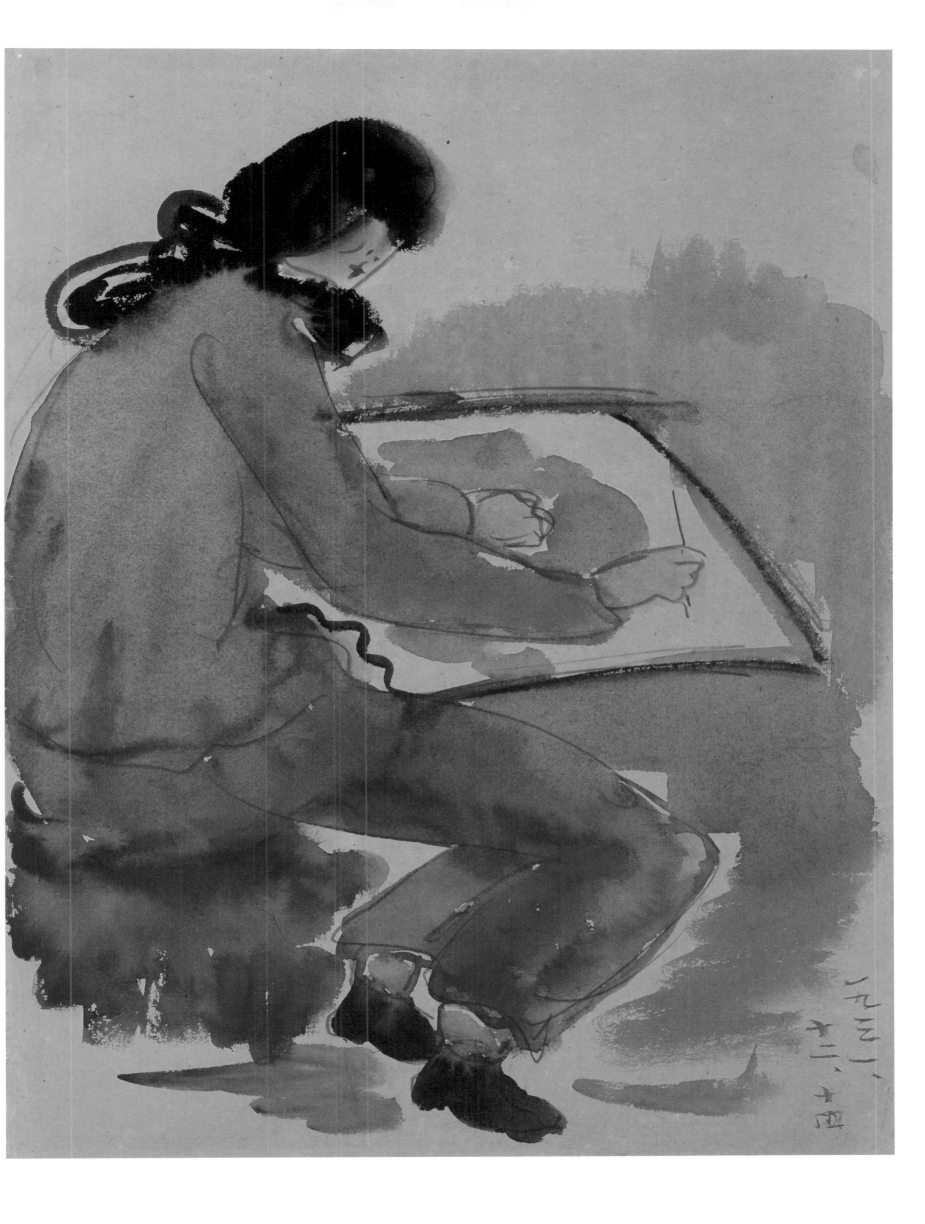

畫室-31.12.14（1） Studio-31.12.14 (1)

1931　紙本淡彩鉛筆　36×28cm

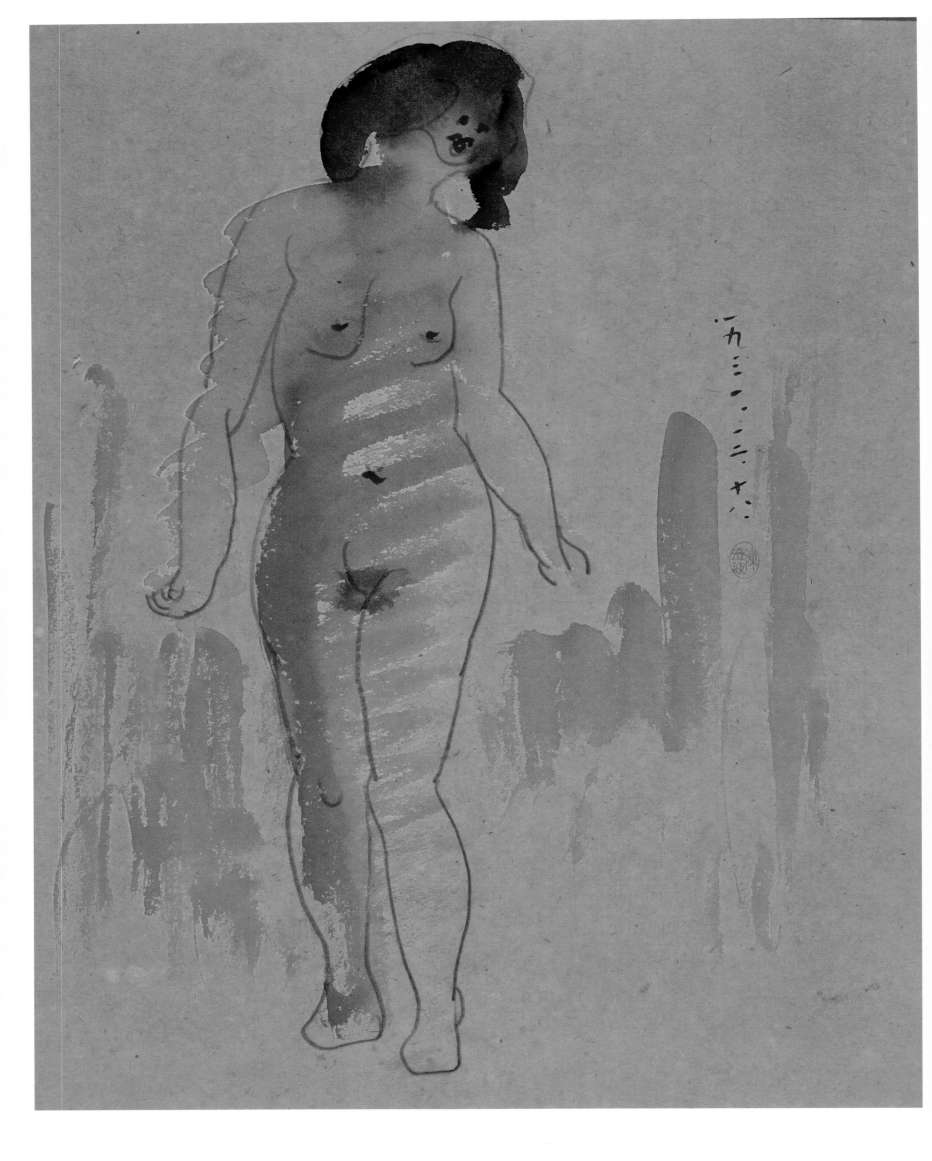

立姿裸女-31.12.18（3）Standing Nude-31.12.18 (3)
1931 紙本淡彩鉛筆　36×28.5cm

[右頁圖]
立姿裸女-31.12.28（4）Standing Nude-31.12.28 (4)
1931　紙本淡彩鉛筆　原寸（36×27cm）

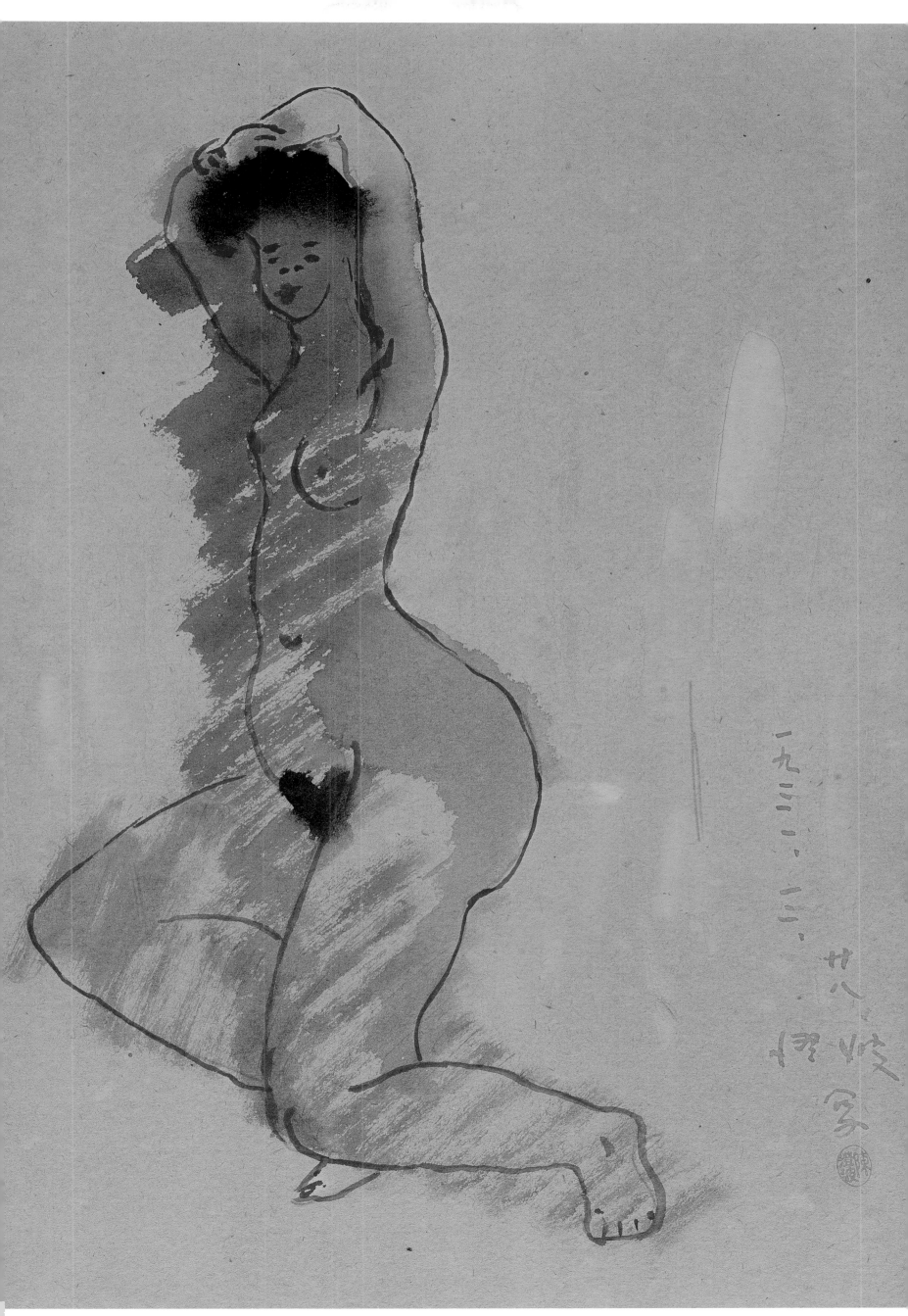

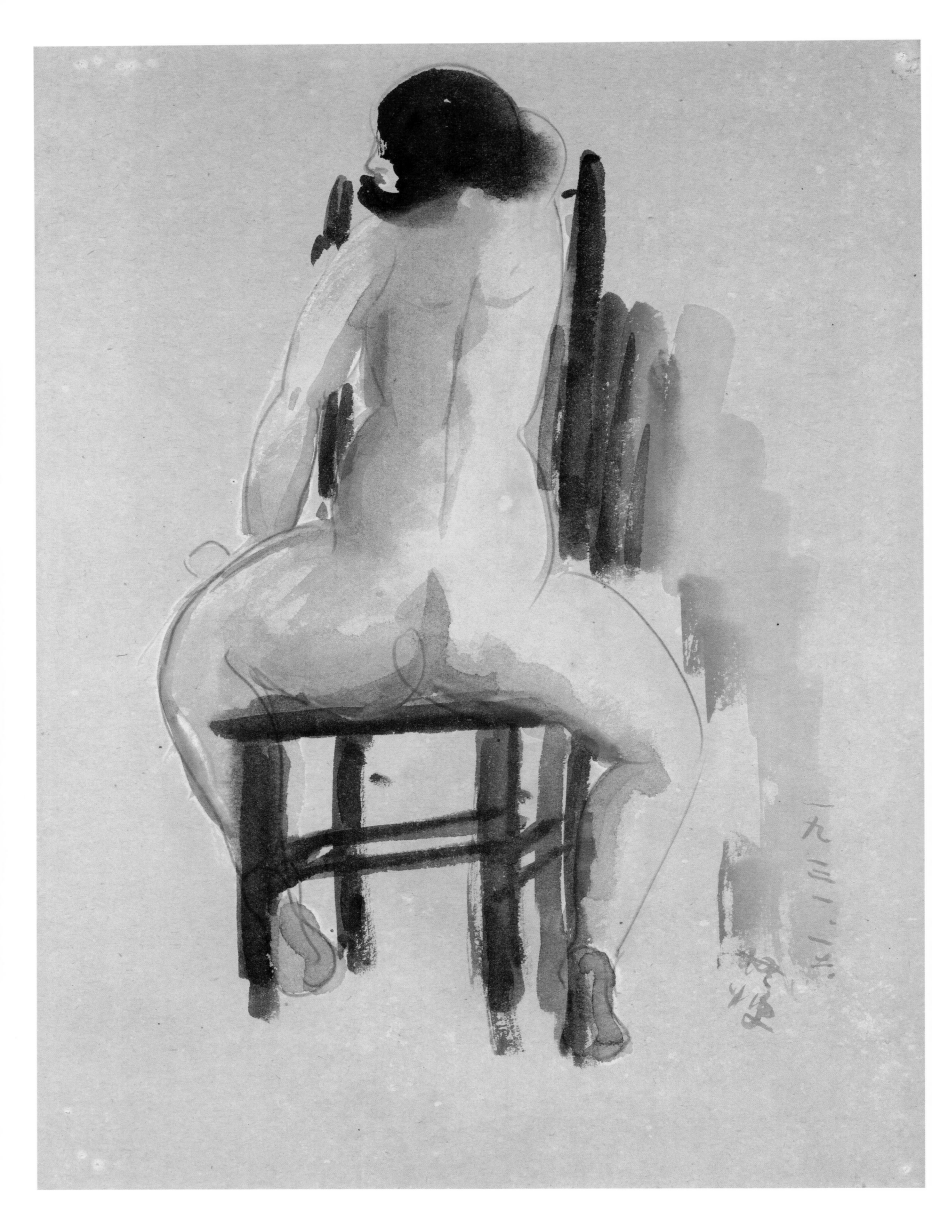

坐姿裸女-31.12（7）Seated Nude-31.12 (7)

1931　紙本淡彩鉛筆　37×28cm

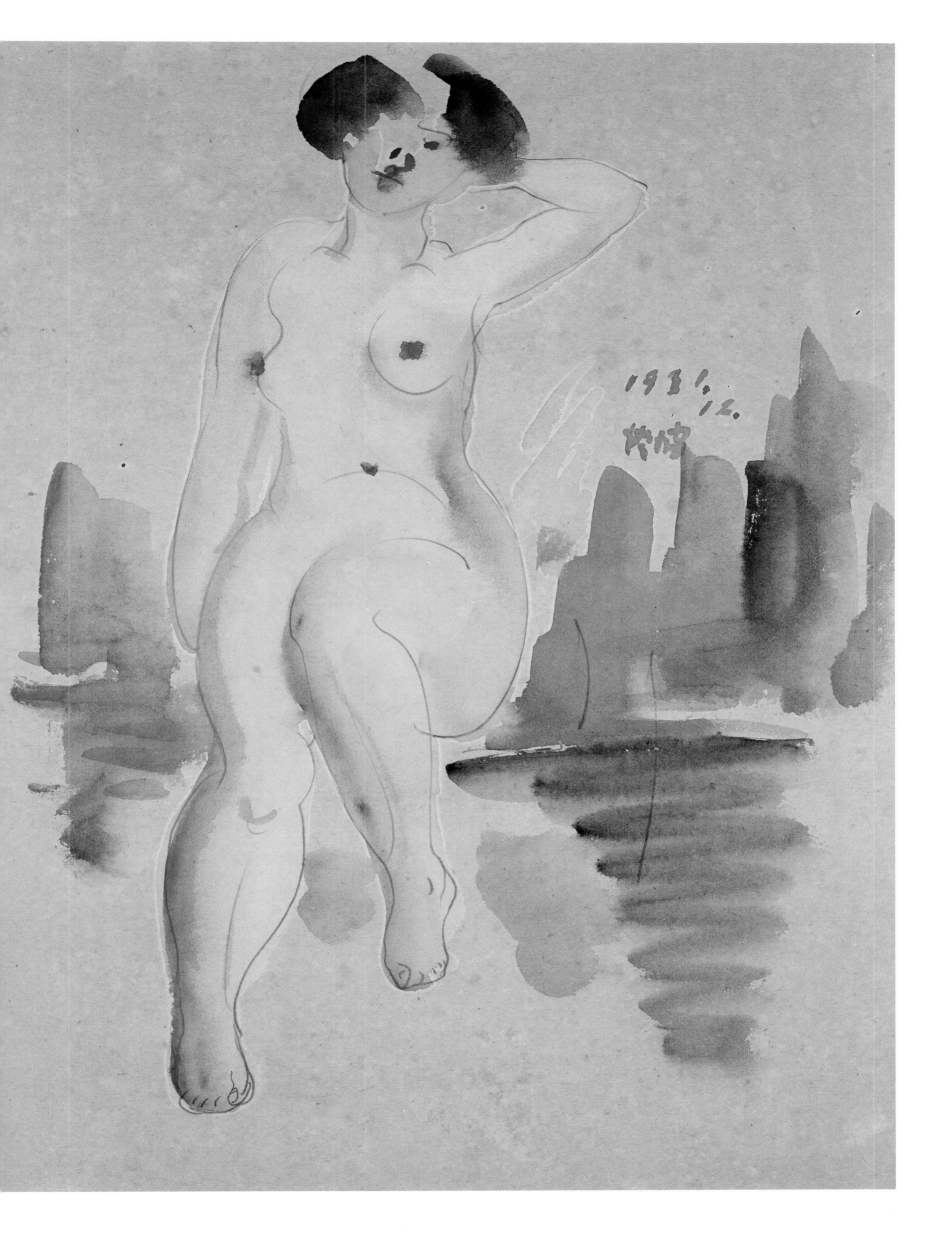

坐姿裸女-31.12（8）Seated Nude-31.12 (8)

1931　紙本淡彩鉛筆　37×28.5cm

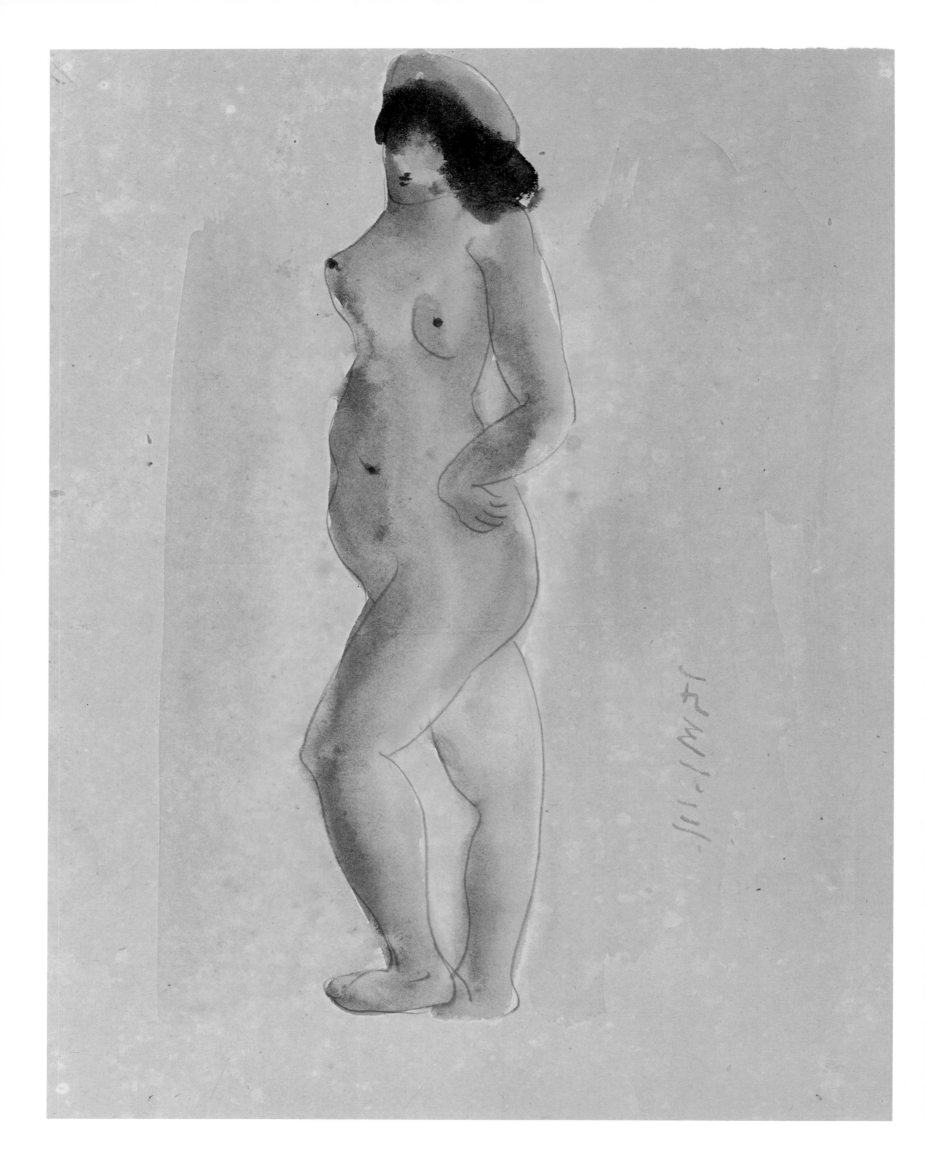

立姿裸女-31.12（5）Standing Nude-31.12 (5)

1931　紙本淡彩鉛筆　36×27.5cm

[右頁圖]

立姿裸女-31.12（6）Standing Nude-31.12 (6)

1931　紙本淡彩鉛筆　36.5×26.5cm

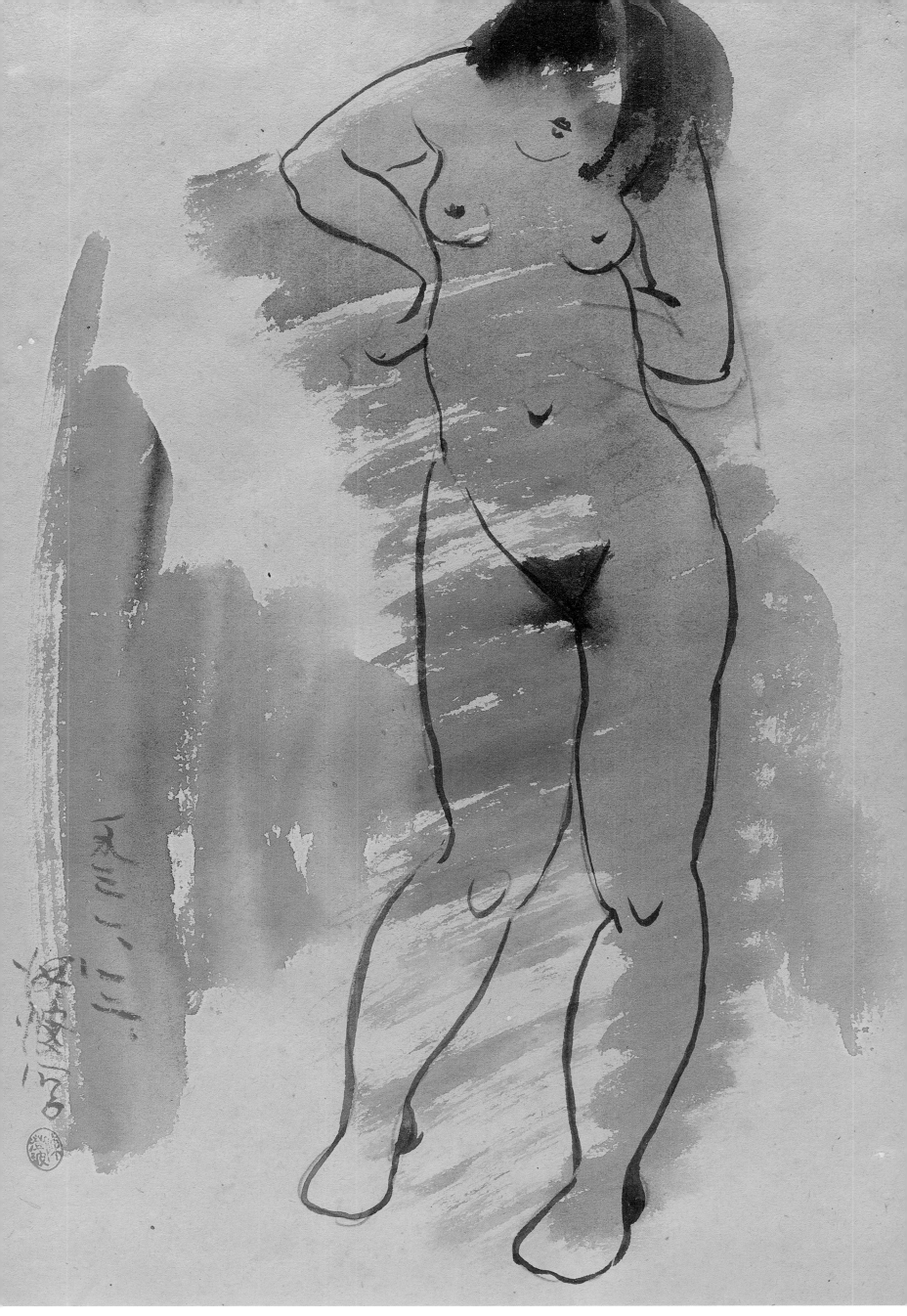

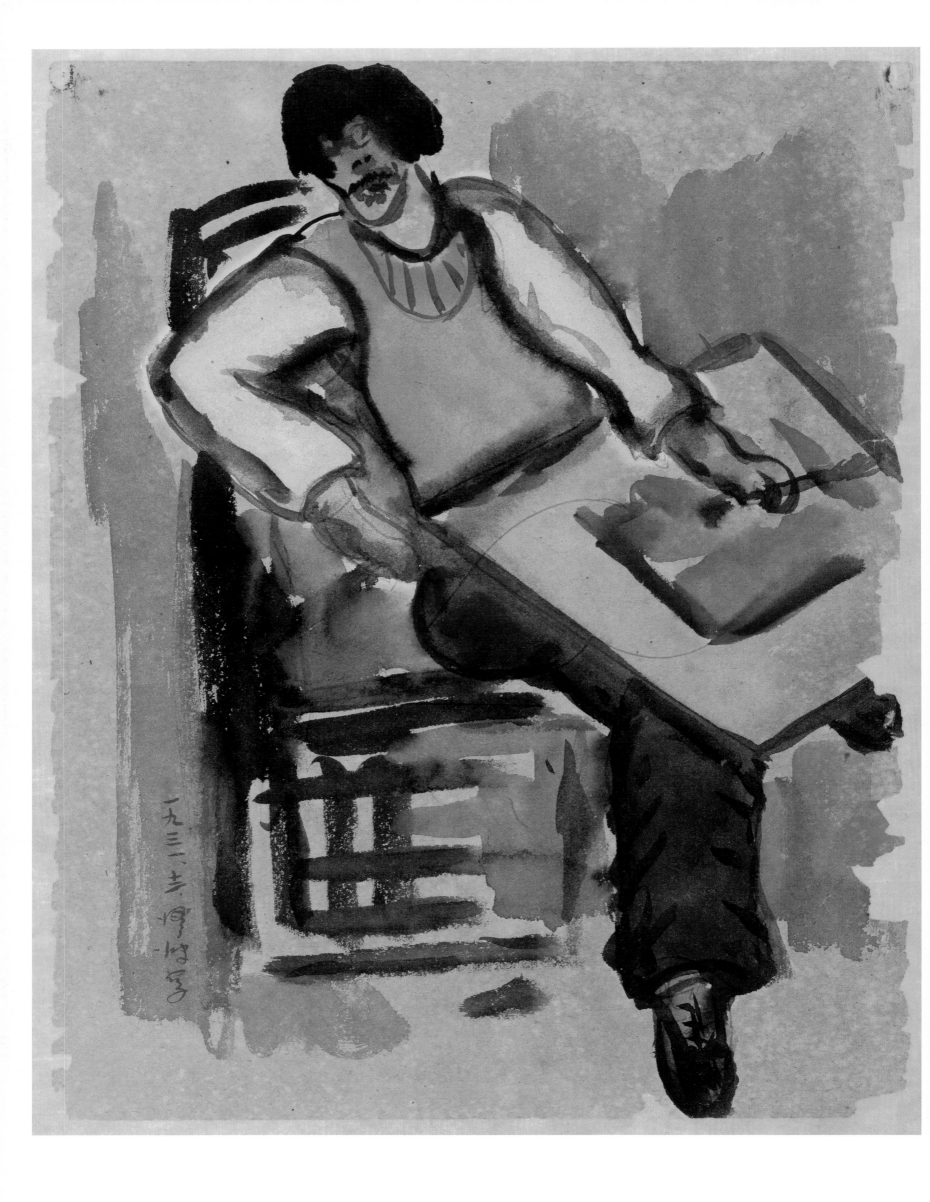

畫室-31.12（2）Studio-31.12 (2)

1931　紙本淡彩鉛筆　36×28cm

淡彩速寫
Watercolor Sketch

1932（1-3）

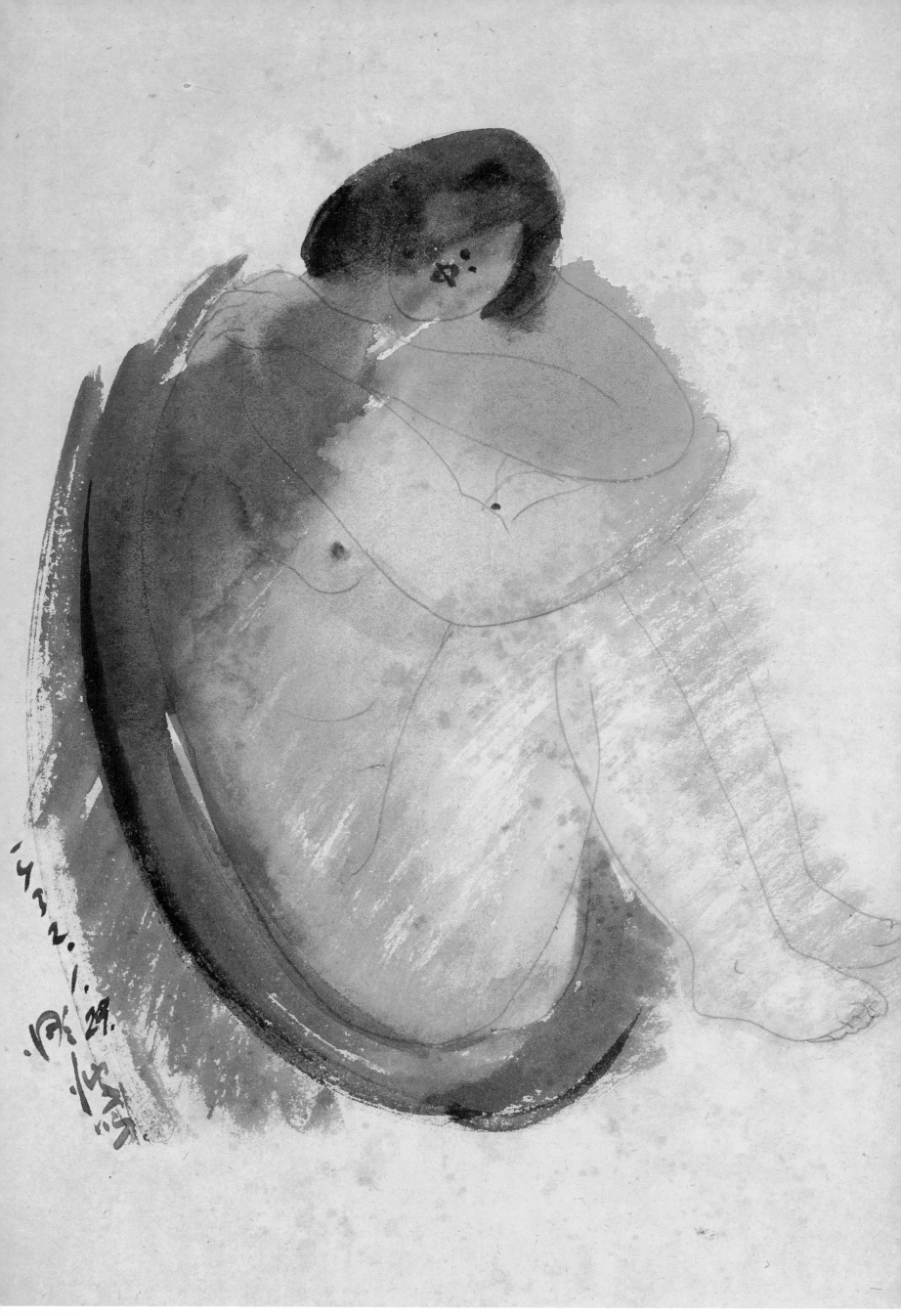

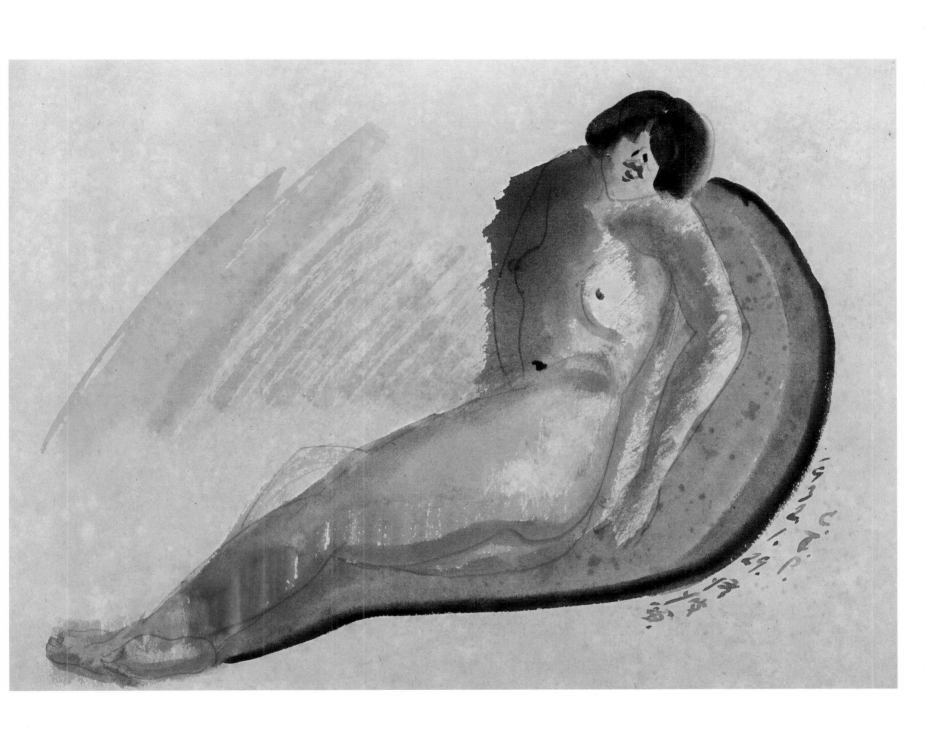

坐姿裸女-32.1.29（10）Seated Nude-32.1.29 (10)

1932　紙本淡彩鉛筆　26×36.5cm

[左頁圖]

坐姿裸女-32.1.29（9）Seated Nude-32.1.29 (9)

1932　紙本淡彩鉛筆　原寸（36.5×26.5cm）

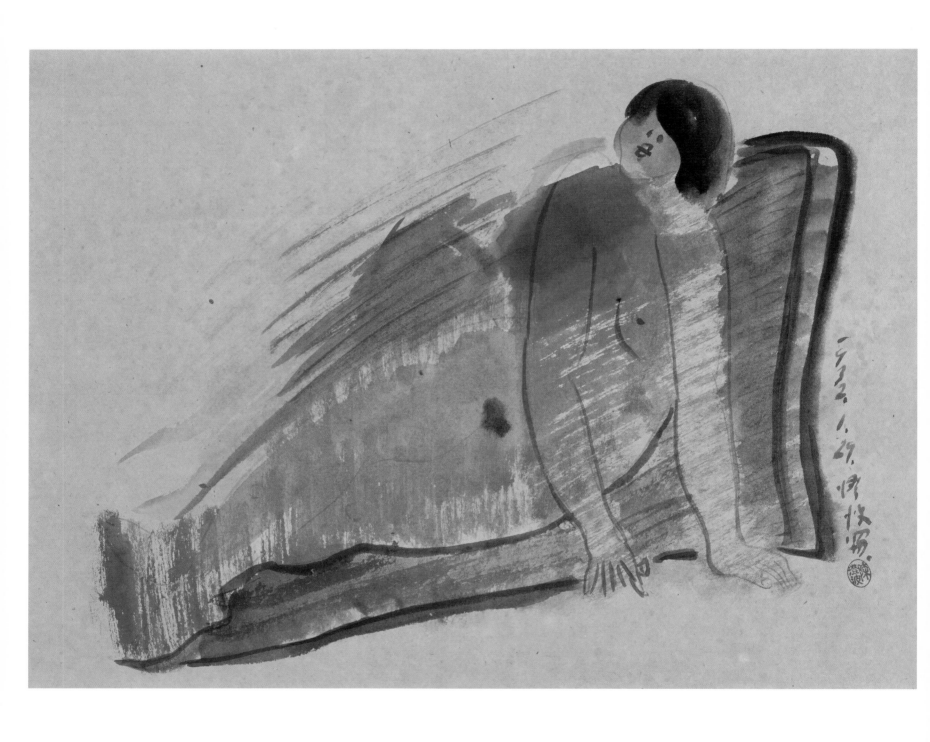

坐姿裸女-32.1.29（11）Seated Nude-32.1.29 (11)

1932　紙本淡彩鉛筆　27×37cm

[右頁圖]

坐姿裸女-32.1.29（12）Seated Nude-32.1.29 (12)

1932　紙本淡彩鉛筆　原寸（36.5×26.5cm）

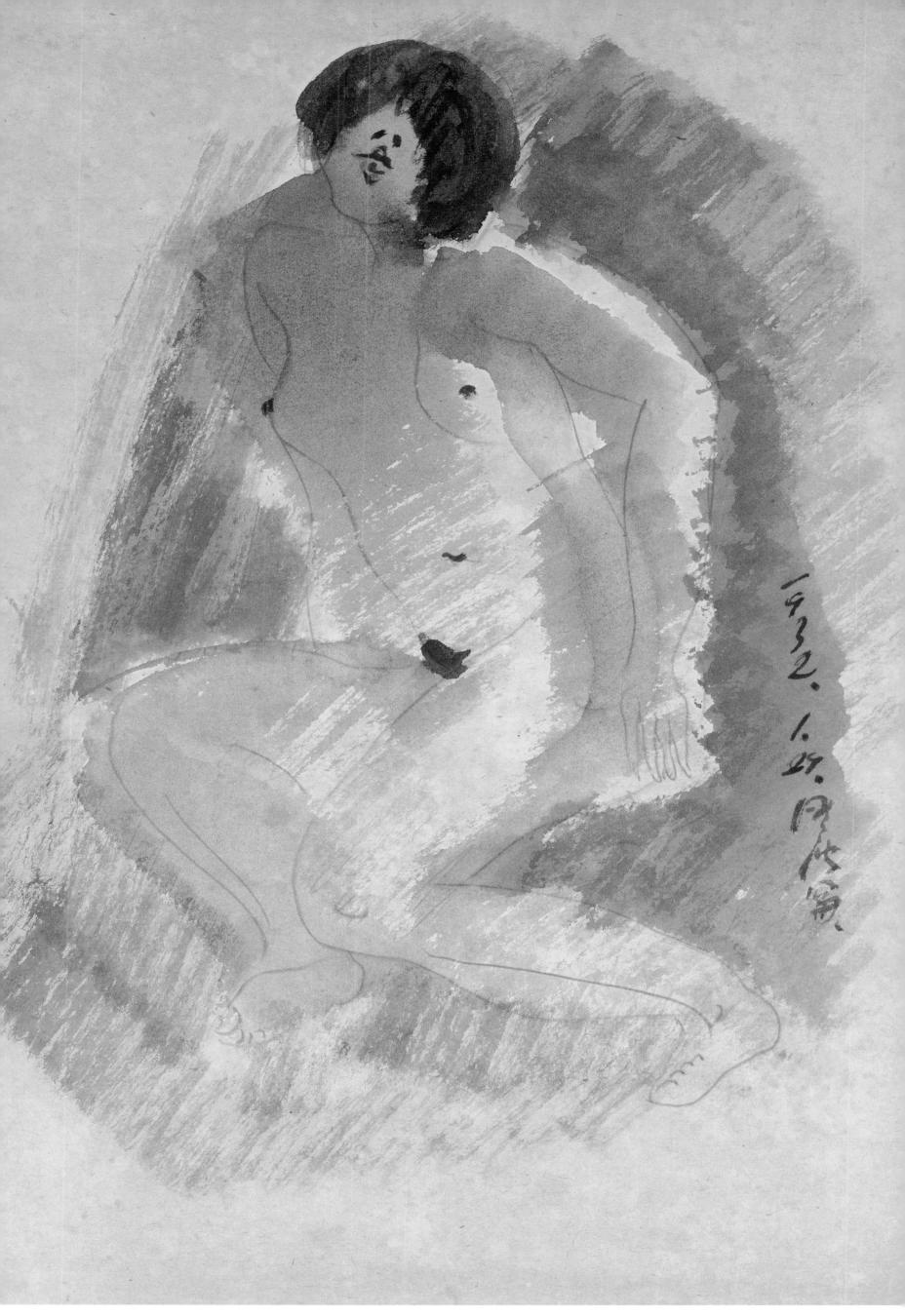

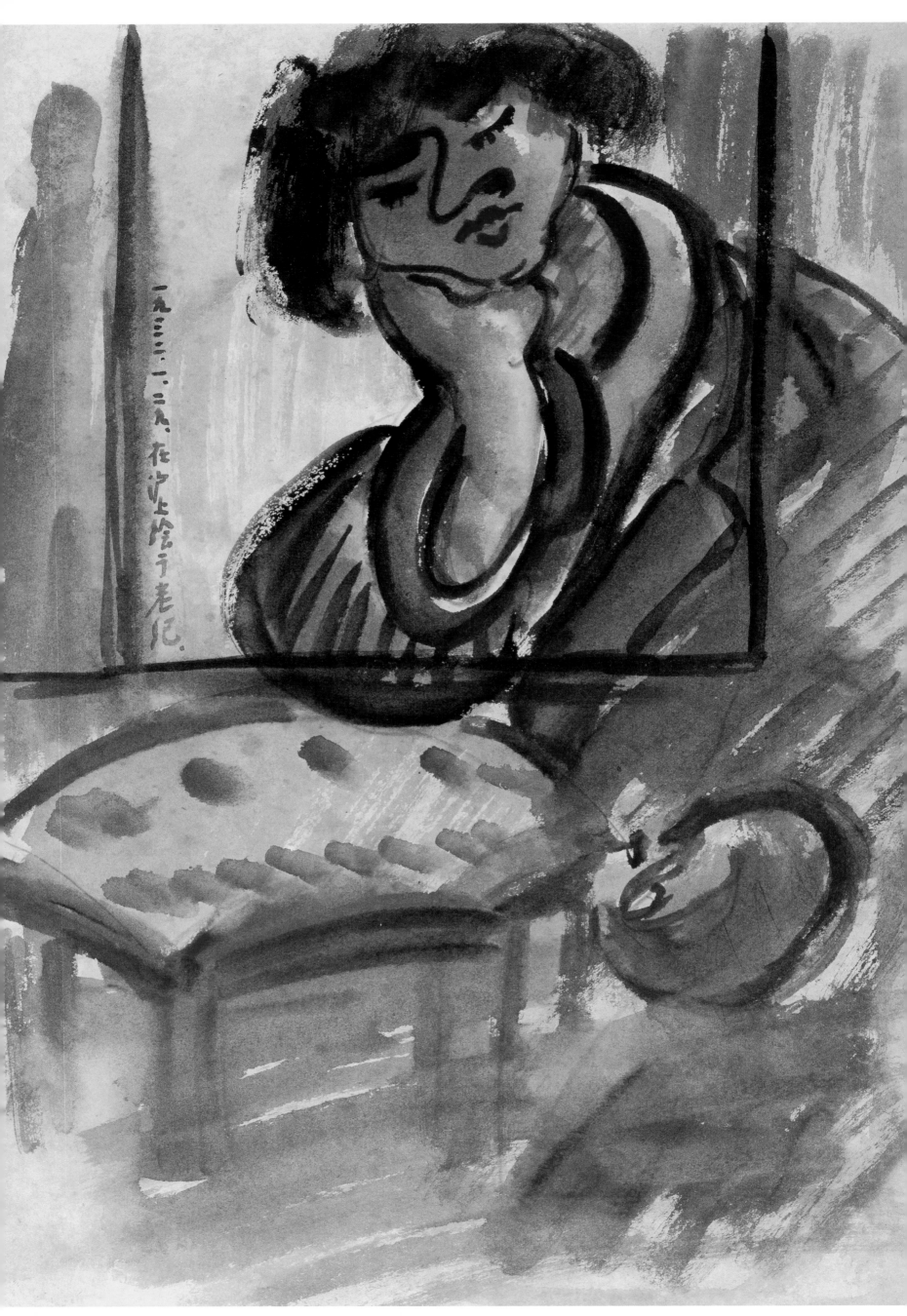

一九三二·二九，在沪上绘于老尼。

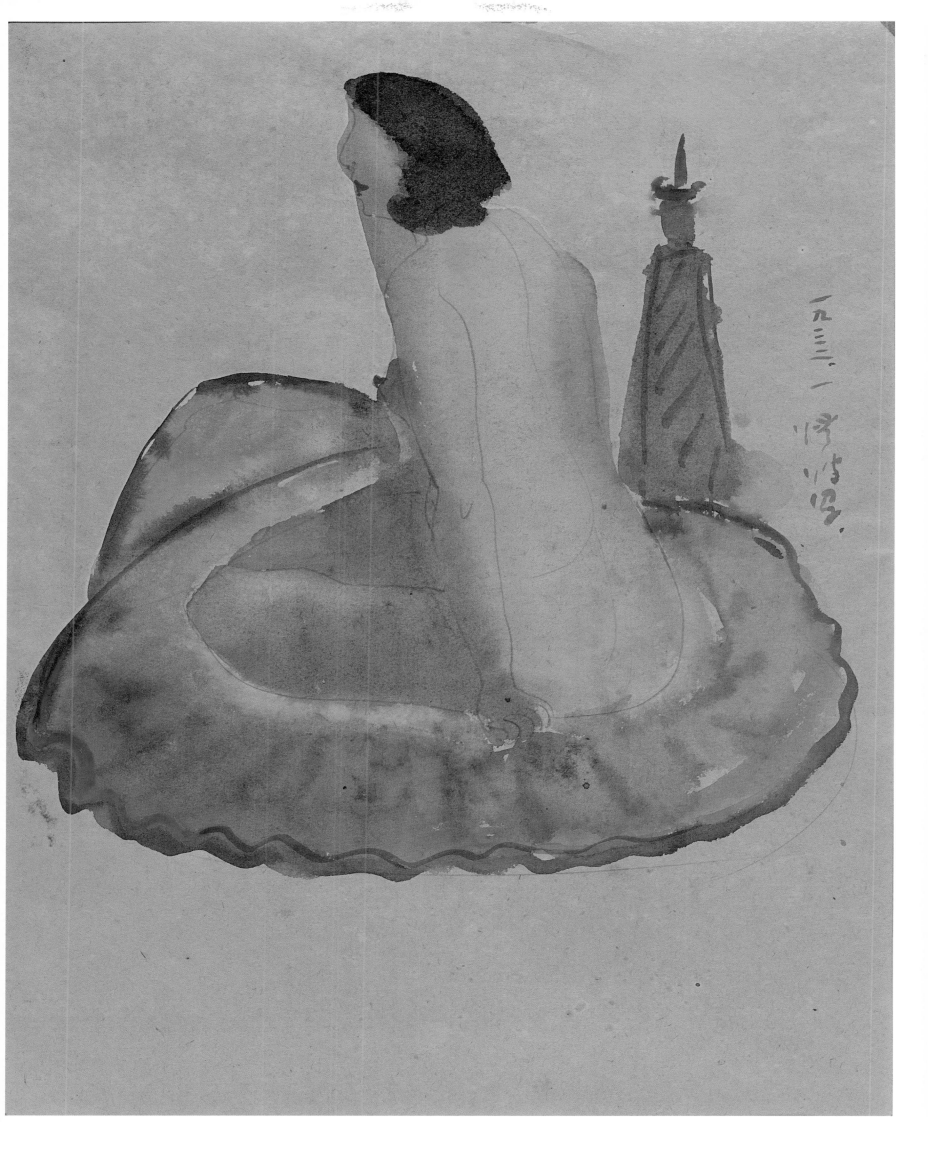

坐姿裸女-32.1（13） Seated Nude-32.1 (13)

1932　紙本淡彩鉛筆　36×28cm

[左頁圖]

畫室-32.1.29（3） Studio-31.1.29 (3)

1932　紙本淡彩鉛筆　原寸（36×26cm）

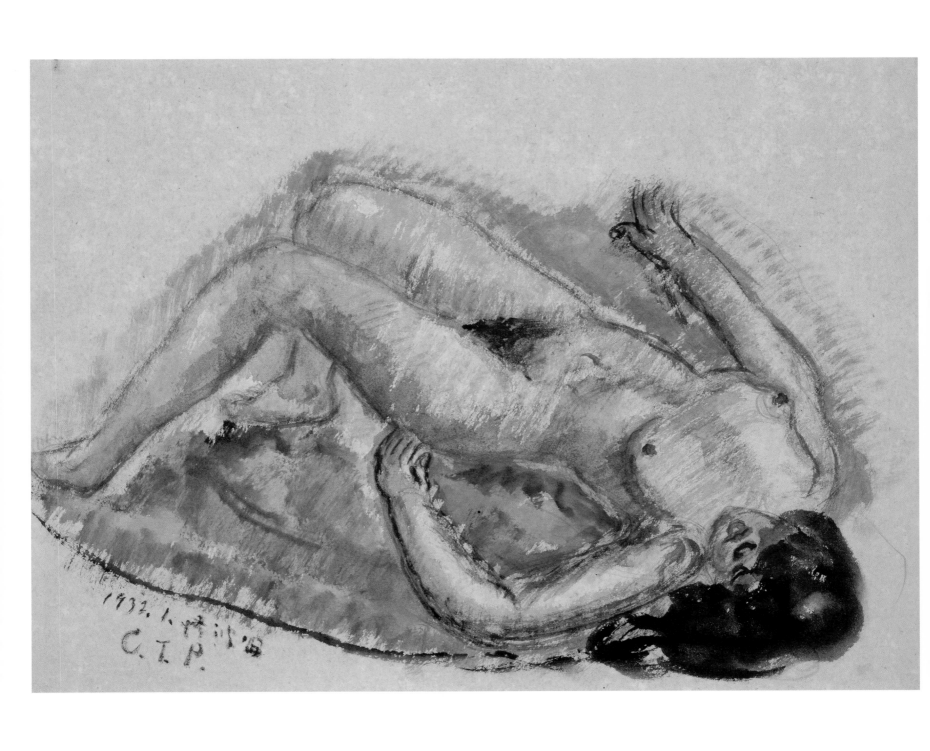

臥姿裸女-32.1（2）Lying Nude-32.1 (2)

1932　紙本淡彩鉛筆　26.5×36.5cm

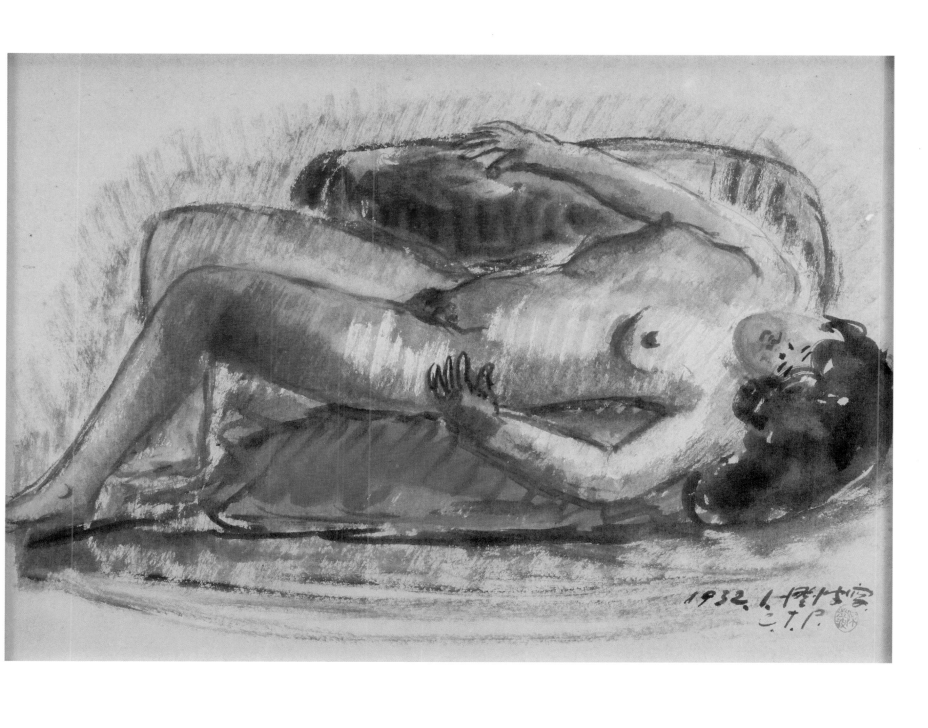

臥姿裸女-32.1（3）Lying Nude-32.1 (3)

1932　紙本淡彩鉛筆　26×36cm

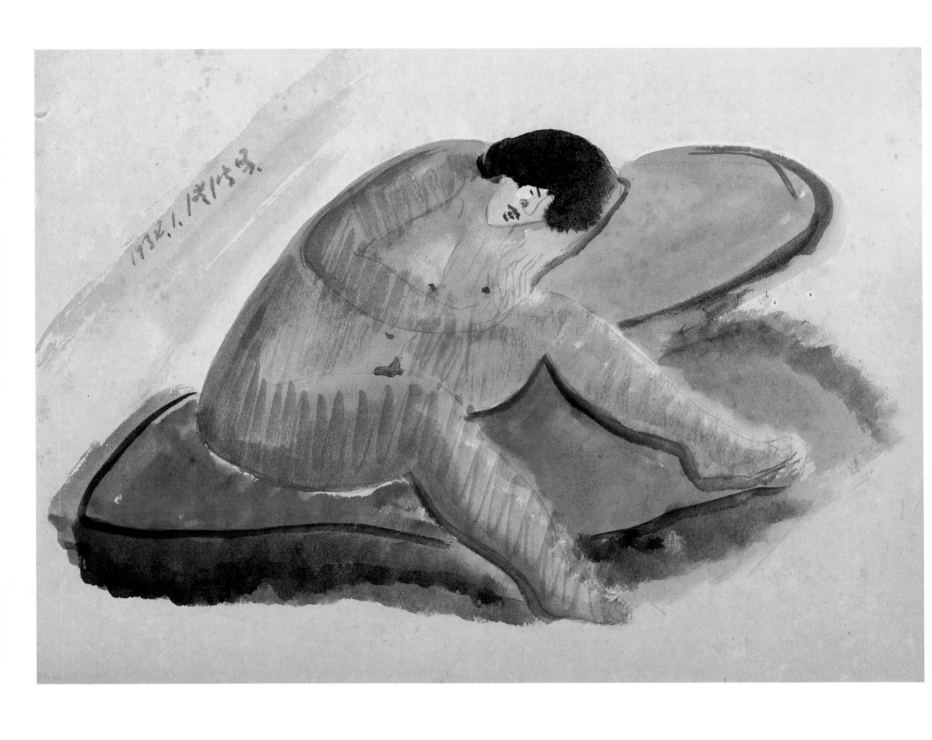

坐姿裸女-32.1（14）Seated Nude-32.1 (14)

1932　紙本淡彩鉛筆　26.5×36cm

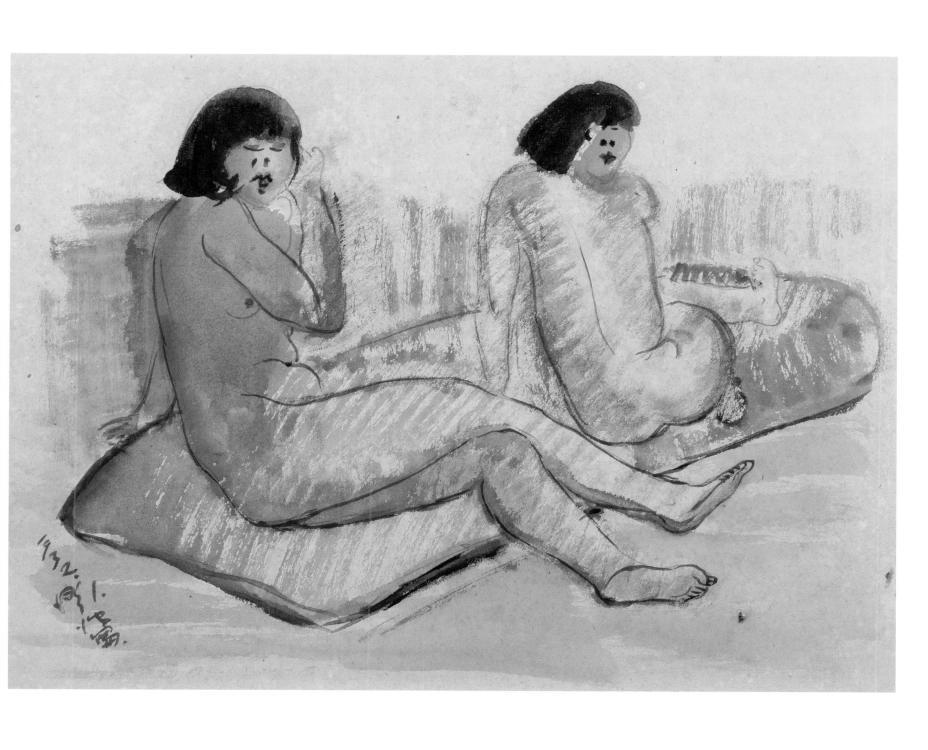

坐姿裸女-32.1（15）Seated Nude-32.1 (15)

1932　紙本淡彩鉛筆　26.5×36cm

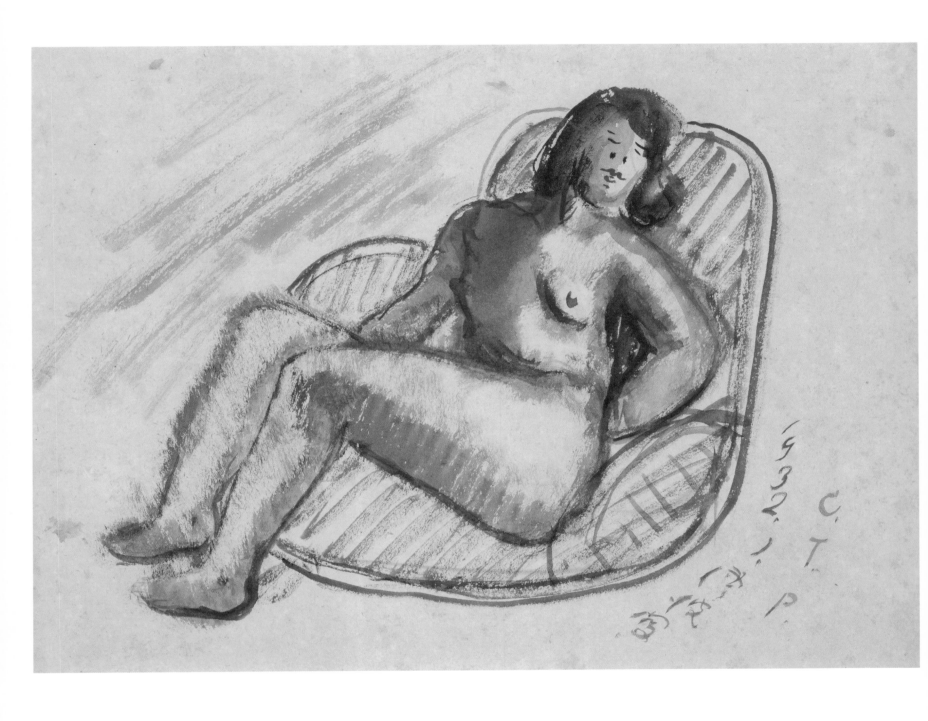

坐姿裸女-32.1（16）Seated Nude-32.1 (16)
1932　紙本淡彩　26.5×36.5cm

[右頁圖]
坐姿裸女-32.1（17）Seated Nude-32.1 (17)
1932　紙本淡彩鉛筆　原寸（36×26.5cm）

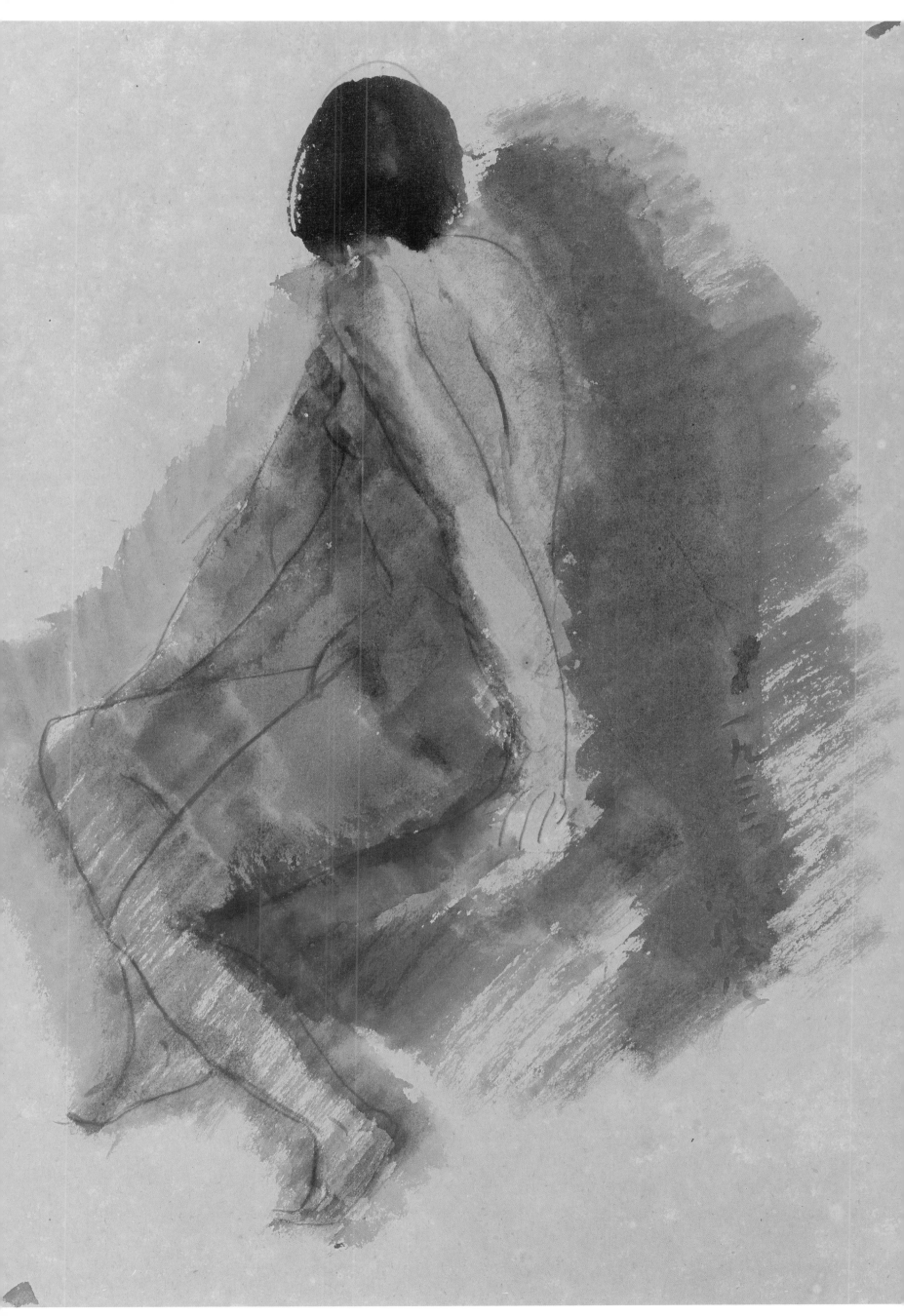

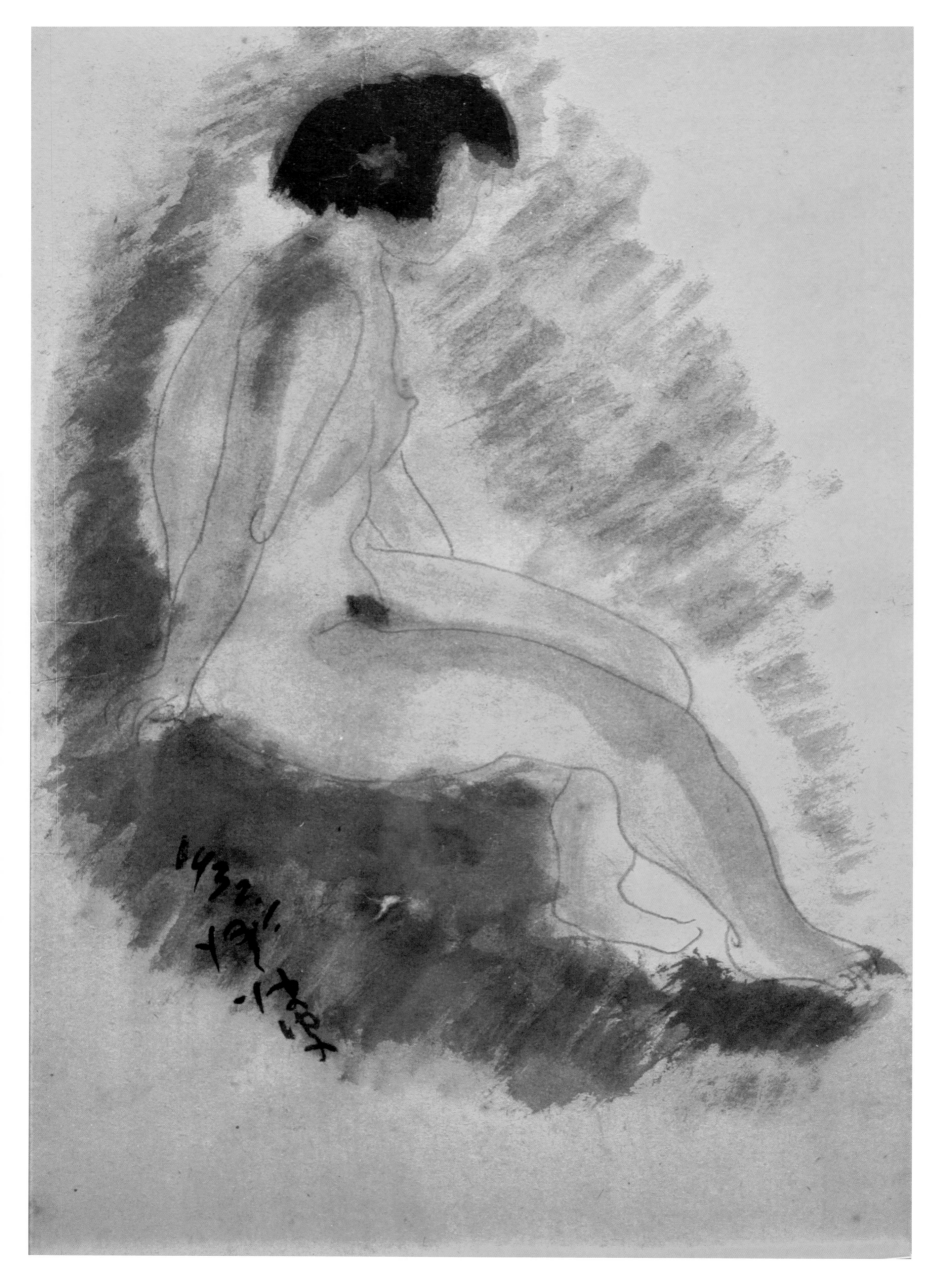

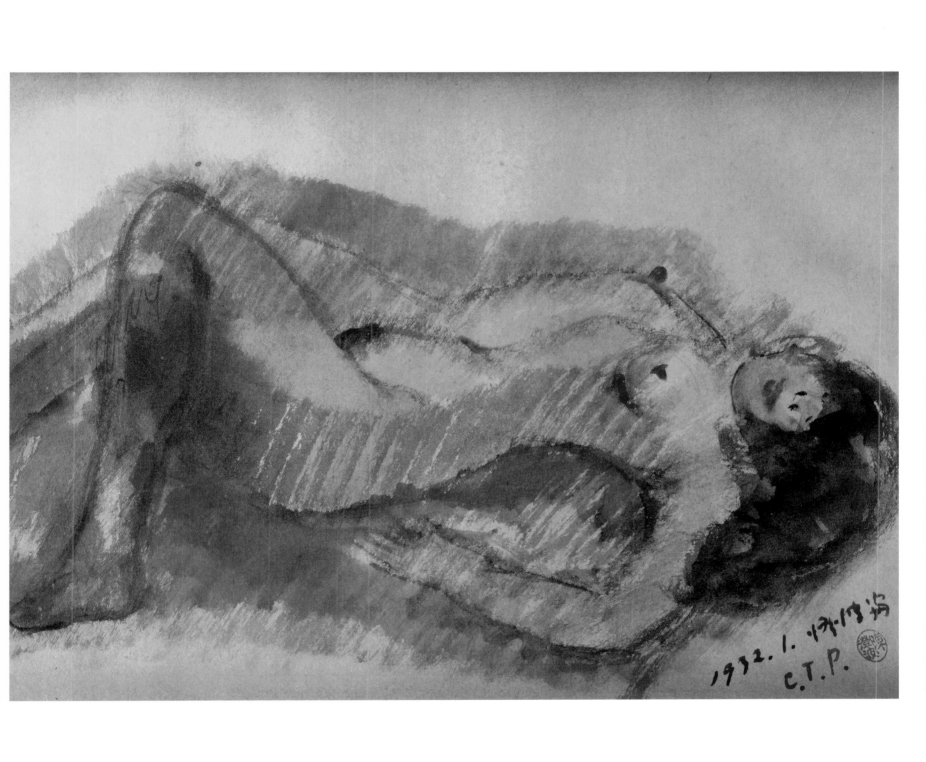

臥姿裸女-32.1（4） Lying Nude-32.1 (4)

1932　紙本淡彩鉛筆　26×36.8cm

[左頁圖]

坐姿裸女-32.1（18） Seated Nude-32.1 (18)

1932　紙本淡彩鉛筆　38.5×26.5cm

臥姿裸女-32.1（5）Lying Nude-32.1 (5)

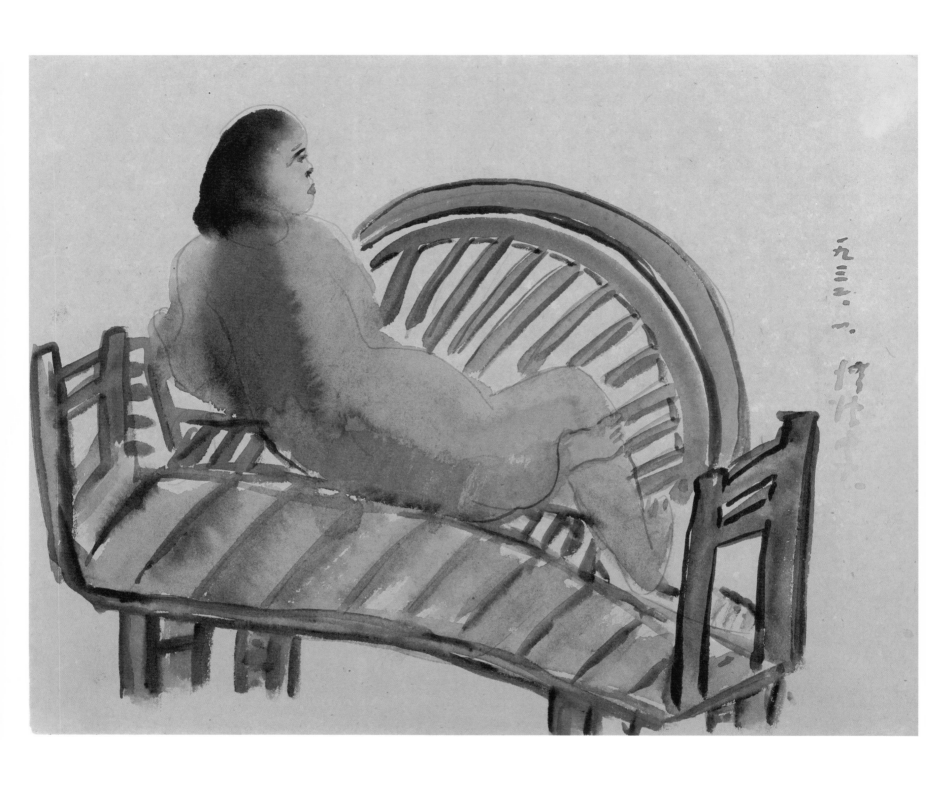

1932　紙本淡彩鉛筆　28×36cm

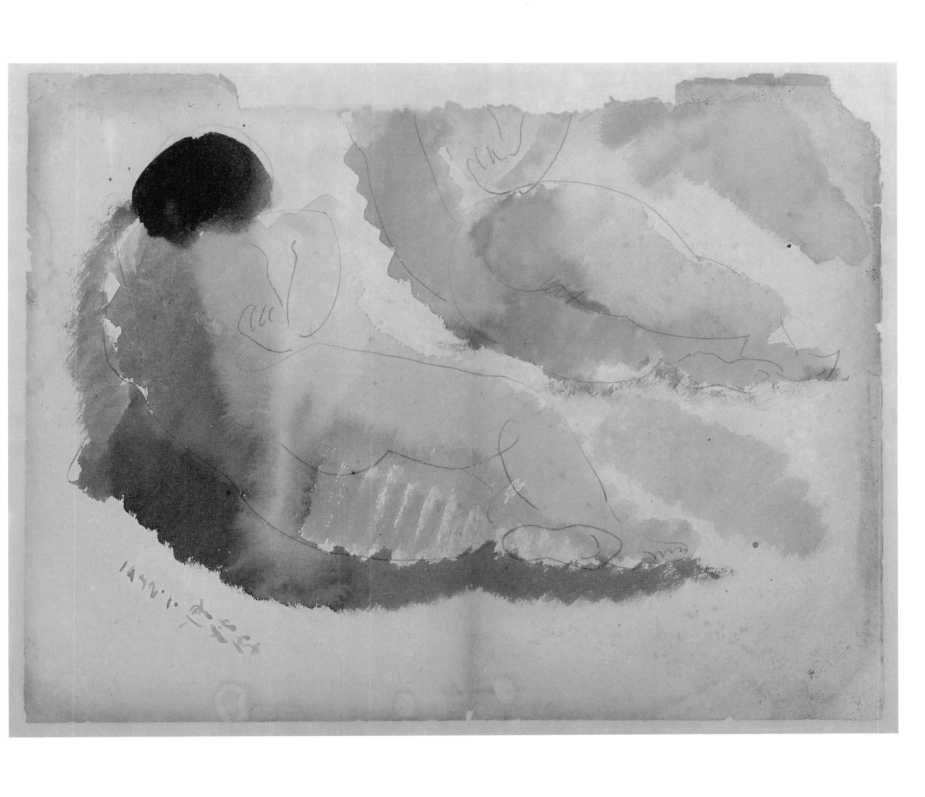

臥姿裸女-32.1（6）Lying Nude-32.1 (6)

1932　紙本淡彩鉛筆　28.5×36.5cm

坐姿裸女-32.1（19） Seated Nude-32.1 (19)

1932　紙本淡彩鉛筆　28.5×36.5cm

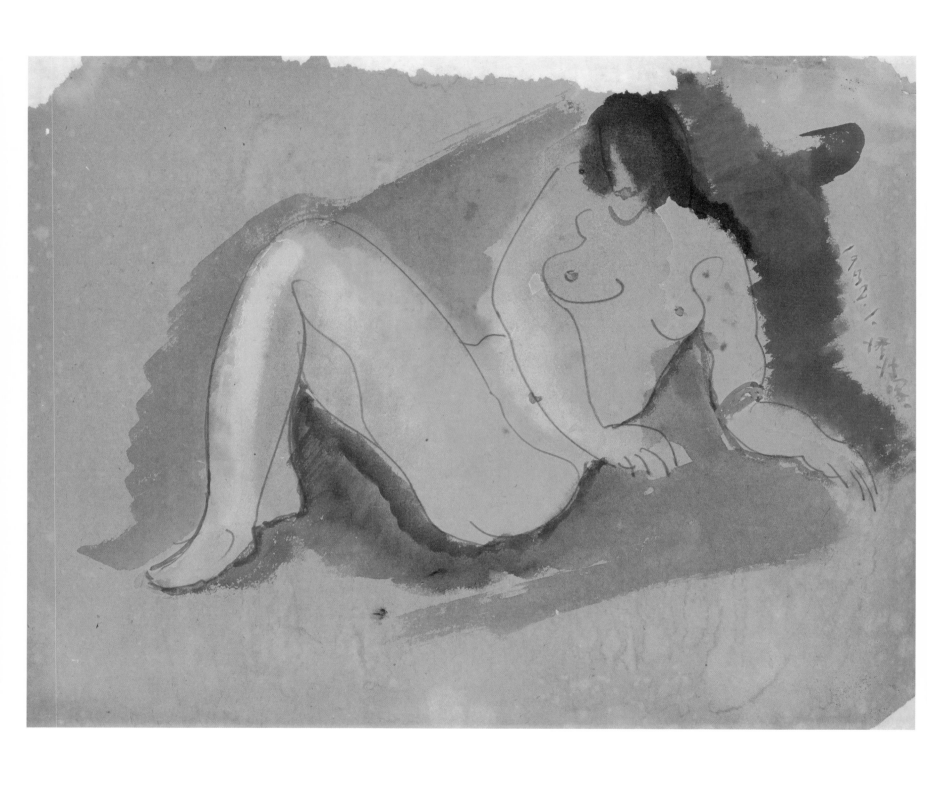

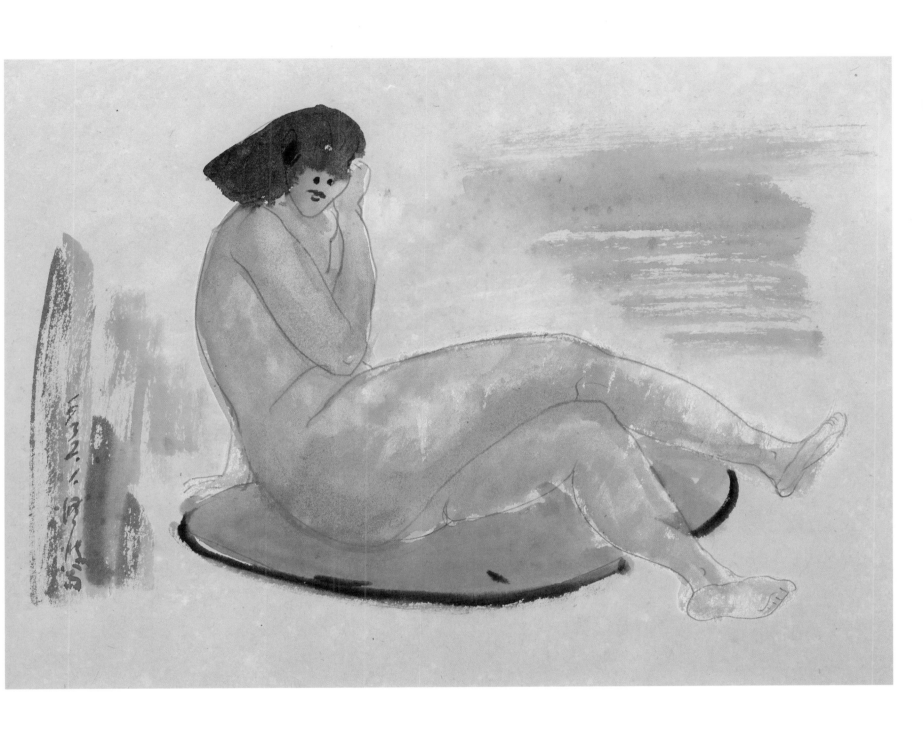

坐姿裸女-32.1（20）Seated Nude-32.1 (20)

1932　紙本淡彩鉛筆　26×36cm

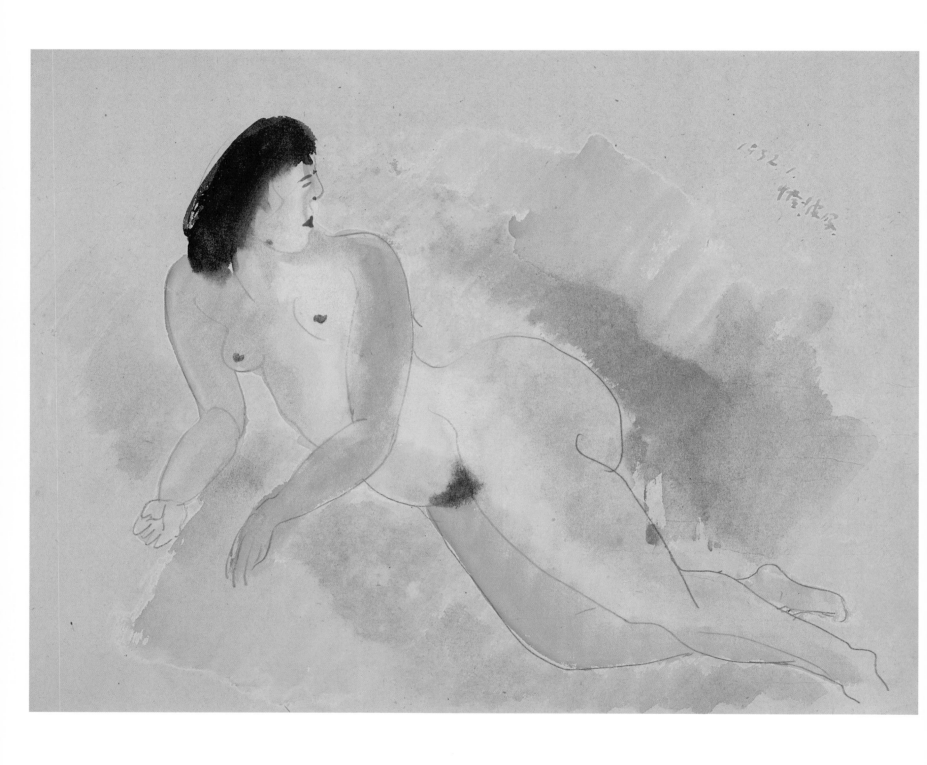

臥姿裸女-32.1（7） Lying Nude-32.1 (7)

1932　紙本淡彩鉛筆　29×37.5 cm

[右頁圖]

坐姿裸女-32.1（21） Seated Nude-32.1 (21)

1932　紙本淡彩鉛筆　37×28.5cm

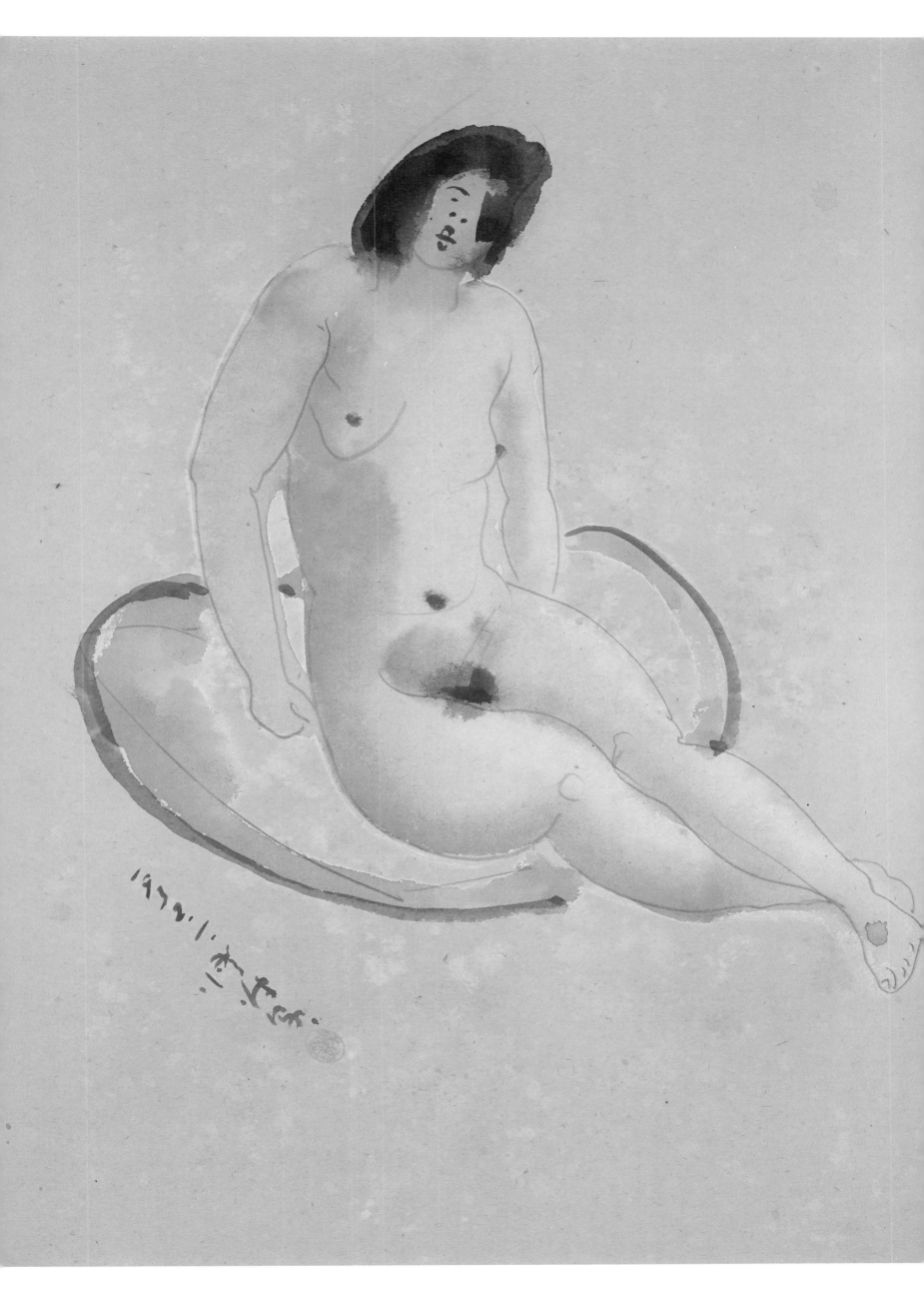

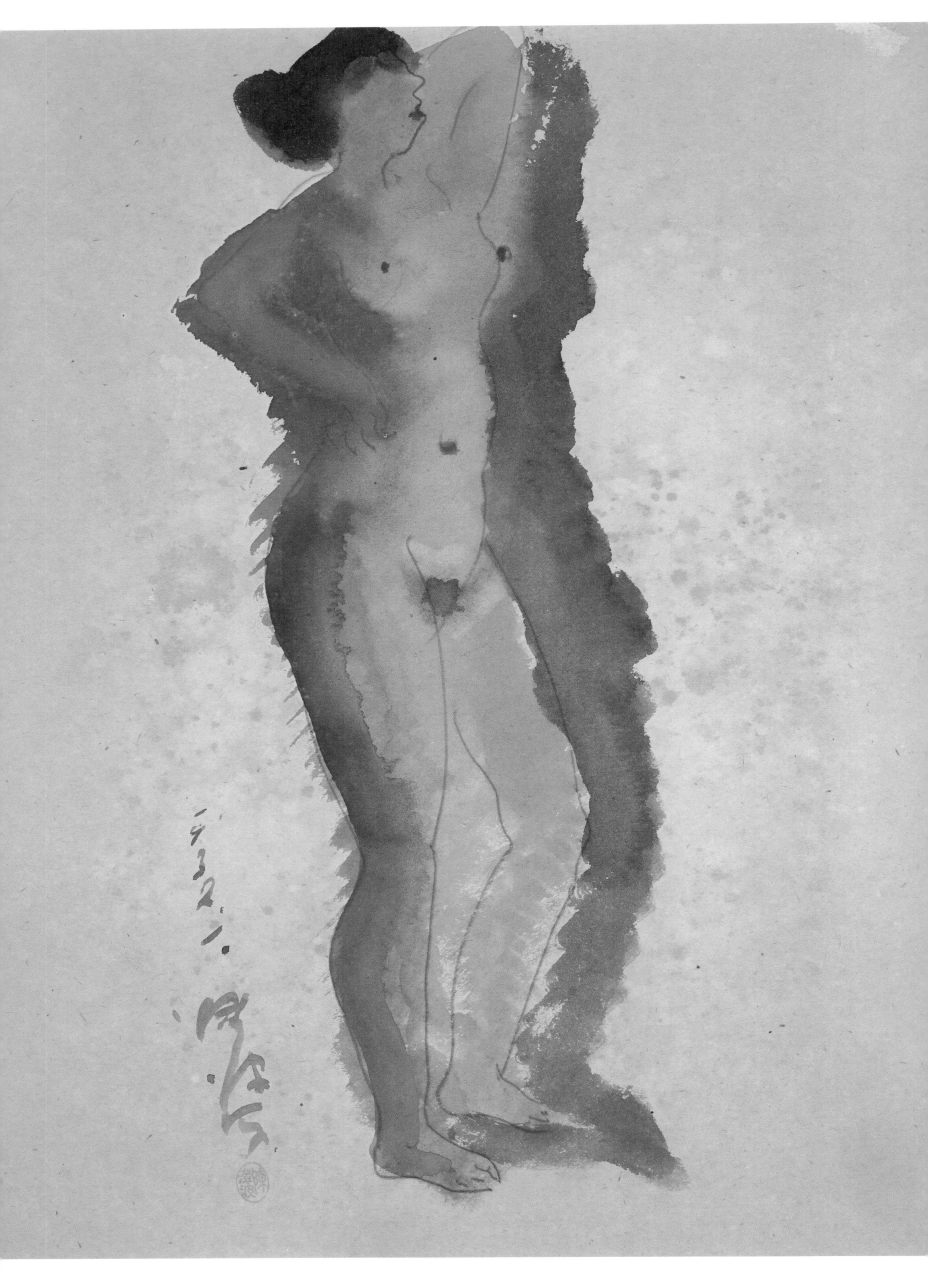

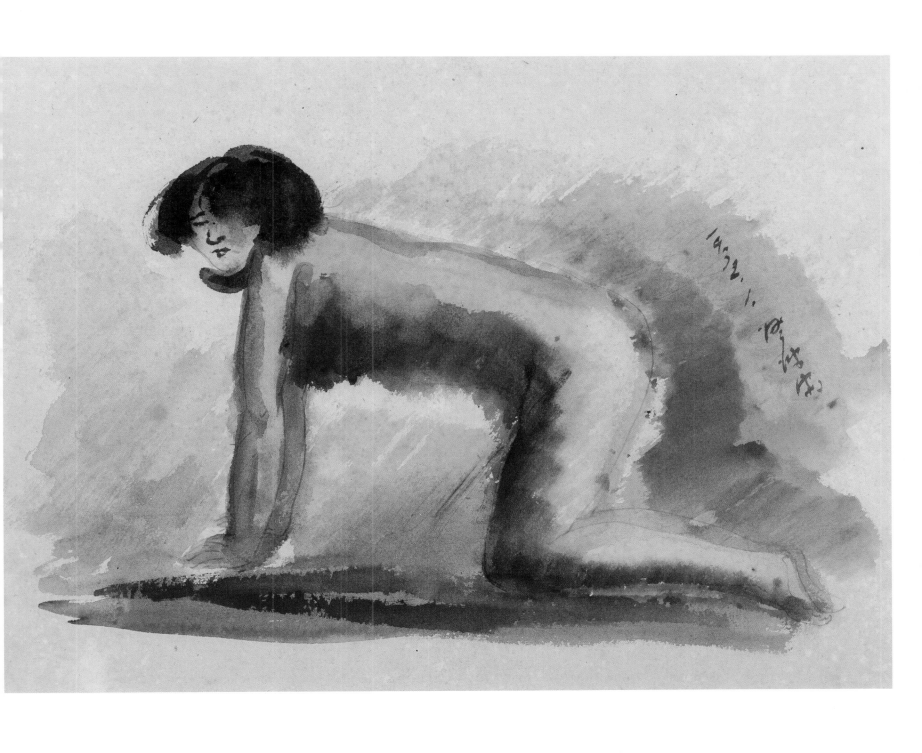

臥姿裸女-32.1（8） Lying Nude-32.1 (8)

1932　紙本淡彩鉛筆　26.5×36cm

[左頁圖]
立姿裸女-32.1（7） Standing Nude-32.1 (7)

1932　紙本淡彩鉛筆　37×28.5cm

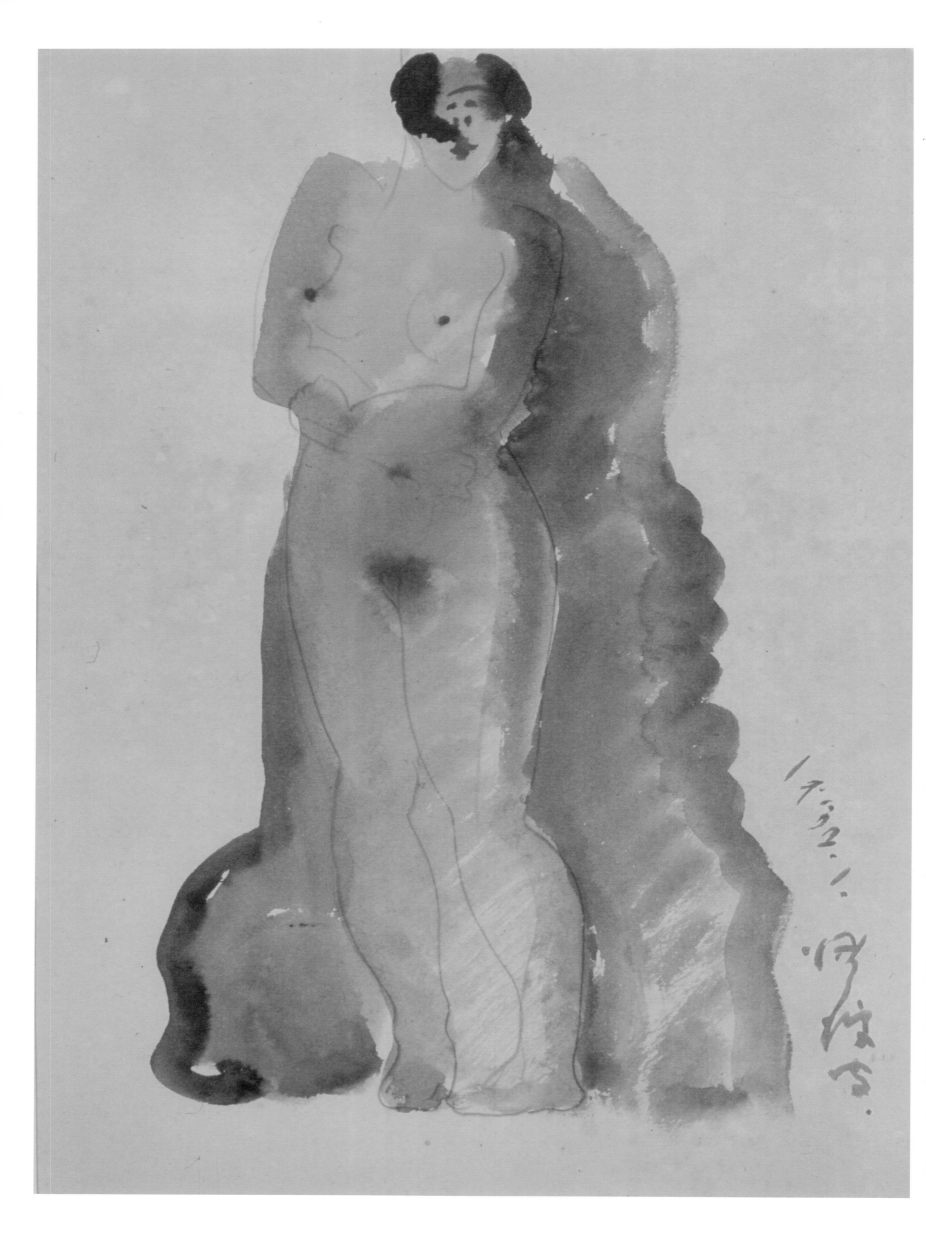

立姿裸女-32.1（8）Standing Nude-32.1 (8)

1932　紙本淡彩鉛筆　37×27cm

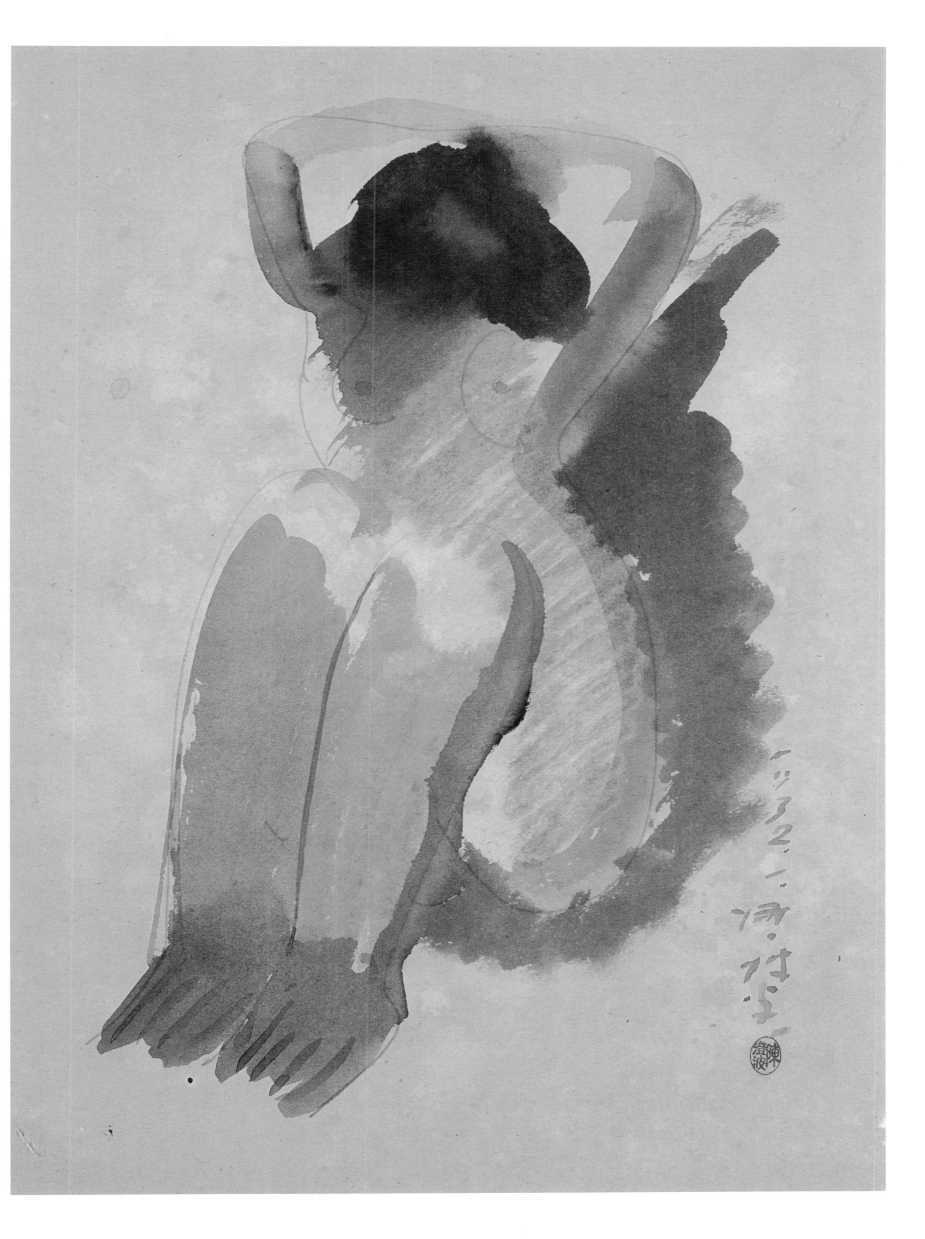

坐姿裸女-32.1（22） Seated Nude-32.1 (22)
1932　紙本淡彩鉛筆　37×27.5cm

坐姿裸女-32.1（23）Seated Nude-32.1 (23)

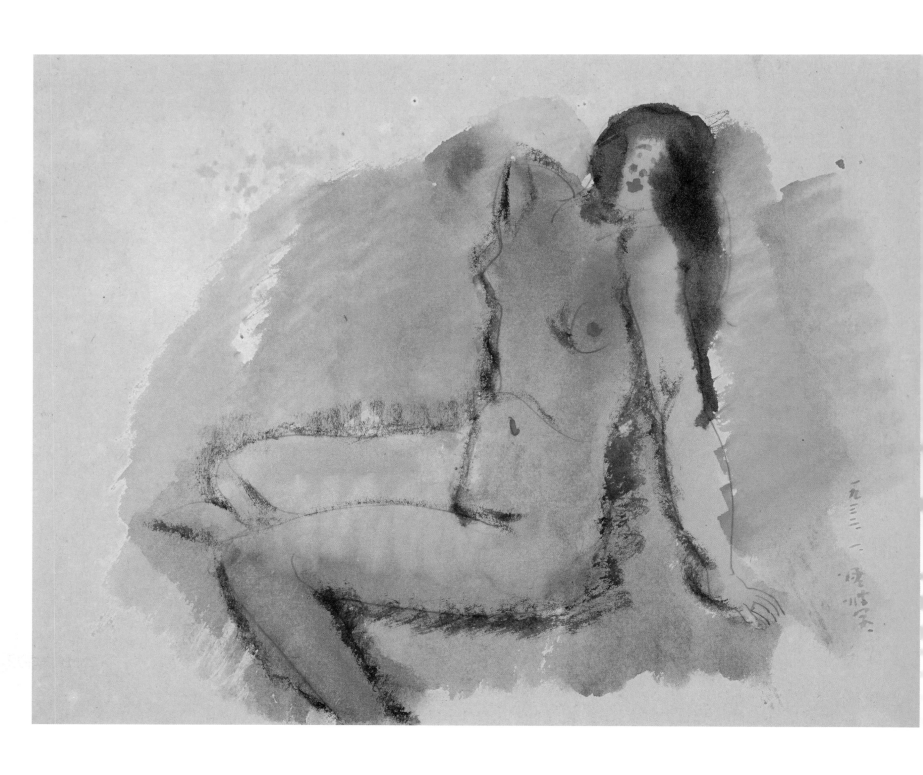

1932　紙本淡彩鉛筆　28.5×36.5cm

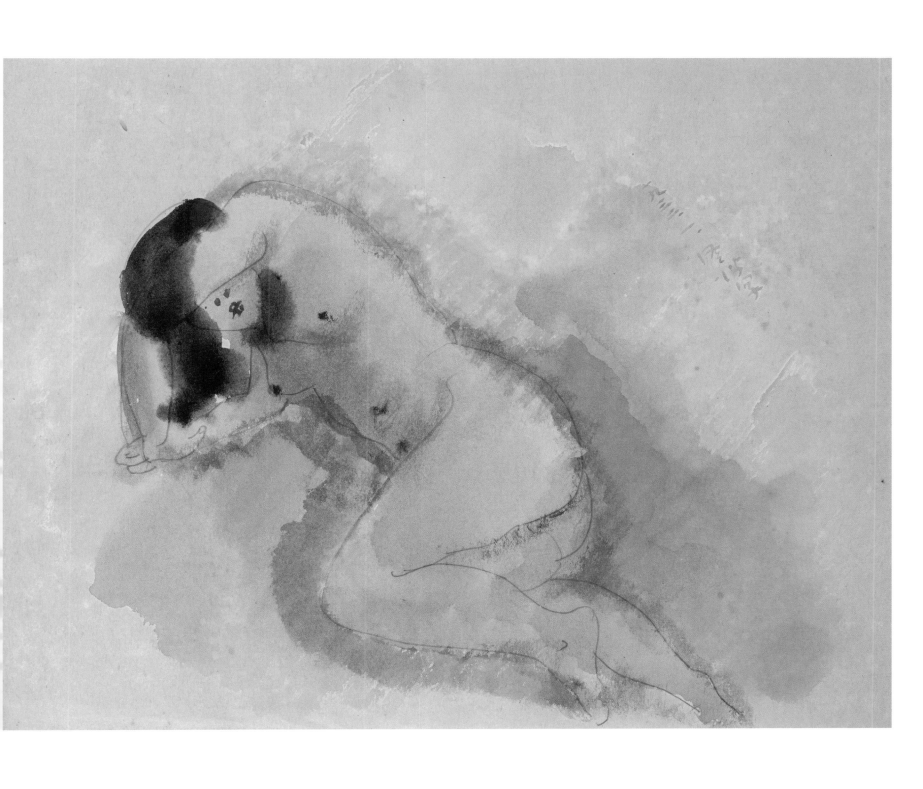

臥姿裸女-32.1（9）Lying Nude-32.1 (9)

1932　紙本淡彩鉛筆　28.5 × 36.5cm

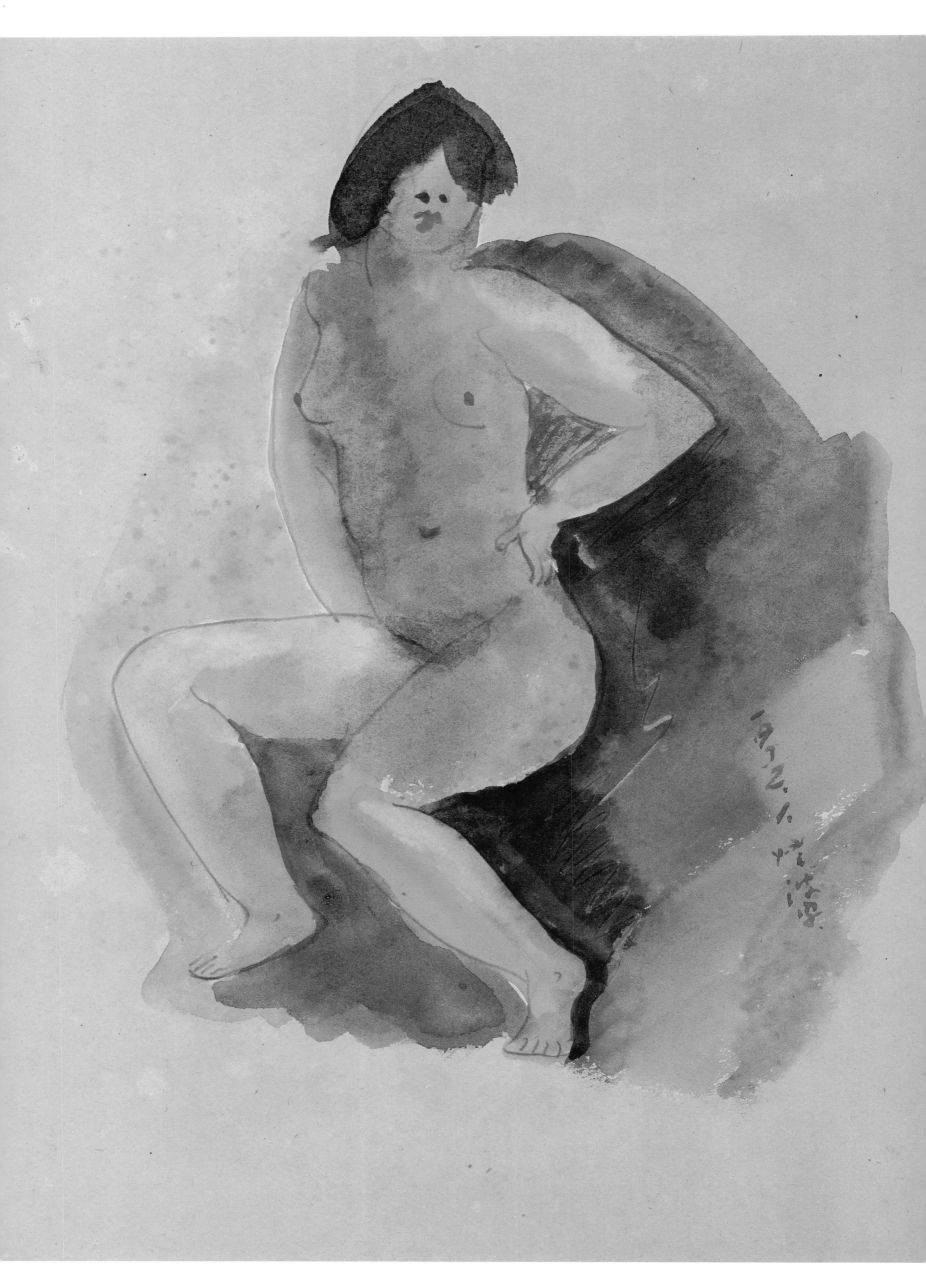

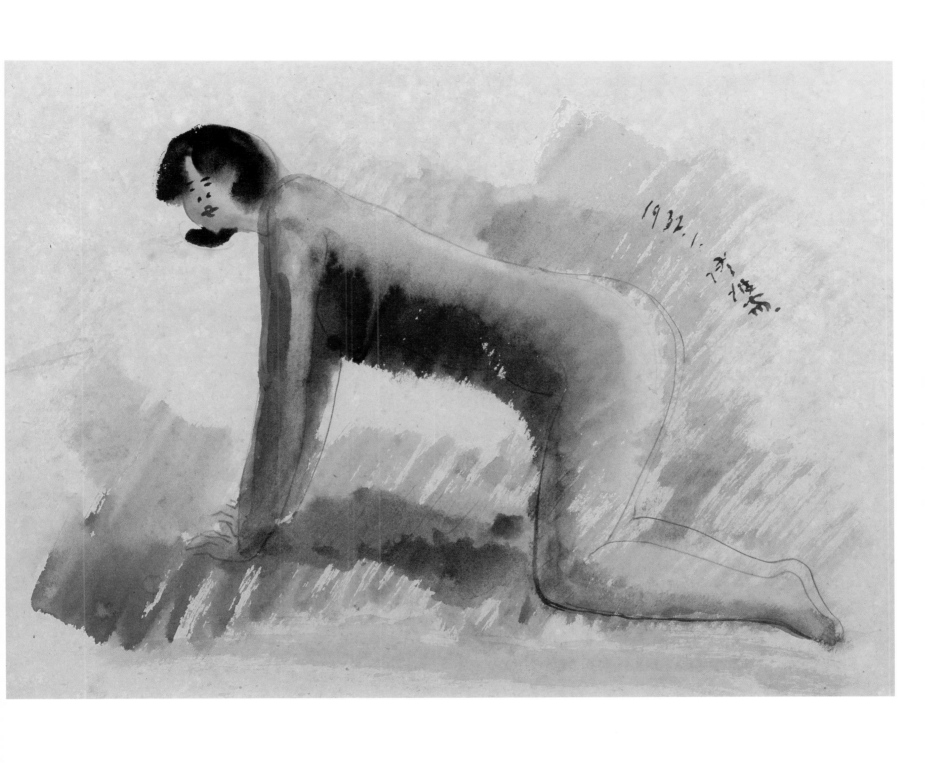

臥姿裸女-32.1（10）Lying Nude-32.1 (10)
1932　紙本淡彩鉛筆　26.5×36cm

[左頁圖]
坐姿裸女-32.1（24）Seated Nude-32.1 (24)
1932　紙本淡彩鉛筆　36×28.5cm

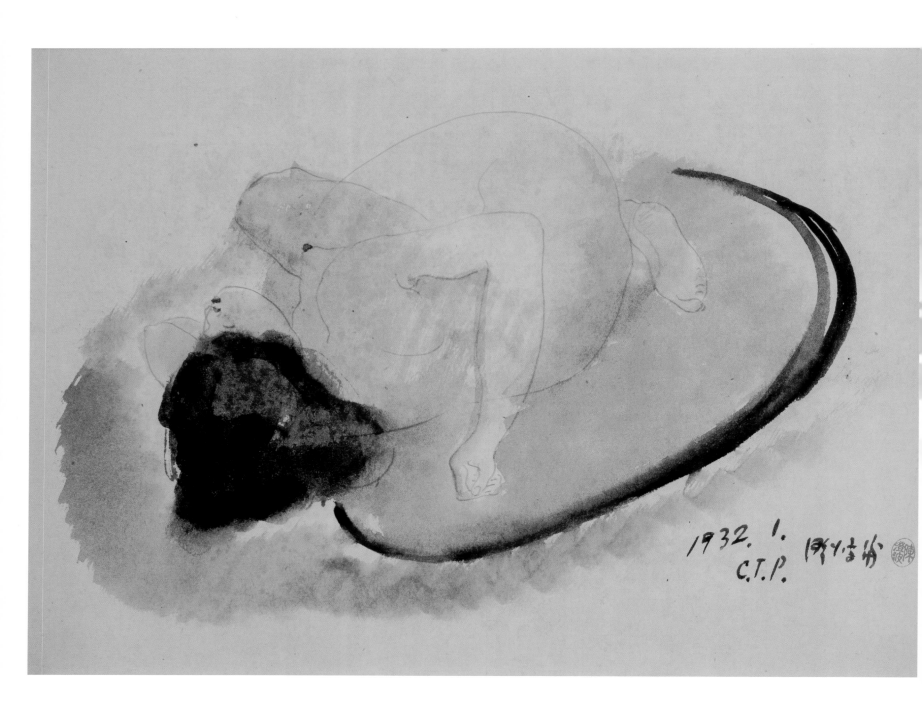

臥姿裸女-32.1（11）Lying Nude-32.1 (11)

1932　紙本淡彩鉛筆　27.1×36.8cm

[右頁圖]

坐姿裸女-32.1（25）Seated Nude-32.1 (25)

1932　紙本淡彩鉛筆　36×28cm

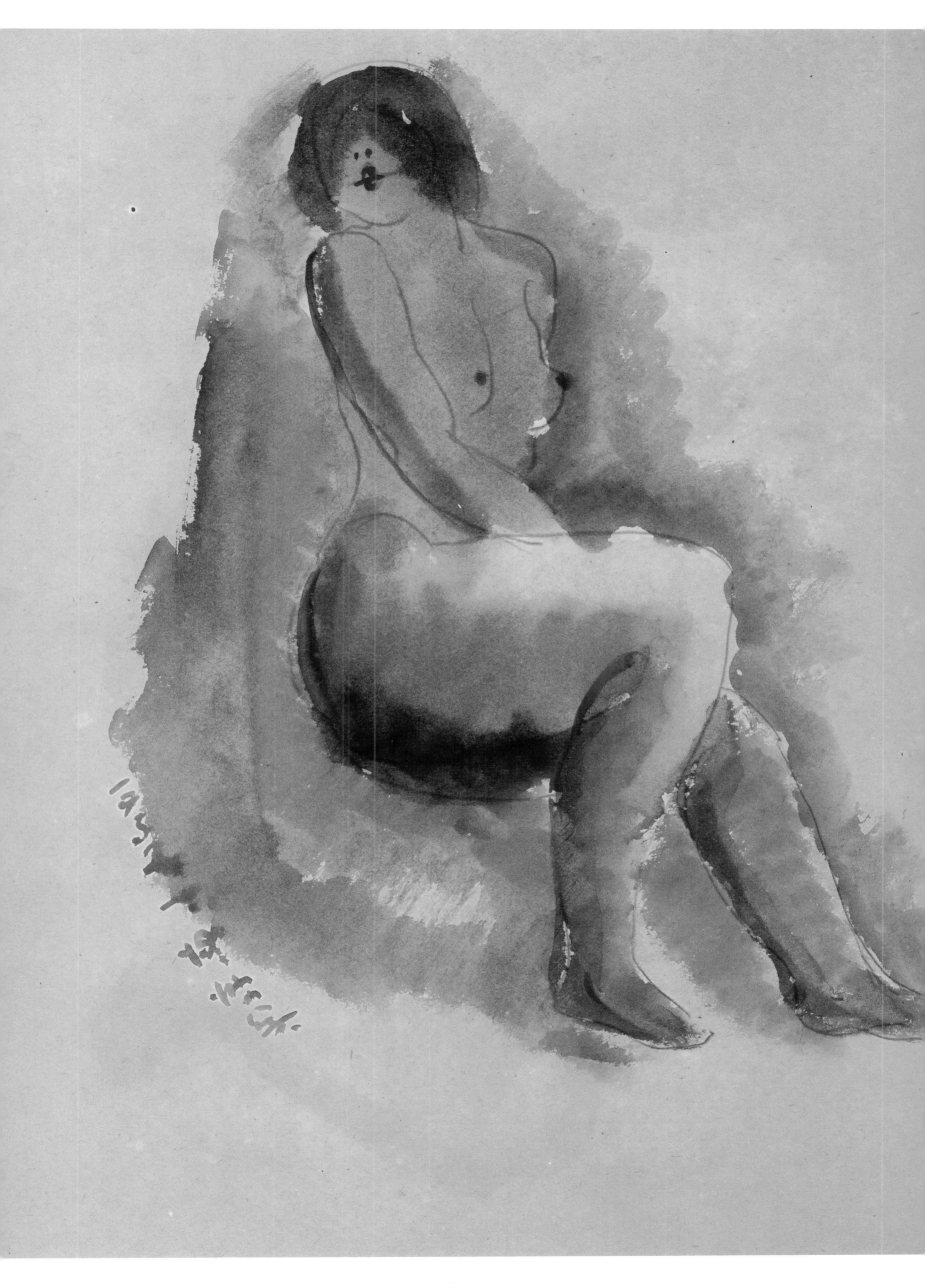

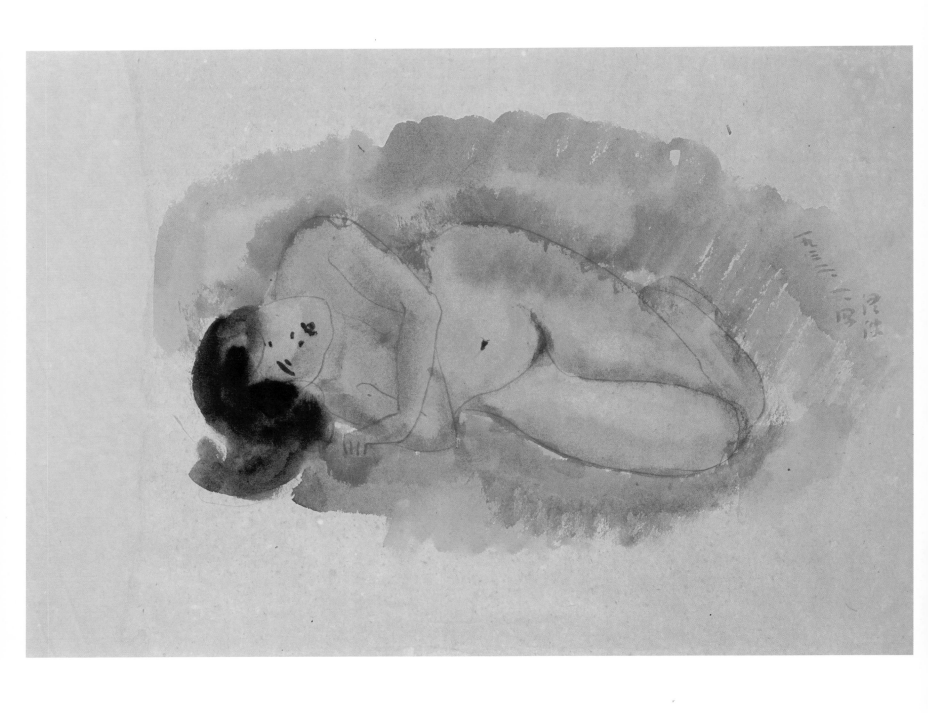

臥姿裸女-32.1（12），Lying Nude-32.1 (12)

1932　紙本淡彩鉛筆　　28.5×36.5cm

[右頁圖]

坐姿裸女-32.1（26）Seated Nude-32.1 (26)

1932　紙本淡彩鉛筆　　36.5×28.5cm

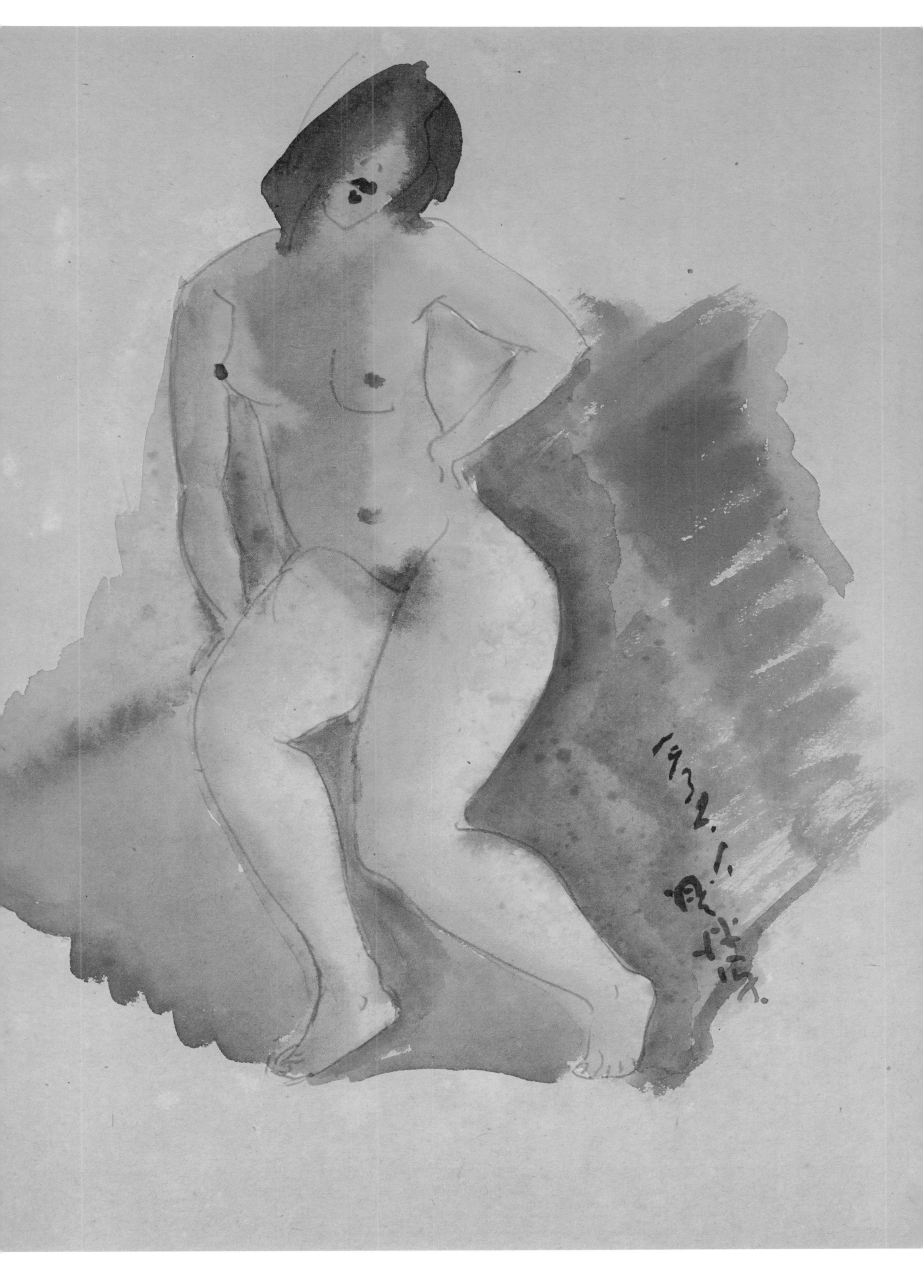

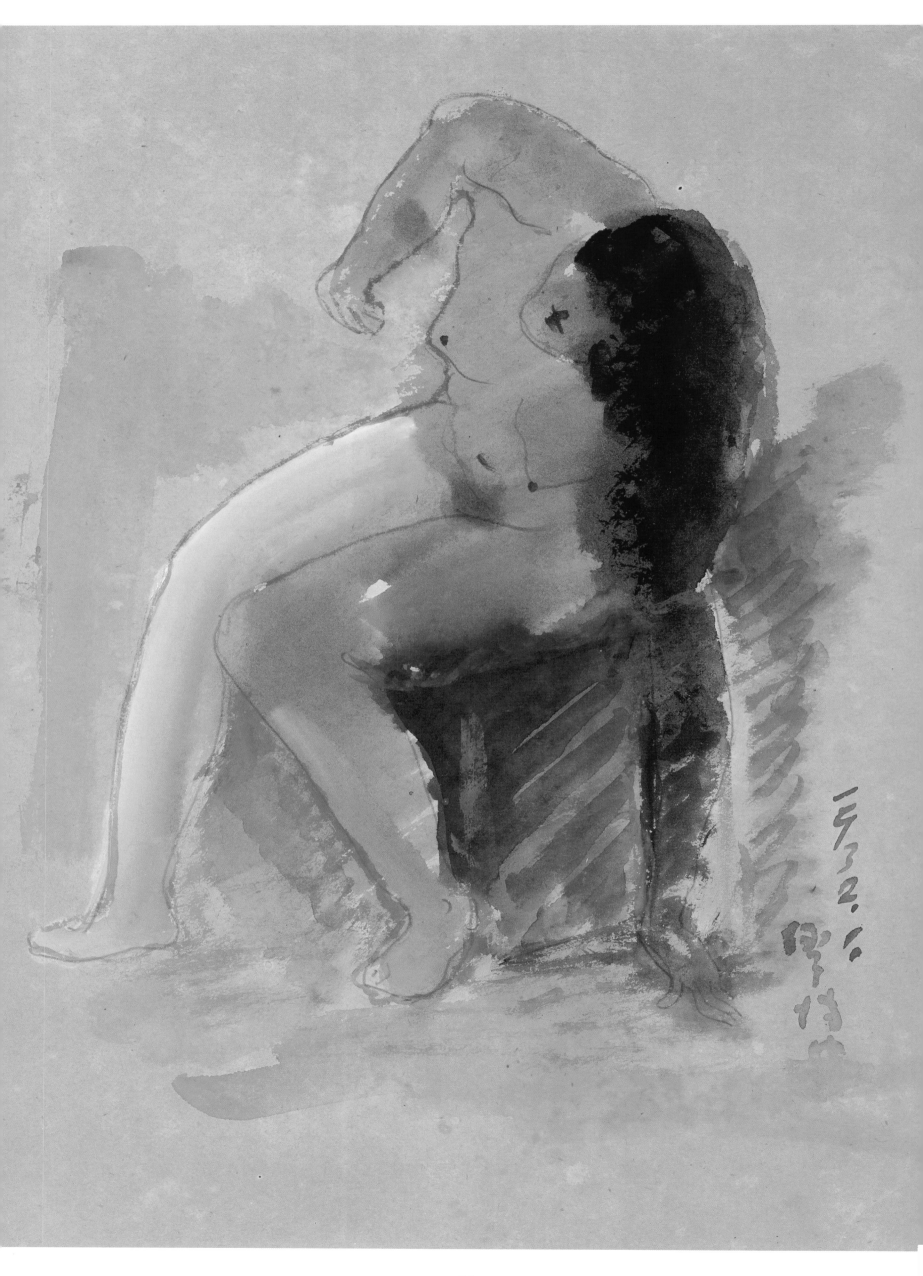

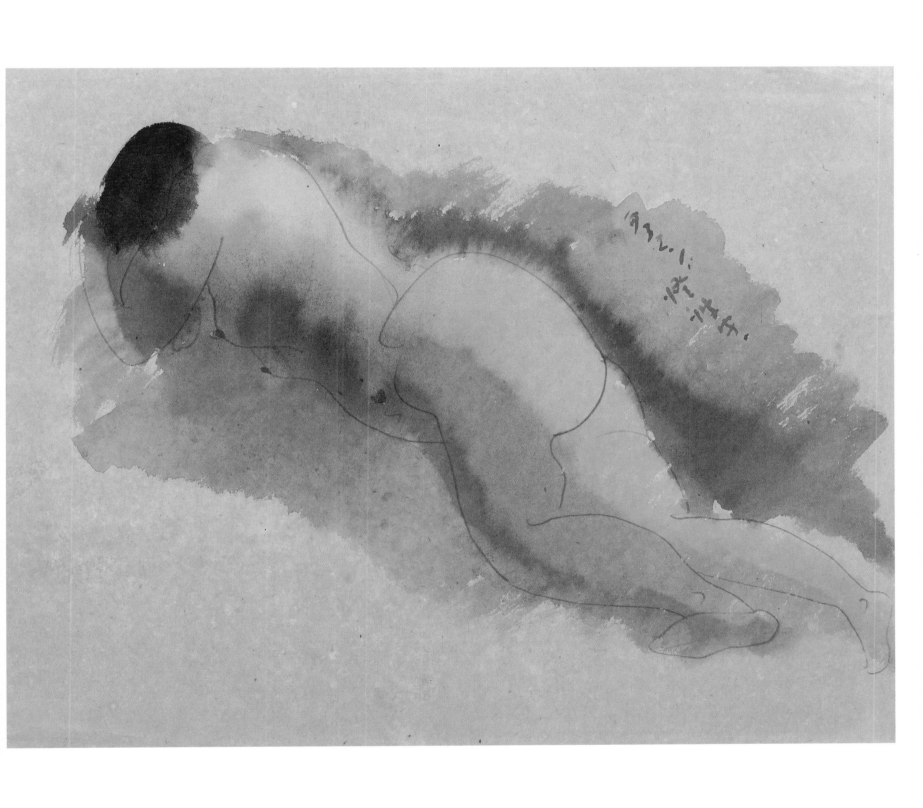

臥姿裸女-32.1（13） Lying Nude-32.1 (13)
1932　紙本淡彩鉛筆　28.5×36.5cm

[左頁圖]
坐姿裸女-32.1（27） Seated Nude-32.1 (27)
1932　紙本淡彩鉛筆　36.5×28.5cm

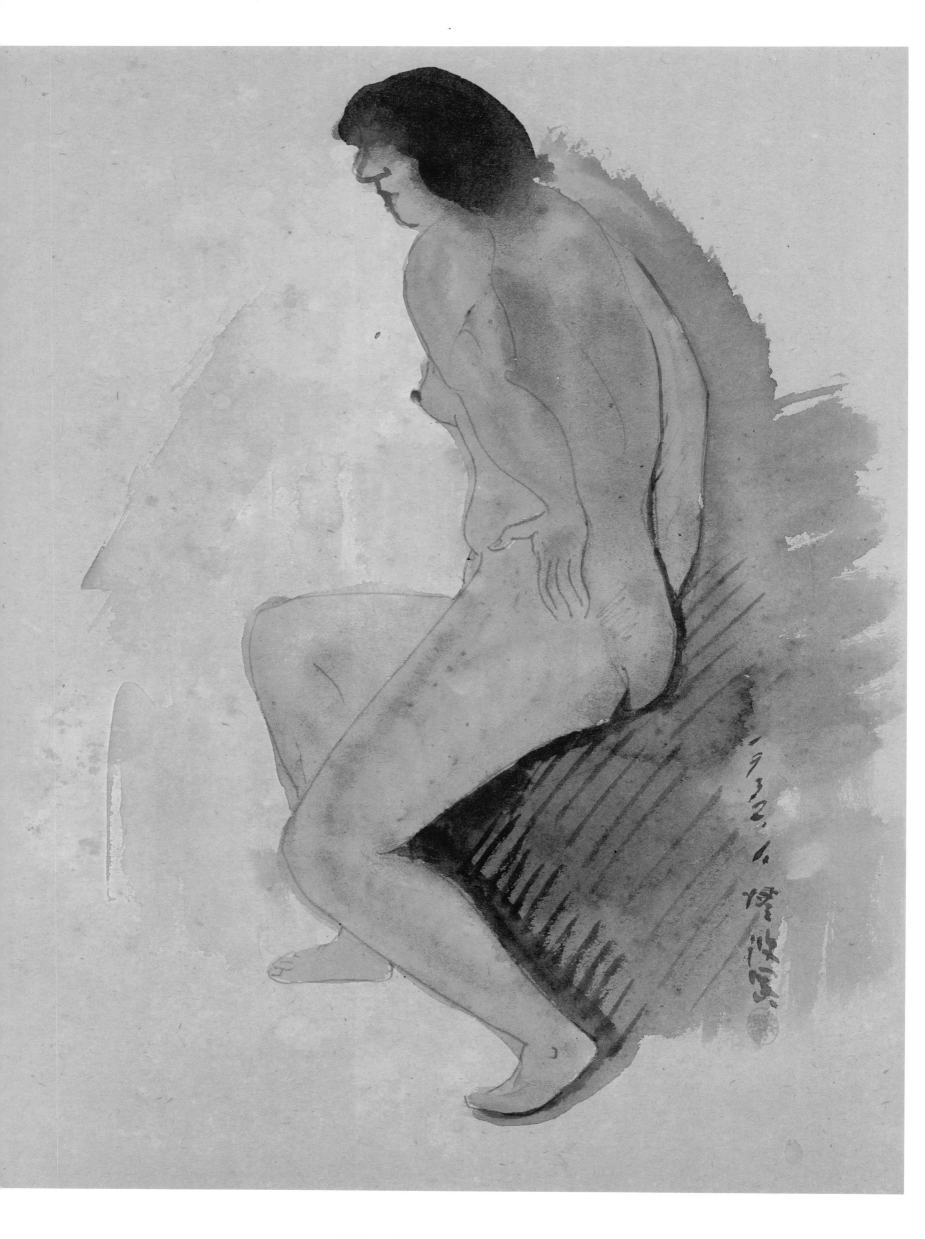

坐姿裸女-32.1（28） Seated Nude-32.1 (28)

1932　紙本淡彩鉛筆　36.5×28.5cm

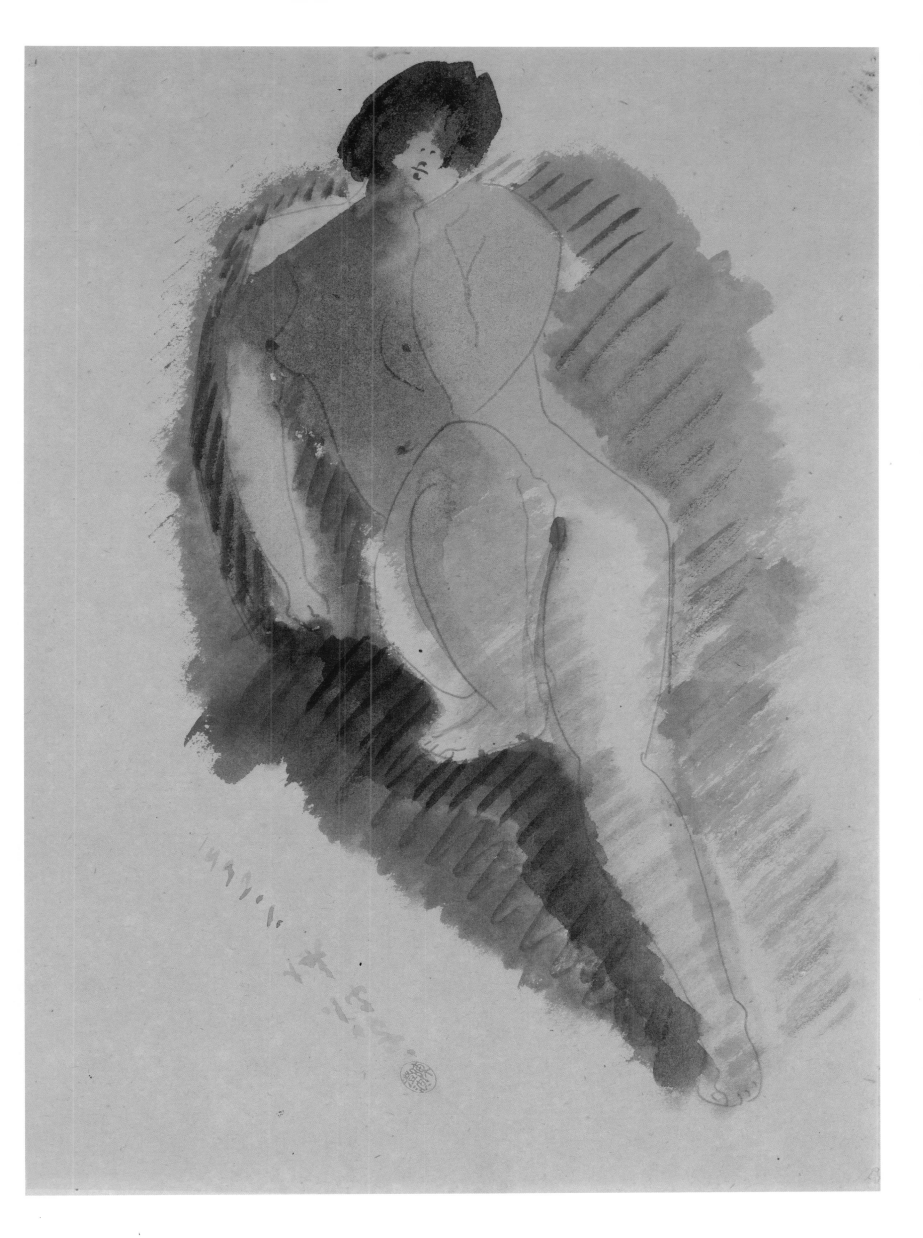

坐姿裸女-32.1（29） Seated Nude-32.1 (29)

1932　紙本淡彩鉛筆　36.5×26.5cm

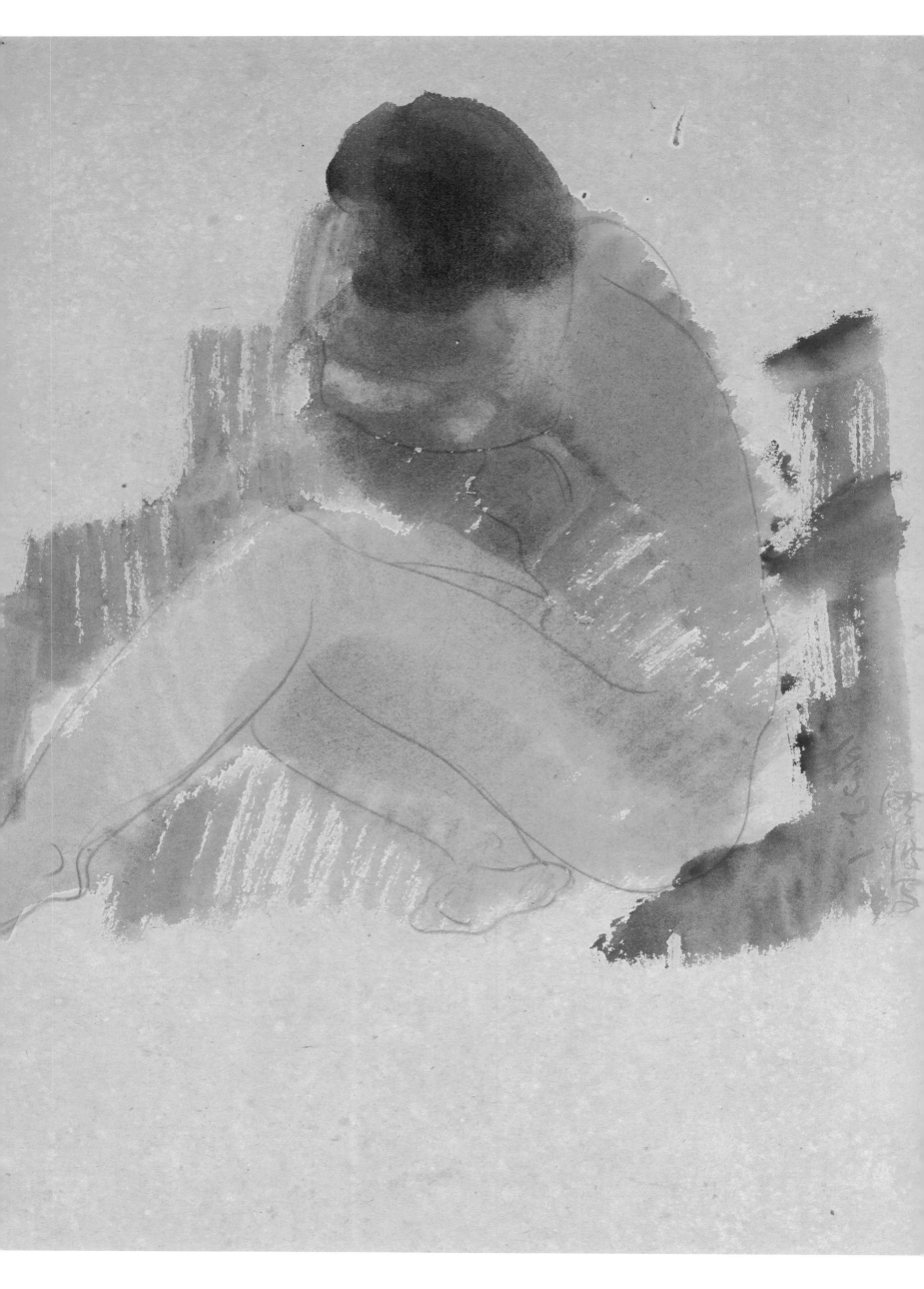

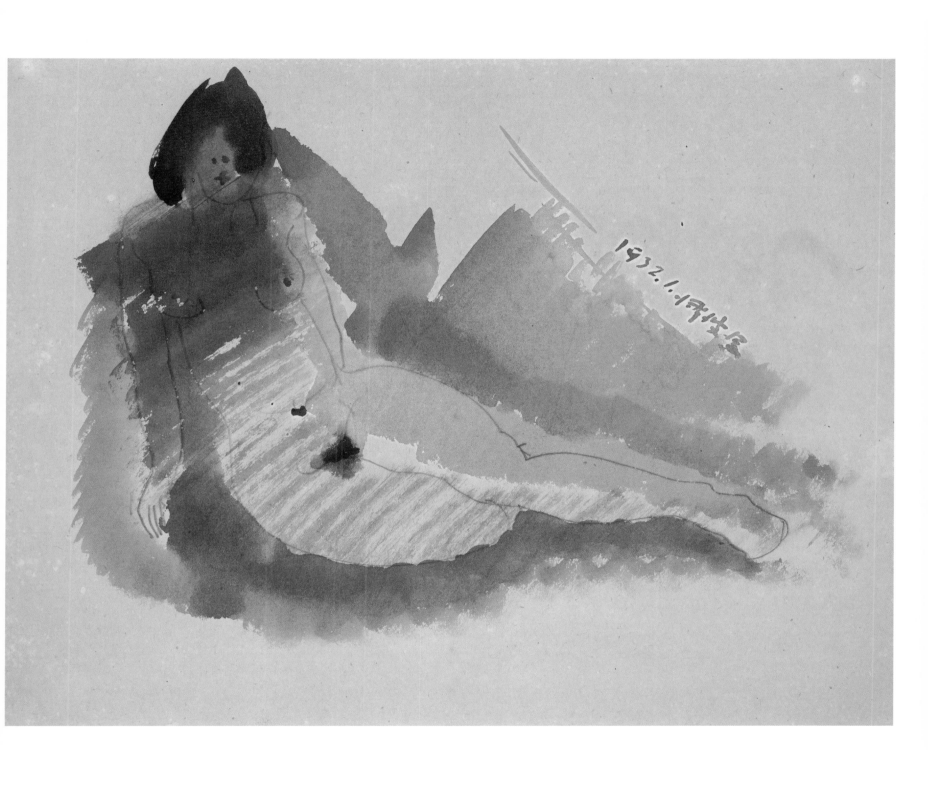

坐姿裸女-32.1（31） Seated Nude-32.1 (31)

1932　紙本淡彩鉛筆　28.5×37cm

[左頁圖]
坐姿裸女-32.1（30） Seated Nude-32.1 (30)

1932　紙本淡彩鉛筆　36.5×28.5cm

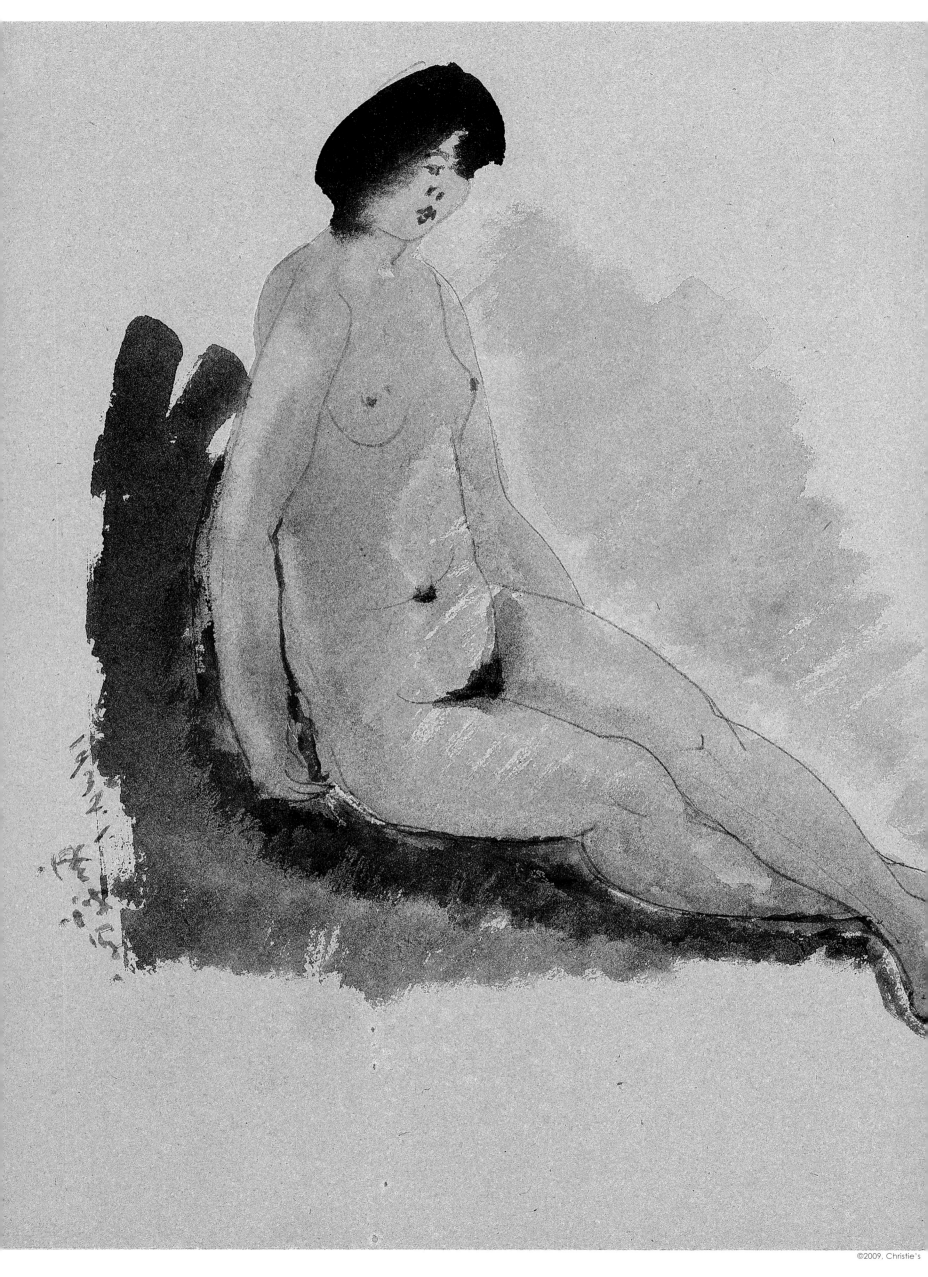

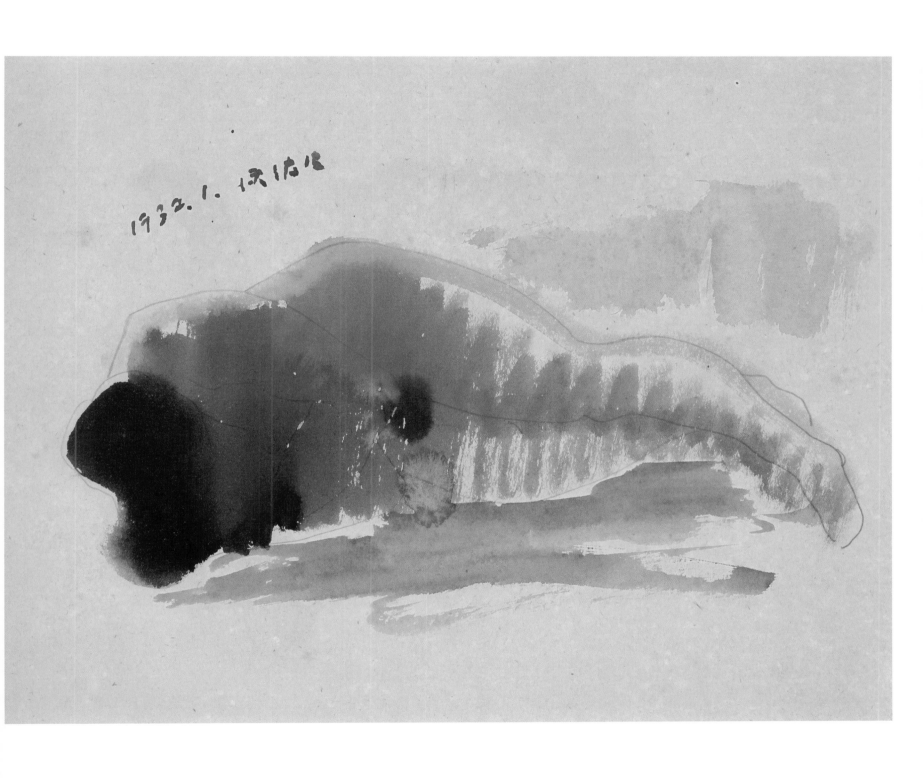

臥姿裸女-32.1（14） Lying Nude-32.1 (14)

1932　紙本淡彩鉛筆　28.5×36.5cm

[左頁圖]

坐姿裸女-32.1（32） Seated Nude-32.1 (32)

1932　紙本淡彩鉛筆　47.3×36.7cm（圖版提供：佳士得）

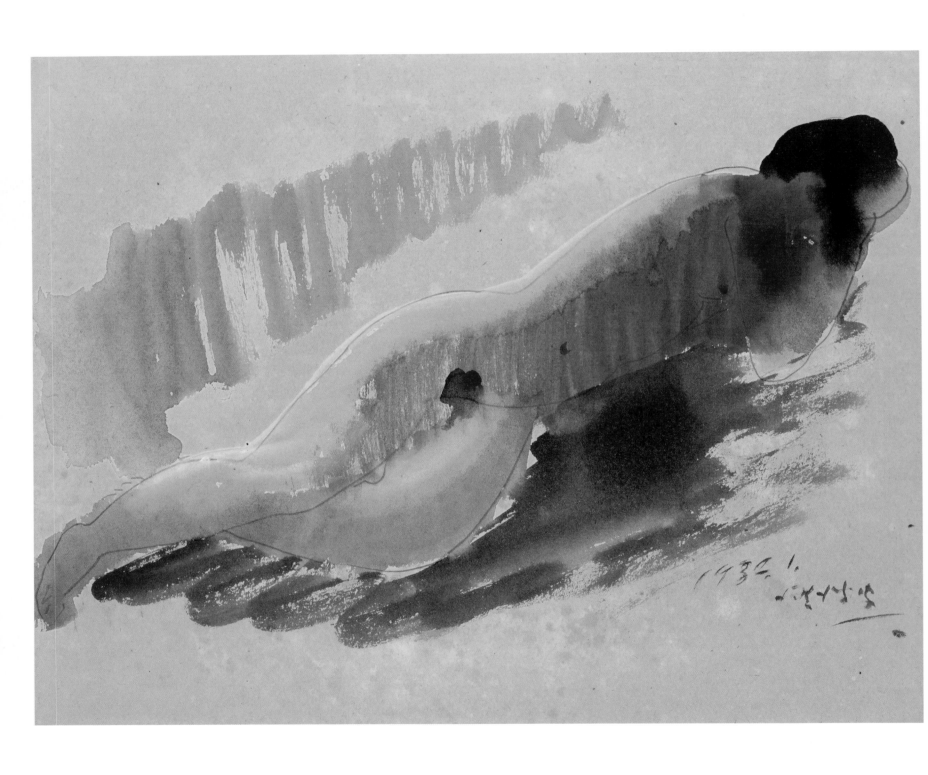

臥姿裸女-32.1（15）Lying Nude-32.1 (15)

1932　紙本淡彩鉛筆　28.5×37cm

坐姿裸女-32.1（33） Seated Nude-32.1 (33)
1932　紙本淡彩鉛筆　26.5×36cm

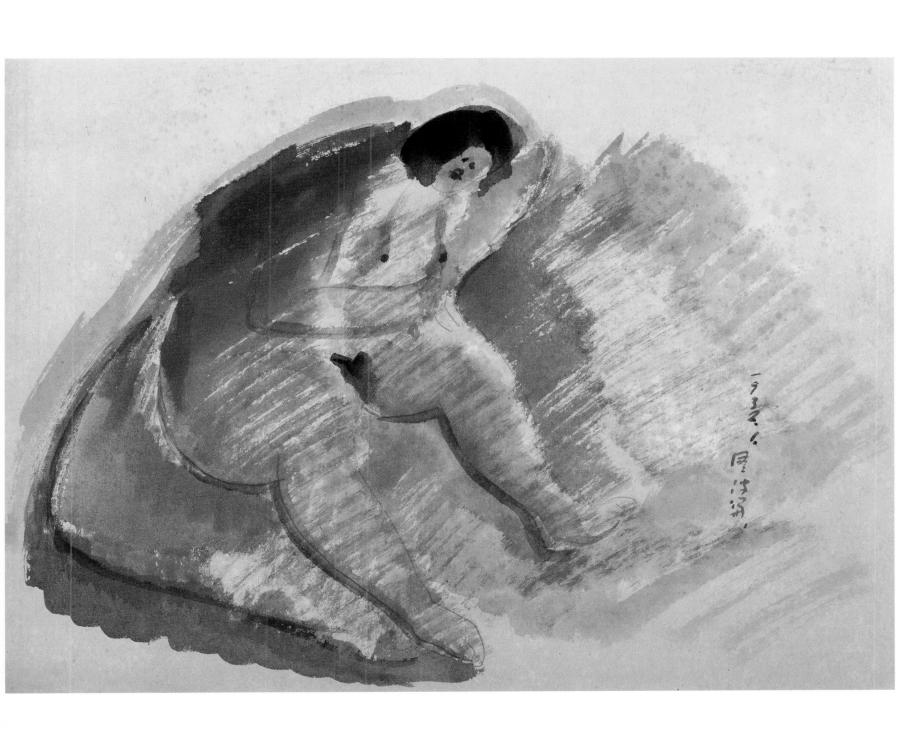

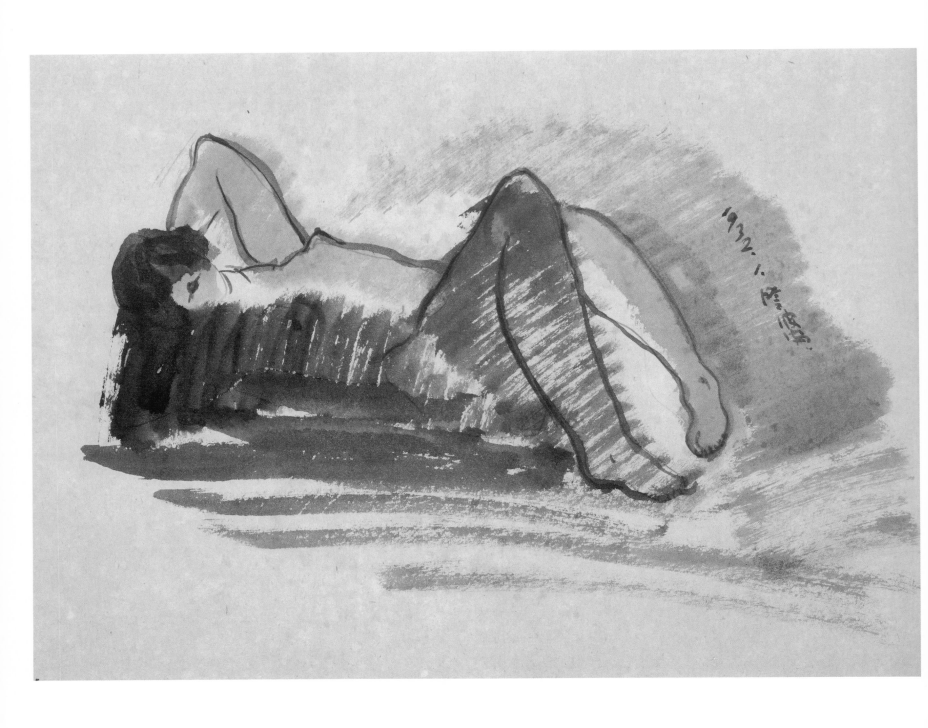

臥姿裸女-32.1（16） Lying Nude-32.1 (16)

1932　紙本淡彩鉛筆　26.5×36.5cm

[右頁圖]

坐姿裸女-32.1（34） Seated Nude-32.1 (34)

1932　紙本淡彩鉛筆　37×29.2cm

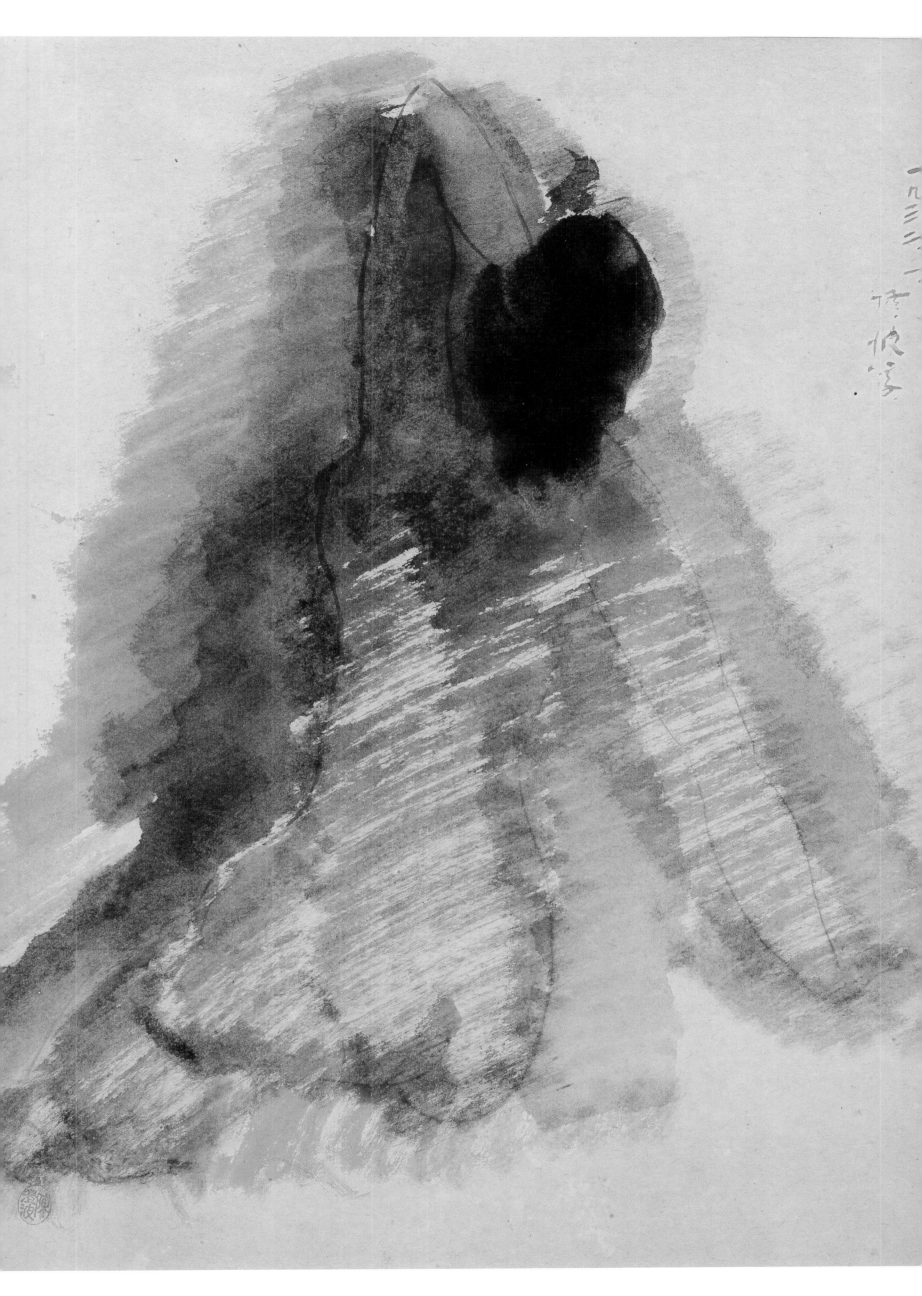

99

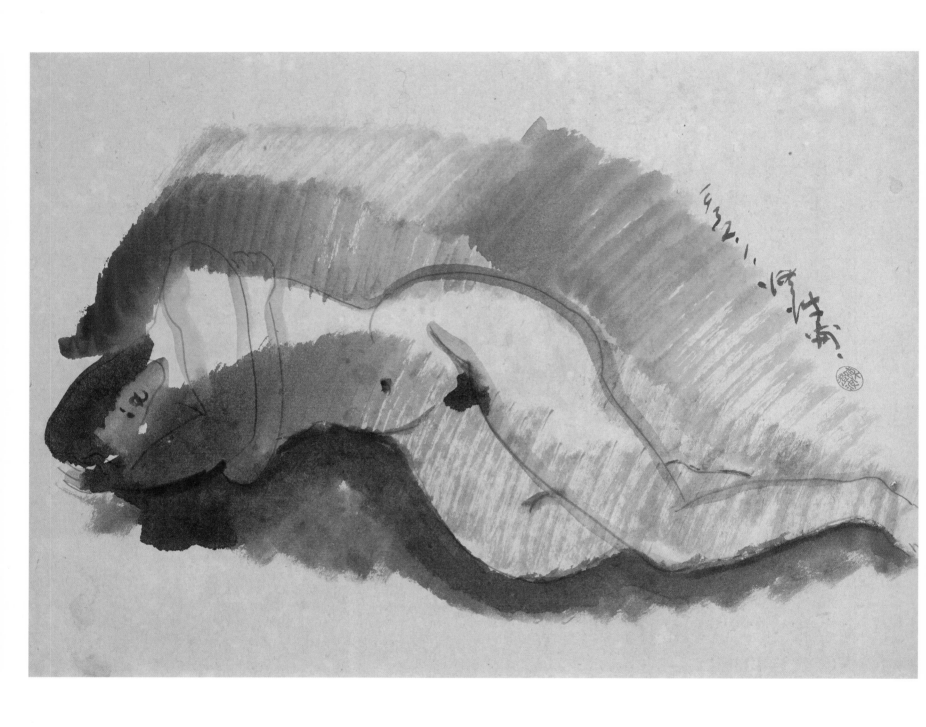

臥姿裸女-32.1（17） Lying Nude-32.1 (17)

1932　紙本淡彩鉛筆　26.5×36.5cm

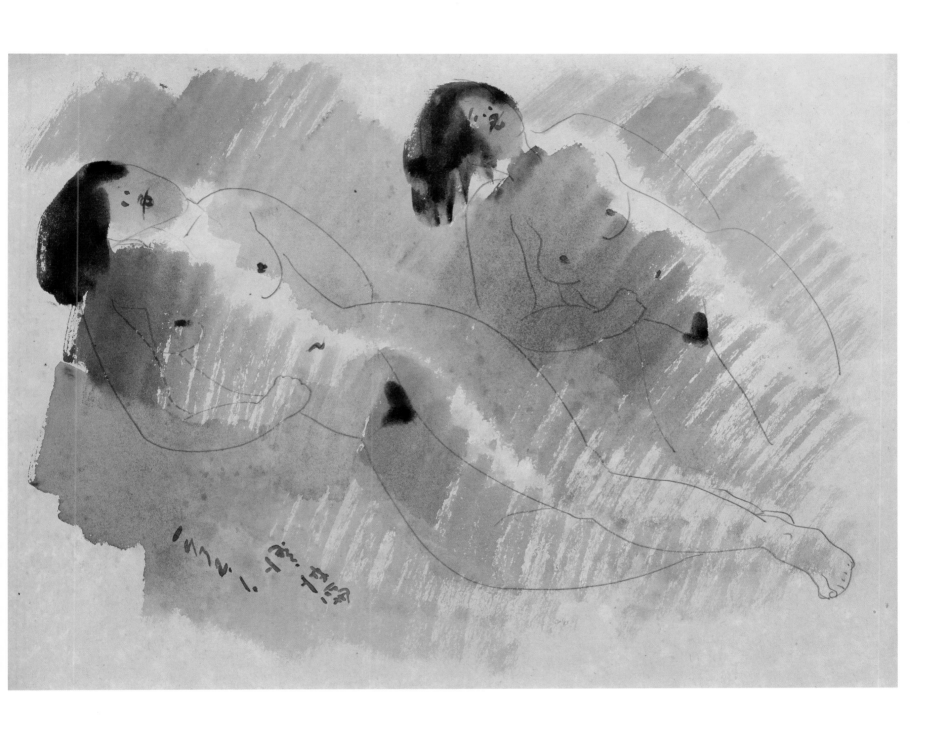

臥姿裸女-32.1（18） Lying Nude-32.1 (18)

1932　紙本淡彩鉛筆　26.5×36cm

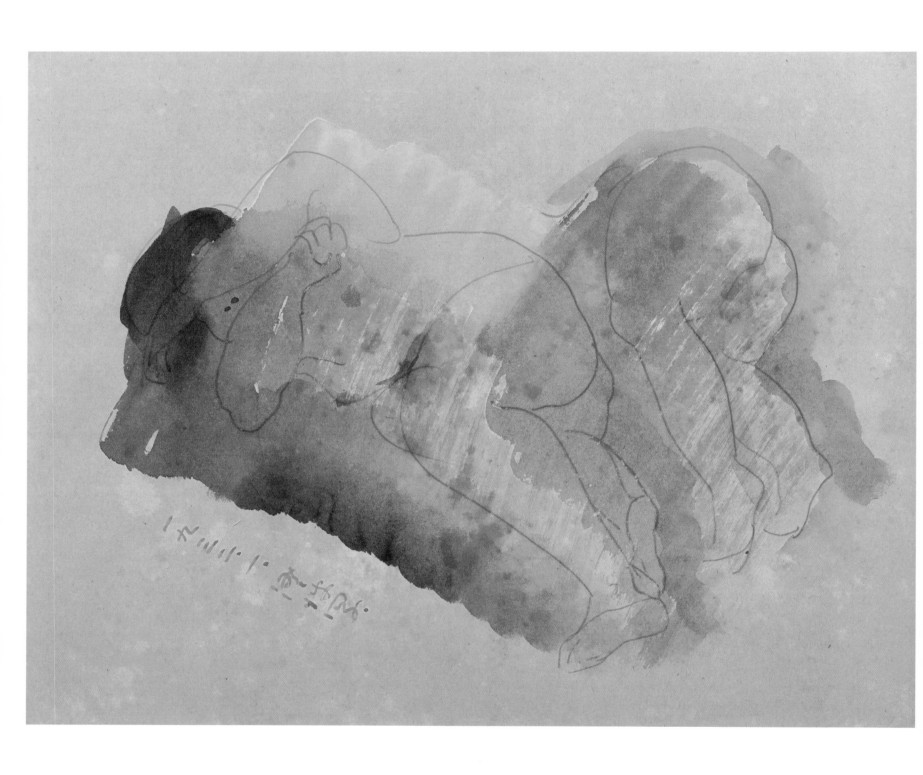

臥姿裸女-32.1（19） Lying Nude-32.1 (19)

1932　紙本淡彩鉛筆　28×36cm

[右頁圖]

坐姿裸女-32.1（35） Seated Nude-32.1 (35)

1932　紙本淡彩鉛筆　36.7×27.1cm

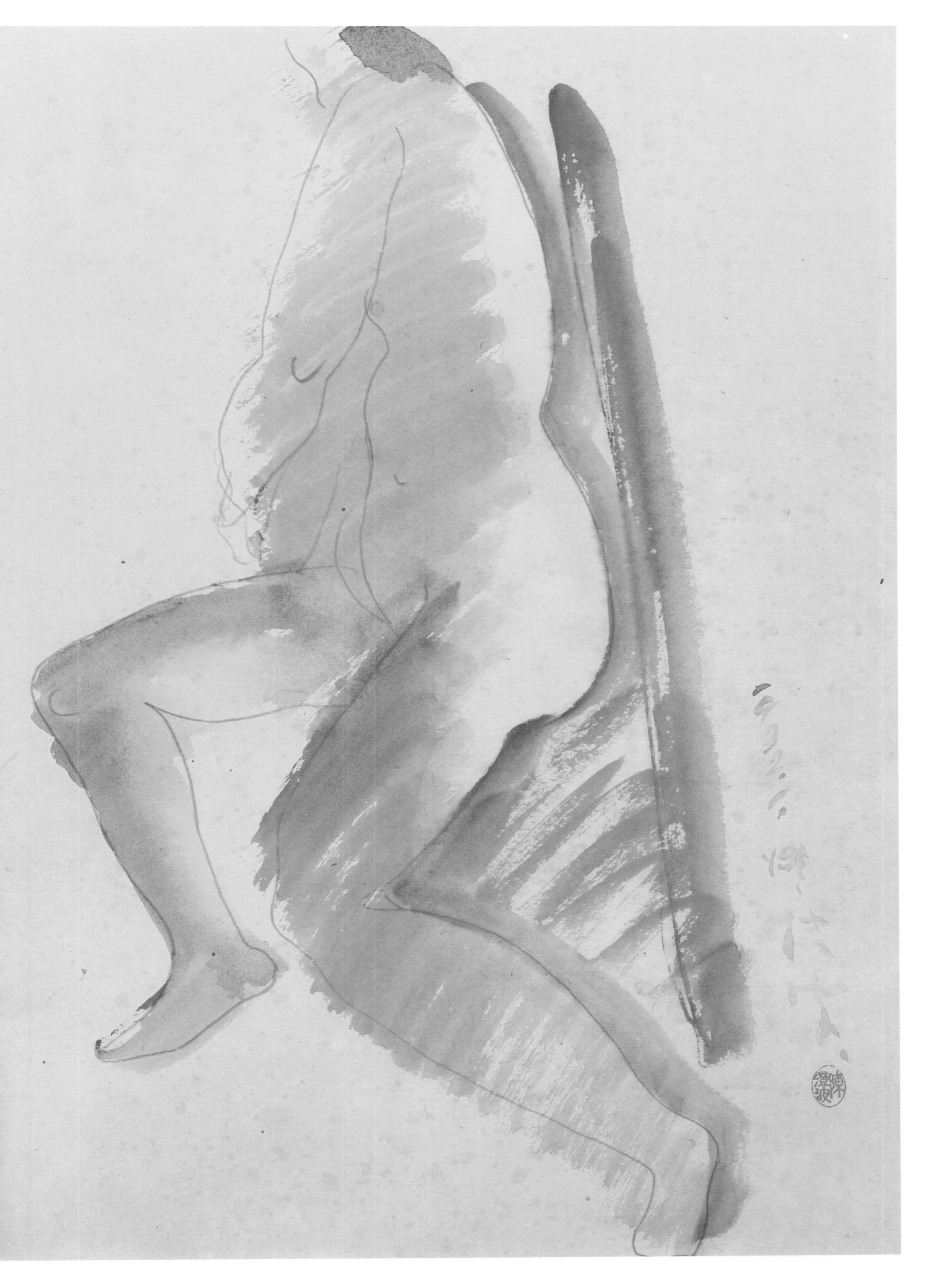

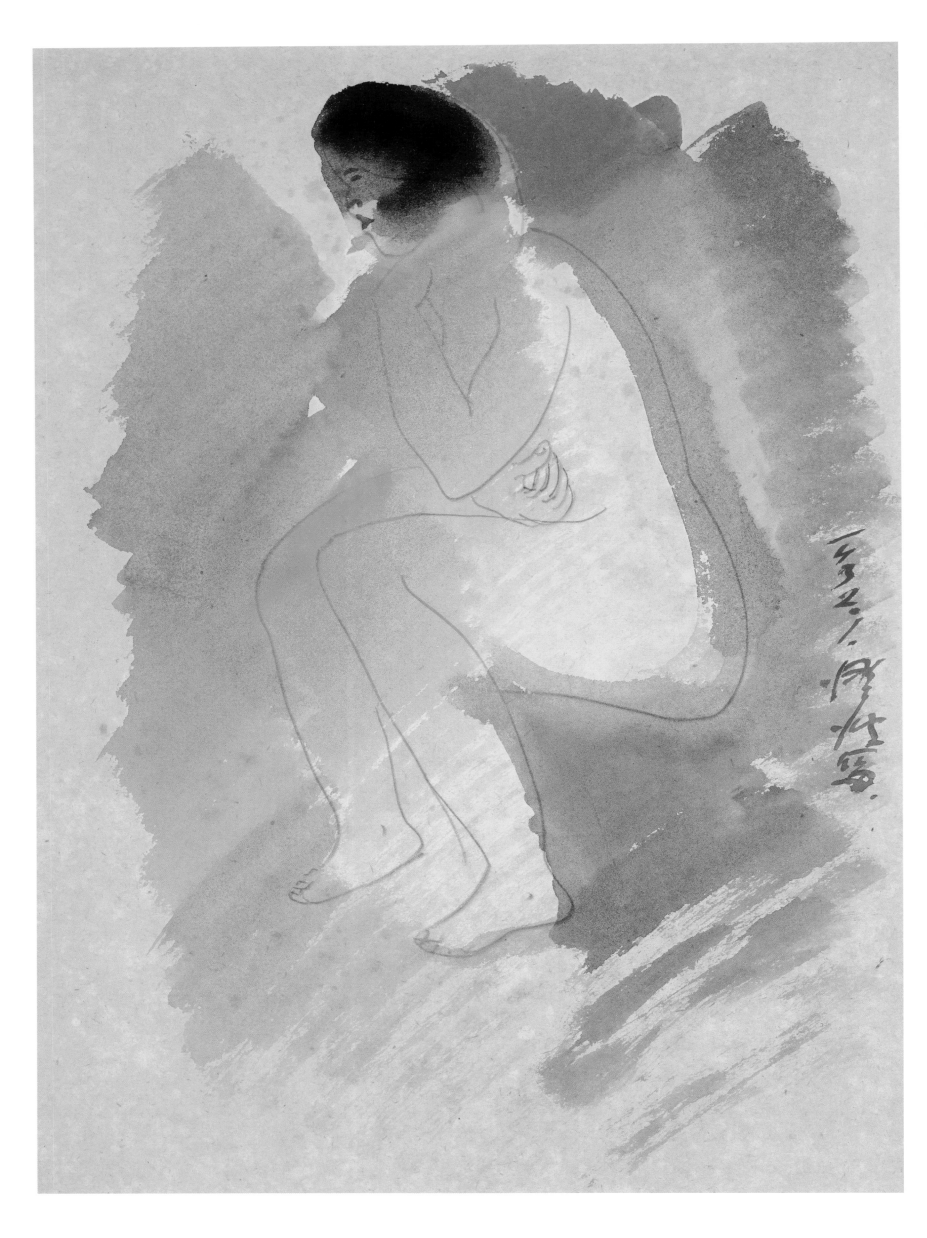

坐姿裸女-32.1（36）Seated Nude-32.1 (36)

1932　紙本淡彩鉛筆　36.5×26.5cm

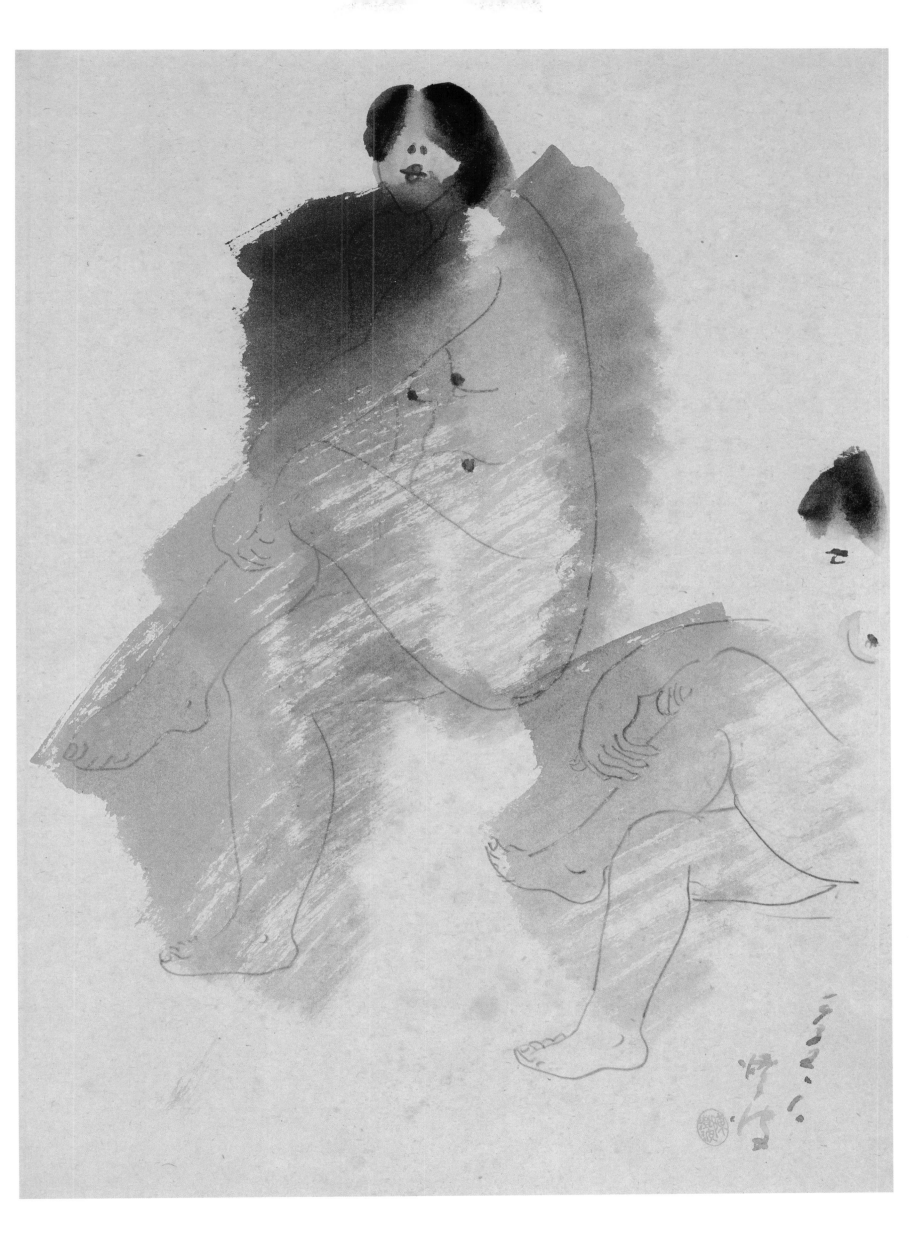

坐姿裸女-32.1（37） Seated Nude-32.1 (37)

1932　紙本淡彩鉛筆　36.5×26.5cm

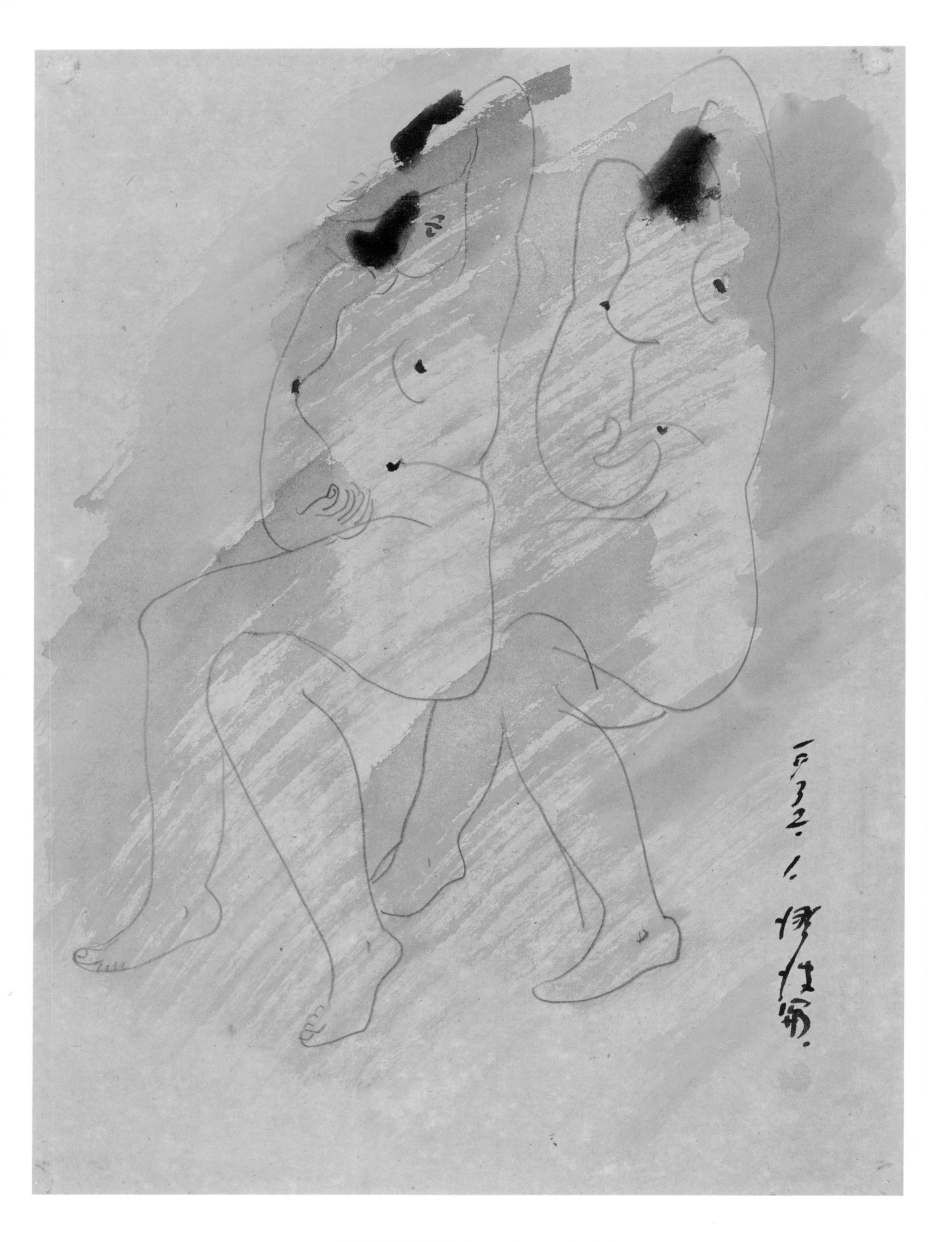

坐姿裸女-32.1（38）Seated Nude-32.1 (38)

1932　紙本淡彩鉛筆　36.5×26.5cm

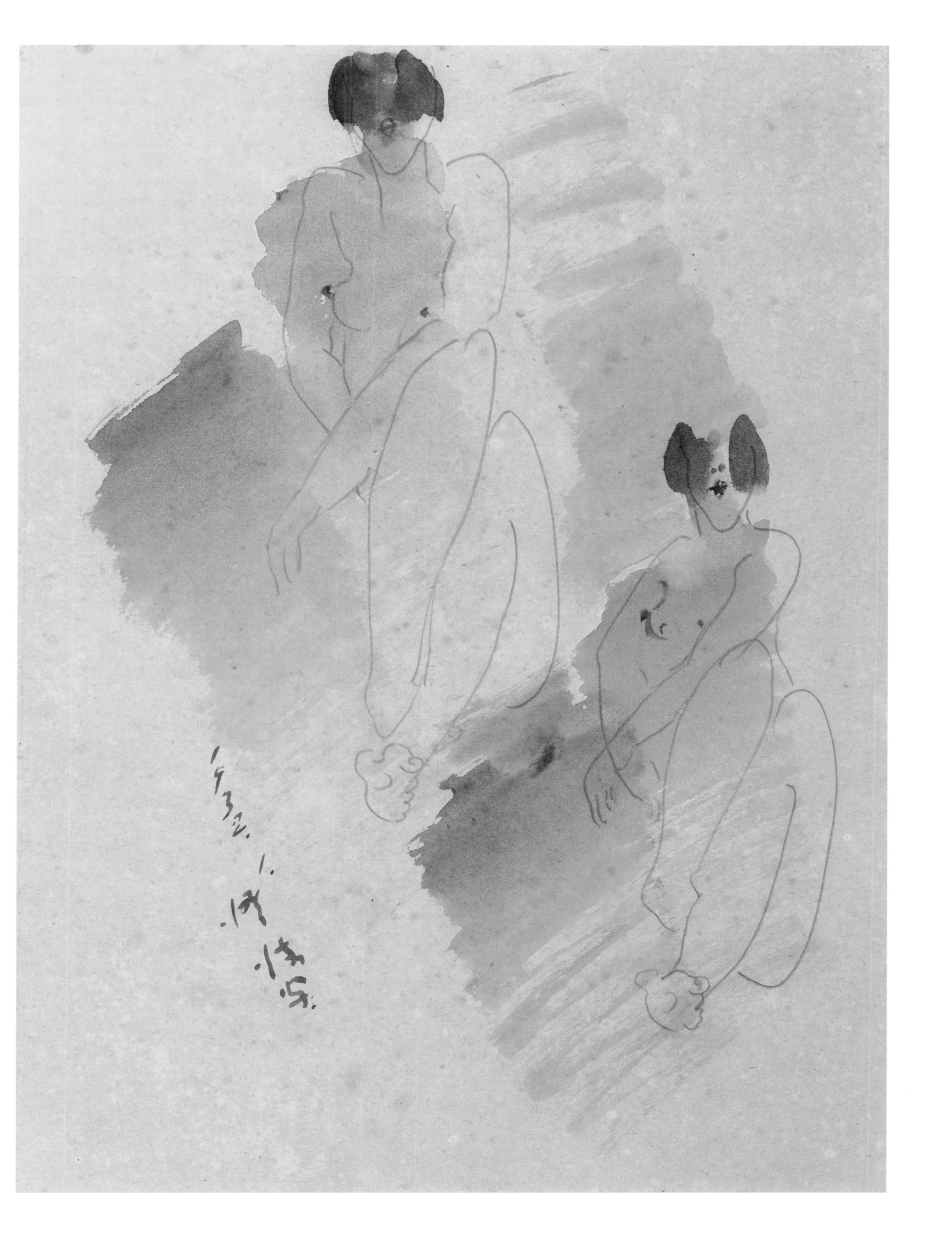

坐姿裸女-32.1（39） Seated Nude-32.1 (39)

1932　紙本淡彩鉛筆　36×26.5cm

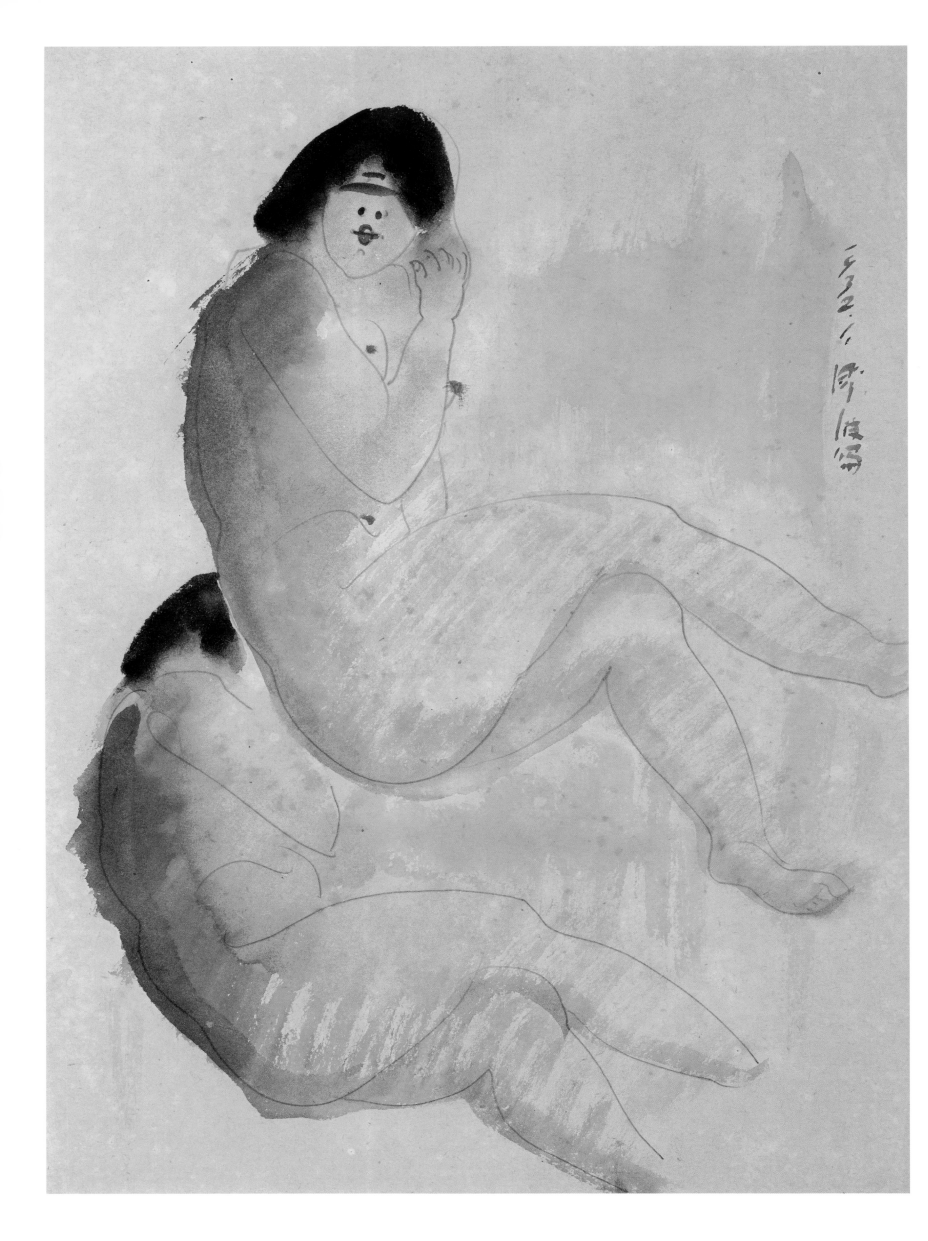

坐姿裸女-32.1（40）Seated Nude-32.1 (40)

1932　紙本淡彩鉛筆　36×26cm

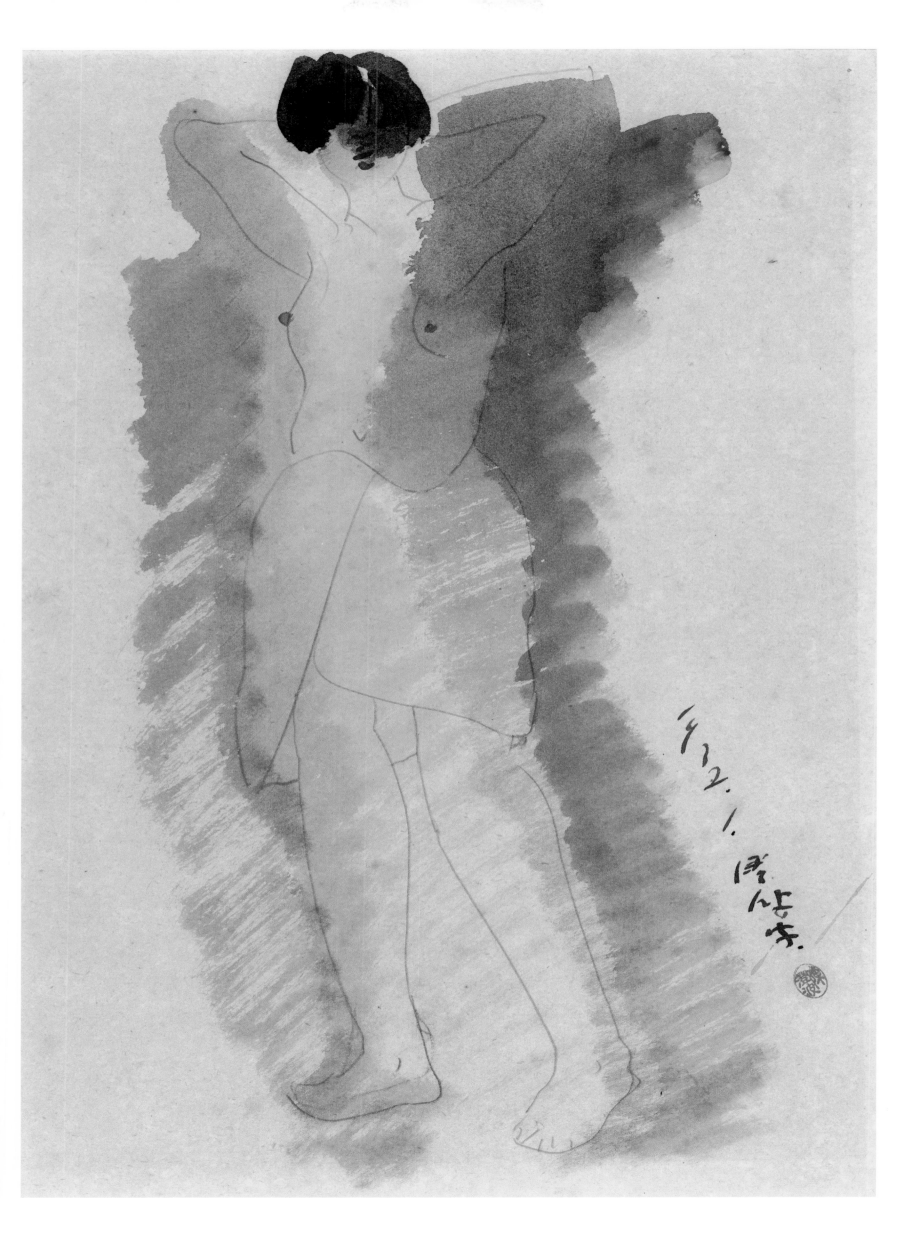

立姿裸女-32.1（9）Standing Nude-32.1 (9)

1932　紙本淡彩鉛筆　45×30cm

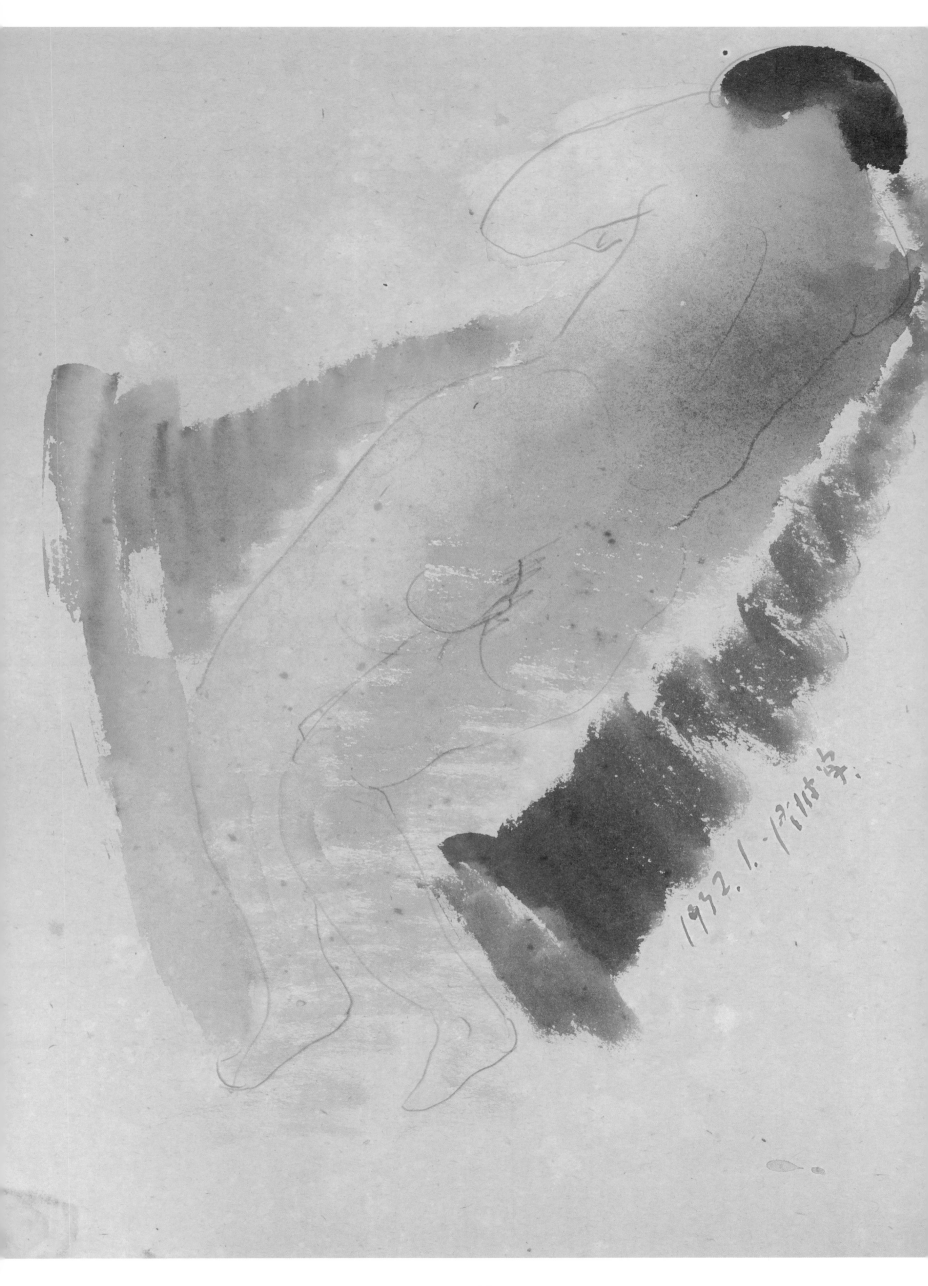

1982. 1. -1건건건 6

110

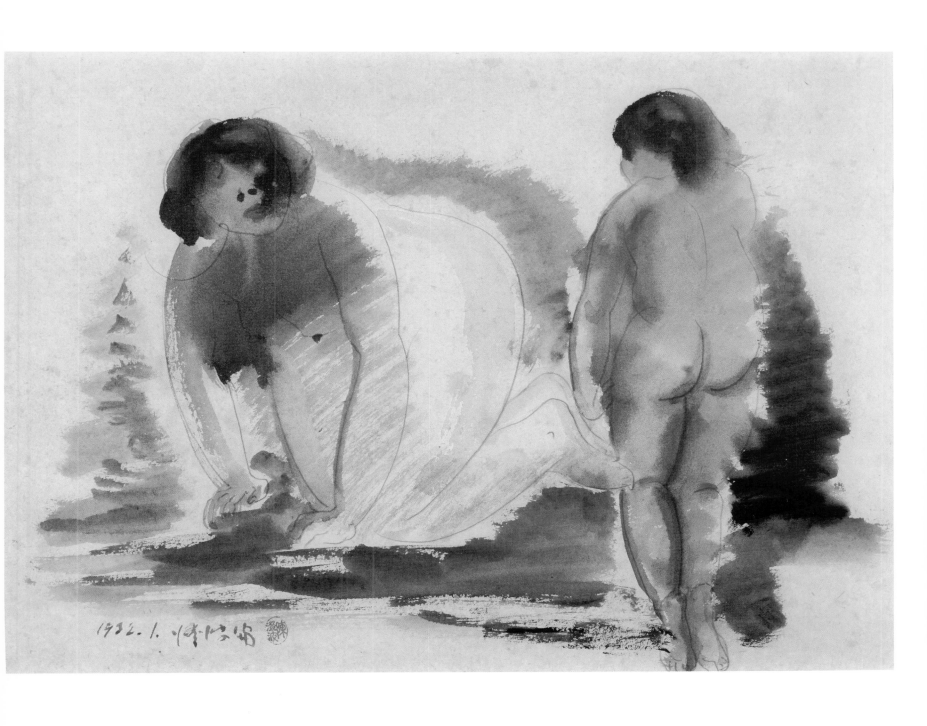

臥姿裸女-32.1（21） Lying Nude-32.1 (21)

1932　紙本淡彩鉛筆　30×45cm

[左頁圖]

臥姿裸女-32.1（20） Lying Nude-32.1 (20)

1932　紙本淡彩鉛筆　37×28.5cm

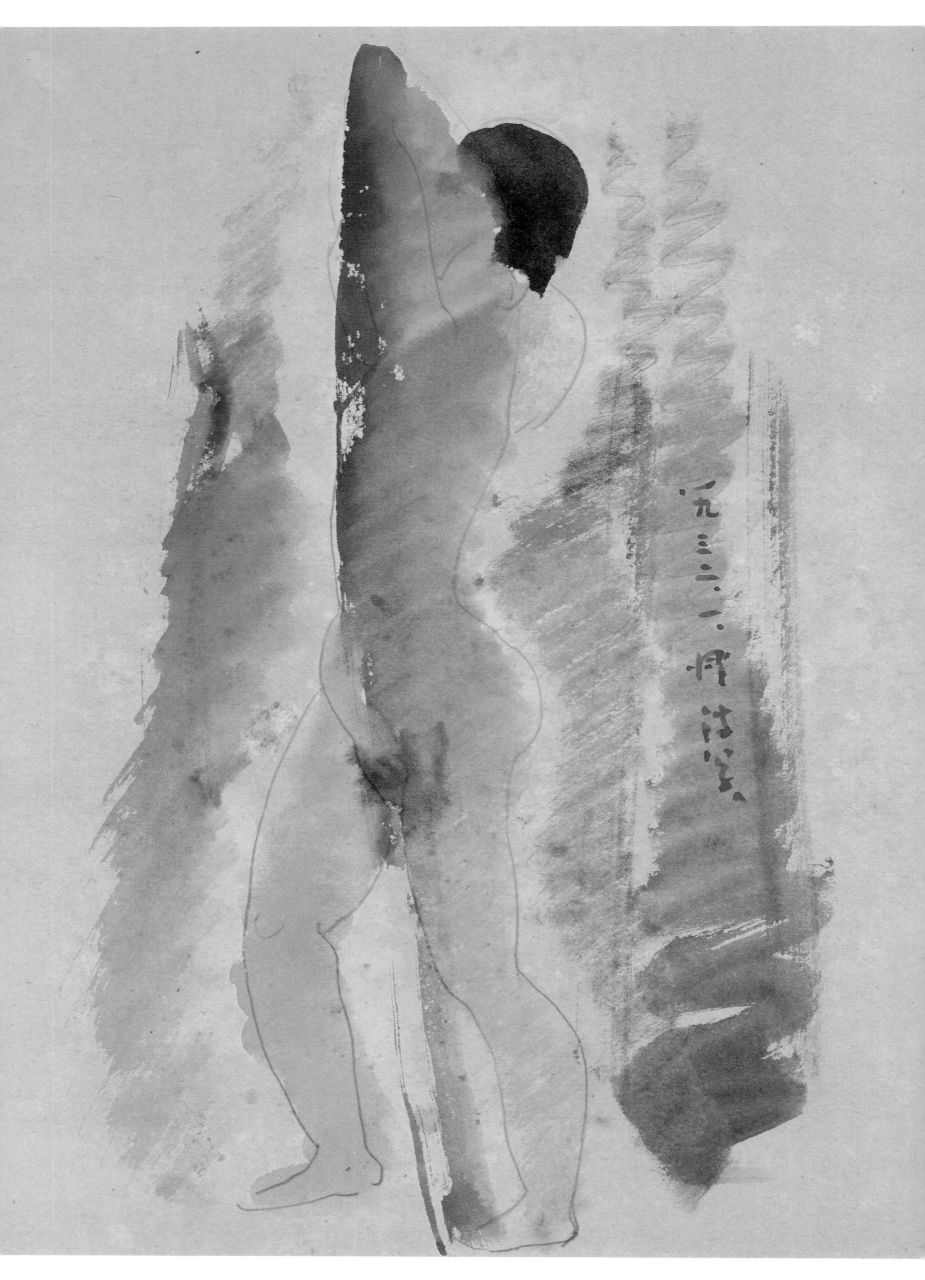

一
九
三
二
、
月
沱
生

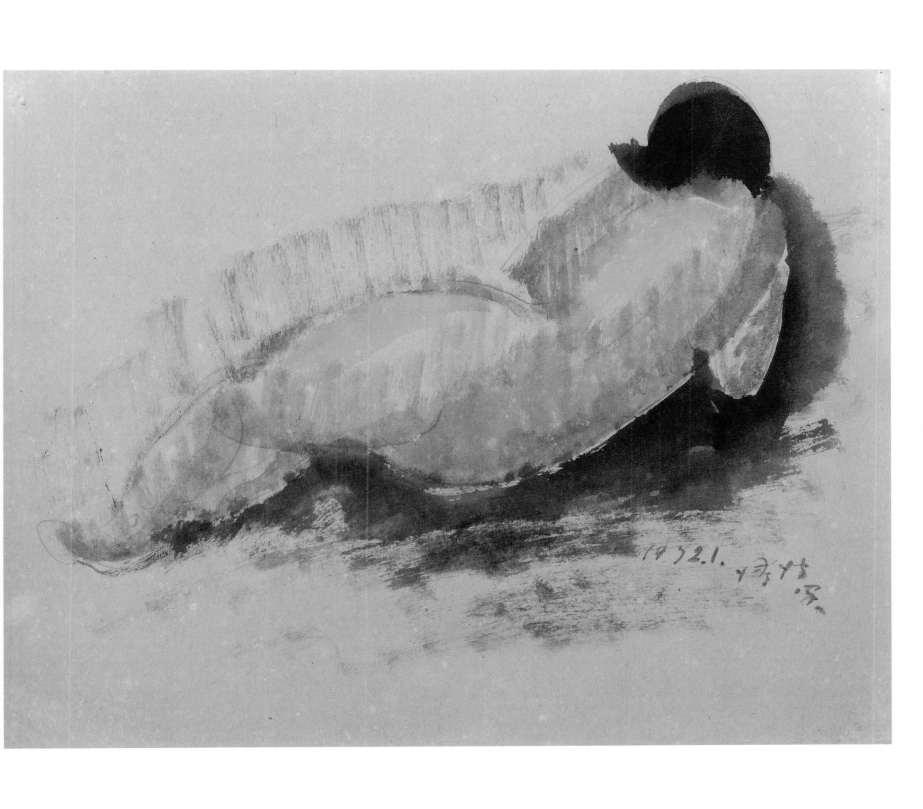

臥姿裸女-32.1（22） Lying Nude-32.1 (22)

1932　紙本淡彩鉛筆　28.5×36cm

[右真圖]

立姿裸女-32.1（10） Standing Nude-32.1 (10)

1932　紙本淡彩鉛筆　36.5×28.5cm

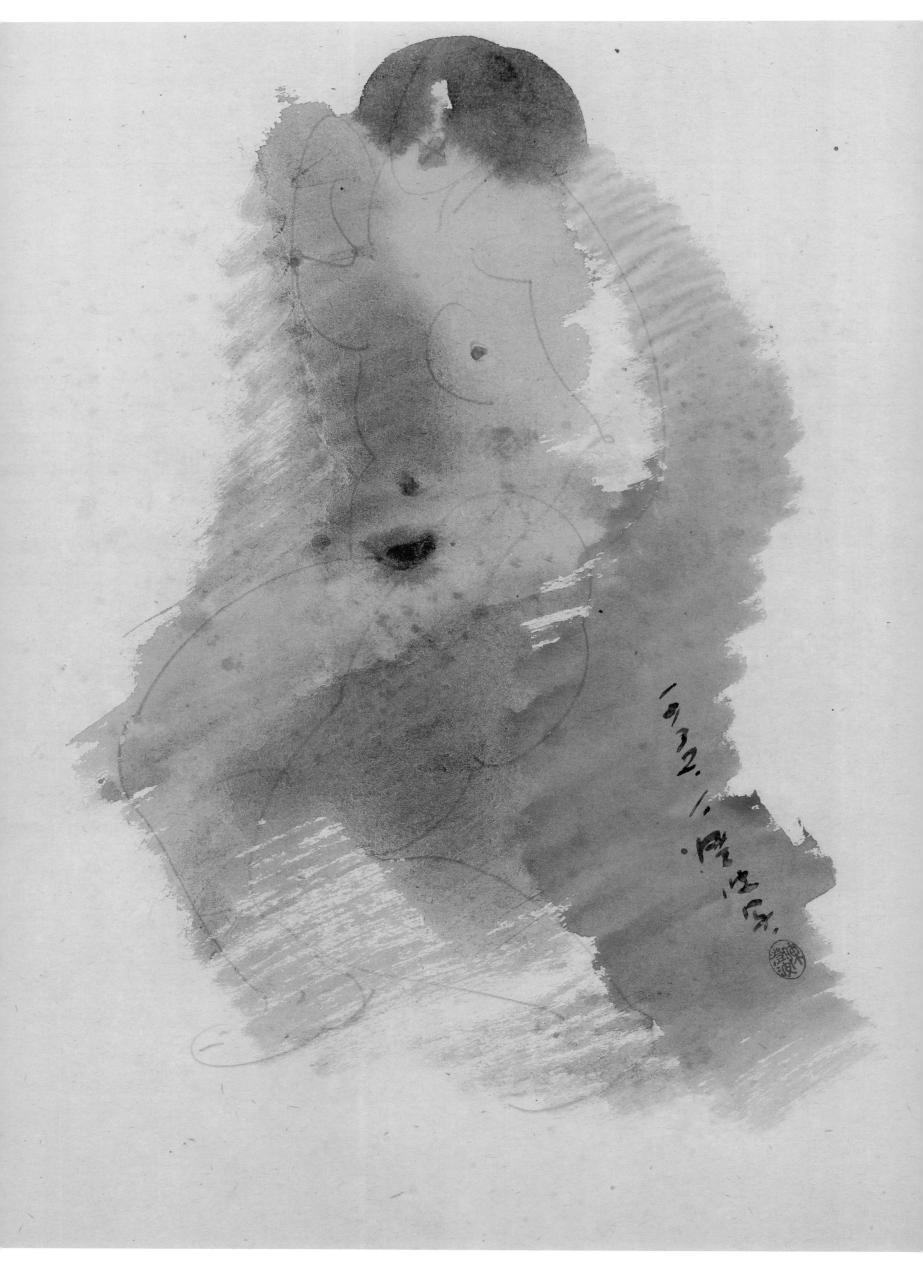

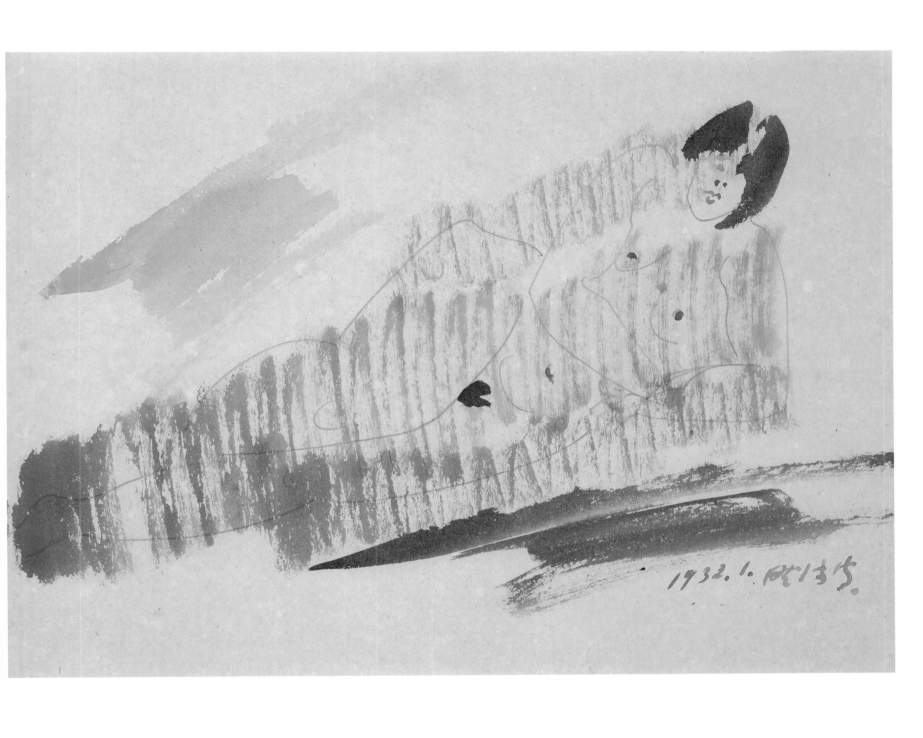

臥姿裸女-32.1（23） Lying Nude-32.1 (23)

1932　紙本淡彩鉛筆　26.5×36.5cm

[左頁圖]
坐姿裸女-32.1（42） Seated Nude-32.1 (42)

1932　紙本淡彩鉛筆　37×29.3cm

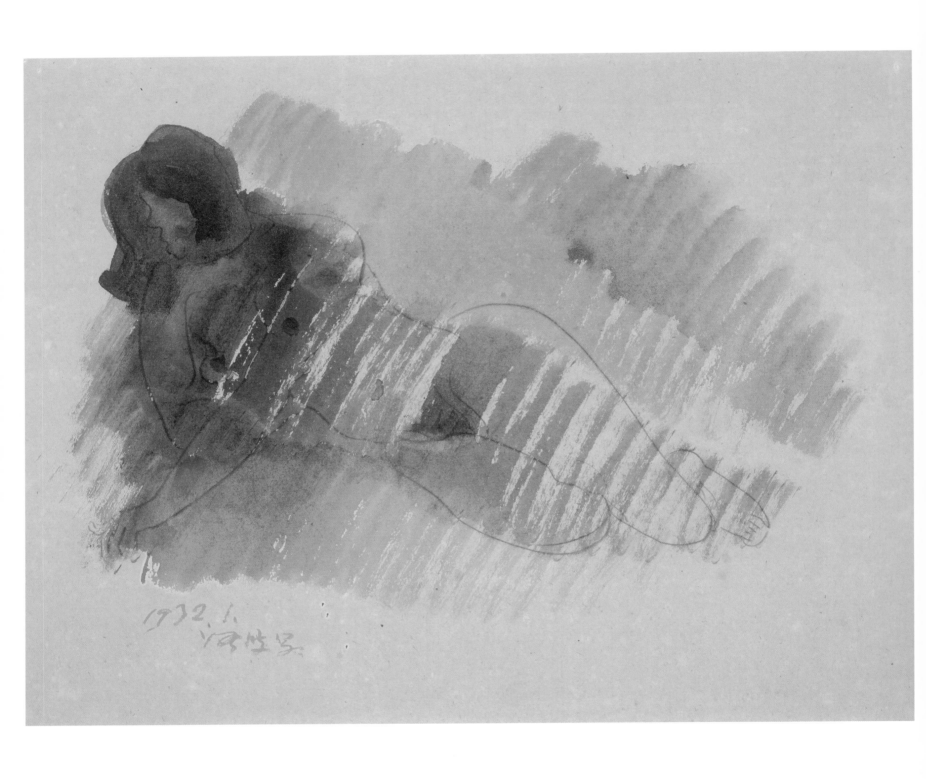

臥姿裸女-32.1（24）Lying Nude-32.1 (24)

1932　紙本淡彩鉛筆　28.5×36.5cm

[右頁圖]

立姿裸女-32.1（11）Standing Nude-32.1 (11)

1932　紙本淡彩鉛筆　36.5×28.5cm

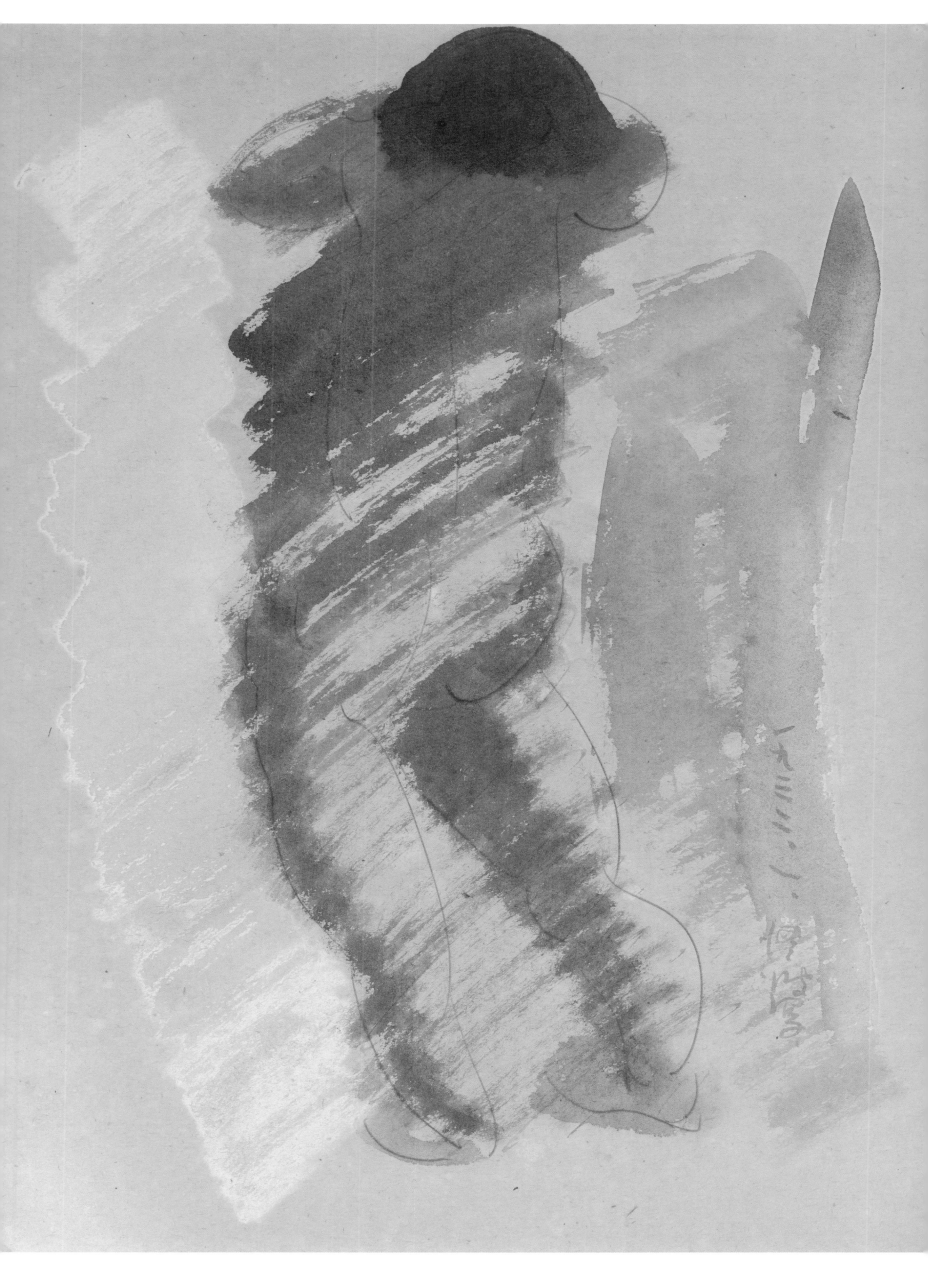

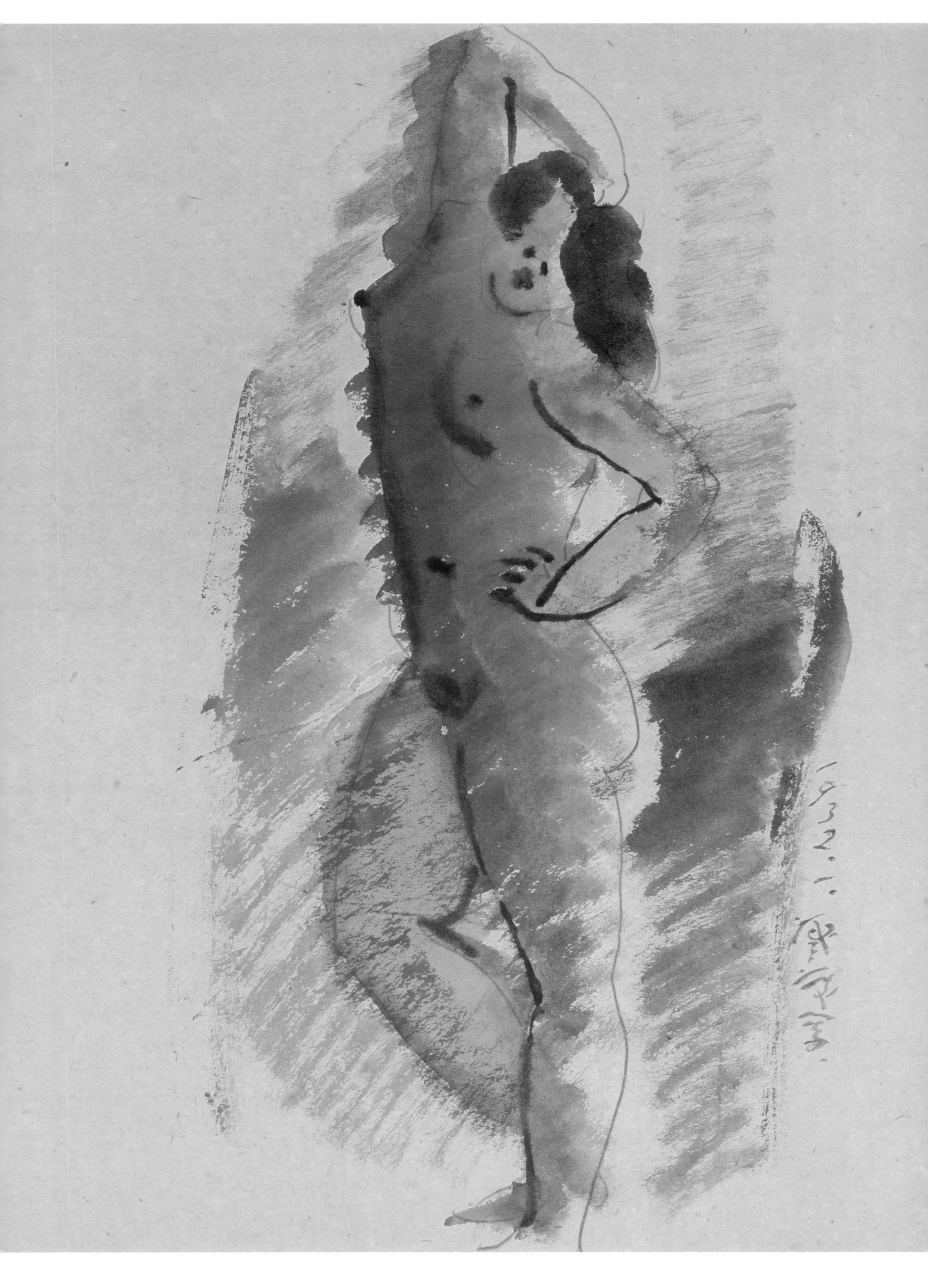

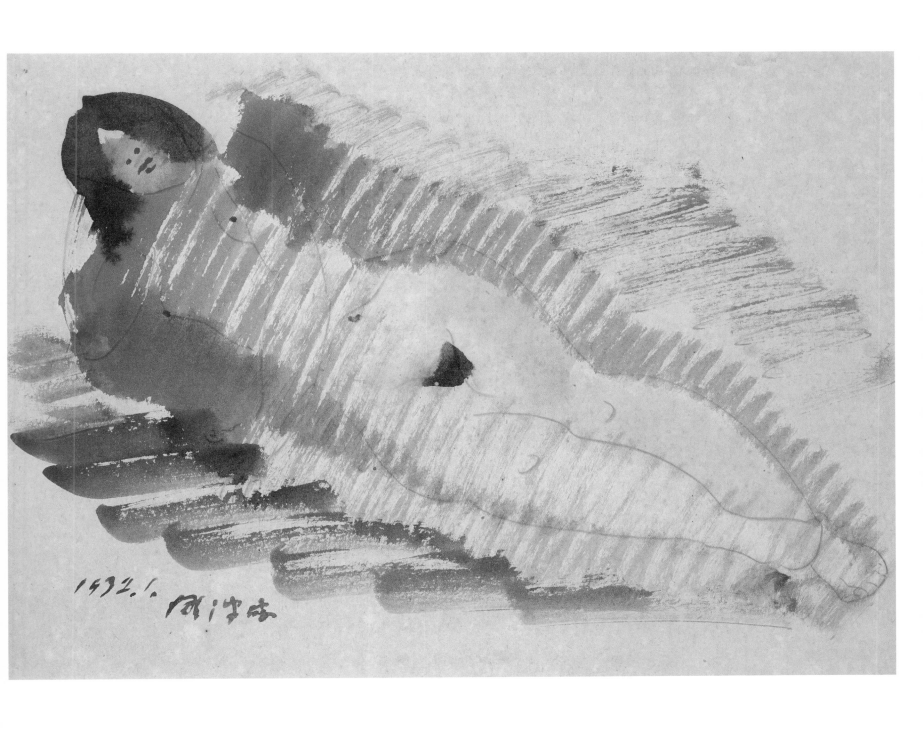

臥姿裸女-32.1（25） Lying Nude-32.1 (25)
1932　紙本淡彩鉛筆　26.5×36.5cm

[左頁圖]
立姿裸女-32.1（12） Standing Nude-32.1 (12)
1932　紙本淡彩鉛筆　36.5×28.5cm

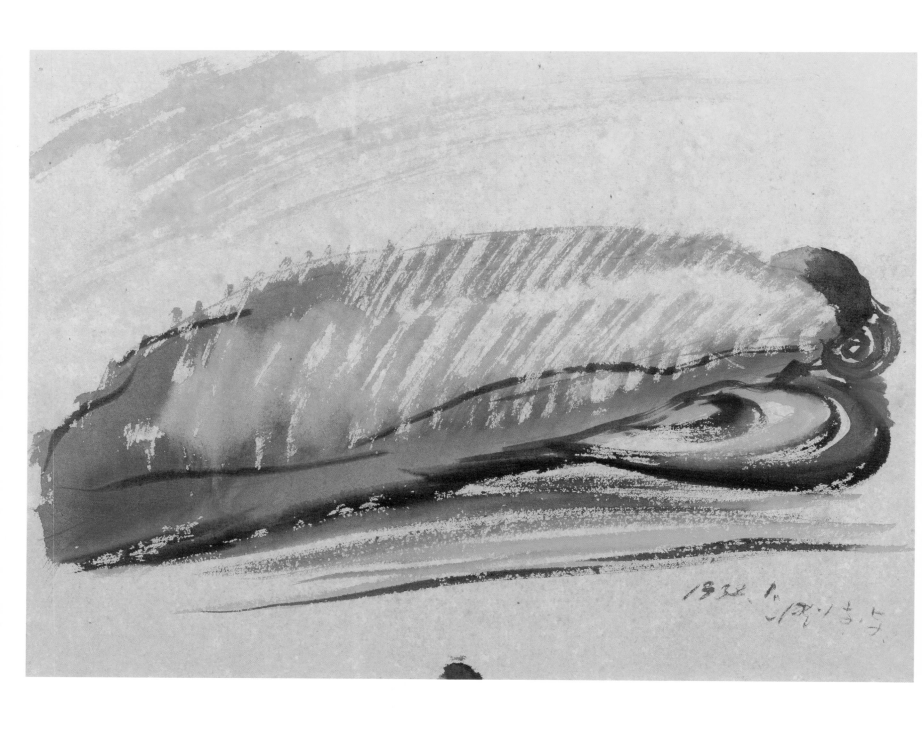

臥姿裸女-32.1（26）Lying Nude-32.1 (26)

1932　紙本淡彩鉛筆　26.5×36cm

[右頁圖]

立姿裸女-32.1（13）Standing Nude-32.1 (13)

1932　紙本淡彩鉛筆　原寸（36×26.5cm）

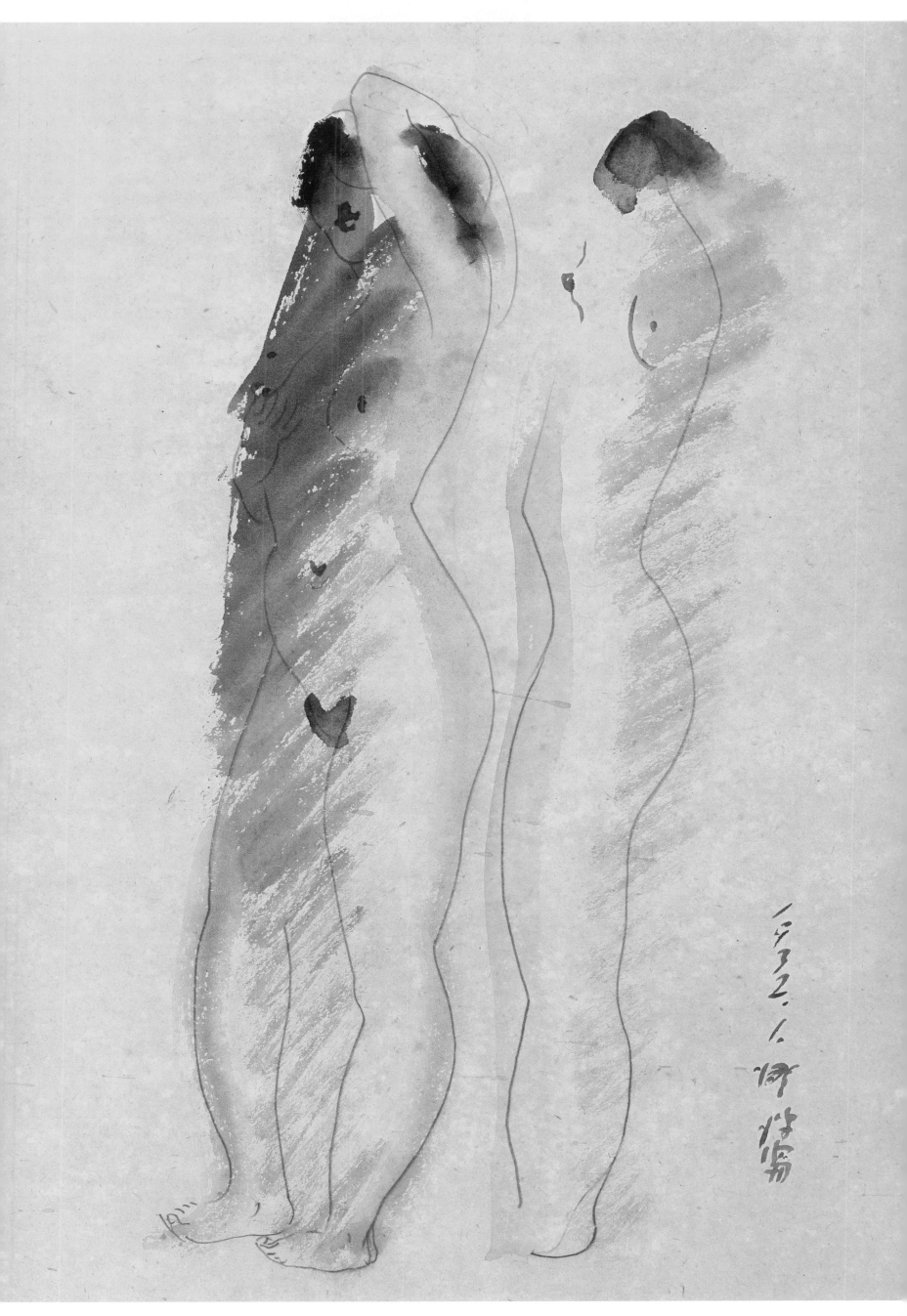

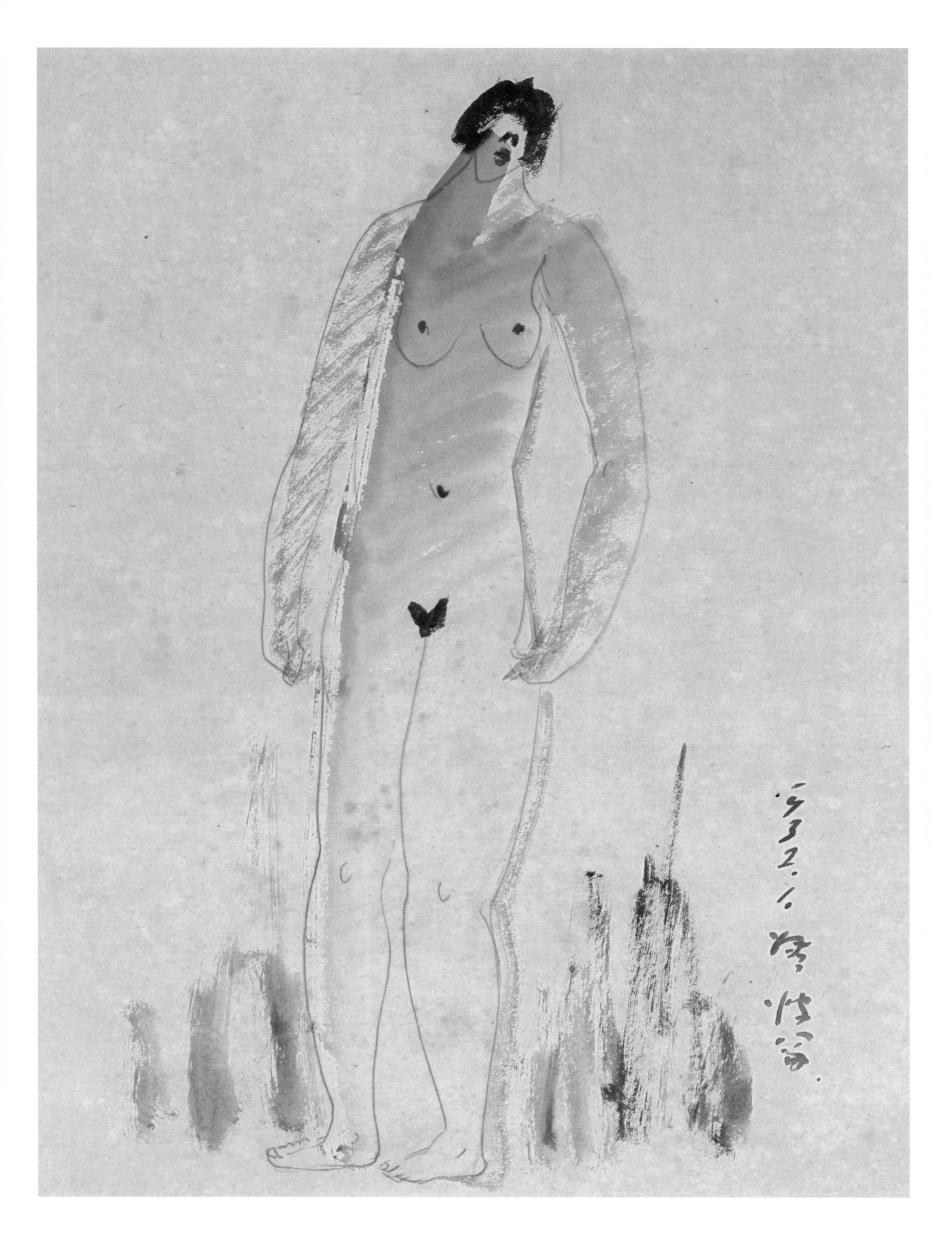

立姿裸女-32.1（14）Standing Nude-32.1 (14)

1932　紙本淡彩鉛筆　原寸（36.5×26.5cm）

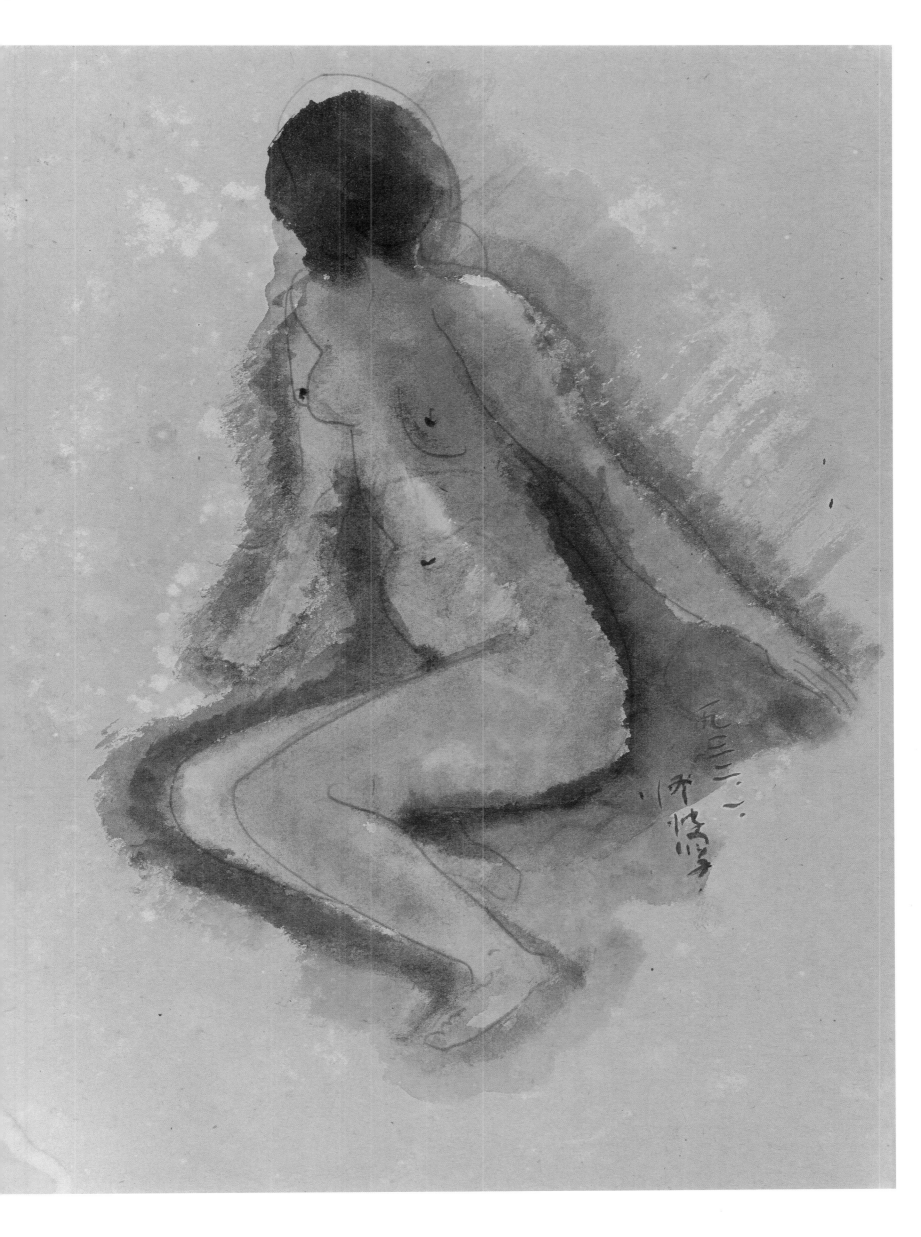

坐姿裸女-32.1（43） Seated Nude-32.1 (43)

1932　紙本淡彩鉛筆　36×28cm

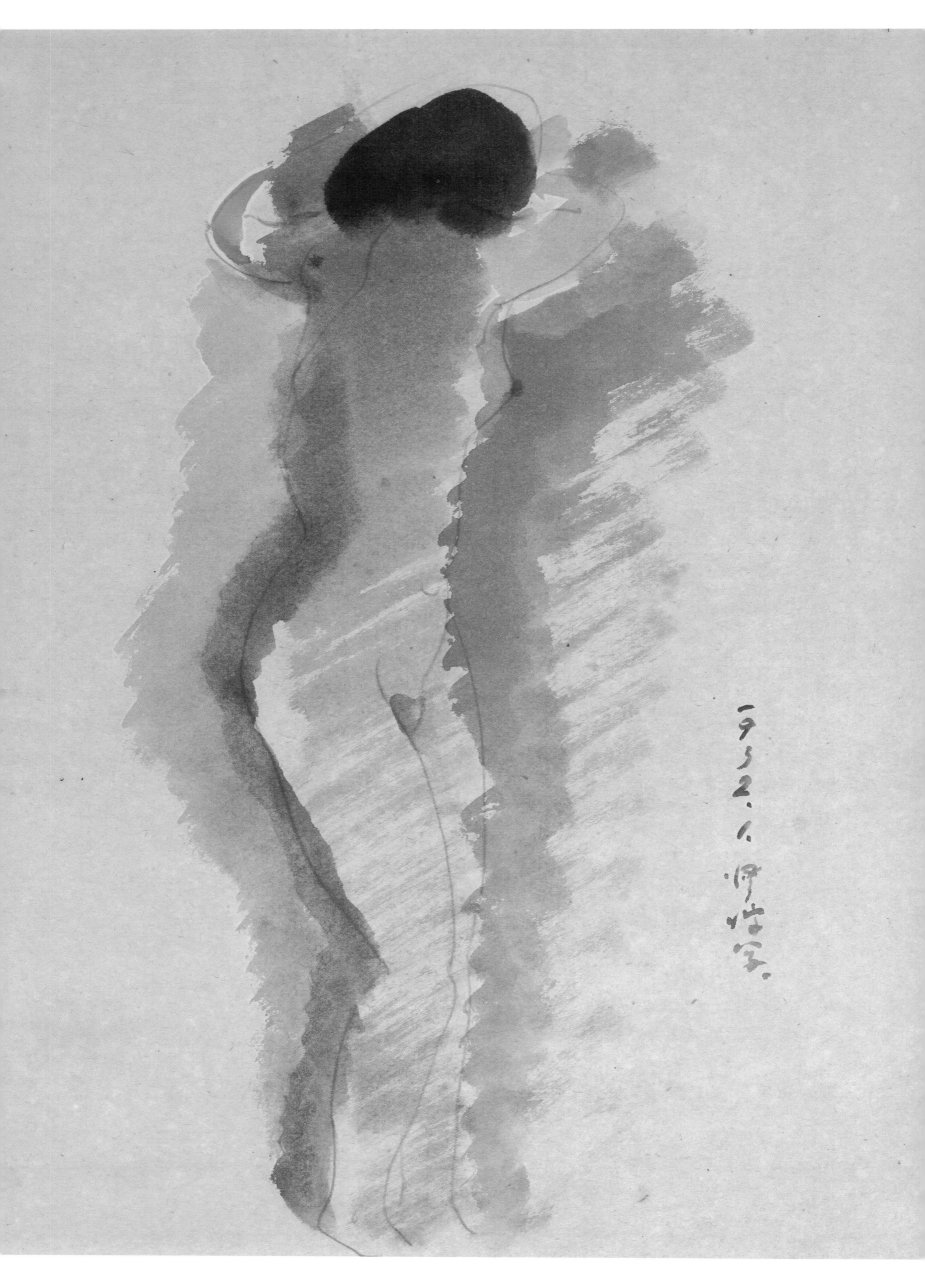

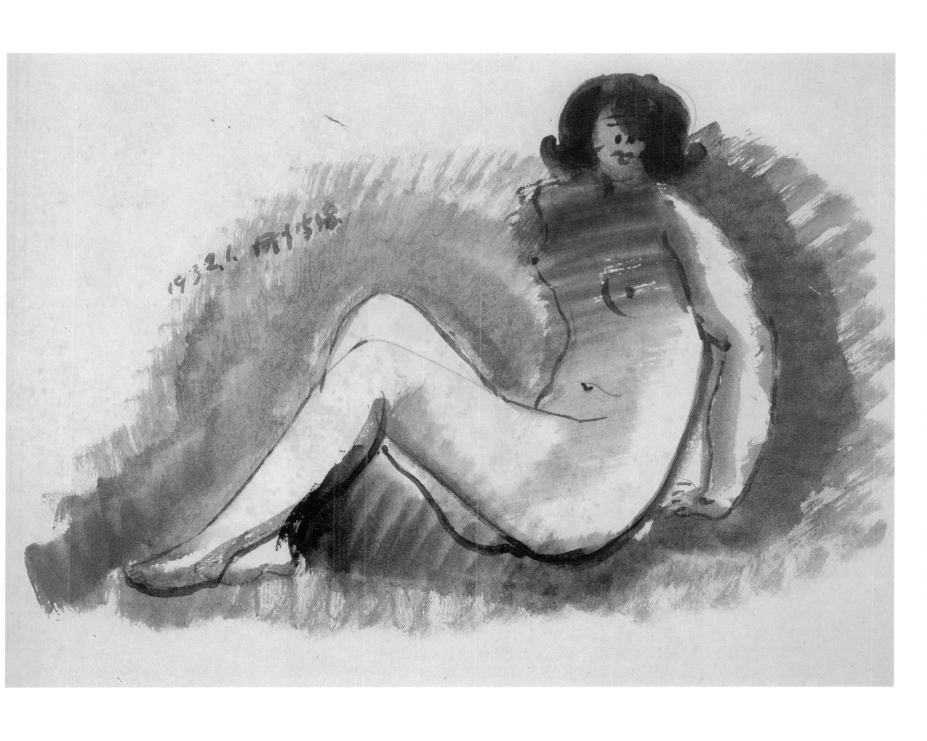

坐姿裸女-32.1（44） Seated Nude-32.1 (44)

1932　紙本淡彩鉛筆　26.5×36.5cm

[左頁圖]
立姿裸女-32.1（15） Standing Nude-32.1 (15)

1932　紙本淡彩鉛筆　36.5×28.5cm

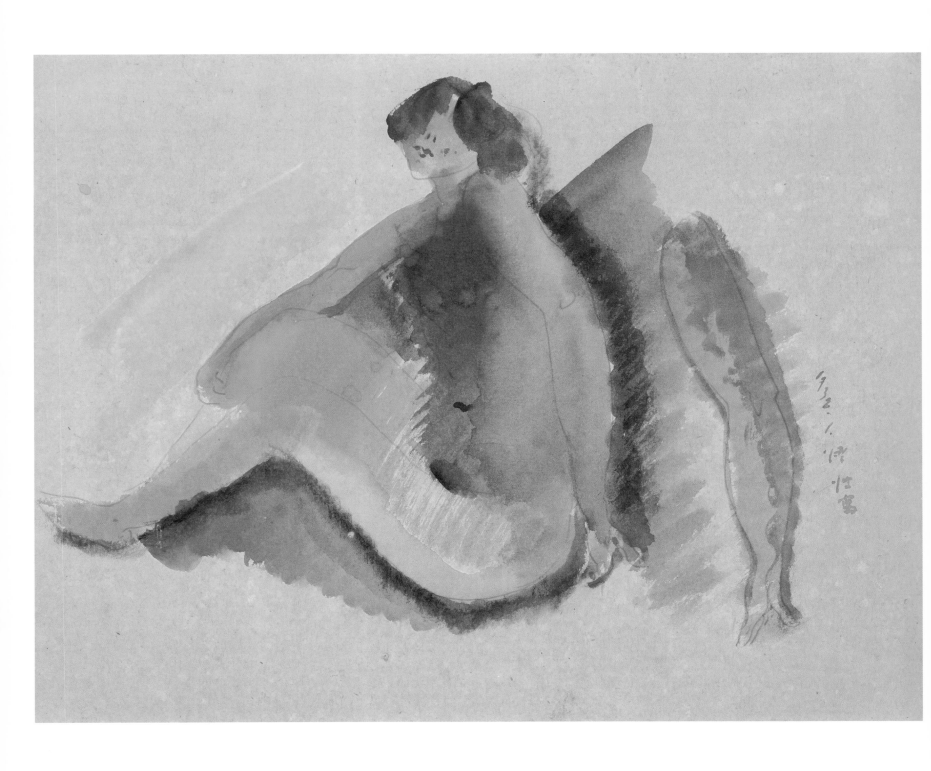

坐姿裸女-32.1（45）Seated Nude-32.1 (45)

1932　紙本淡彩鉛筆　28.5×47cm

[右頁圖]

坐姿裸女-32.1（46）Seated Nude-32.1 (46)

1932　紙本淡彩鉛筆　37×28.5cm

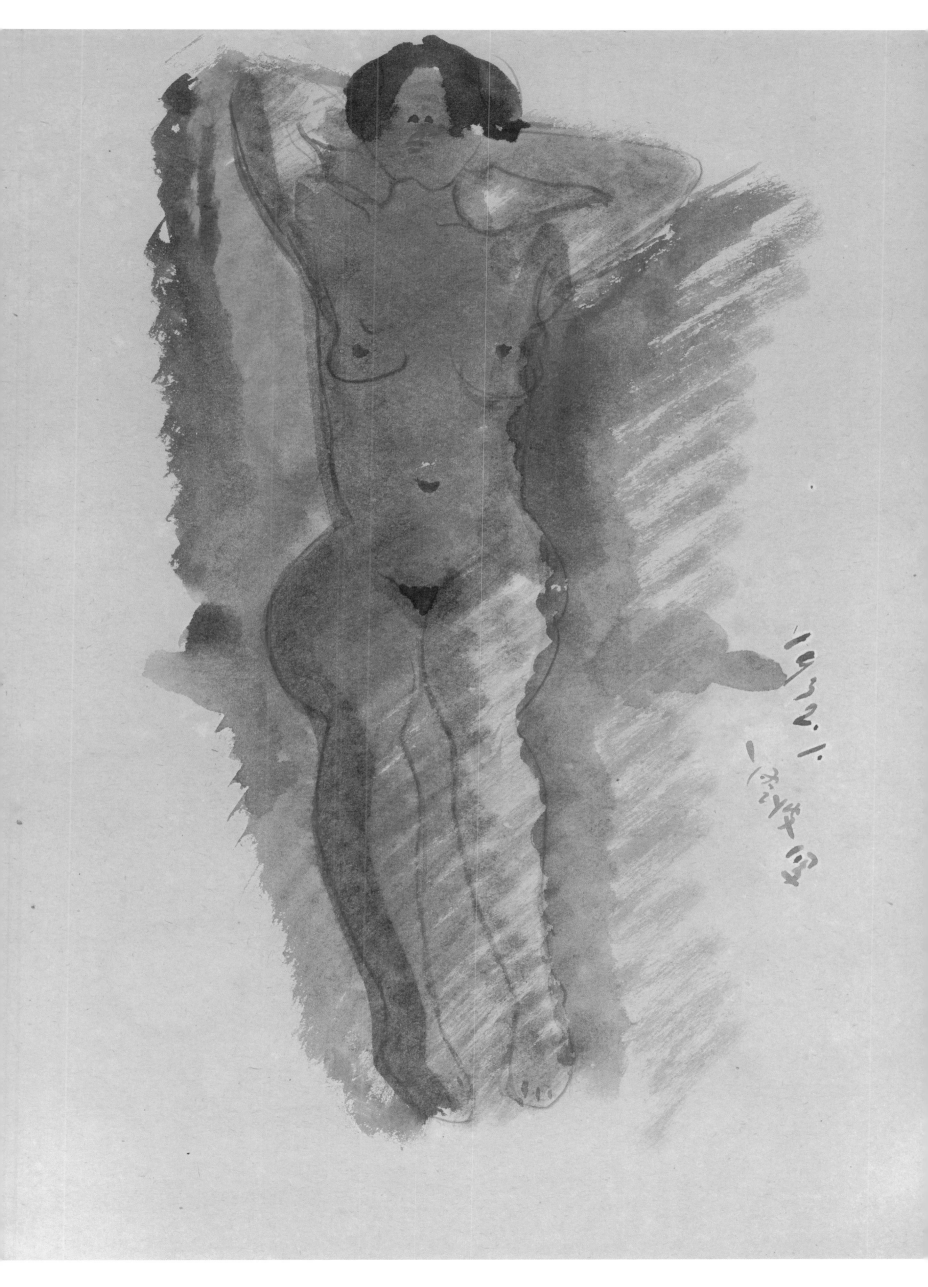

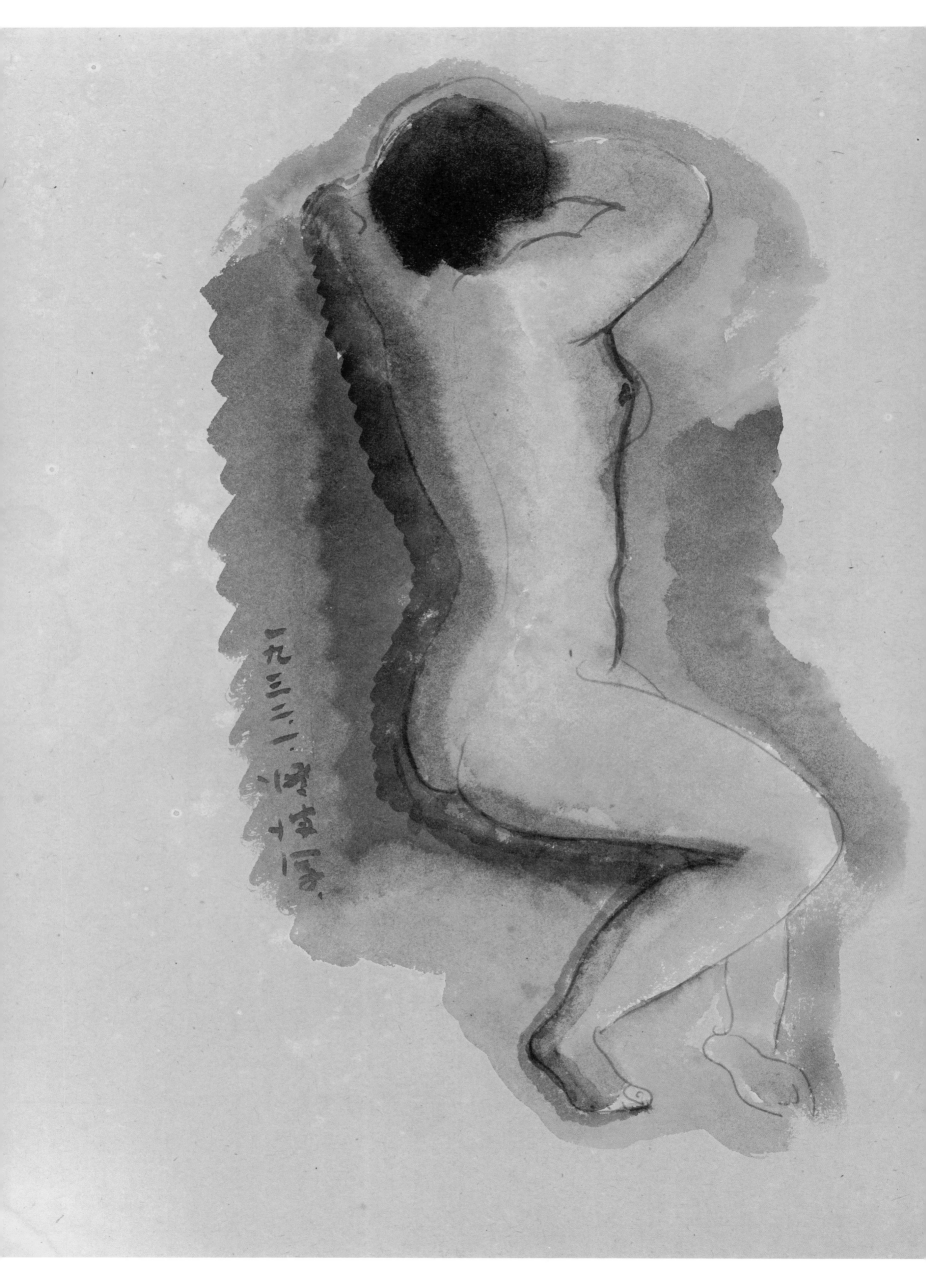

一九三二・一 潘玉良作

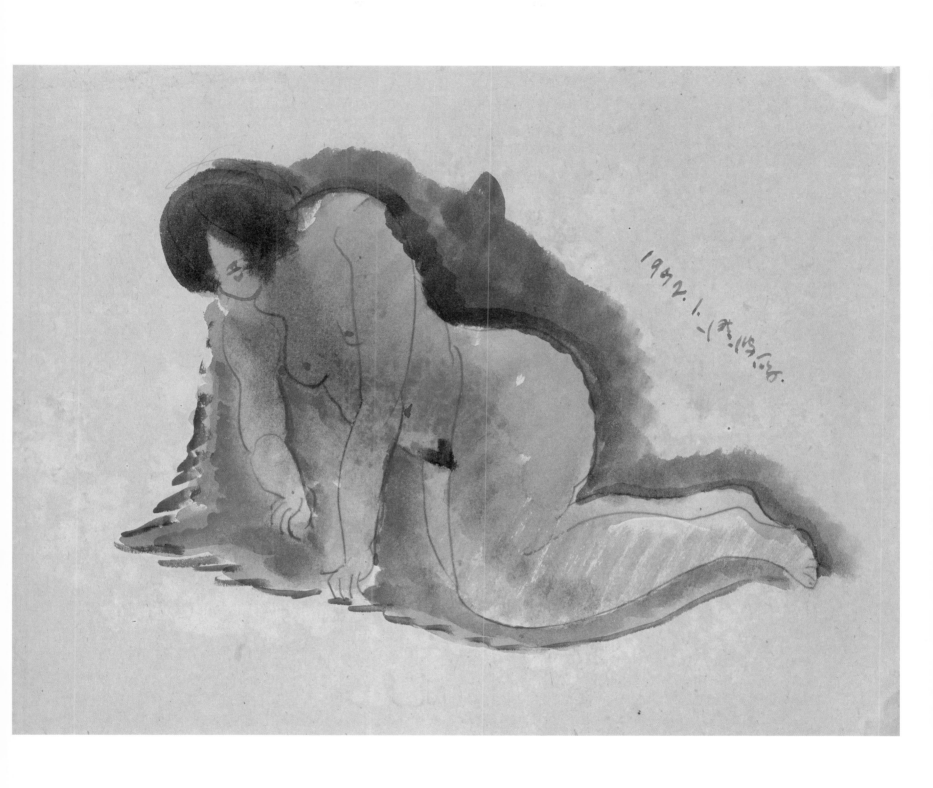

臥姿裸女-32.1（27） Lying Nude-32.1 (27)

1932　紙本淡彩鉛筆　28.5×37cm

[左頁圖]
坐姿裸女-32.1（47） Seated Nude-32.1 (47)

1932　紙本淡彩鉛筆　36.5×28.5cm

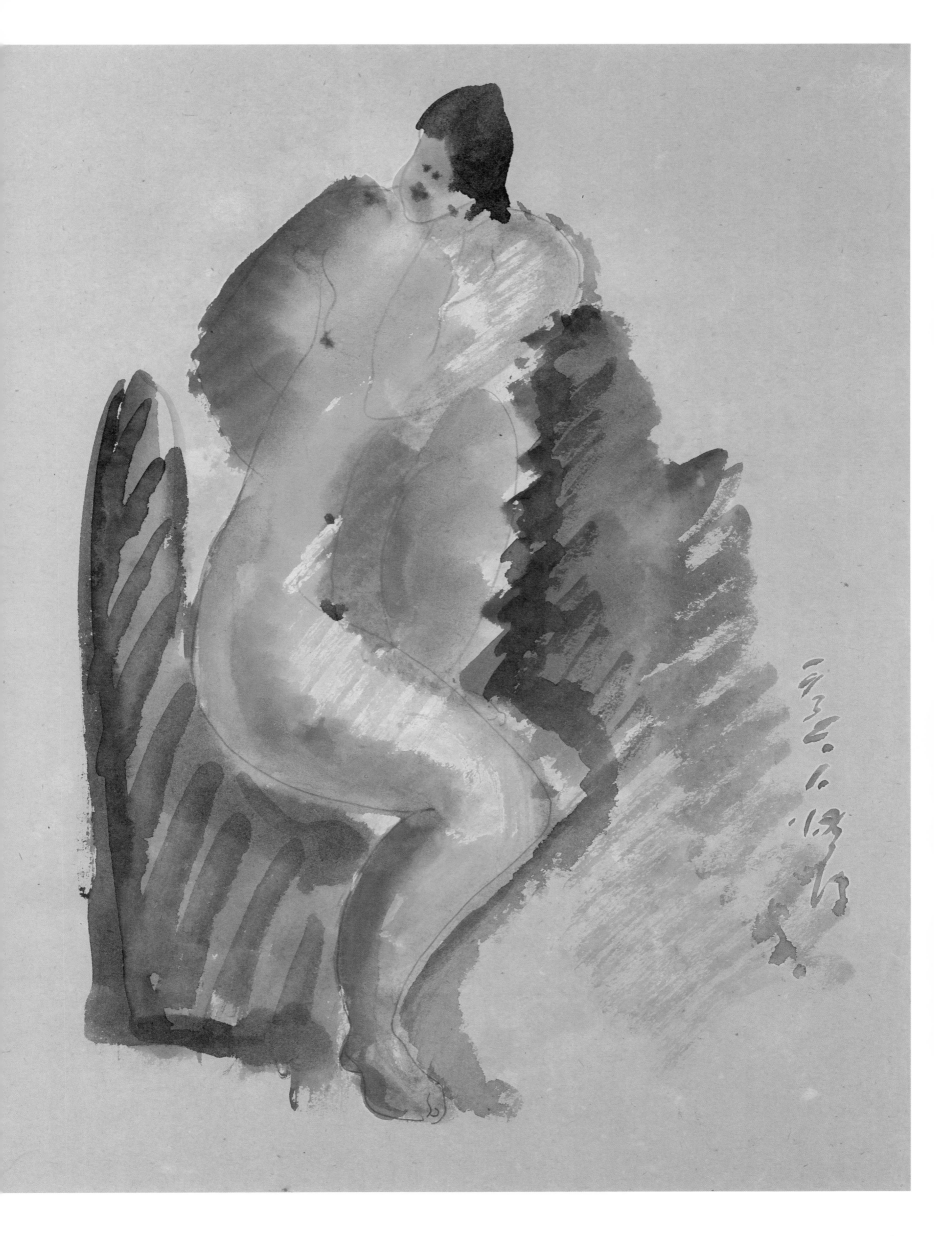

坐姿裸女-32.1（48）Seated Nude-32.1 (48)

1932　紙本淡彩鉛筆　36×28cm

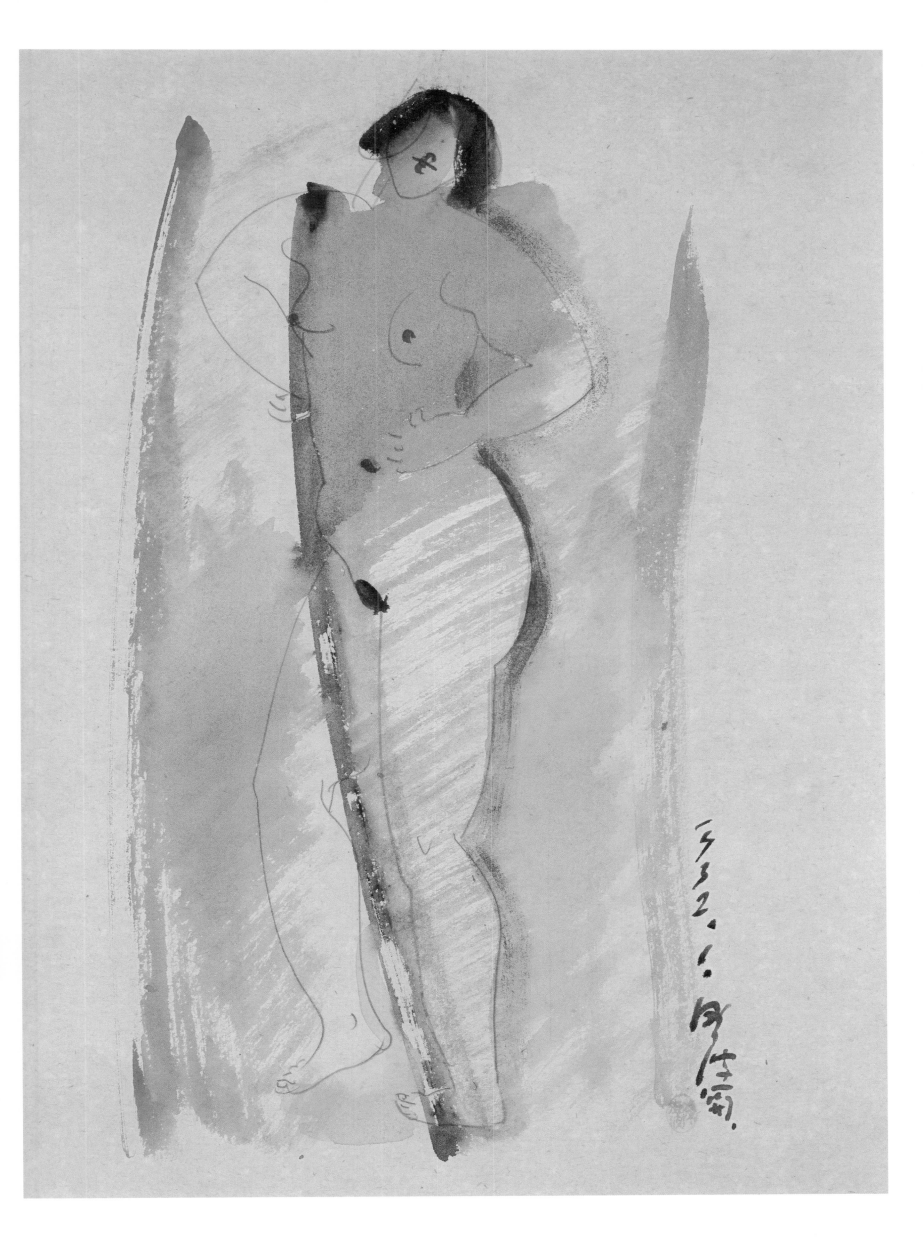

立姿裸女-32.1（16） Standing Nude-32.1 (16)

1932　紙本淡彩鉛筆　36.5×26.5cm

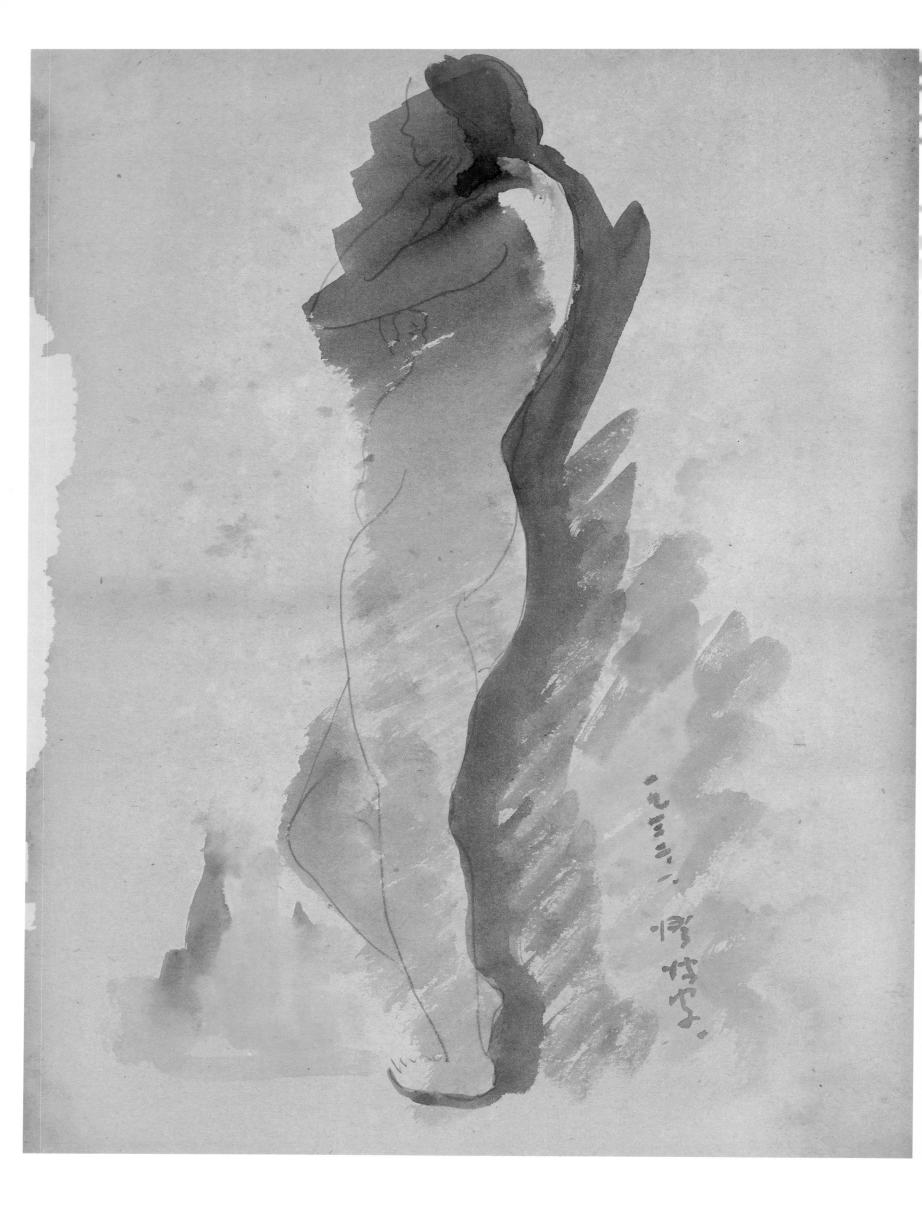

立姿裸女-32.1（17） Standing Nude-32.1 (17)

1932　紙本淡彩鉛筆　36.5×28.5cm

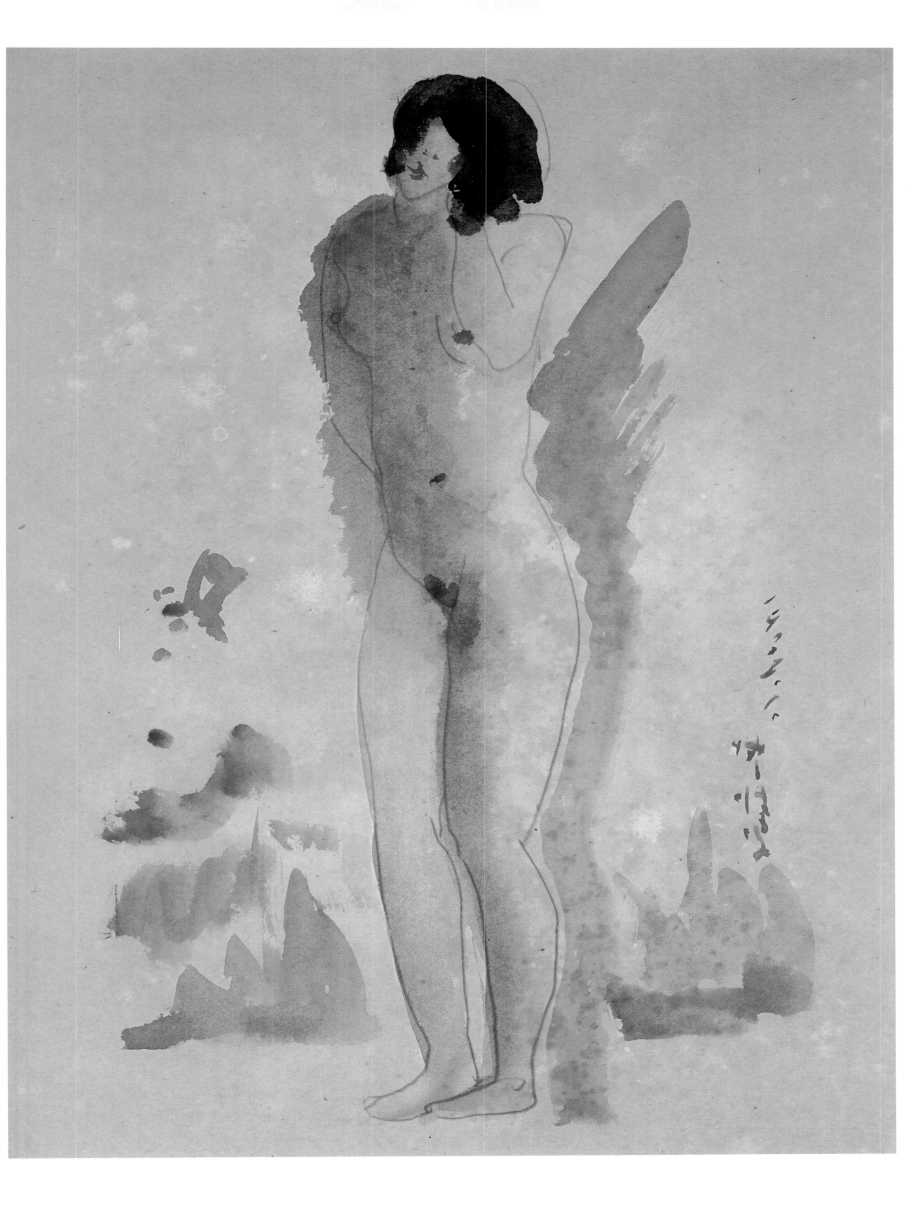

立姿裸女-32.1（18） Standing Nude-32.1 (18)
1932　紙本淡彩鉛筆　36.5×28.5cm

133

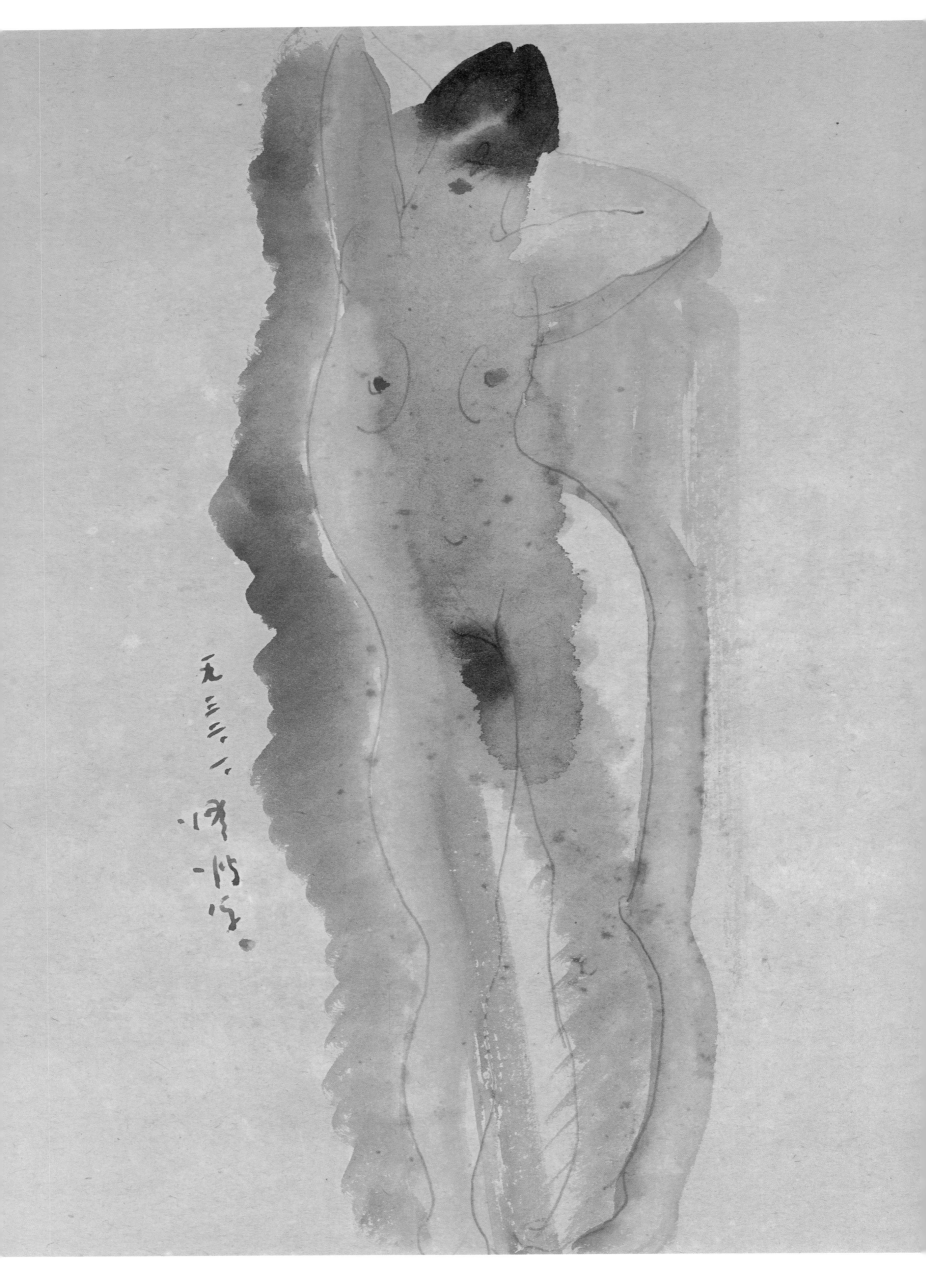

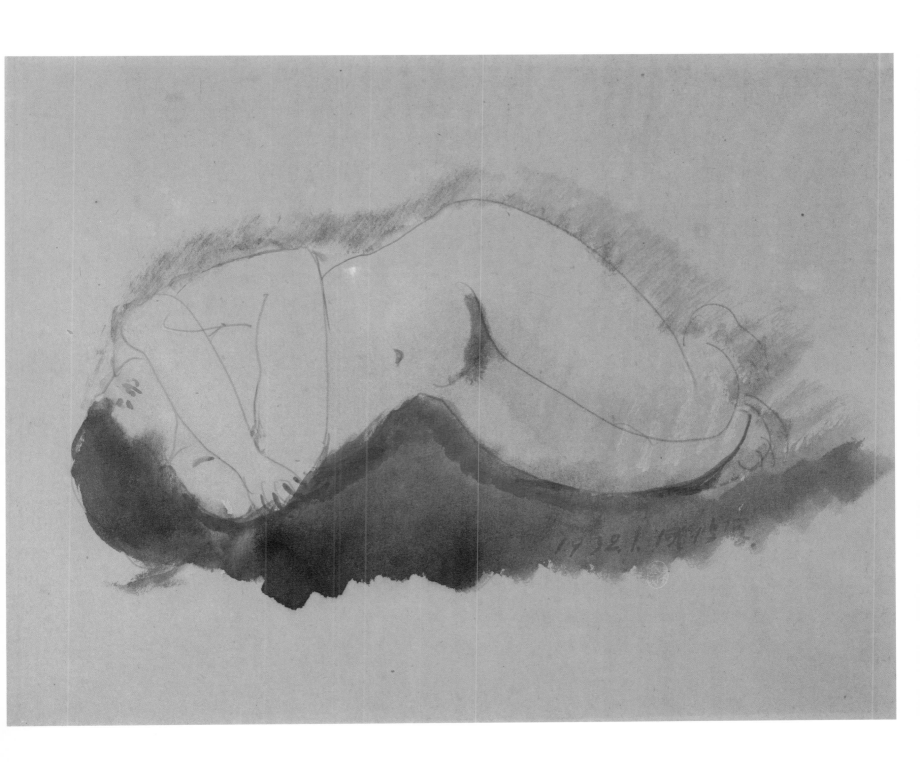

臥姿裸女-32.1（28） Lying Nude-32.1 (28)

1932　紙本淡彩鉛筆　28.5×36.5cm

[左頁圖]
立姿裸女-32.1（19） Standing Nude-32.1 (19)

1932　紙本淡彩鉛筆　37×28.5cm

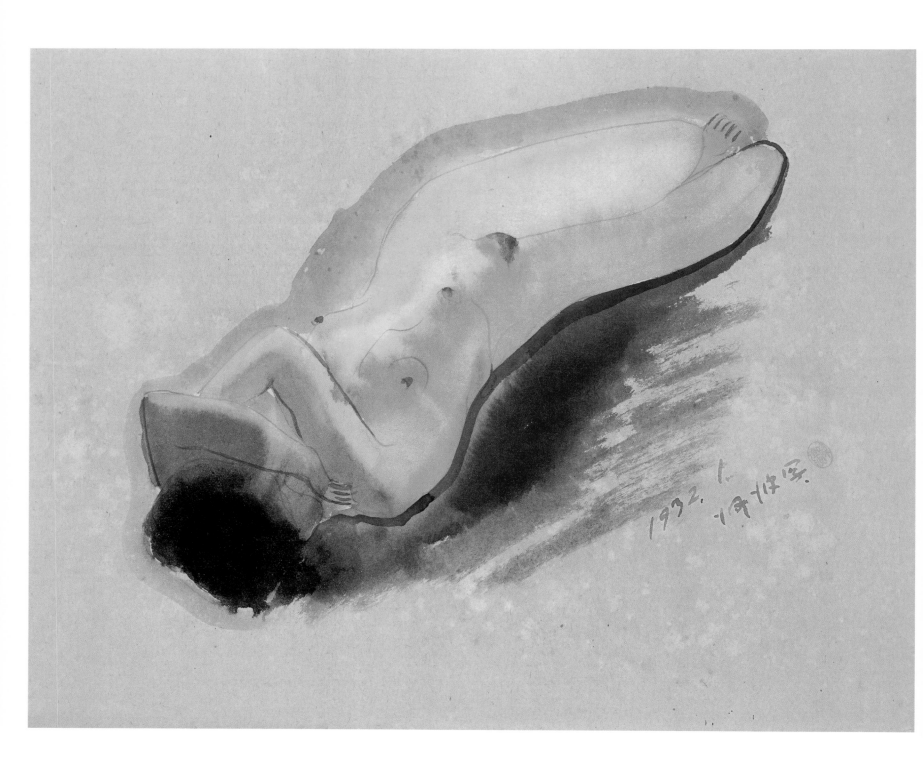

臥姿裸女-32.1（29） Lying Nude-32.1 (29)

1932　紙本淡彩鉛筆　28.5×36.5cm

[右頁圖]

立姿裸女-32.1（20） Standing Nude-32.1 (20)

1932　紙本淡彩鉛筆　37×28.5cm

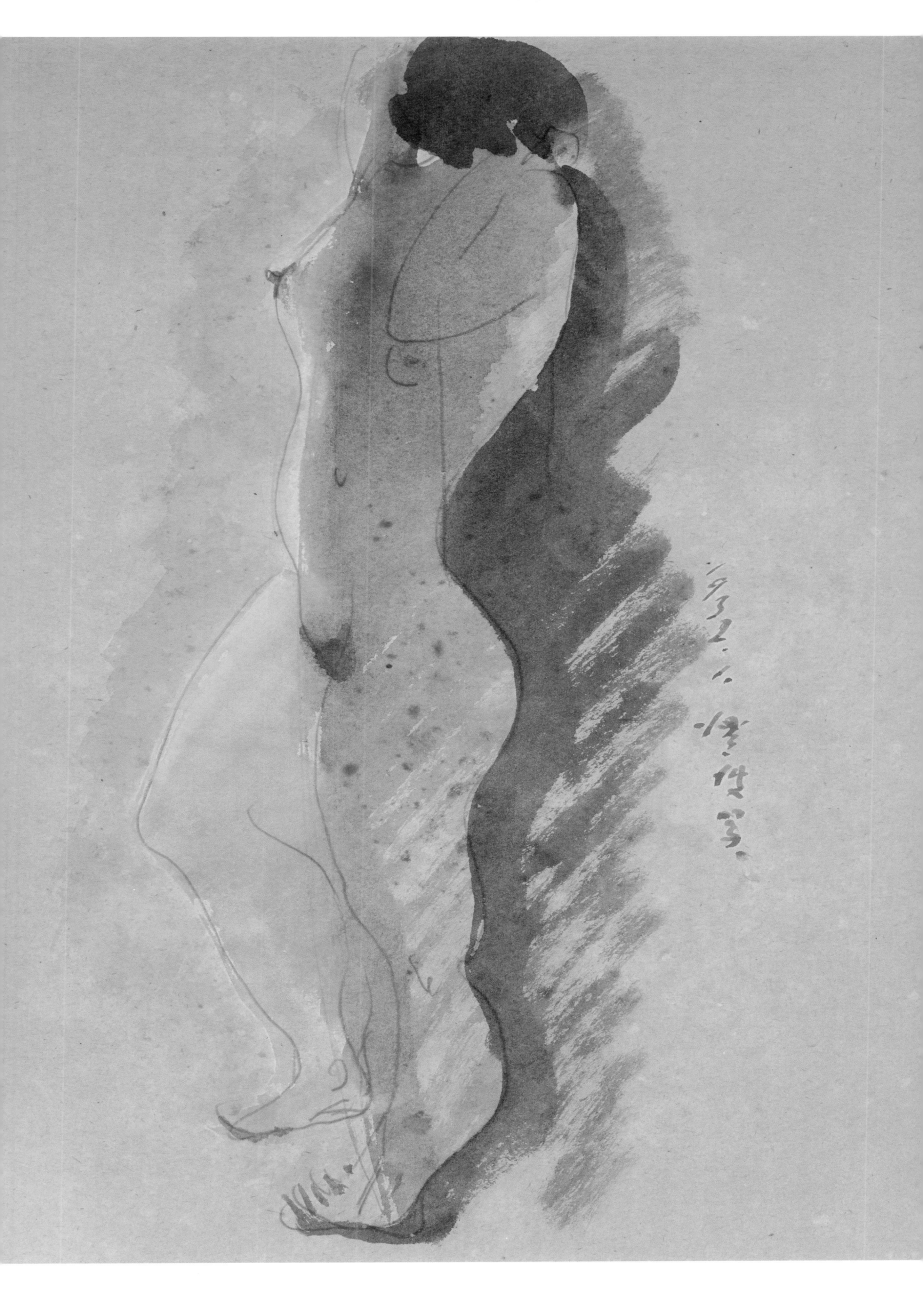

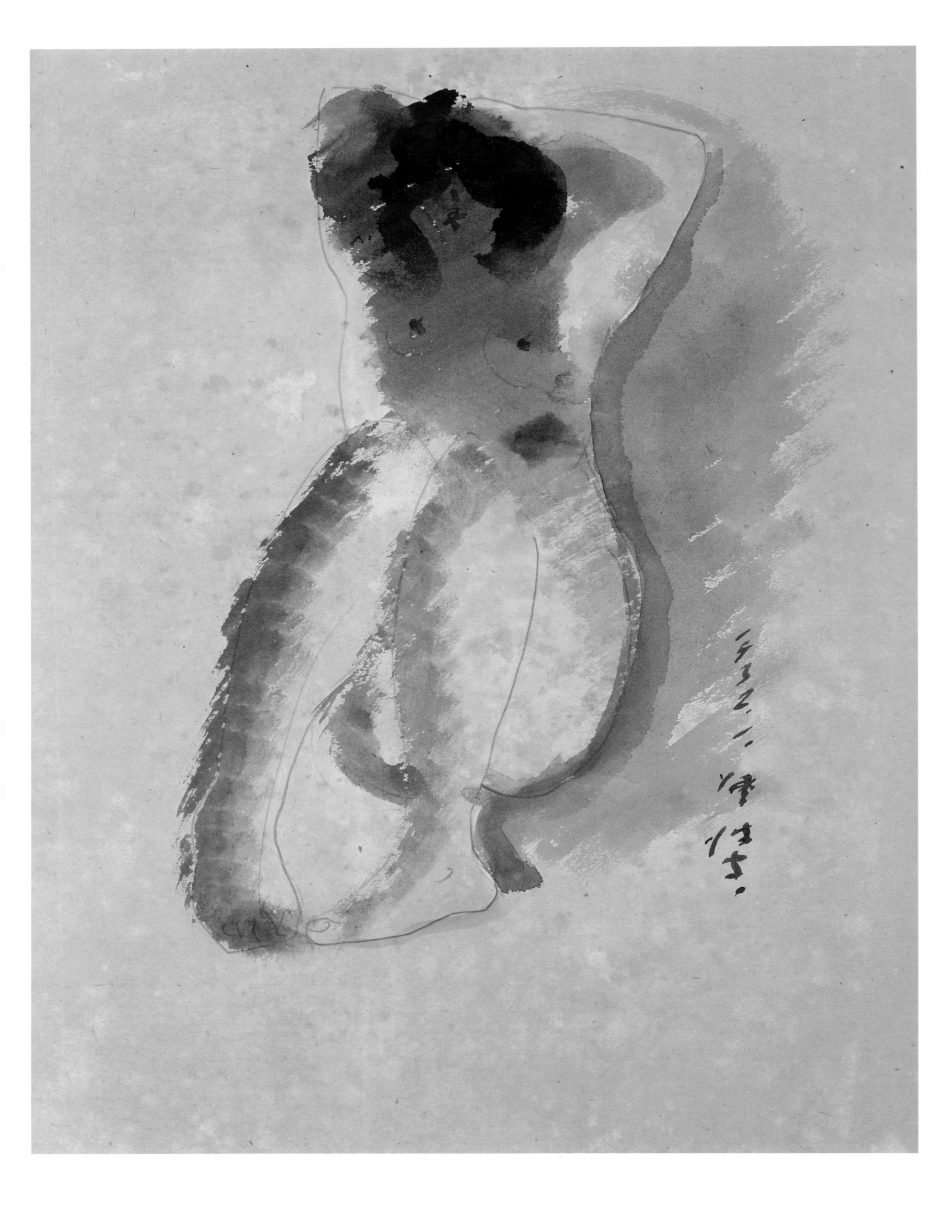

坐姿裸女-32.1（49）Seated Nude-32.1 (49)

1932　紙本淡彩鉛筆　36×28.5cm

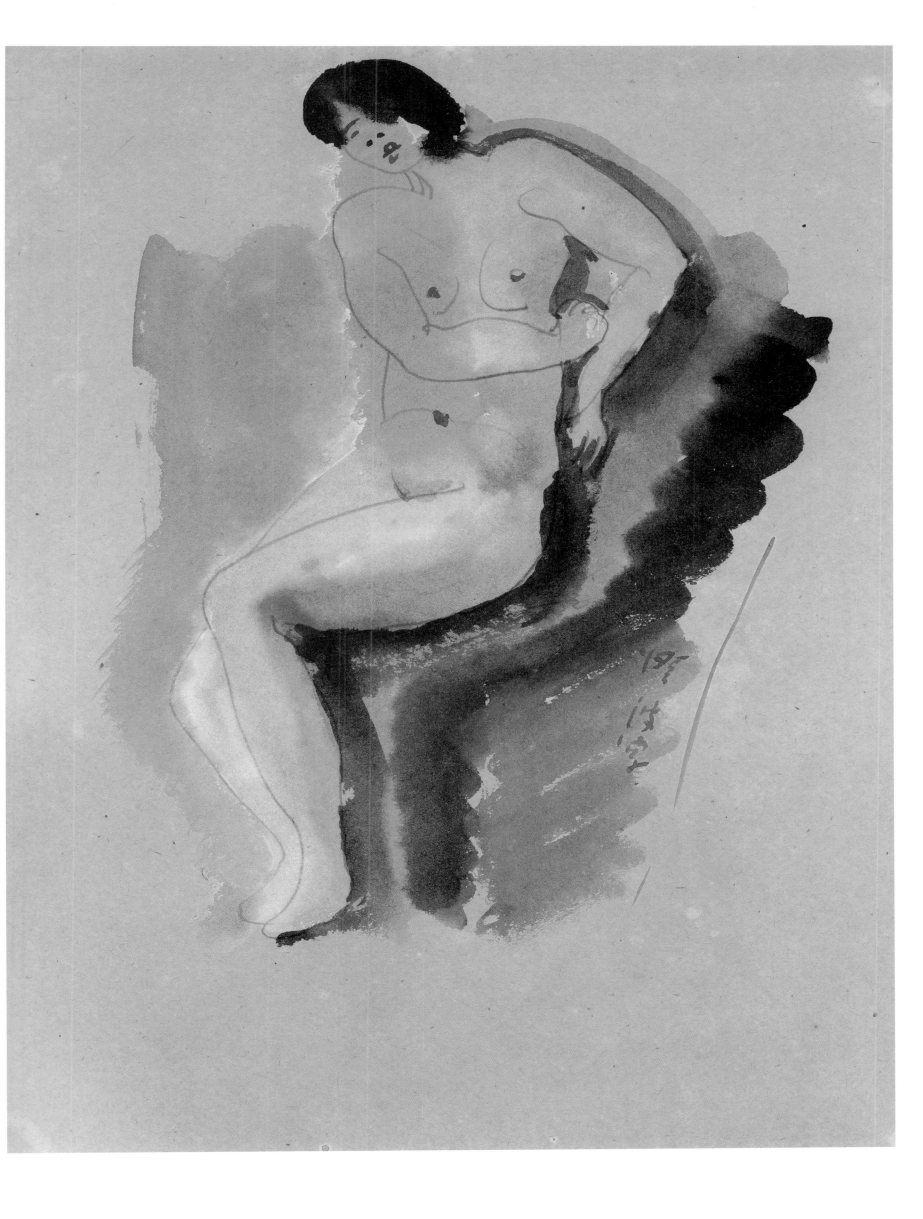

坐姿裸女-32.1（50）Seated Nude-32.1 (50)

1932　紙本淡彩鉛筆　36.5×28.5cm

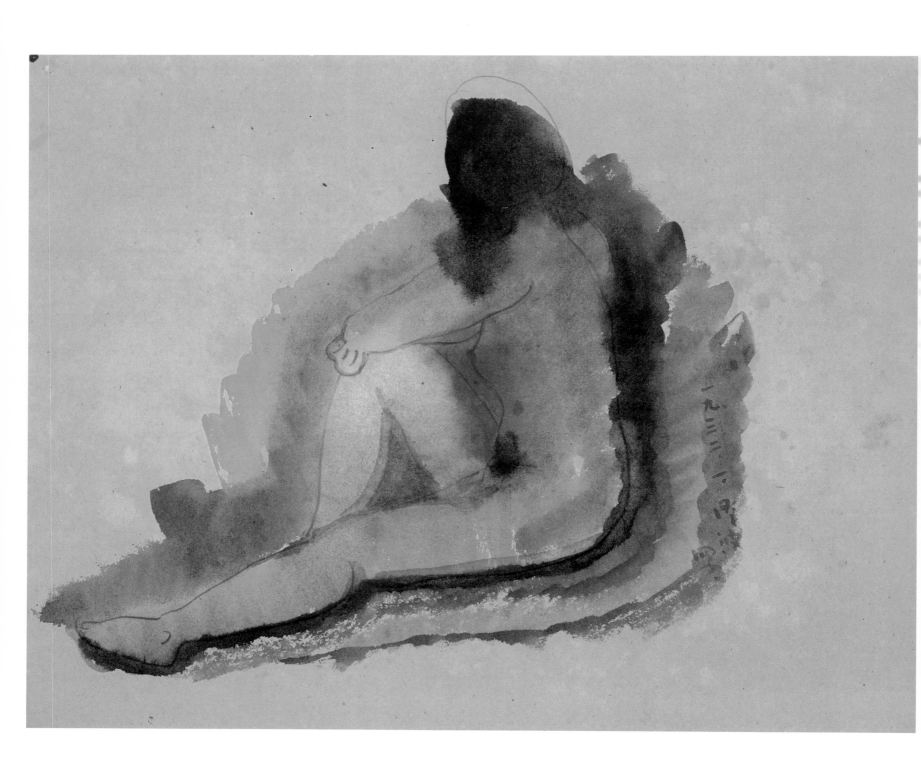

坐姿裸女-32.1（51）Seated Nude-32.1 (51)

1932　紙本淡彩鉛筆　28.5×36.5cm

[右頁圖]

坐姿裸女-32.1（52）Seated Nude-32.1 (52)

1932　紙本淡彩鉛筆　36×28.5cm

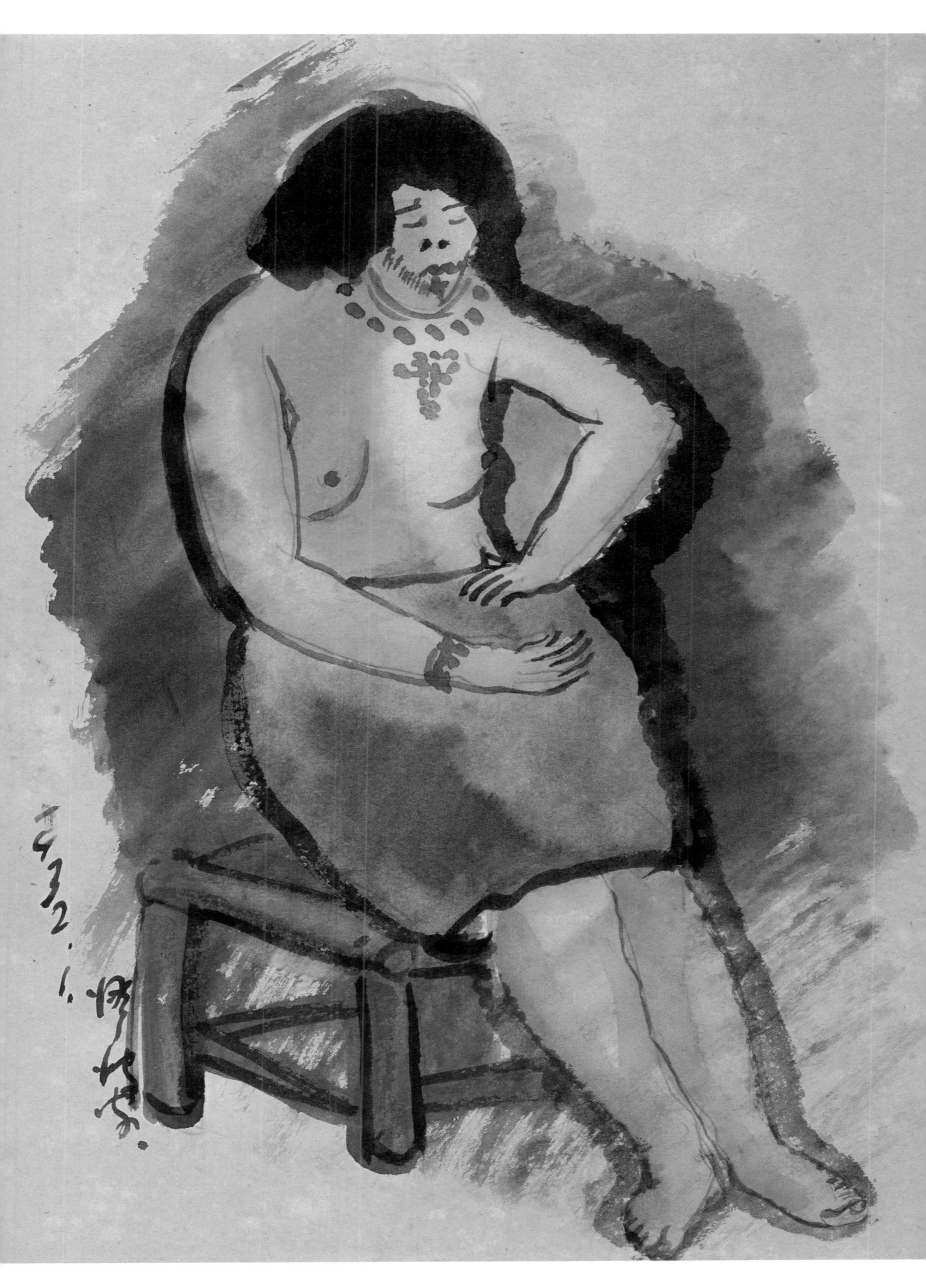

141

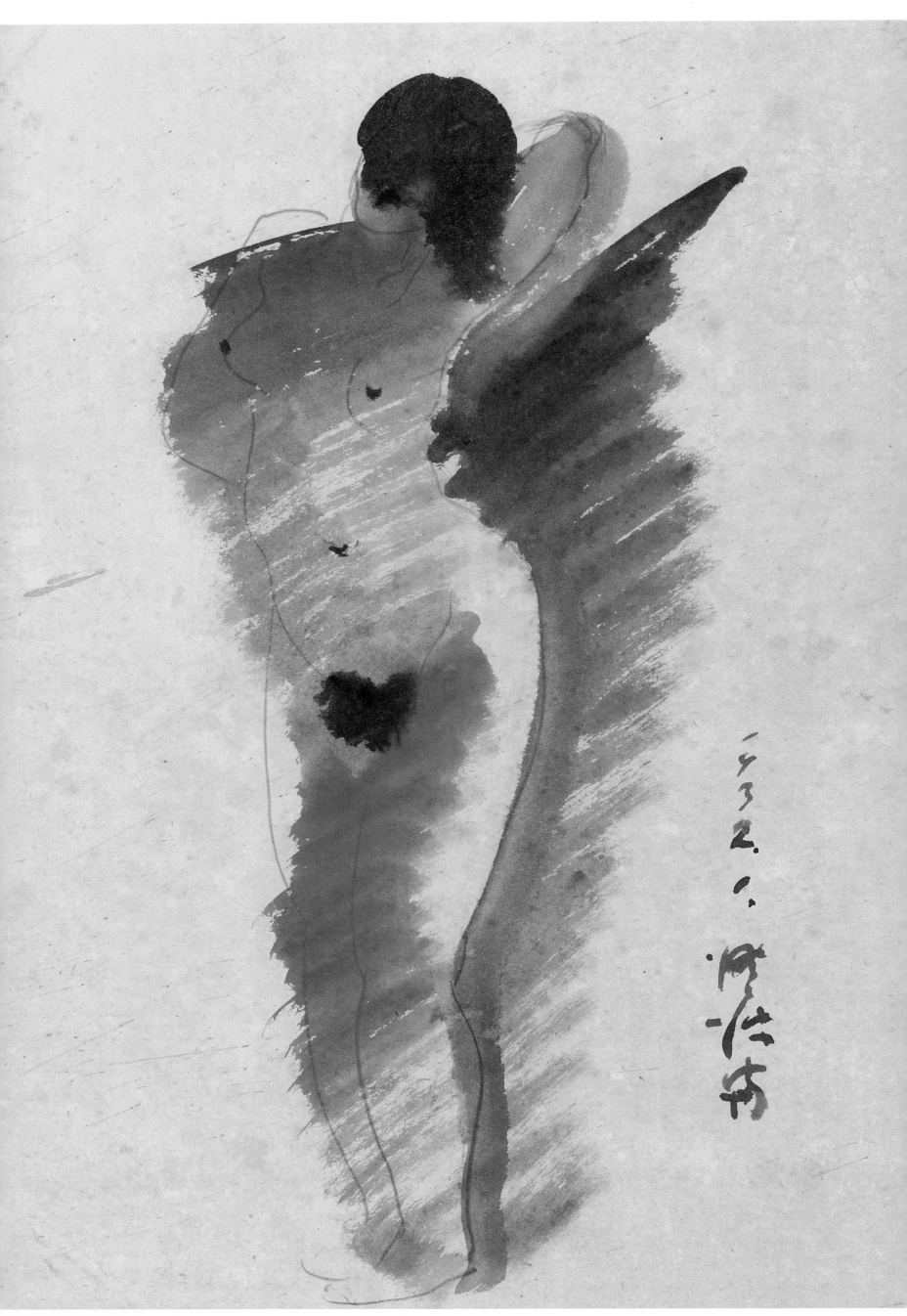

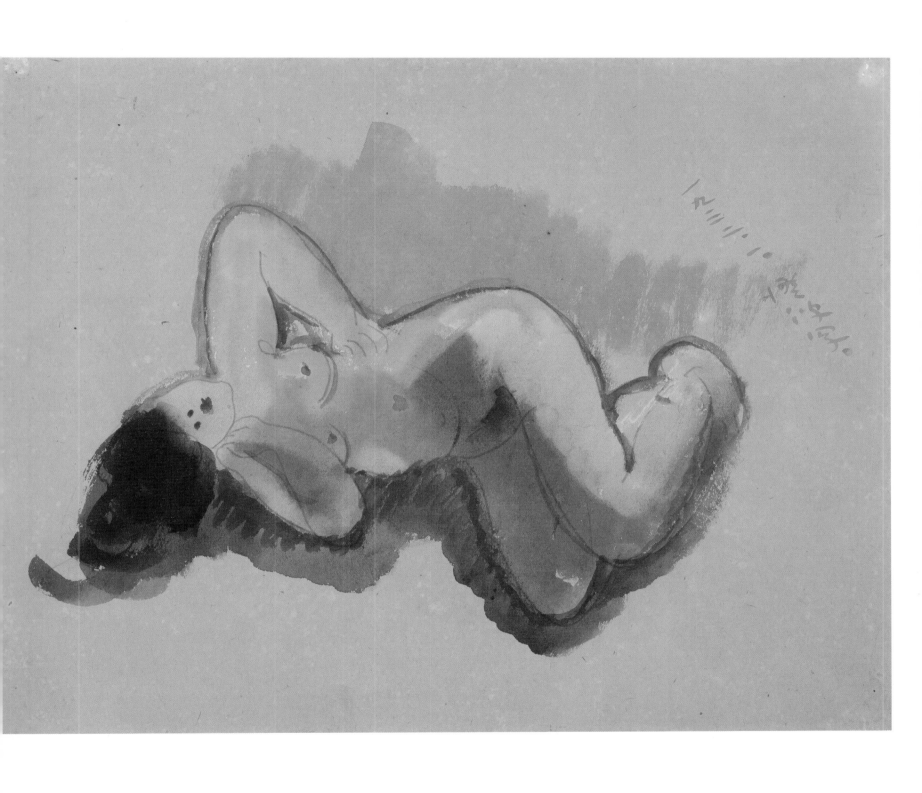

臥姿裸女-32.1（30） Lying Nude-32.1 (30)

1932　紙本淡彩鉛筆　28.5×36.5cm

[左頁圖]

立姿裸女-32.1（21） Standing Nude-32.1 (21)

1932　紙本淡彩鉛筆　原寸（36×26cm）

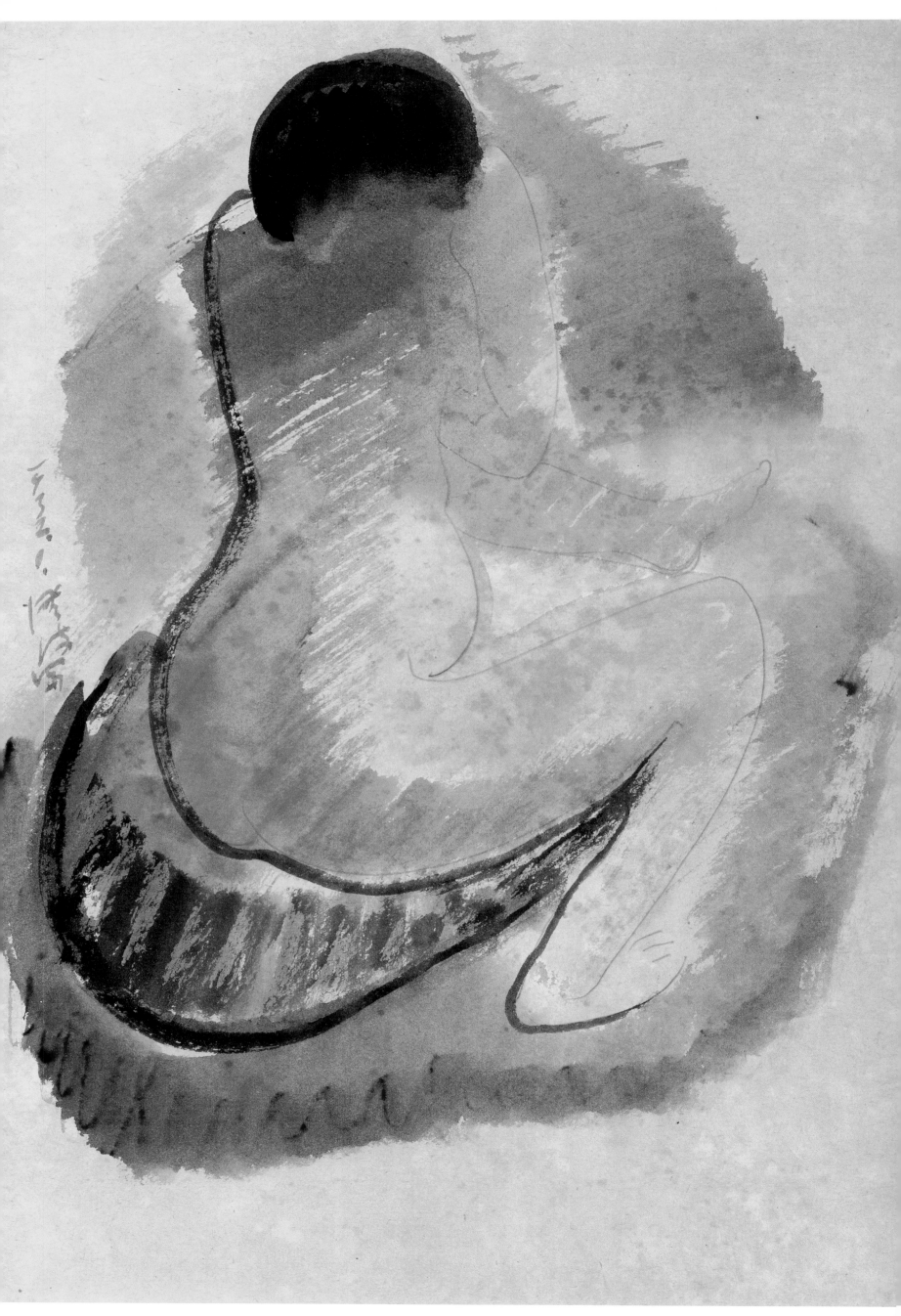

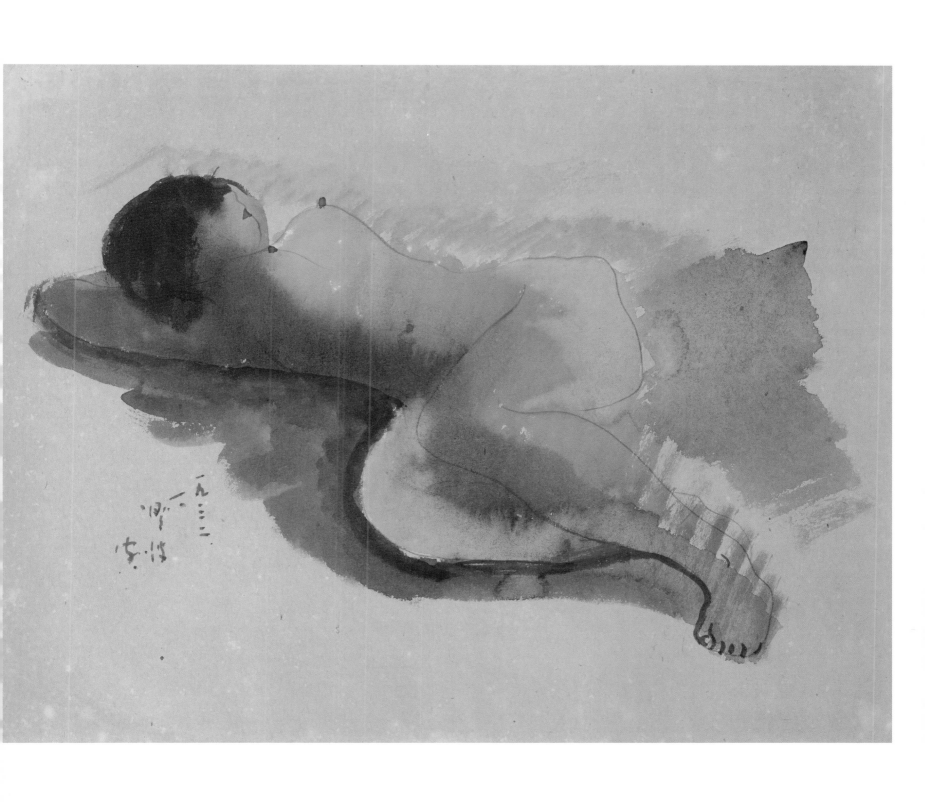

臥姿裸女-32.1（31） Lying Nude-32.1 (31)

1932　紙本淡彩鉛筆　28.5×36.5cm

[左頁圖]

坐姿裸女-32.1（53） Seated Nude-32.1 (53)

1932　紙本淡彩鉛筆　原寸（36×26.5cm）

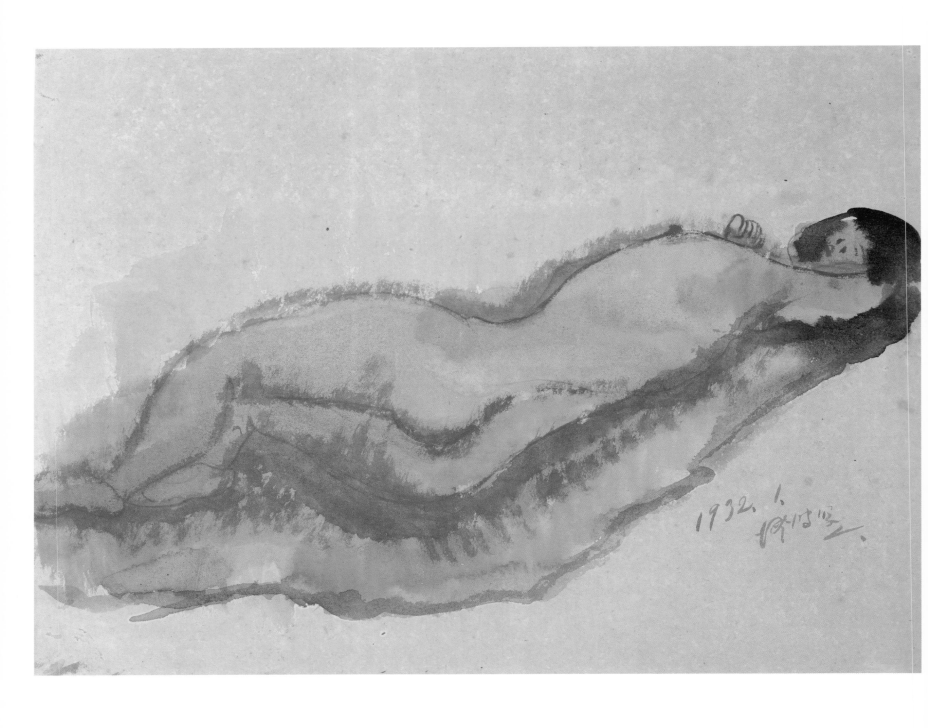

臥姿裸女-32.1（32）Lying Nude-32.1 (32)

1932　紙本淡彩鉛筆　26.5×36.5cm

[左頁圖]
坐姿裸女-32.1（54）Seated Nude-32.1 (54)

1932　紙本淡彩鉛筆　原寸（36.5×26cm）

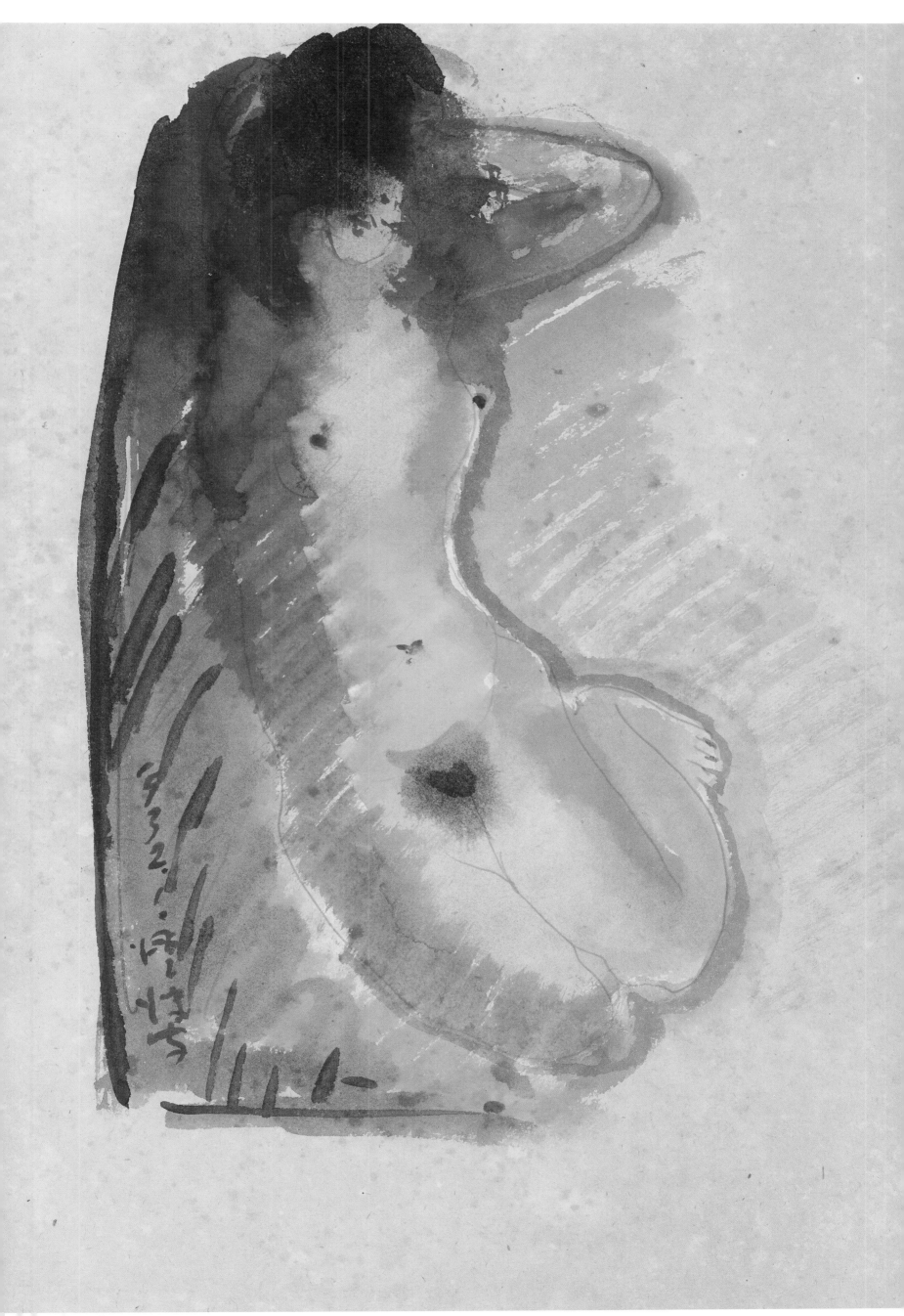

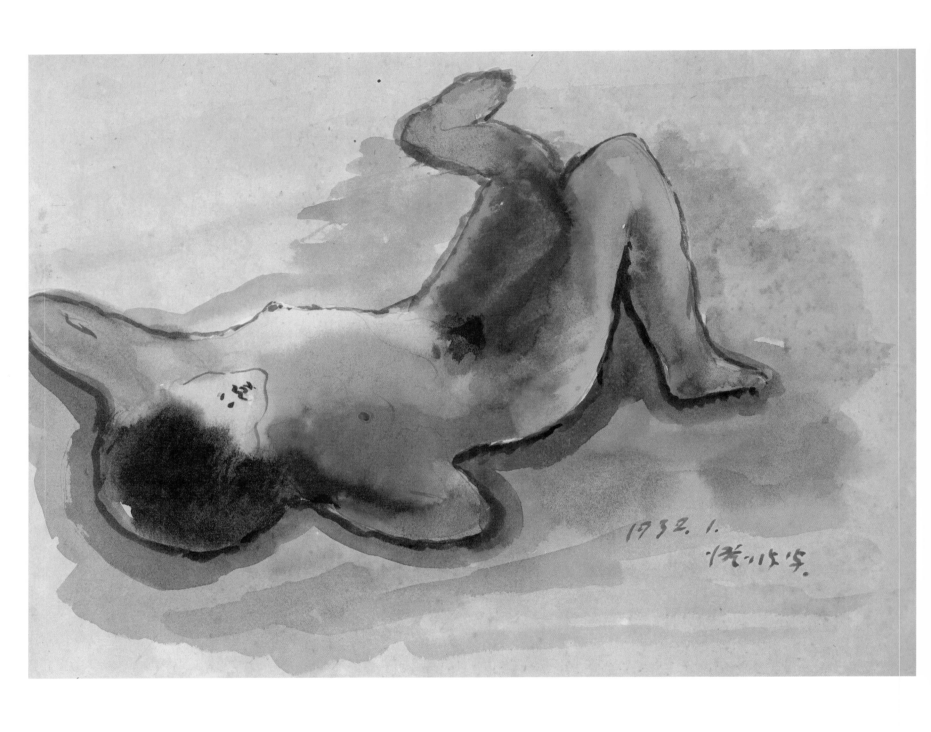

臥姿裸女-32.1（33）Lying Nude-32.1 (33)

1932　紙本淡彩鉛筆　26.5×36.5cm

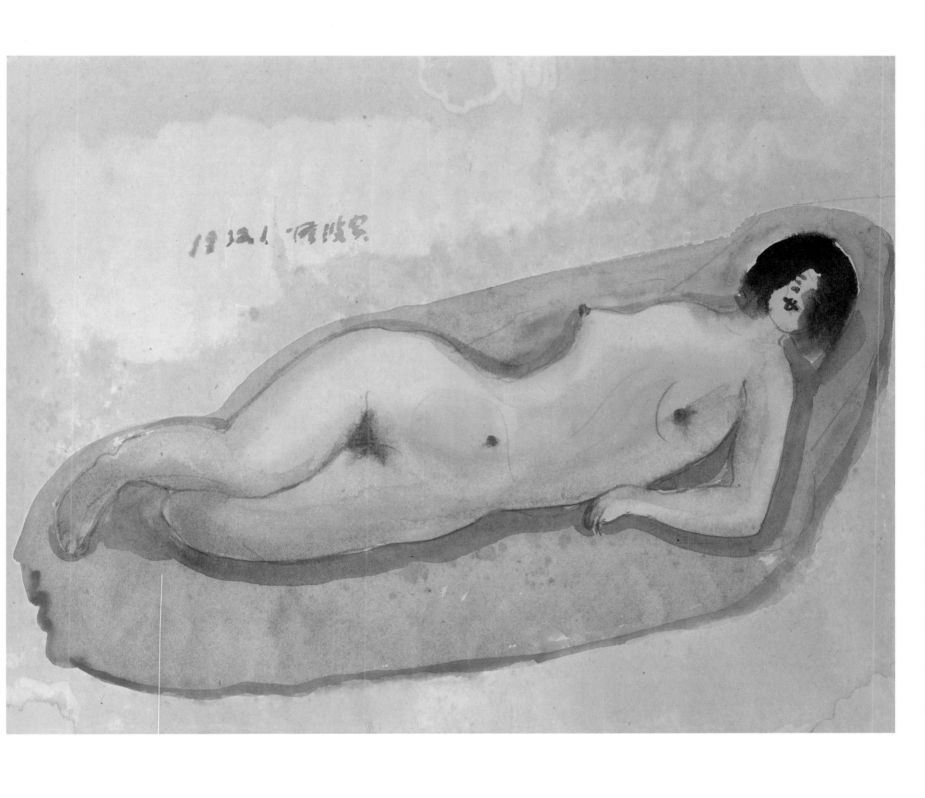

臥姿裸女-32.1（34）Lying Nude-32.1 (34)

1932　紙本淡彩鉛筆　28.5×36.5cm

149

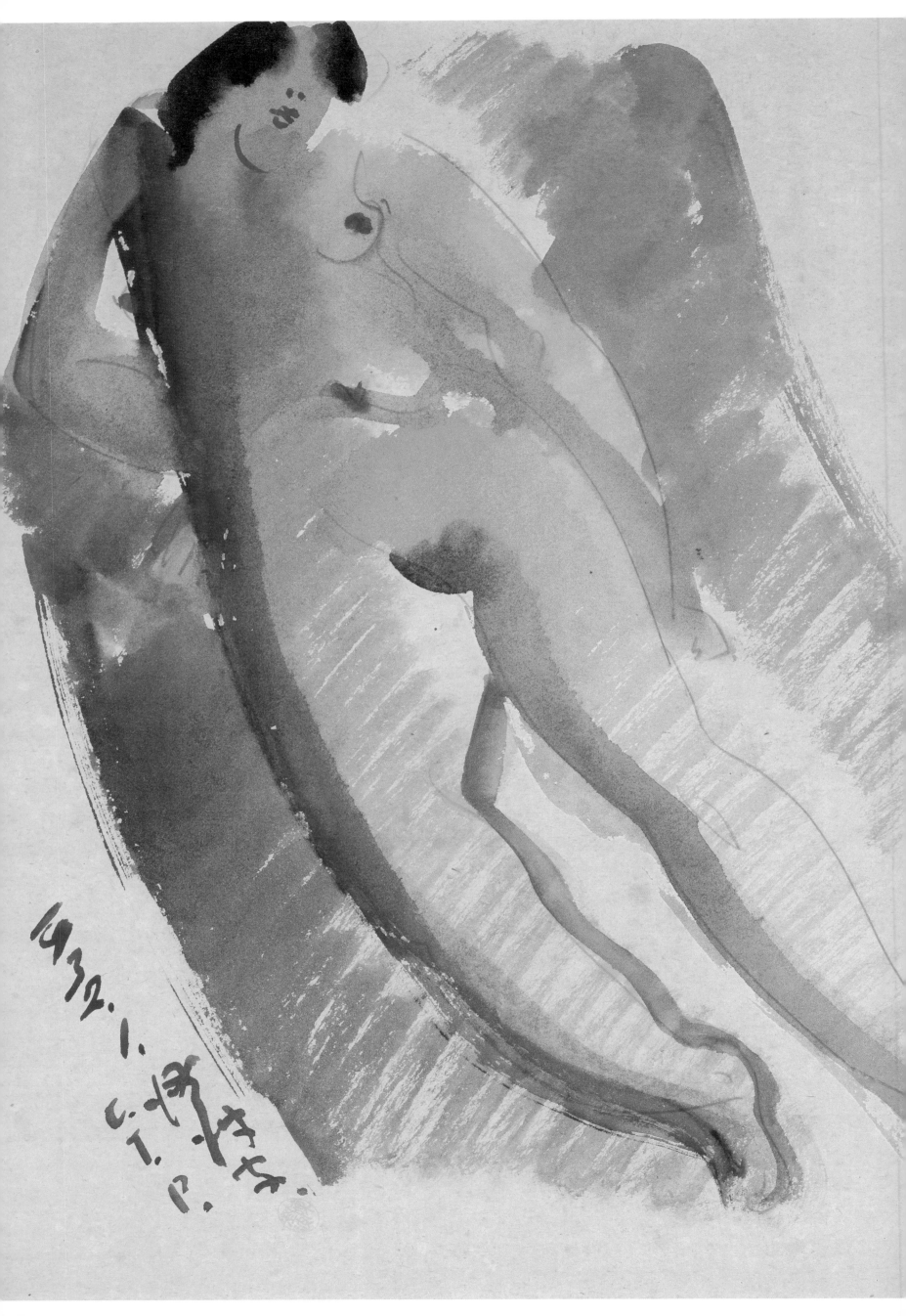

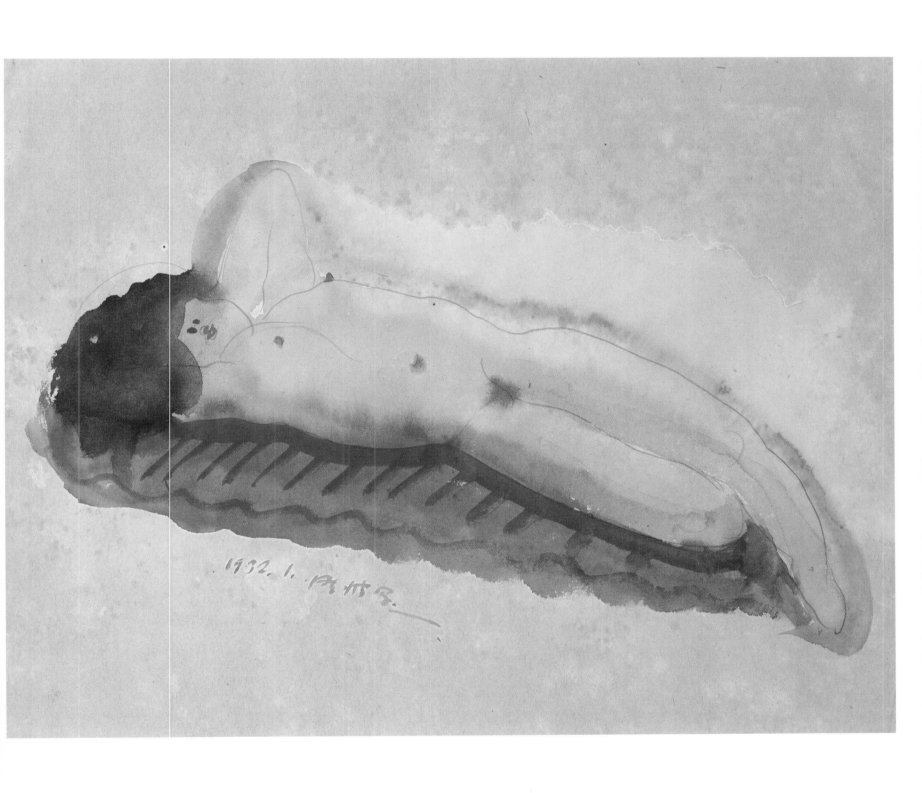

臥姿裸女-32.1（35） Lying Nude-32.1 (35)

1932　紙本淡彩鉛筆　28.5×36.5cm

[左頁圖]

立姿裸女-32.1（22） Standing Nude-32.1 (22)

1932　紙本淡彩鉛筆　原寸（36.5×26.5cm）

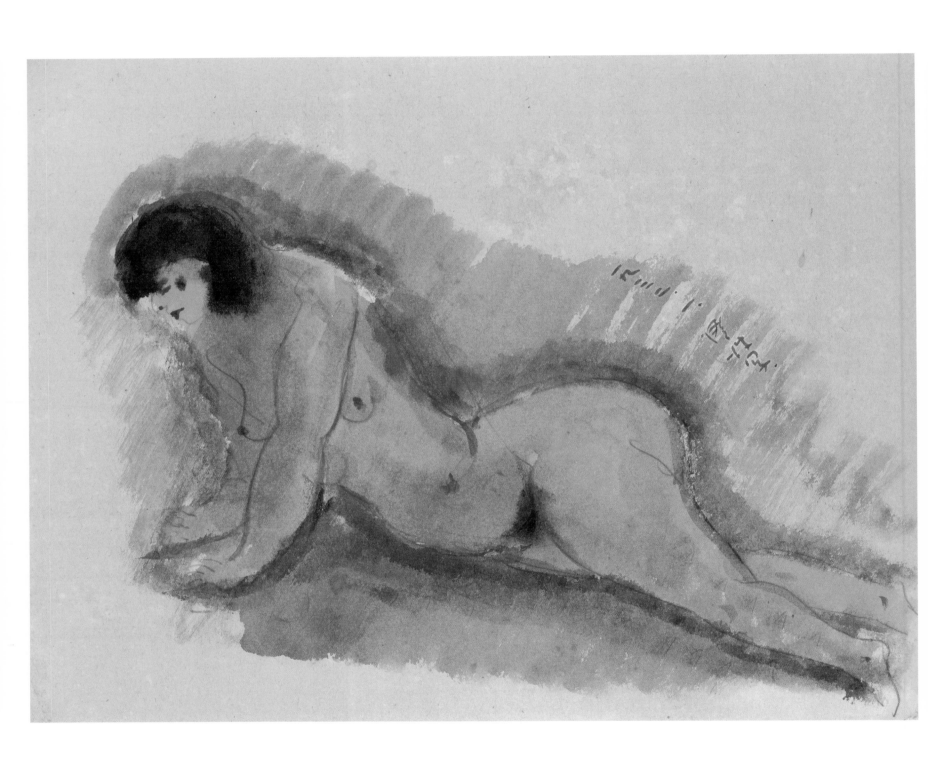

臥姿裸女-32.1（36） Lying Nude-32.1 (36)

1932　紙本淡彩鉛筆　28.5×37cm

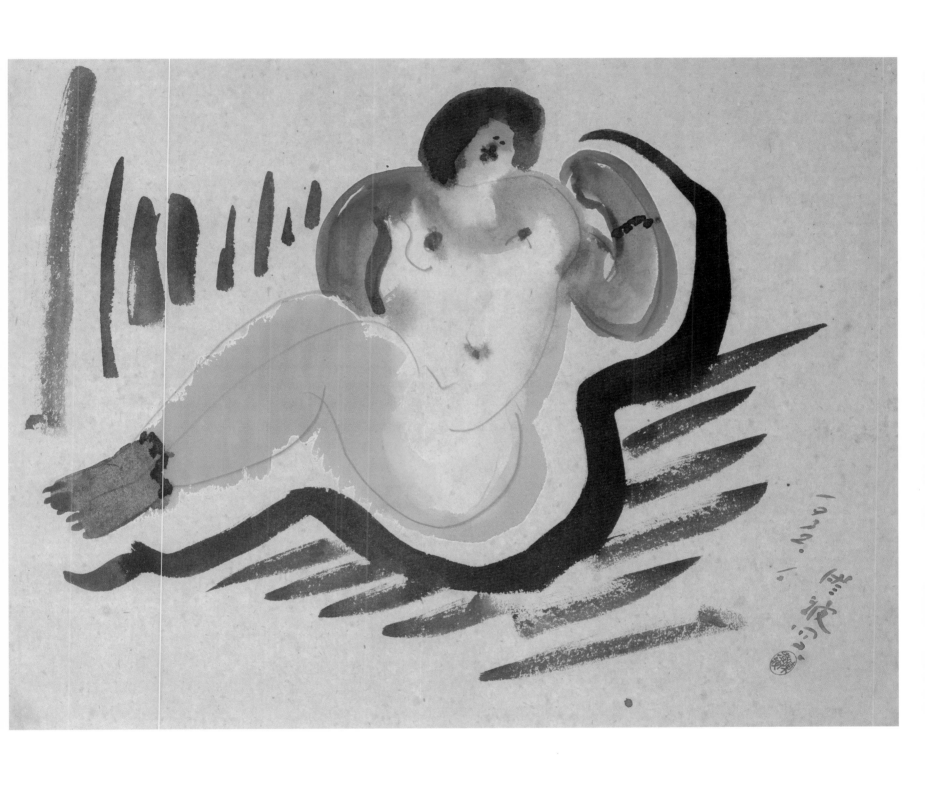

坐姿裸女-32.1（55）Seated Nude-32.1 (55)

1932　紙本淡彩鉛筆　28.5×36.5cm

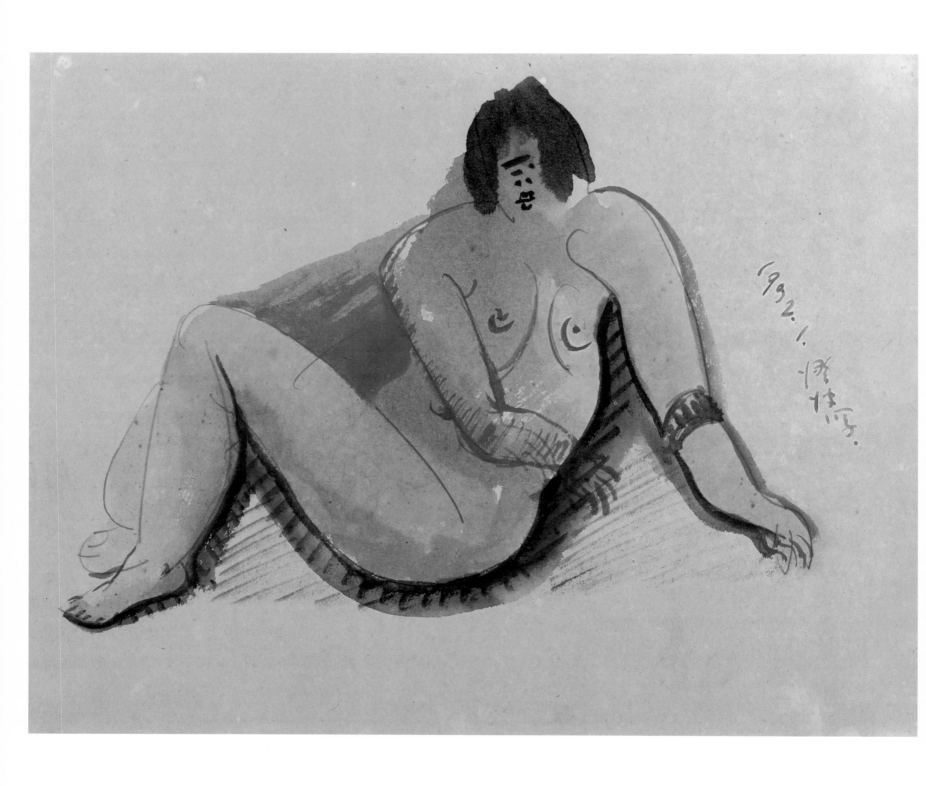

坐姿裸女-32.1（56） Seated Nude-32.1 (56)

1932　紙本淡彩鉛筆　28.5×36cm

[右頁圖]

立姿裸女-32.1（23） Standing Nude-32.1 (23)

1932　紙本淡彩鉛筆　原寸（36×26cm）

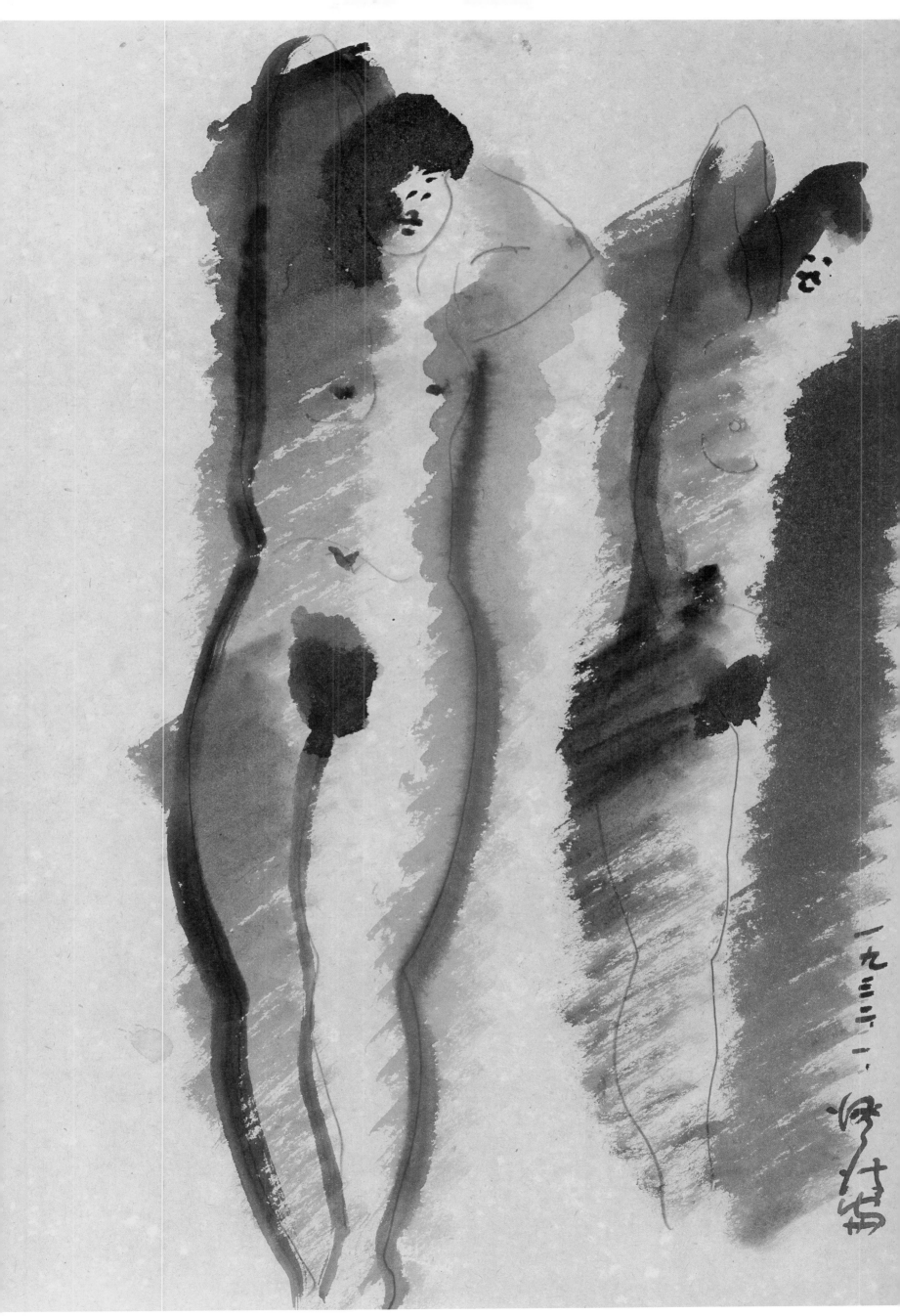

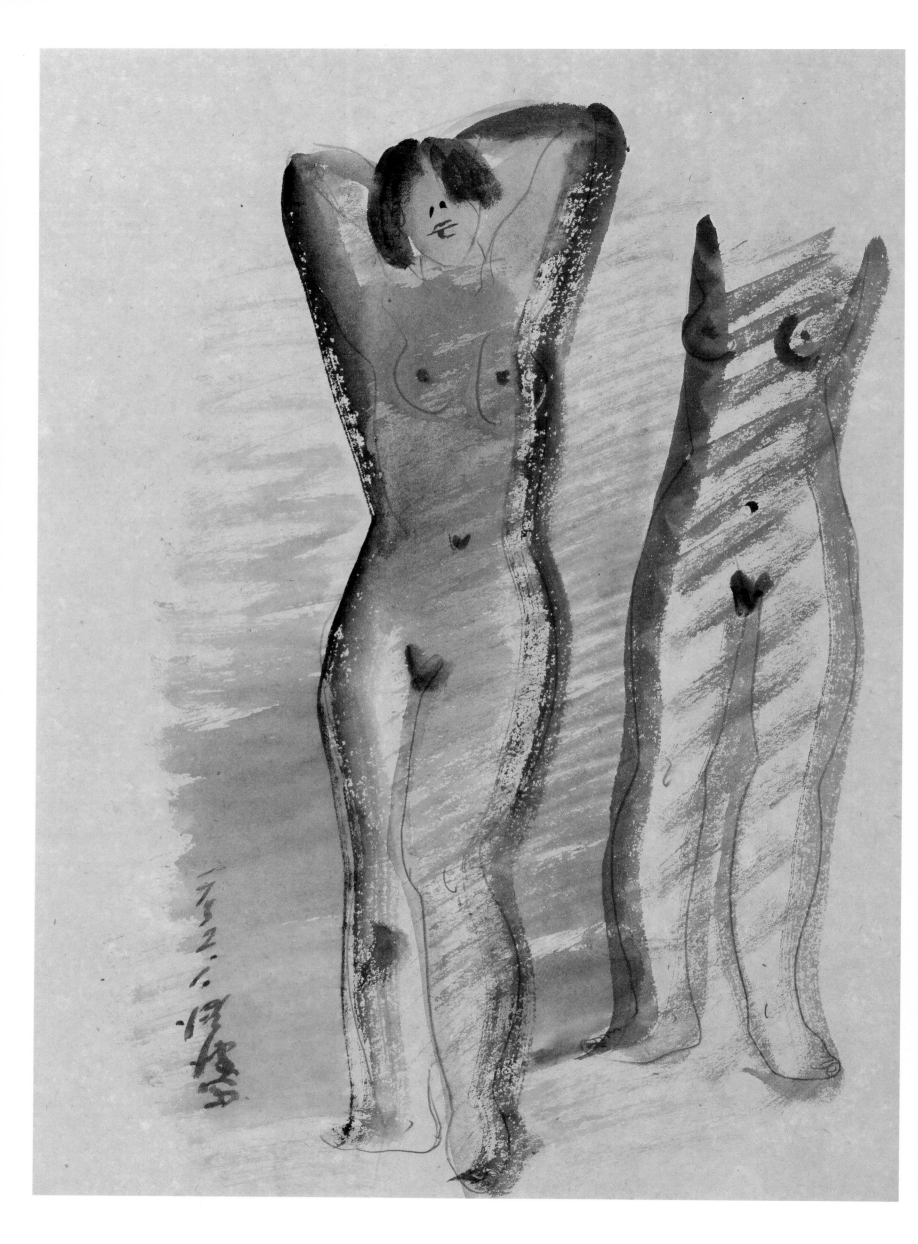

立姿裸女-32.1（24）Standing Nude-32.1 (24)

1932　紙本淡彩鉛筆　36.3×26.5cm

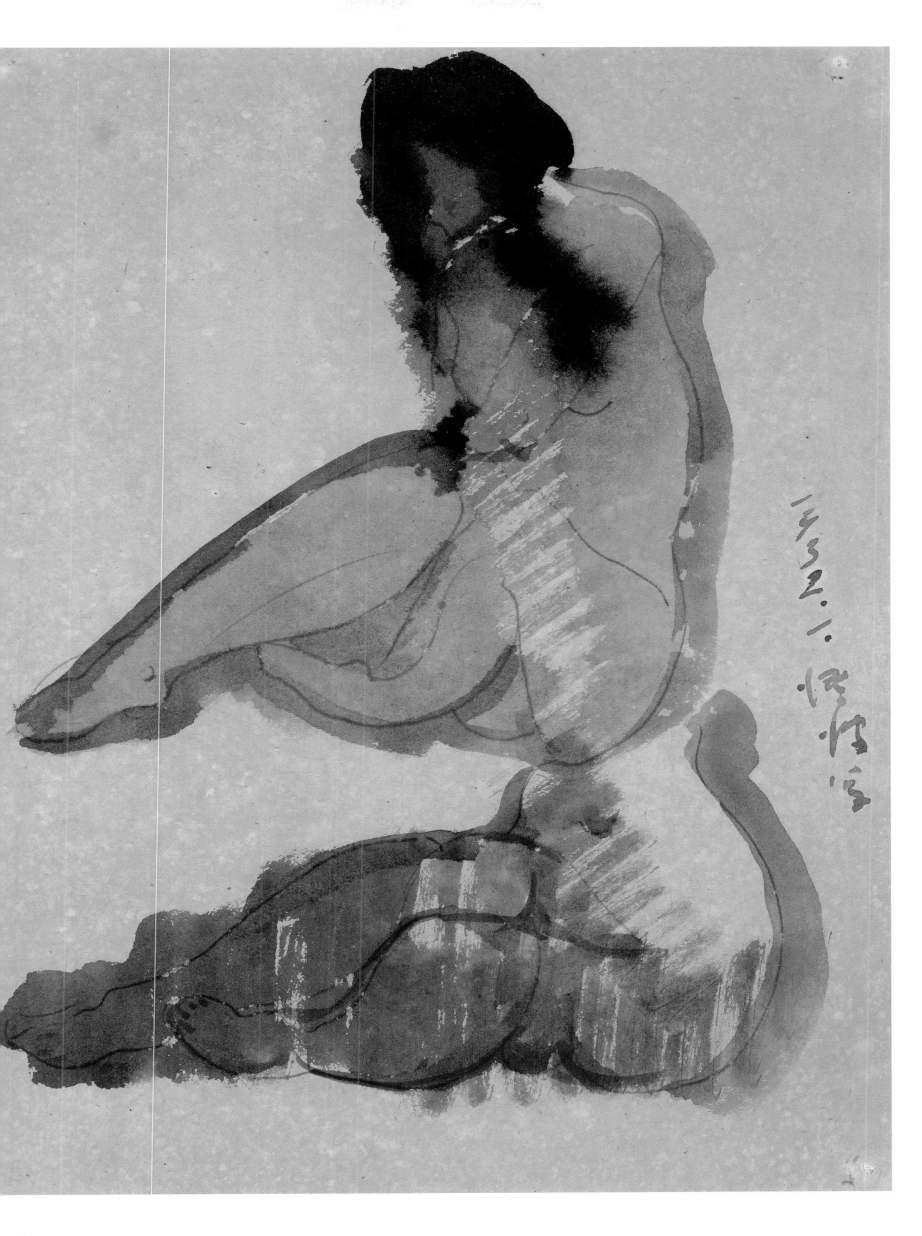

坐姿裸女-32.1（57）Seated Nude-32.1 (57)
1932　紙本淡彩鉛筆　37×28.5cm

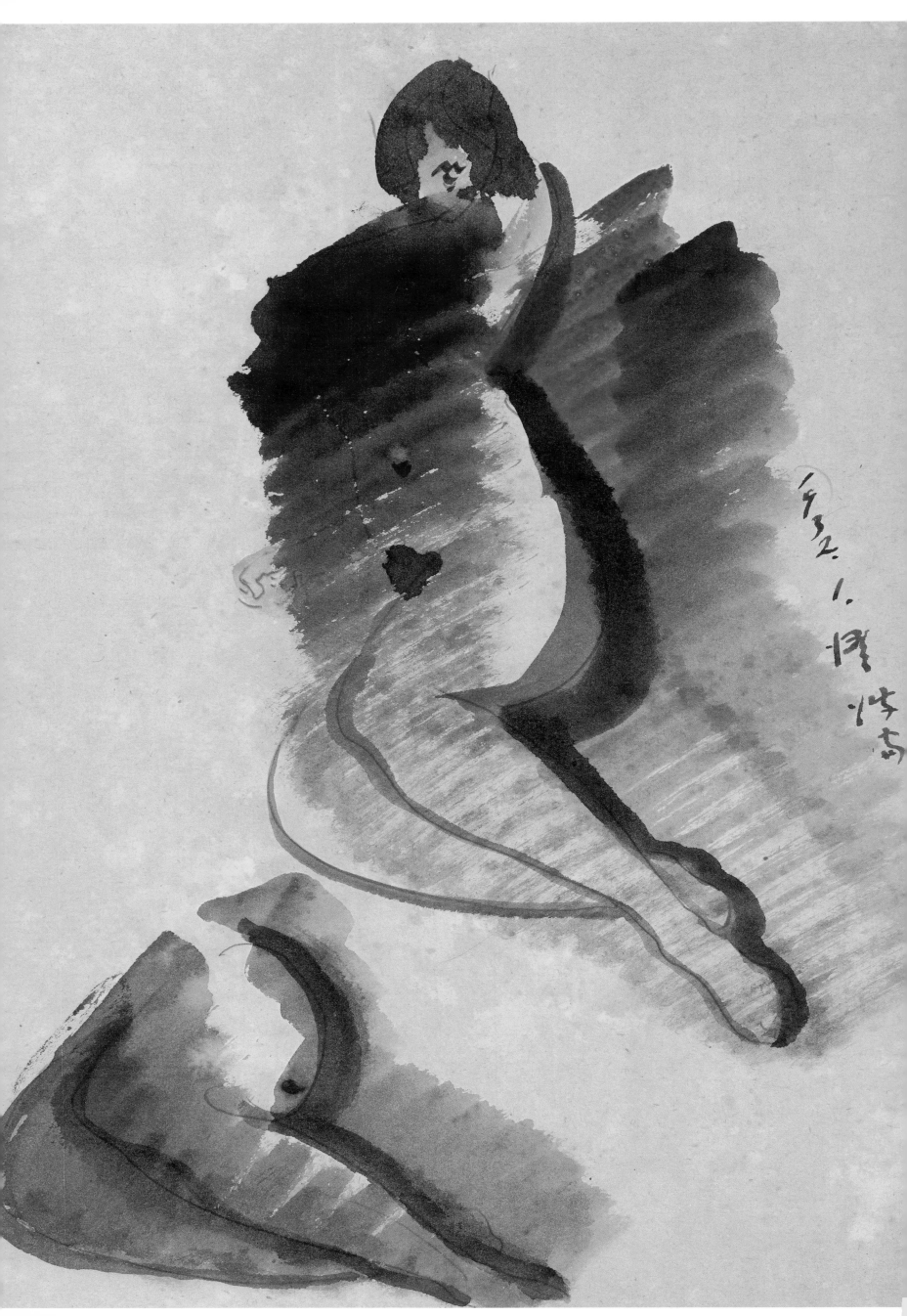

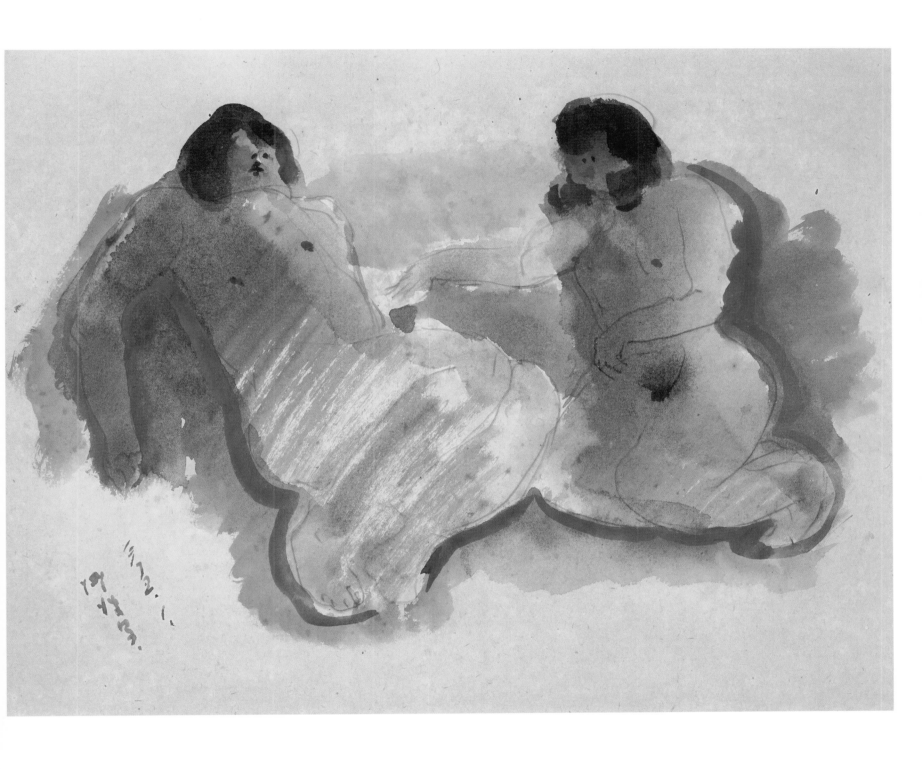

坐姿裸女-32.1（59） Seated Nude-32.1 (59)

1932　紙本淡彩鉛筆　28.5×37cm

[左頁圖]

坐姿裸女-32.1（58） Seated Nude-32.1 (58)

1932　紙本淡彩鉛筆　原寸（36×26.5cm）

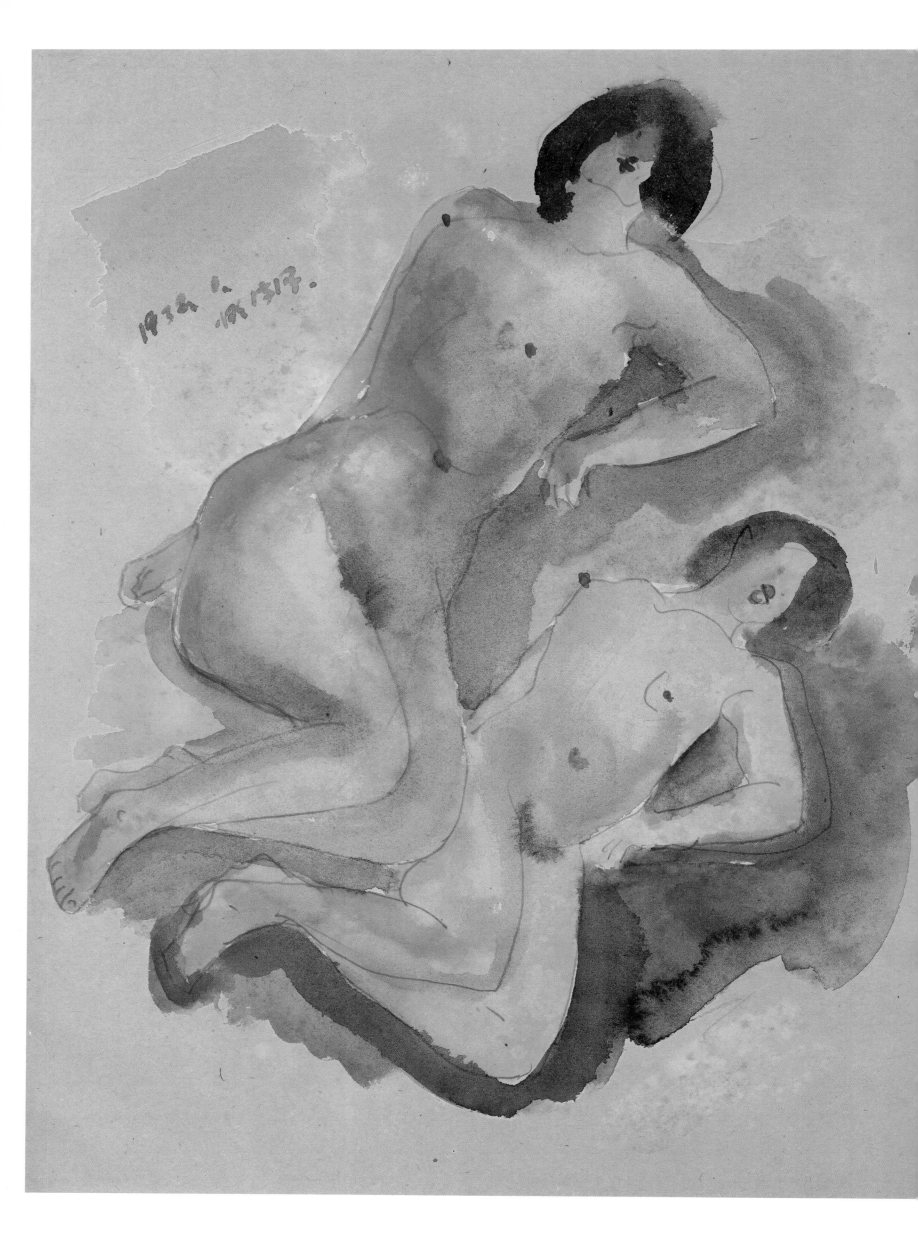

臥姿裸女-32.1（37） Lying Nude-32.1 (37)

1932　紙本淡彩鉛筆　36.5×28.5cm

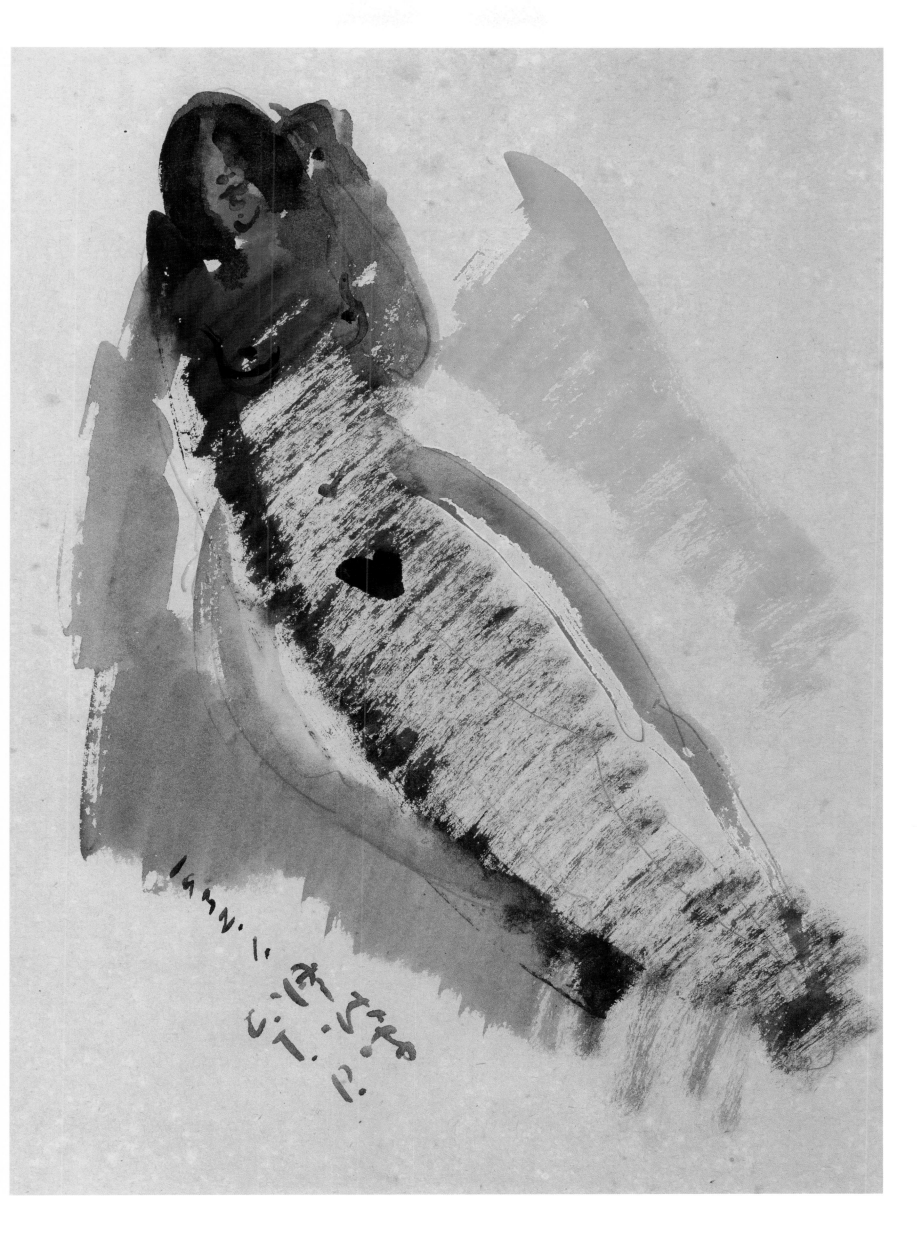

立姿裸女-32.1（25） Standing Nude-32.1 (25)

1932　紙本淡彩鉛筆　36×26.5cm

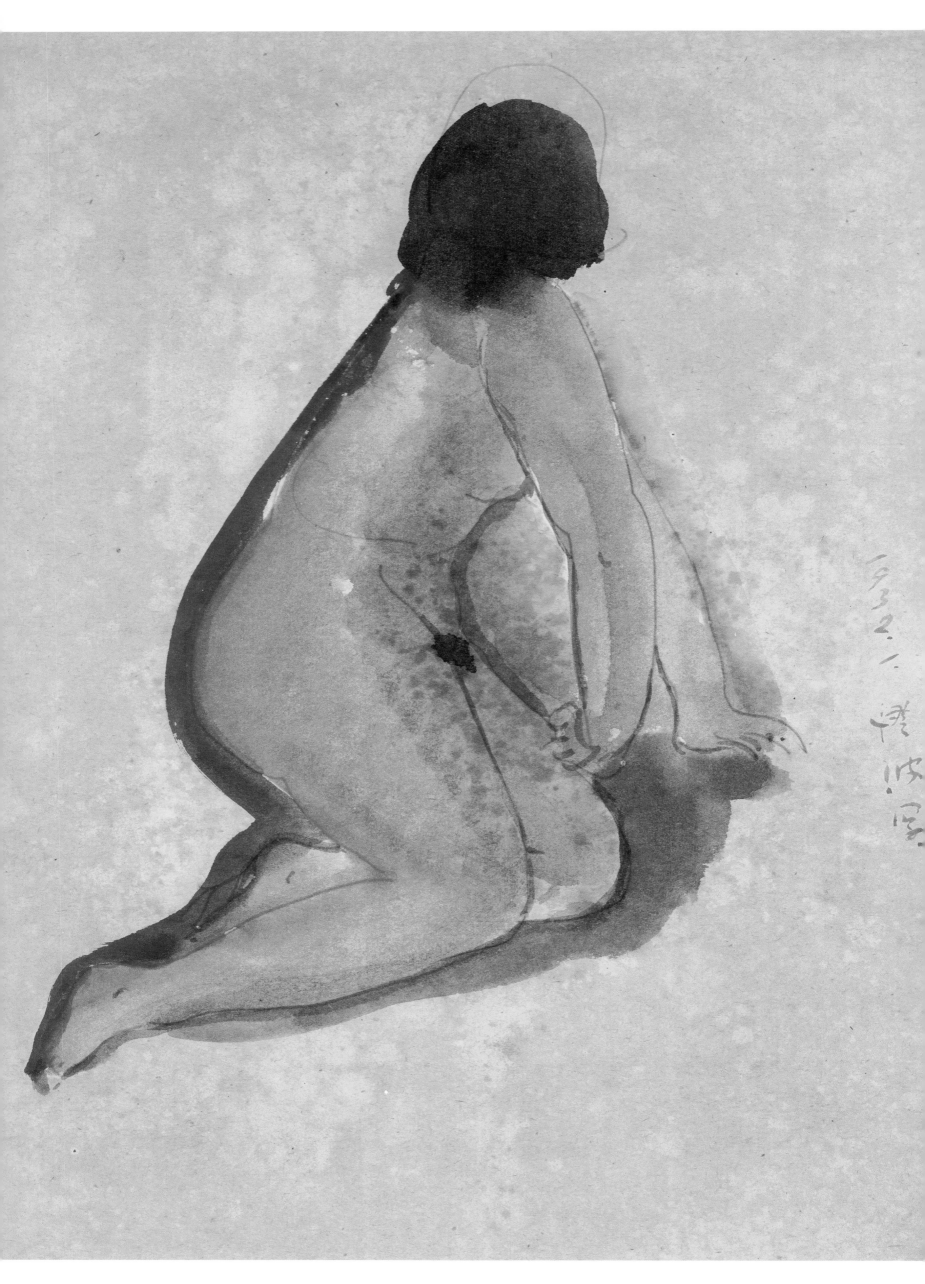

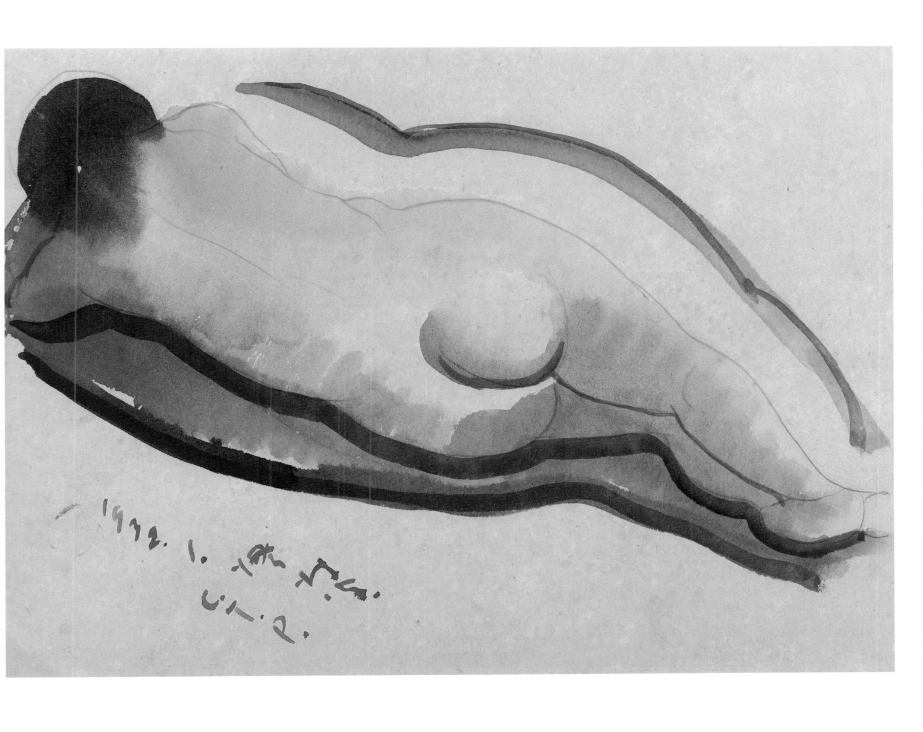

臥姿裸女-32.1（38） Lying Nude-32.1 (38)
1932　紙本淡彩鉛筆　26×36cm

[左頁圖]
坐姿裸女-32.1（60） Seated Nude-32.1 (60)
1932　紙本淡彩鉛筆　36.5×28.5cm

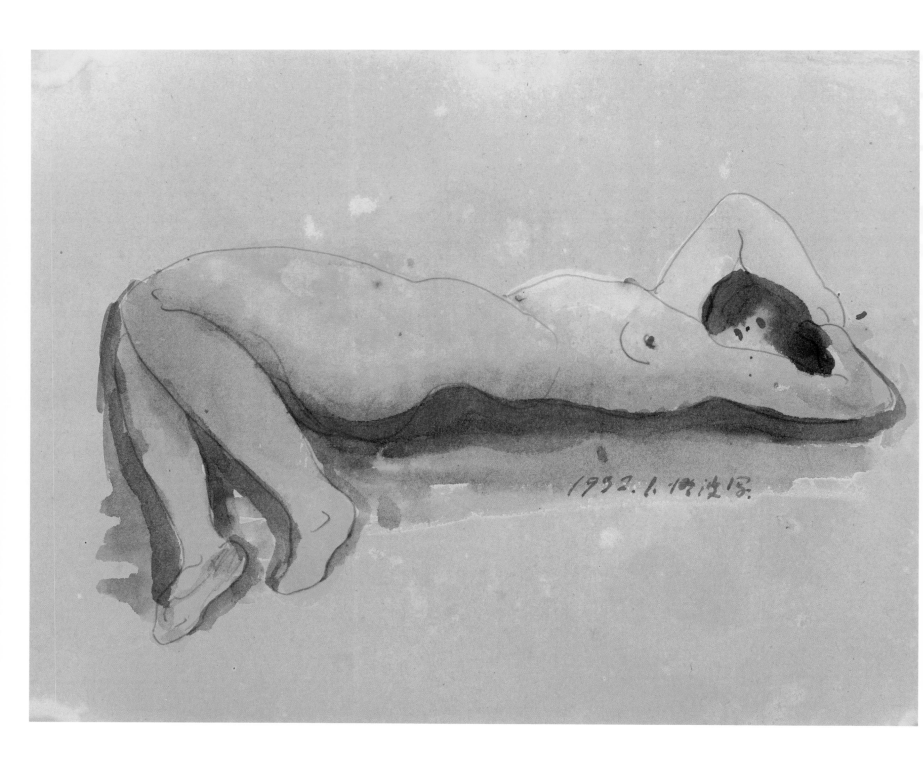

臥姿裸女-32.1（39） Lying Nude-32.1 (39)

1932　紙本淡彩鉛筆　28×36cm

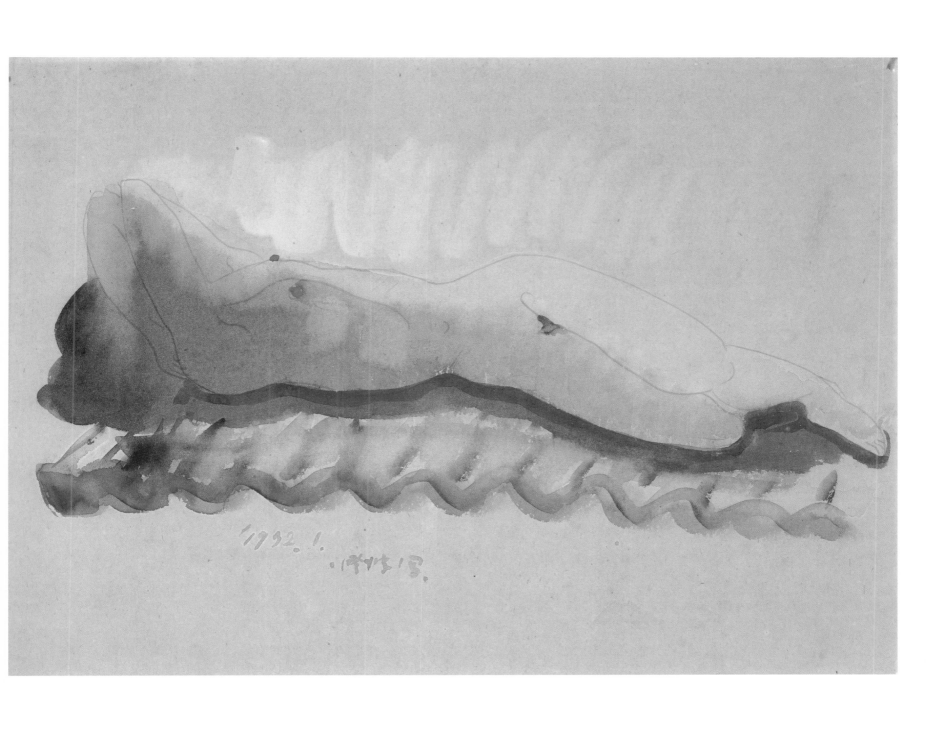

臥姿裸女-32.1（40） Lying Nude-32.1 (40)

1932　紙本淡彩鉛筆　26.5×36.5cm

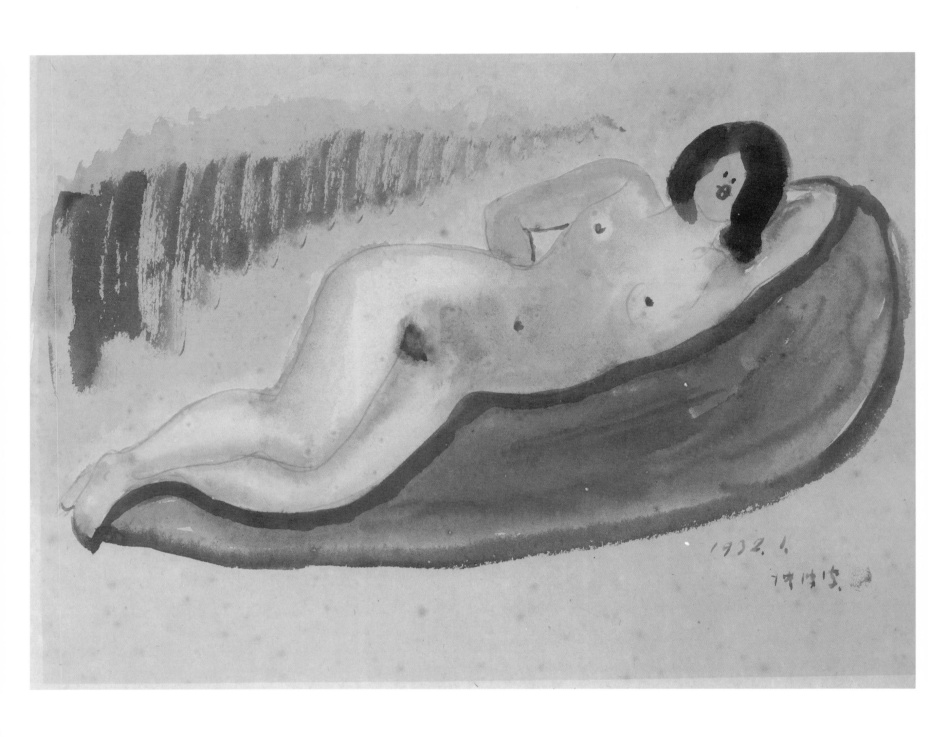

臥姿裸女-32.1（41） Lying Nude-32.1 (41)

1932　紙本淡彩鉛筆　26.5×36cm

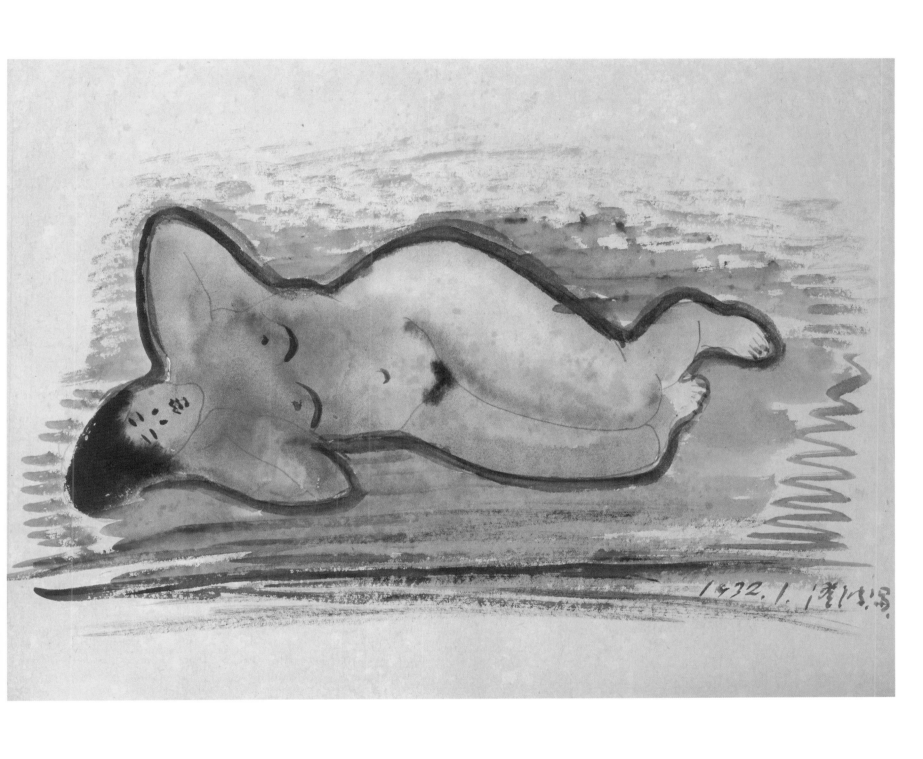

臥姿裸女-32.1（42）Lying Nude-32.1 (42)

1932　紙本淡彩鉛筆　26.5×36.5cm

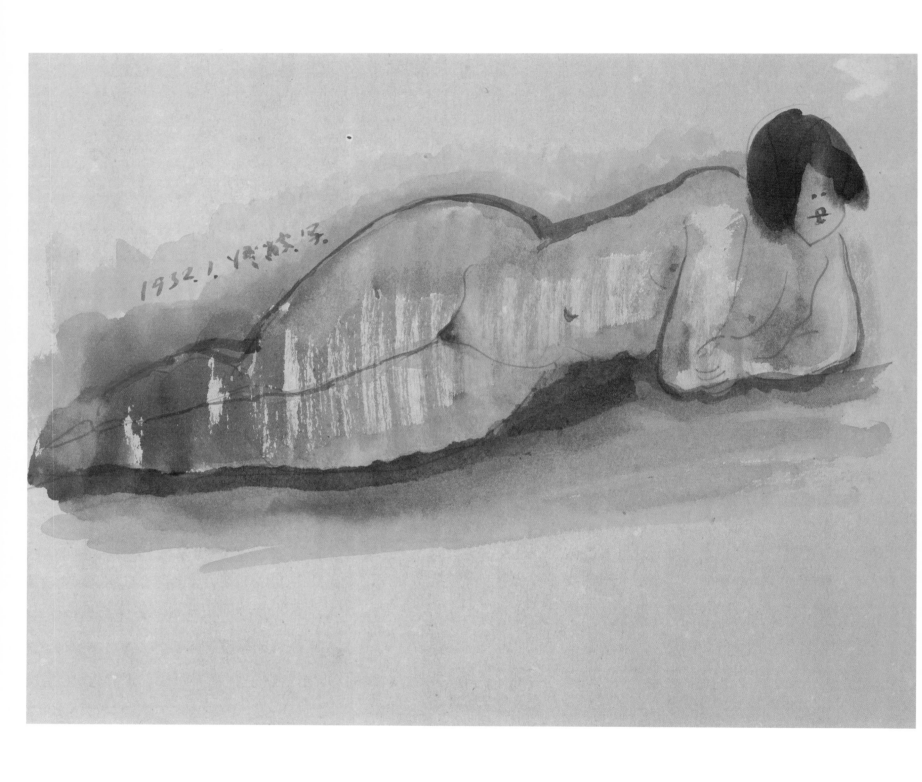

臥姿裸女-32.1（43）Lying Nude-32.1 (43)

1932　紙本淡彩鉛筆　28.5×36cm

[右頁圖]

臥姿裸女-32.1（44）Lying Nude-32.1 (44)

1932　紙本淡彩鉛筆　原寸（36.5×26.5cm）

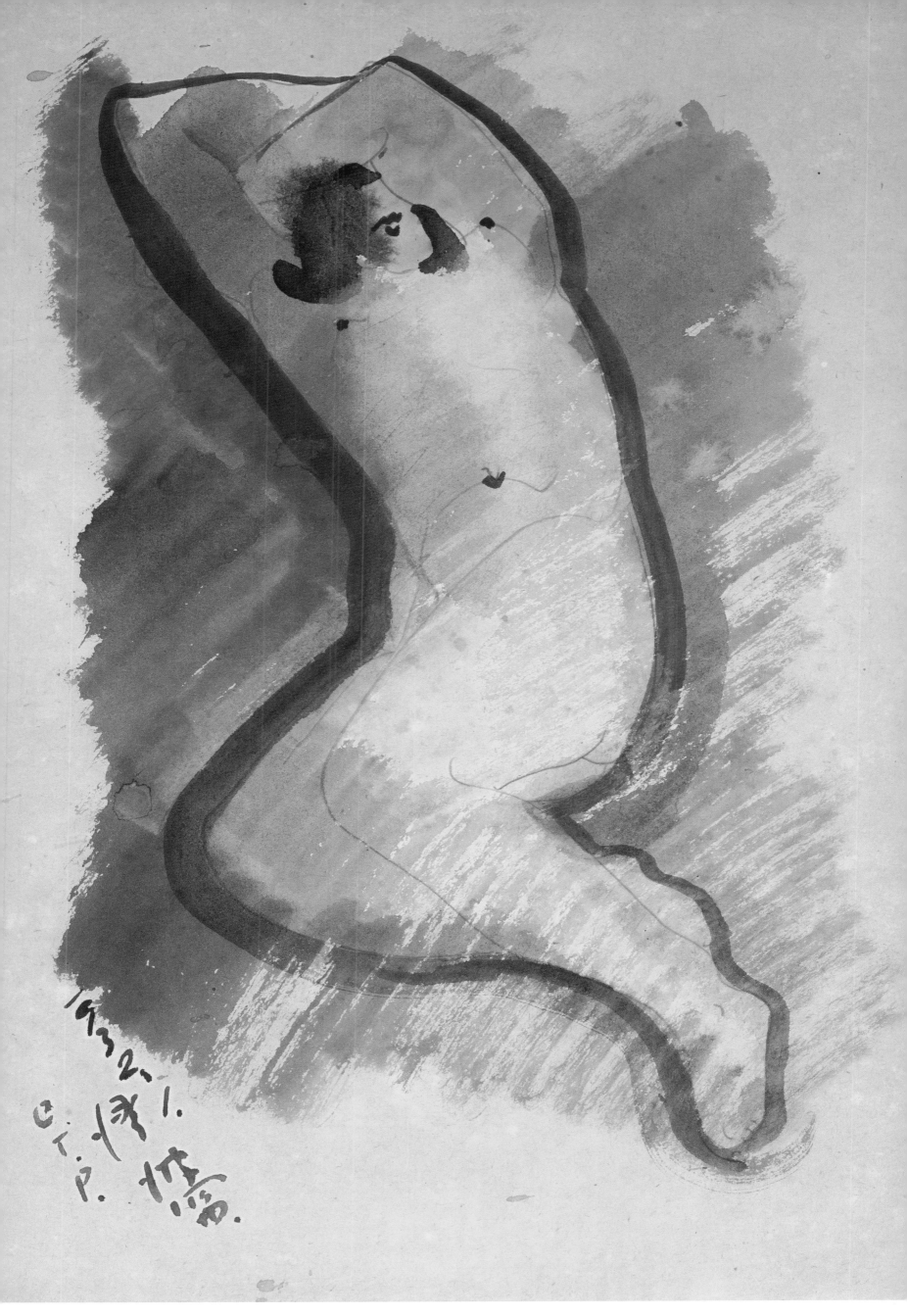

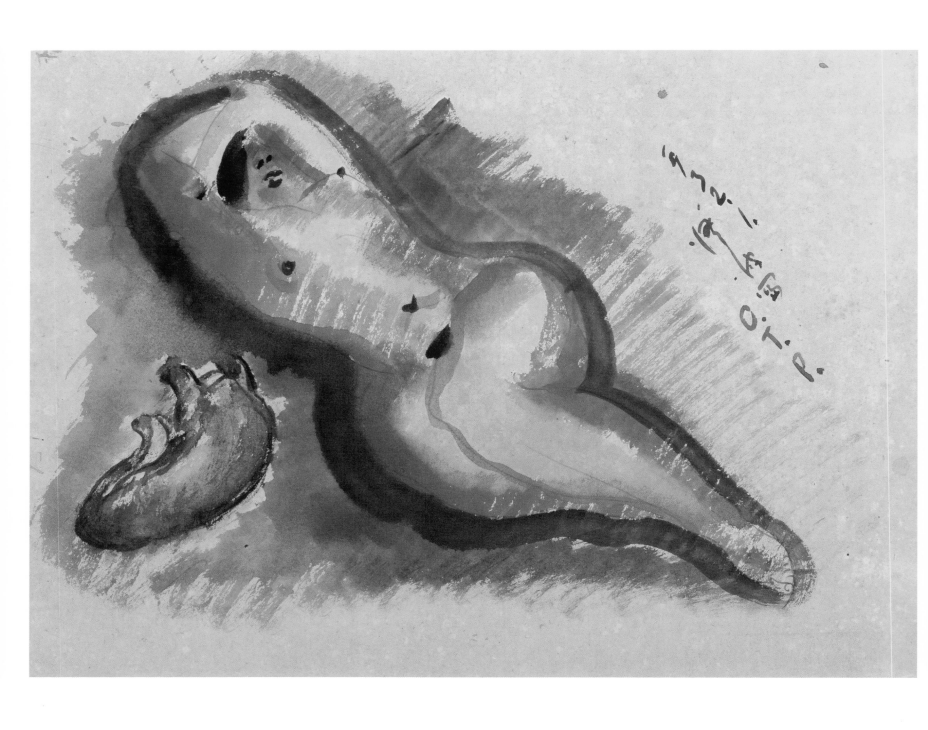

臥姿裸女-32.1（45） Lying Nude-32.1 (45)

1932　紙本淡彩鉛筆　26×36.5cm

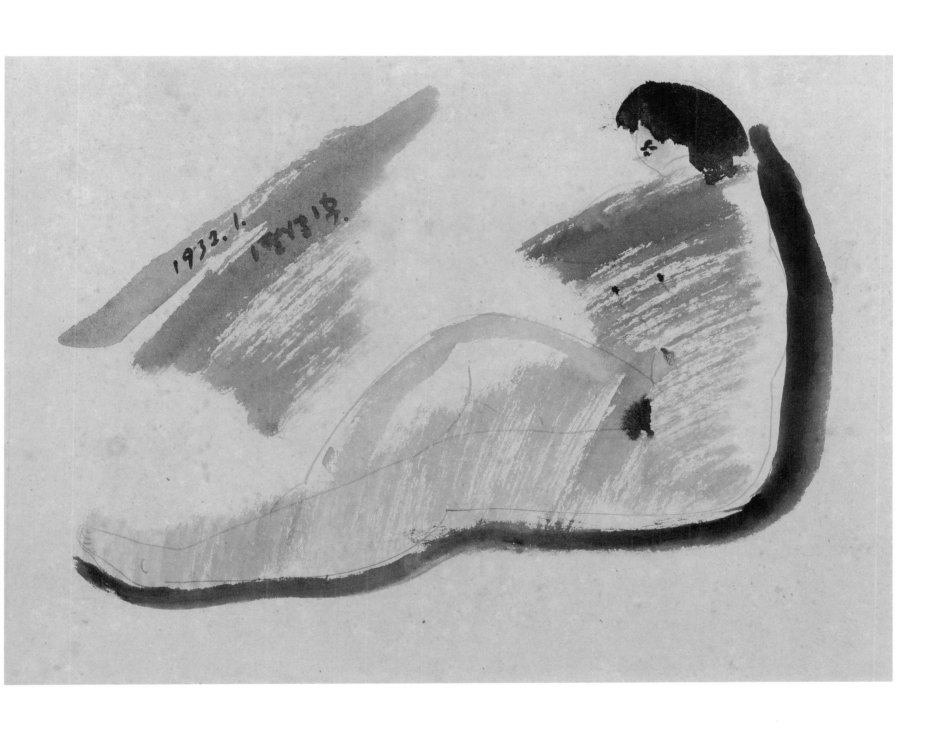

坐姿裸女-32.1（61） Seated Nude-32.1 (61)
1932　紙本淡彩鉛筆　26×36.5cm

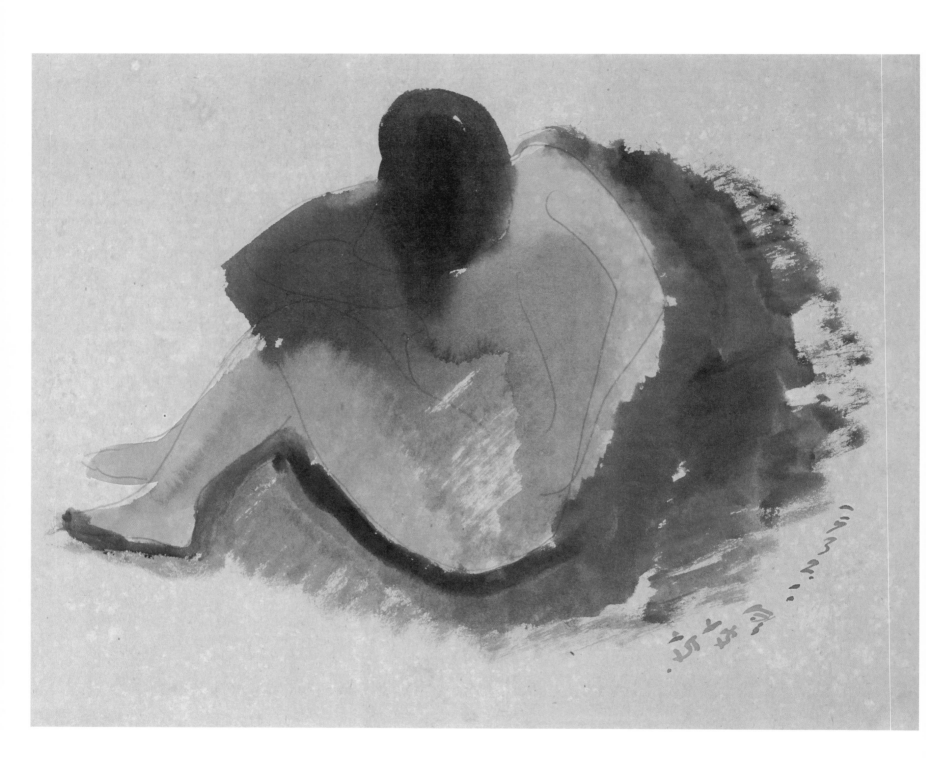

坐姿裸女-32.1（62） Seated Nude-32.1 (62)

1932　紙本淡彩鉛筆　28.5×36.5cm

[右頁圖]

臥姿裸女-32.1（46） Lying Nude-32.1 (46)

1932　紙本淡彩鉛筆　原寸（36.5×26.5cm）

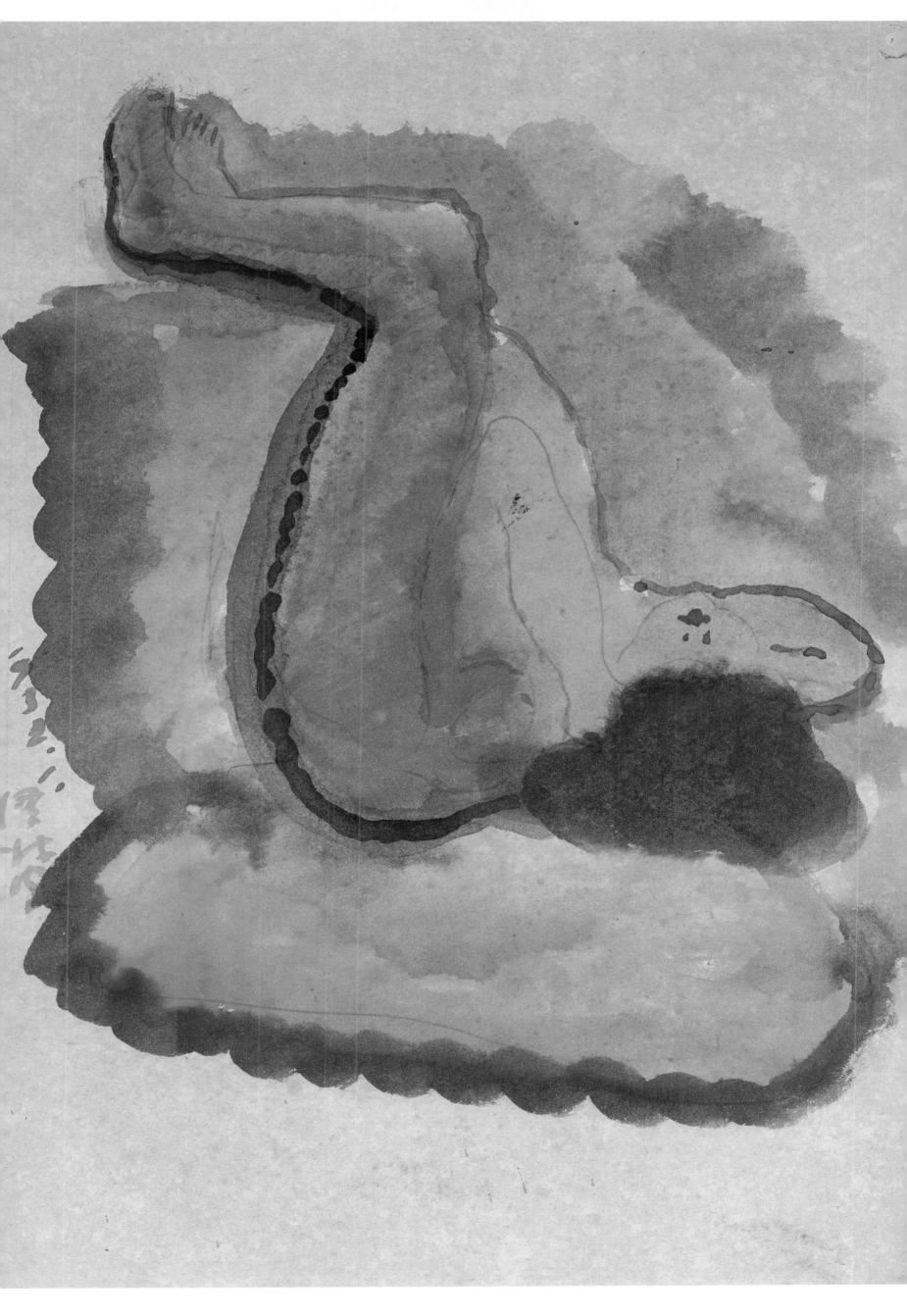

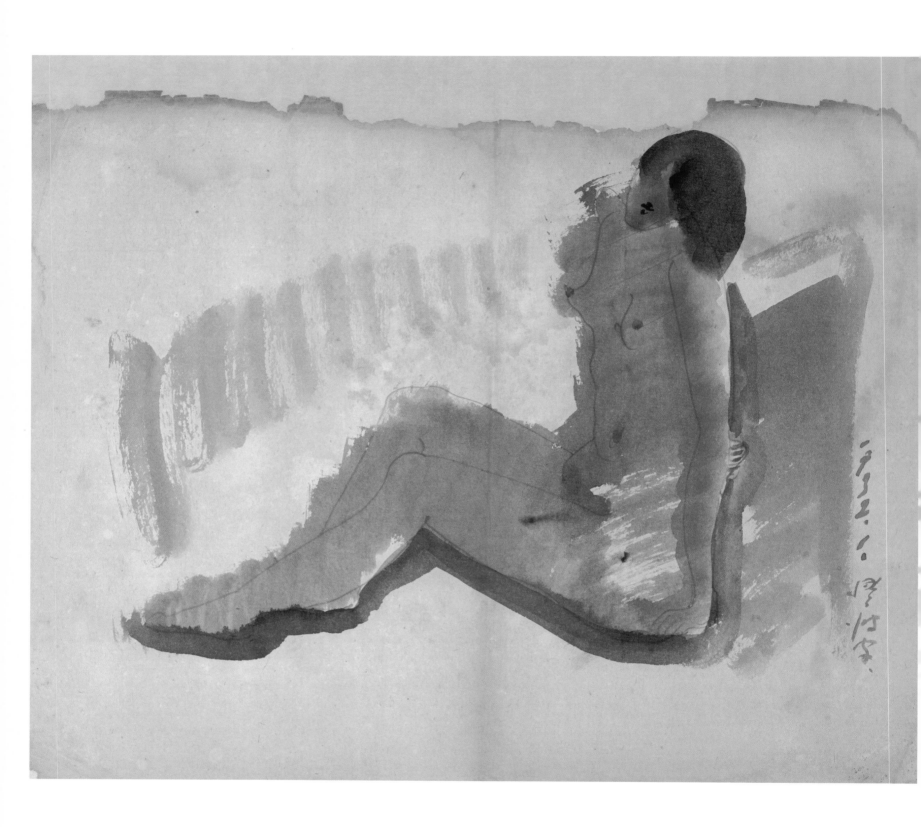

坐姿裸女-32.1（63）Seated Nude-32.1 (63)
1932　紙本淡彩鉛筆　28.5×36.5cm

[右頁圖]
坐姿裸女-32.1（64）Seated Nude-32.1 (64)
1932　紙本淡彩鉛筆　原寸（36×26.5cm）

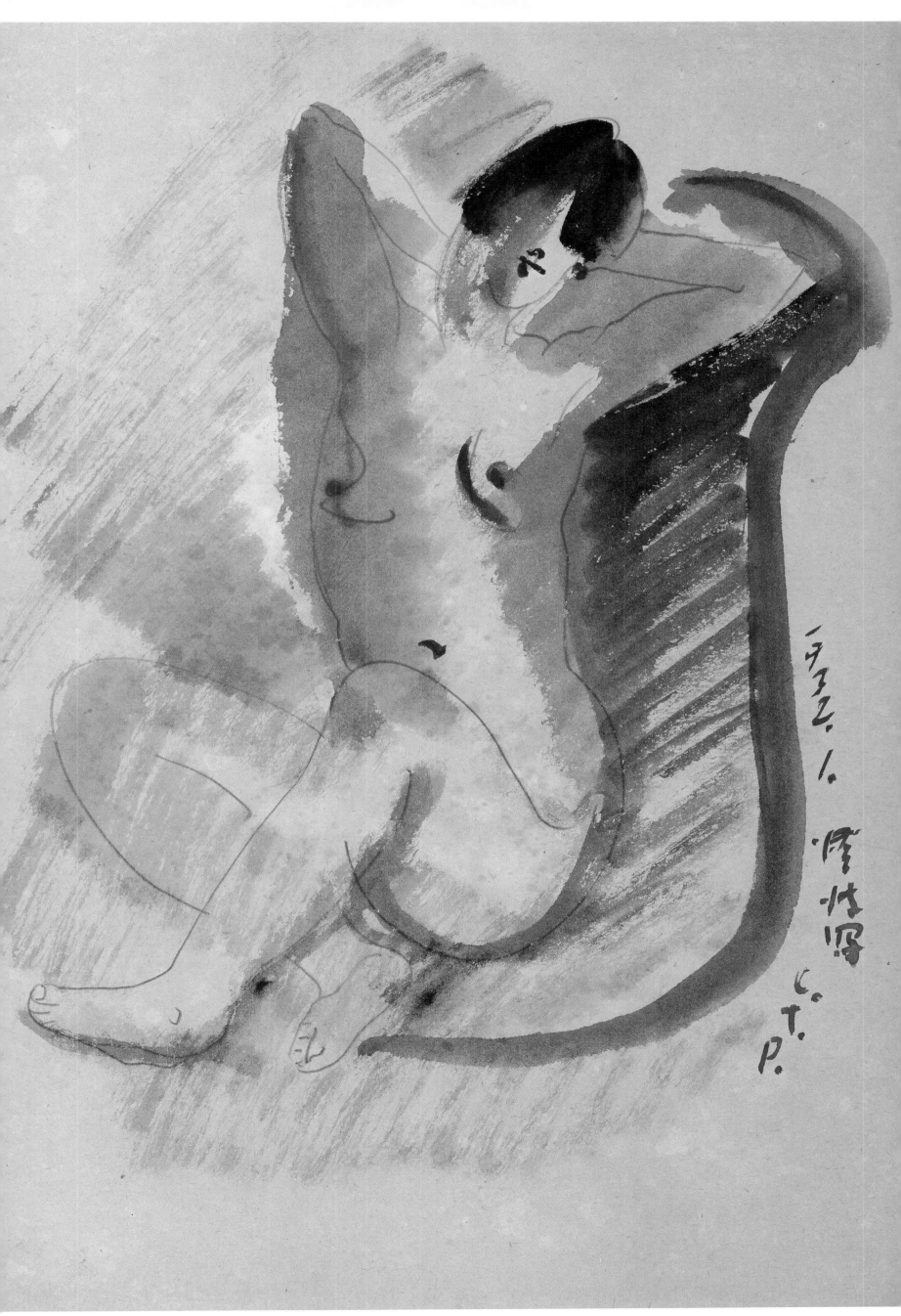

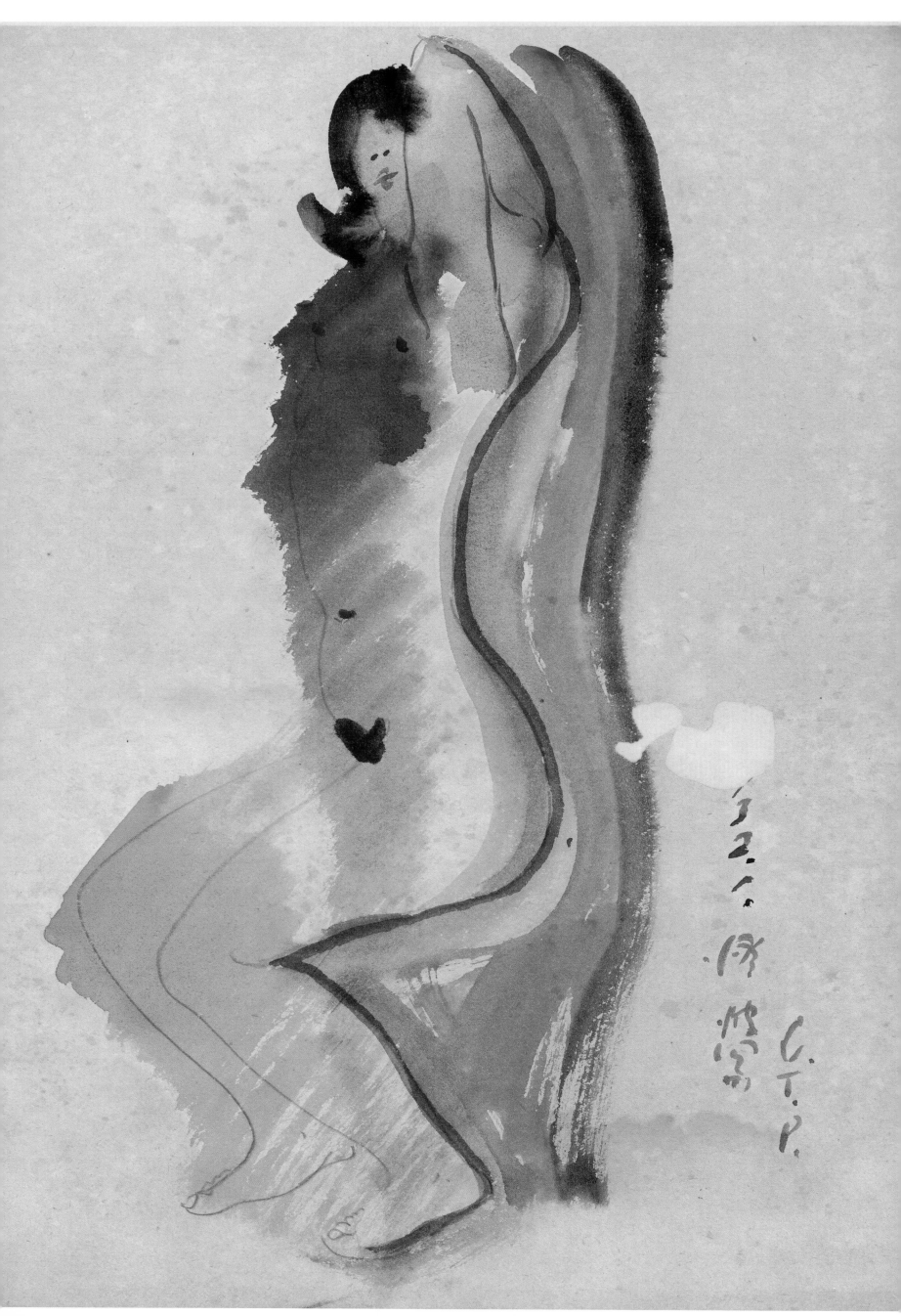

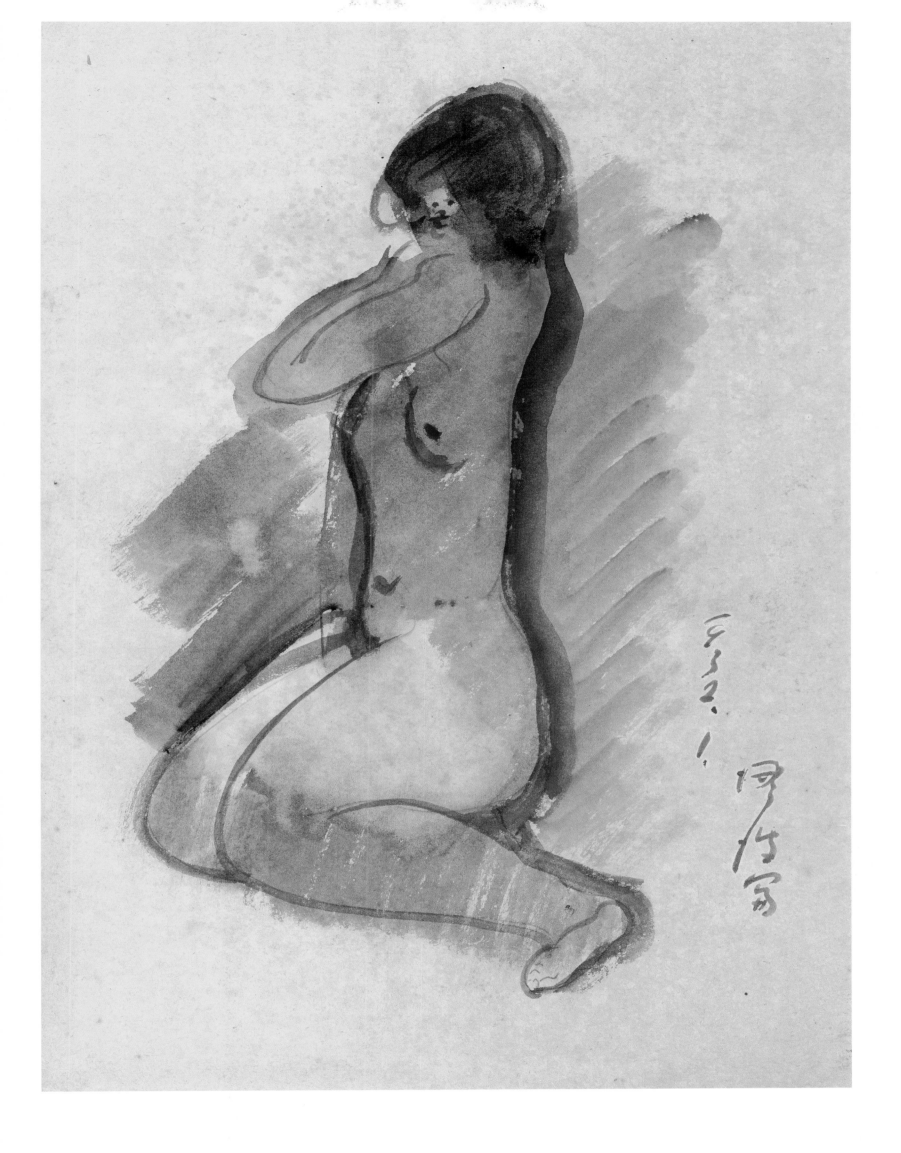

坐姿裸女-32.1（66）Seated Nude-32.1 (66)
1932　紙本淡彩鉛筆　36×26.5cm

[左頁圖]
坐姿裸女-32.1（65）Seated Nude-32.1 (65)
1932　紙本淡彩鉛筆　原寸（36×26cm）

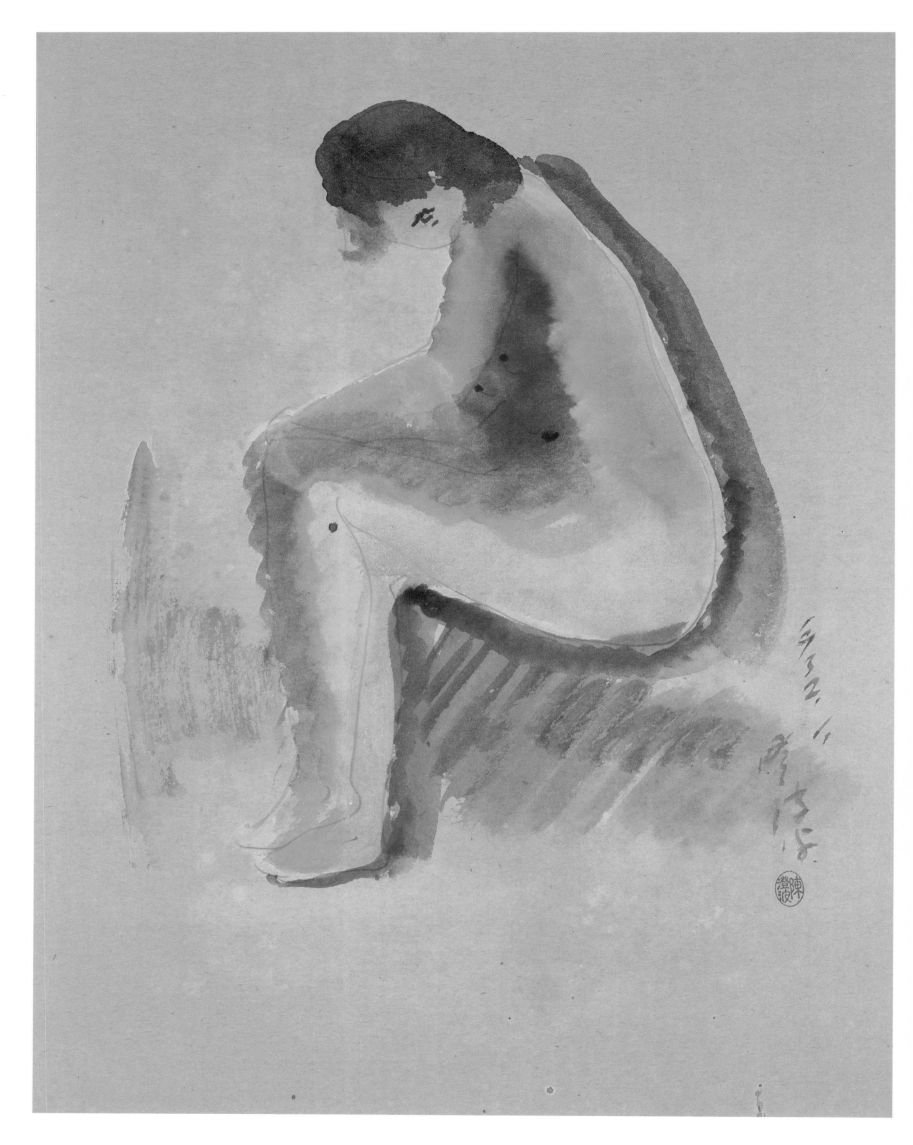

坐姿裸女-32.1（67）Seated Nude-32.1 (67)
1932　紙本淡彩鉛筆　37×28.5cm

[右頁圖]
坐姿裸女-32.1（68）Seated Nude-32.1 (68)
1932　紙本淡彩鉛筆　原寸（36.5×26.5cm）

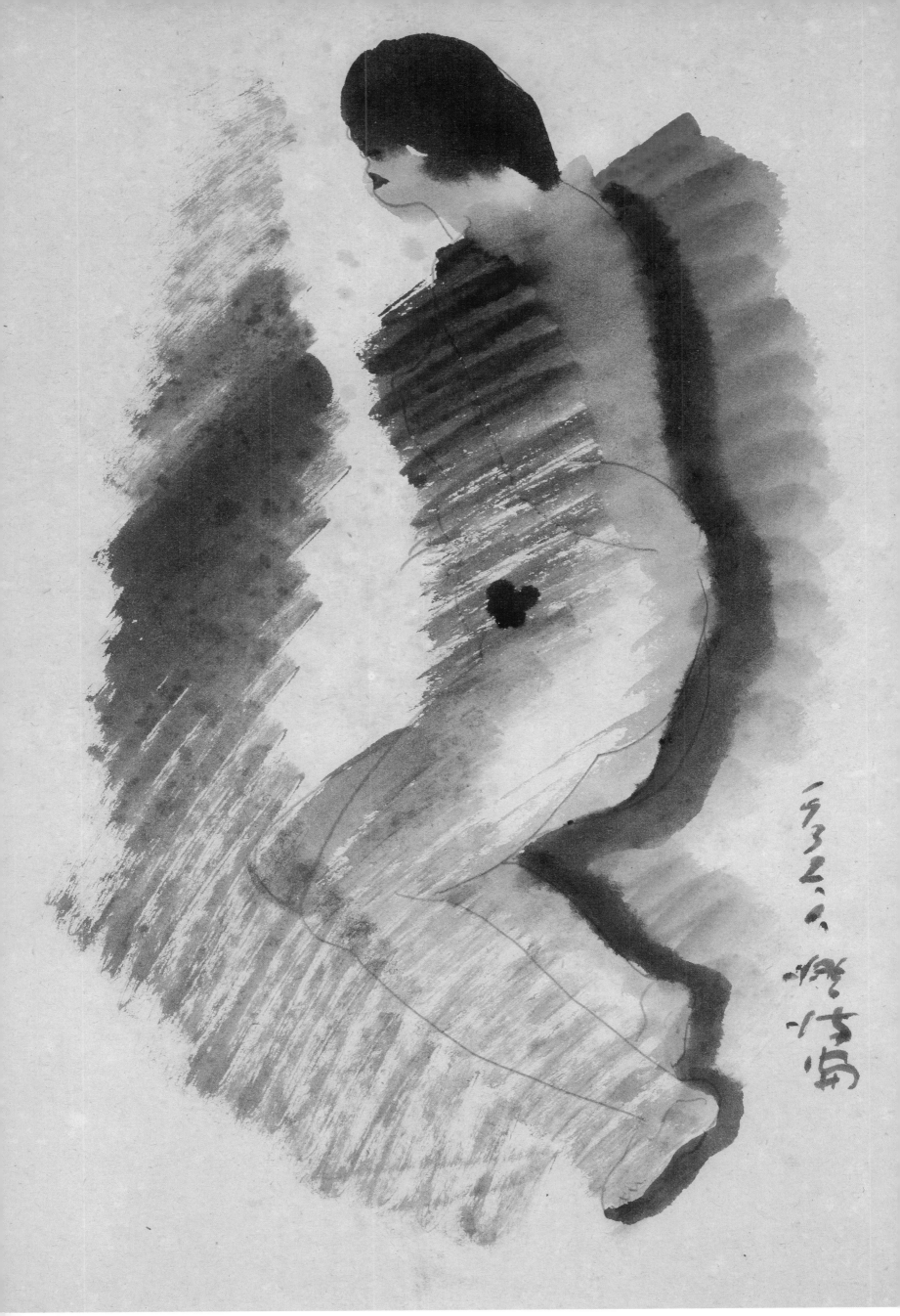

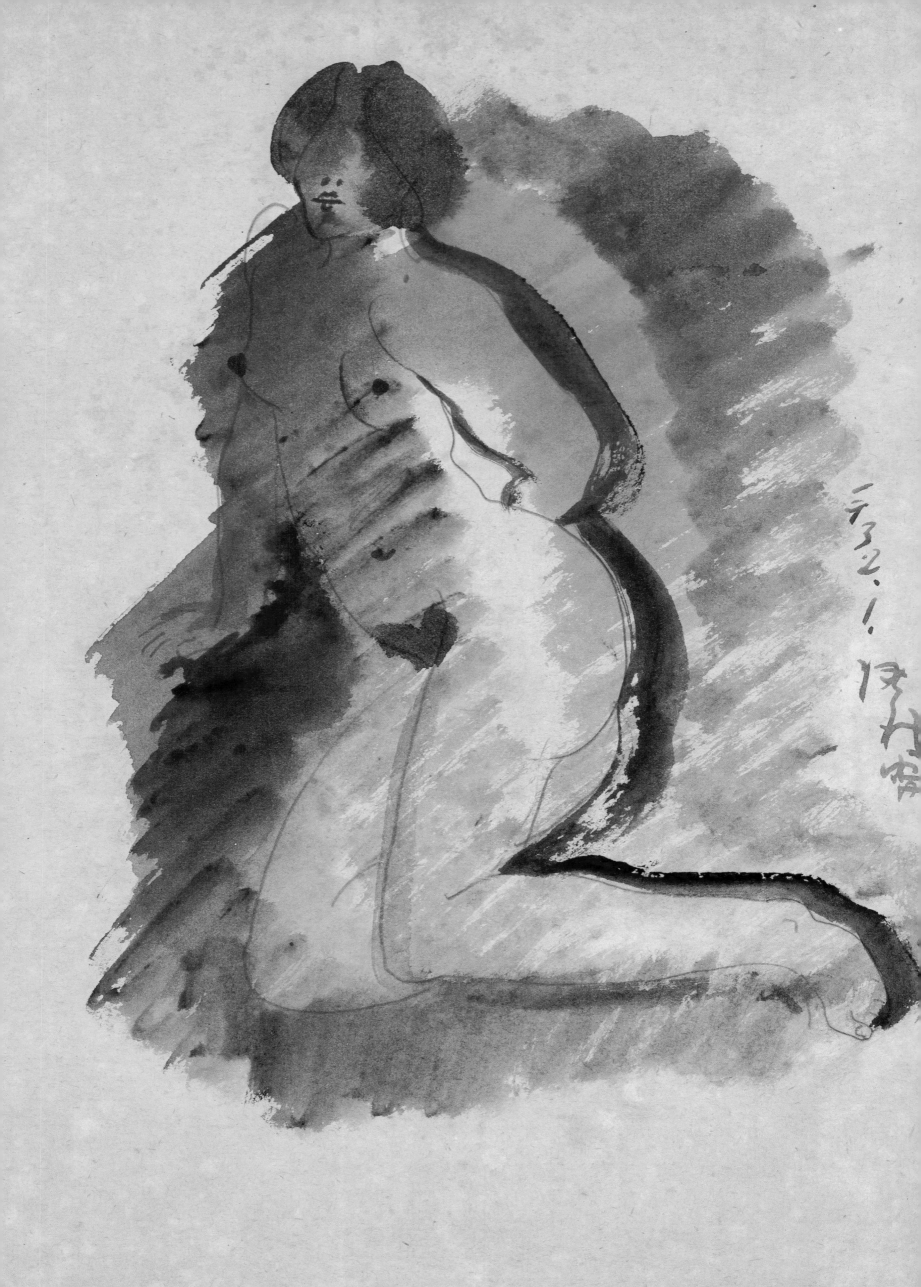

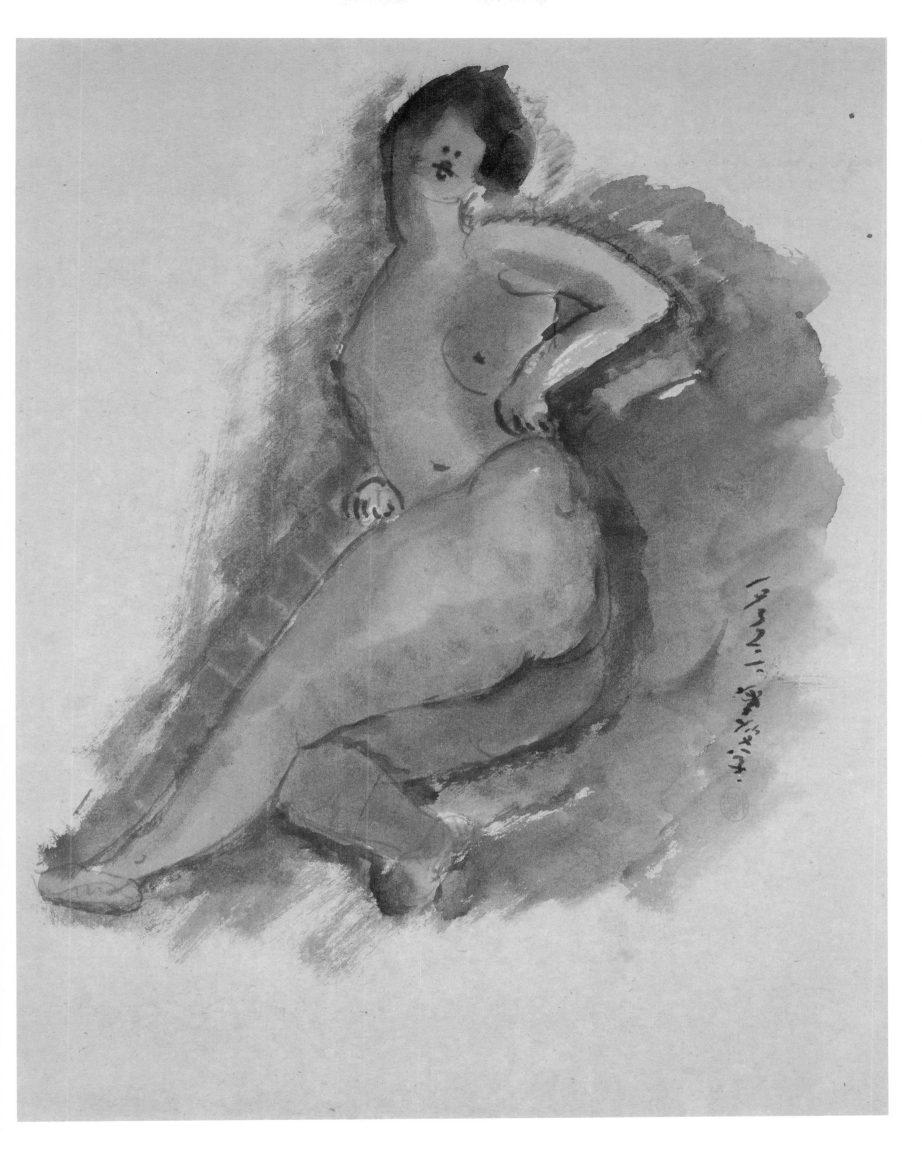

坐姿裸女-32.1（70）Seated Nude-32.1 (70)

1932　紙本淡彩鉛筆　36.5×28.5cm

[左頁圖]

坐姿裸女-32.1（69）Seated Nude-32.1 (69)

1932　紙本淡彩鉛筆　原寸（36.5×26.5cm）

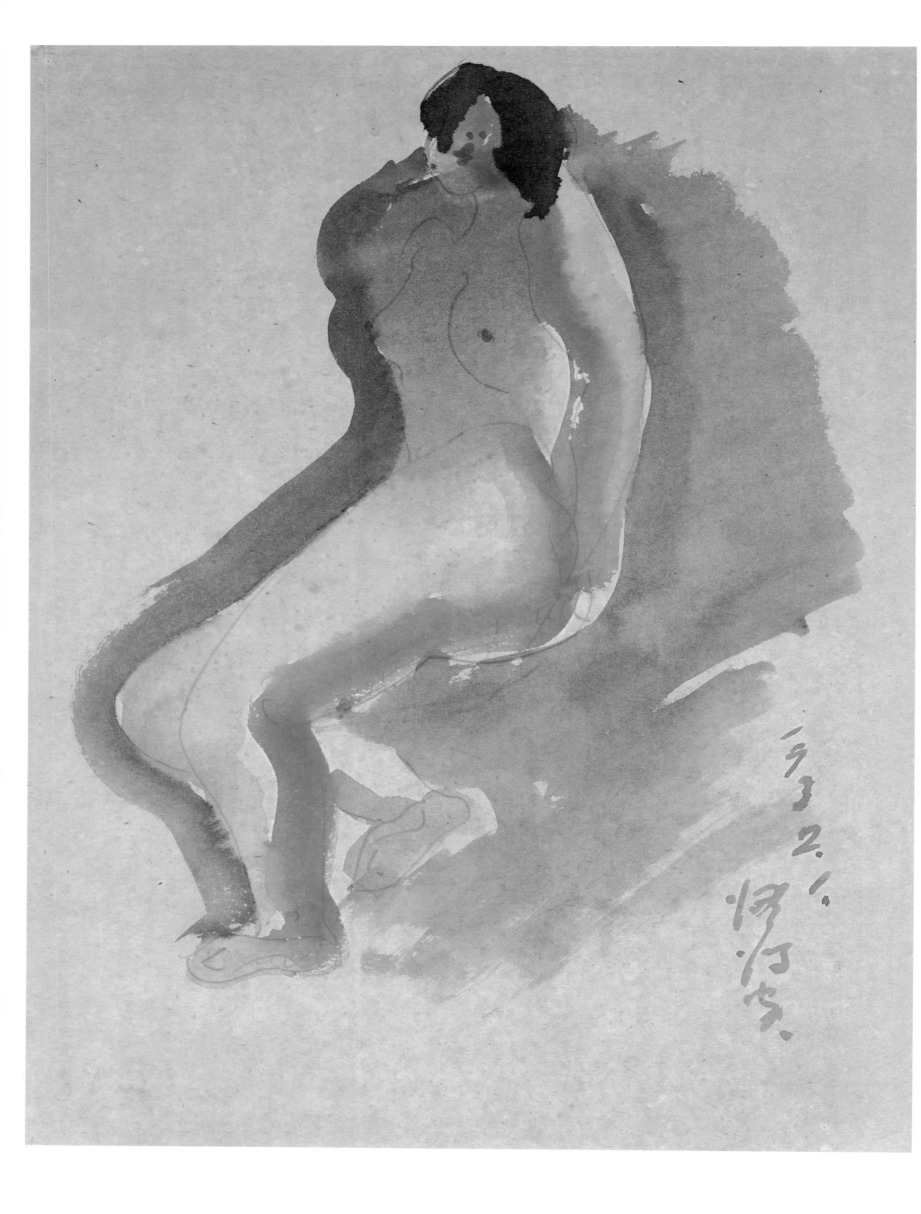

坐姿裸女-32.1（71） Seated Nude-32.1 (71)

1932　紙本淡彩鉛筆　36.5×28.5cm

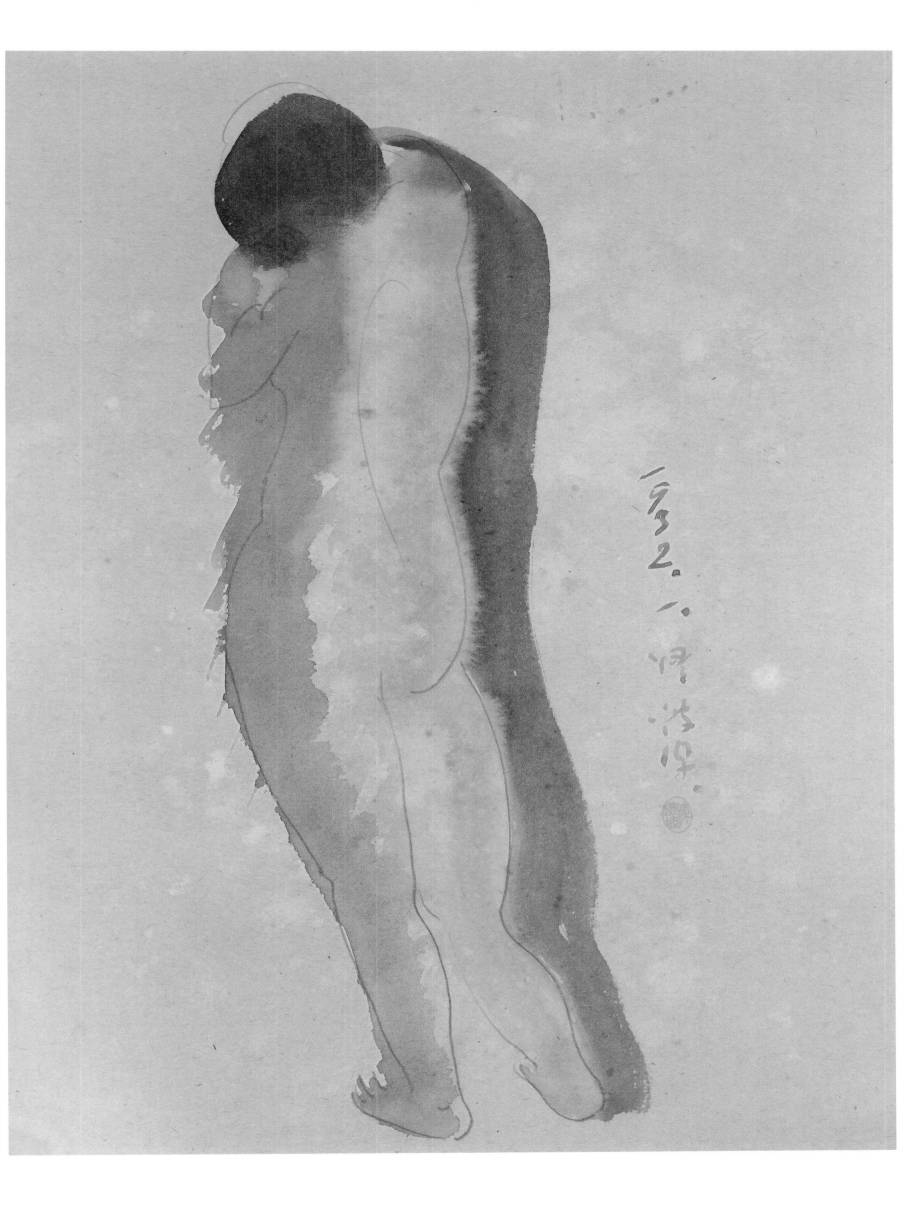

立姿裸女-32.1（26） Standing Nude-32.1 (26)

1932　紙本淡彩鉛筆　36.5×28.5cm

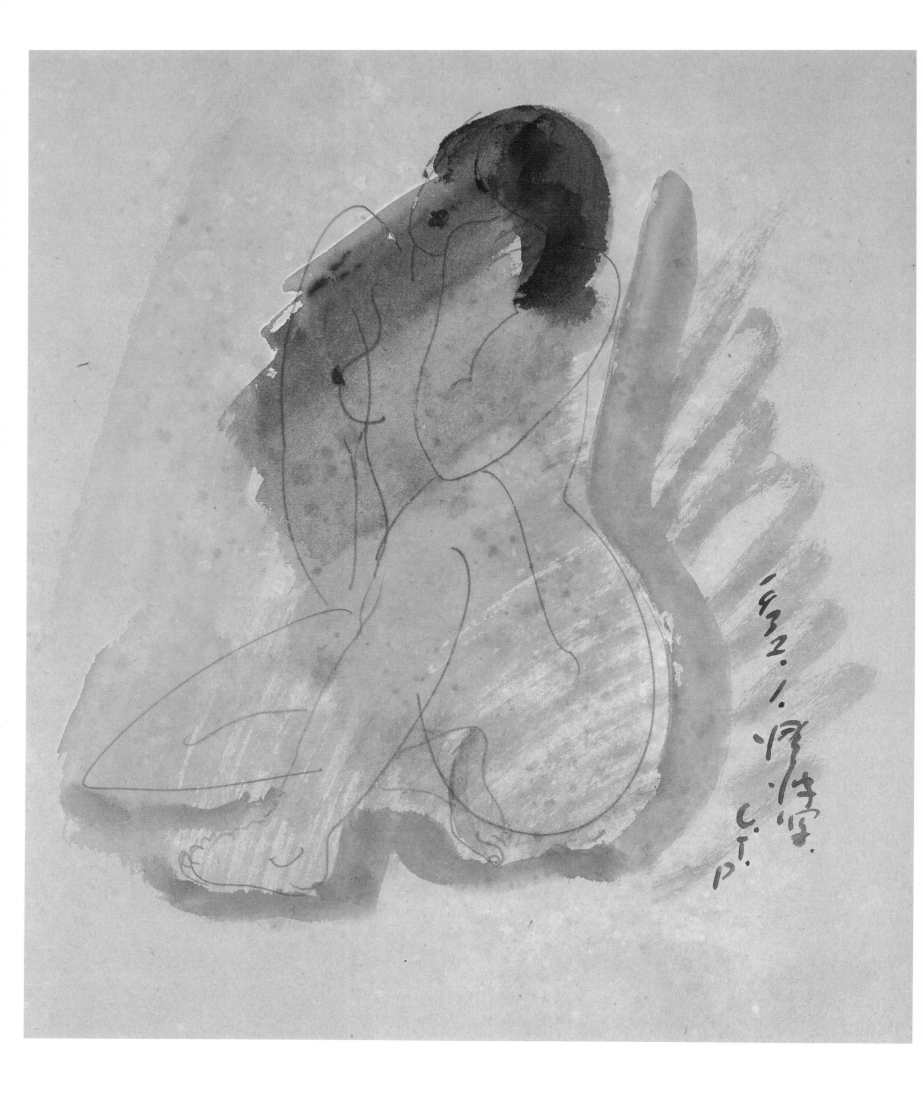

坐姿裸女-32.1（72）Seated Nude-32.1 (72)
1932　紙本淡彩鉛筆　31×27cm

[右頁圖]
坐姿裸女-32.1（73）Seated Nude-32.1 (73)
1932　紙本淡彩鉛筆　原寸（36.5×26.5cm）

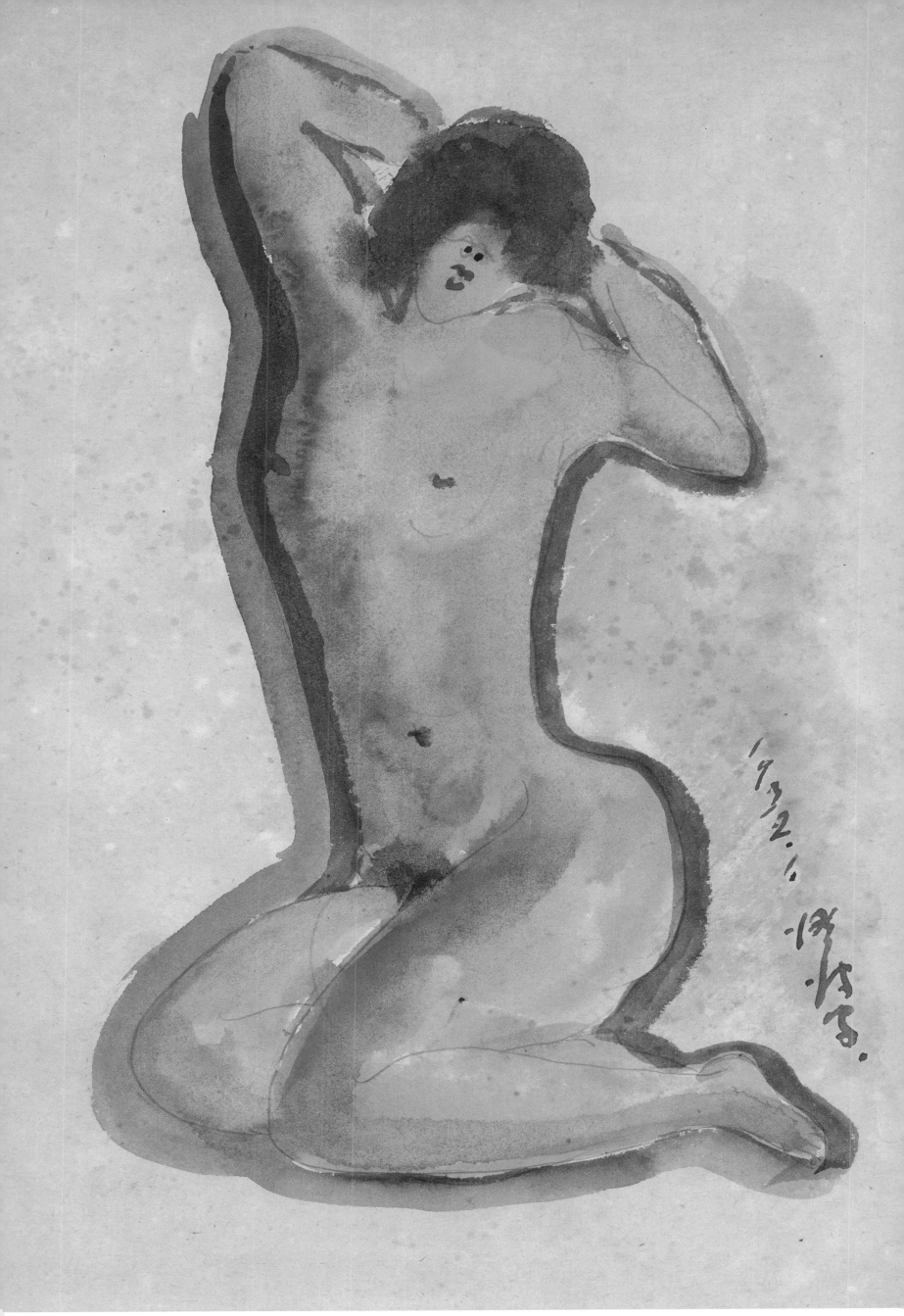

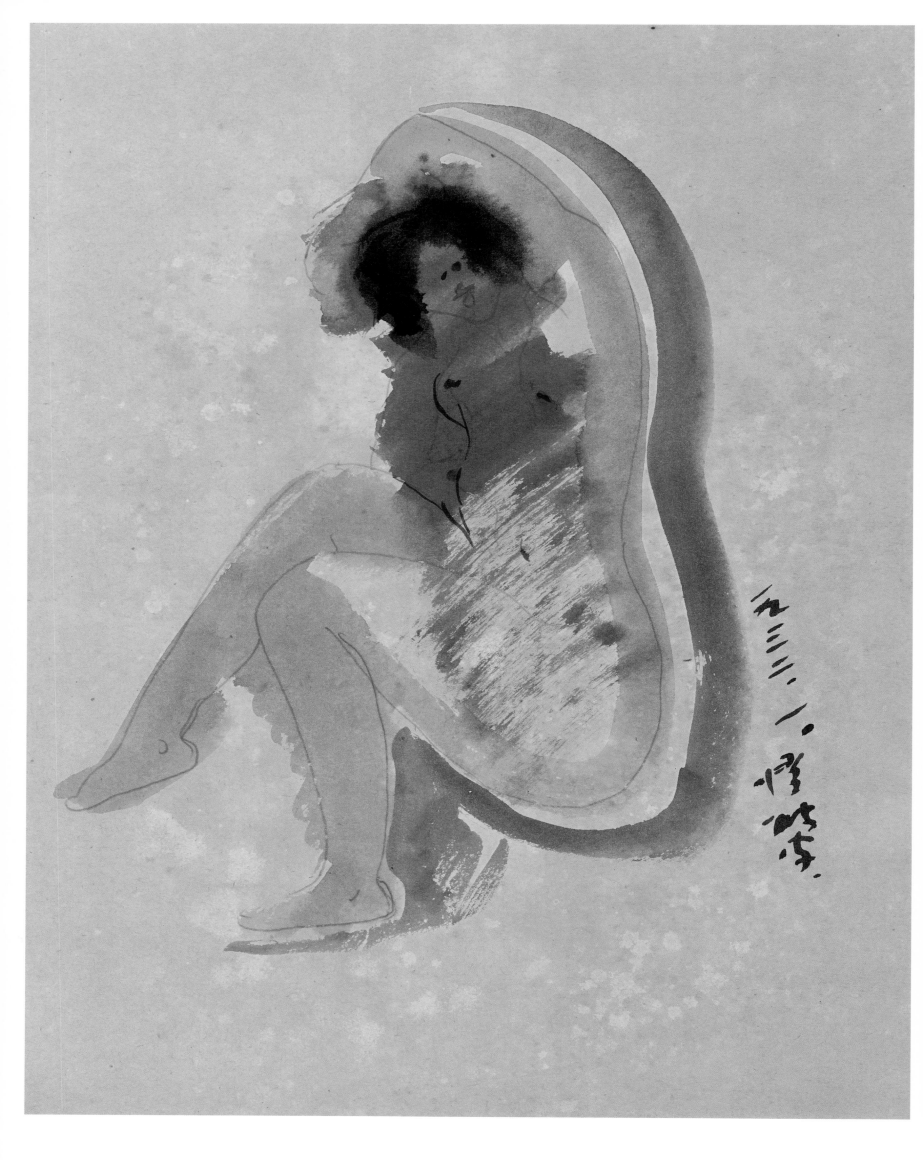

坐姿裸女-32.1（74）Seated Nude-32.1 (74)
1932　紙本淡彩鉛筆　36×28.5cm

[右頁圖]
坐姿裸女-32.1（75）Seated Nude-32.1 (75)
1932　紙本淡彩鉛筆　原寸（36×26cm）

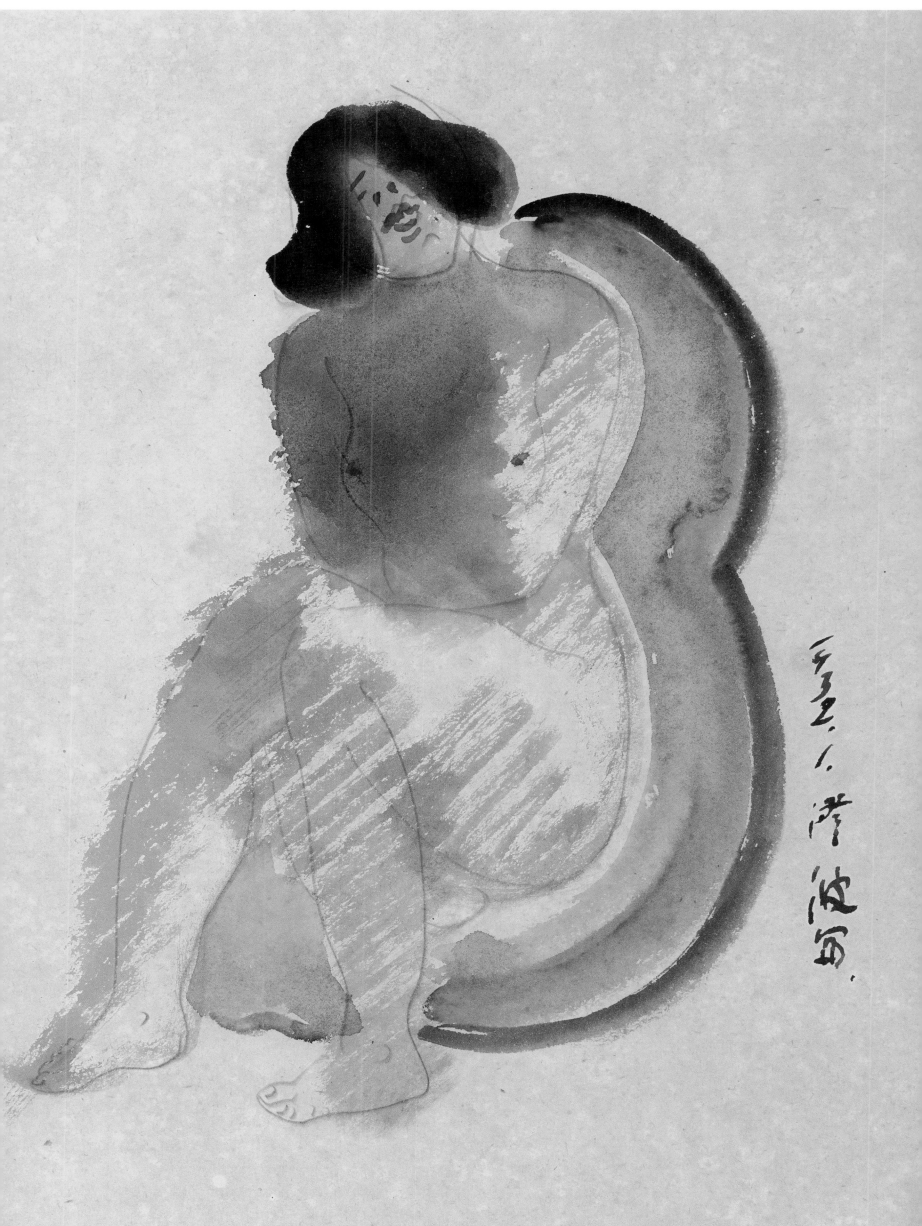

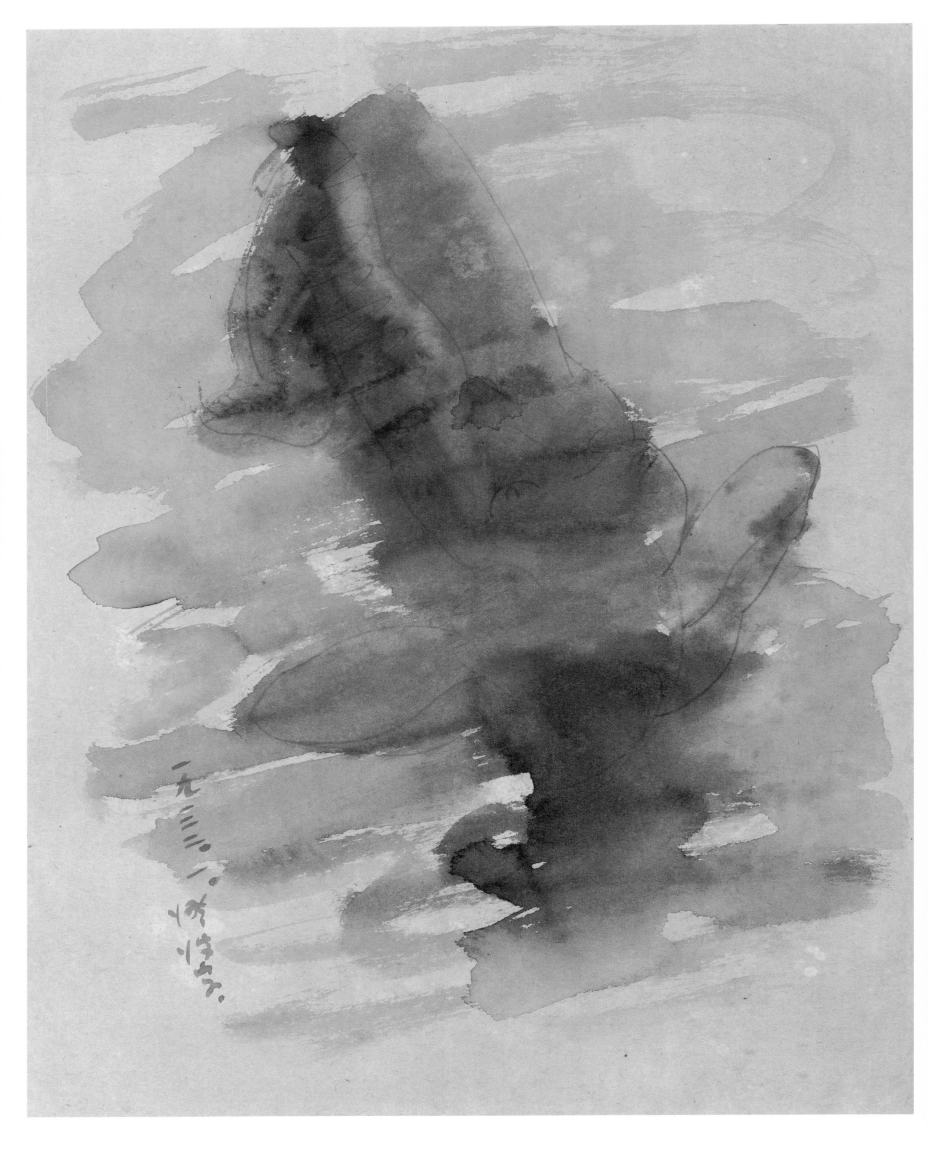

臥姿裸女-32.1（47） Lying Nude-32.1 (47)

1932　紙本淡彩鉛筆　36×28.5cm

[右頁圖]

坐姿裸女-32.1（76） Seated Nude-32.1 (76)

1932　紙本淡彩鉛筆　原寸（34×26.5cm）

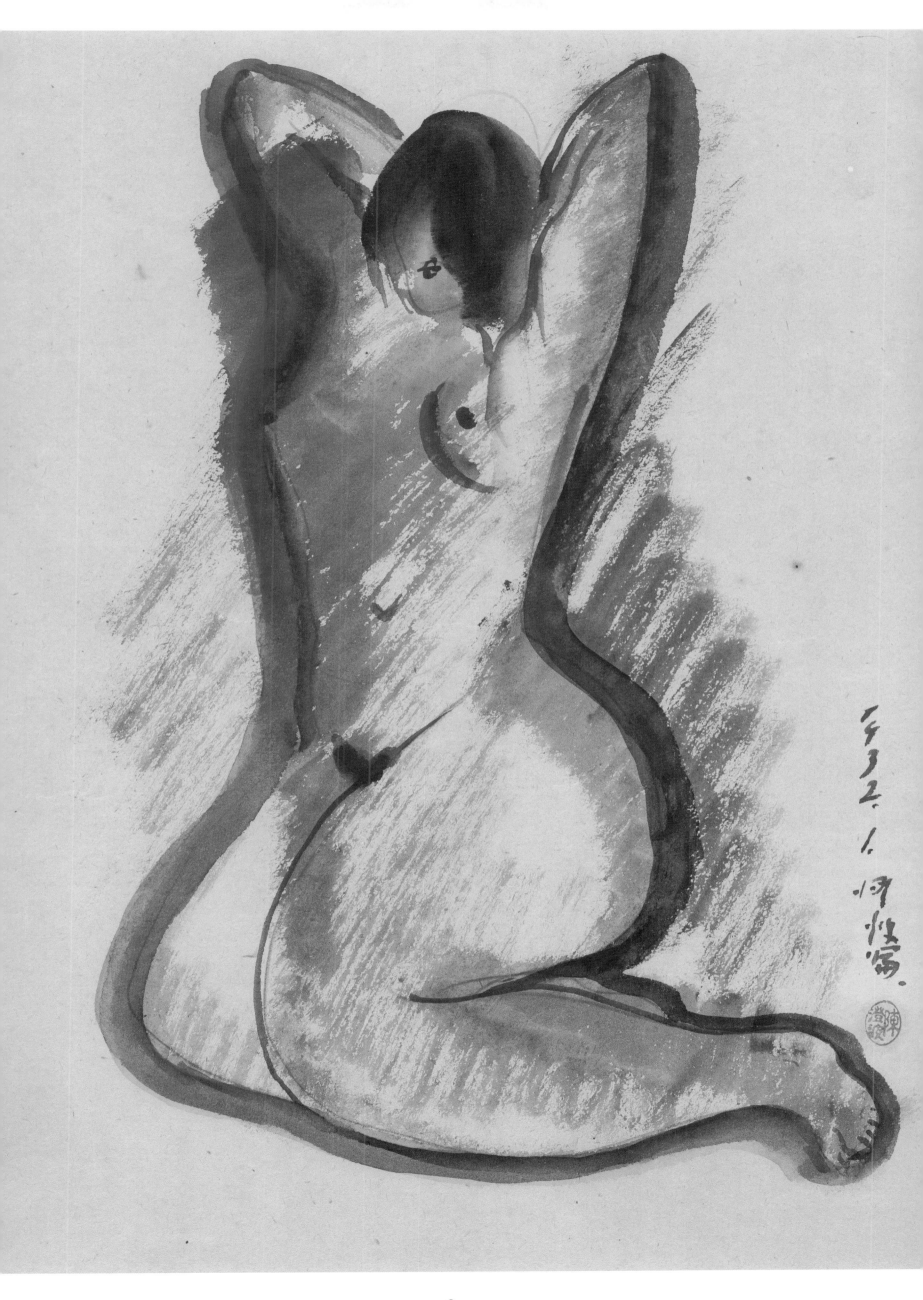

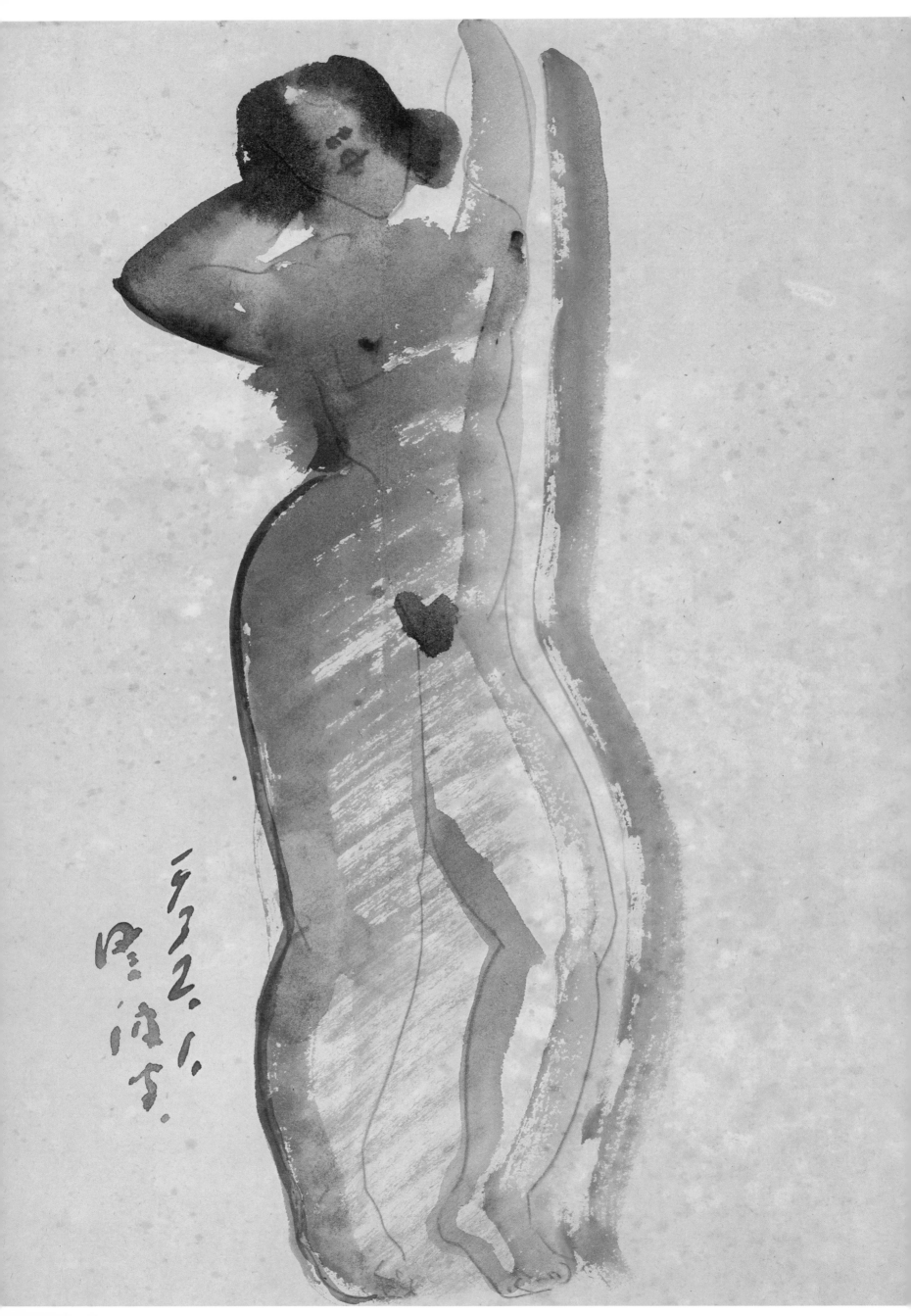

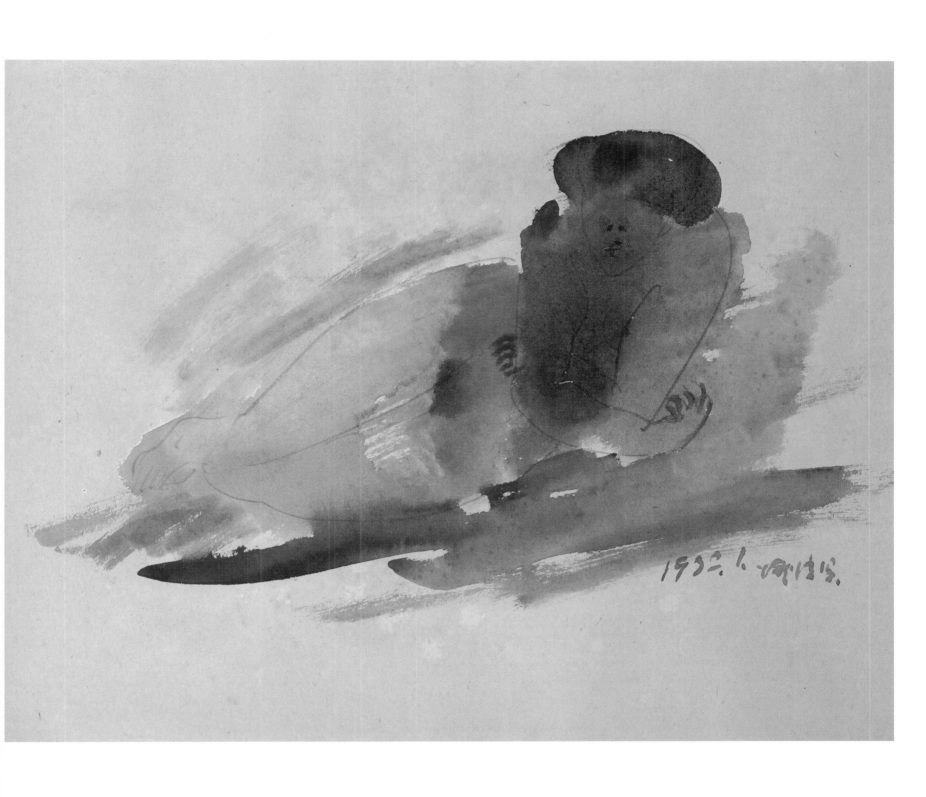

臥姿裸女-32.1（48） Lying Nude-32.1 (48)

1932　紙本淡彩鉛筆　28.5×36.5cm

[左頁圖]

立姿裸女-32.1（27） Standing Nude-32.1 (27)

1932　紙本淡彩鉛筆　原寸（36×26.5cm）

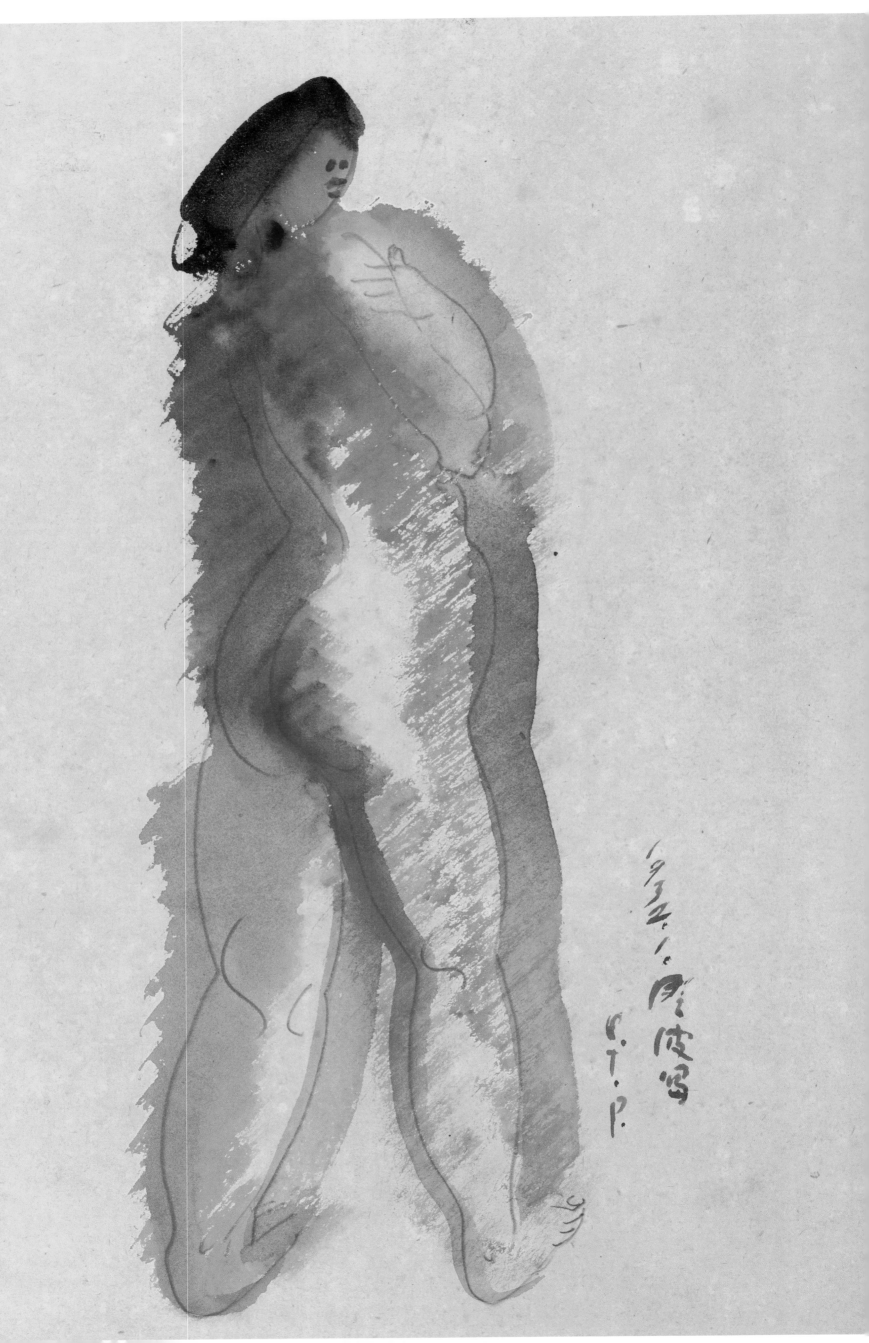

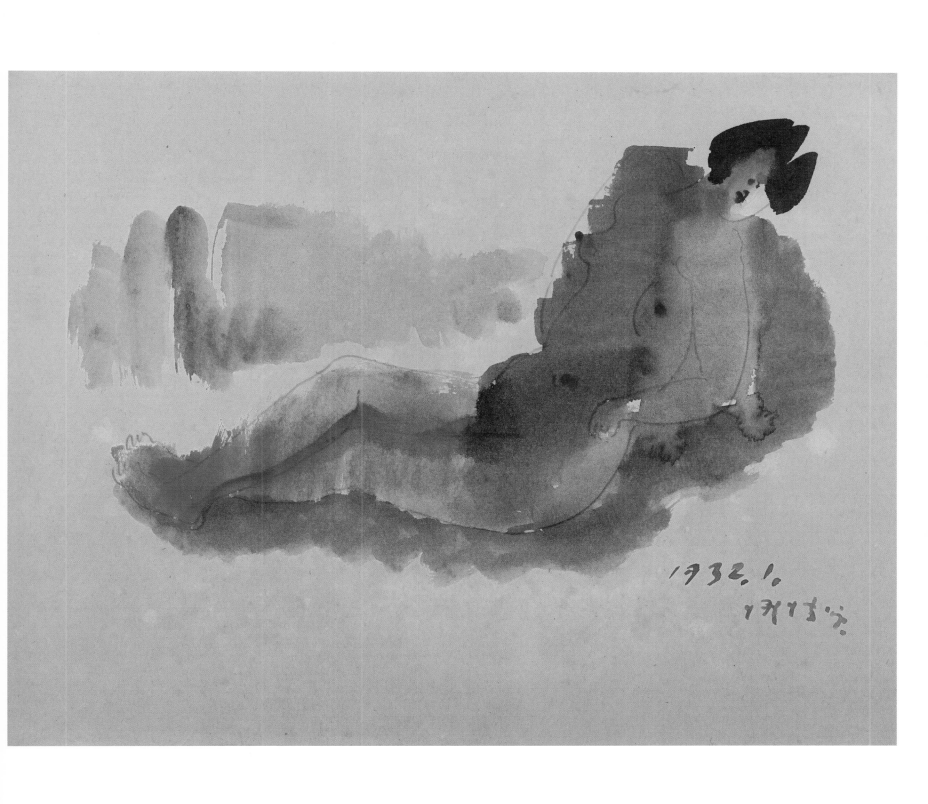

坐姿裸女-32.1（77） Seated Nude-32.1 (77)

1932　紙本淡彩鉛筆　28.5×36.5cm

[左頁圖]

立姿裸女-32.1（28） Standing Nude-32.1 (28)

1932　紙本淡彩鉛筆　原寸（36.5×26cm）

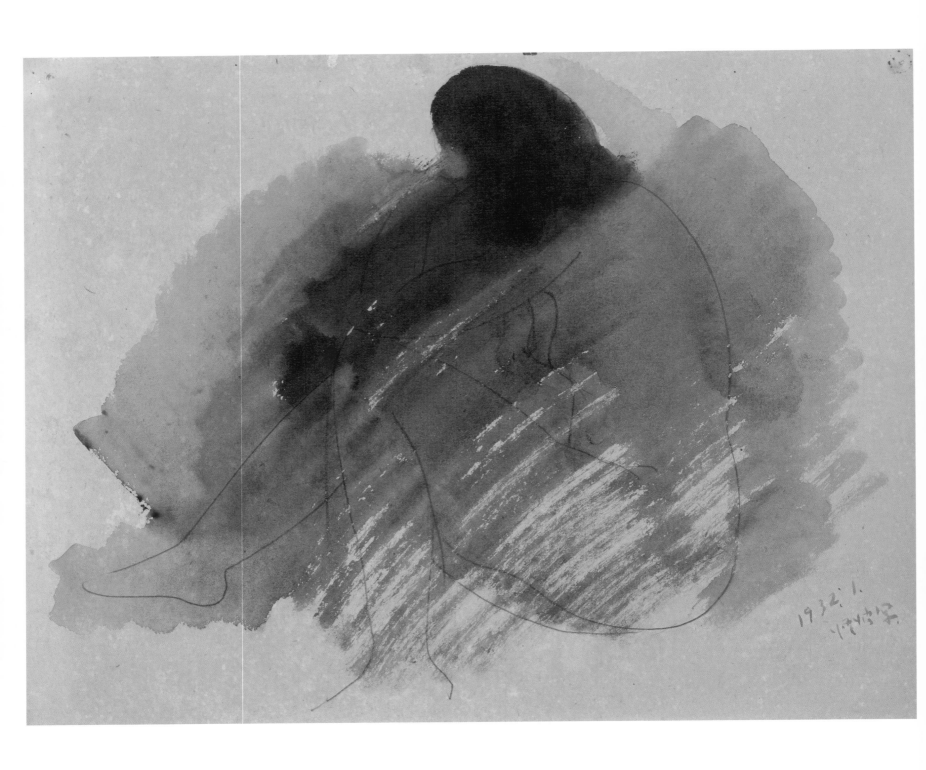

坐姿裸女-32.1（78） Seated Nude-32.1 (78)

1932　紙本淡彩鉛筆　28.5×37cm

[右頁畫]

坐姿裸女-32.1（79） Seated Nude-32.1 (79)

1932　紙本淡彩鉛筆　原寸（36.5×26.5cm）

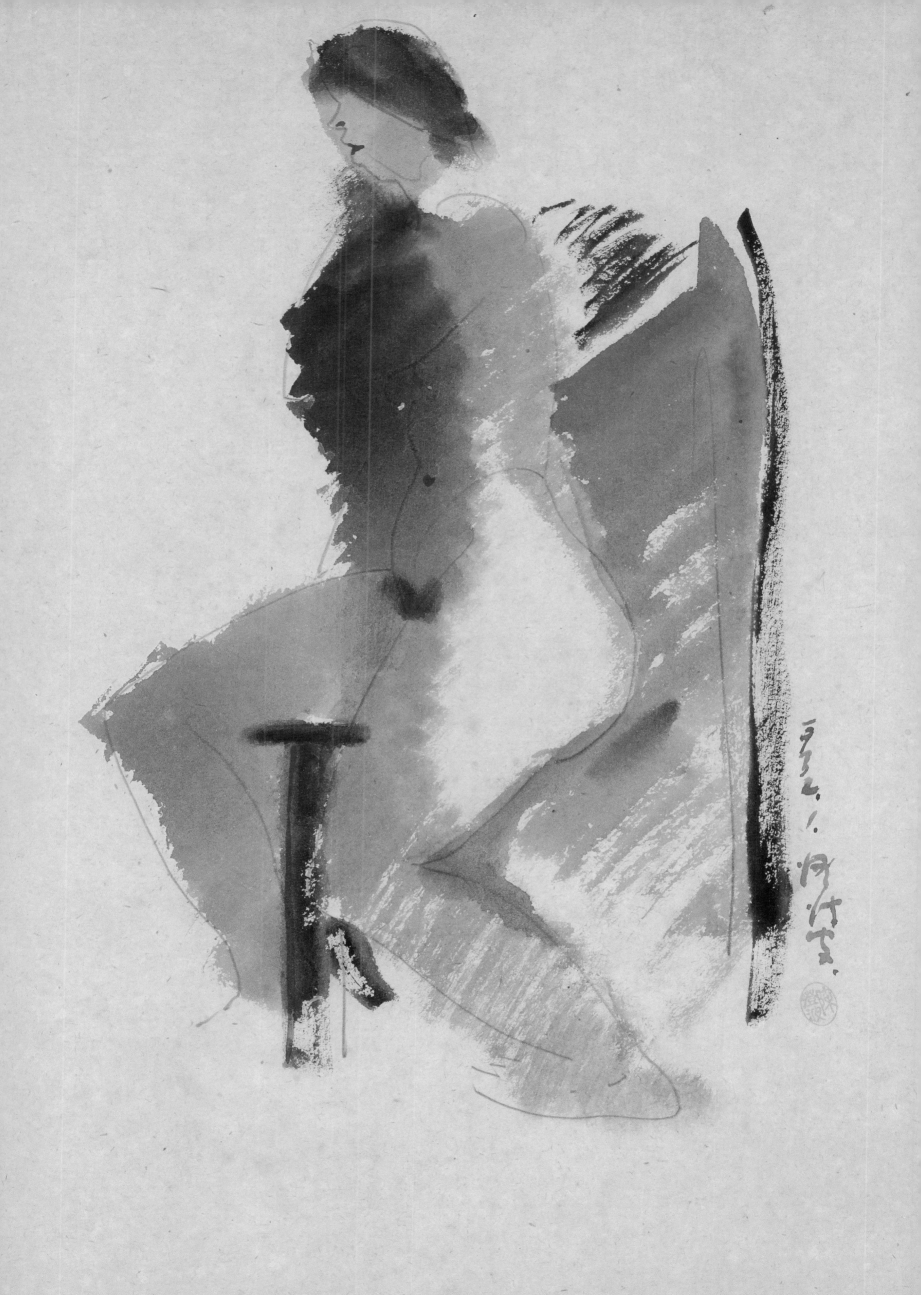

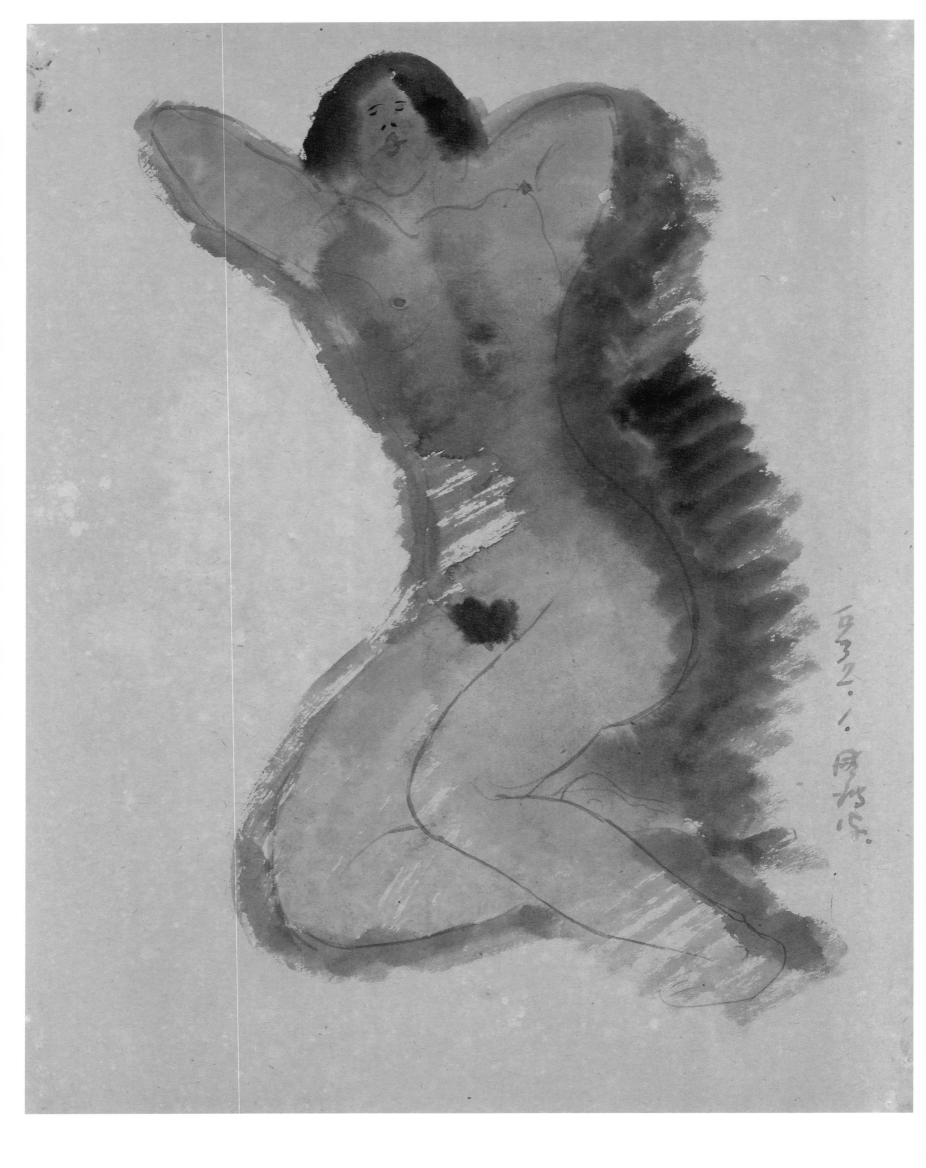

臥姿裸女-32.1（49） Lying Nude-32.1 (49)
1932　紙本淡彩鉛筆　36.5×28.5cm

[右頁圖]
坐姿裸女-32.1（80） Seated Nude-32.1 (80)
1932　紙本淡彩鉛筆　原寸（36.5×26.5cm）

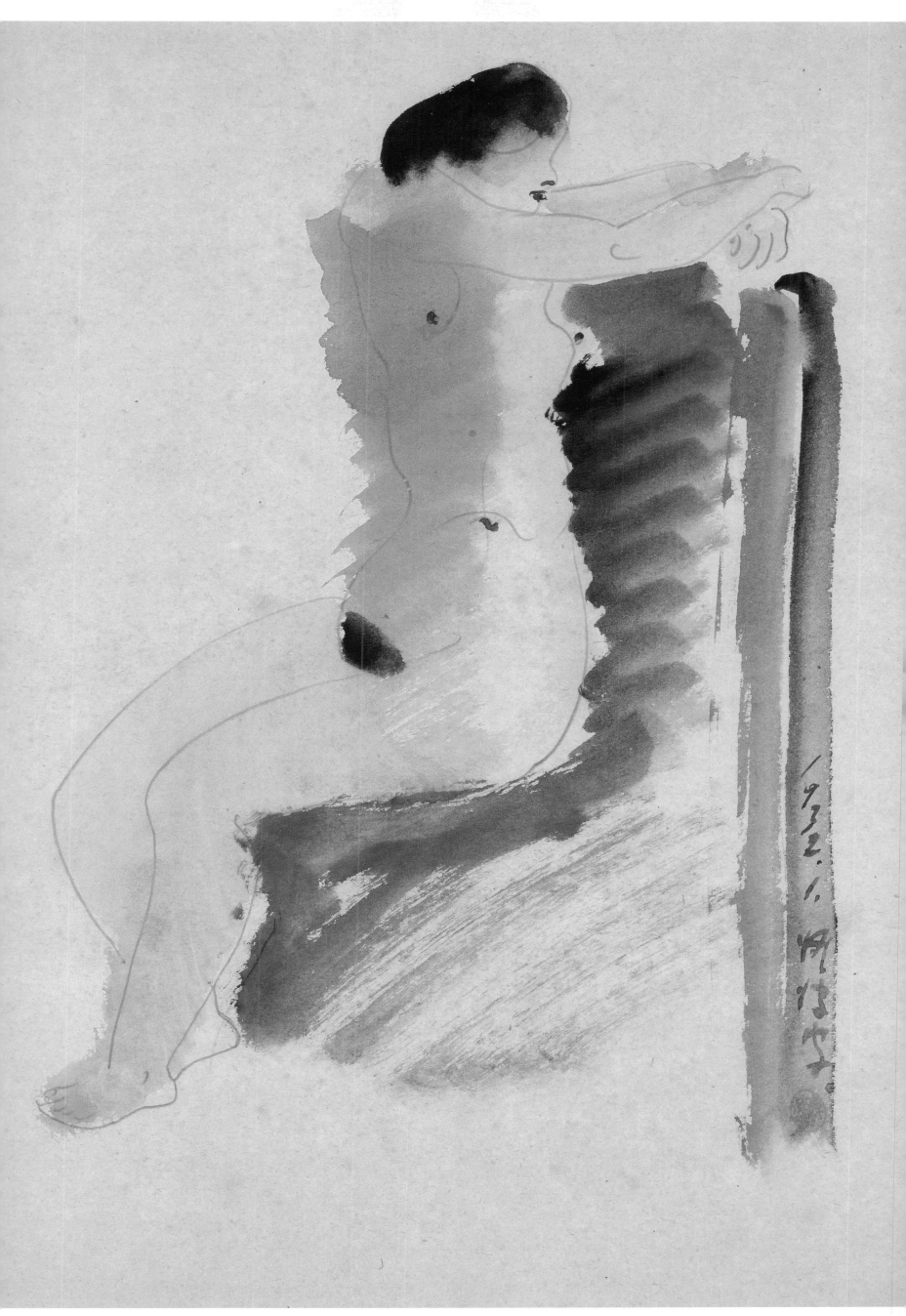

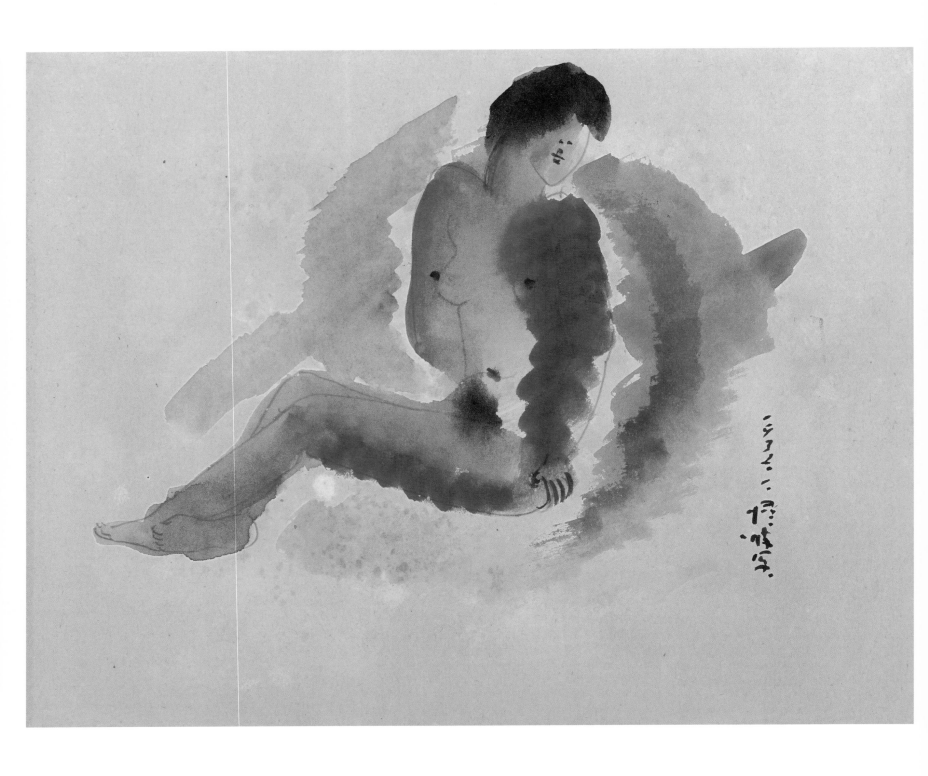

坐姿裸女-32.1（81） Seated Nude-32.1 (81)

1932　紙本淡彩鉛筆　28.5×36.5cm

[右頁圖]

立姿裸女-32.1（29） Standing Nude-32.1 (29)

1932　紙本淡彩鉛筆　原寸（36×26.5cm）

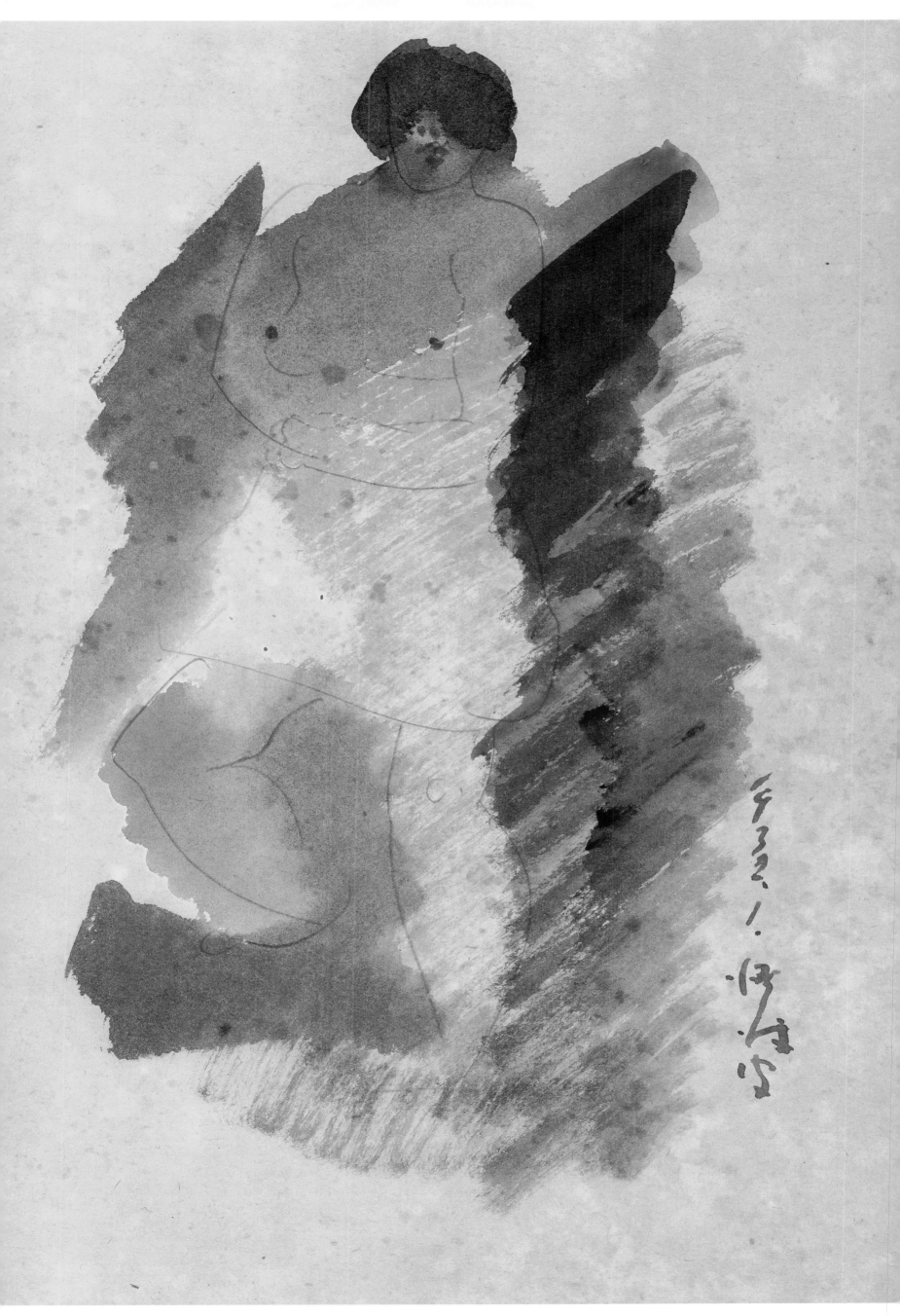

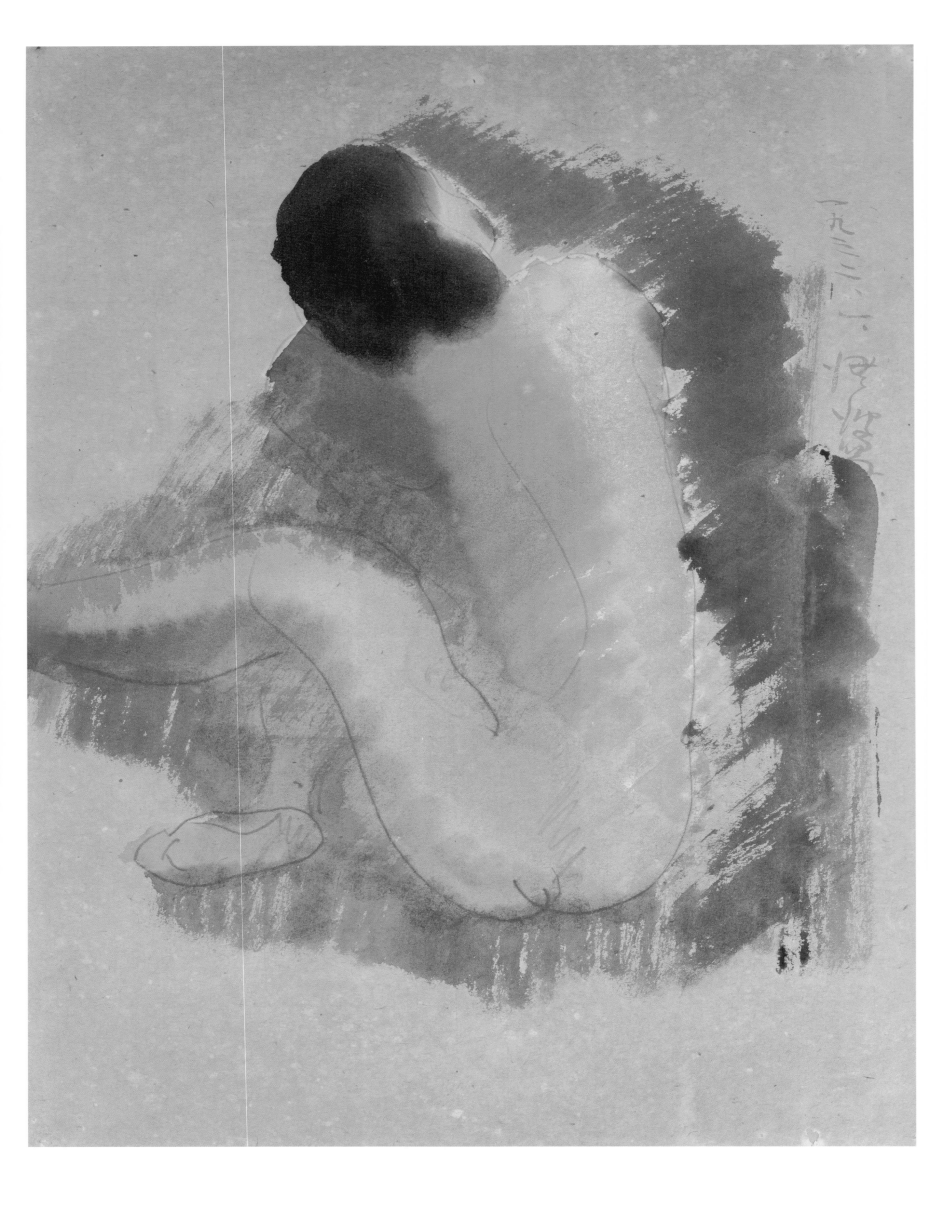

坐姿裸女-32.1（82）Seated Nude-32.1 (82)

1932　紙本淡彩鉛筆　36.5×28.5cm

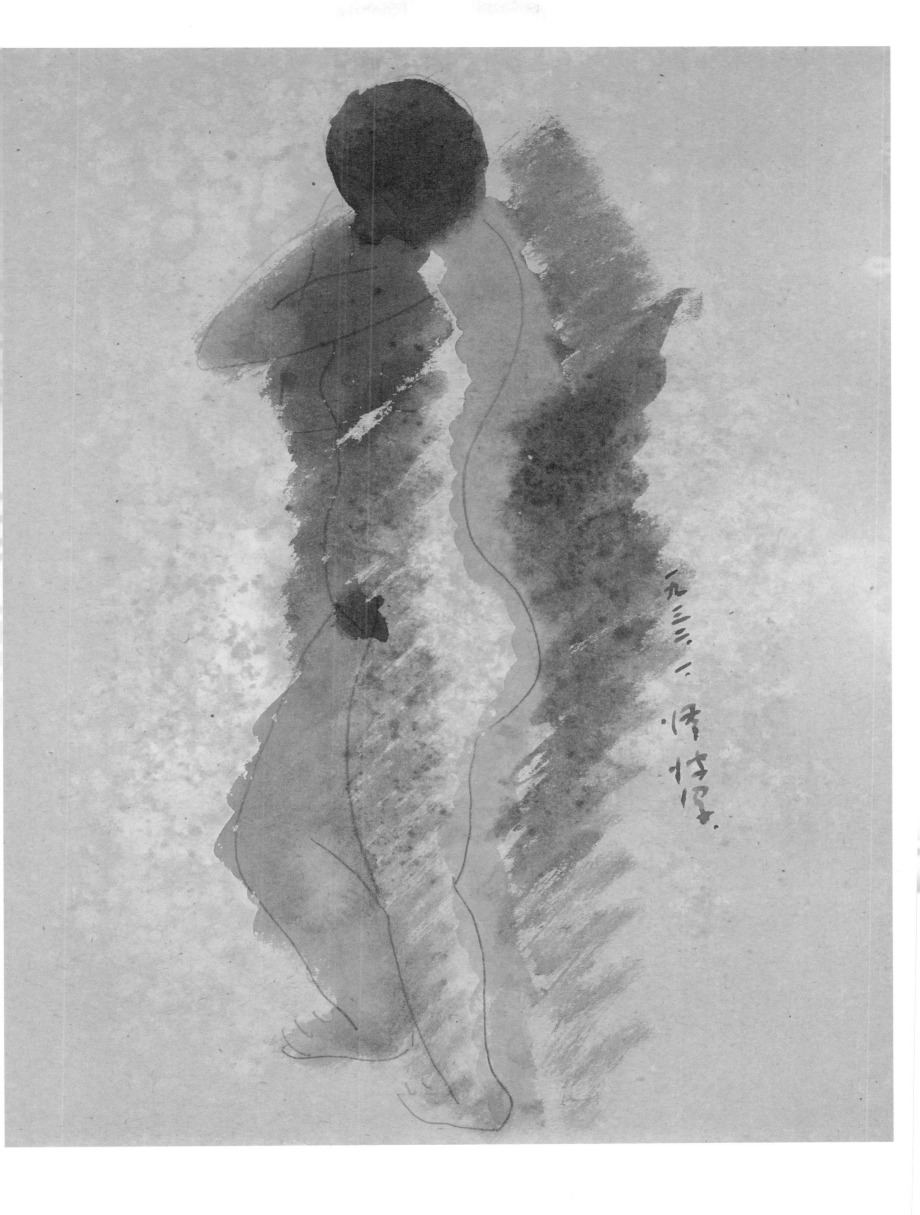

立姿裸女-32.1（30）Standing Nude-32.1 (30)

1932　紙本淡彩鉛筆　36.5×28.5cm

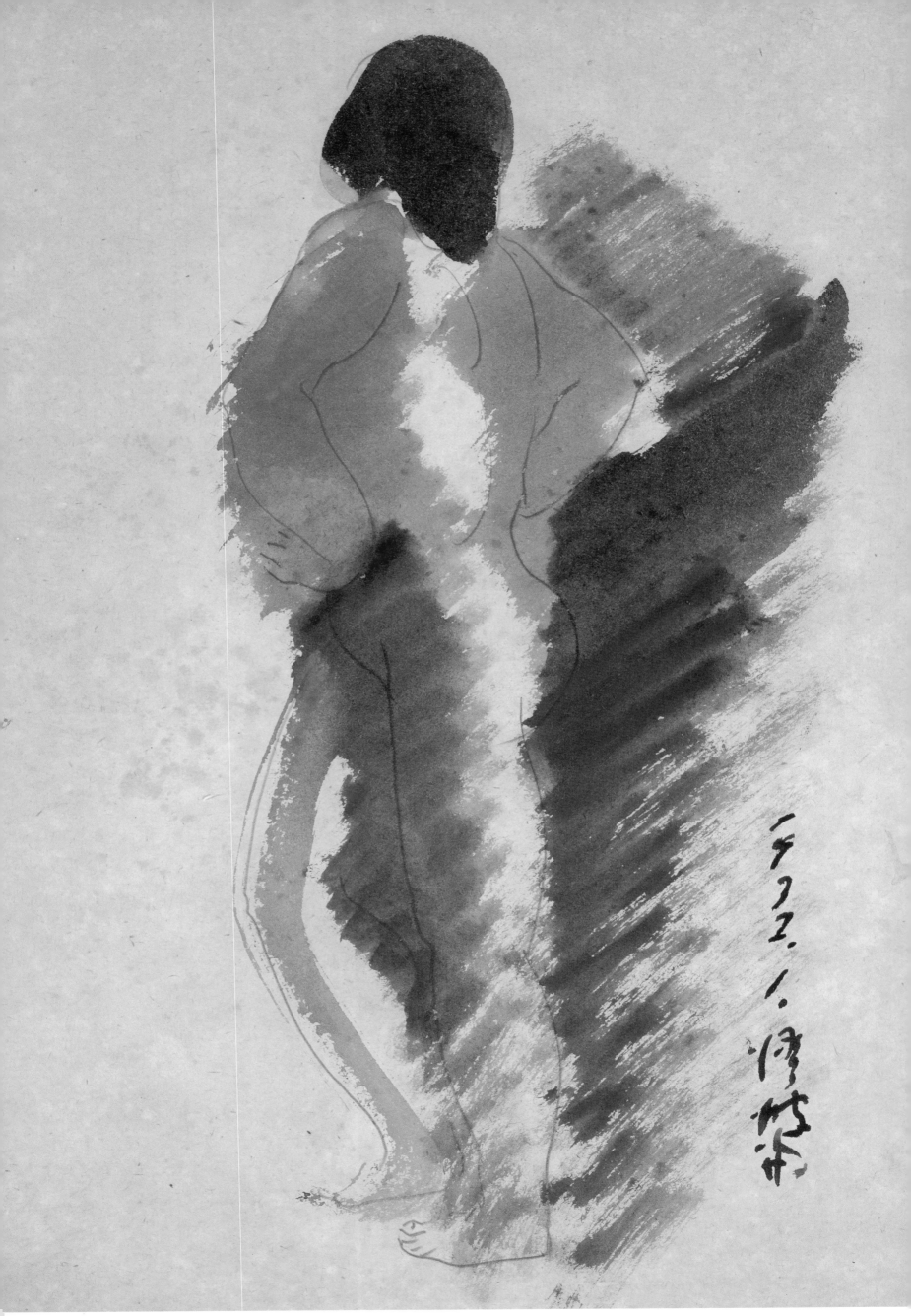

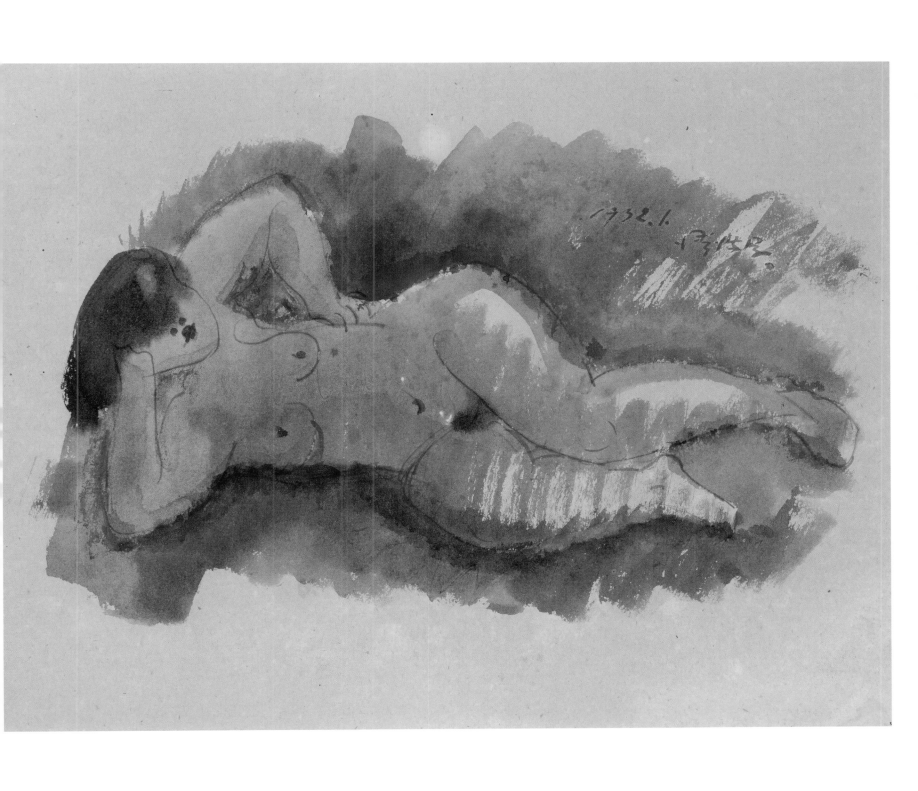

臥姿裸女-32.1（50） Lying Nude-32.1 (50)

1932　紙本淡彩鉛筆　28.5×37cm

_[左頁圖]
立姿裸女-32.1（31） Standing Nude-32.1 (31)

1932　紙本淡彩鉛筆　原寸（36.5×26.5cm）

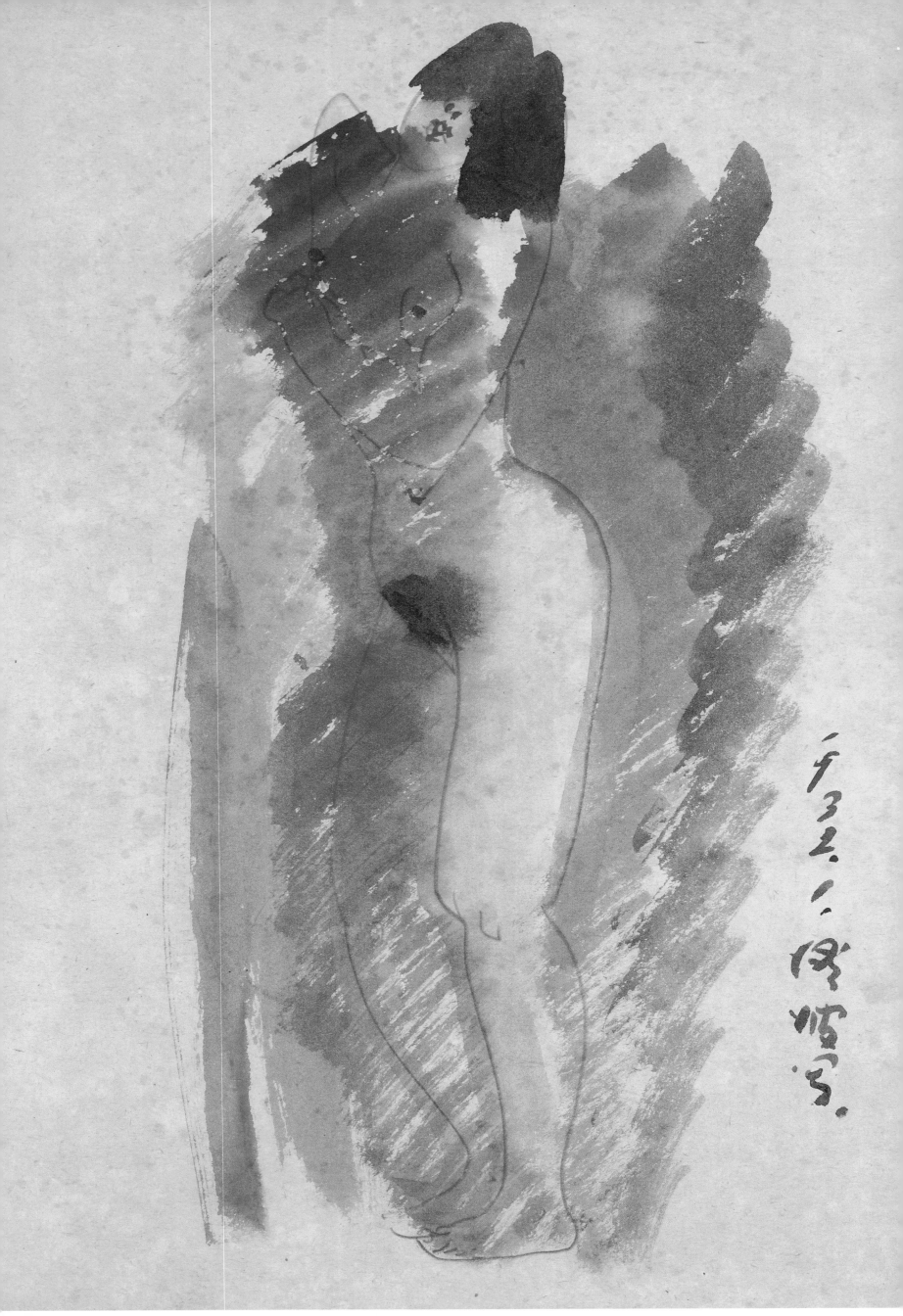

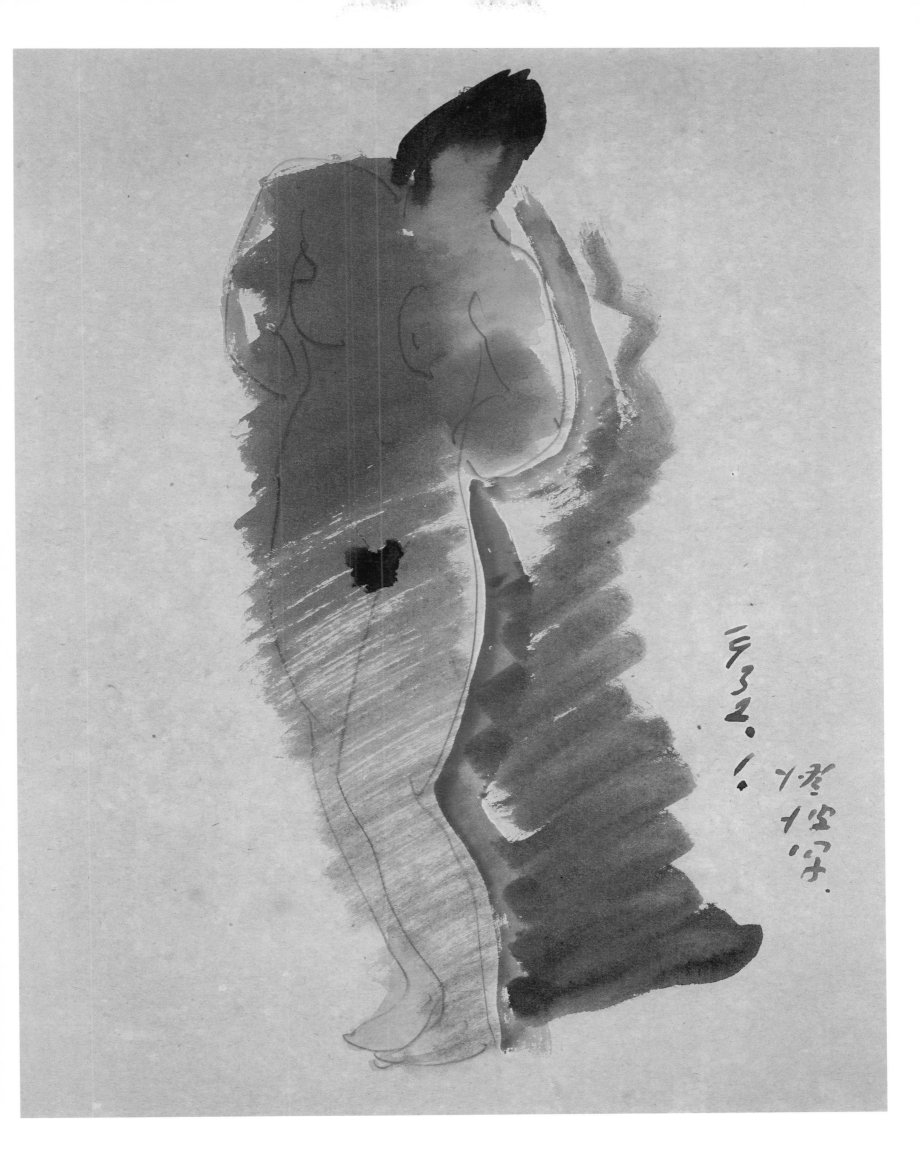

立姿裸女-32.1（33） Standing Nude-32.1 (33)
1932　紙本淡彩鉛筆　37×28.5cm

[左頁圖]
立姿裸女-32.1（32） Standing Nude-32.1 (32)
1932　紙本淡彩鉛筆　原寸（36.5×26.5cm）

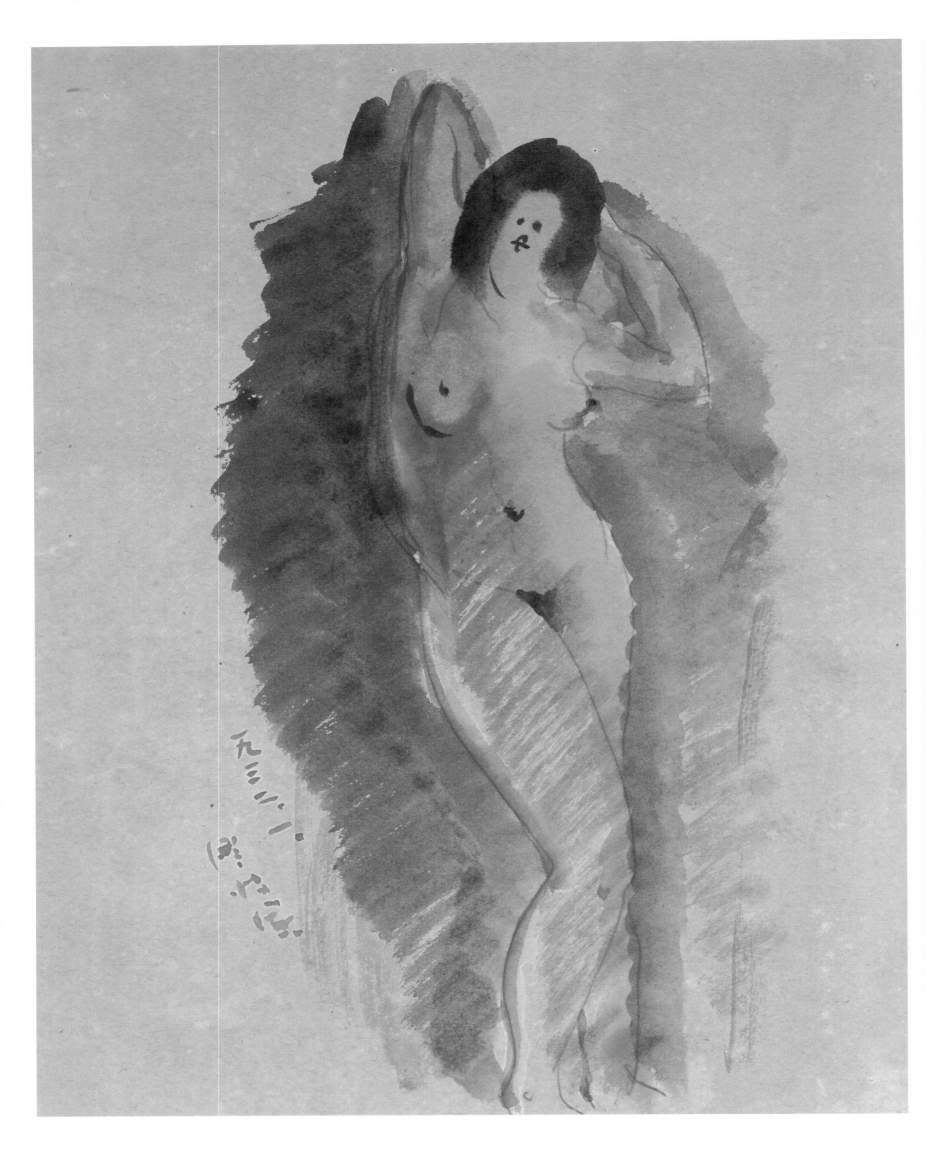

立姿裸女-32.1（34）Standing Nude-32.1 (34)

1932　紙本淡彩鉛筆　36.5×26.5cm

[右頁圖]

立姿裸女-32.1（35）Standing Nude-32.1 (35)

1932　紙本淡彩鉛筆　原寸（36.5×26.5cm）

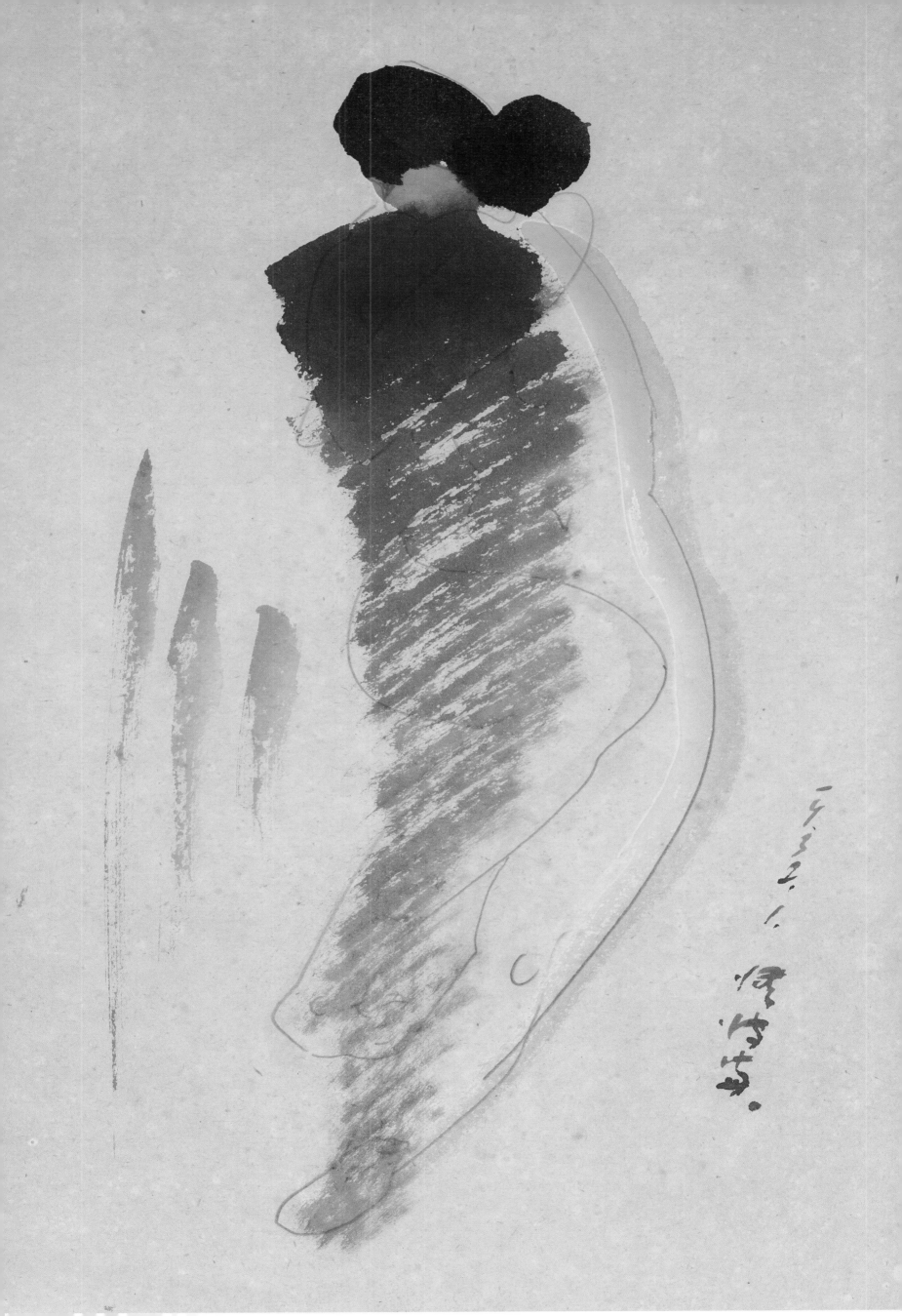

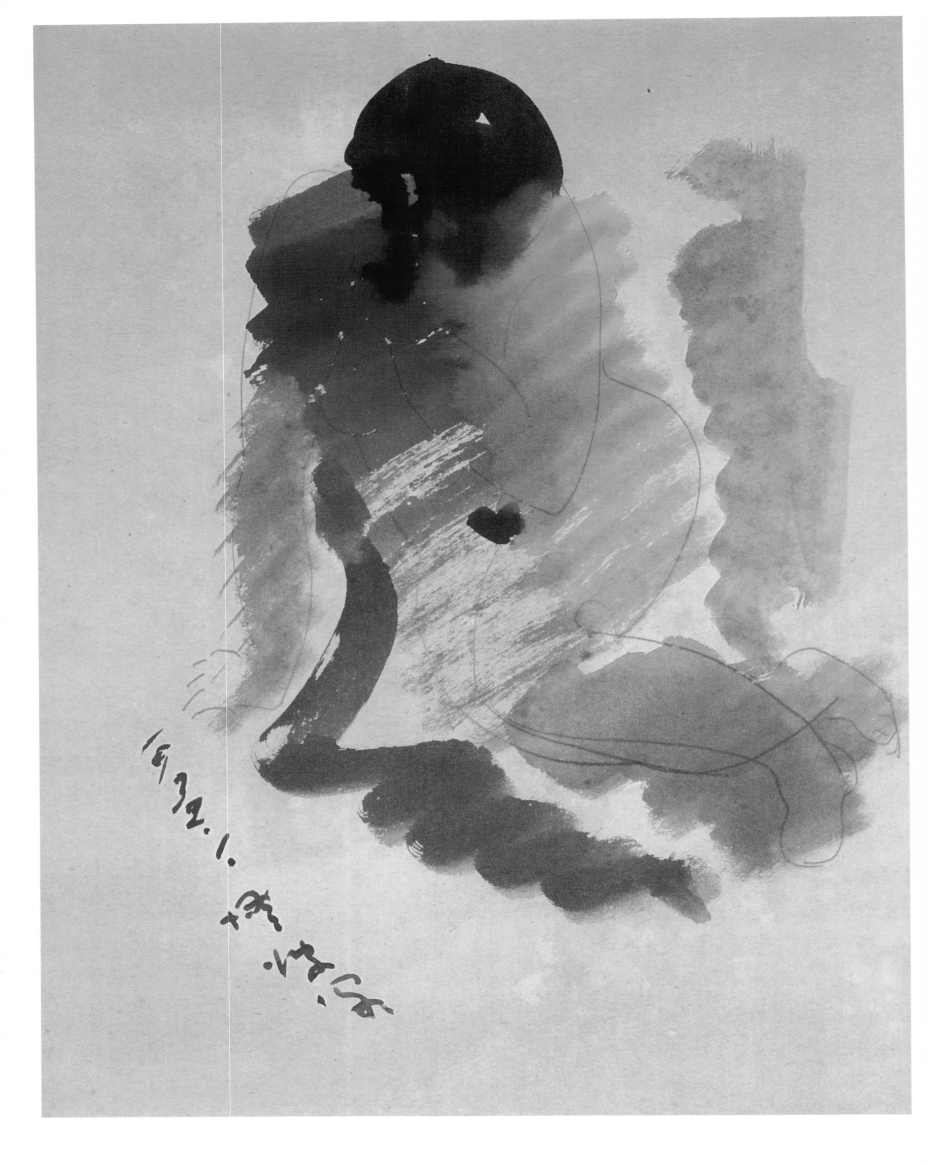

坐姿裸女-32.1（83）Seated Nude-32.1 (83)

1932　紙本淡彩鉛筆　36.5×28.5cm

[右頁圖]

坐姿裸女-32.1（84）Seated Nude-32.1 (84)

1932　紙本淡彩鉛筆　原寸（36×26.5cm）

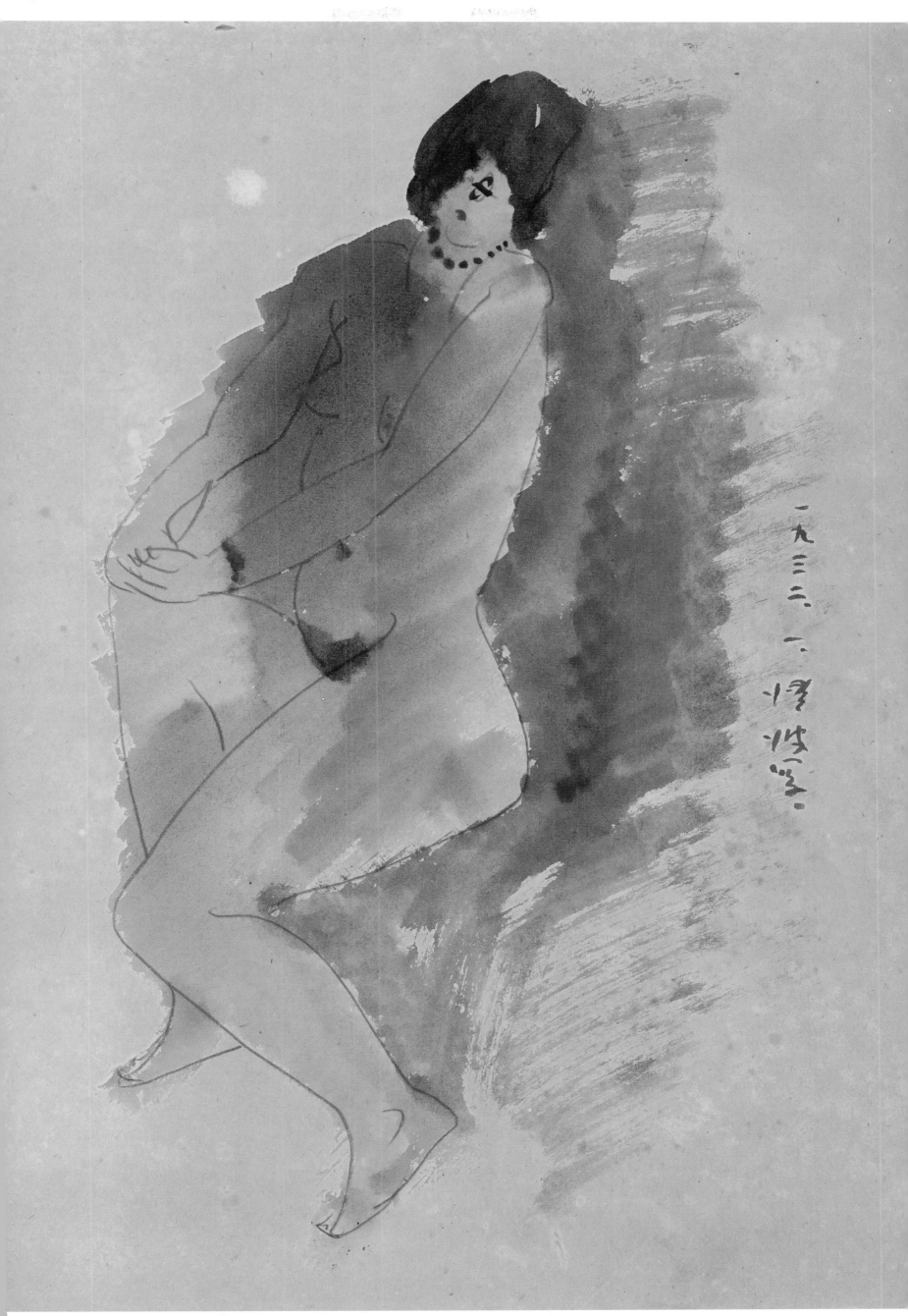

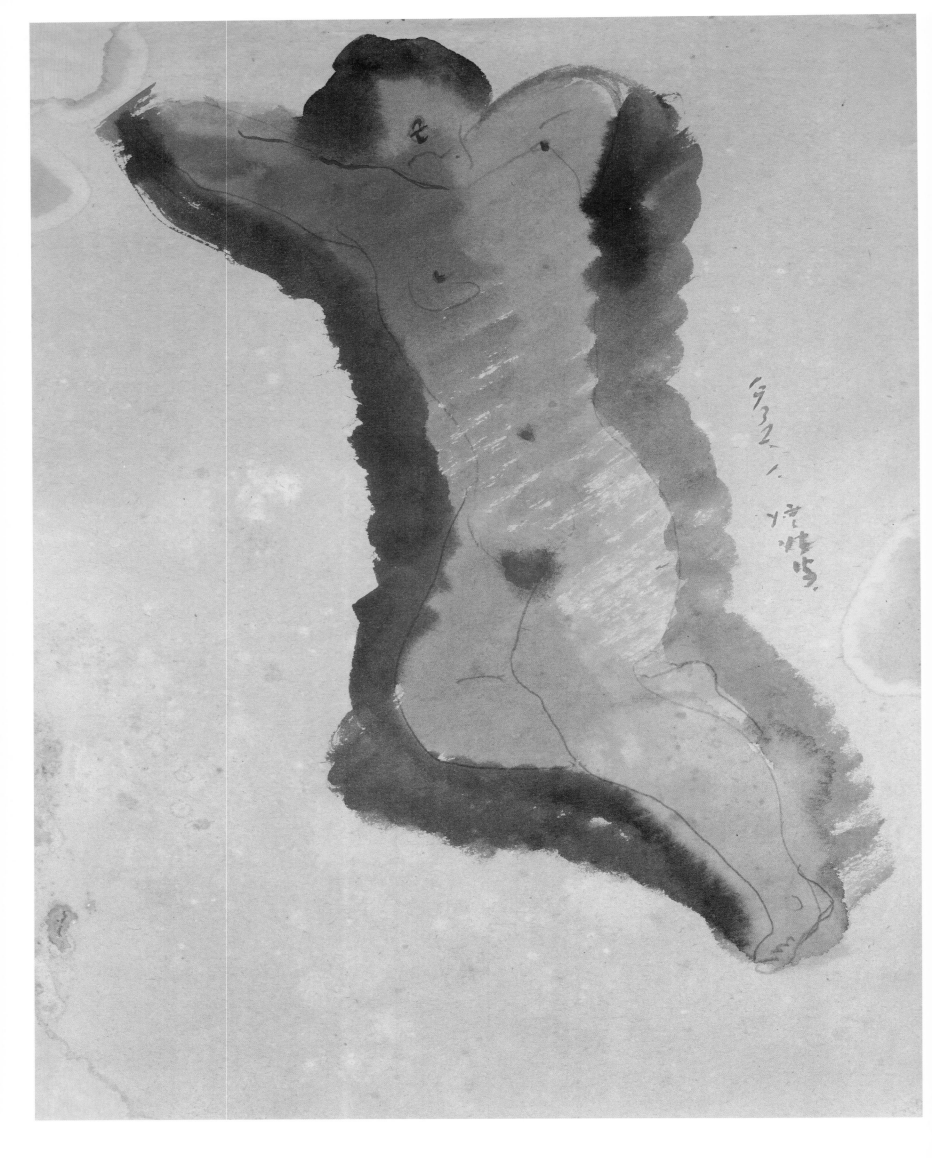

臥姿裸女-32.1（51）Lying Nude-32.1 (51)

1932　紙本淡彩鉛筆　36.5×28.5cm

[右頁圖]

坐姿裸女-32.1（85）Seated Nude-32.1 (85)

1932　紙本淡彩鉛筆　原寸（36×26.5cm）

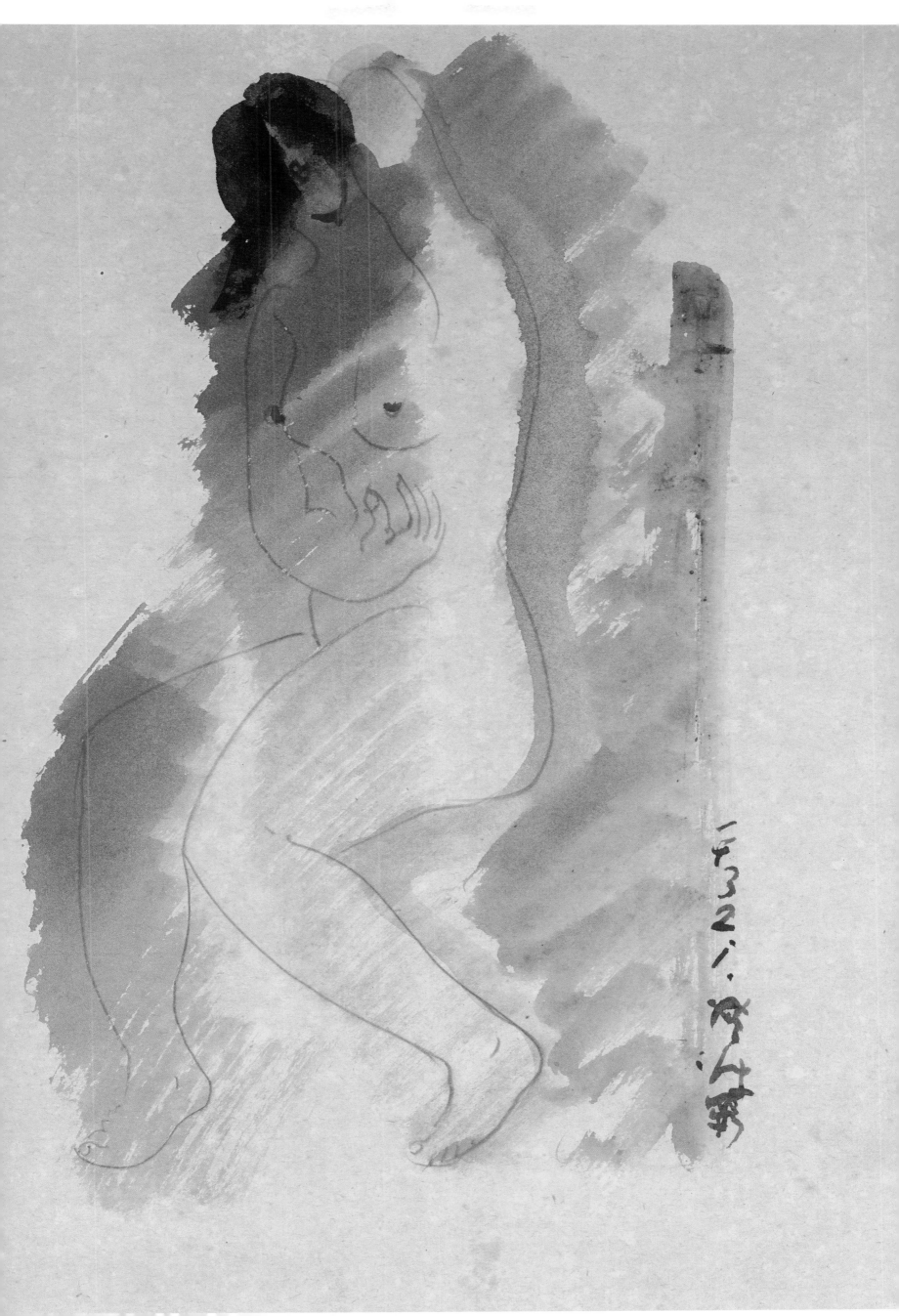

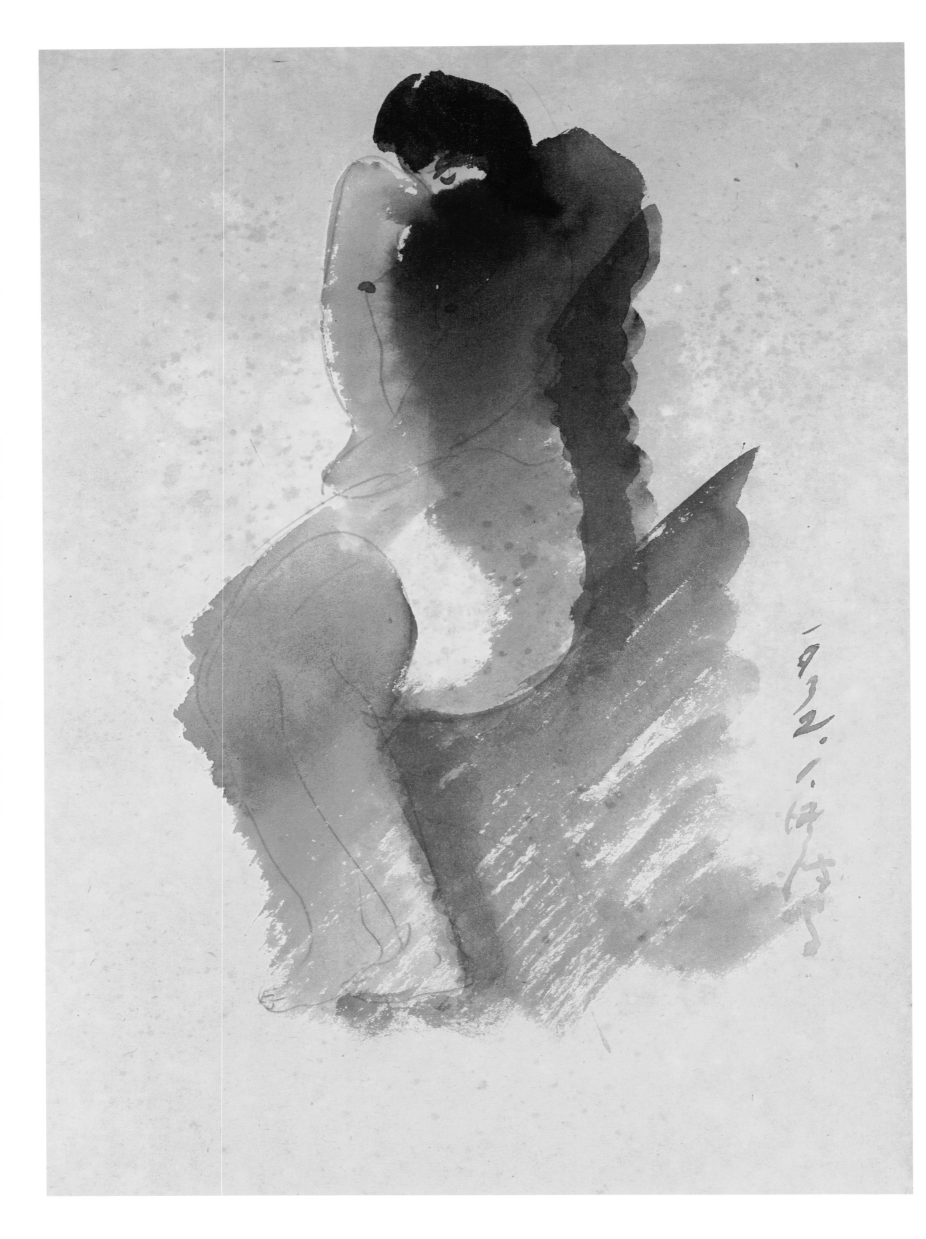

坐姿裸女-32.1（86） Seated Nude-32.1 (86)
1932　紙本淡彩鉛筆　36.5×26.5cm

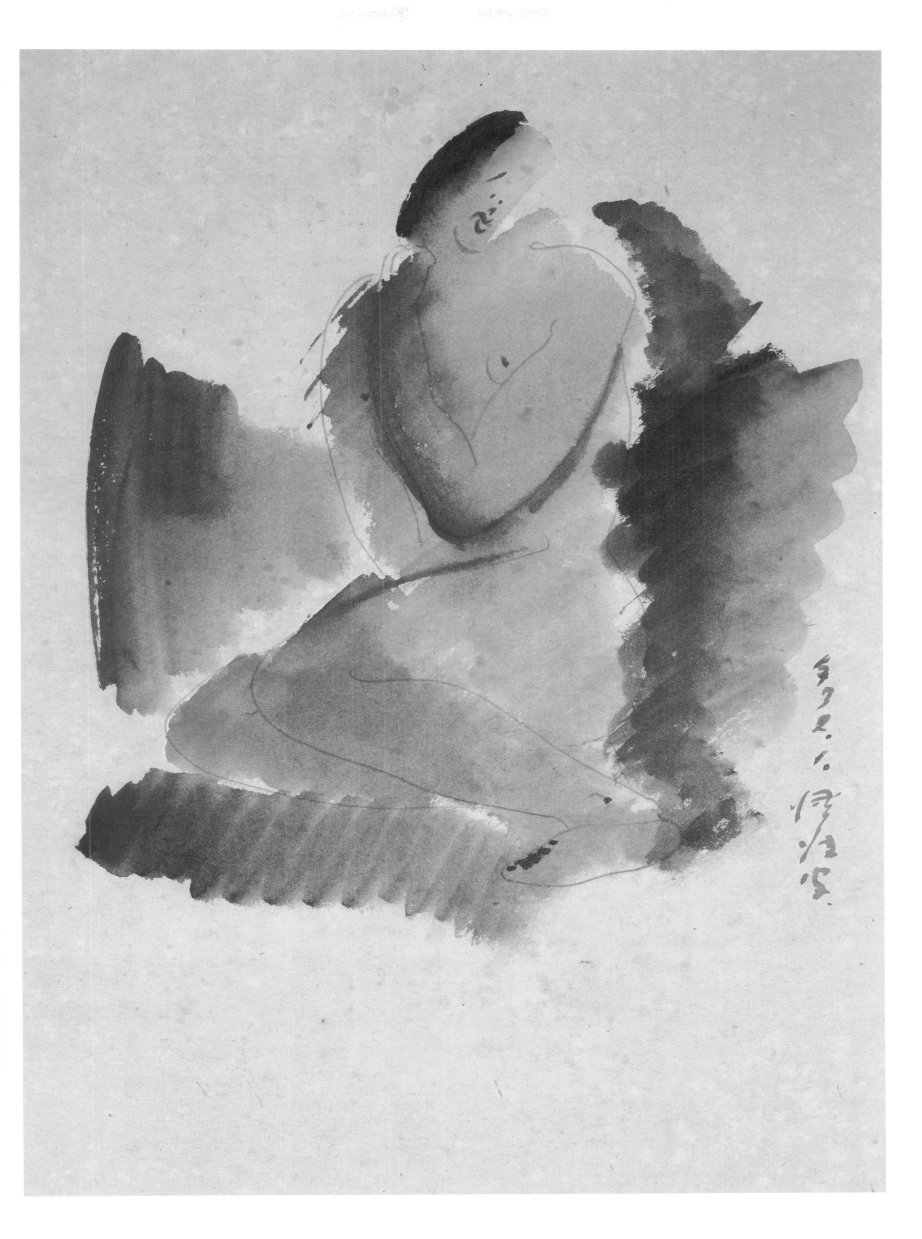

坐姿裸女-32.1（87） Seated Nude-32.1 (87)

1932　紙本淡彩鉛筆　36.5×26.5cm

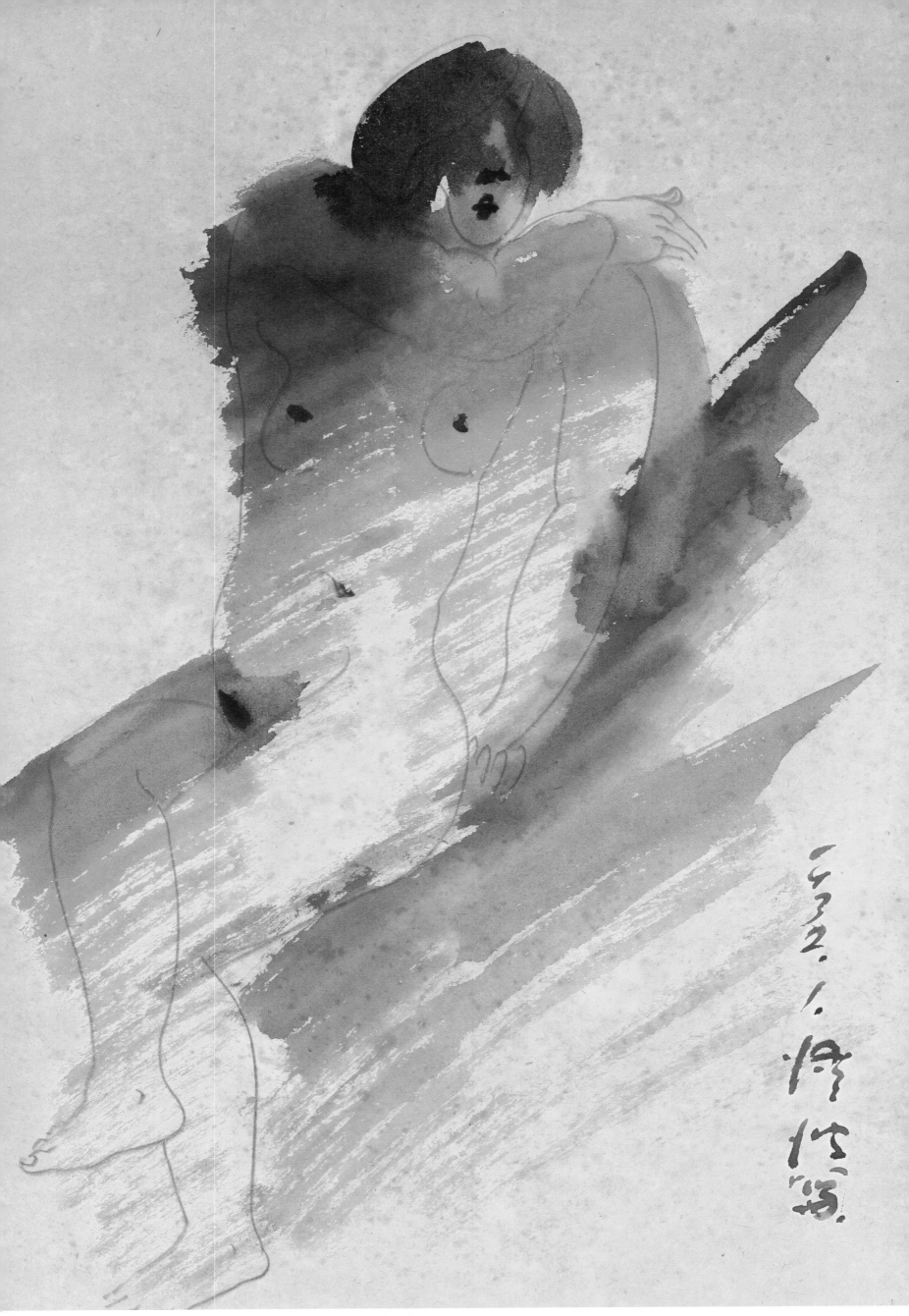

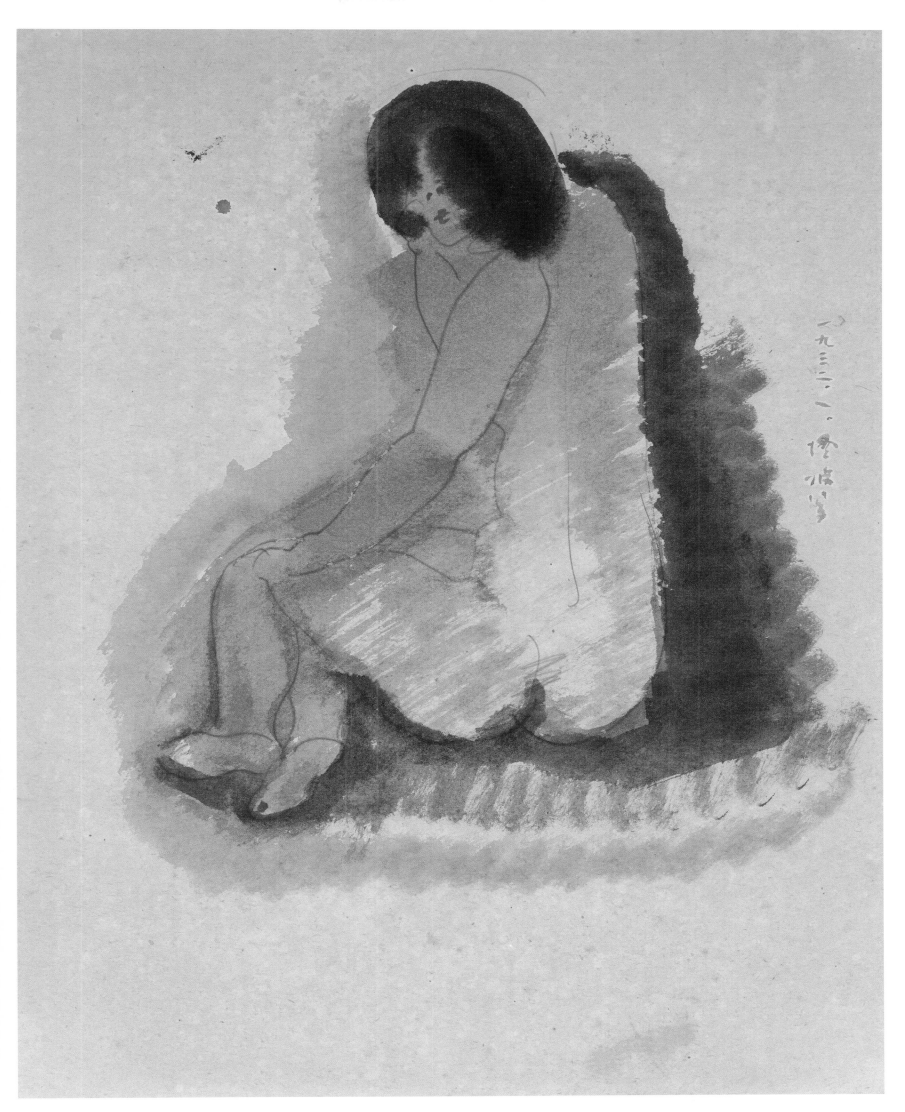

坐姿裸女-32.1（89）Seated Nude-32.1 (89)

1932　紙本淡彩鉛筆　36.5×28.5cm

[左頁圖]

坐姿裸女-32.1（88）Seated Nude-32.1 (88)

1932　紙本淡彩鉛筆　原寸（36.5×26.5cm）

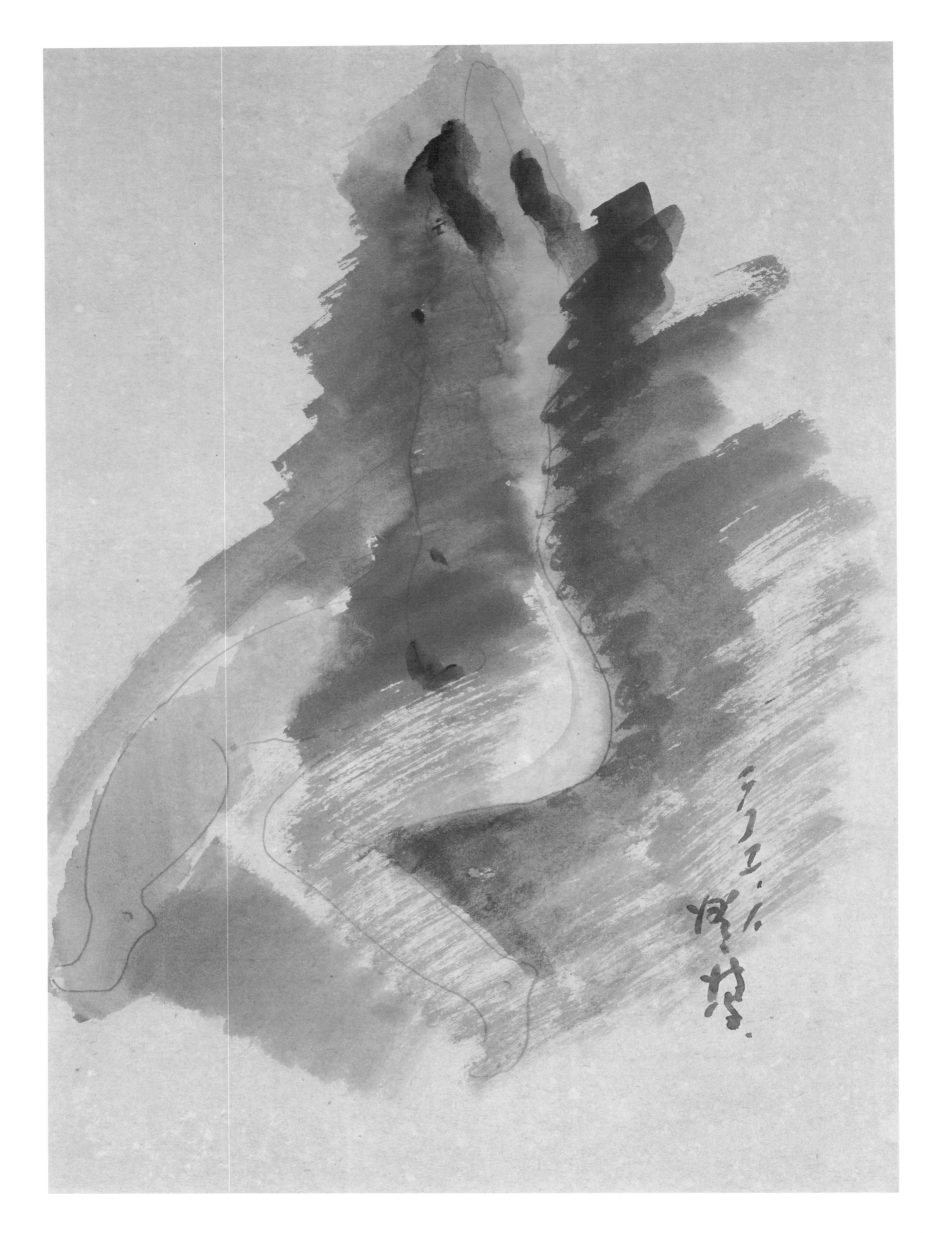

坐姿裸女-32.1（90） Seated Nude-32.1 (90)

1932　紙本淡彩鉛筆　36.5×26.5cm

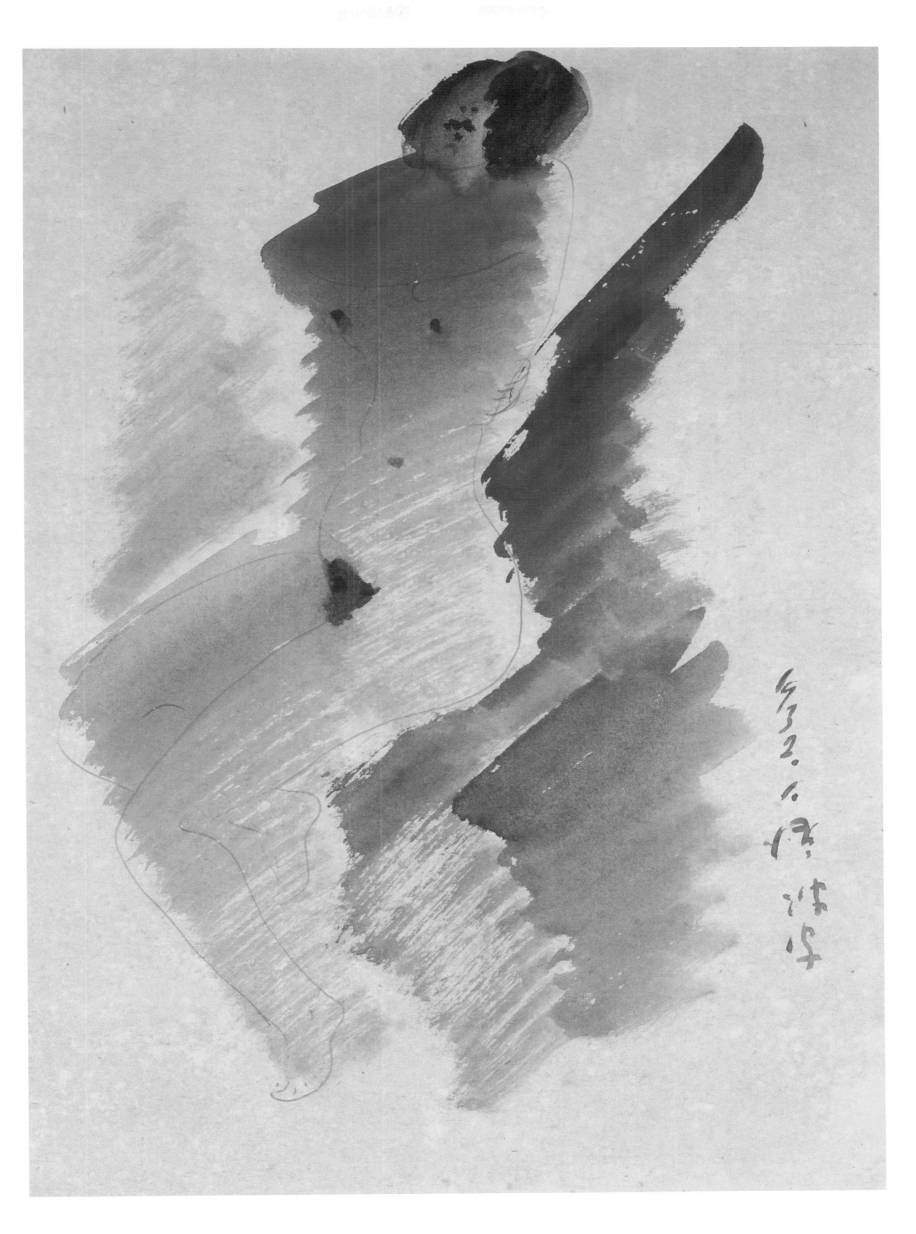

坐姿裸女-32.1（91） Seated Nude-32.1 (91)
1932　紙本淡彩鉛筆　36.5×26.5cm

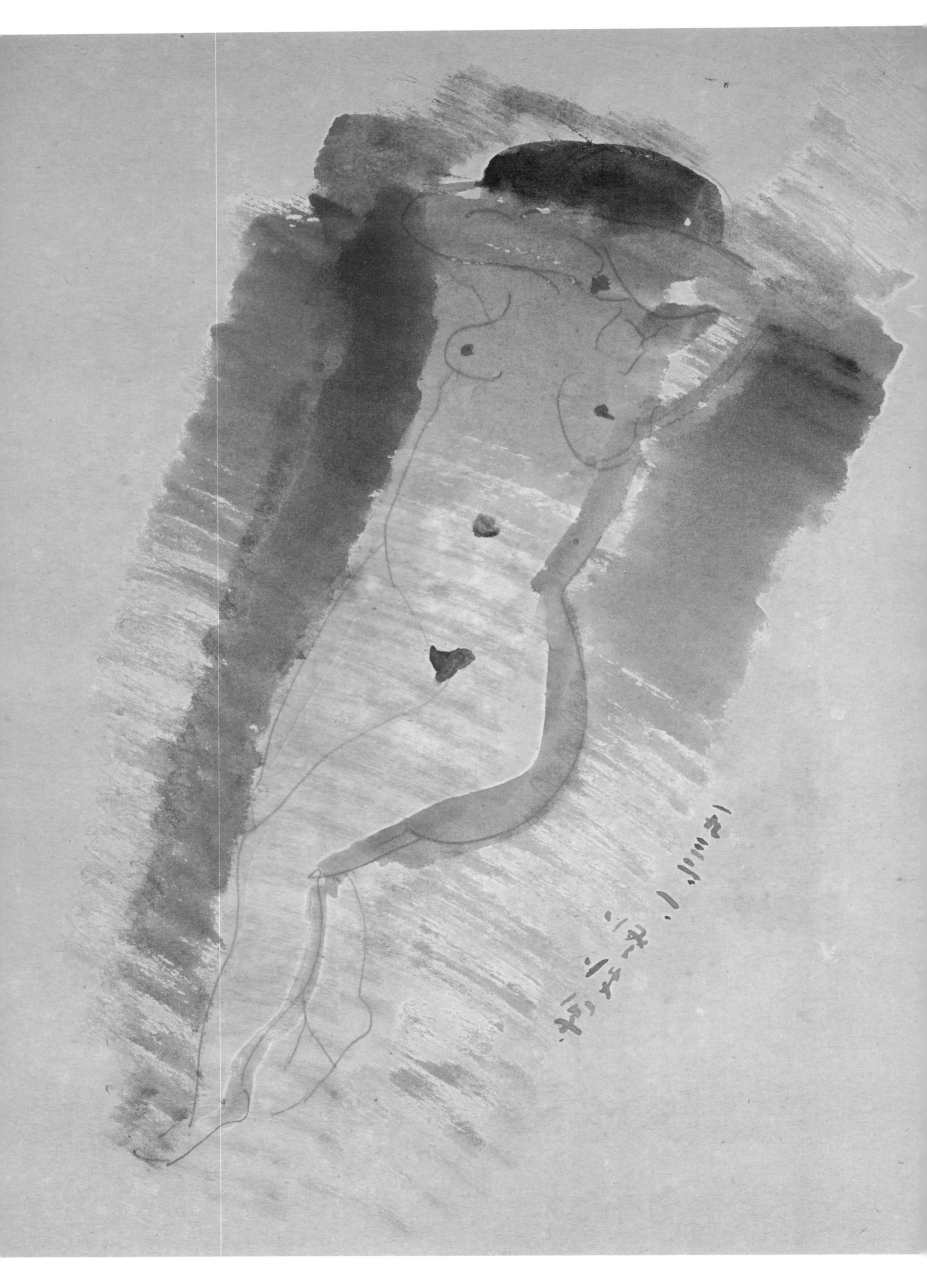

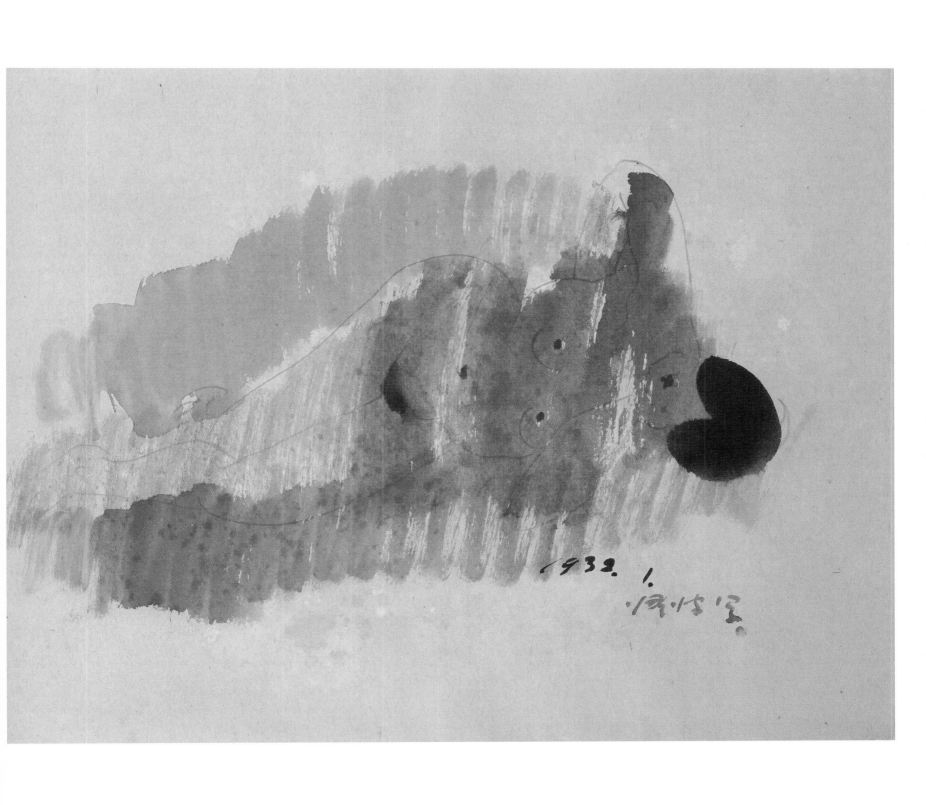

臥姿裸女-32.1（53）Lying Nude-32.1 (53)
1932　紙本淡彩鉛筆　28.5×36.5cm

[左頁圖]
臥姿裸女-32.1（52）Lying Nude-32.1 (52)
1932　紙本淡彩鉛筆　36.5×28cm

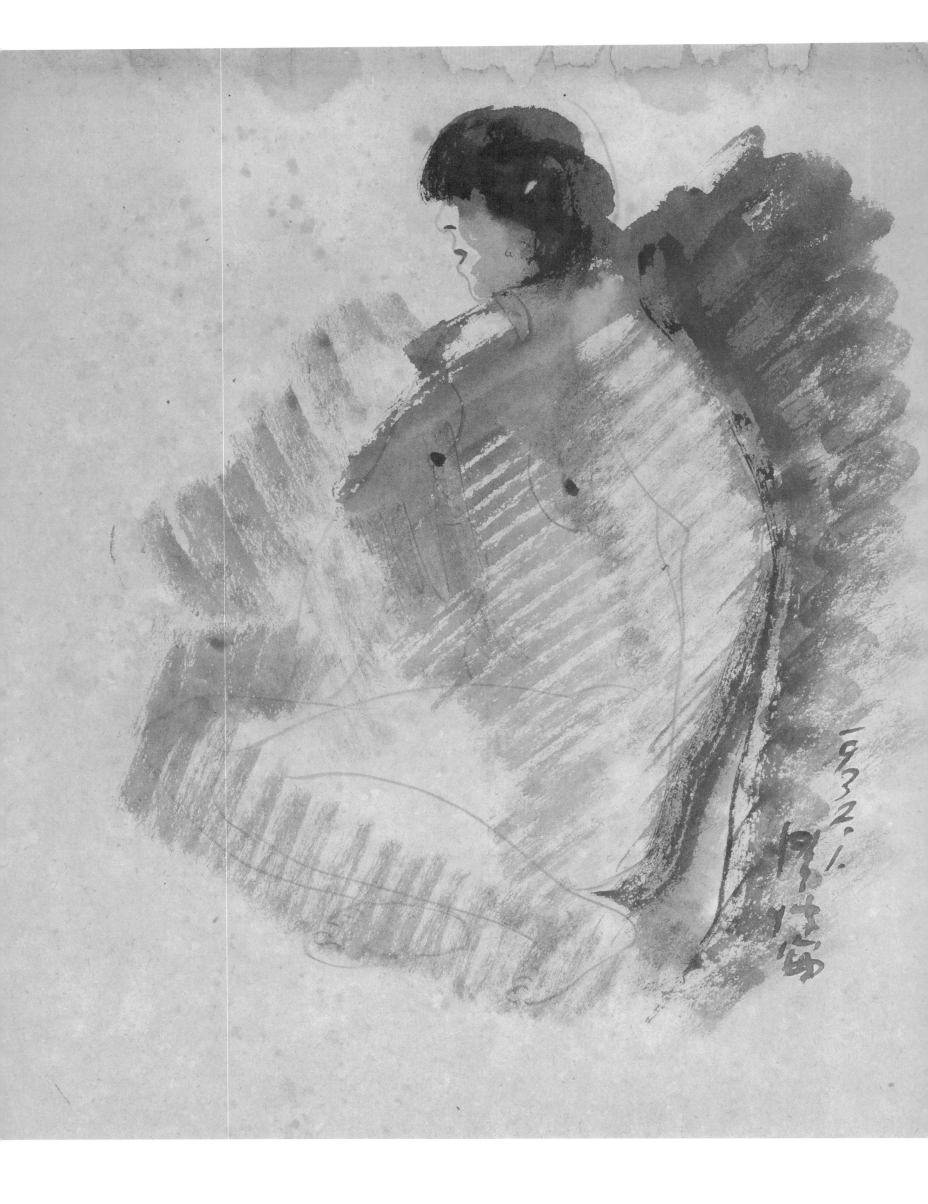

坐姿裸女-32.1（92）Seated Nude-32.1 (92)

1932　紙本淡彩鉛筆　30.5×27.5cm

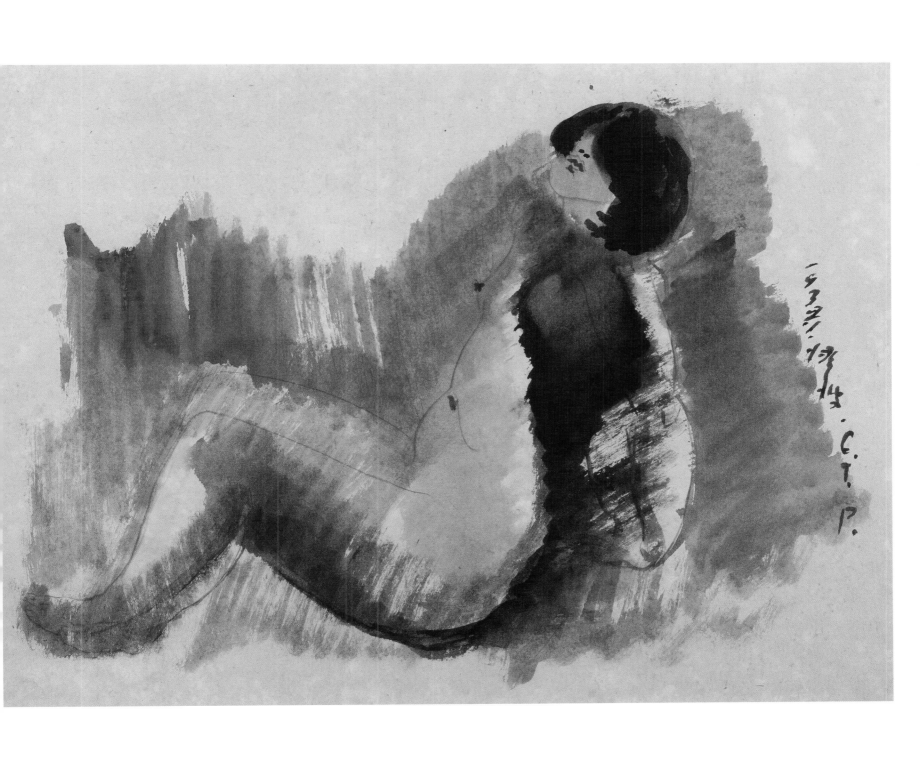

坐姿裸女-32.1（93）Seated Nude-32.1 (93)

1932　紙本淡彩鉛筆　26.5×36cm

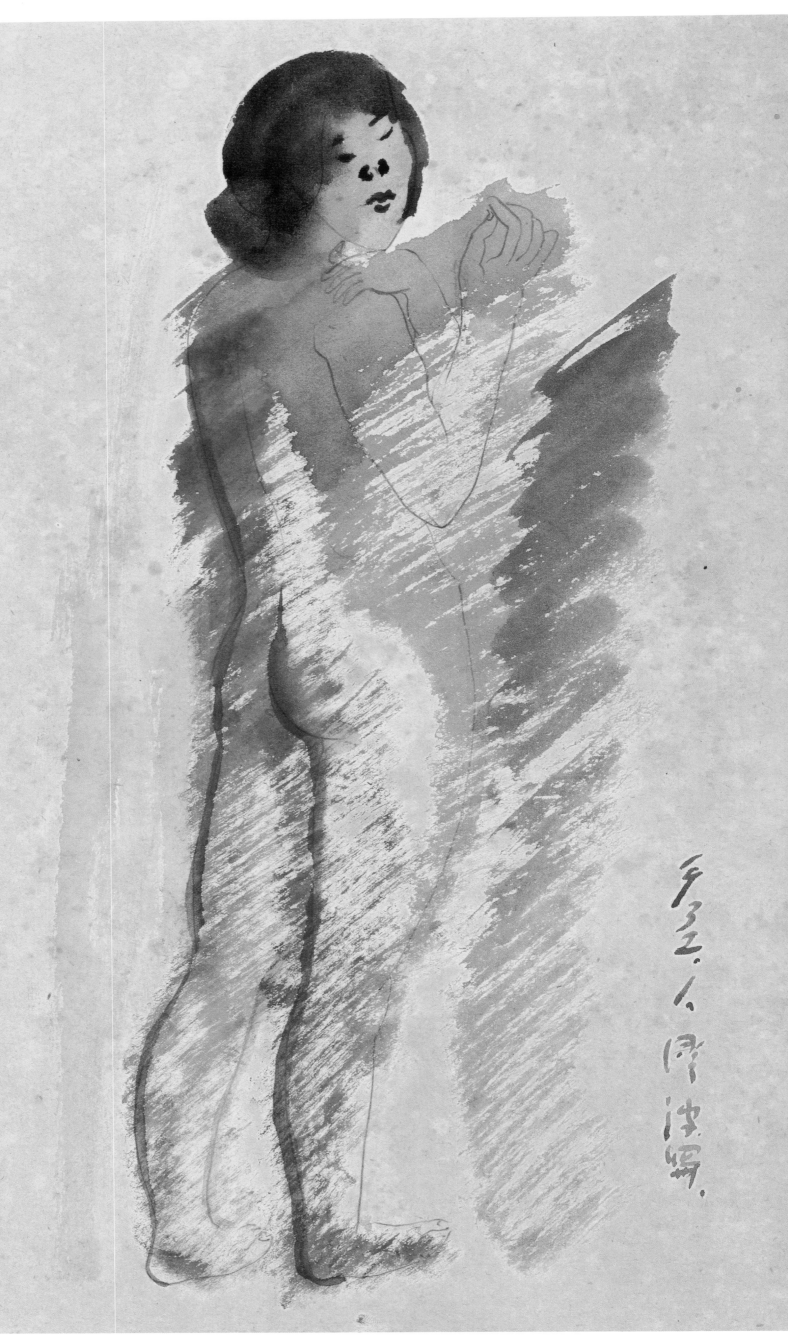

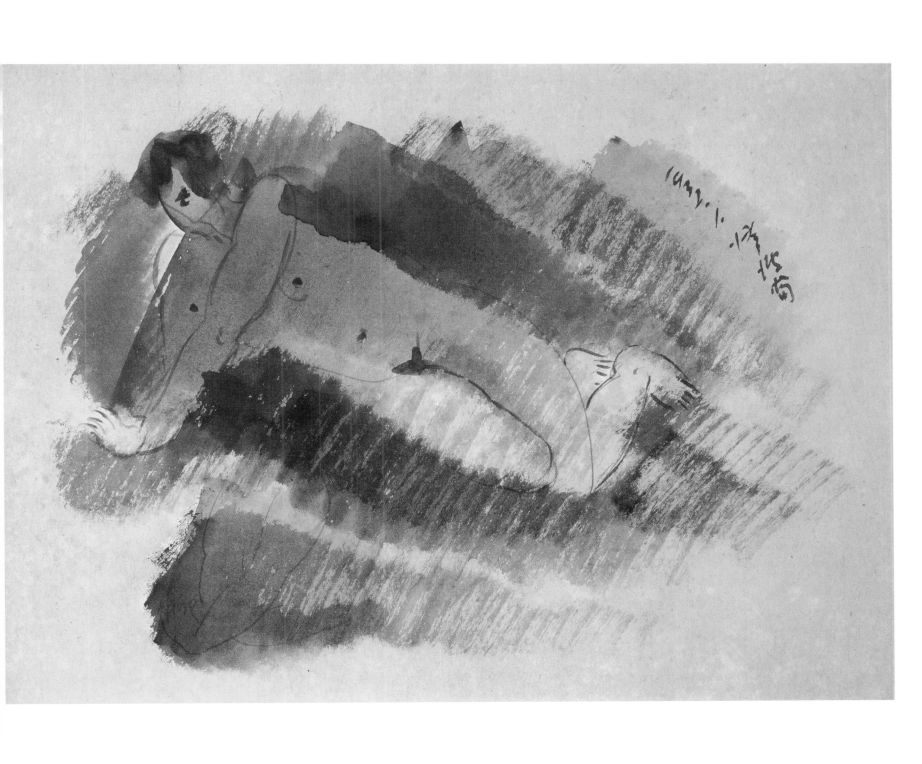

臥姿裸女-32.1（54） Lying Nude-32.1 (54)

1932　紙本淡彩鉛筆　26.5×36.5cm

[左頁圖]
立姿裸女-32.1（36） Standing Nude-32.1 (36)

1932　紙本淡彩鉛筆　原寸（36×26.5cm）

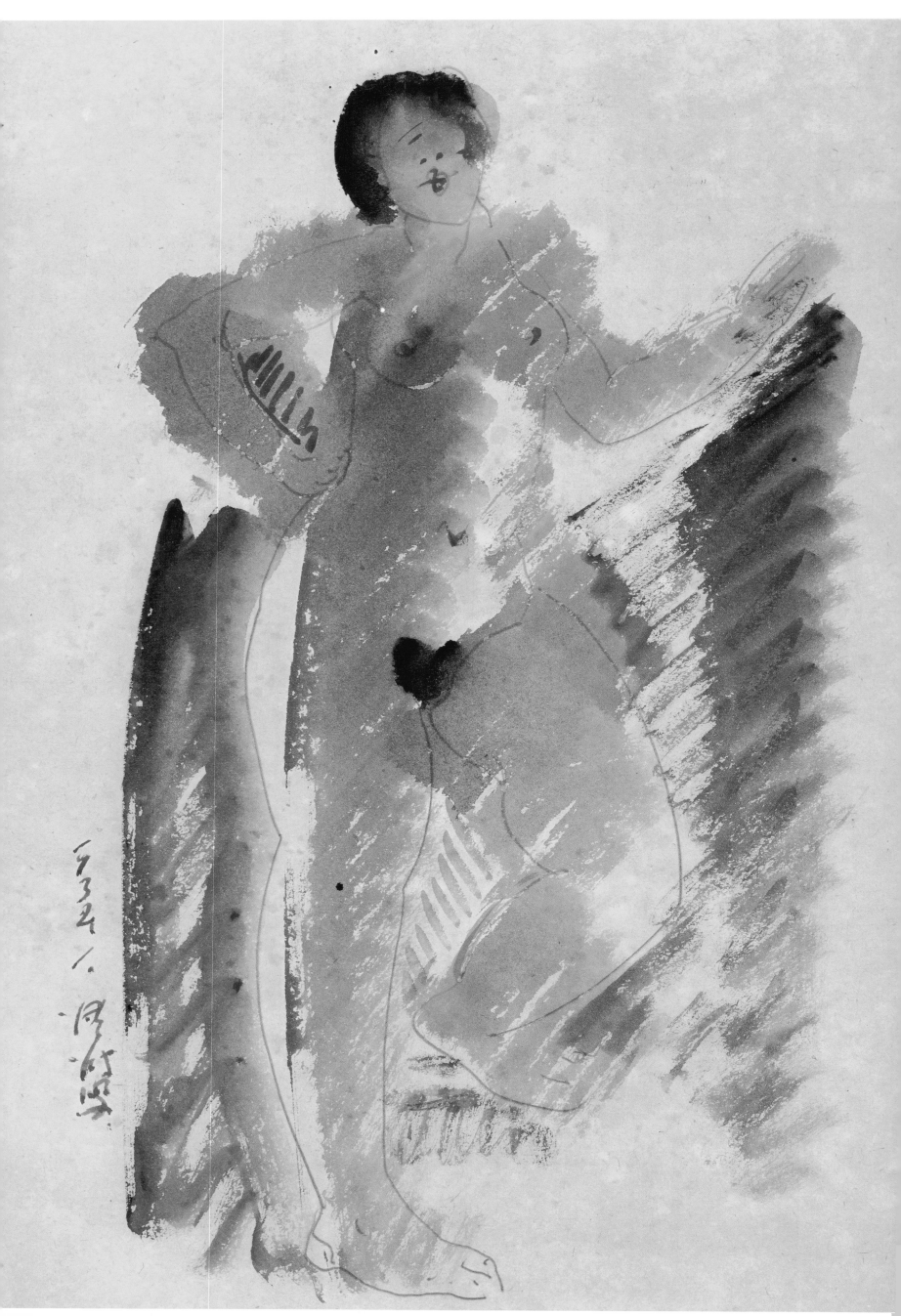

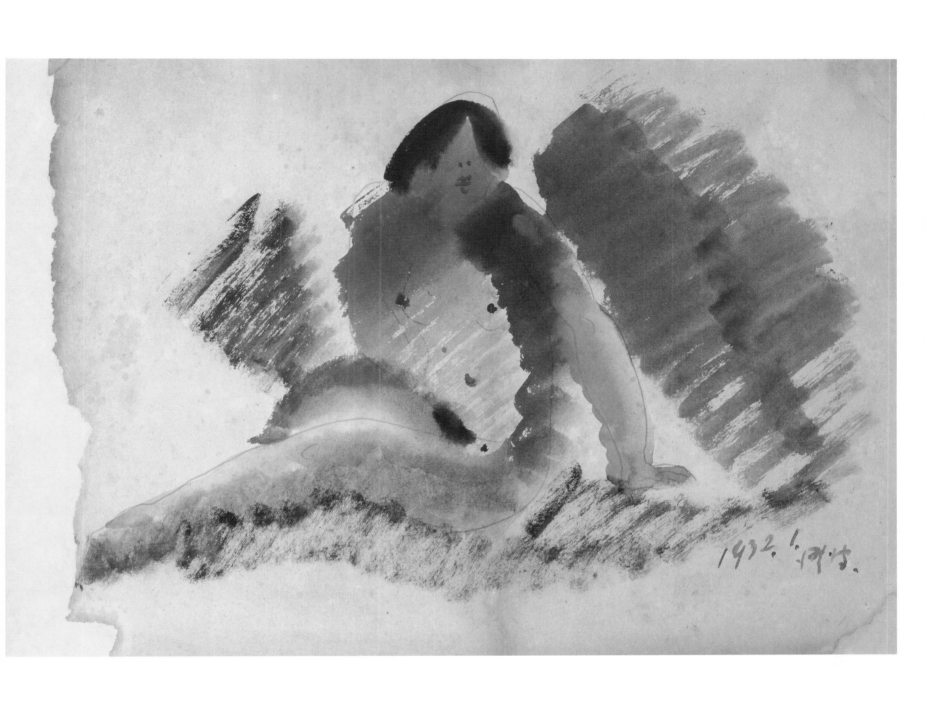

坐姿裸女-32.1（94） Seated Nude-32.1 (94)
1932　紙本淡彩鉛筆　26.5×36.5cm

[左頁圖]
立姿裸女-32.1（37） Standing Nude-32.1 (37)
1932　紙本淡彩鉛筆　原寸（36×26.5cm）

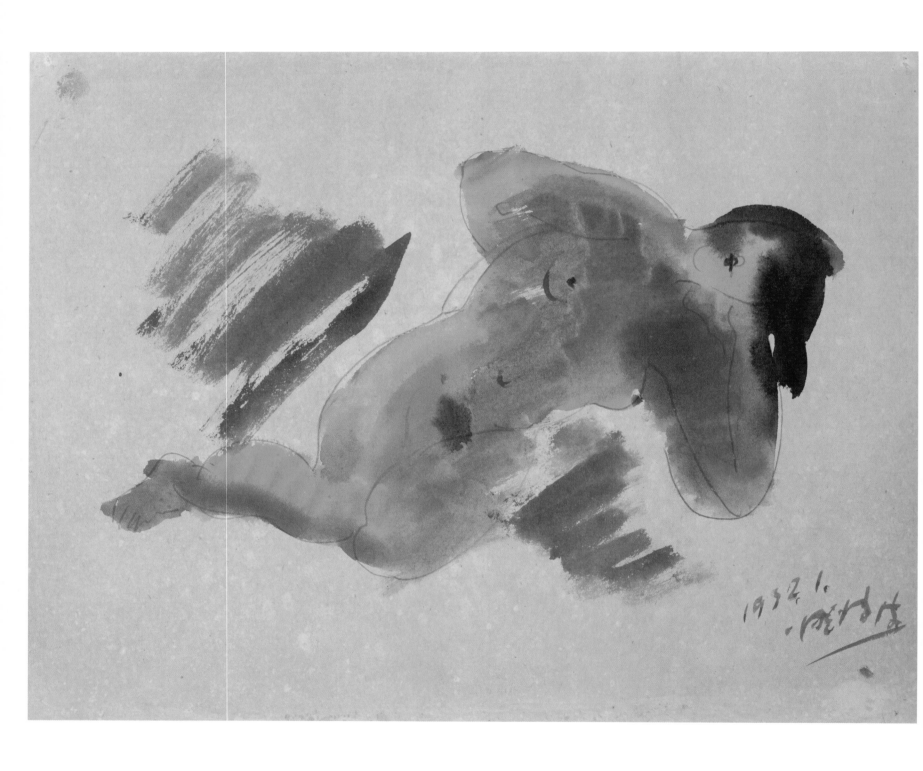

臥姿裸女-32.1（55） Lying Nude-32.1 (55)

1932　紙本淡彩鉛筆　28.5×36.5cm

[右頁圖]

立姿裸女-32.1（38） Standing Nude-32.1 (38)

1932　紙本淡彩鉛筆　原寸（36×26.5cm）

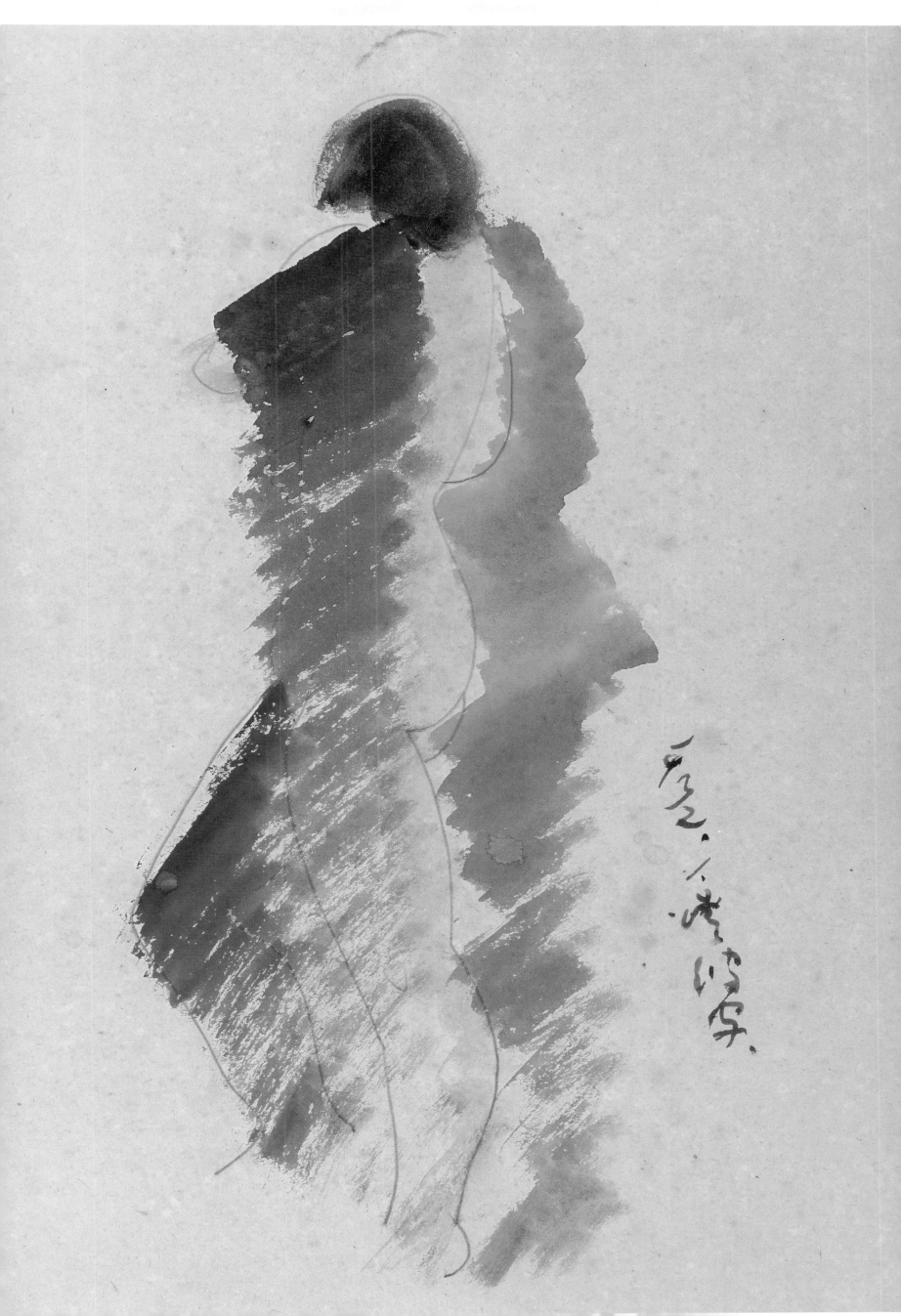

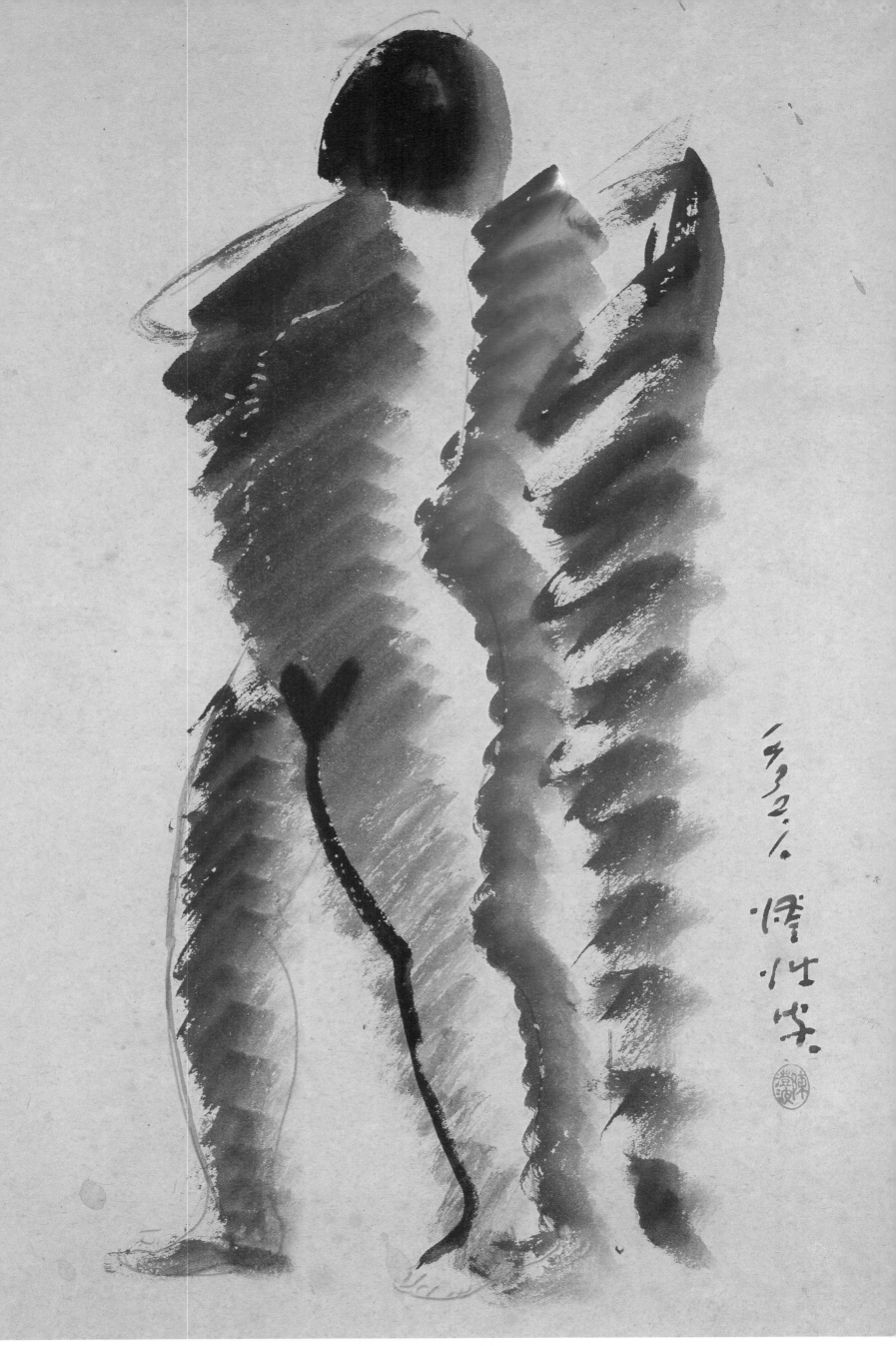

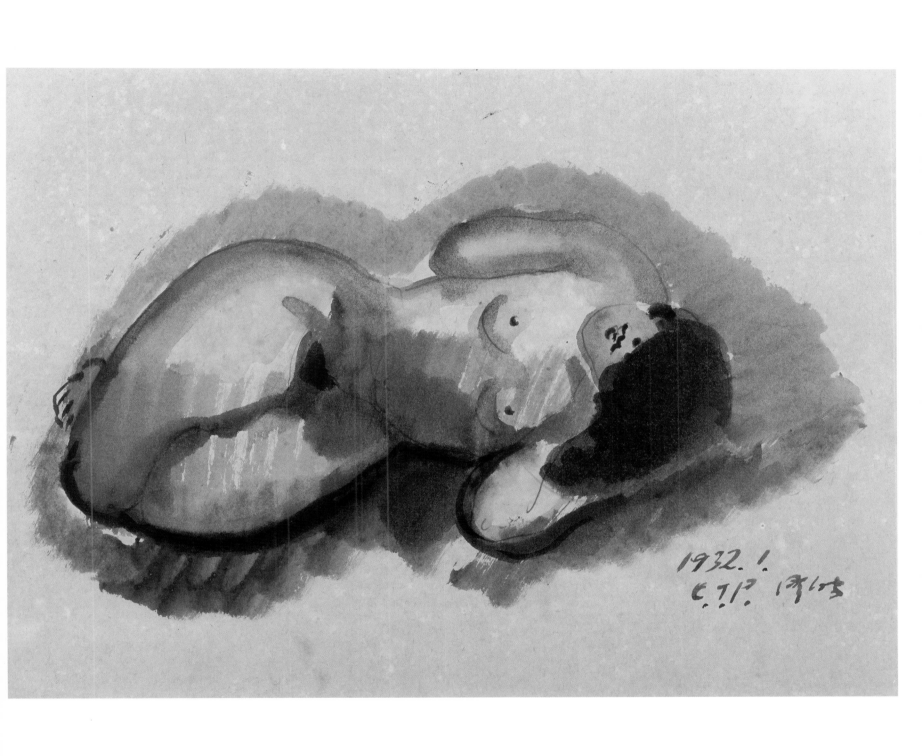

臥姿裸女-32.1（56） Lying Nude-32.1 (56)

1932　紙本淡彩鉛筆　26.5×36cm

[左頁圖]

立姿裸女-32.1（39） Standing Nude-32.1 (39)

1932　紙本淡彩鉛筆　原寸（36.5×26.5cm）

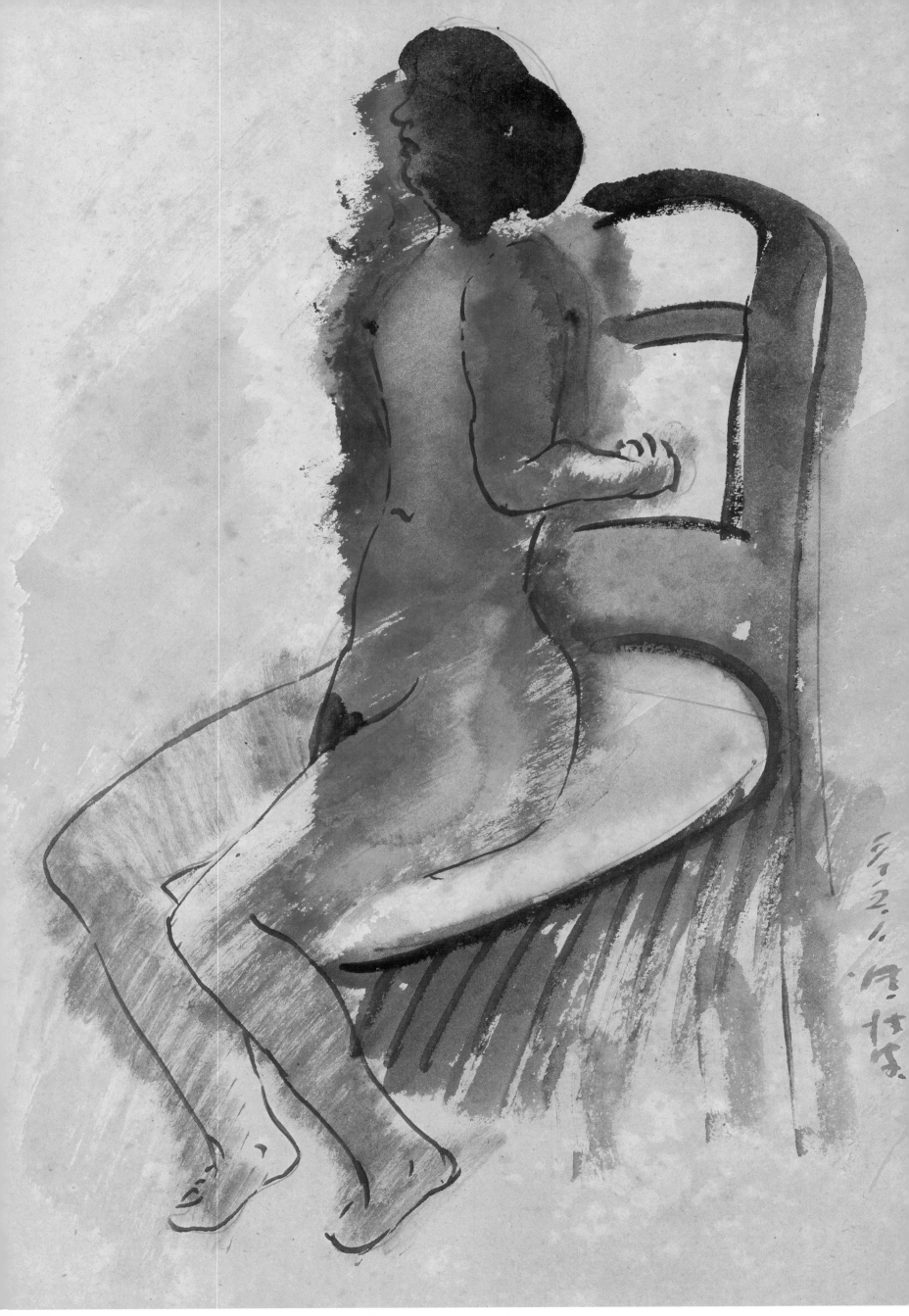

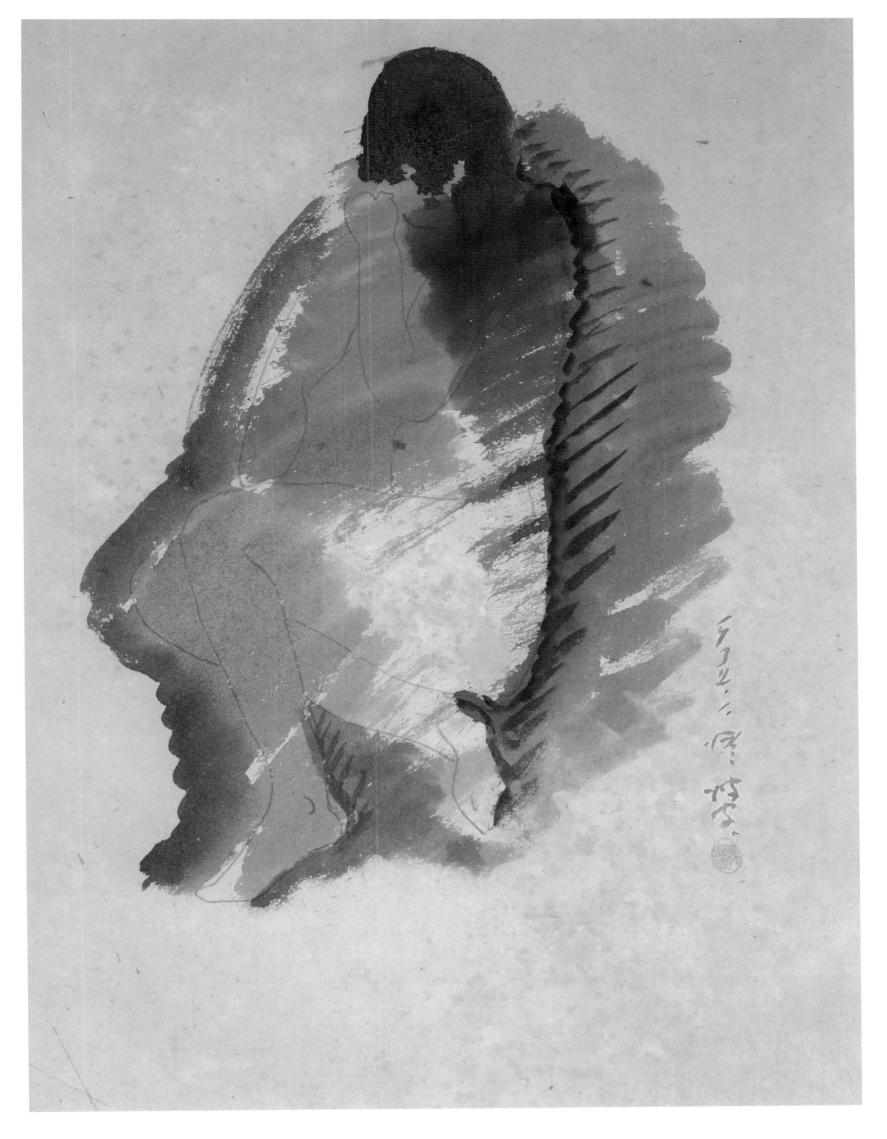

坐姿裸女-32.1（96） Seated Nude-32.1 (96)
1932　紙本淡彩鉛筆　36.5×26.5cm

[左頁圖]
坐姿裸女-32.1（95） Seated Nude-32.1 (95)
1932　紙本淡彩鉛筆　原寸（36.5×26cm）

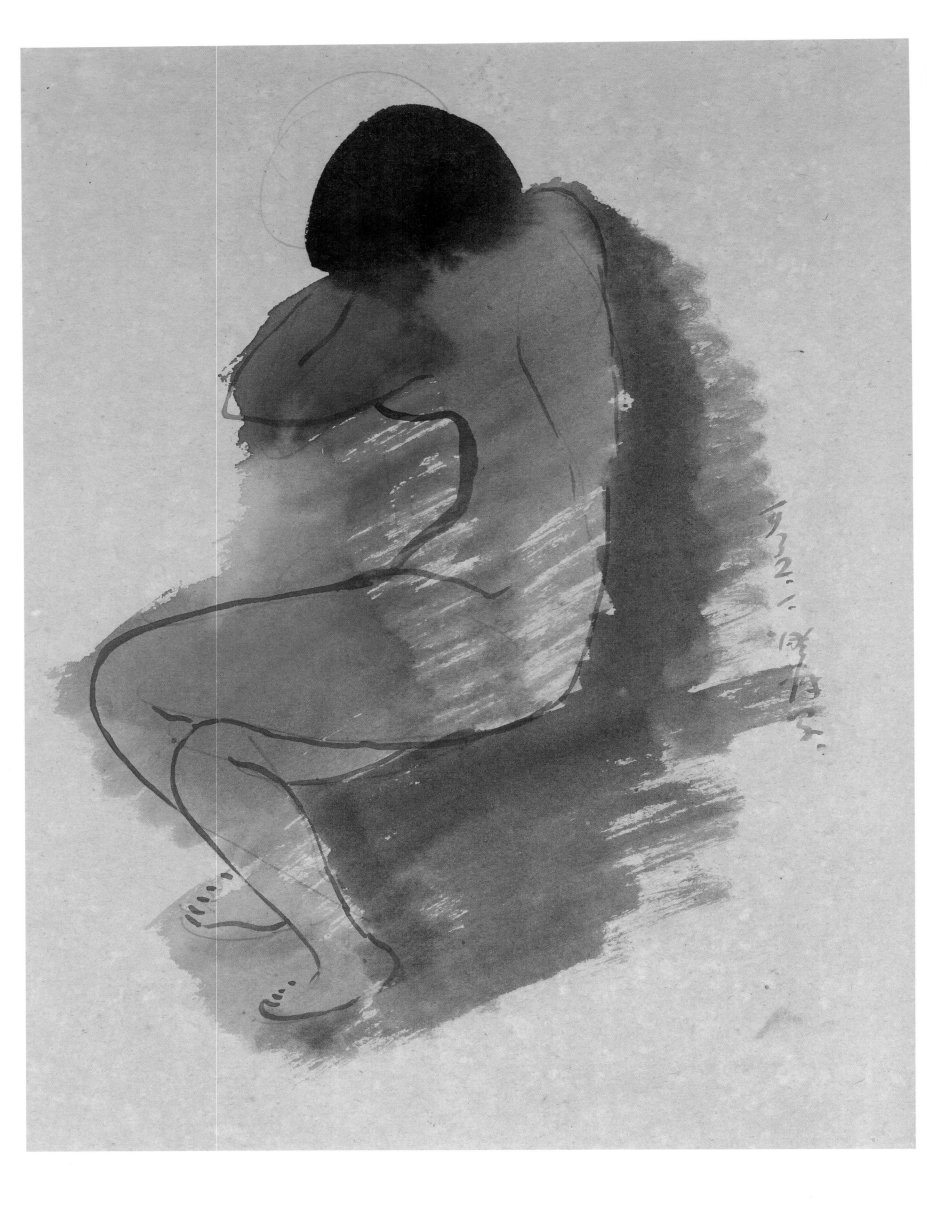

坐姿裸女-32.1（97） Seated Nude-32.1 (97)

1932　紙本淡彩鉛筆　36.5×28.5cm

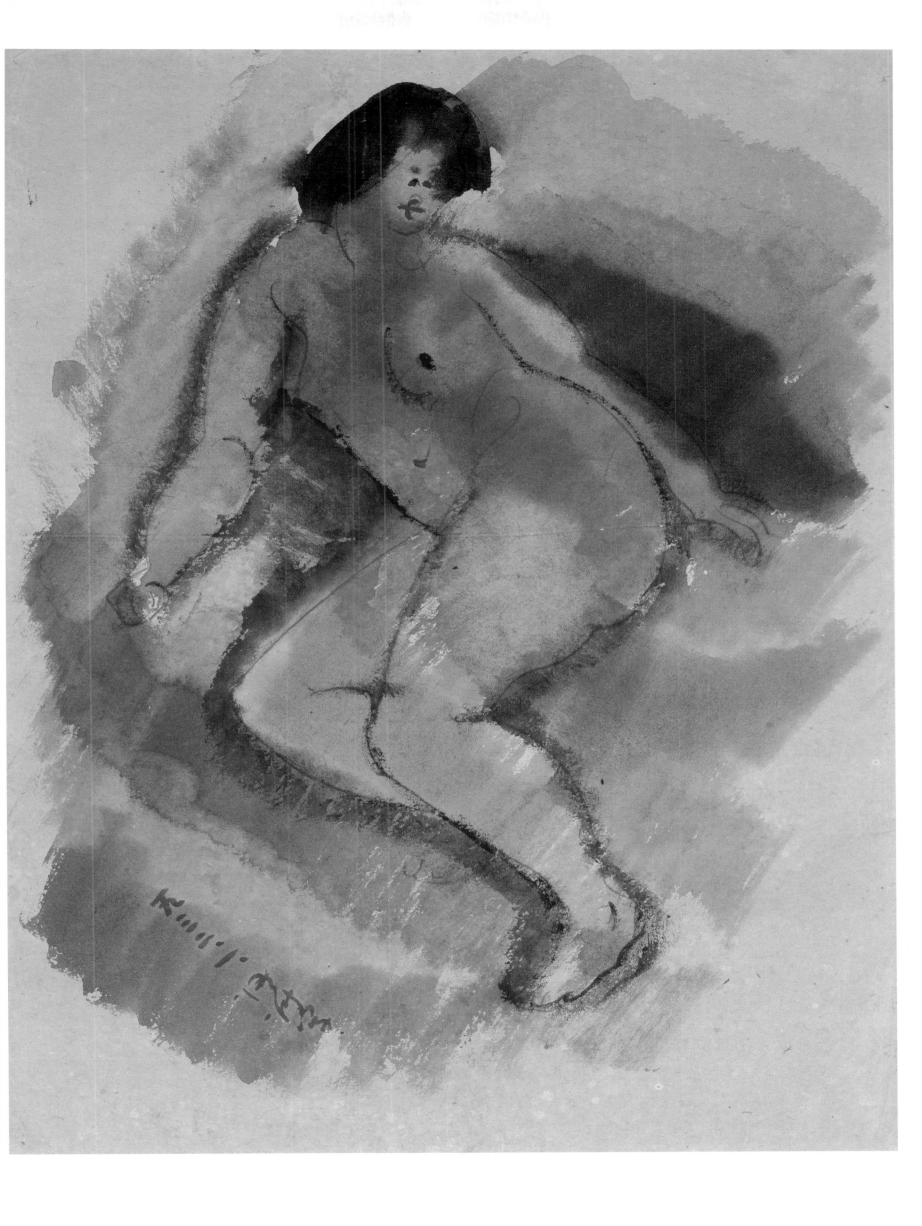

坐姿裸女-32.1（98）Seated Nude-32.1 (98)

1932　紙本淡彩鉛筆　36.5×28.5cm

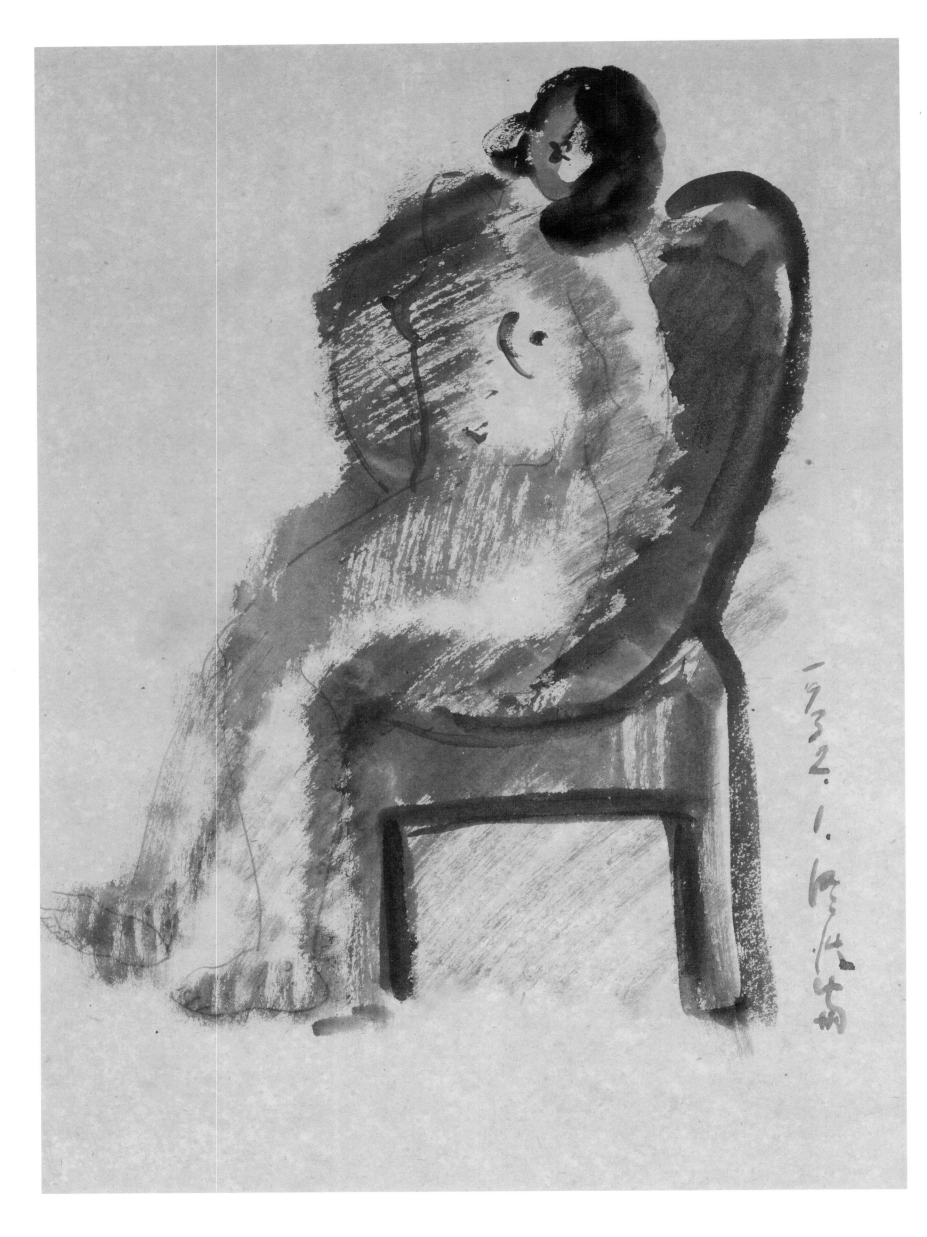

坐姿裸女-32.1（99）Seated Nude-32.1 (99)

1932　紙本淡彩鉛筆　36.5×26.5cm

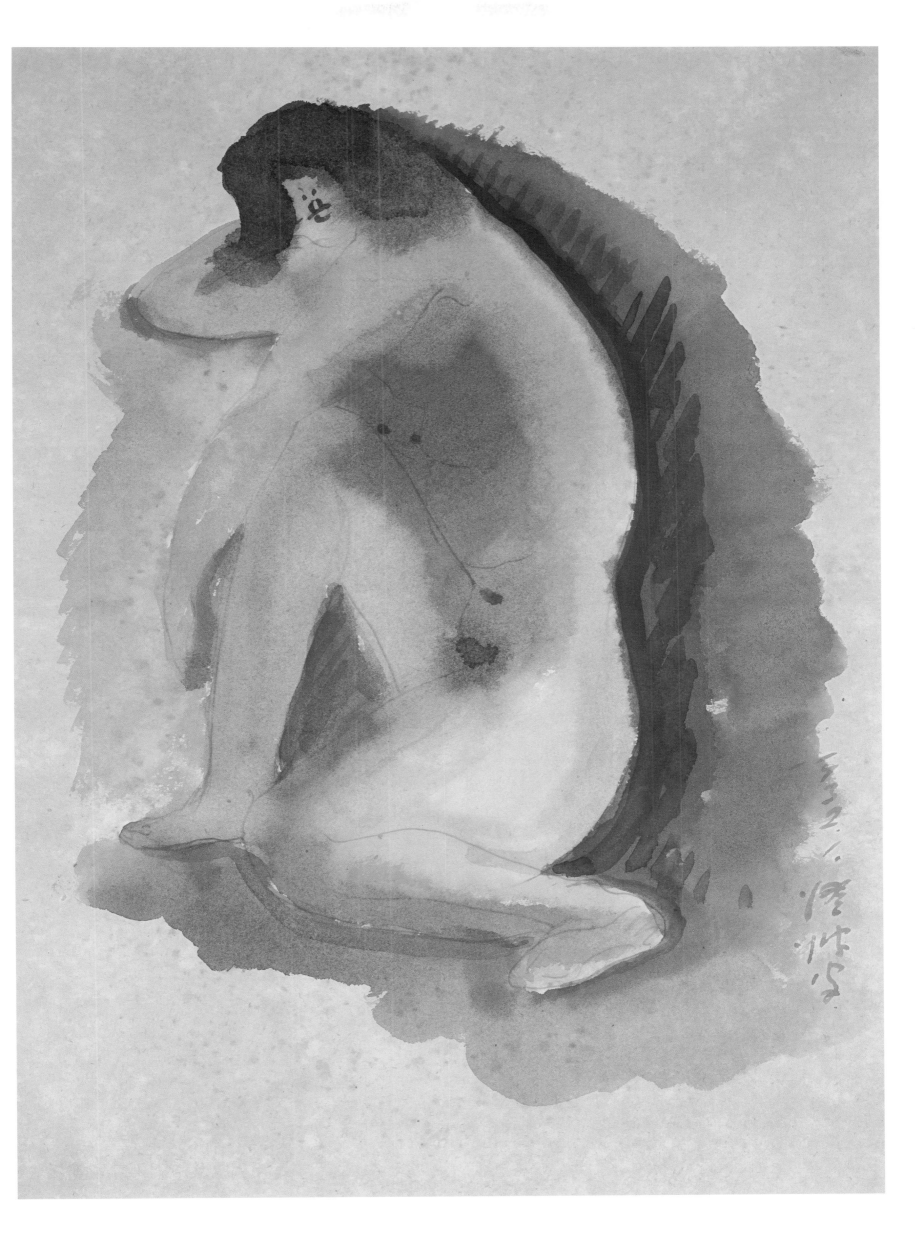

坐姿裸女-32.1（100） Seated Nude-32.1 (100)

1932　紙本淡彩鉛筆　36.5×26.5cm

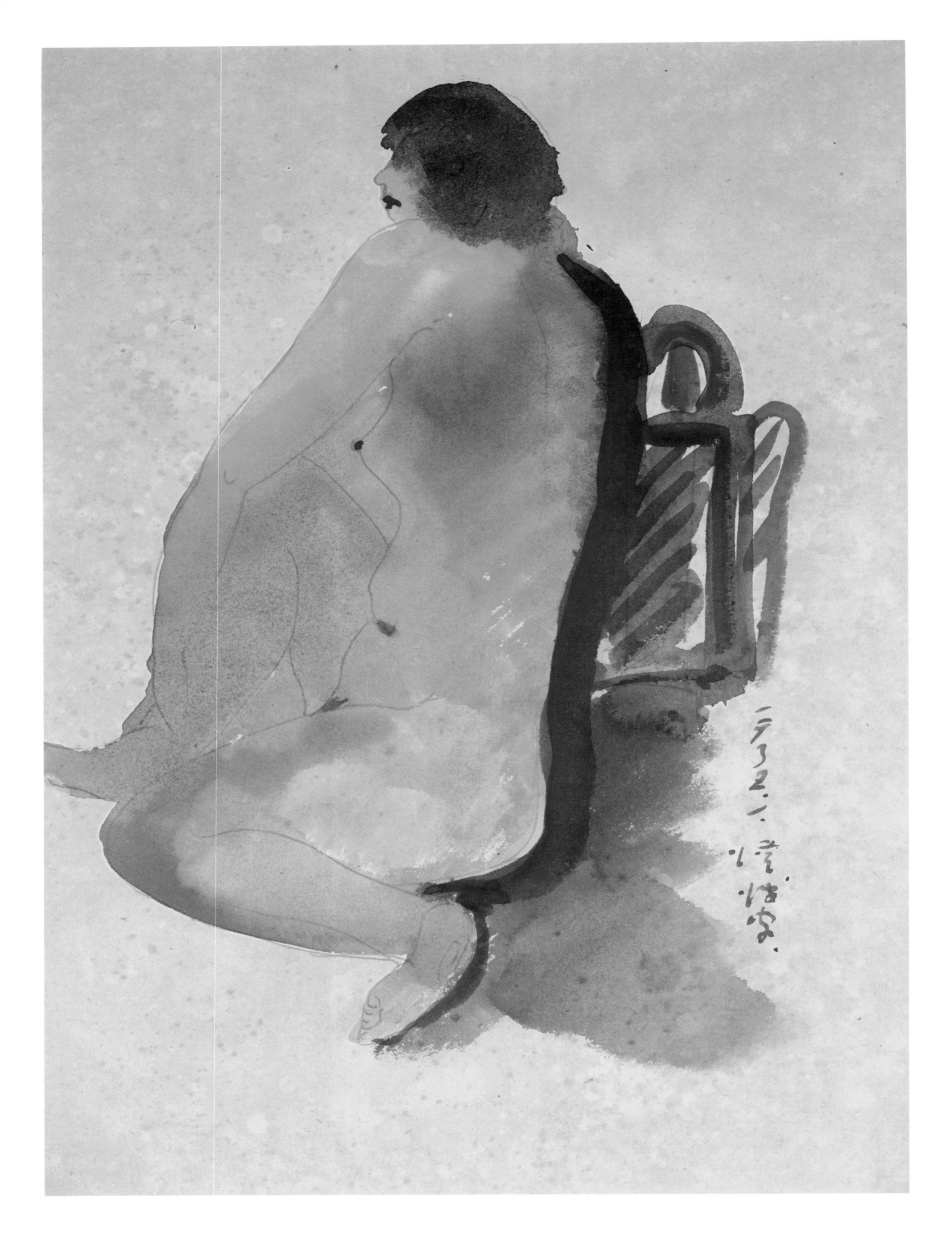

坐姿裸女-32.1（101） Seated Nude-32.1 (101)

1932 紙本淡彩鉛筆 36.5×26.5cm

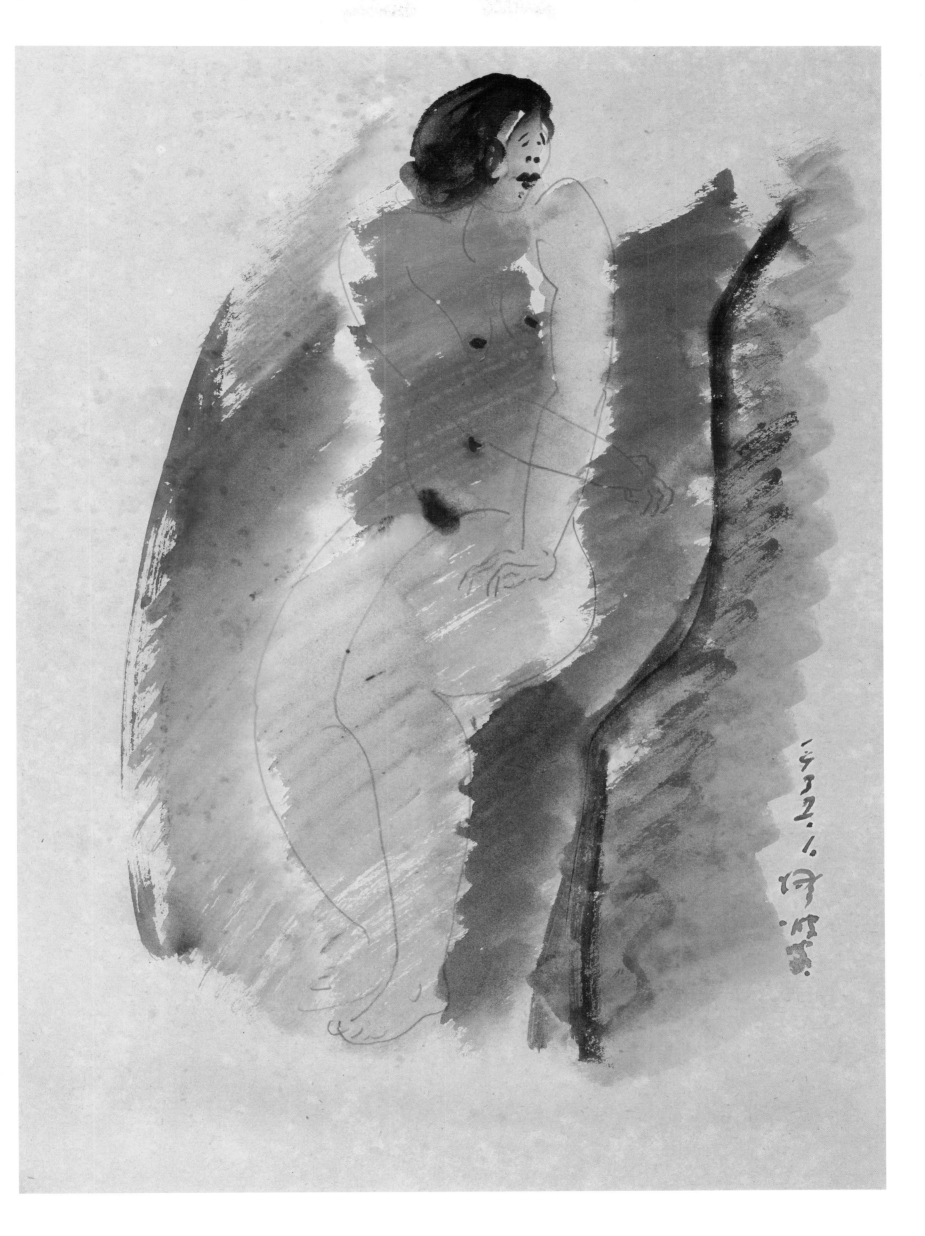

坐姿裸女-32.1（102） Seated Nude-32.1 (102)

1932　紙本淡彩鉛筆　36×26.5cm

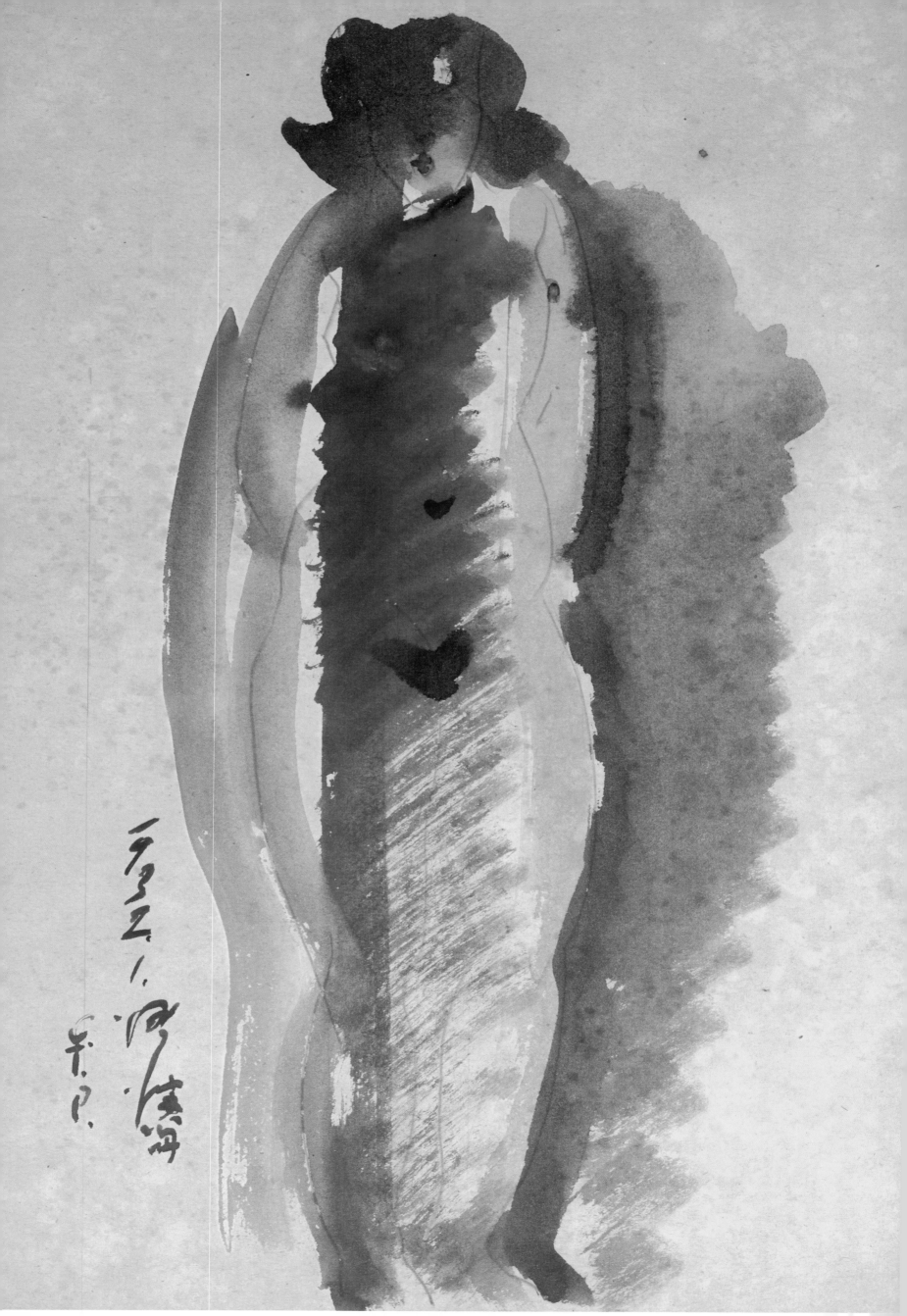

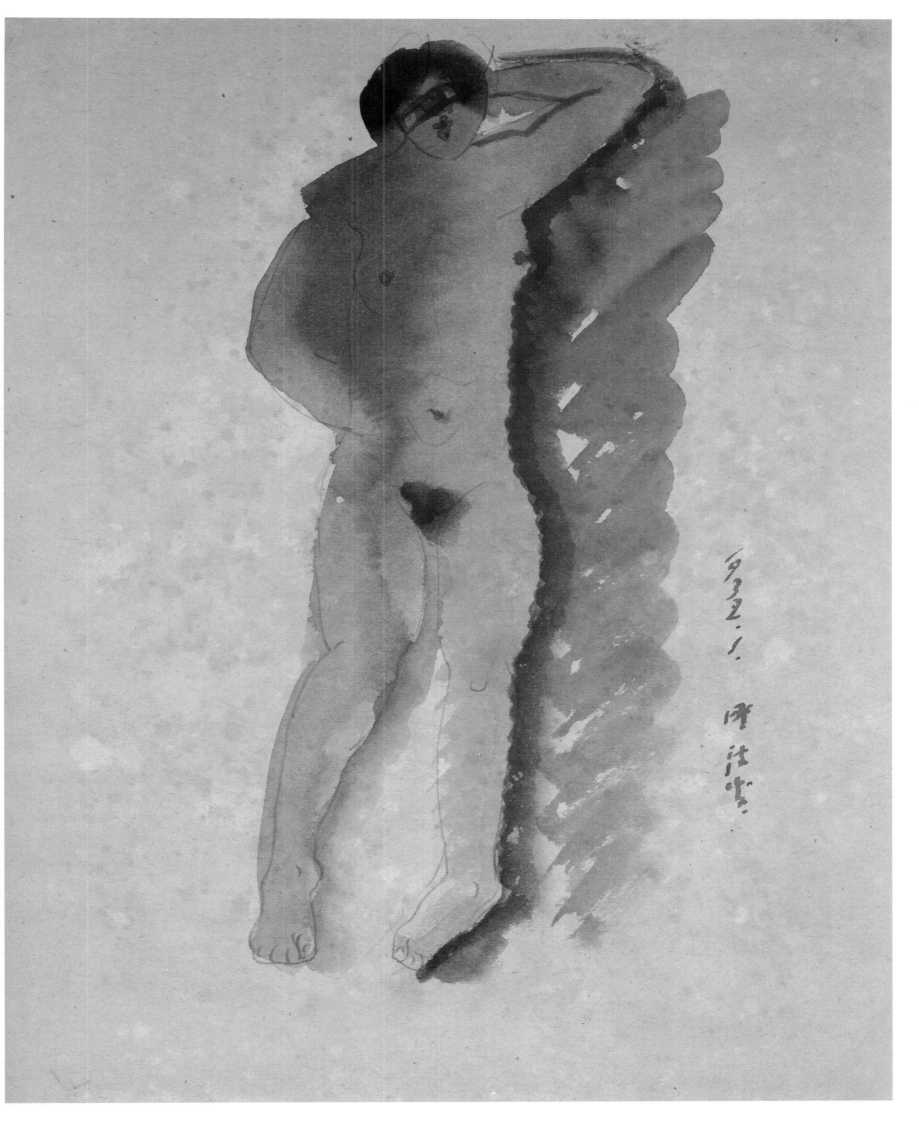

立姿裸女-32.1（41） Standing Nude-32.1 (41)

1932　紙本淡彩鉛筆　36.5×28.5cm

[左頁圖]

立姿裸女-32.1（40） Standing Nude-32.1 (40)

1932　紙本淡彩鉛筆　原寸（36.5×26.5cm）

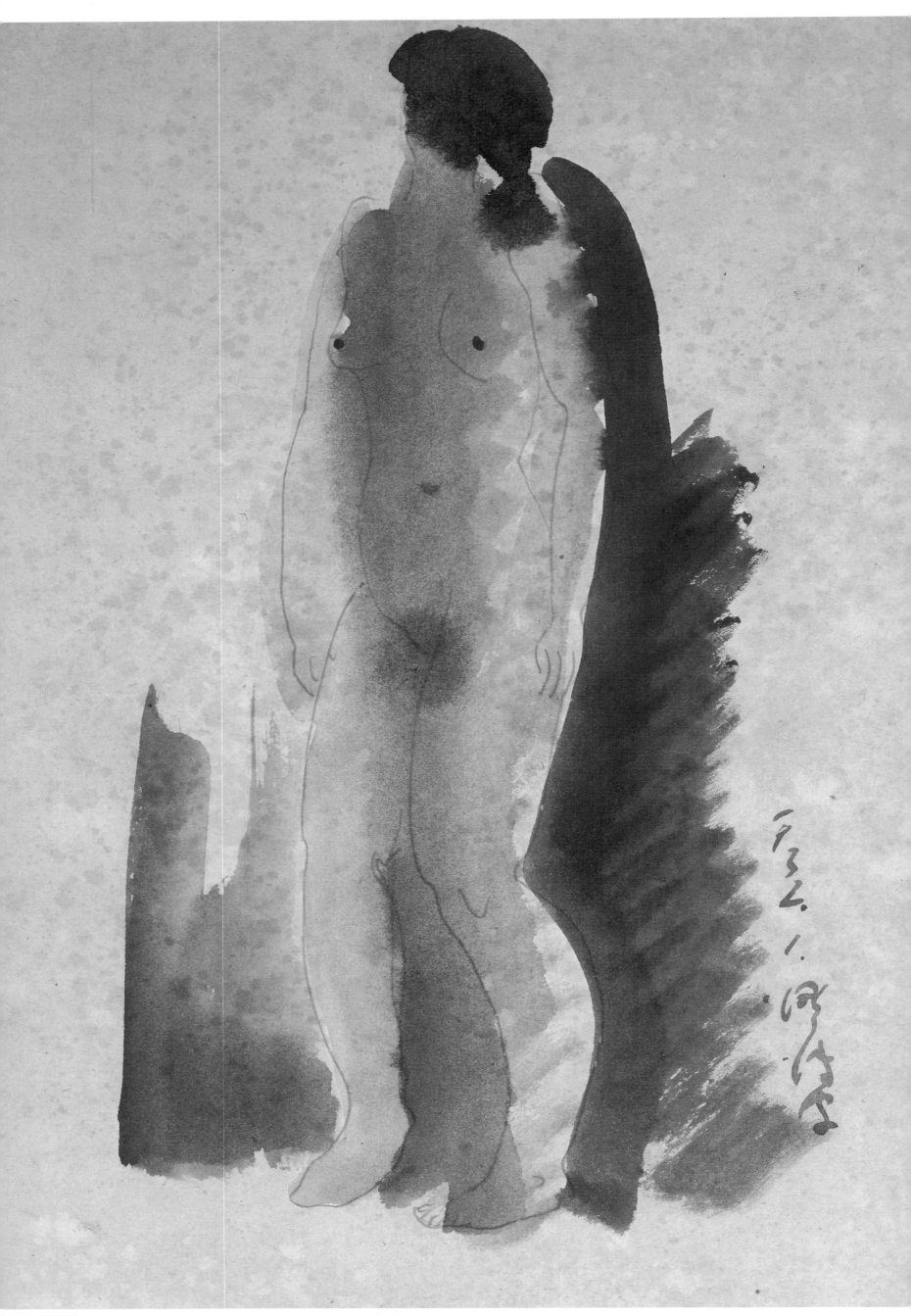

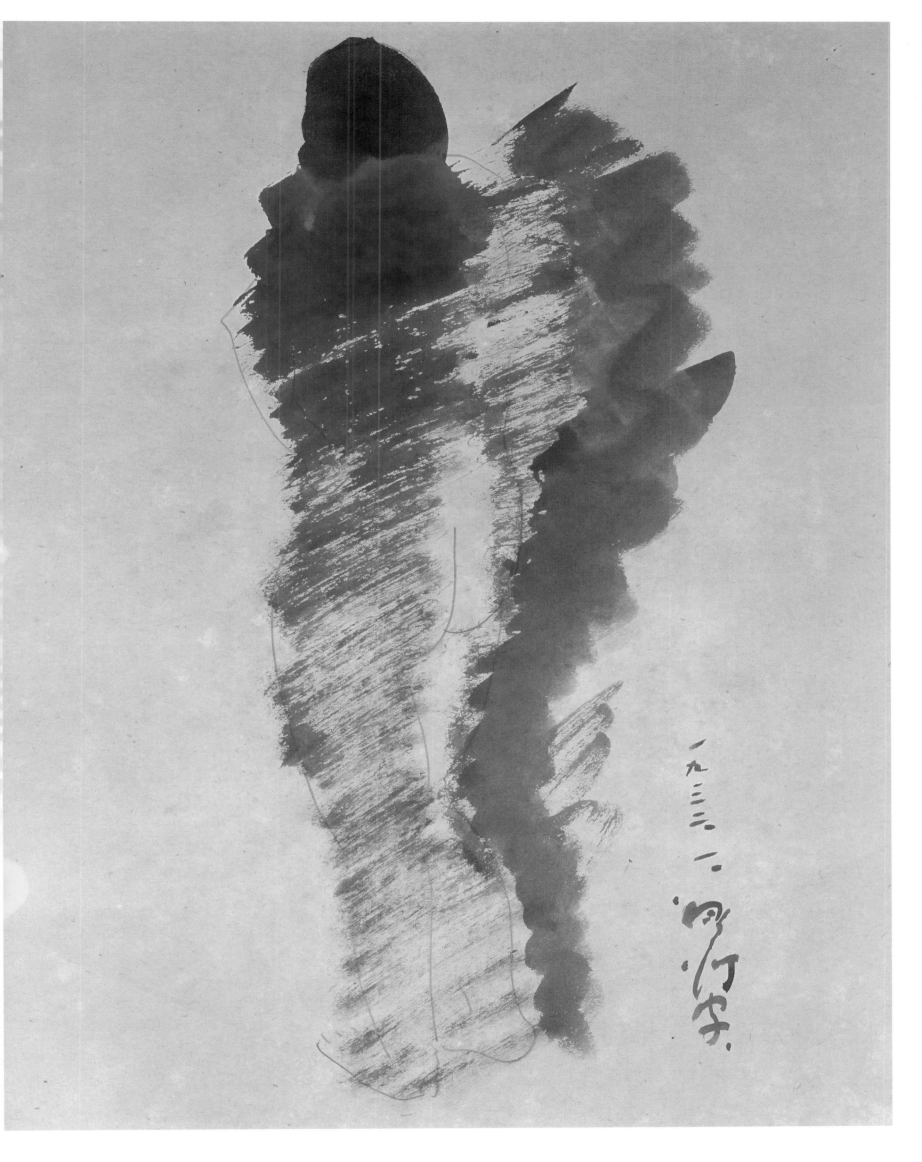

立姿裸女-32.1（43）Standing Nude-32.1 (43)
1932　紙本淡彩鉛筆　36.5×28.5cm

[左頁圖]
立姿裸女-32.1（42）Standing Nude-32.1 (42)
1932　紙本淡彩鉛筆　原寸（36×26.5cm）

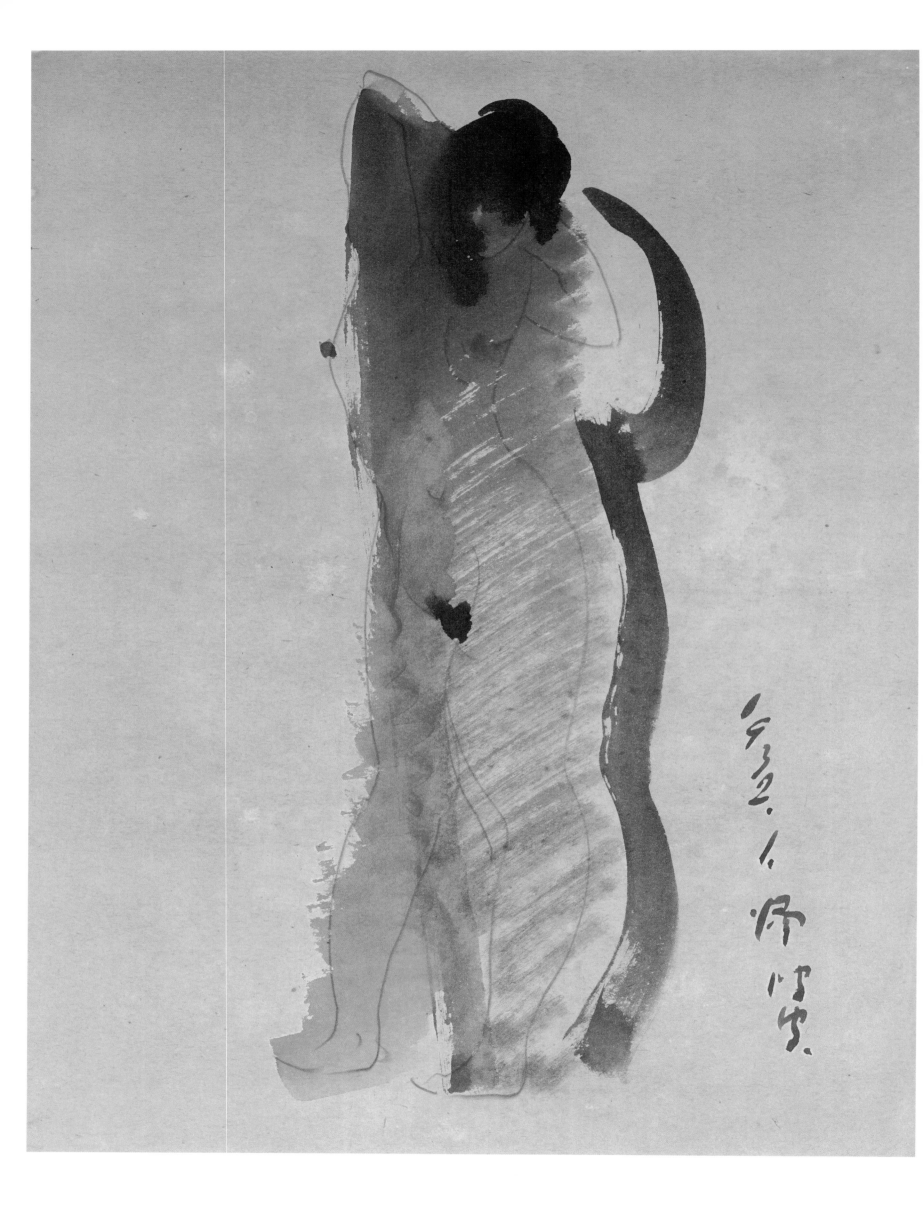

立姿裸女-32.1（44）Standing Nude-32.1 (44)

1932　紙本淡彩鉛筆　36.5×28.5cm

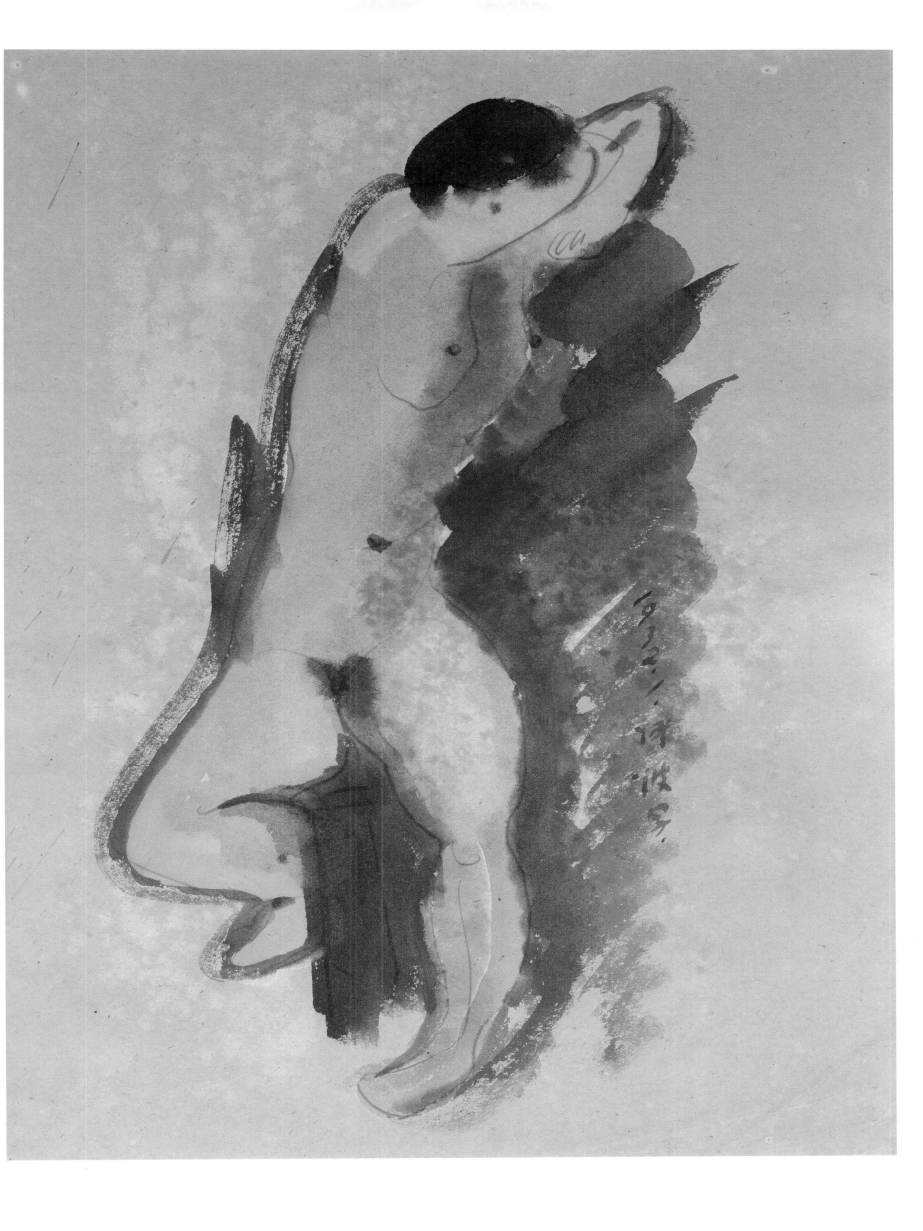

立姿裸女-32.1（45）Standing Nude-32.1 (45)

1932　紙本淡彩鉛筆　36.5×28.5cm

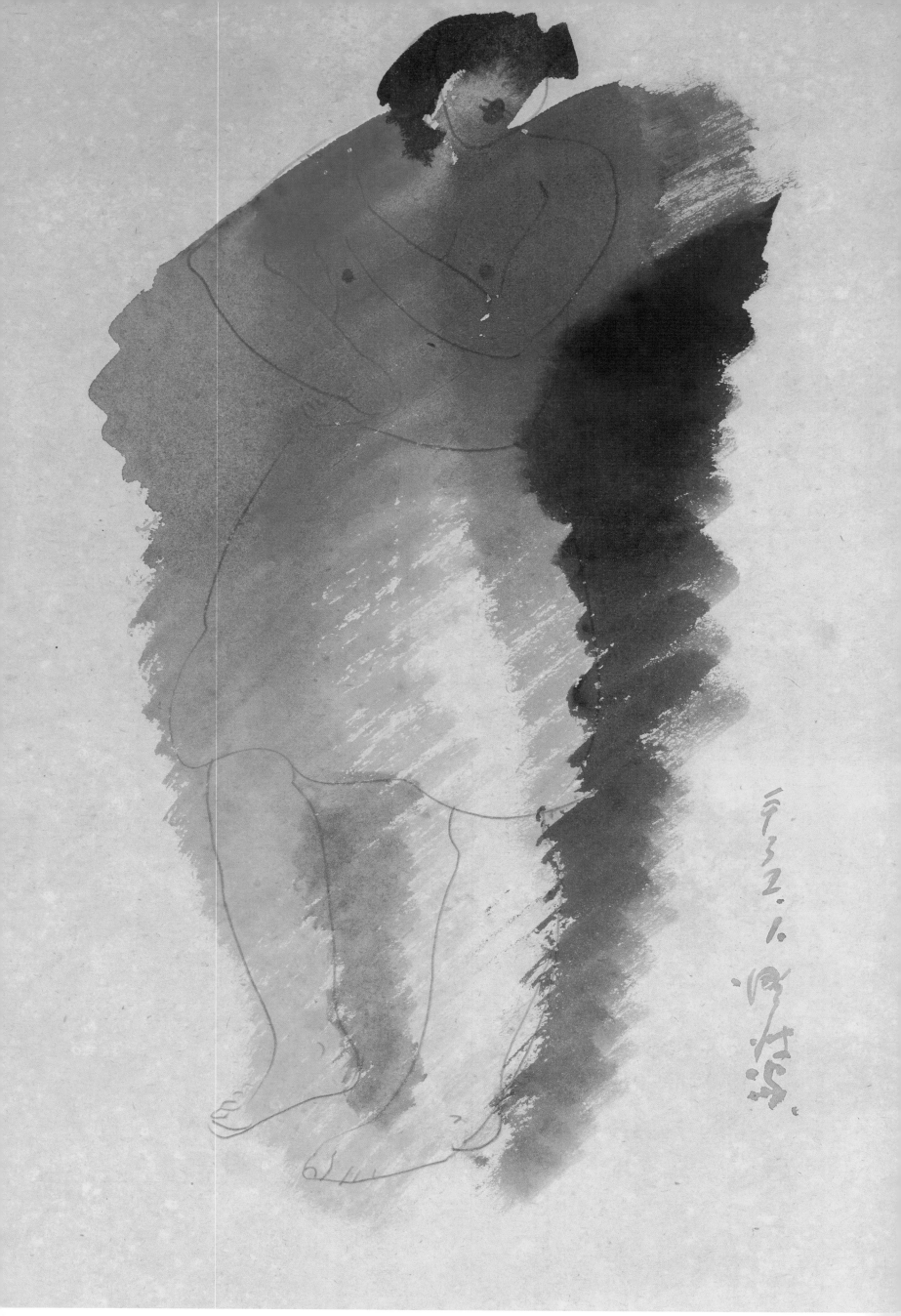

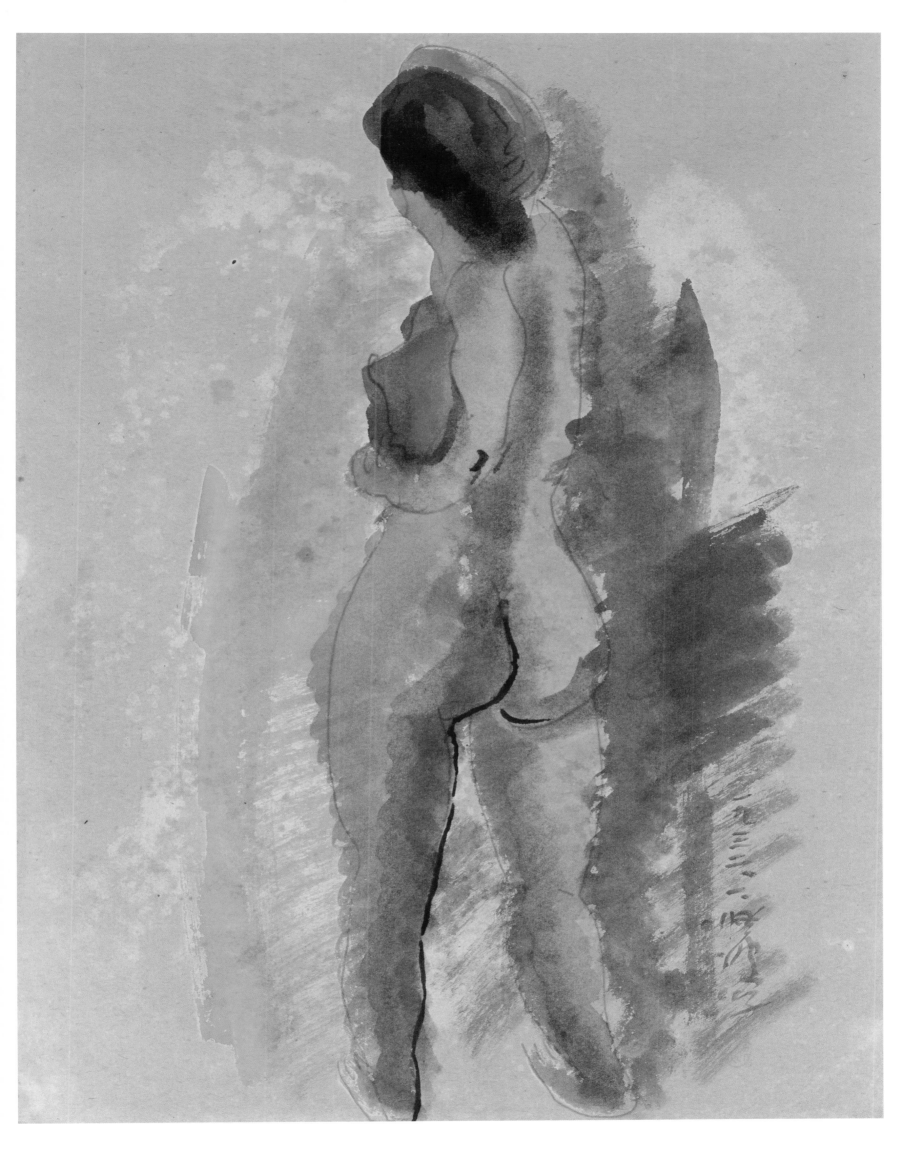

立姿裸女-32.1（47） Standing Nude-32.1 (47)
1932　紙本淡彩鉛筆　36.5×28.5cm

[左頁圖]
立姿裸女-32.1（46） Standing Nude-32.1 (46)
1932　紙本淡彩鉛筆　原寸（36.5×26.5cm）

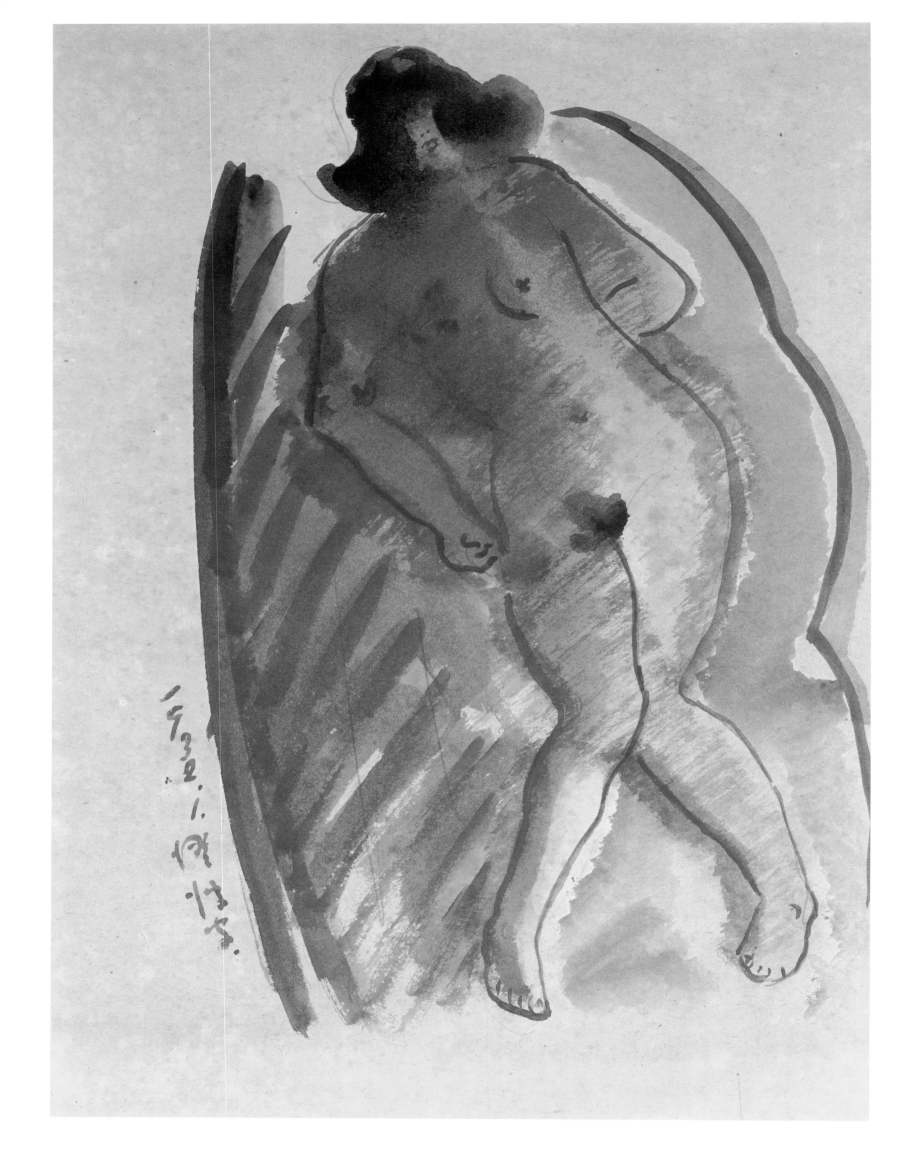

立姿裸女-32.1（48）Standing Nude-32.1 (48)

1932 紙本淡彩鉛筆 36.5×26.5cm

[右頁圖]

坐姿裸女-32.1（103）Seated Nude-32.1 (103)

1932 紙本淡彩鉛筆 原寸（36×26cm）

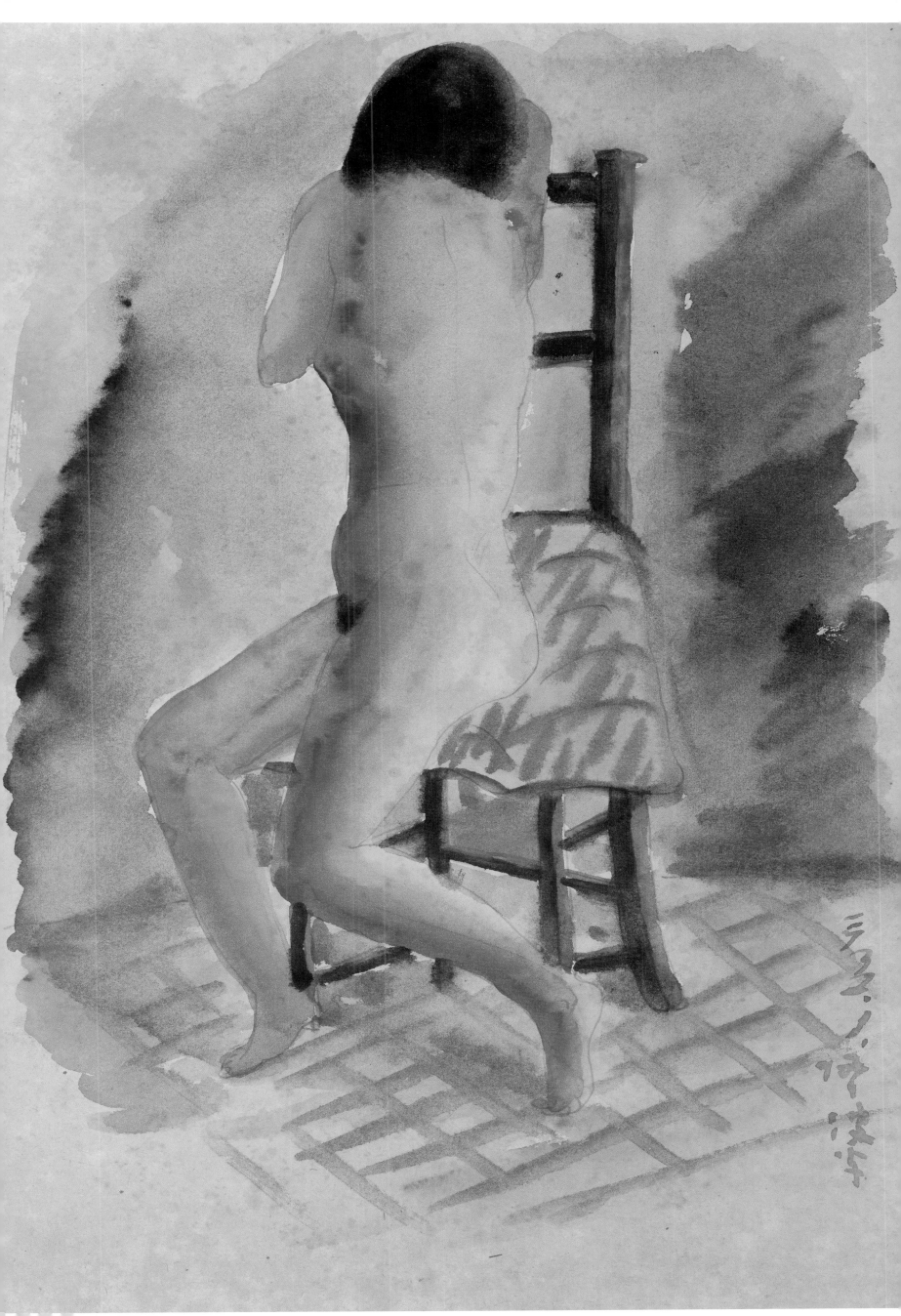

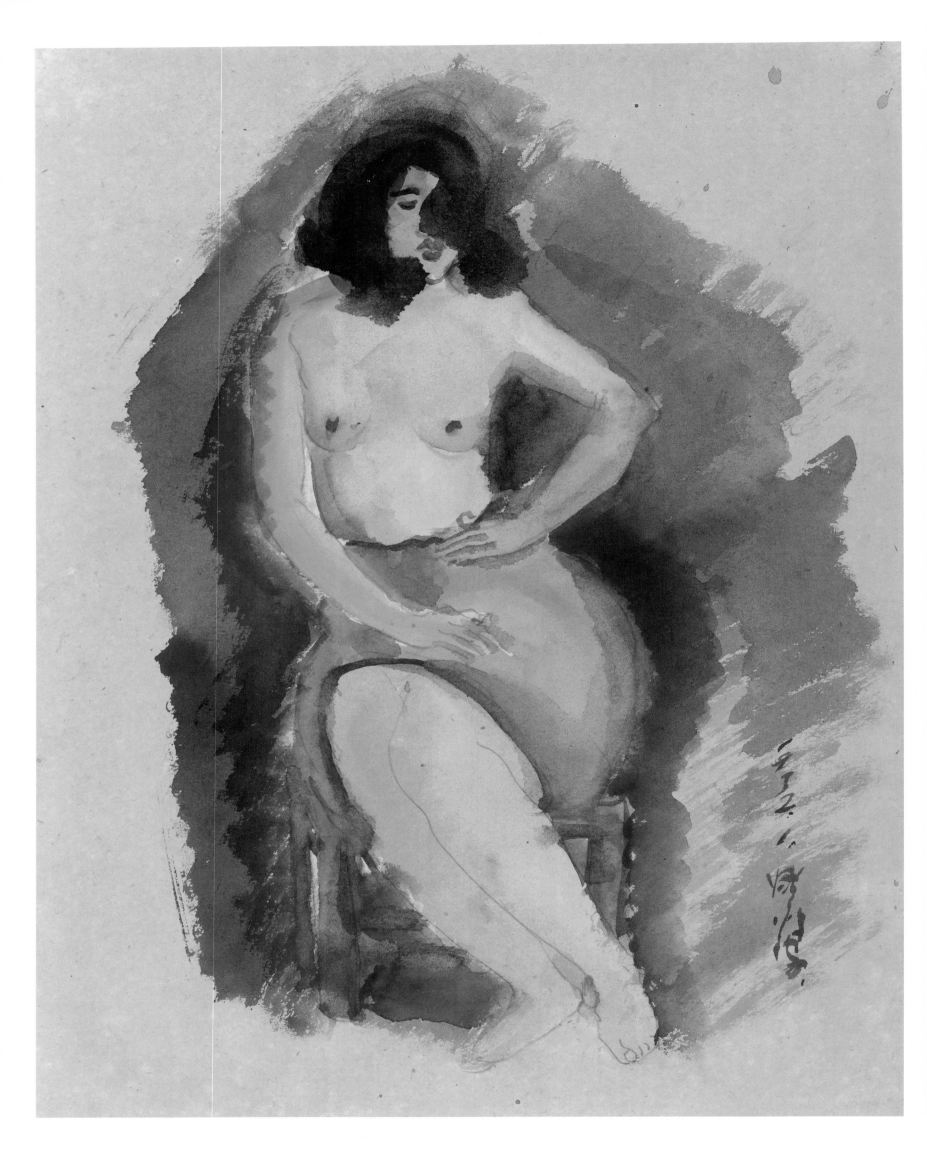

坐姿裸女-32.1（104）Seated Nude-32.1 (104)

1932　紙本淡彩鉛筆　36.3×28cm

[右頁圖]

畫室-32.1（4）Studio-32.1 (4)

1932　紙本淡彩鉛筆　原寸（36.5×26cm）

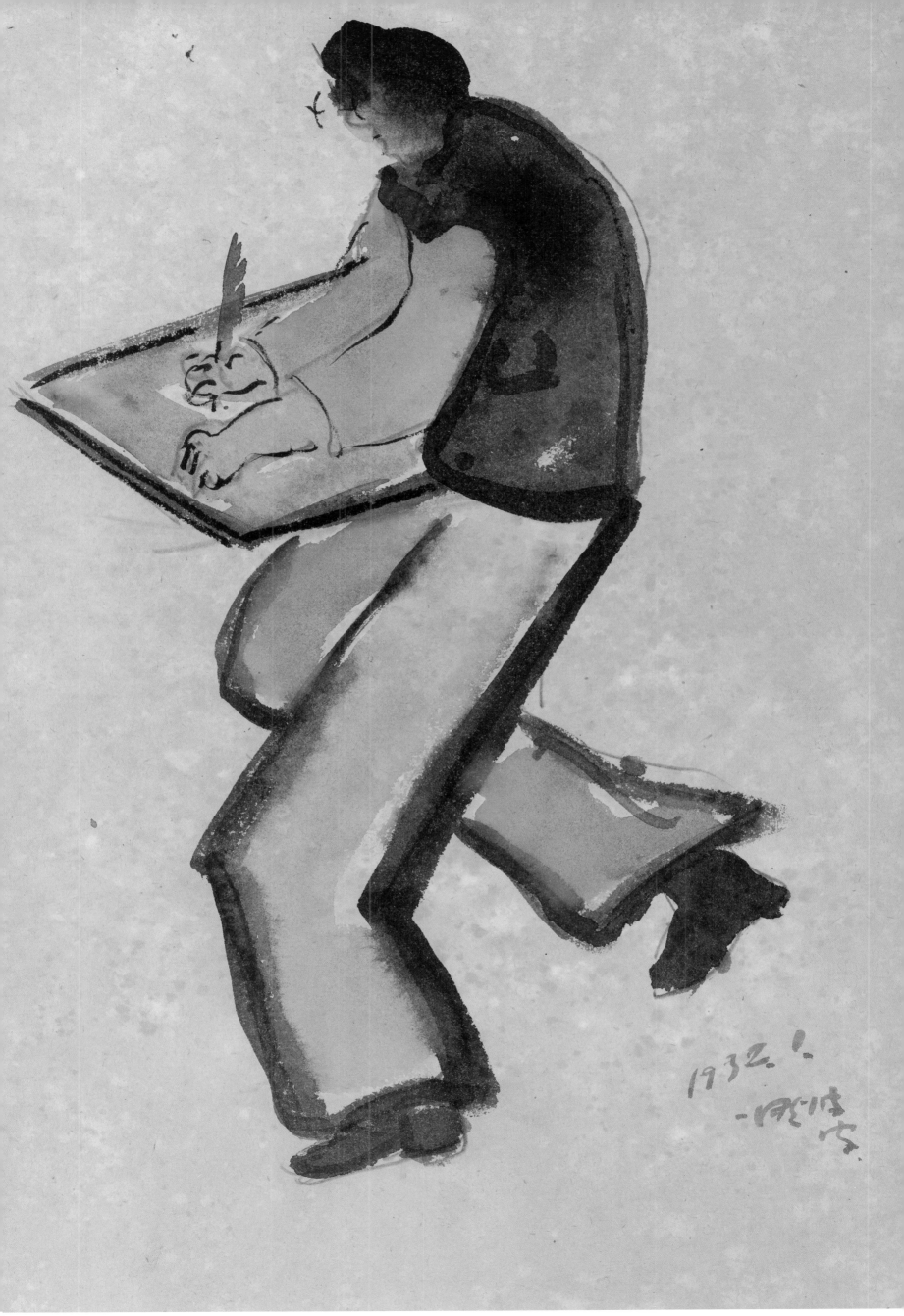

1932.

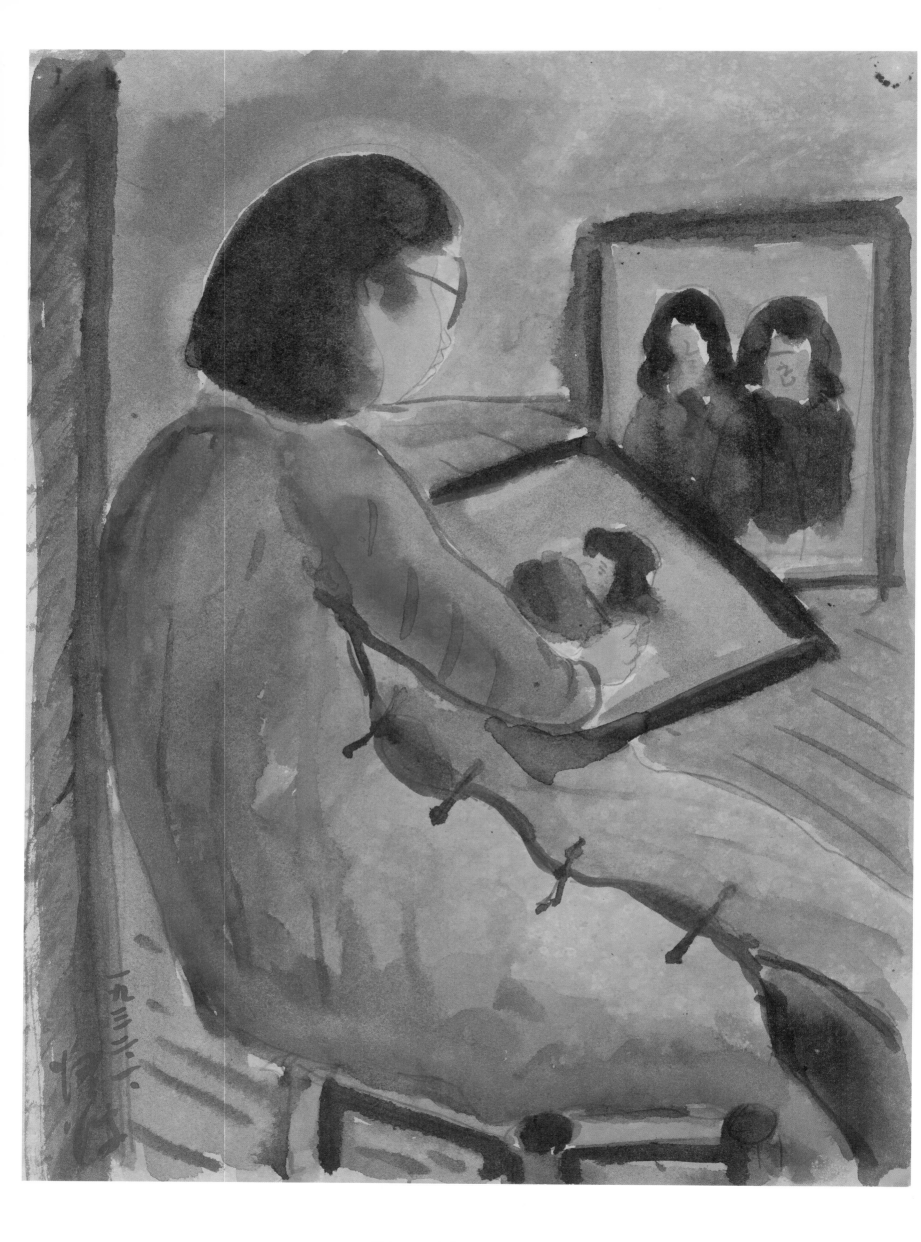

畫室-32.1（5） Studio-32.1 (5)

1932　紙本淡彩鉛筆　35.5×26.5cm

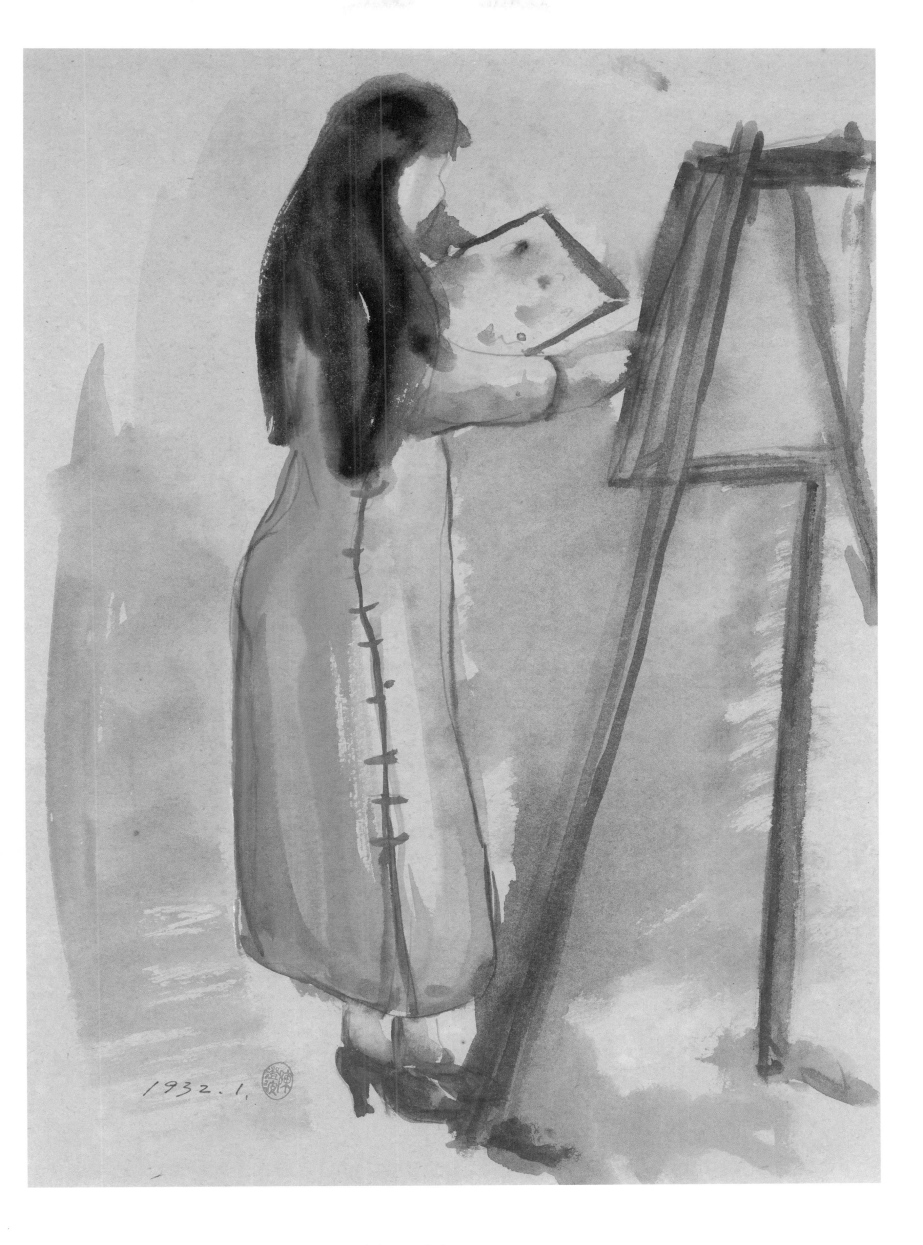

1932.1,

畫室-32.1（6）Studio-32.1 (6)
1932　紙本淡彩鉛筆　36.5×26.5cm

人物-32.1（2） Figure-32.1 (2)
1932　紙本淡彩鉛筆　37×28.5cm

[右頁圖]
人物-32.1（3） Figure-32.1 (3)
1932　紙本淡彩鉛筆　原寸（36×26cm）

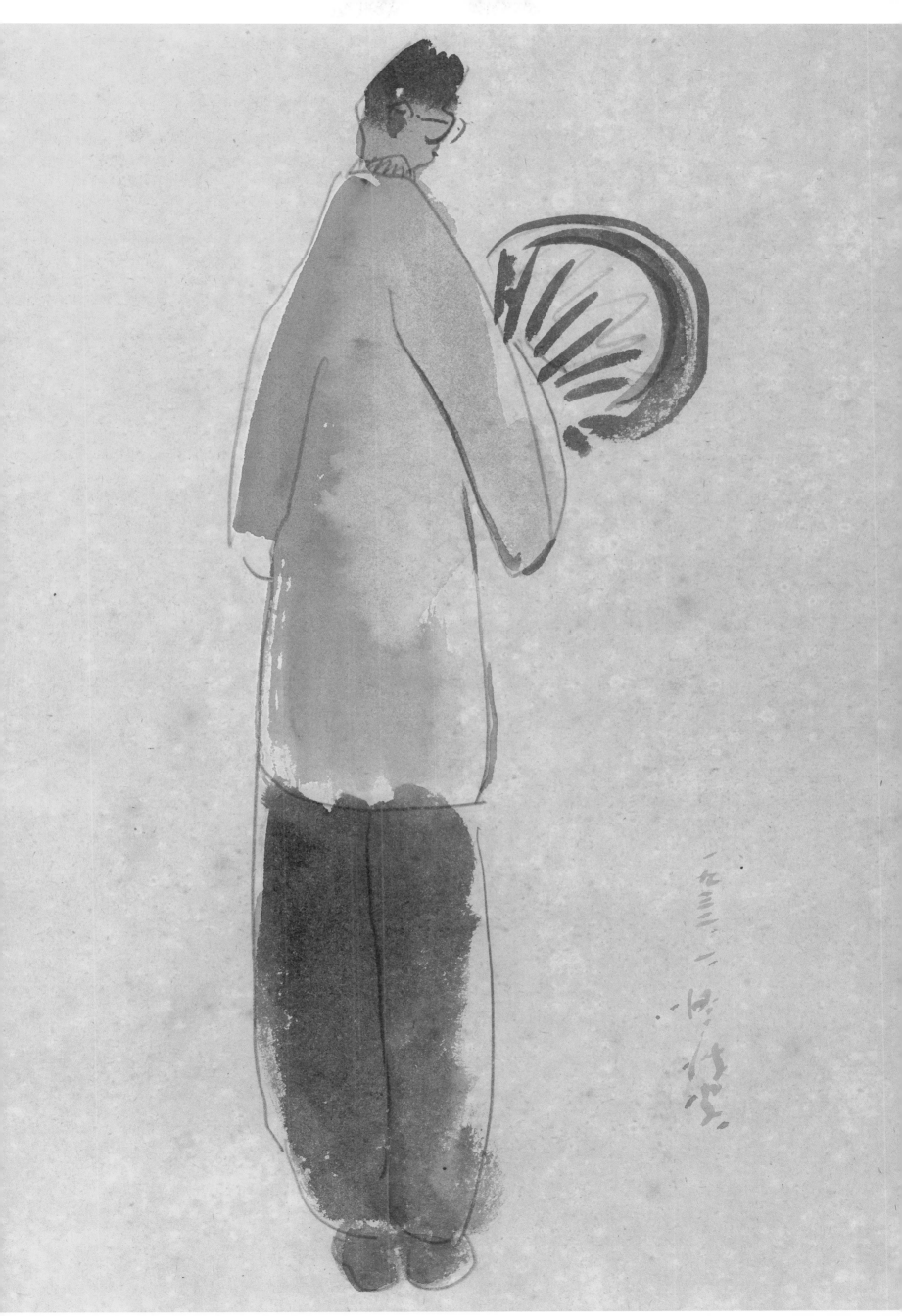

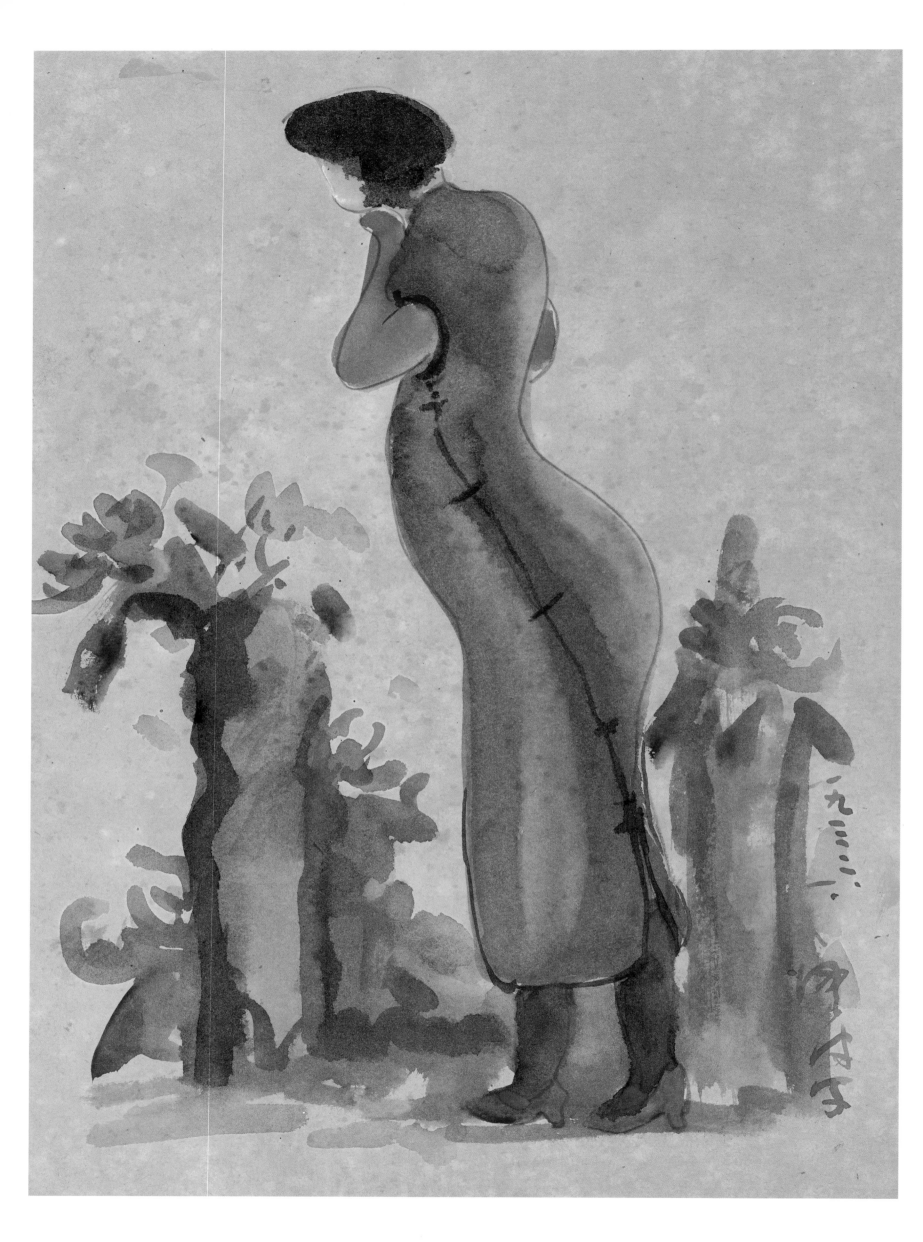

人物-32.1（4）Figure-32.1 (4)

1932　紙本淡彩鉛筆　36.3×26.5cm

人物-32.1（5）Figure-32.1 (5)

1932　紙本淡彩鉛筆　36.5×26.5cm

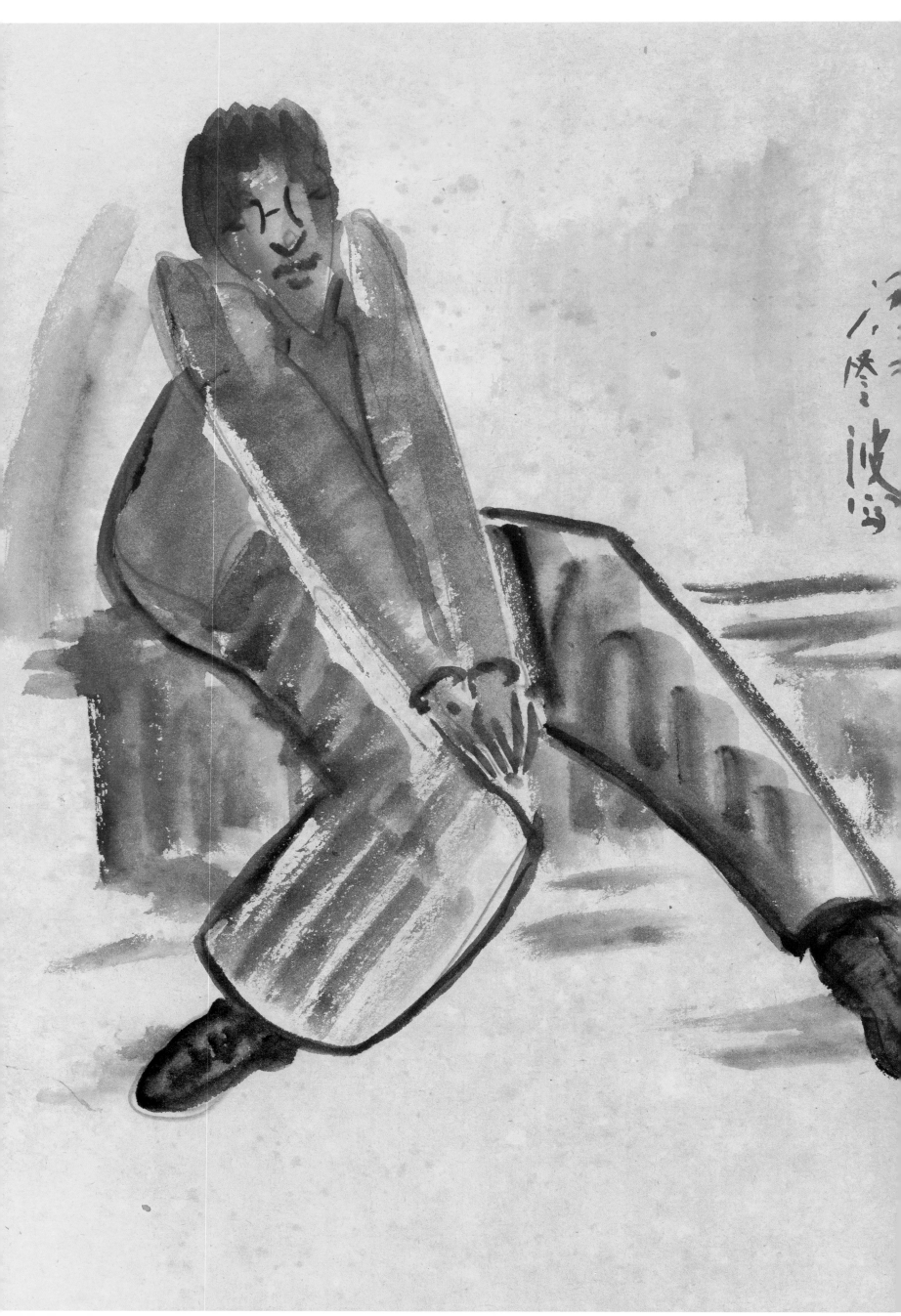

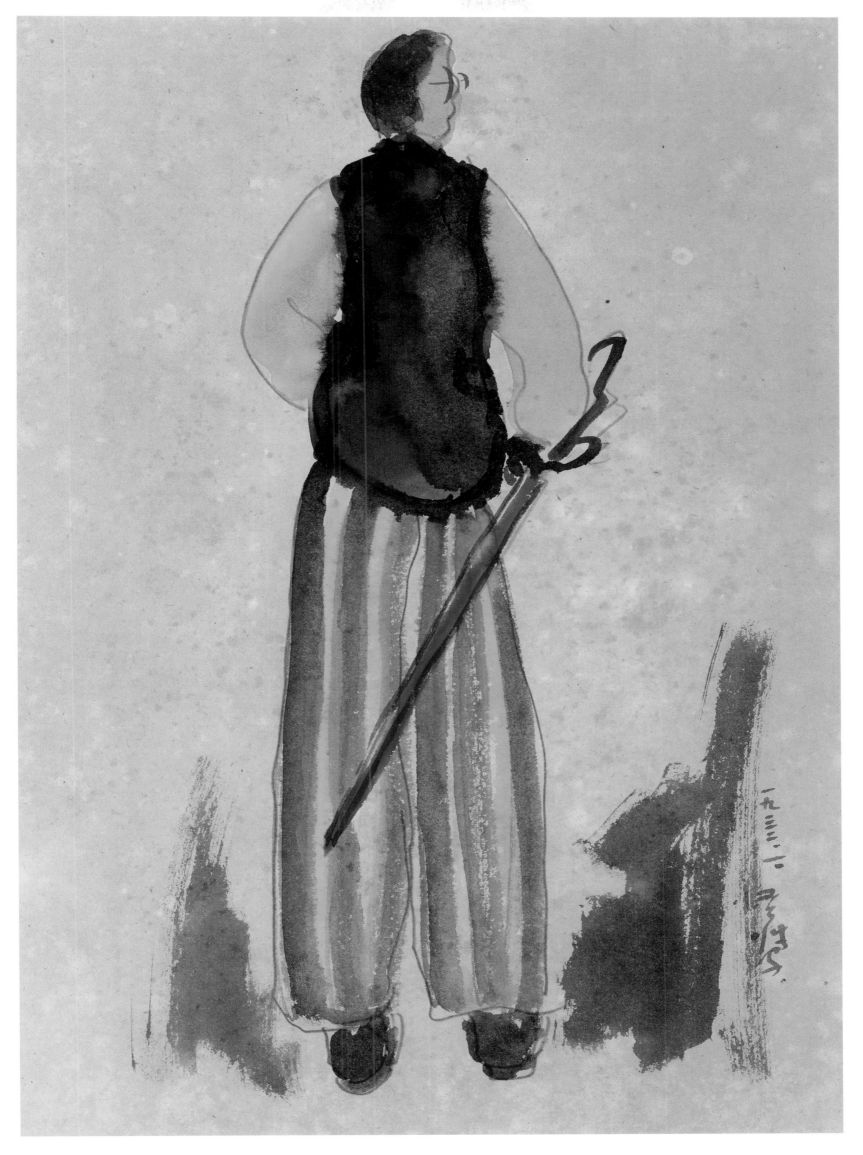

人物-32.1（7）Figure-32.1 (7)
1932　紙本淡彩鉛筆　36.5×26cm

[左頁圖]
人物-32.1（6）Figure-32.1 (6)
1932　紙本淡彩鉛筆　原寸（36×26cm）

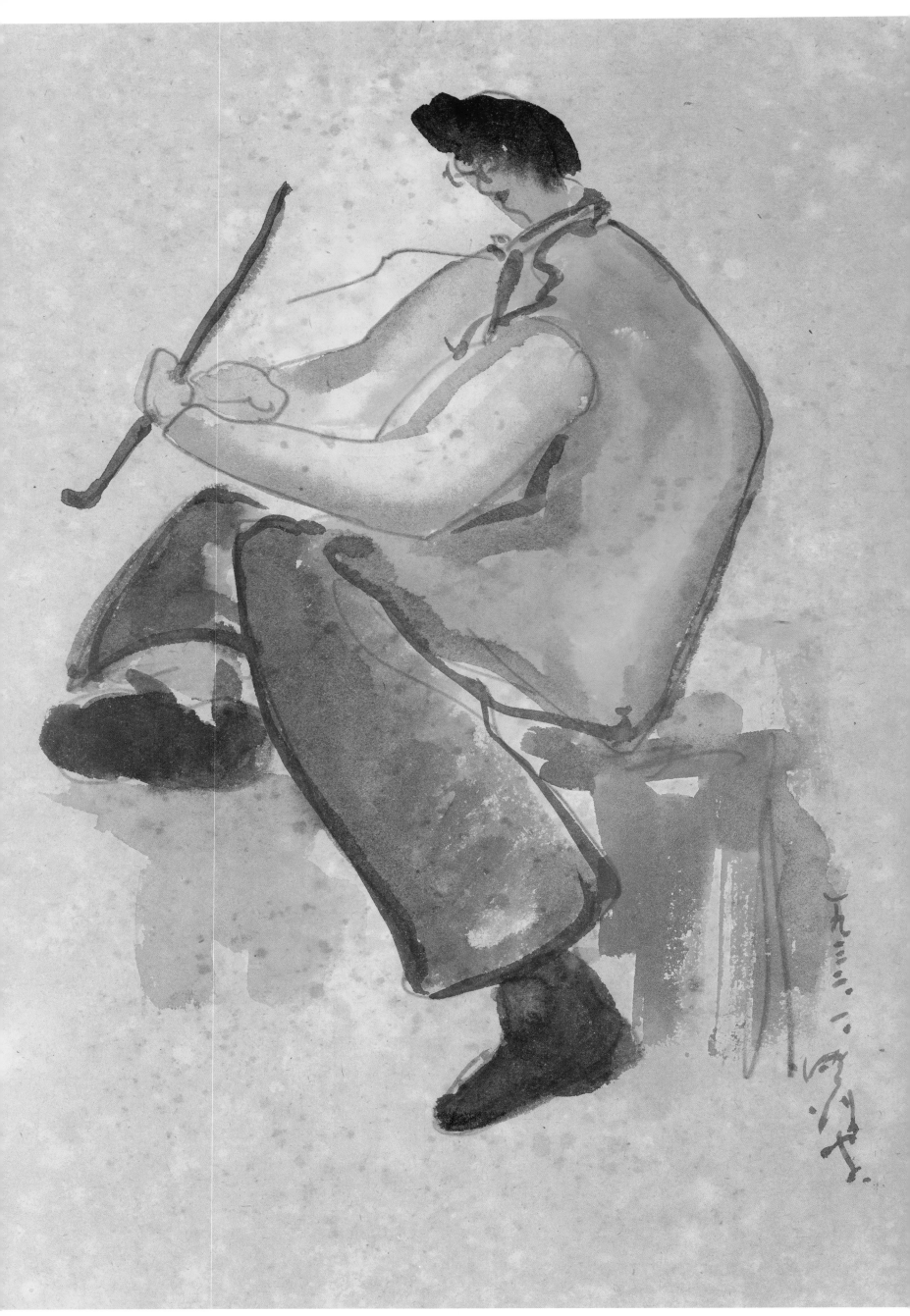

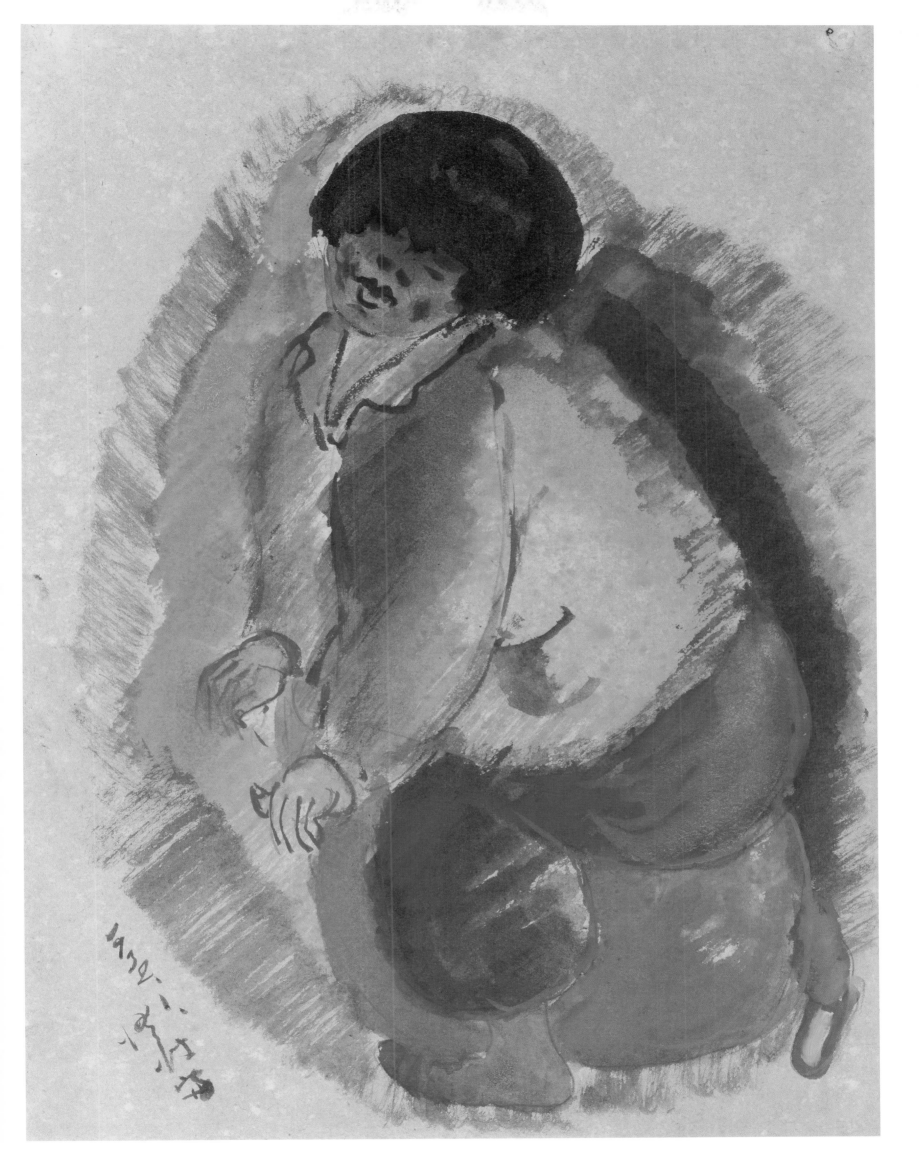

人物-32.1（9） Figure-32.1 (9)
1932　紙本淡彩鉛筆　36×26.5cm

[左頁圖]
人物-32.1（8） Figure-32.1 (8)
1932　紙本淡彩鉛筆　原寸（36.5×26cm）

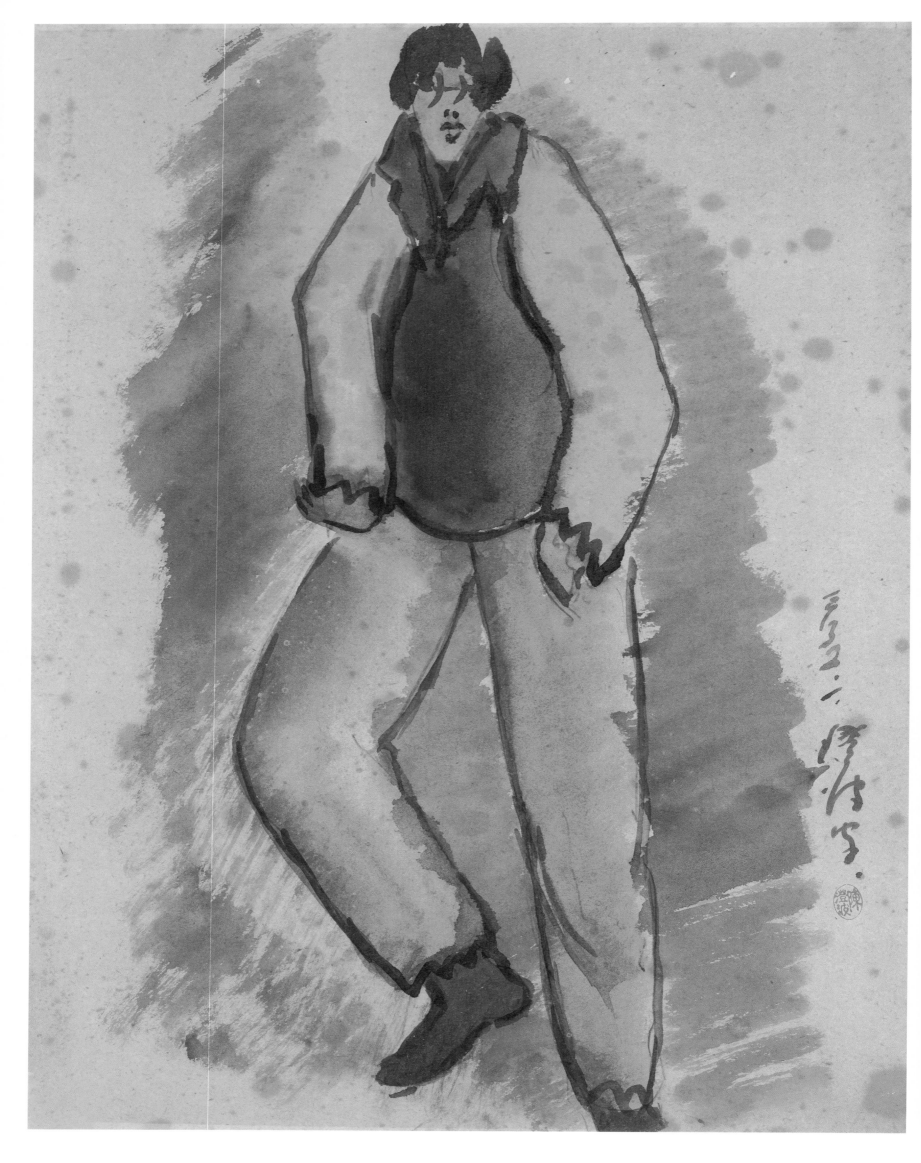

人物-32.1（10） Figure-32.1 (10)

1932　紙本淡彩鉛筆　37×28.5cm

［右頁圖］

人物-32.1（11） Figure-32.1 (11)

1932　紙本淡彩鉛筆　原寸（36×26.5cm）

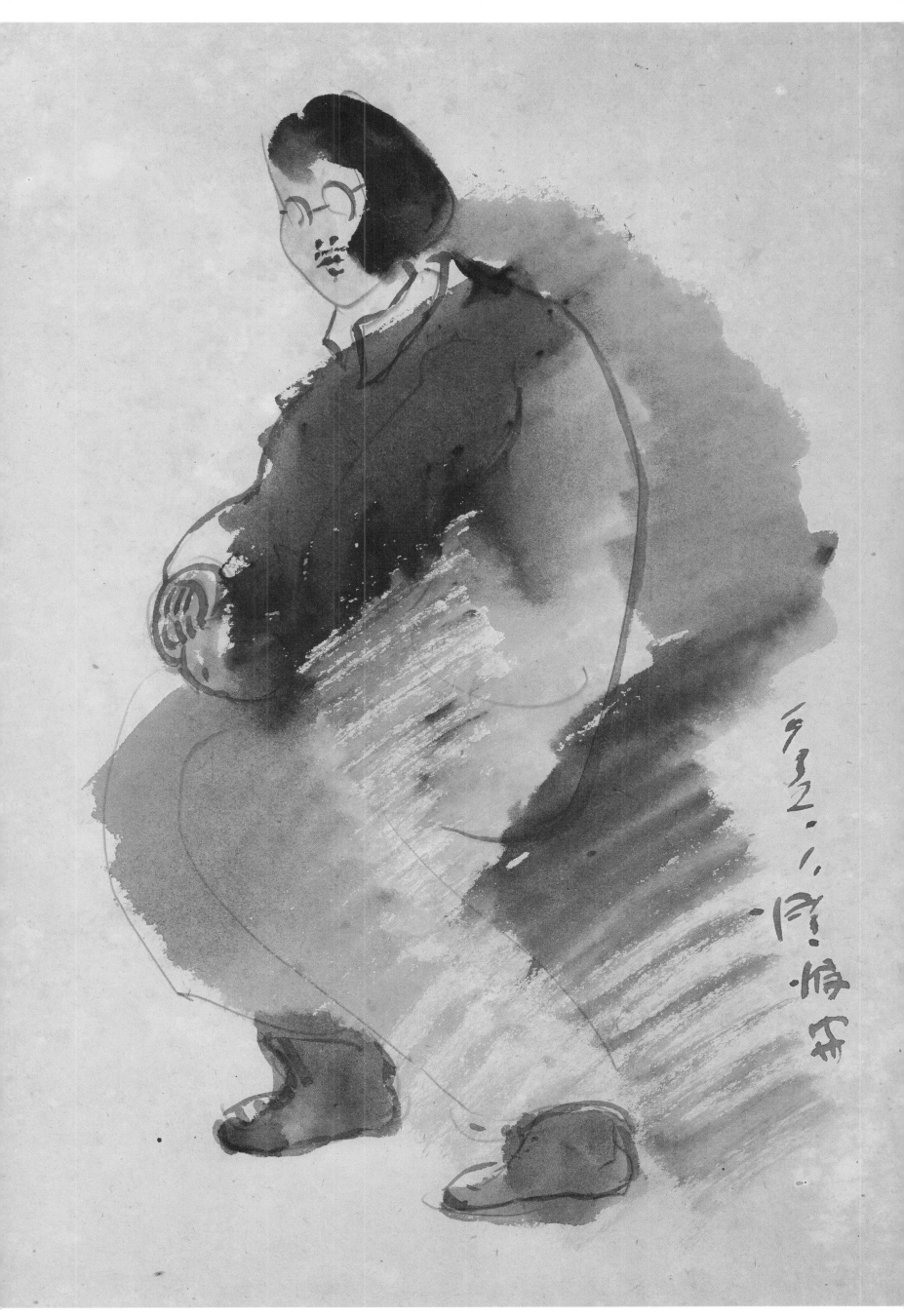

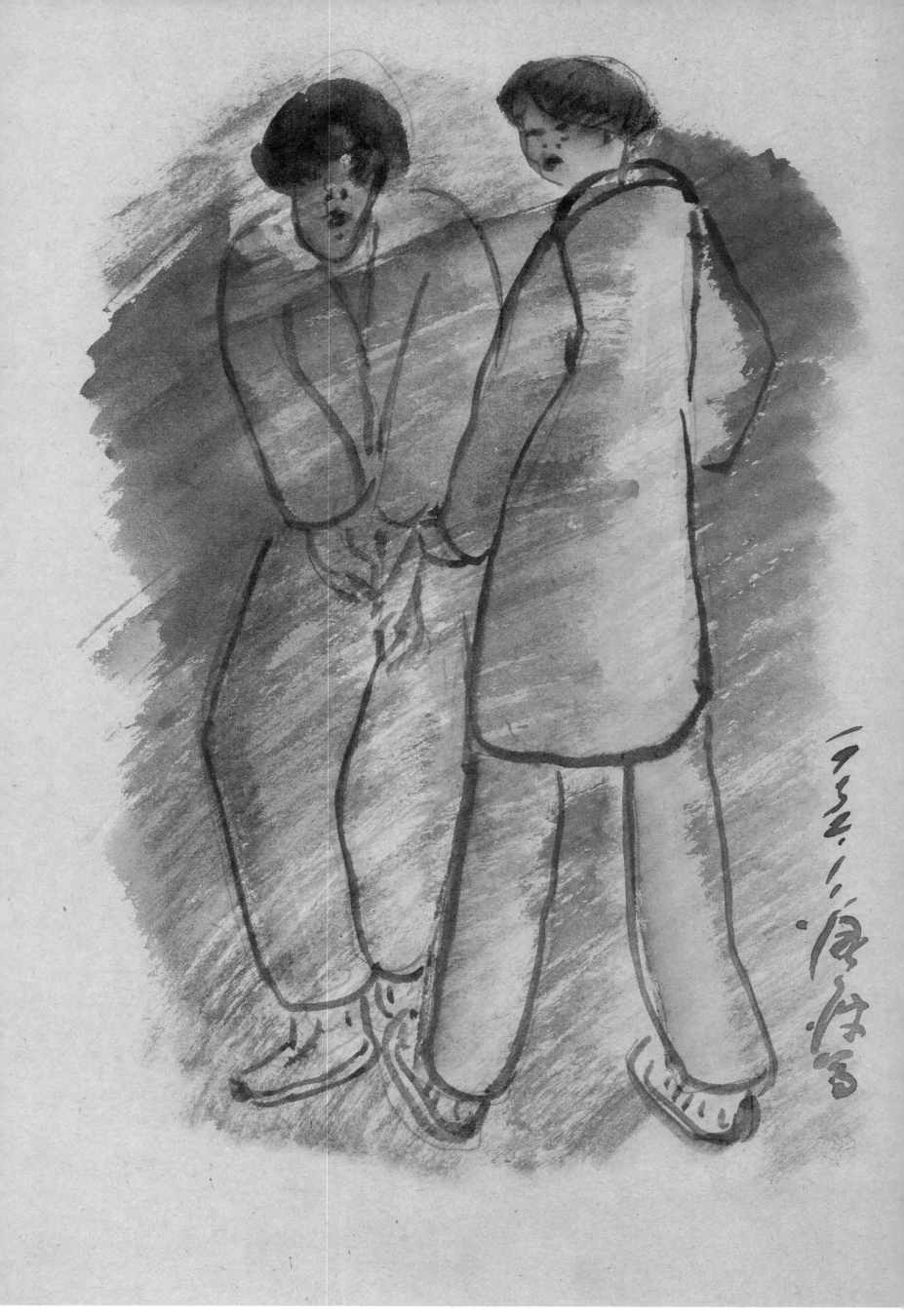

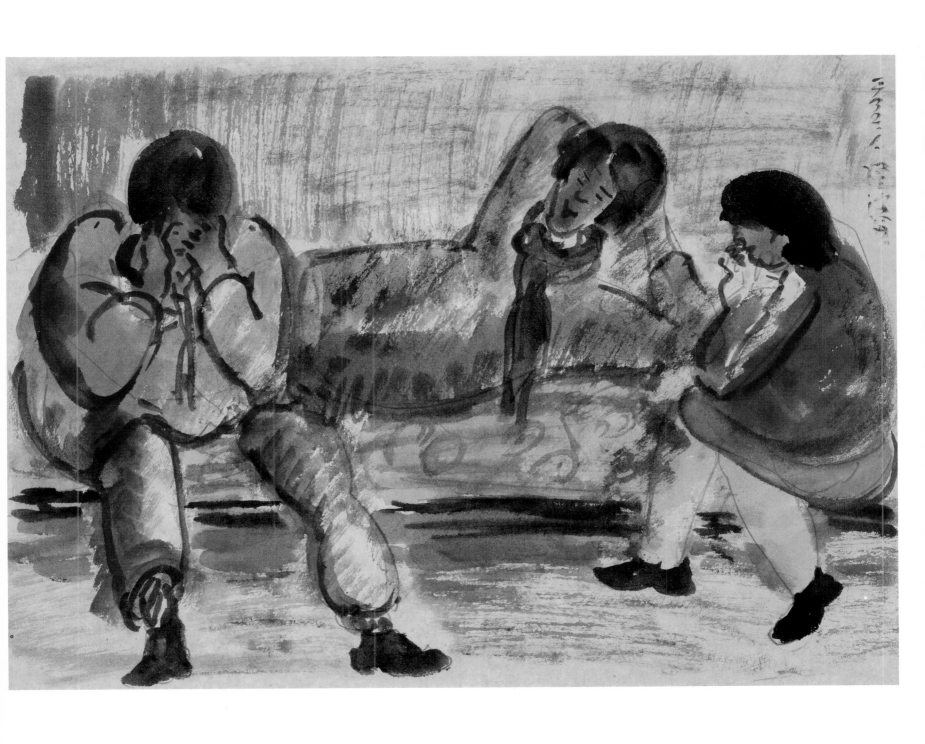

群像-32.1（2）Group Portrait-32.1 (2)
1932　紙本淡彩鉛筆　26.5×36.5cm

[左頁圖]
群像-32.1（1）Group Portrait-32.1 (1)
1932　紙本淡彩鉛筆　原寸（36.5×26.5cm）

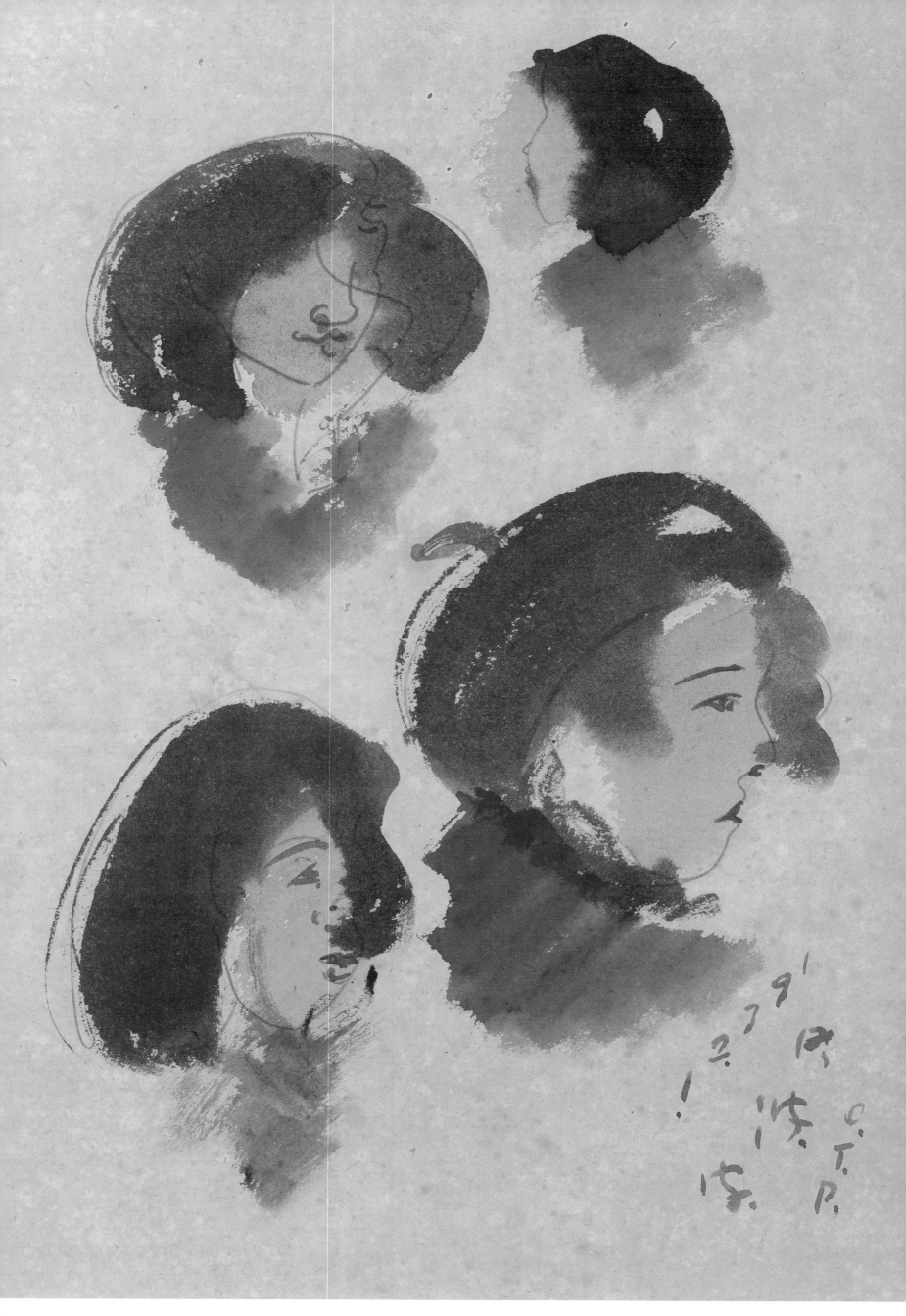

貓-32.1　Cat-32.1

1932　紙本淡彩　27×30.5cm

[左頁圖]

群像-32.1（3） Group Portrait-32.1 (3)

1932　紙本淡彩鉛筆　原寸（36.3×26.5cm）

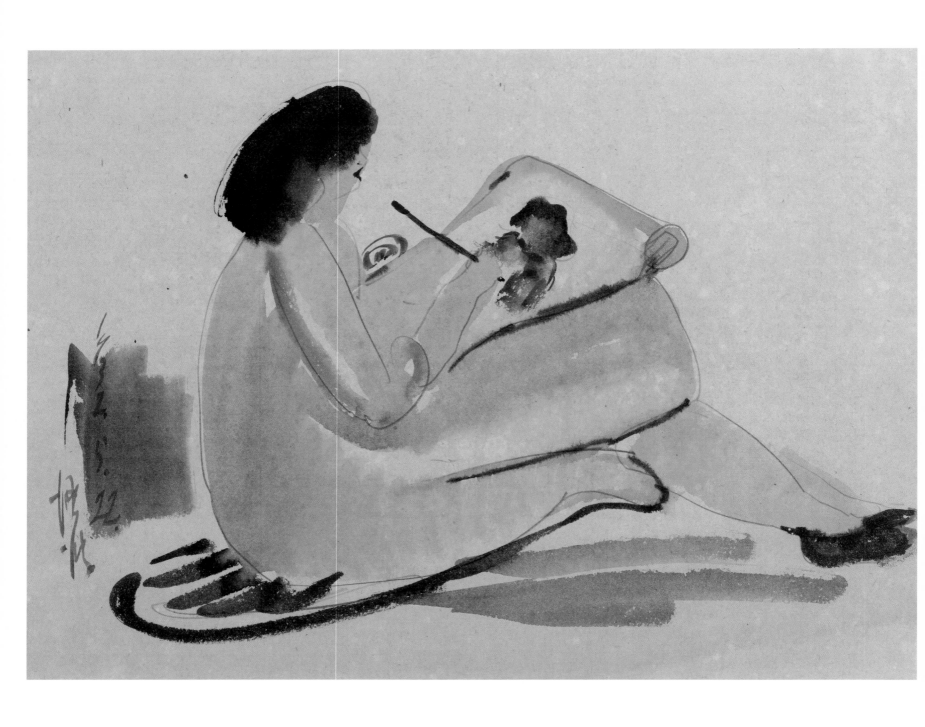

畫室-32.3.22（7） Studio-32.3.22 (7)

1932　紙本淡彩鉛筆　26.5×36cm

[右頁圖]

立姿裸女-32.2.14（49） Standing Nude-32.2.14 (49)

1932　紙本淡彩鉛筆　原寸（36×26.5cm）

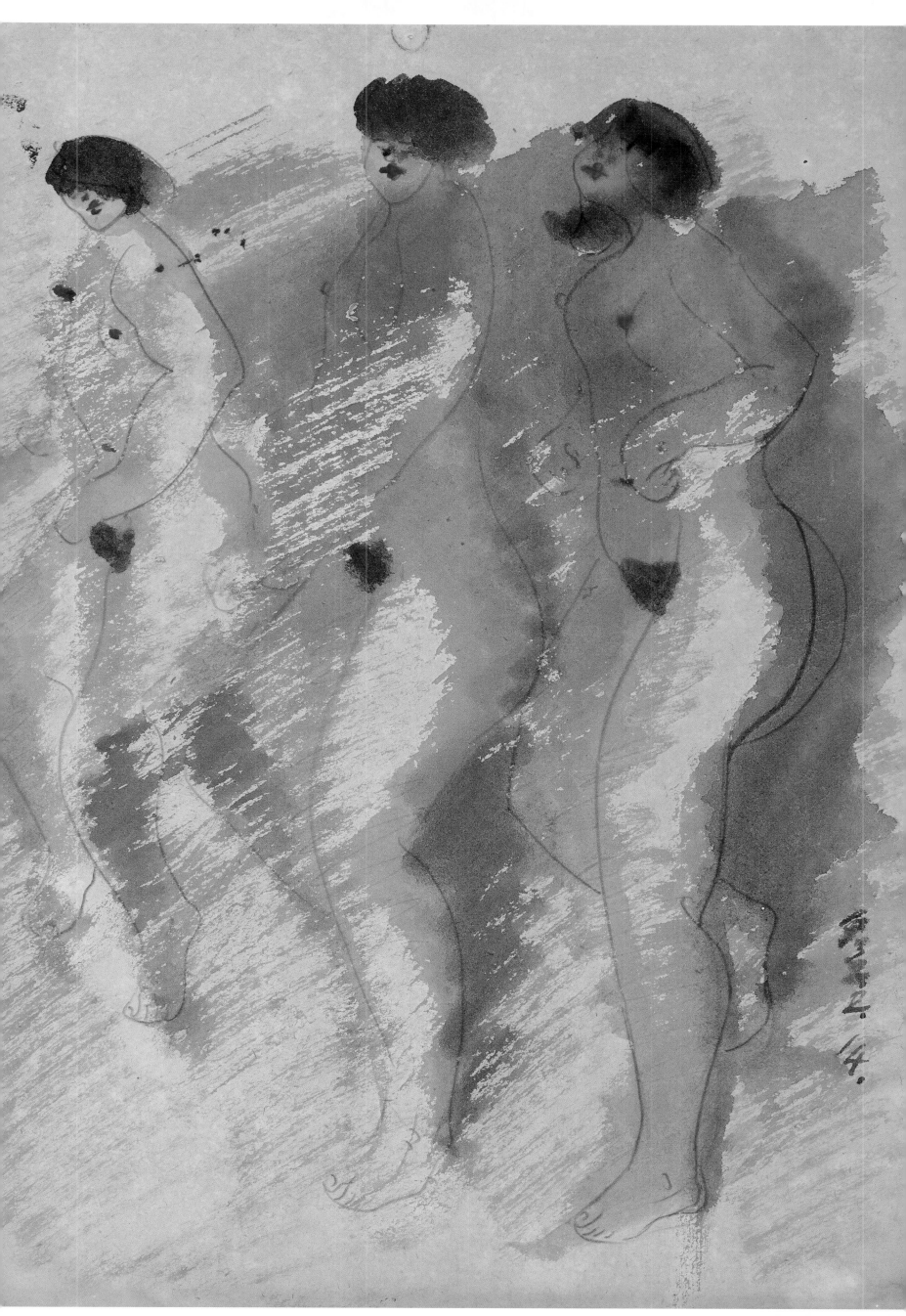

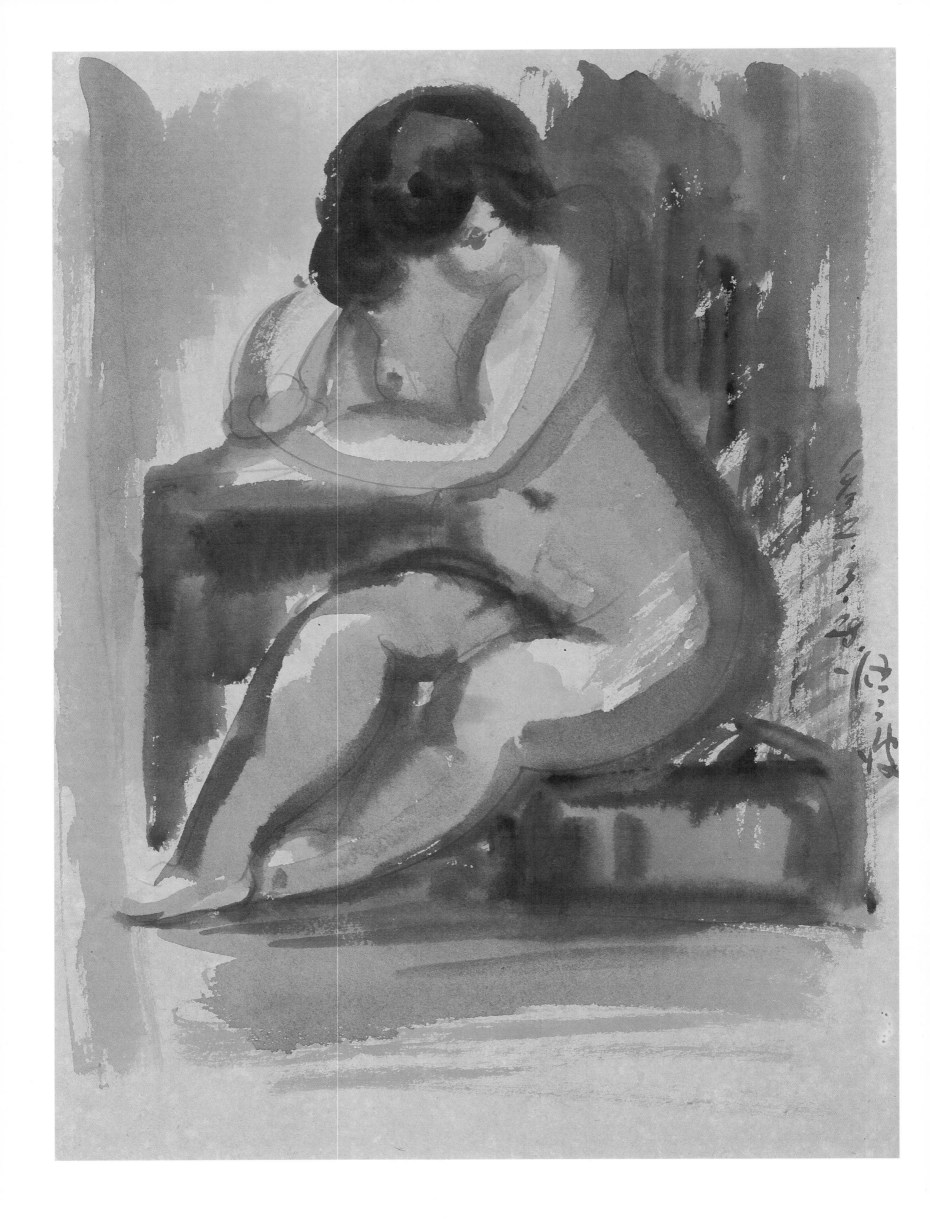

坐姿裸女-32.3.28（106）Seated Nude-32.3.28 (106)

1932　紙本淡彩鉛筆　36×26.5cm

淡彩速寫
Watercolor Sketch

1932.4-1933

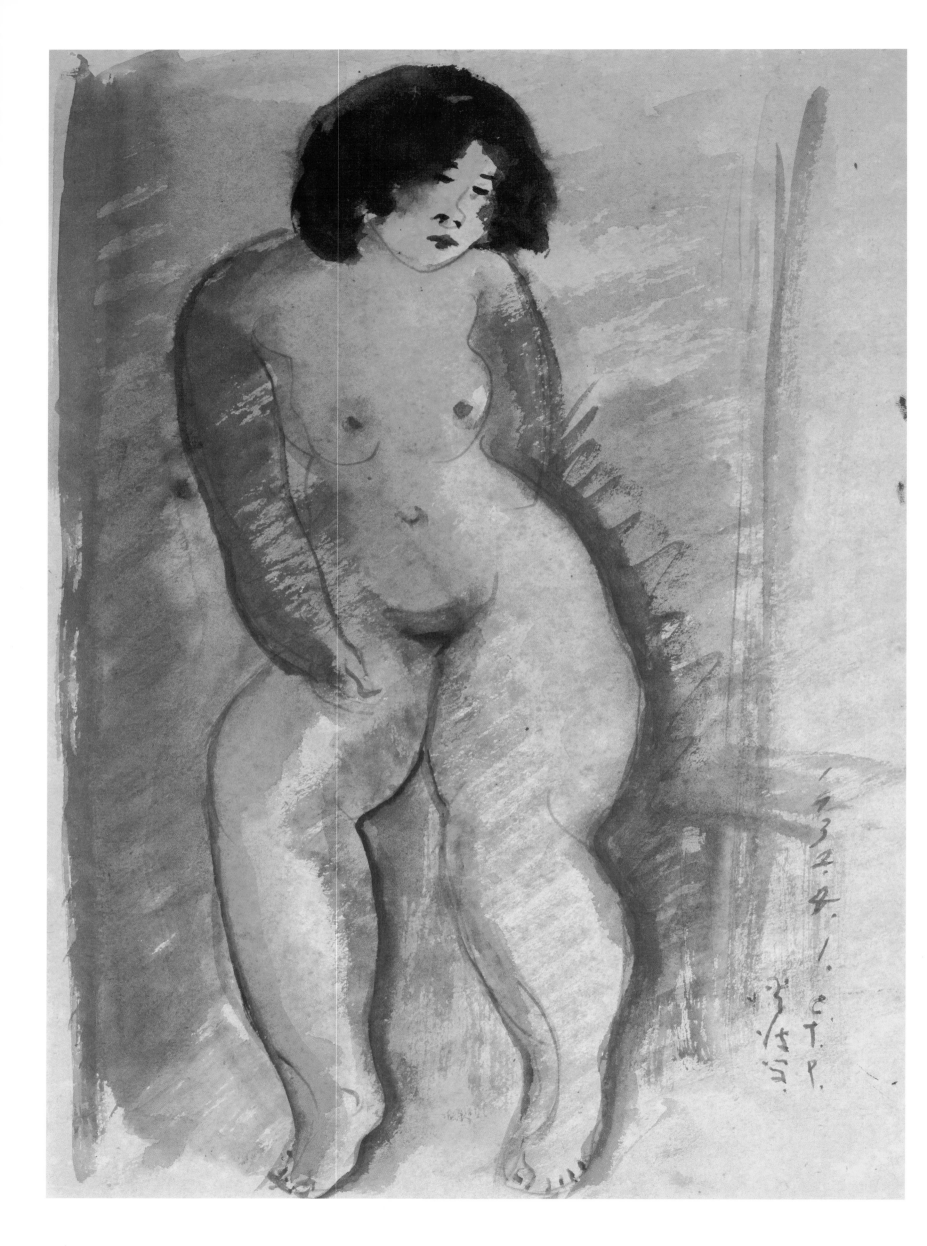

立姿裸女-32.4.1（50） Standing Nude-32.4.1 (50)

1932　紙本淡彩鉛筆　36.5×26.5cm

頭像-32.4.1（1）Portrait-32.4.1 (1)

1932　紙本淡彩　36.5×26.5cm

271

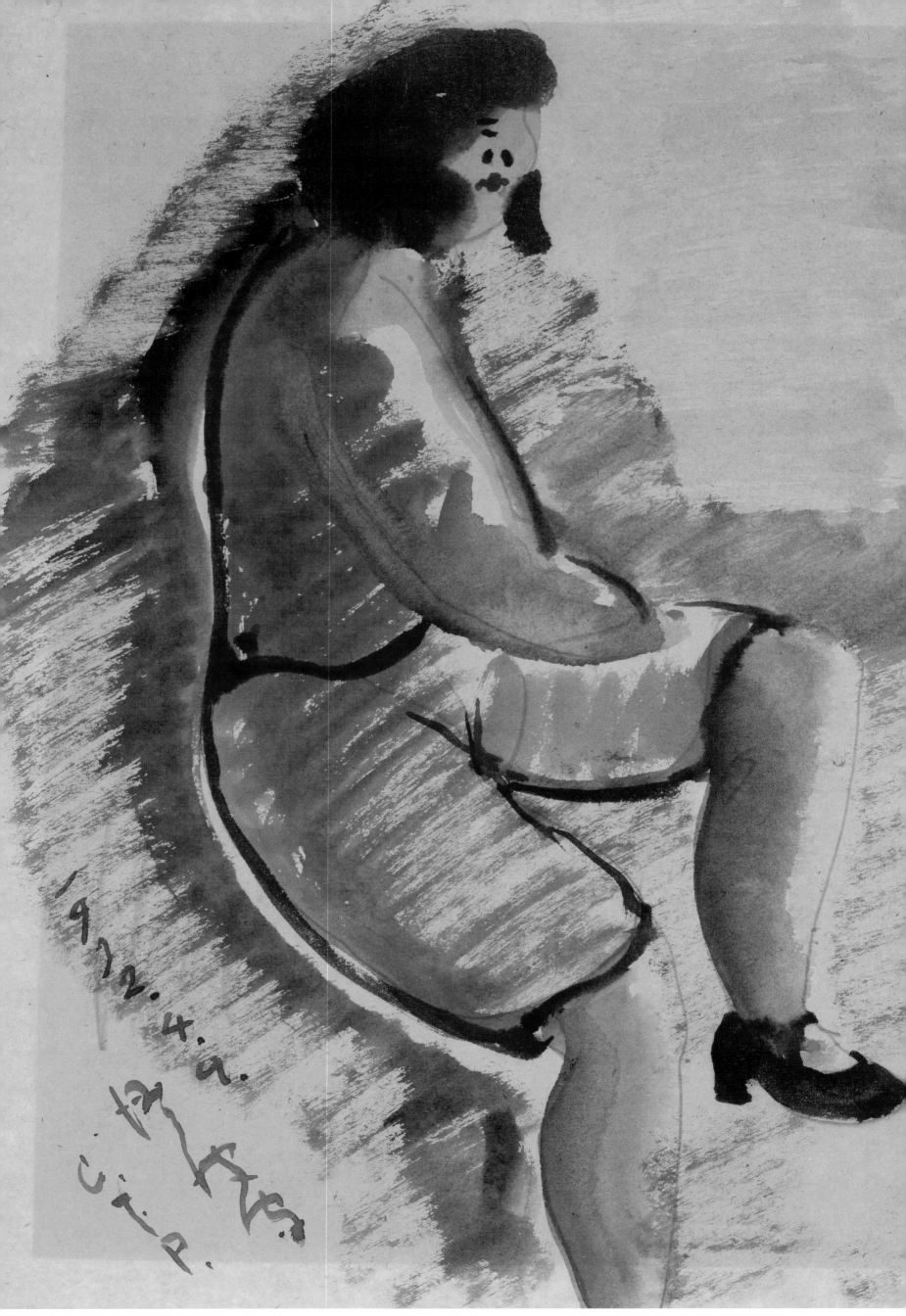

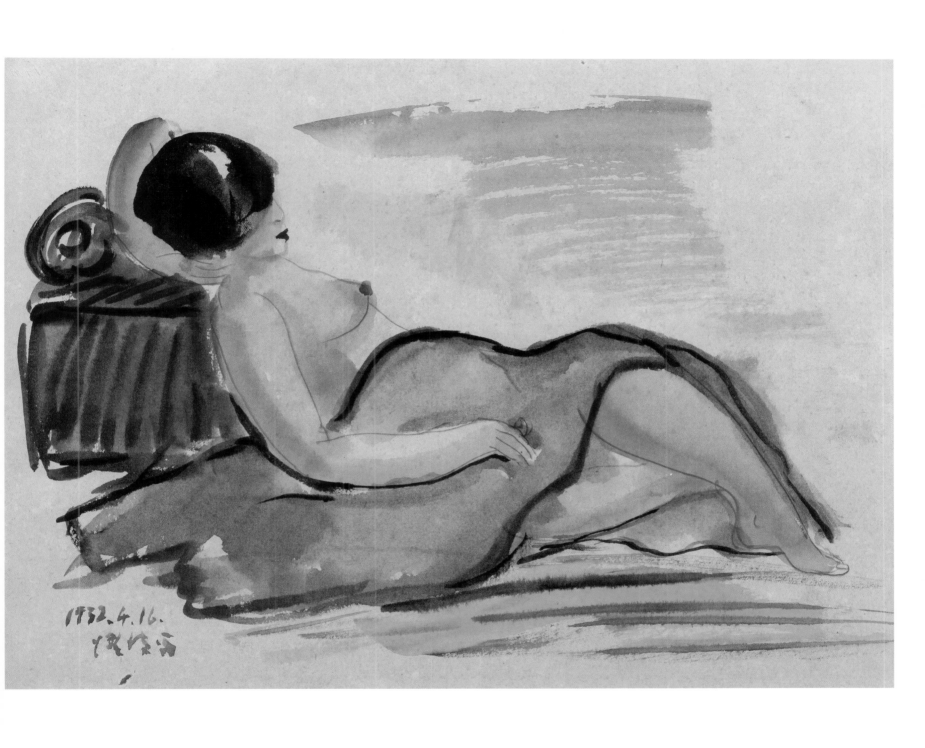

坐姿裸女-32.4.16（107） Seated Nude-32.4.16 (107)
1932　紙本淡彩鉛筆　26.5×36.3cm

[左頁圖]
人物-32.4.9（12） Figure-32.4.9 (12)
1932　紙本淡彩鉛筆　原寸（36.5×26cm）

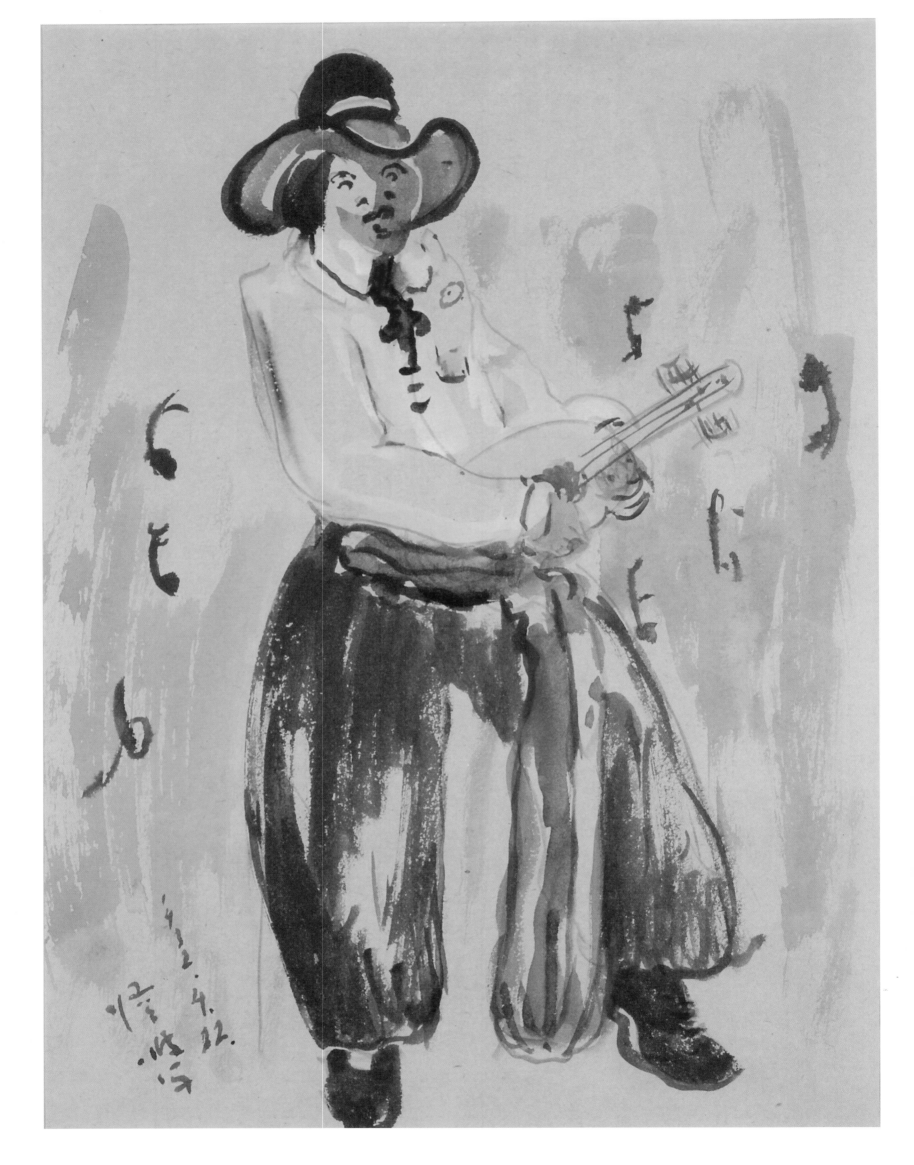

人物-32.4.22（13） Figure-32.4.22 (13)

1932　紙本淡彩鉛筆　37×26.5cm

[右頁圖]

群像-32.4.16（4） Group Portrait-32.4.16 (4)

1932　紙本淡彩鉛筆　原寸（36×26.5cm）

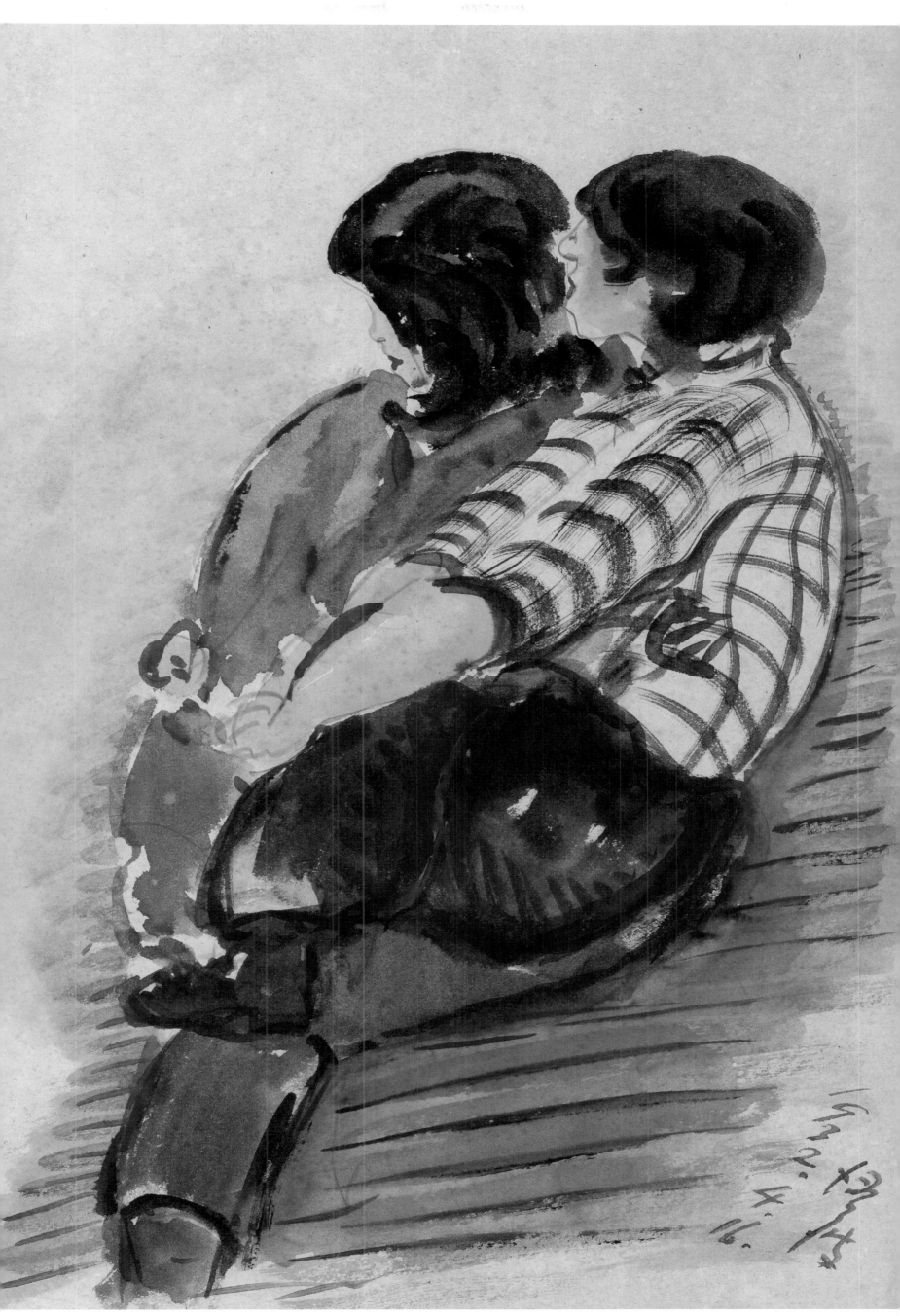

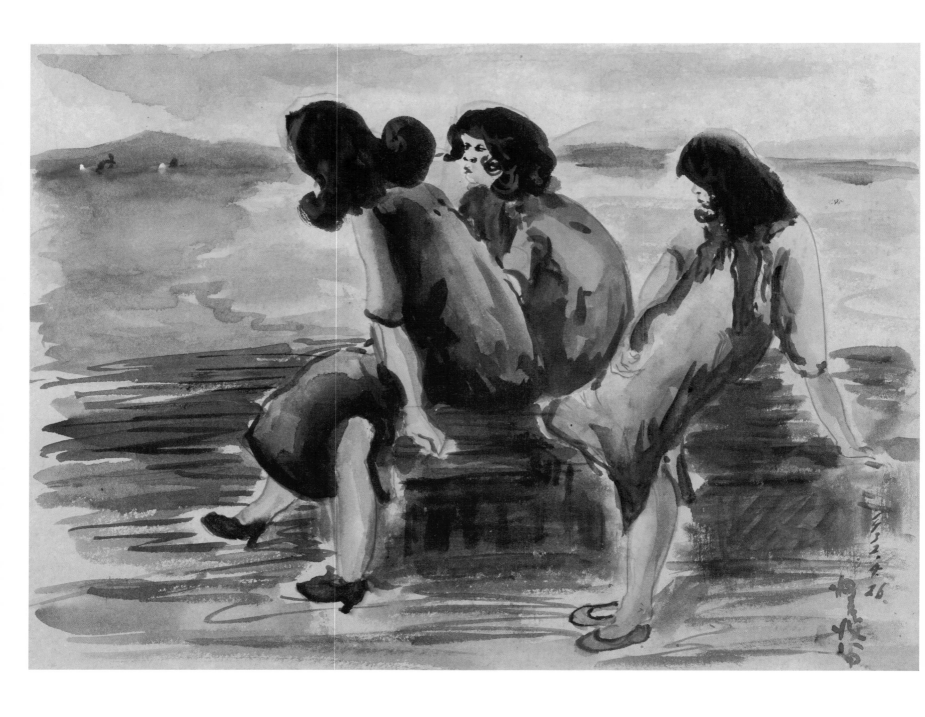

群像-32.4.26（5）Group Portrait-32.4.26 (5)

1932　紙本淡彩鉛筆　26.5×36.3cm

[右頁圖]

花-32.4　Flower-32.4

1932　紙本淡彩鉛筆　原寸（36.5×26.5cm）

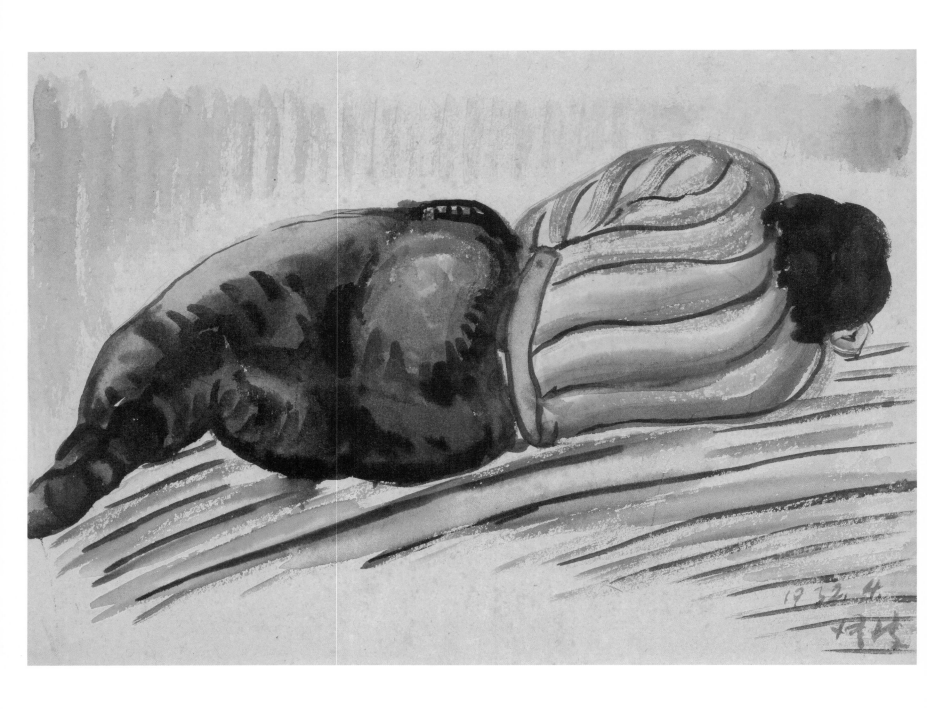

人物-32.4（14） Figure-32.4 (14)

1932　紙本淡彩鉛筆　26.5×36.5cm

[右頁圖]

街景-32.4　Street-32.4

1932　紙本淡彩鉛筆　原寸（36×26.5cm）

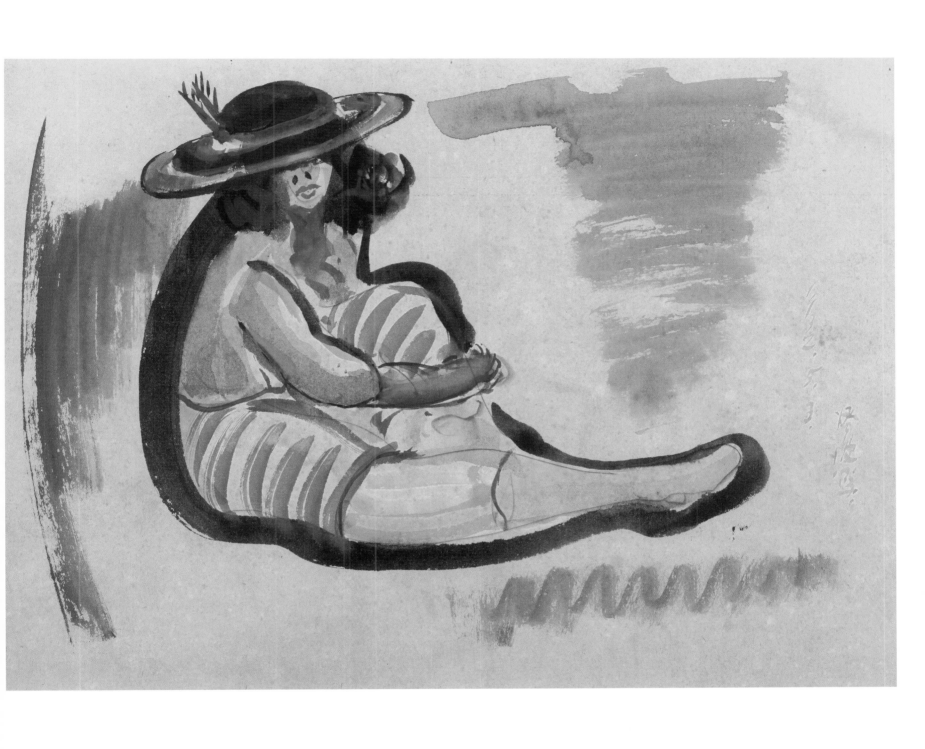

人物-32.5.3（16） Figure-32.5.3 (16)

1932　紙本淡彩鉛筆　26.5×36cm

[左頁圖]

人物-32.5.3（15） Figure-32.5.3 (15)

1932　紙本淡彩鉛筆　原寸（36.5×26.5cm）

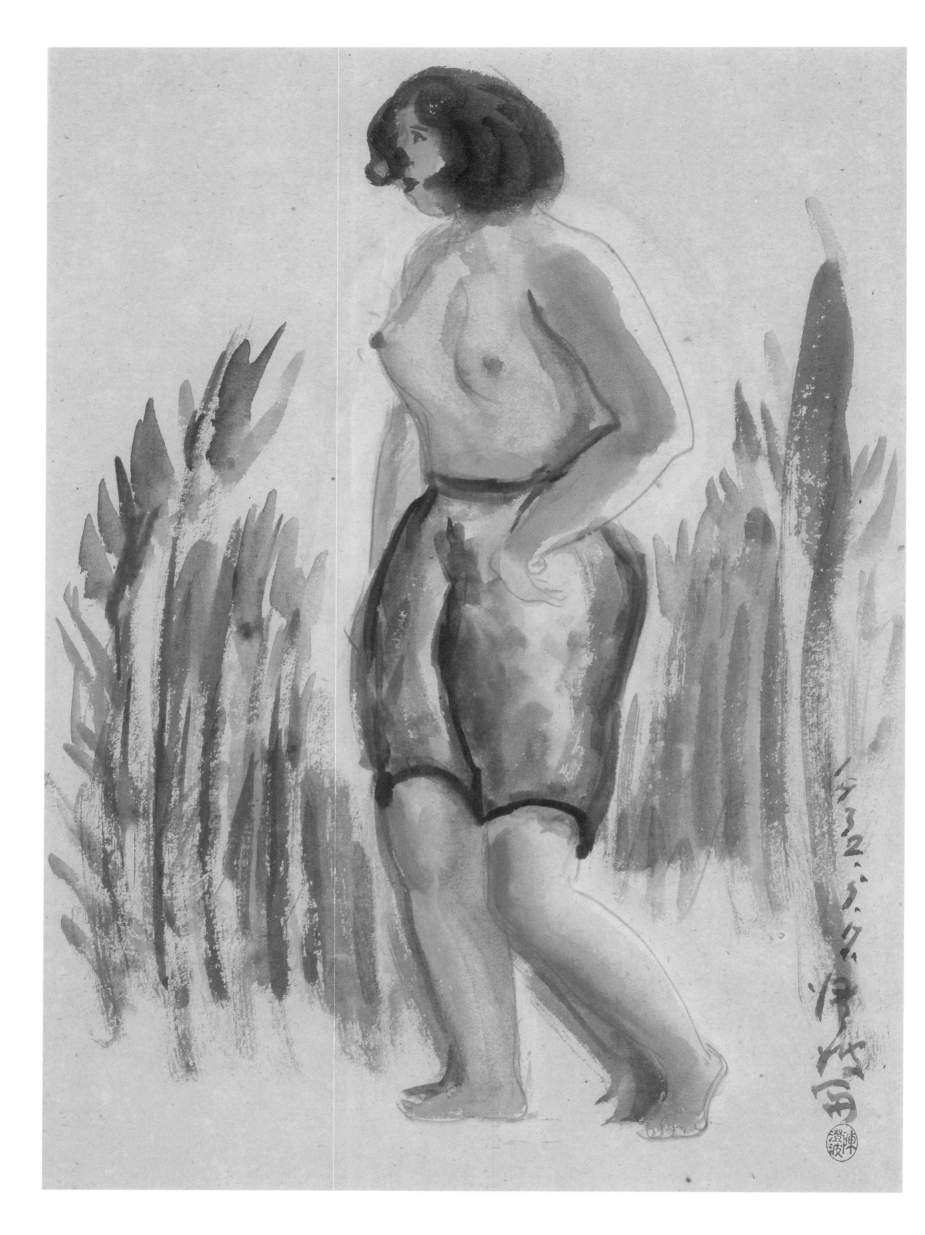

立姿裸女-32.5.7（51） Standing Nude-32.5.7 (51)

1932　紙本淡彩鉛筆

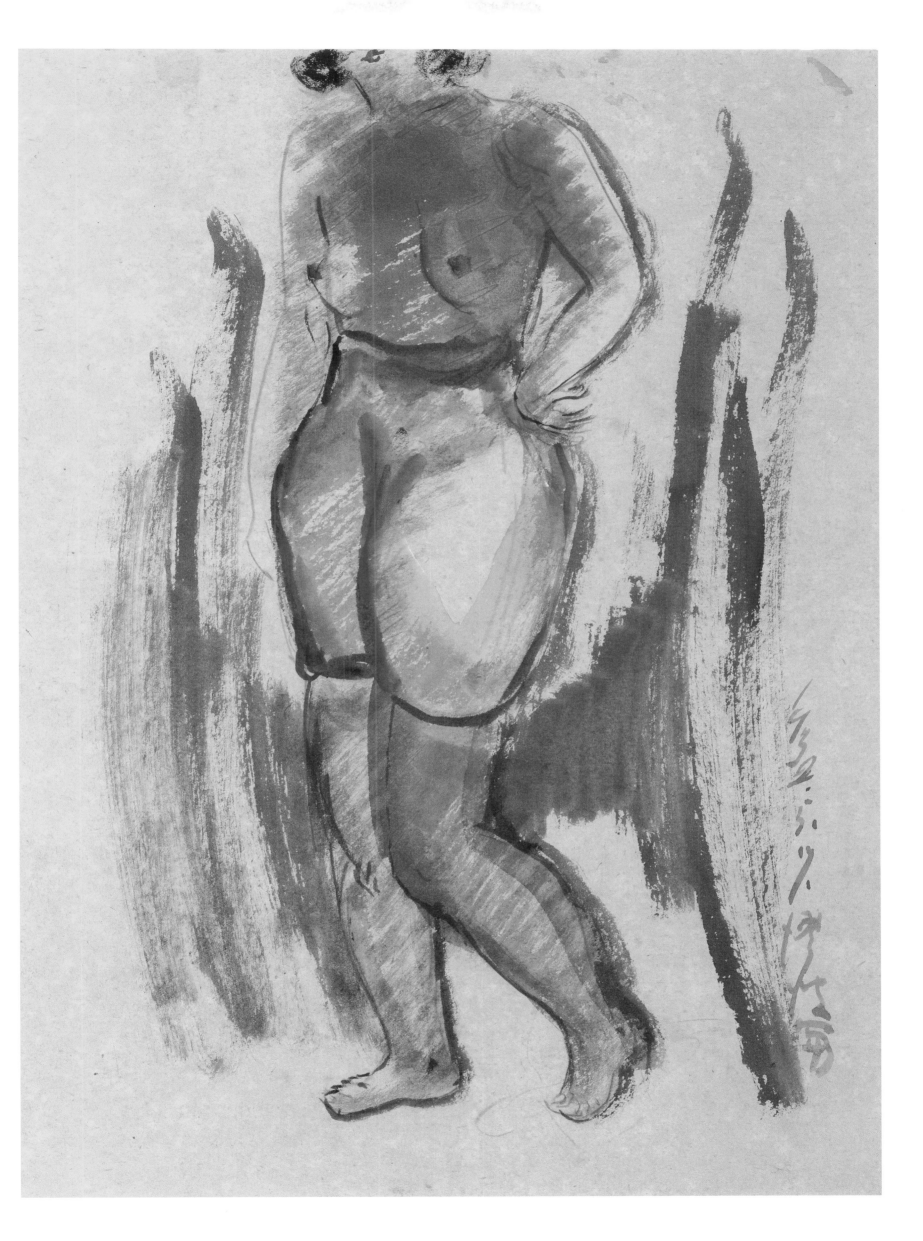

立姿裸女-32.5.7（52） Standing Nude-32.5.7 (52)

1932　紙本淡彩鉛筆　36×26.5cm

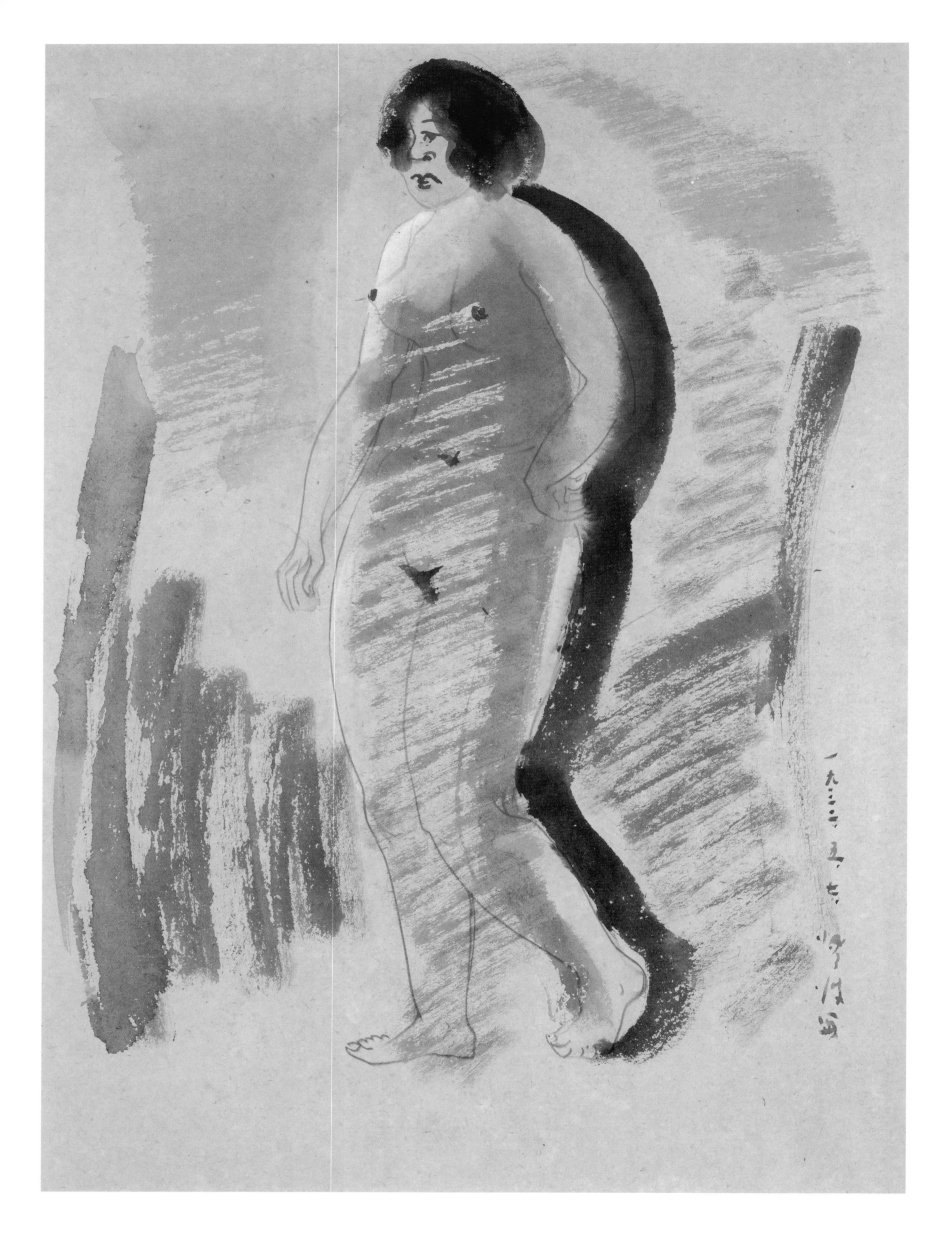

立姿裸女-32.5.7（53）Standing Nude-32.5.7 (53)

1932　紙本淡彩鉛筆　36.5×26.5cm

人物-32.5.7（17） Figure-32.5.7 (17)

1932　紙本淡彩鉛筆　36×26.5cm

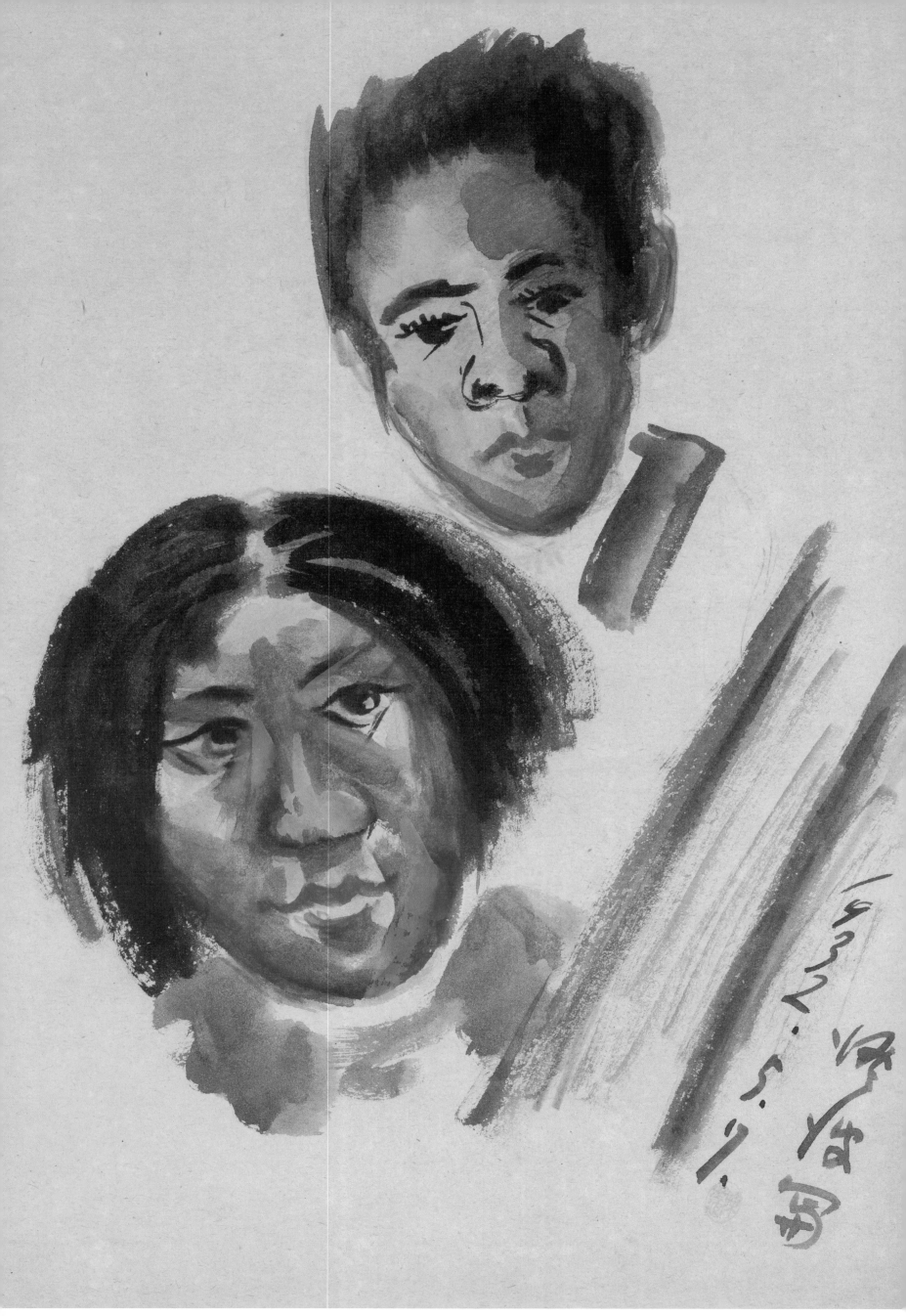

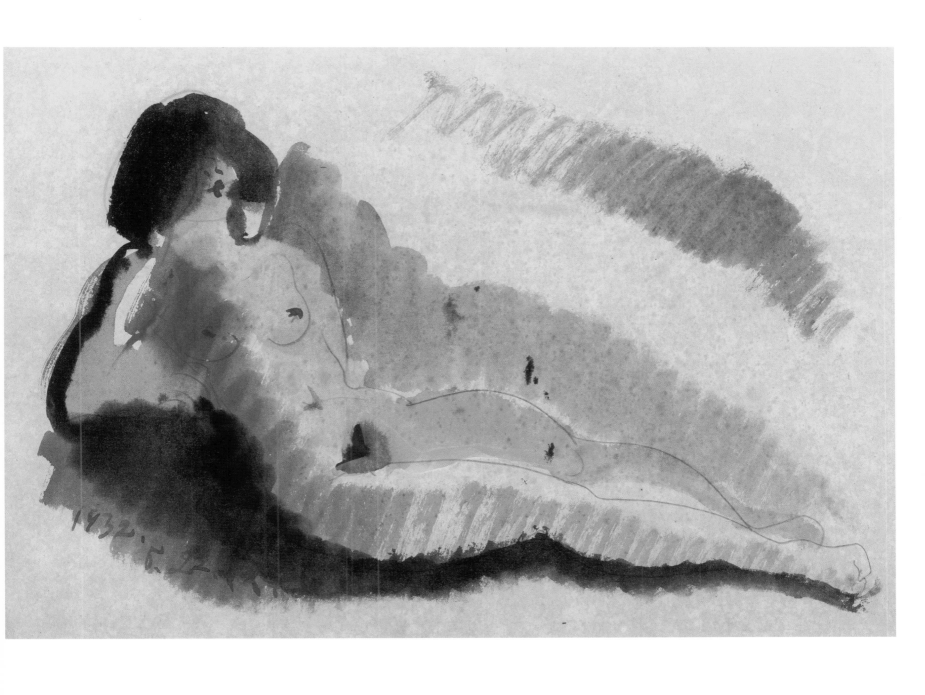

坐姿裸女-32.5.22（109） Seated Nude-32.5.22 (109)

1932　紙本淡彩鉛筆　26×36.5cm

[左頁圖]
群像-32.5.7（6） Group Portrait-32.5.7 (6)

1932　紙本淡彩鉛筆　原寸（36.5x26.5cm）

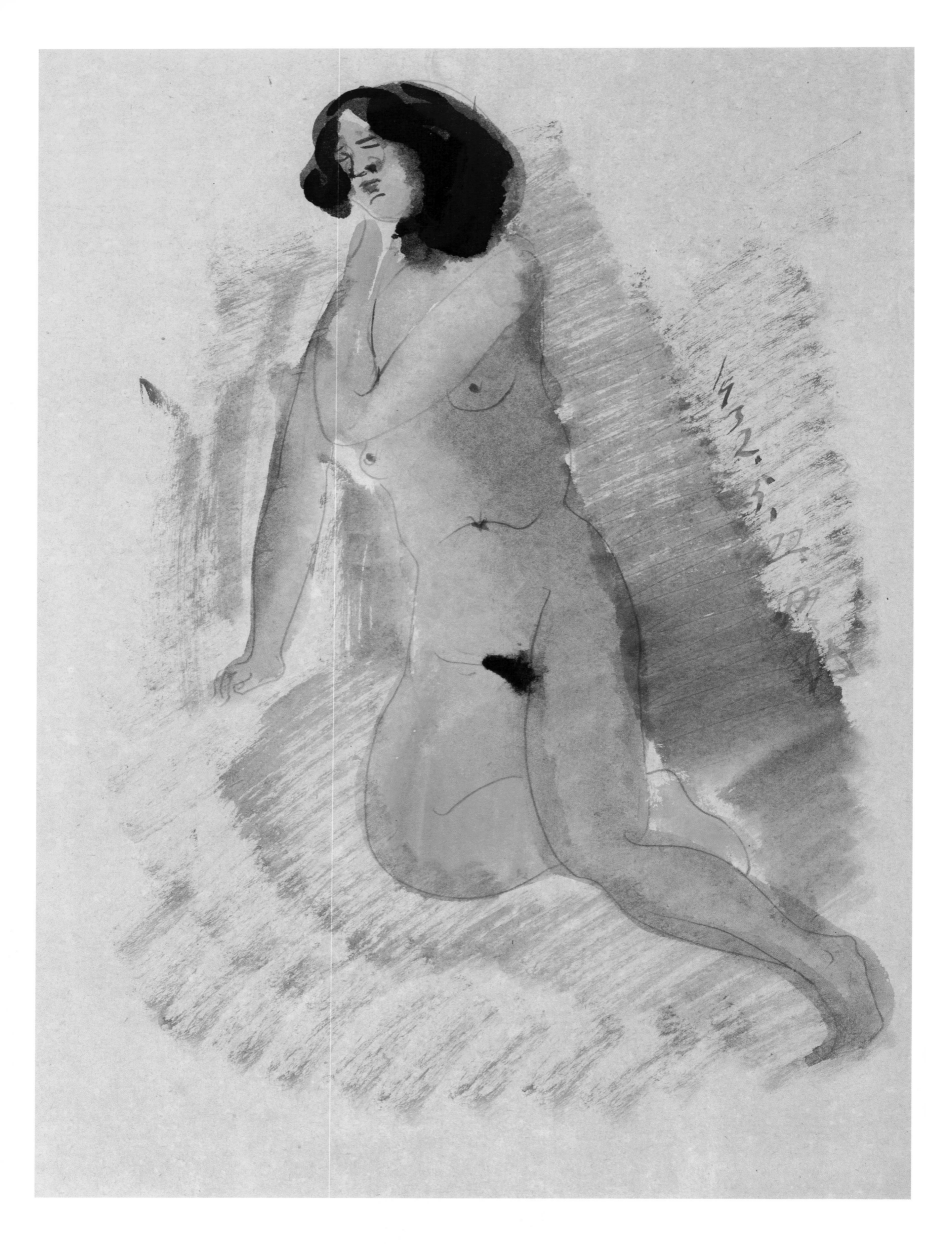

坐姿裸女-32.5.22（110） Seated Nude-32.5.22(110)

1932　紙本淡彩鉛筆　36×26.5cm

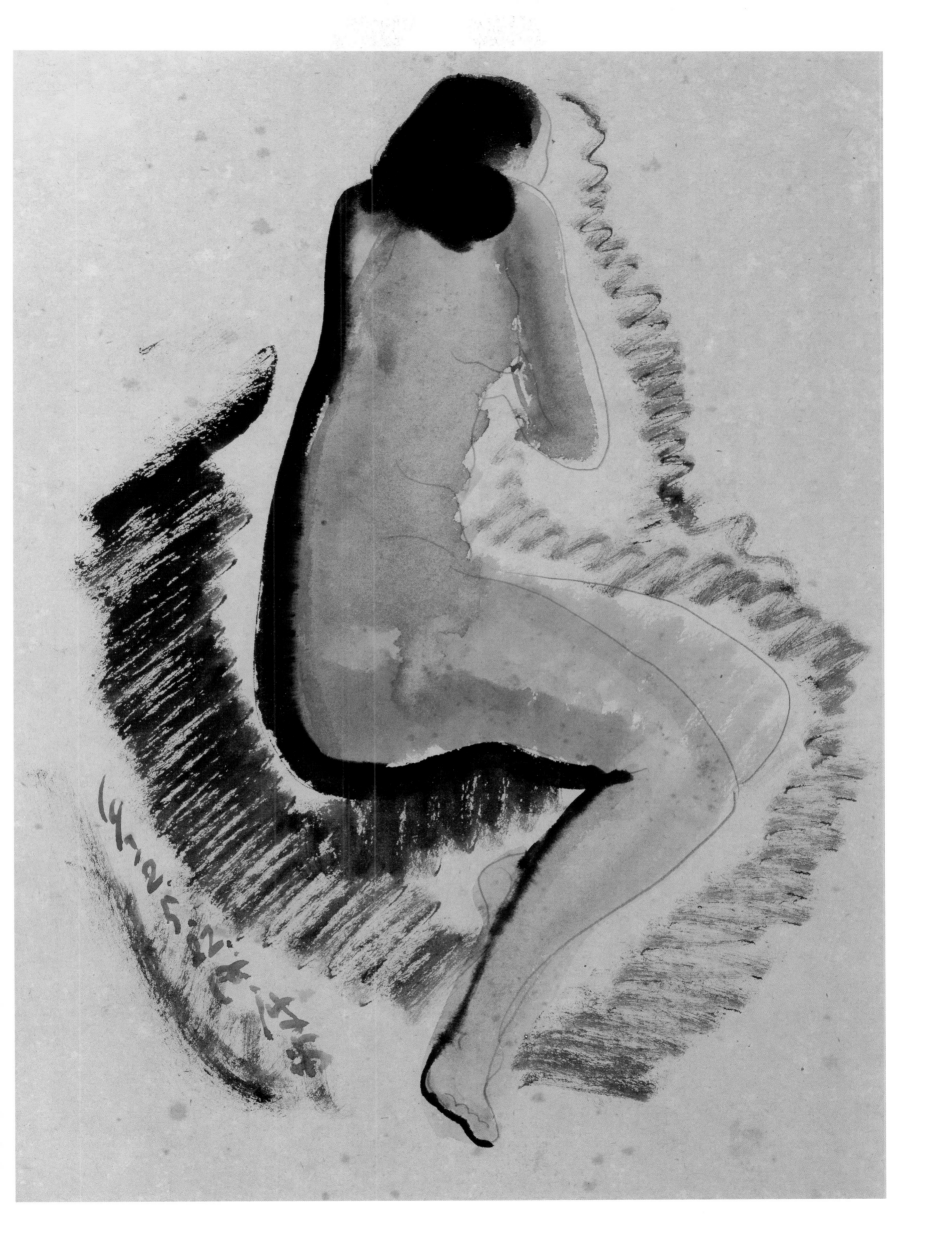

坐姿裸女-32.5.22（111） Seated Nude-32.5.22 (111)

1932　紙本淡彩鉛筆　36×26.5cm

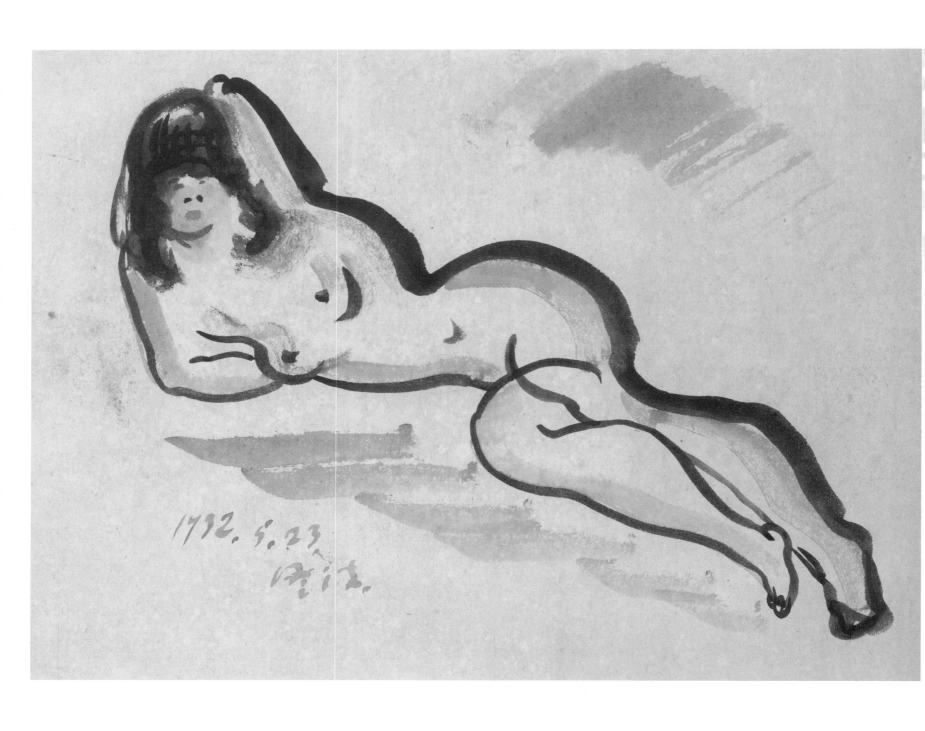

臥姿裸女-32.5.23（57） Lying Nude-32.5.23 (57)

1932　紙本淡彩　26.5×36.5cm

［右頁圖］

立姿裸女-32.5.23（54） Standing Nude-32.5.23 (54)

1932　紙本淡彩鉛筆　原寸（36.5×26.5cm）

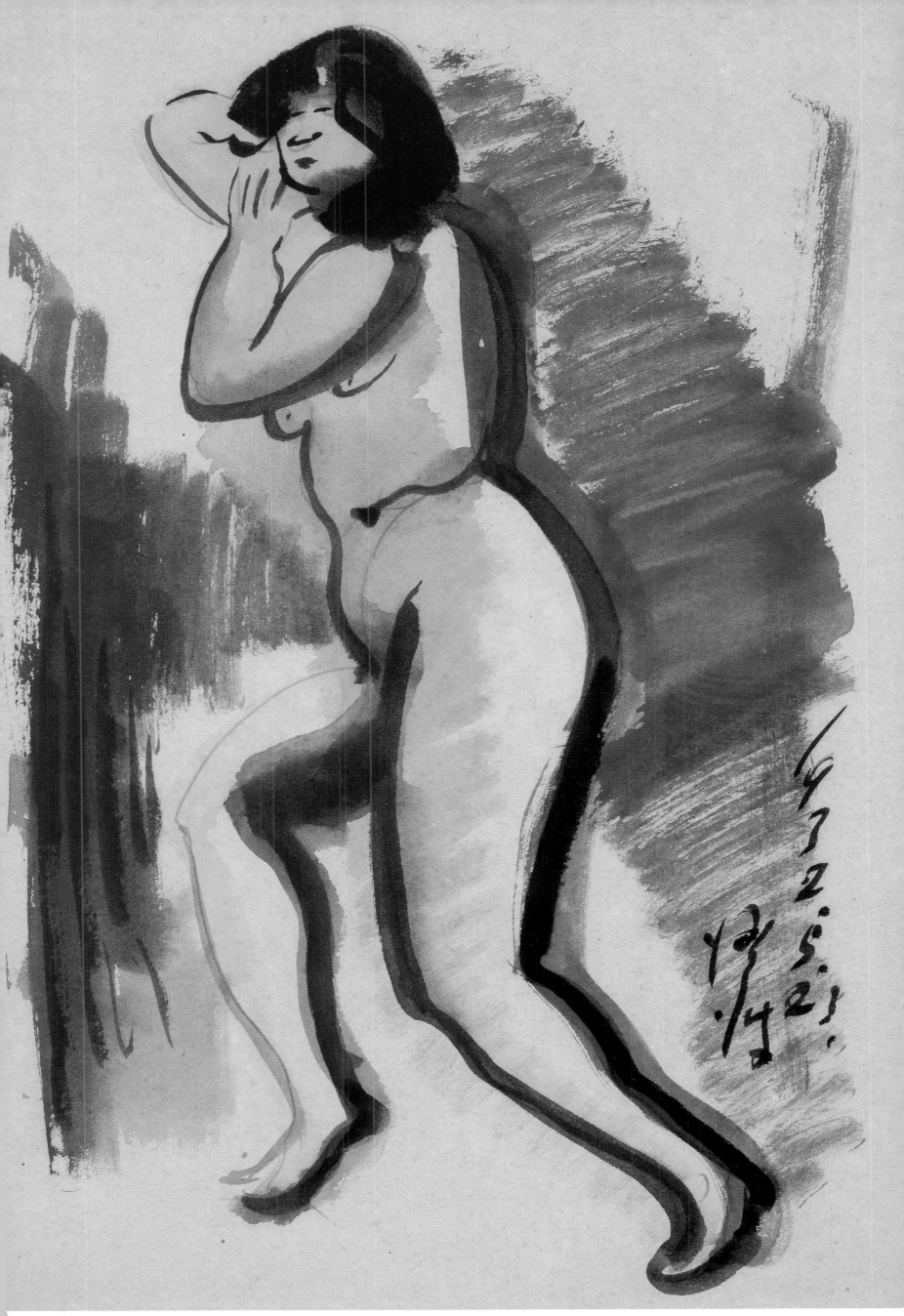

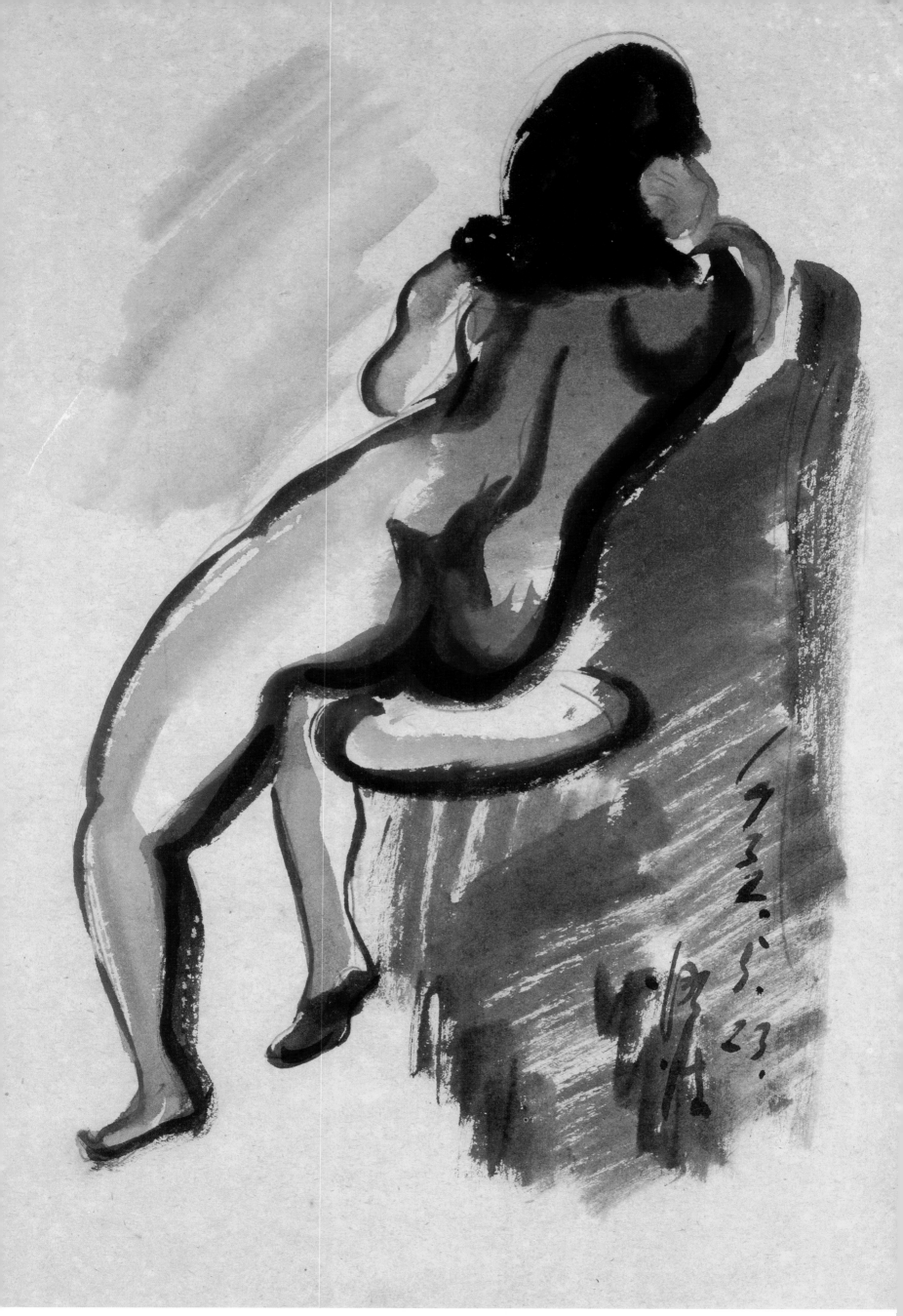

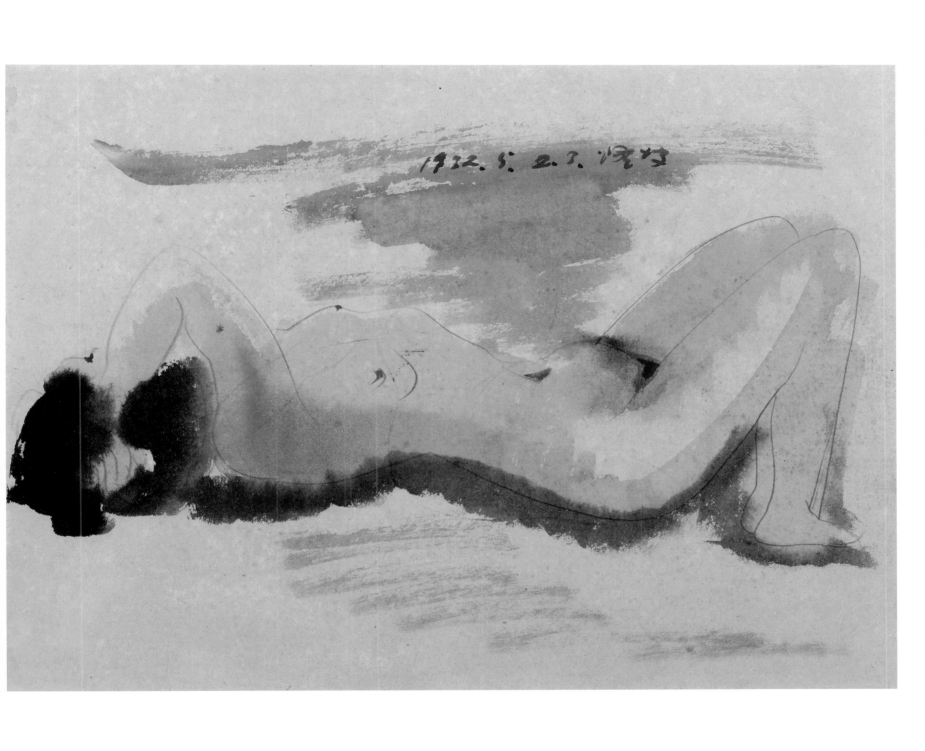

臥姿裸女-32.5.23（58） Lying Nude-32.5.23 (58)

1932　紙本淡彩鉛筆　26.5×36cm

[左頁圖]

坐姿裸女-32.5.23（112） Seated Nude-32.5.23 (112)

1932　紙本淡彩鉛筆　原寸（36.5×26.5cm）

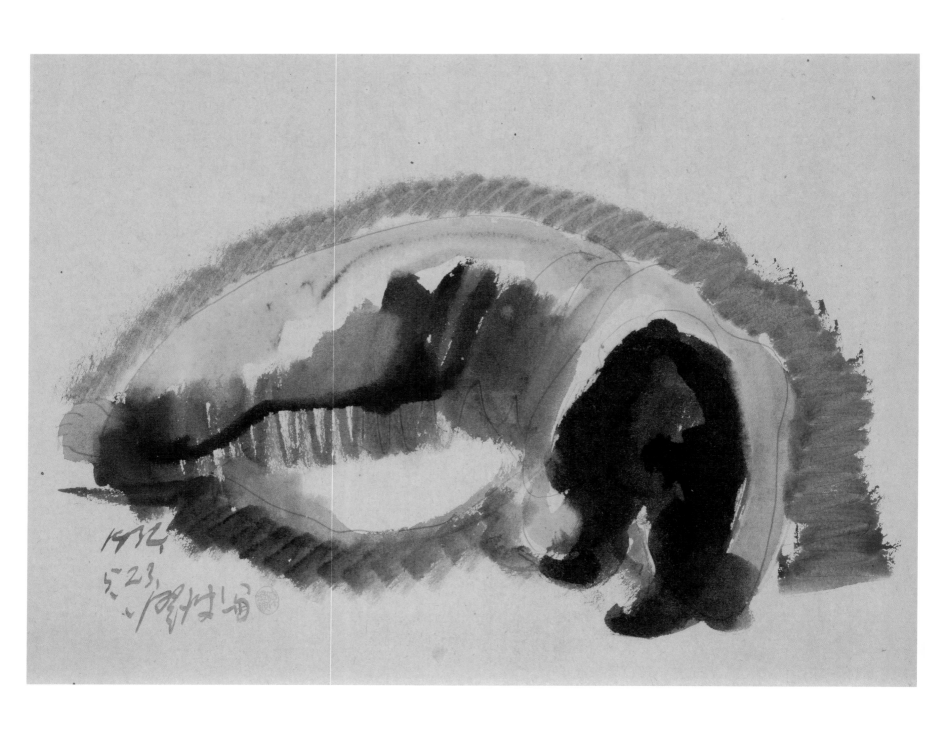

臥姿裸女-32.5.23（59） Lying Nude-32.5.23 (59)

1932　紙本淡彩鉛筆　26.5×36.5cm

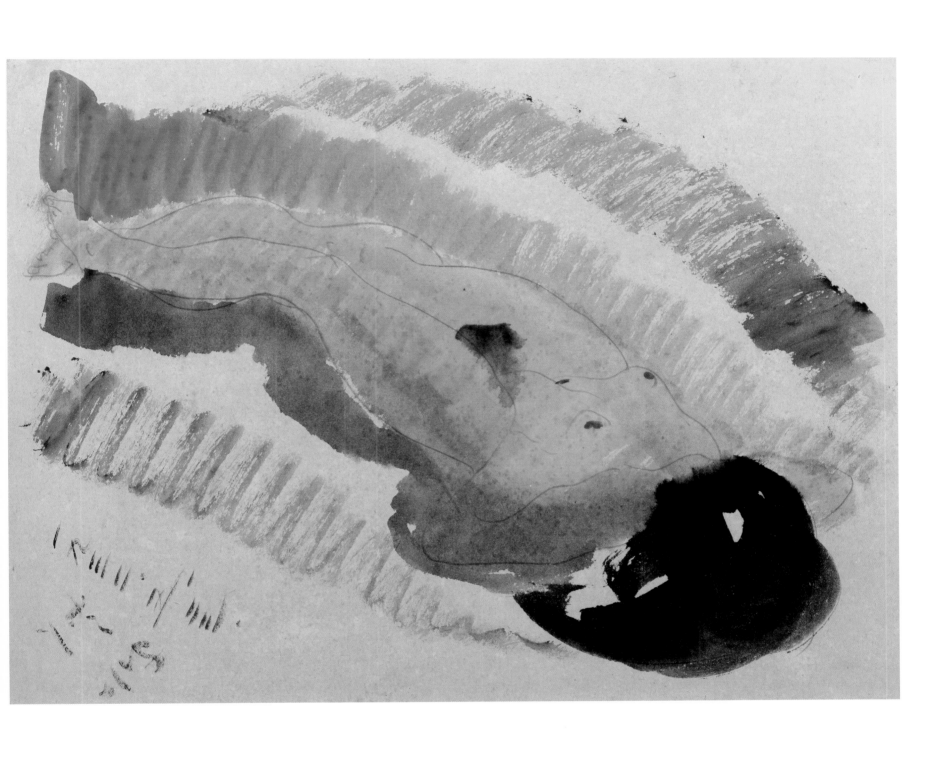

臥姿裸女-32.5.23（60）Lying Nude-32.5.23 (60)

1932　紙本淡彩鉛筆　26.5×36cm

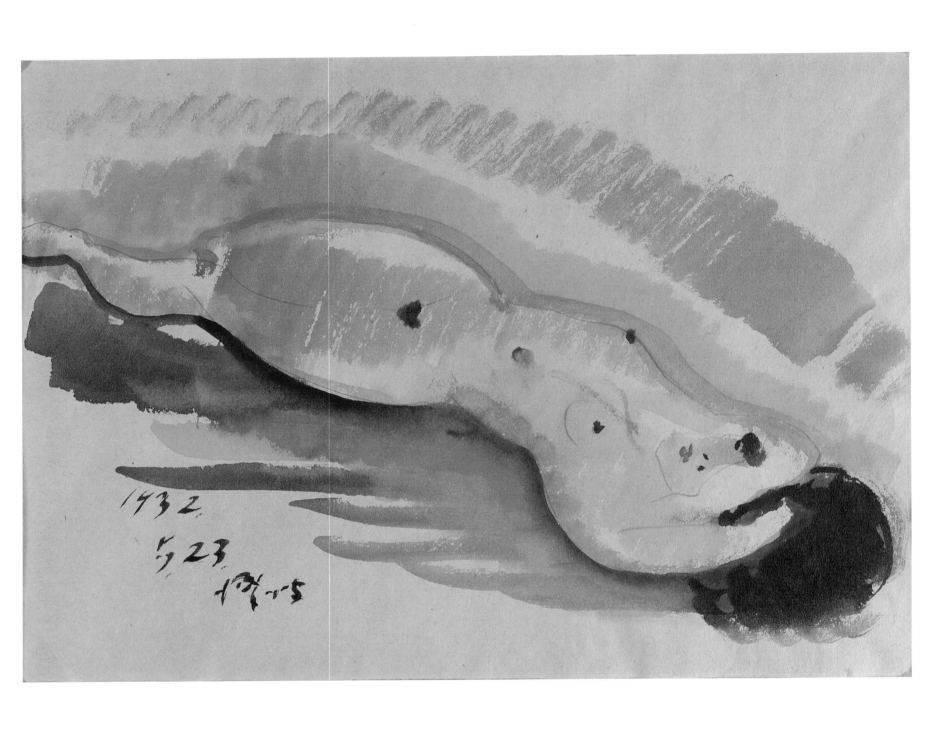

臥姿裸女-32.5.23（61） Lying Nude-32.5.23 (61)

1932　紙本淡彩鉛筆　25.8×35.8cm

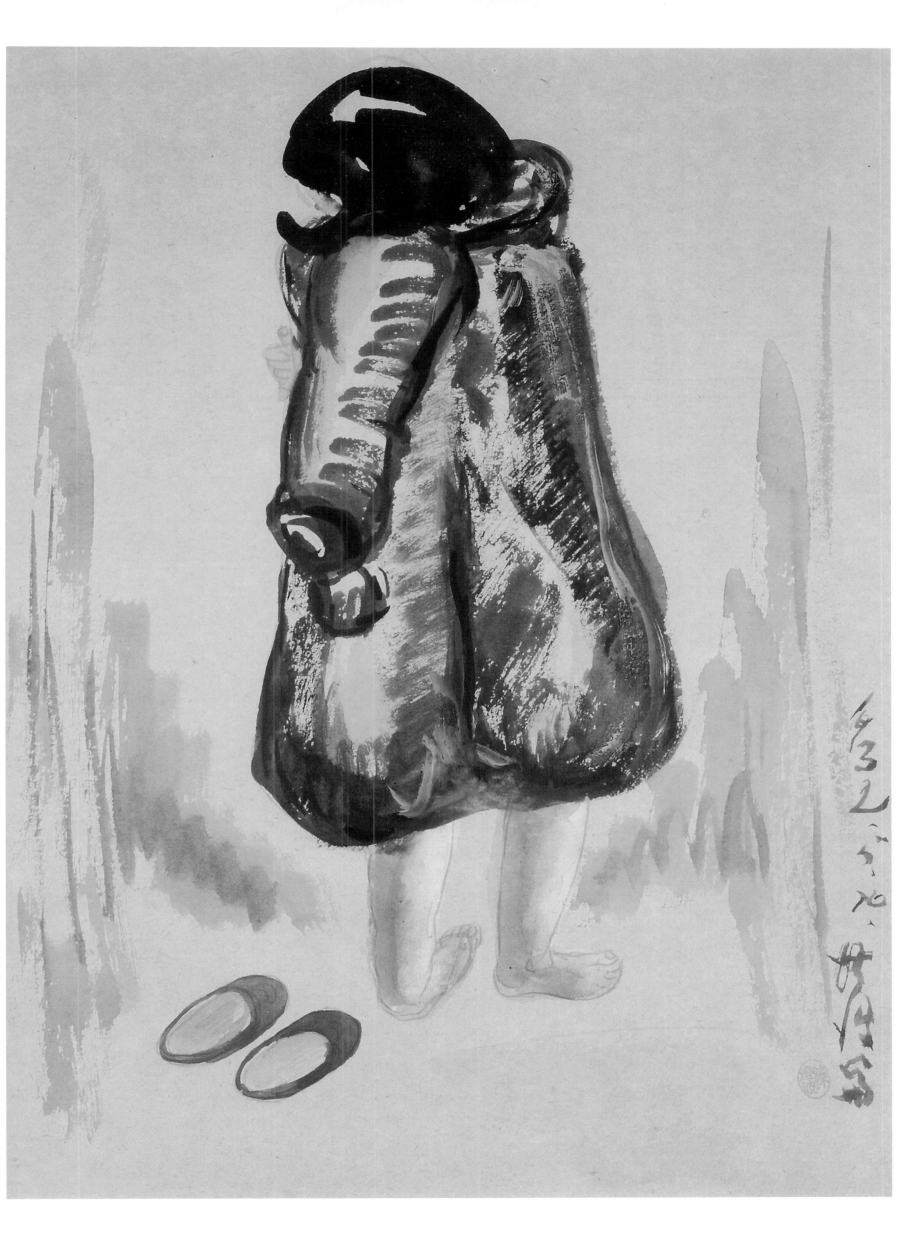

人物-32.5.26（18）Figure-32.5.26 (18)

1932　紙本淡彩鉛筆　36.5×26.5cm

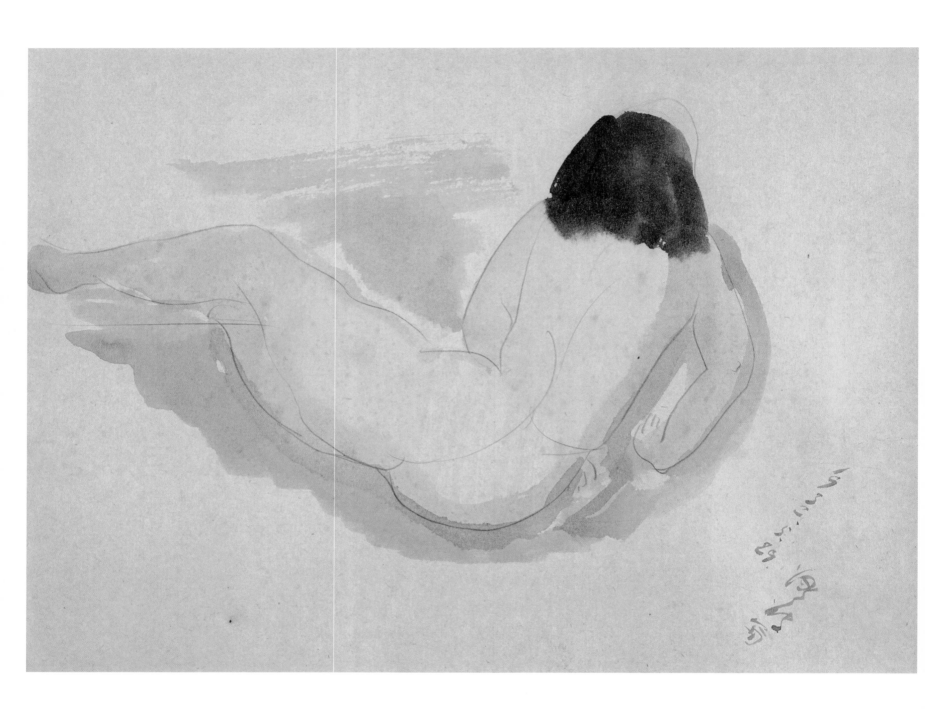

臥姿裸女-32.5.29（62） Lying Nude-32.5.29 (62)

1932　紙本淡彩鉛筆　27×37.4cm

[右頁圖]

坐姿裸女-32.5.29（113） Seated Nude-32.5.29 (113)

1932　紙本淡彩鉛筆　原寸（36.5×26.5cm）

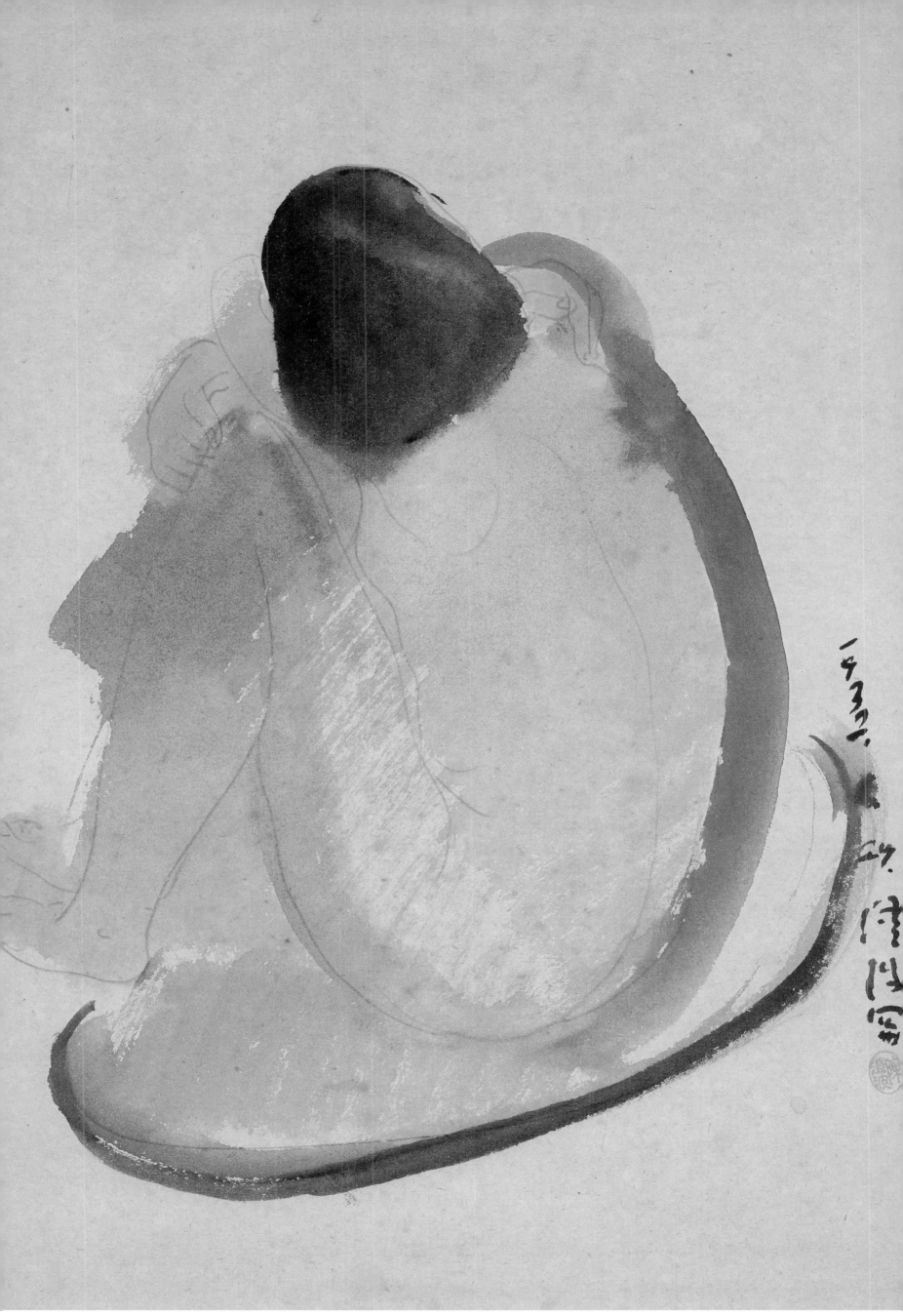

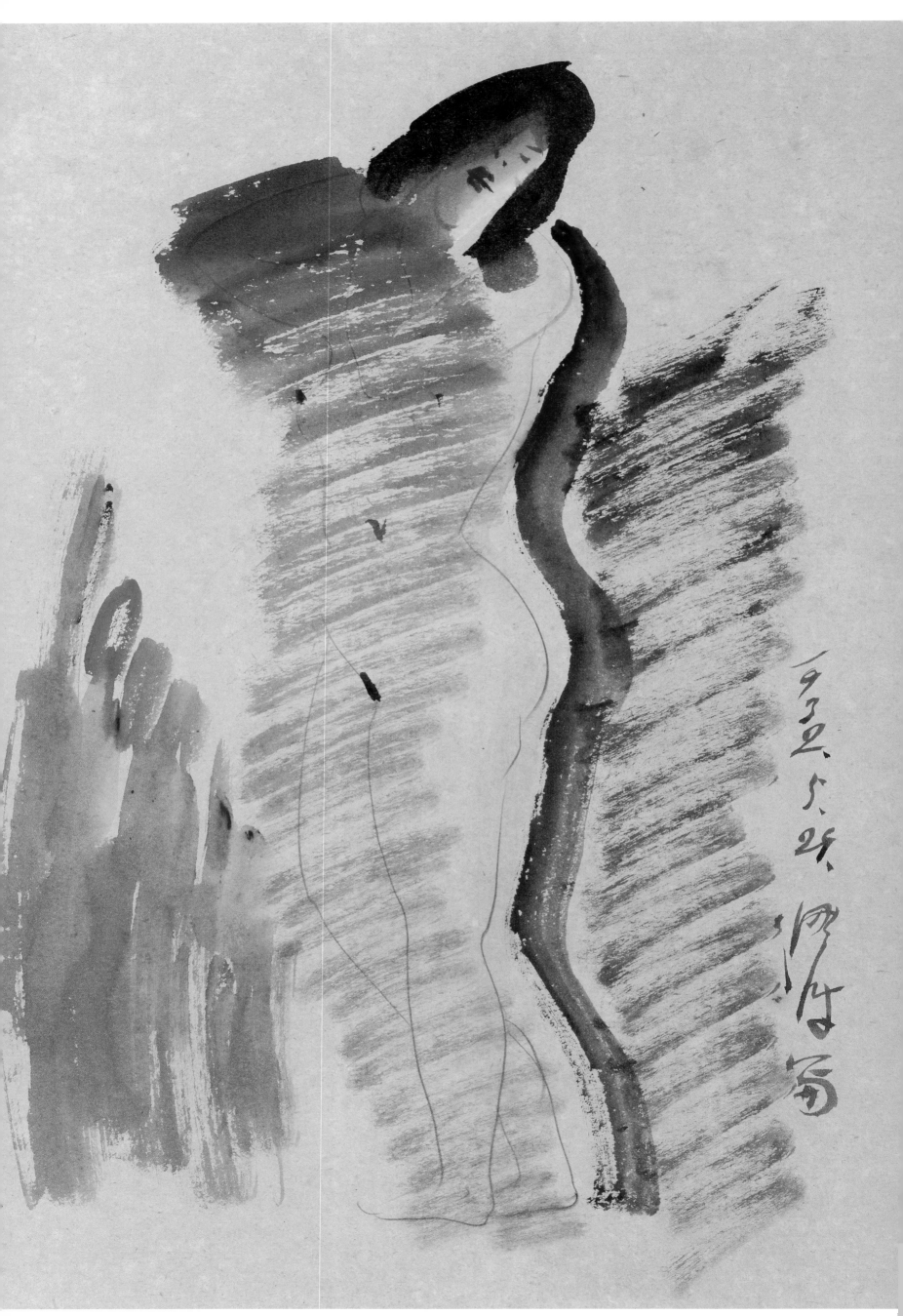

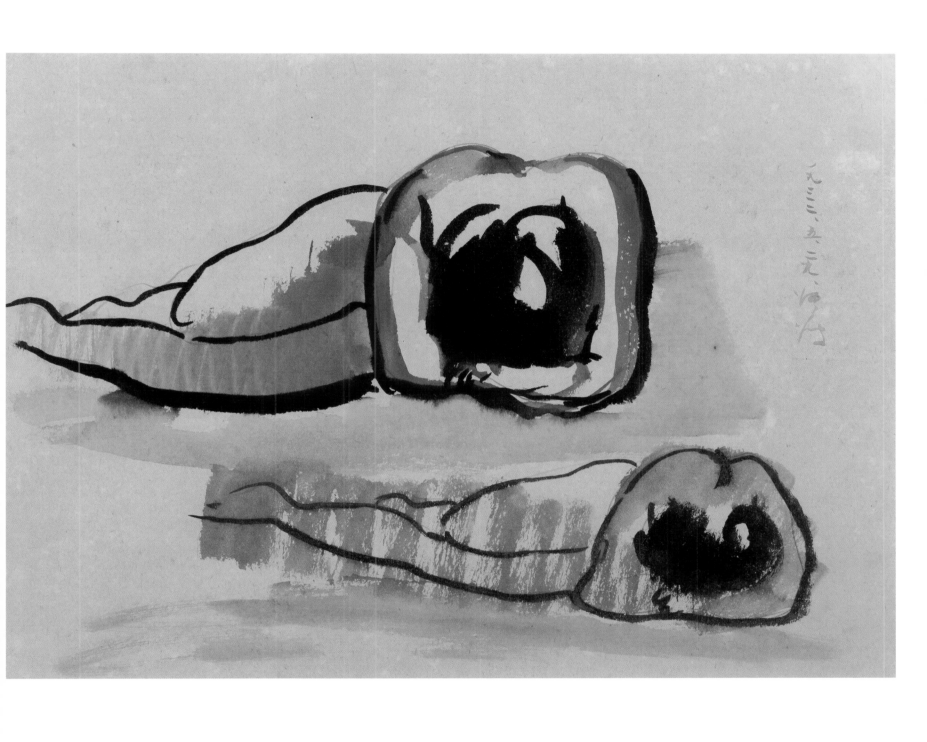

臥姿裸女-32.5.29（63） Lying Nude-32.5.29 (63)

1932　紙本淡彩鉛筆　26×36cm

[左頁圖]
立姿裸女-32.5.29（55） Standing Nude-32.5.29 (55)

1932　紙本淡彩鉛筆　原寸（36×26cm）

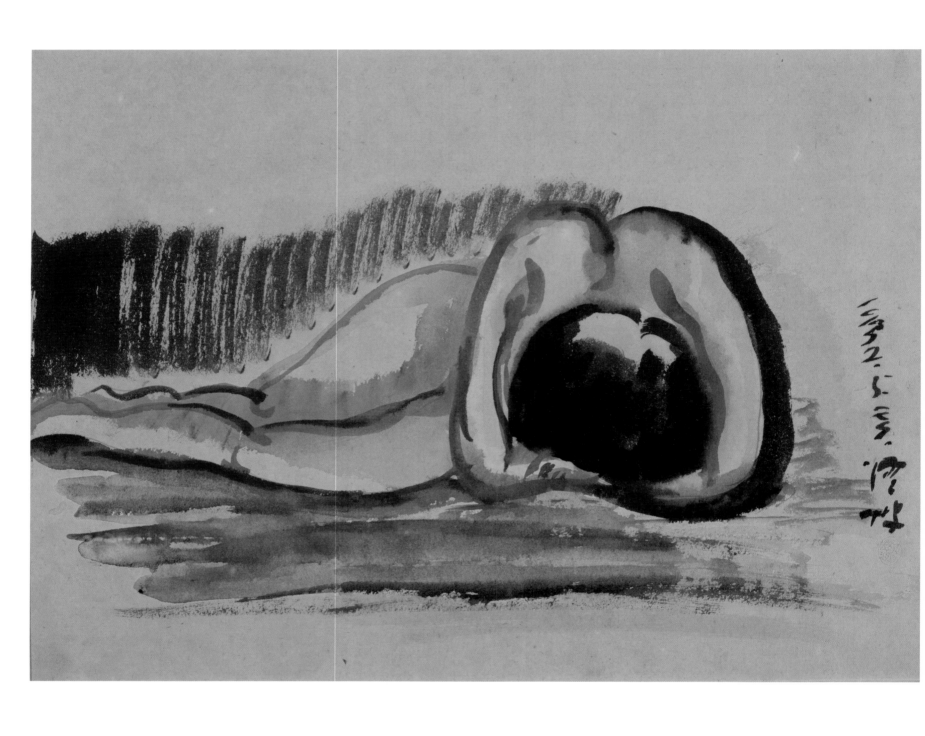

臥姿裸女-32.5.29（64） Lying Nude-32.5.29 (64)

1932　紙本淡彩　26.5×36cm

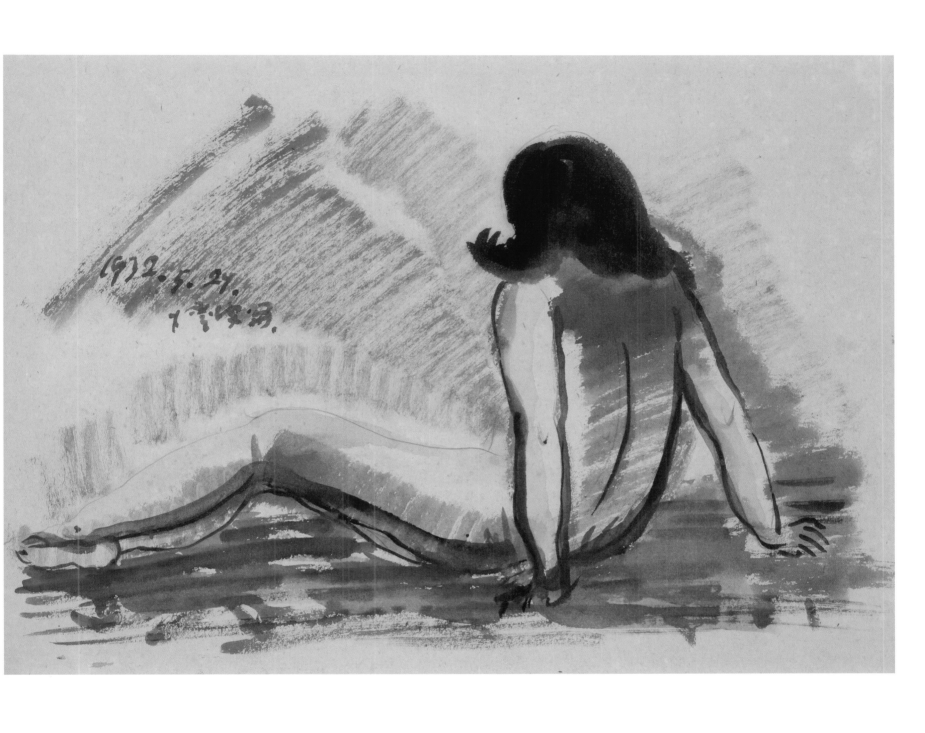

坐姿裸女-32.5.29（114）Seated Nude-32.5.29 (114)

1932　紙本淡彩鉛筆　26.5×36.5cm

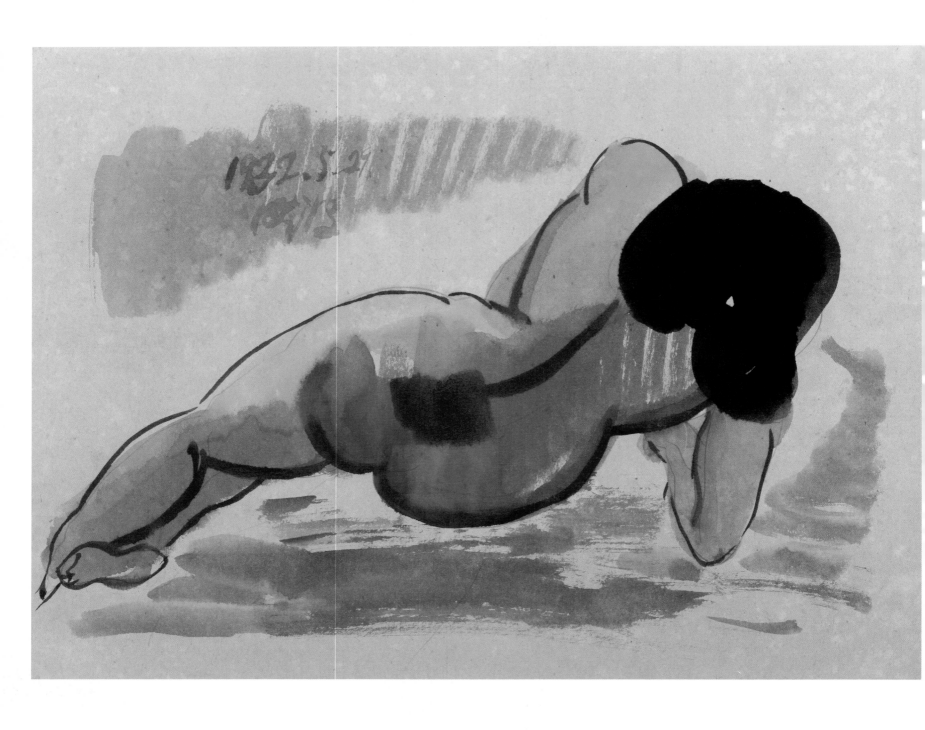

臥姿裸女-32.5.29（65） Lying Nude-32.5.29 (65)

1932　紙本淡彩鉛筆　26×36cm

[右頁圖]

坐姿裸女-32.5.29（115） Seated Nude-32.5.29 (115)

1932　紙本淡彩鉛筆　原寸（36×26.5cm）

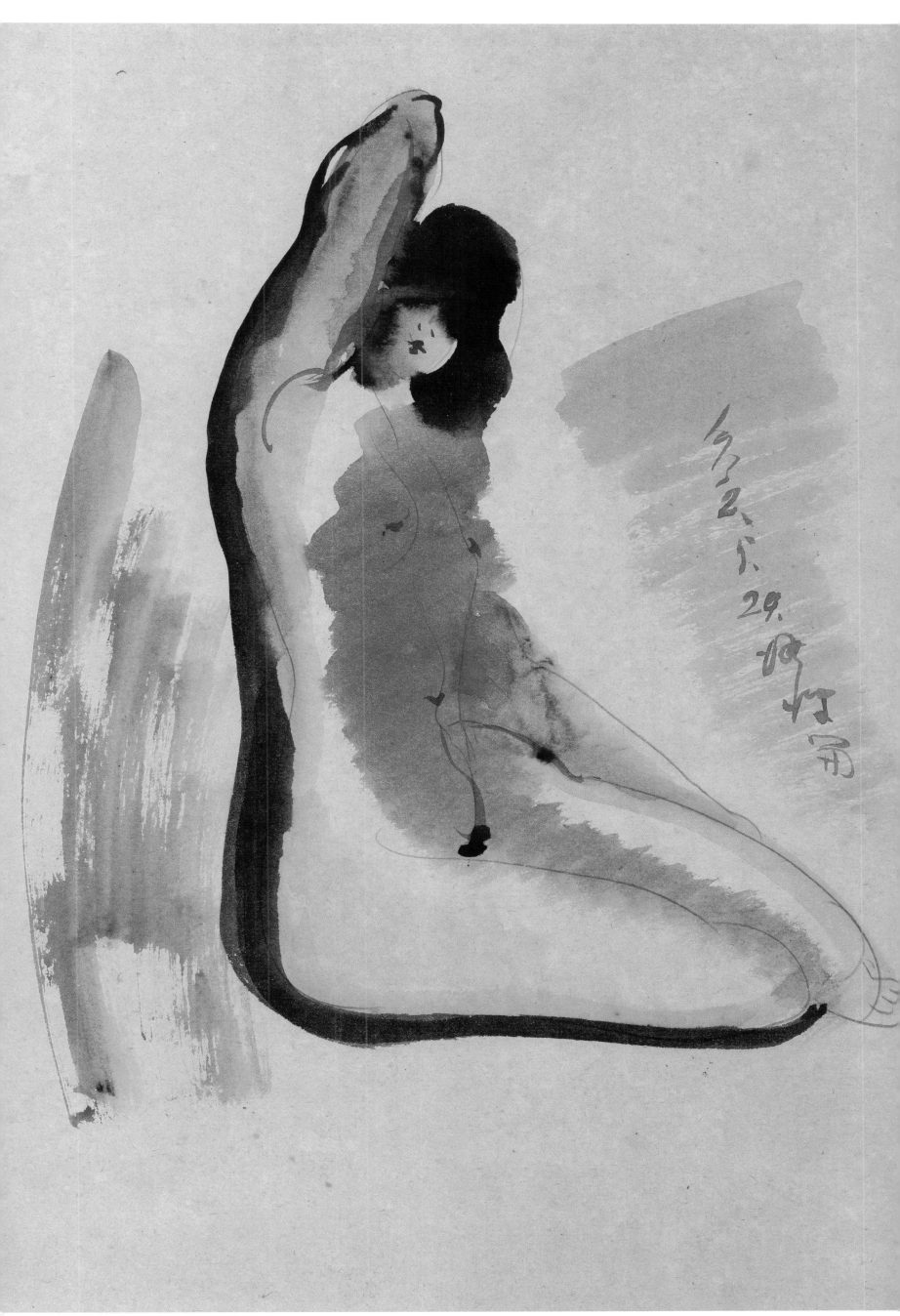

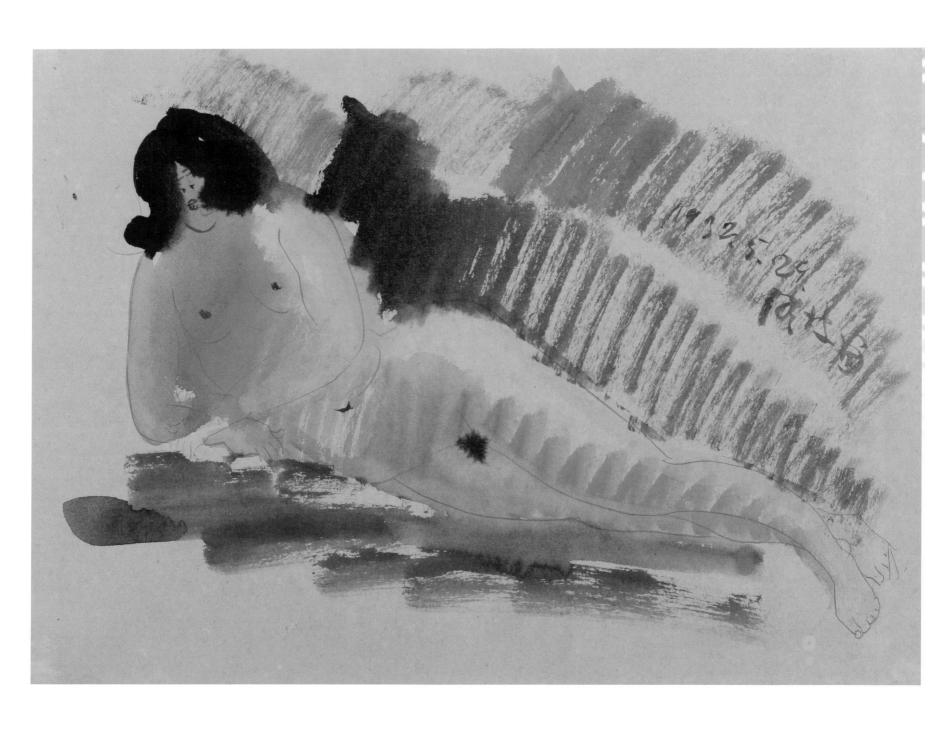

臥姿裸女-32.5.29（66） Lying Nude-32.5.29 (66)

1932　紙本淡彩鉛筆　26.5×36cm

[右頁圖]

坐姿裸女-32.5.29（116） Seated Nude-32.5.29 (116)

1932　紙本淡彩鉛筆　36.5×27cm

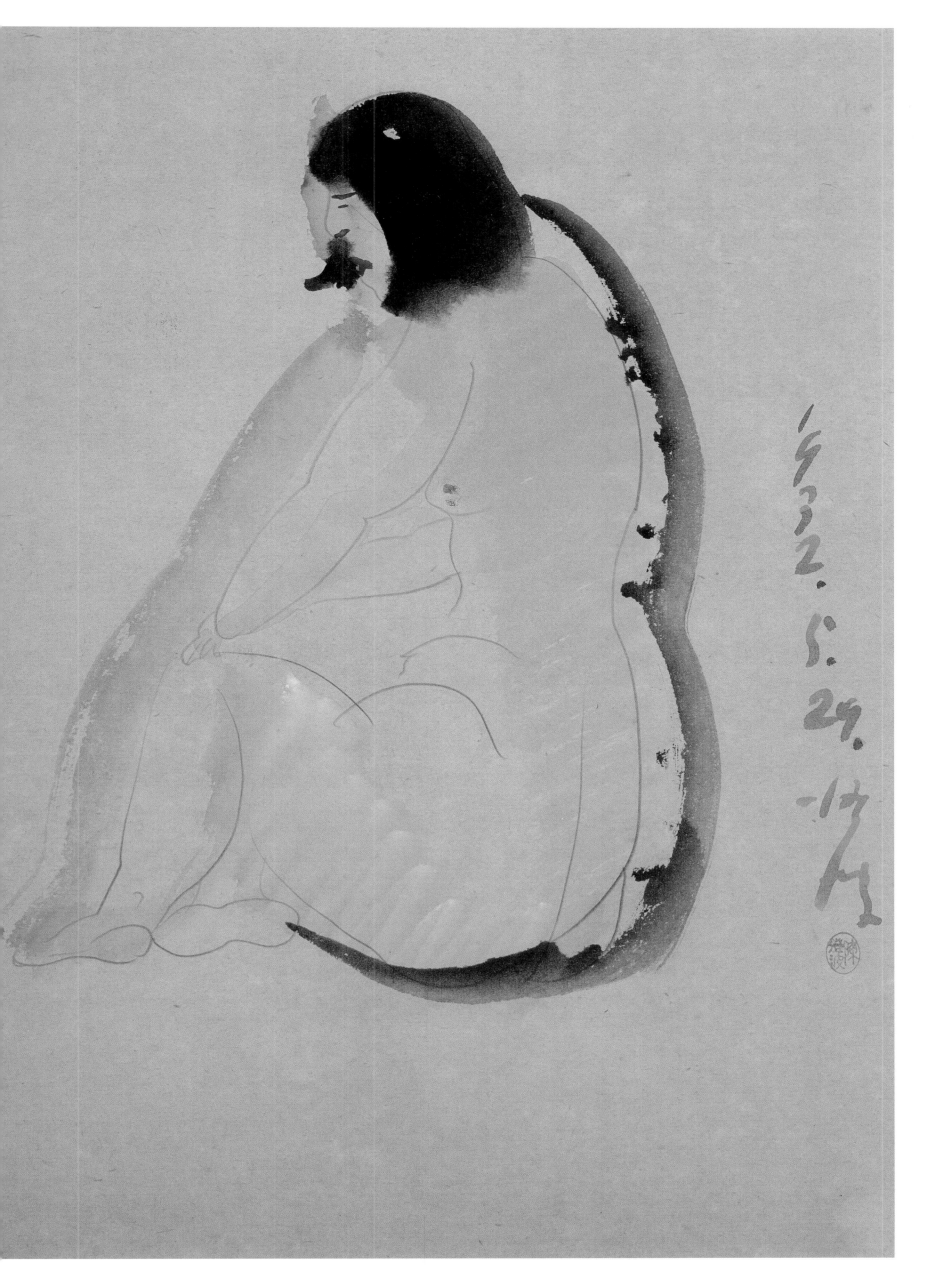

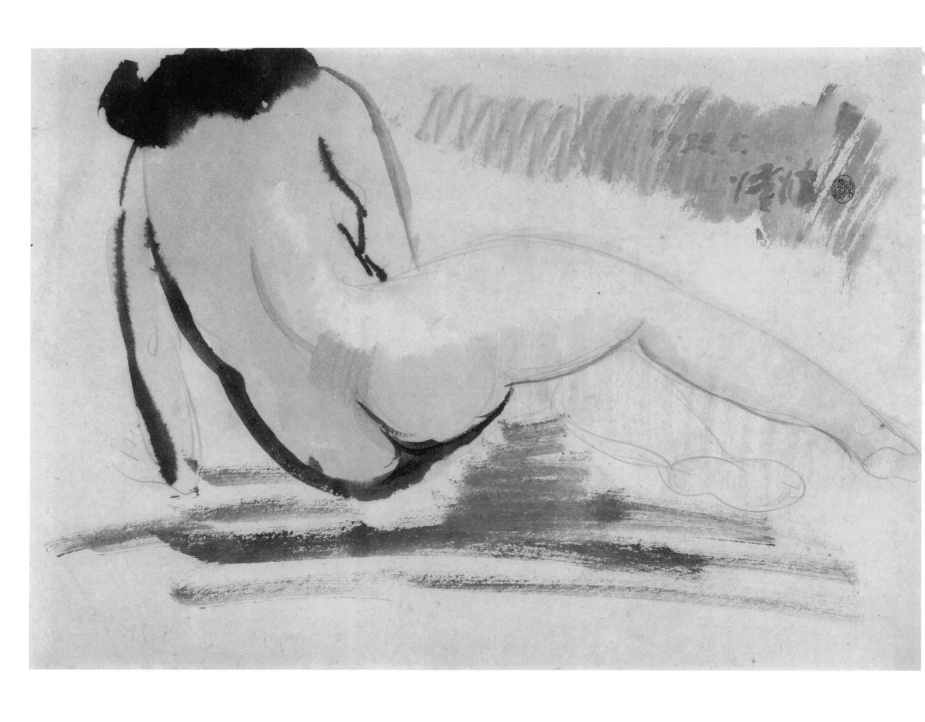

坐姿裸女-32.5.29（117） Seated Nude-32.5.29 (117)

1932　紙本淡彩鉛筆　26.5×36.5cm

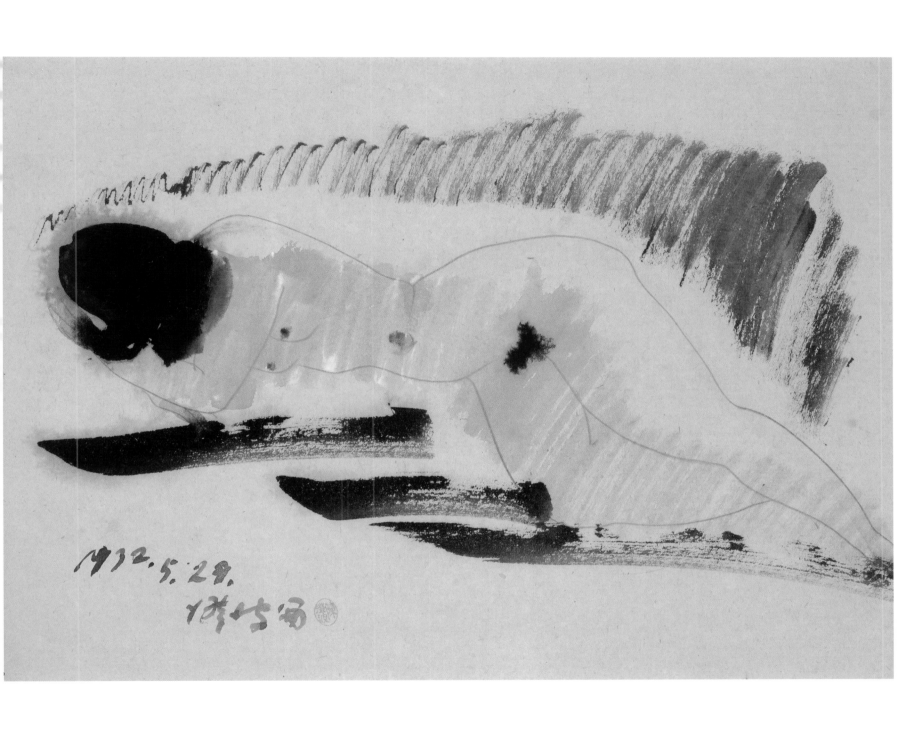

臥姿裸女-32.5.29（67） Lying Nude-32.5.29 (67)

1932　紙本淡彩鉛筆　26.5×36.5cm

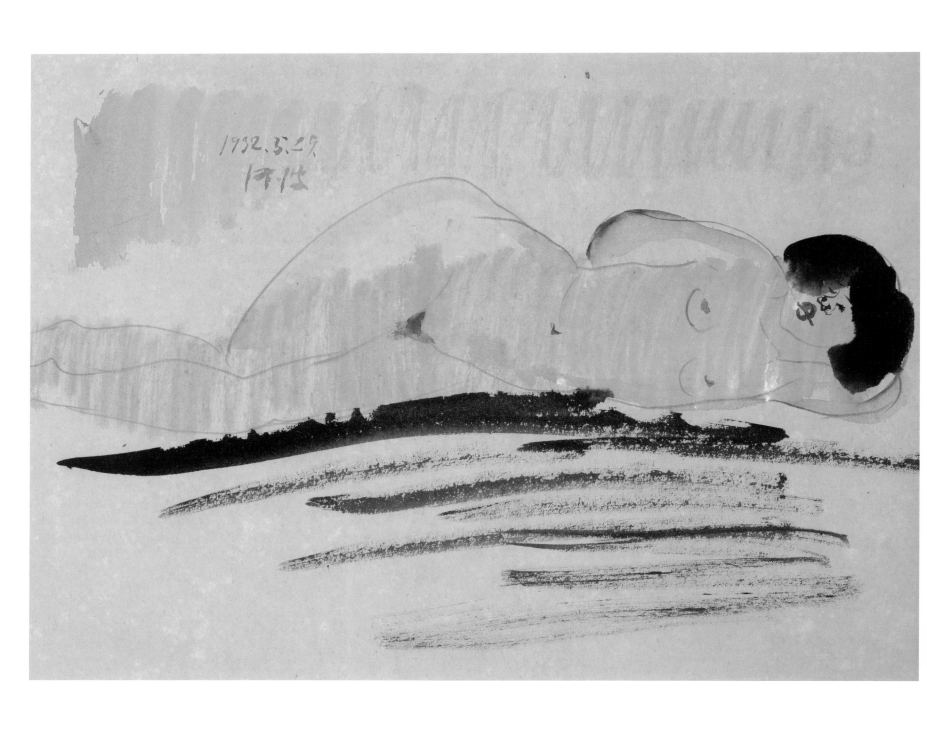

臥姿裸女-32.5.29（68）Lying Nude-32.5.29 (68)

1932　紙本淡彩鉛筆　26.5×36.5cm

坐姿裸女-32.5.29（118） Seated Nude-32.5.29 (118)

1932　紙本淡彩鉛筆　26.5×36cm

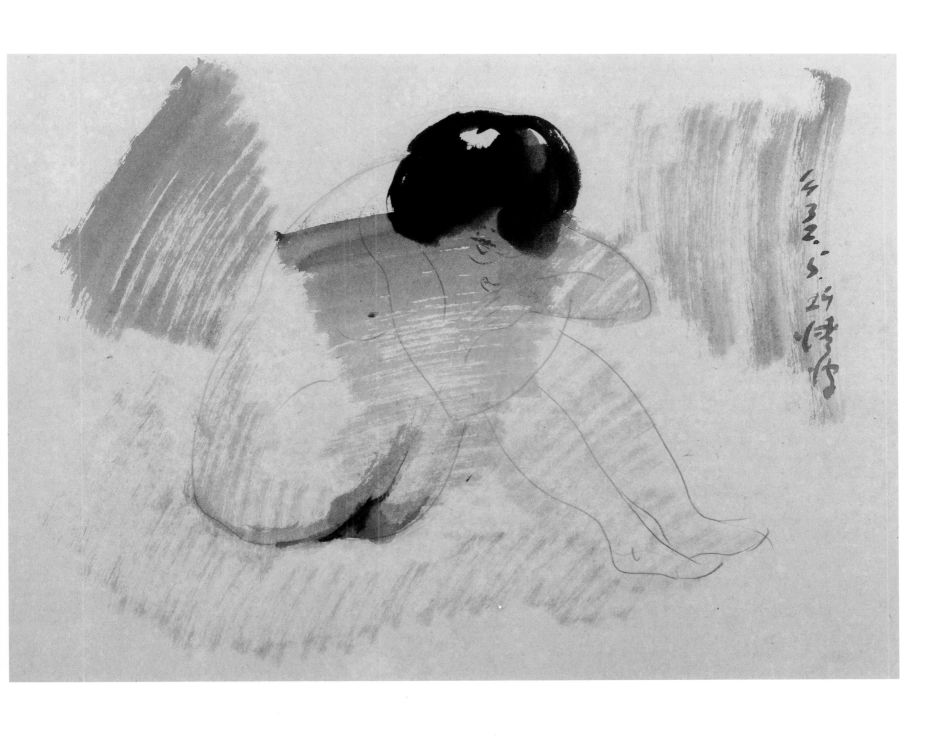

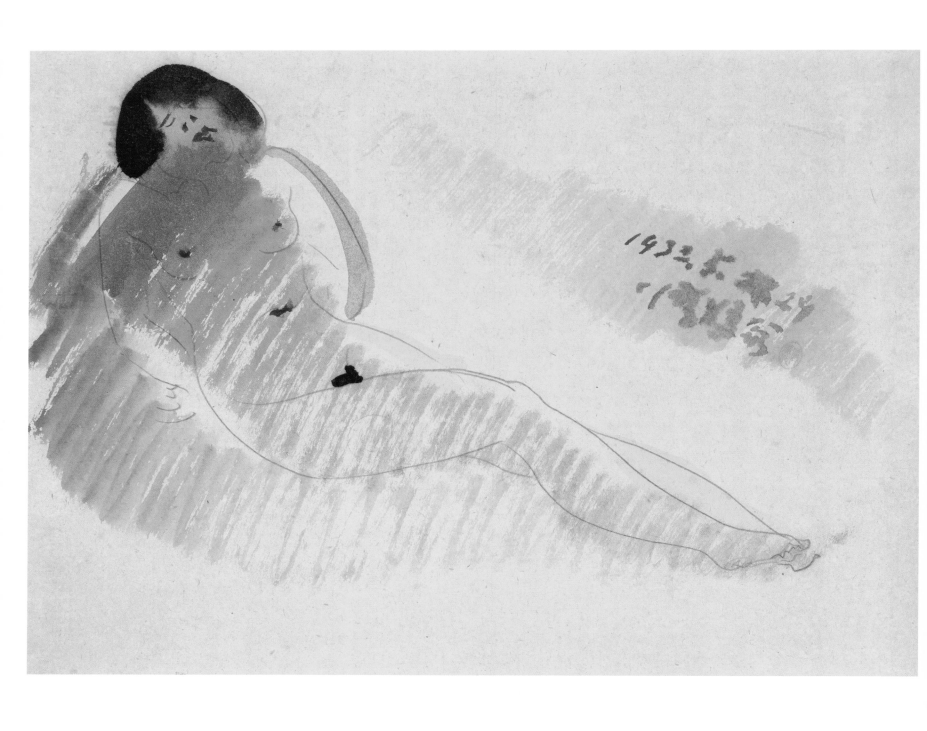

坐姿裸女-32.5.29（119） Seated Nude-32.5.29 (119)

1932　紙本淡彩鉛筆　26.5×36.5cm

[右頁圖]

人物-32.5.29（19） Figure-32.5.29 (19)

1932　紙本淡彩鉛筆　原寸（36.5×26.5cm）

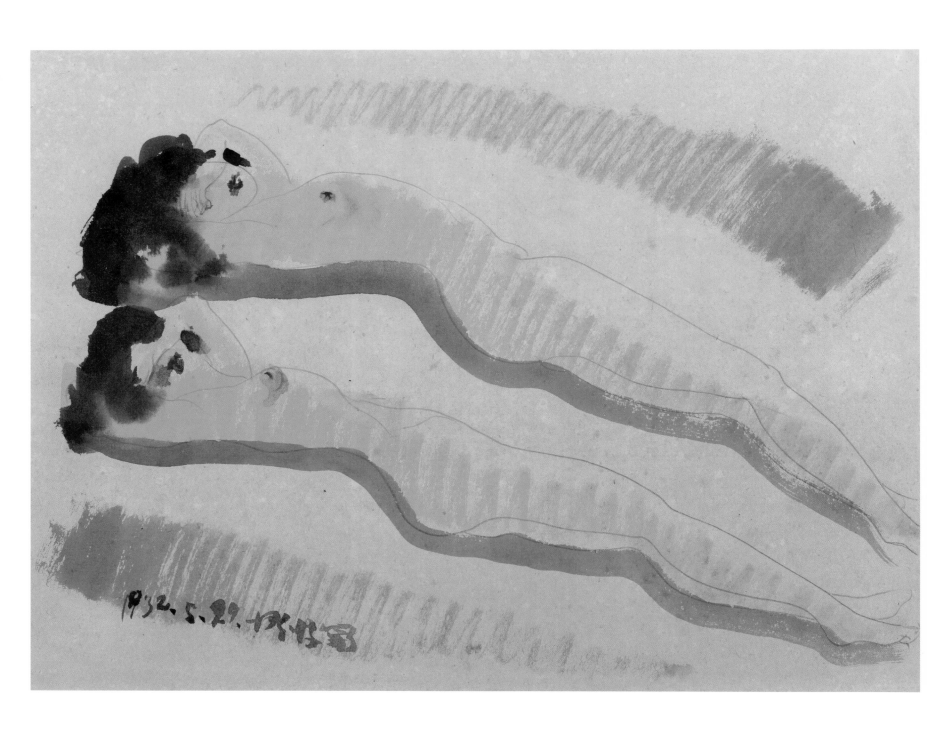

臥姿裸女-32.5.29（69） Lying Nude-32.5.29 (69)

1932　紙本淡彩鉛筆　26.5×36cm

[右頁圖]

臥姿裸女-32.5.29（70） Lying Nude-32.5.29 (70)

1932　紙本淡彩鉛筆　尺寸不詳

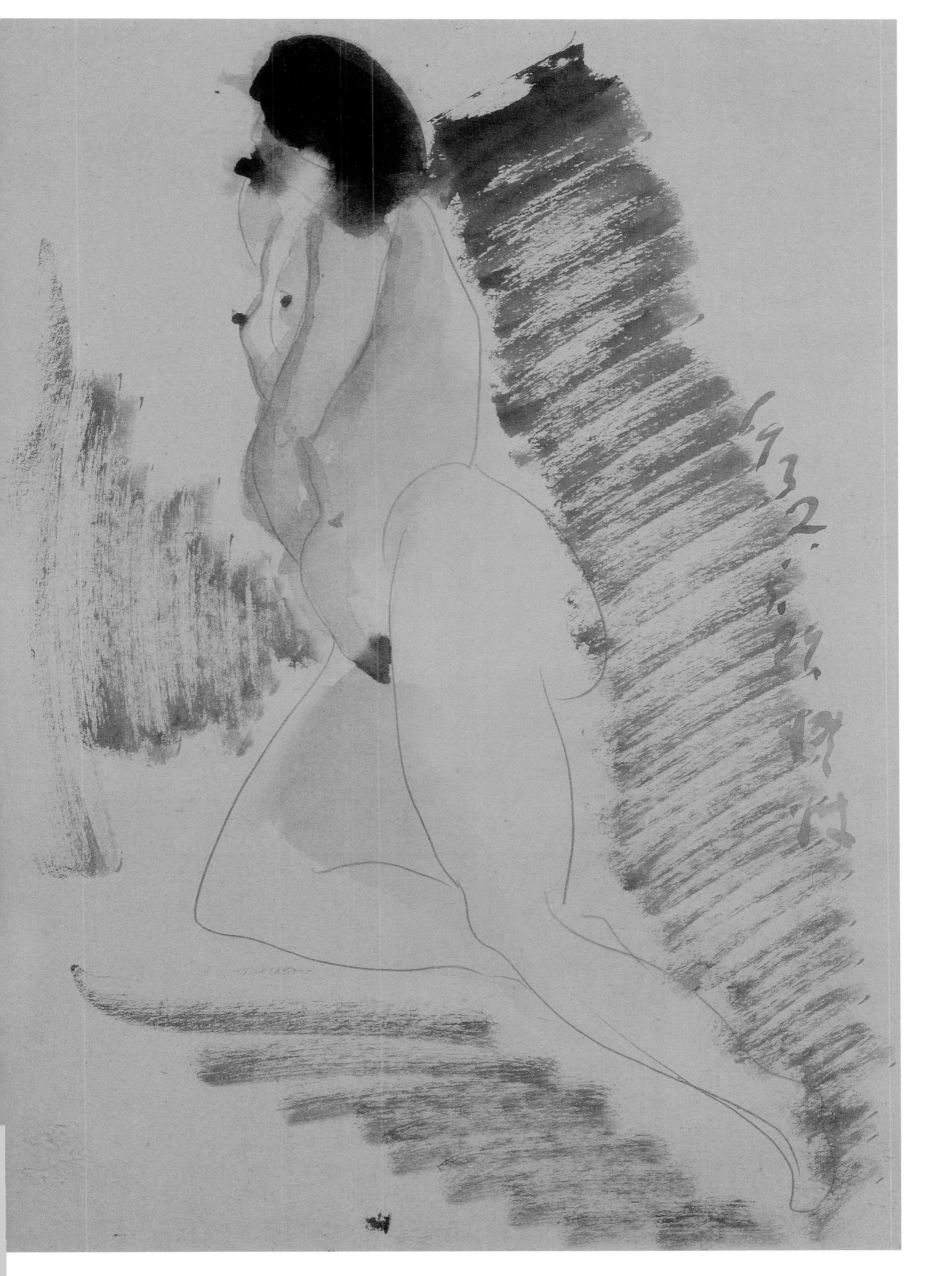

頭像-32.7（2） Portrait-32.7 (2)
1932　紙本淡彩　36.5×26cm

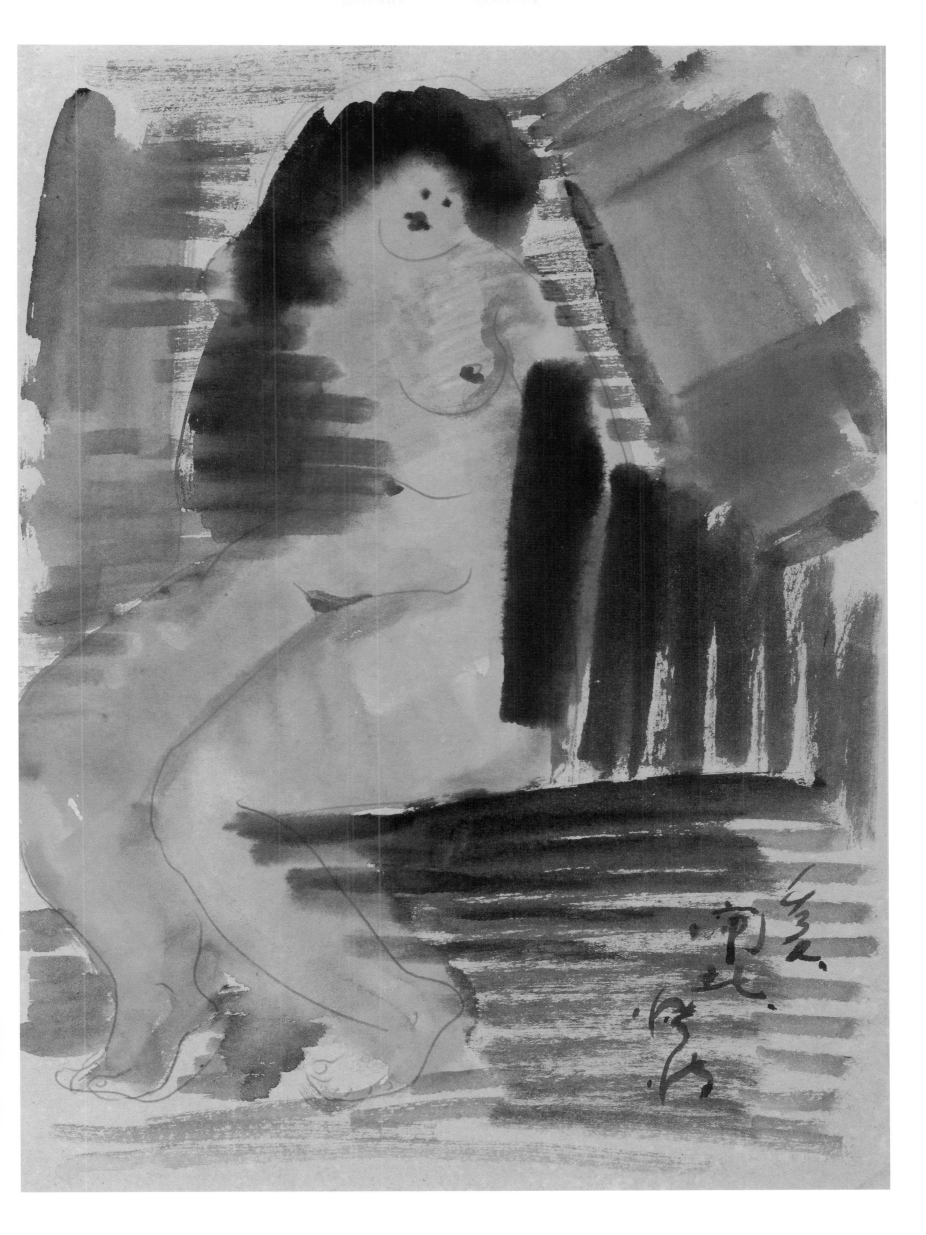

坐姿裸女-32（121） Seated Nude-32 (121)
1932　紙本淡彩鉛筆　36×26.5cm

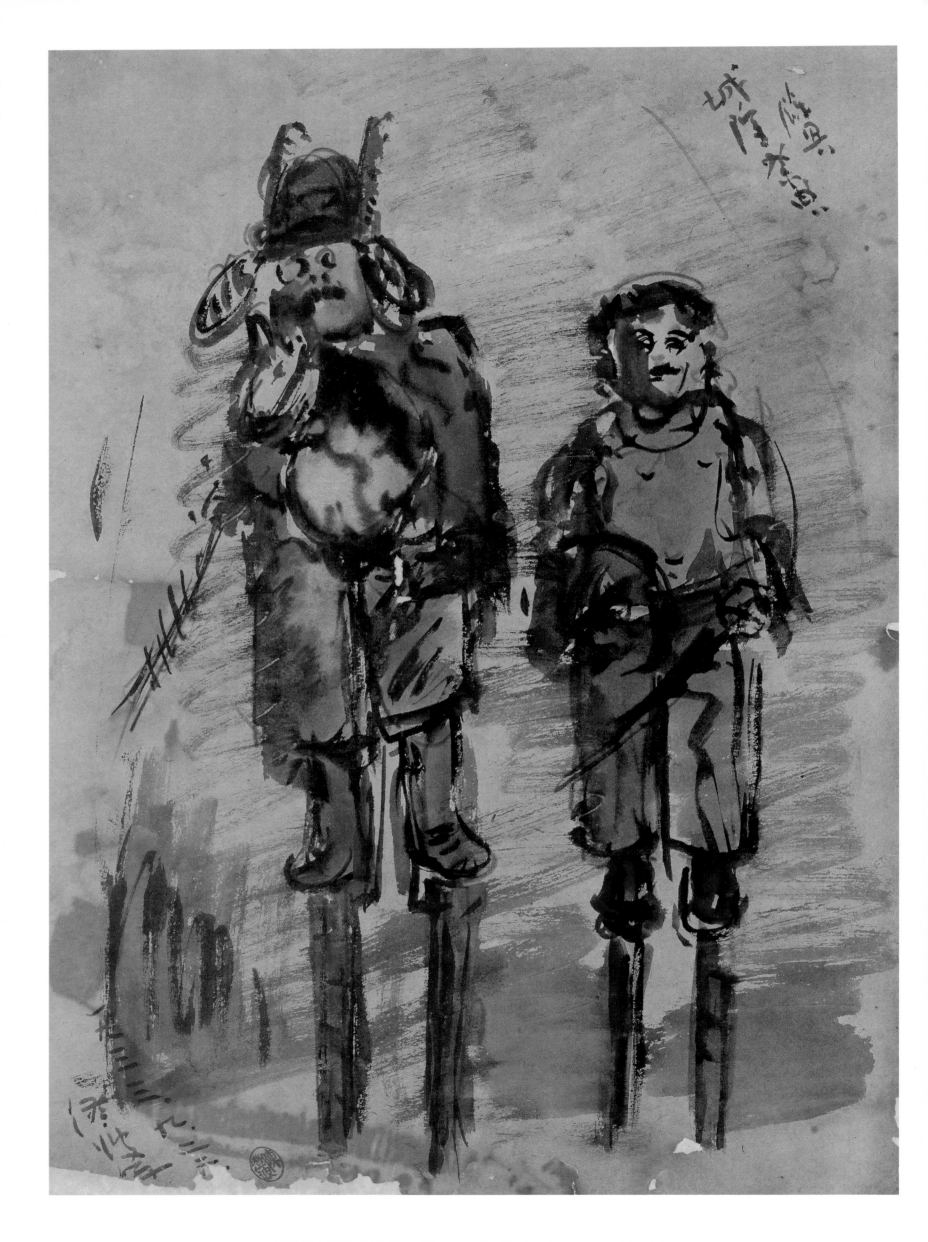

城隍祭典餘興-33.9.22　City God Festival Entertainment-33.9.22

1933　紙本淡彩鉛筆　36.5×26.5cm

淡彩速寫
Watercolor Sketch

其他（年代不詳）

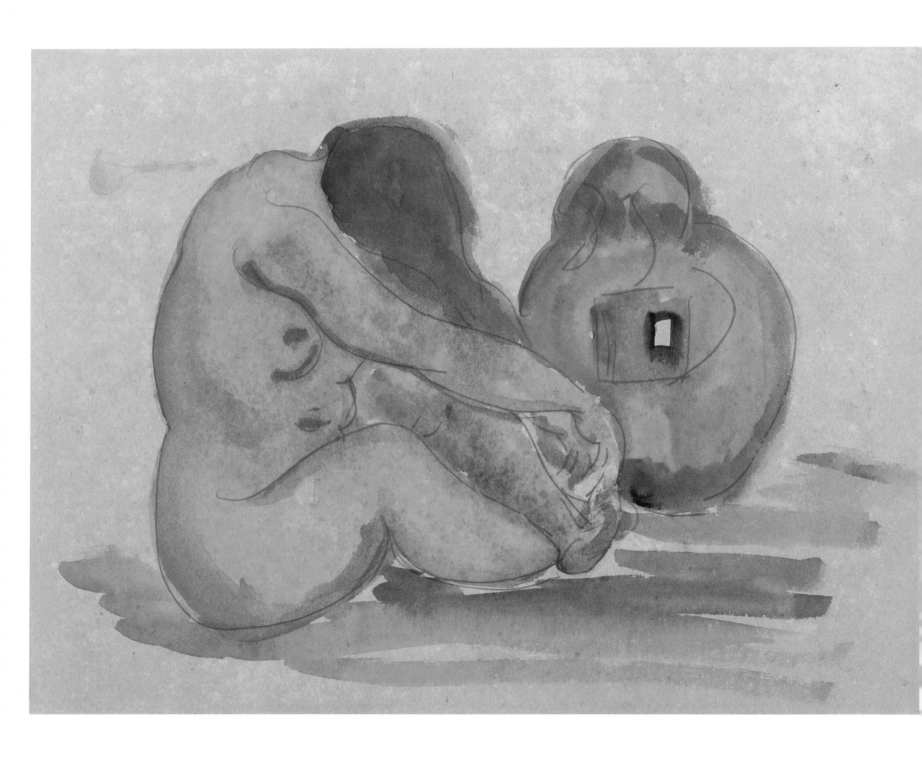

坐姿裸女（122）Seated Nude (122)
年代不詳　紙本淡彩鉛筆　27.5×36cm

[右頁圖]
坐姿裸女（123）Seated Nude (123)
年代不詳　紙本淡彩鉛筆　37×28.5cm
（圖片／資料提供者：財團法人台南市奇美文化基金會）

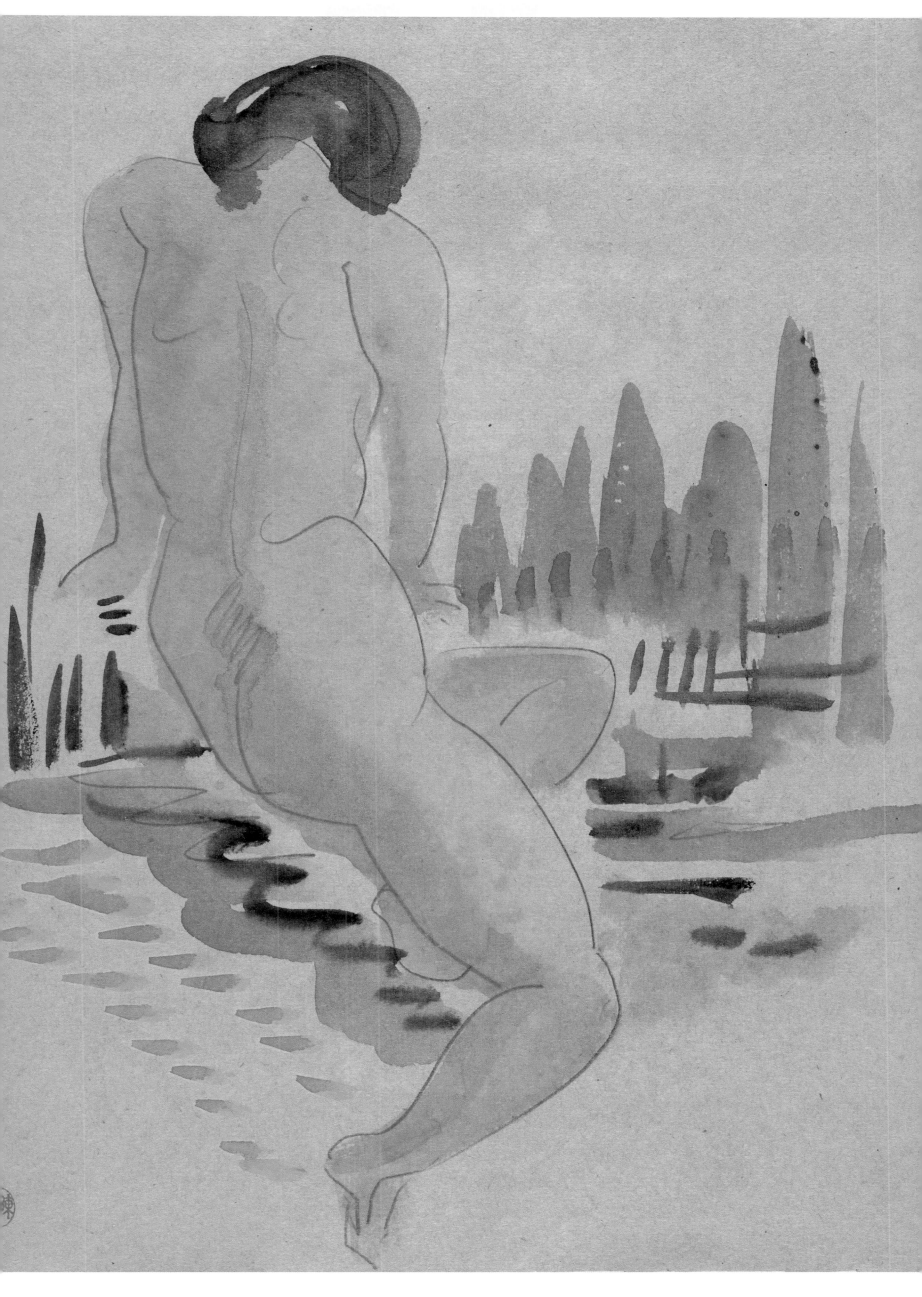

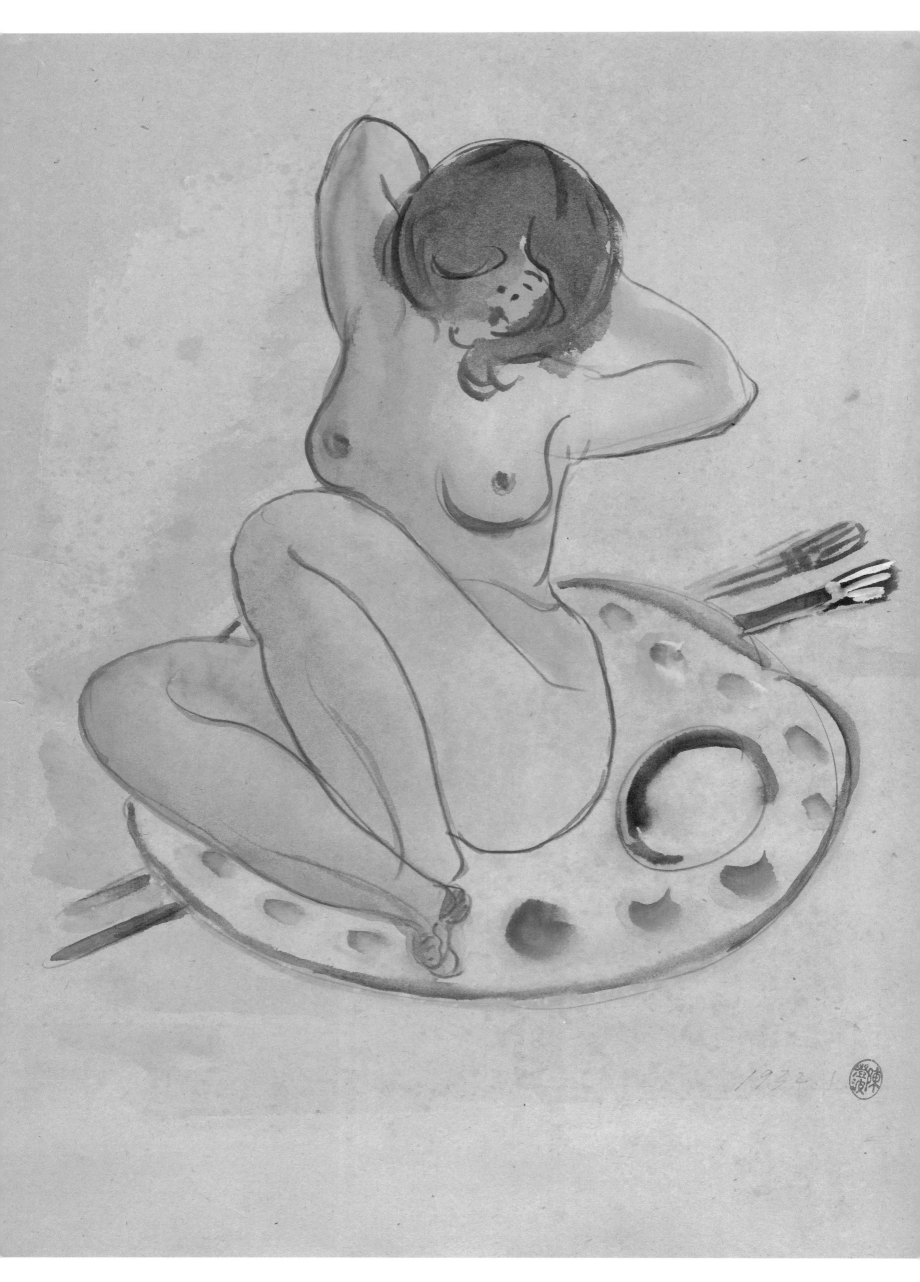

1932.1

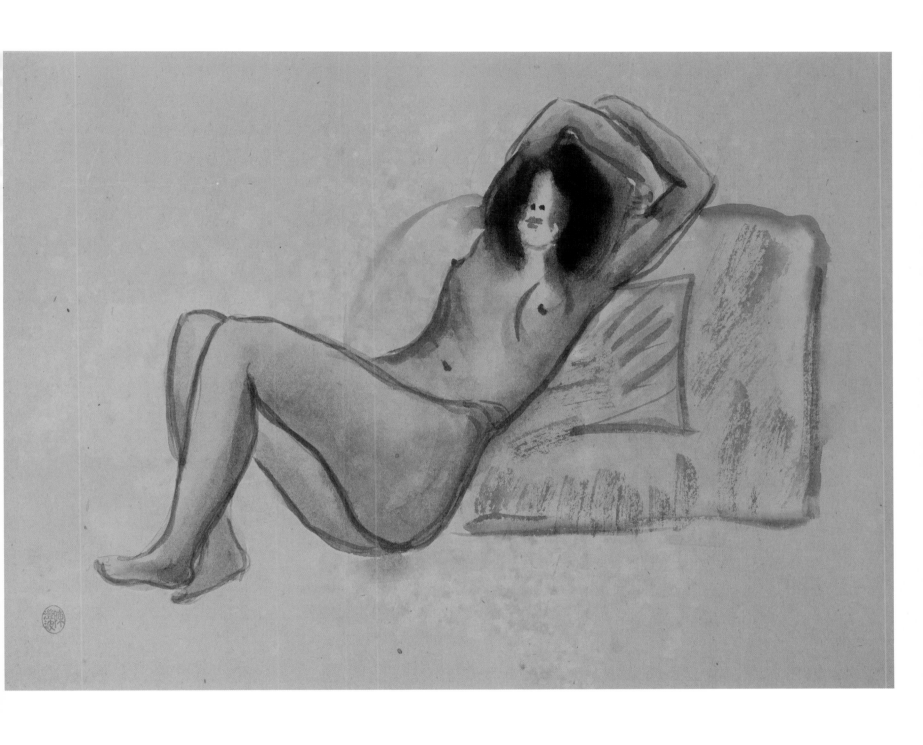

坐姿裸女（125） Seated Nude (125)
年代不詳　紙本淡彩　26.5×36cm

[左頁圖]
坐姿裸女（124） Seated Nude (124)
年代不詳　紙本淡彩鉛筆　37×28.6cm

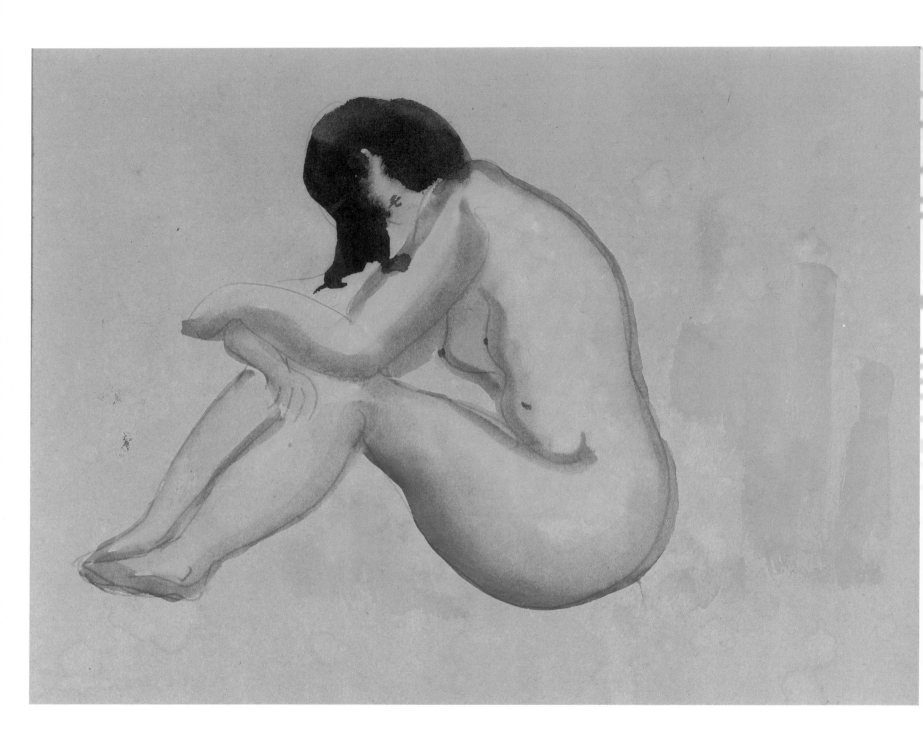

坐姿裸女（126）Seated Nude (126)

年代不詳　紙本淡彩鉛筆　28.5×37cm

[右頁圖]

坐姿裸女（127）Seated Nude (127)

年代不詳　紙本淡彩鉛筆　36×28cm

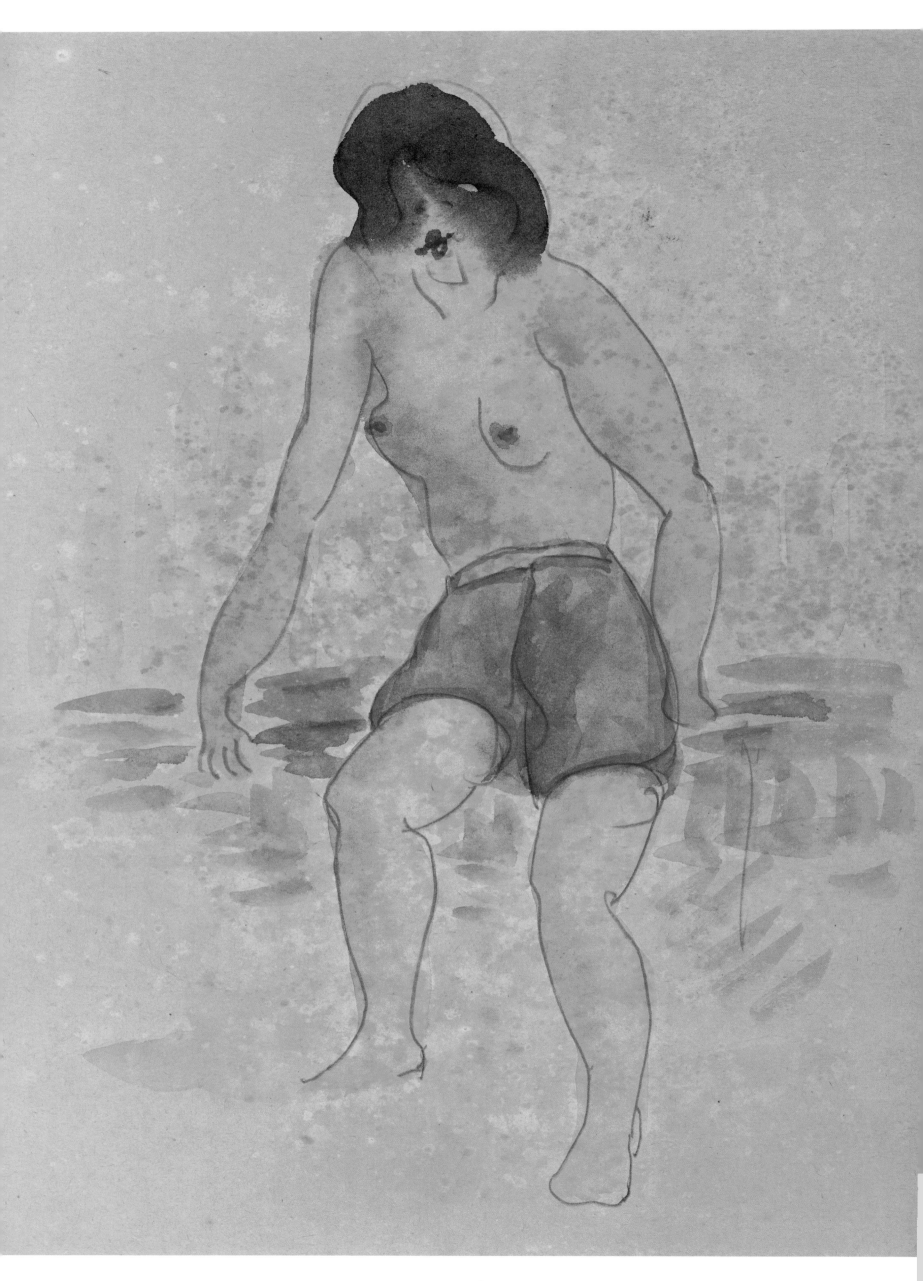

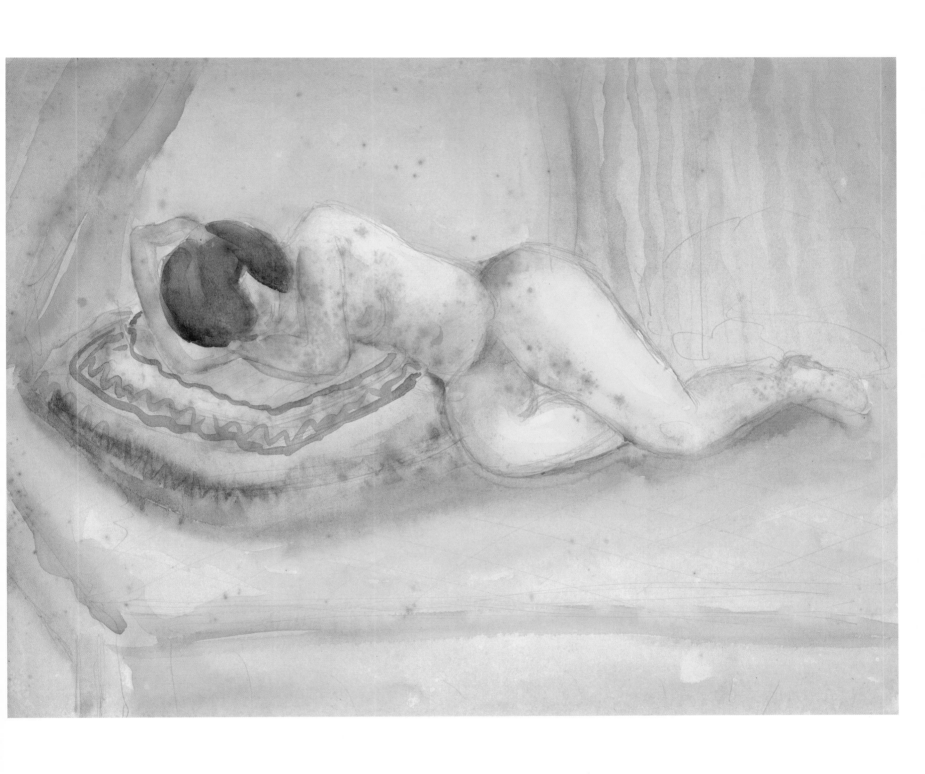

臥姿裸女（71） Lying Nude (71)
年代不詳　紙本淡彩鉛筆　28.5×37.5cm

[左頁圖]
坐姿裸女（128） Seated Nude (128)
年代不詳　紙本淡彩鉛筆　36×28cm

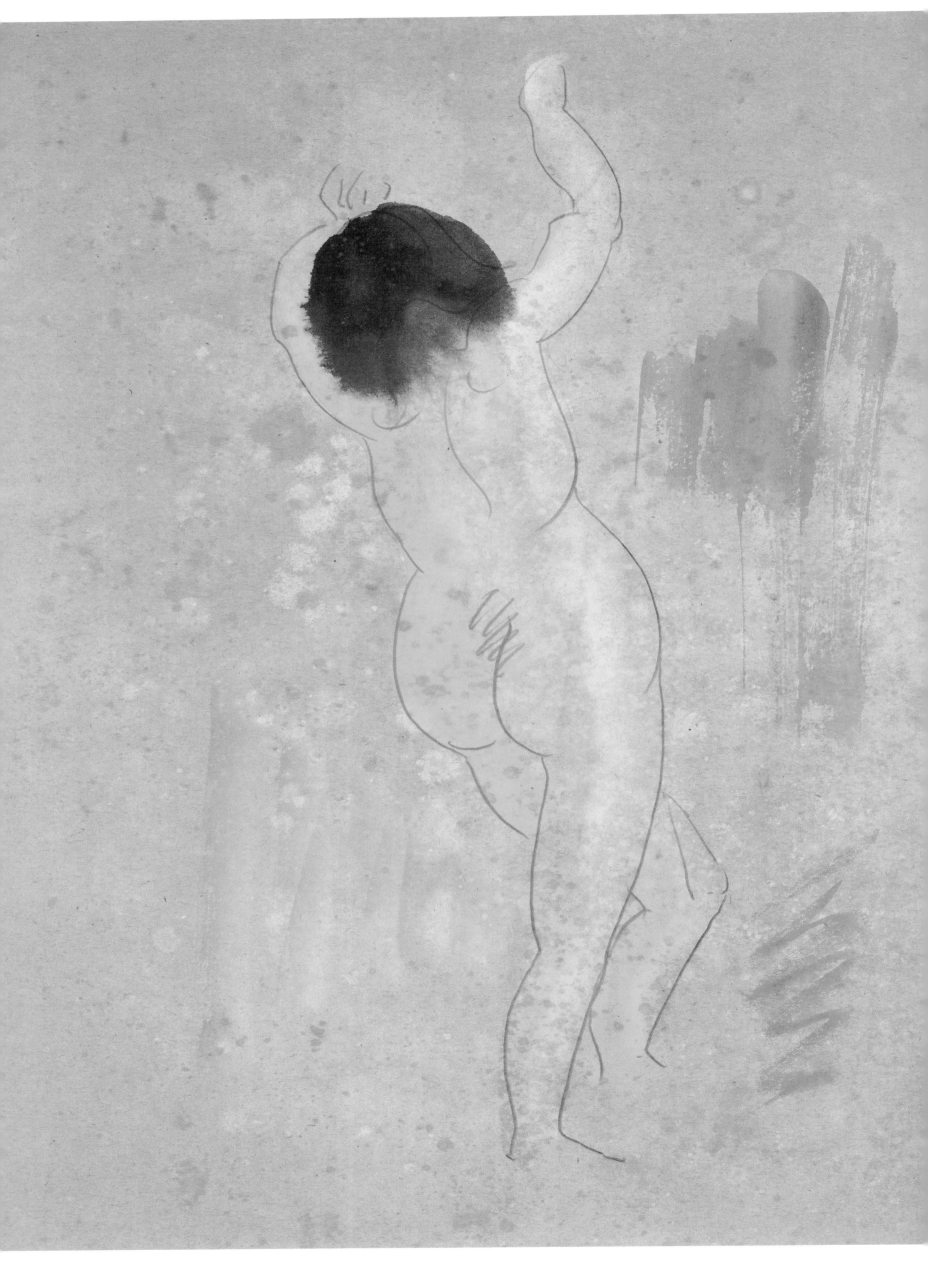

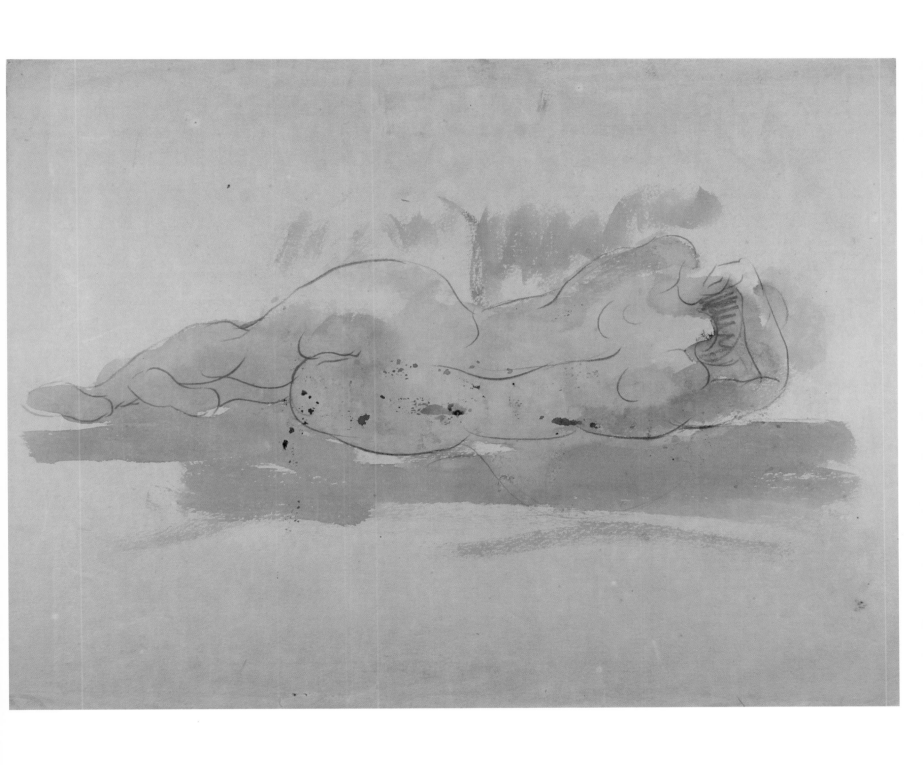

臥姿裸女（72）Lying Nude (72)
年代不詳　紙本淡彩鉛筆　29.5×38cm

[左頁圖]
立姿裸女（56）Standing Nude (56)
年代不詳　紙本淡彩鉛筆　37×28cm

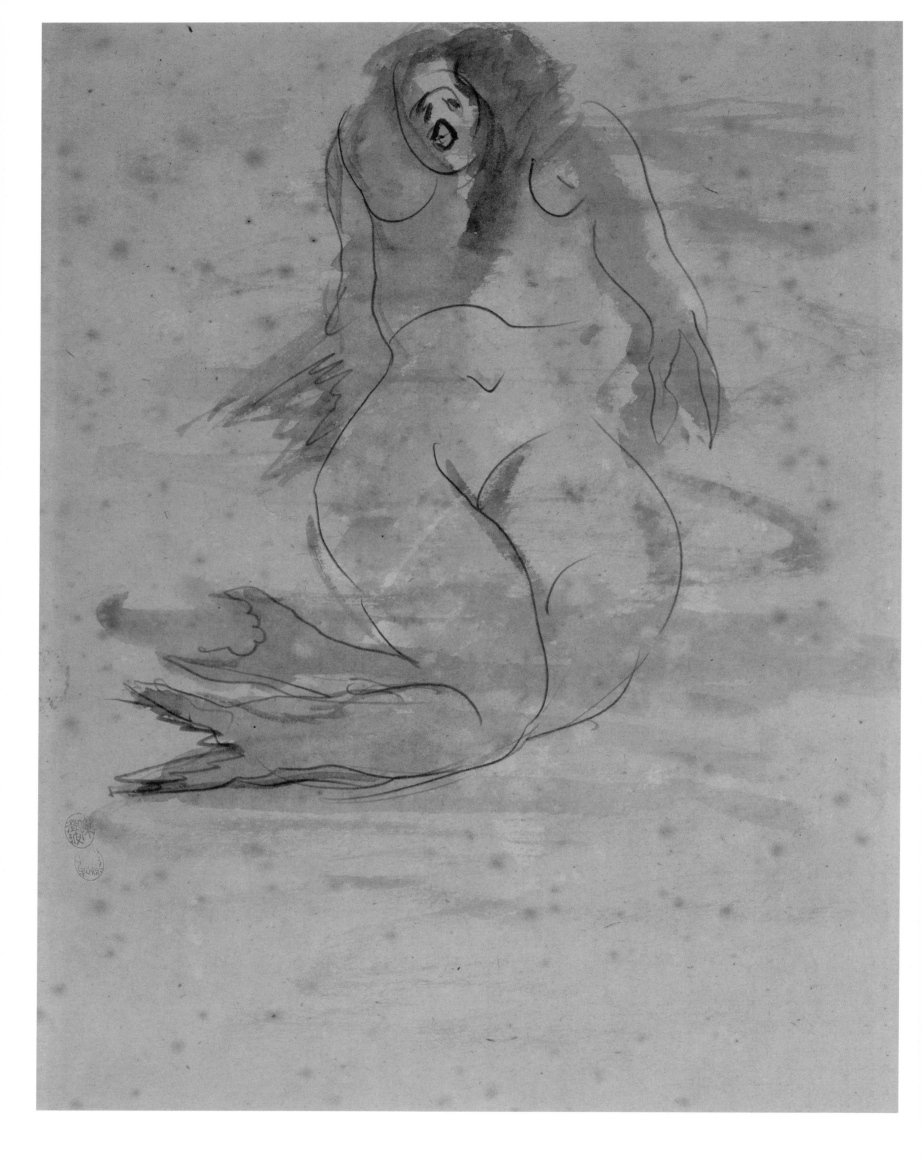

坐姿裸女（129）Seated Nude (129)

年代不詳　紙本淡彩鉛筆　36.5×27.5cm

[右頁圖]

立姿裸女（57）Standing Nude (57)

年代不詳　紙本淡彩鉛筆　原寸（36×26.5cm）

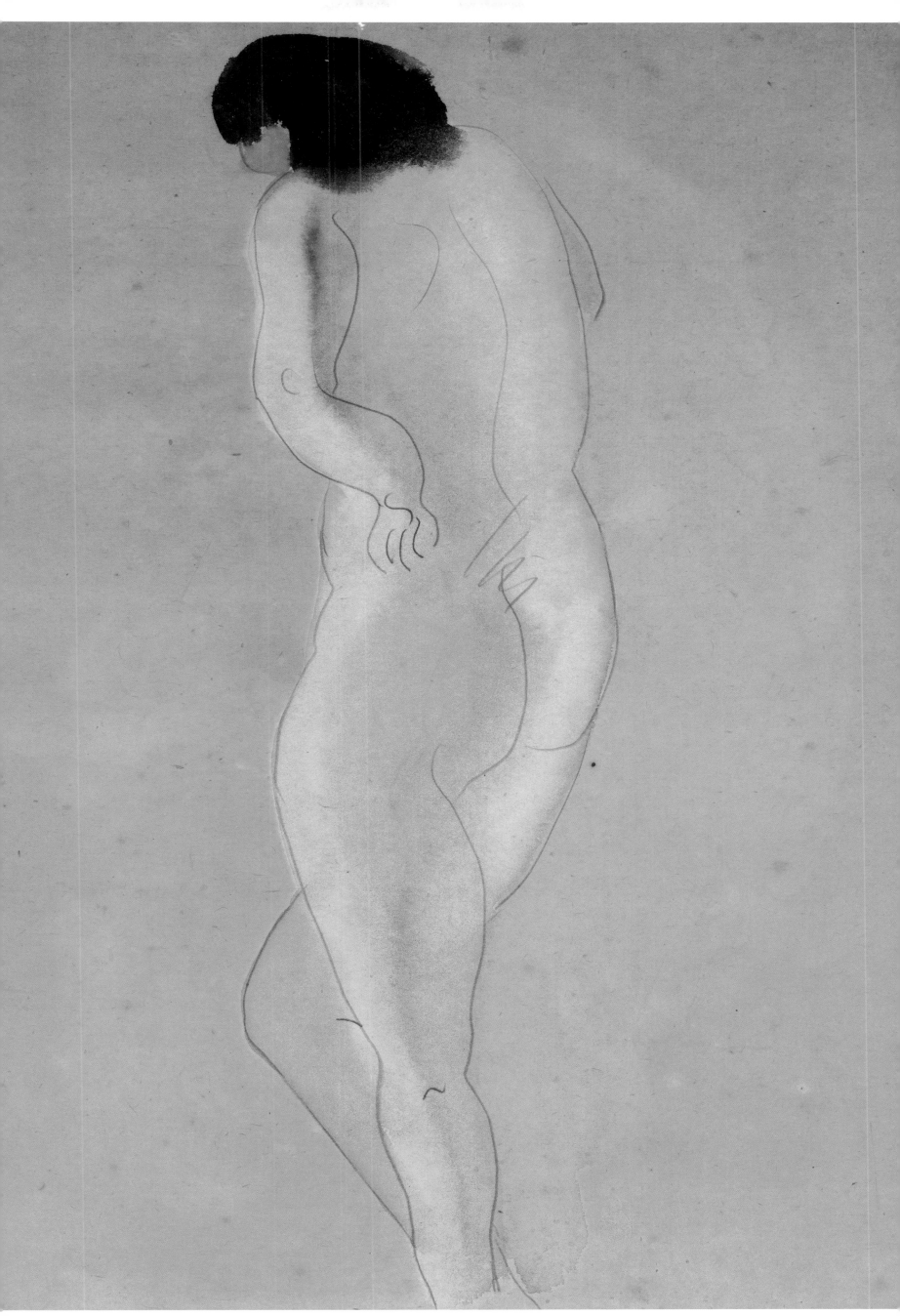

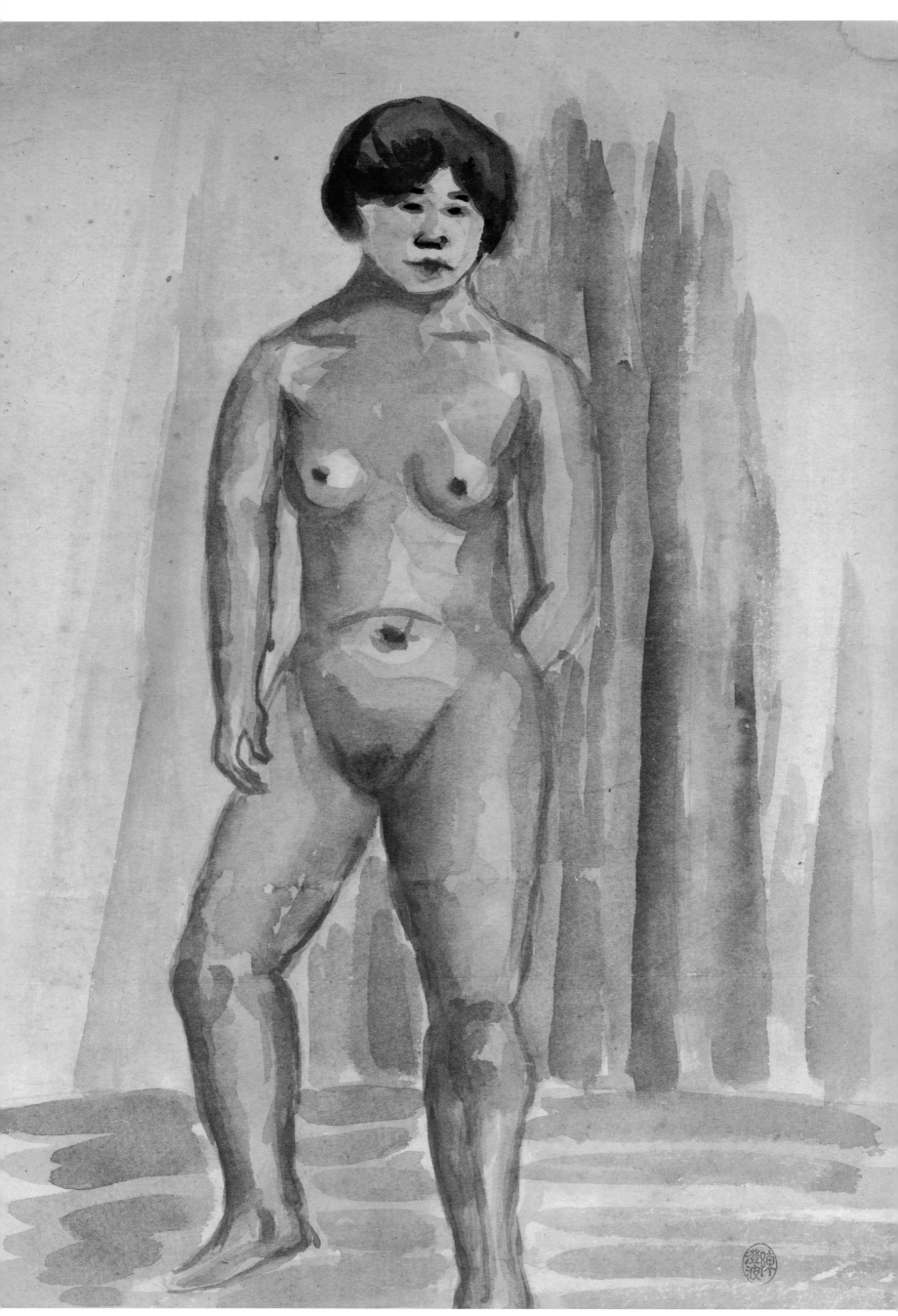

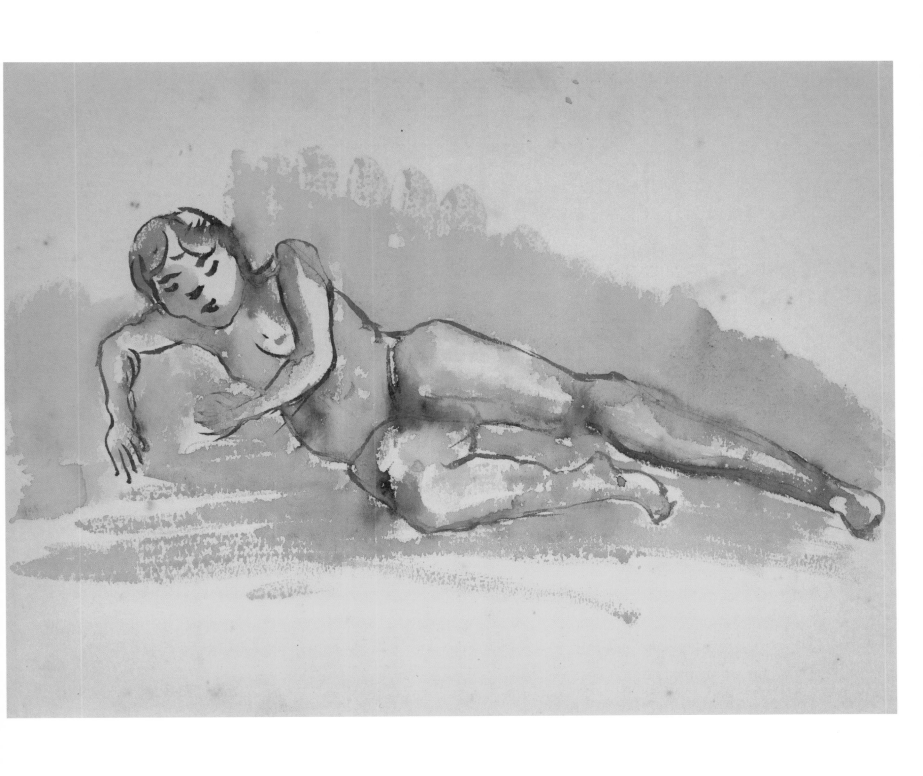

臥姿裸女（73） Lying Nude (73)

年代不詳　紙本淡彩　28.5×37.5cm

[左頁圖]
立姿裸女（58） Standing Nude (58)

年代不詳　紙本淡彩　原寸（36×25.5cm）

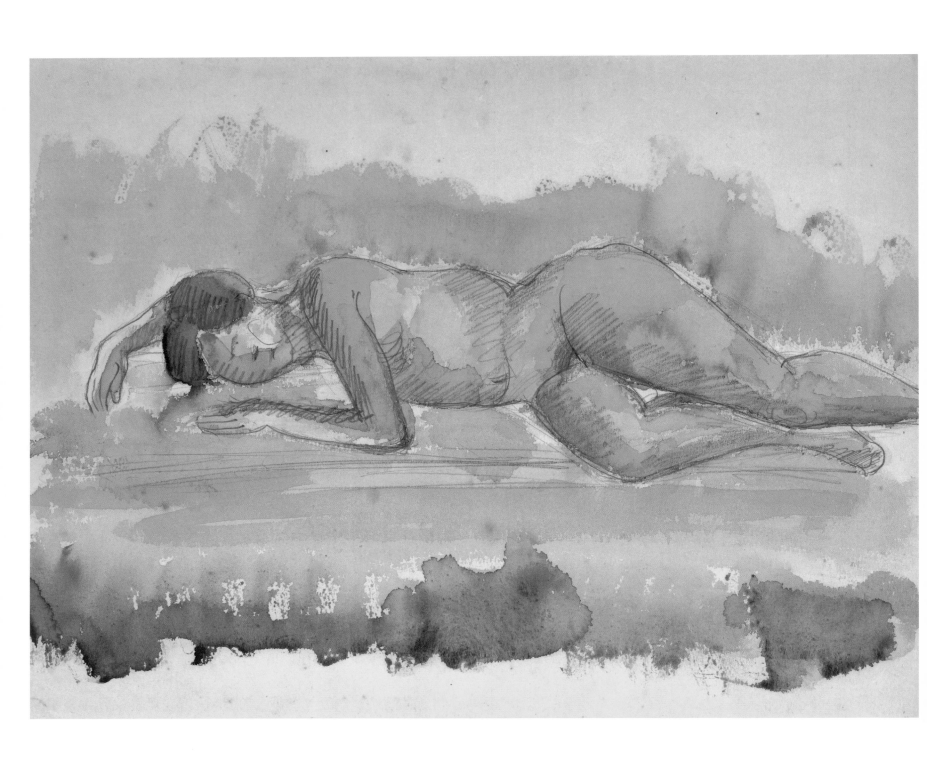

臥姿裸女（74） Lying Nude (74)

年代不詳　紙本淡彩鉛筆　28.5×37.5cm

[右頁圖]
立姿裸女（59） Standing Nude (59)

年代不詳　紙本淡彩鉛筆　37.5×28.5cm

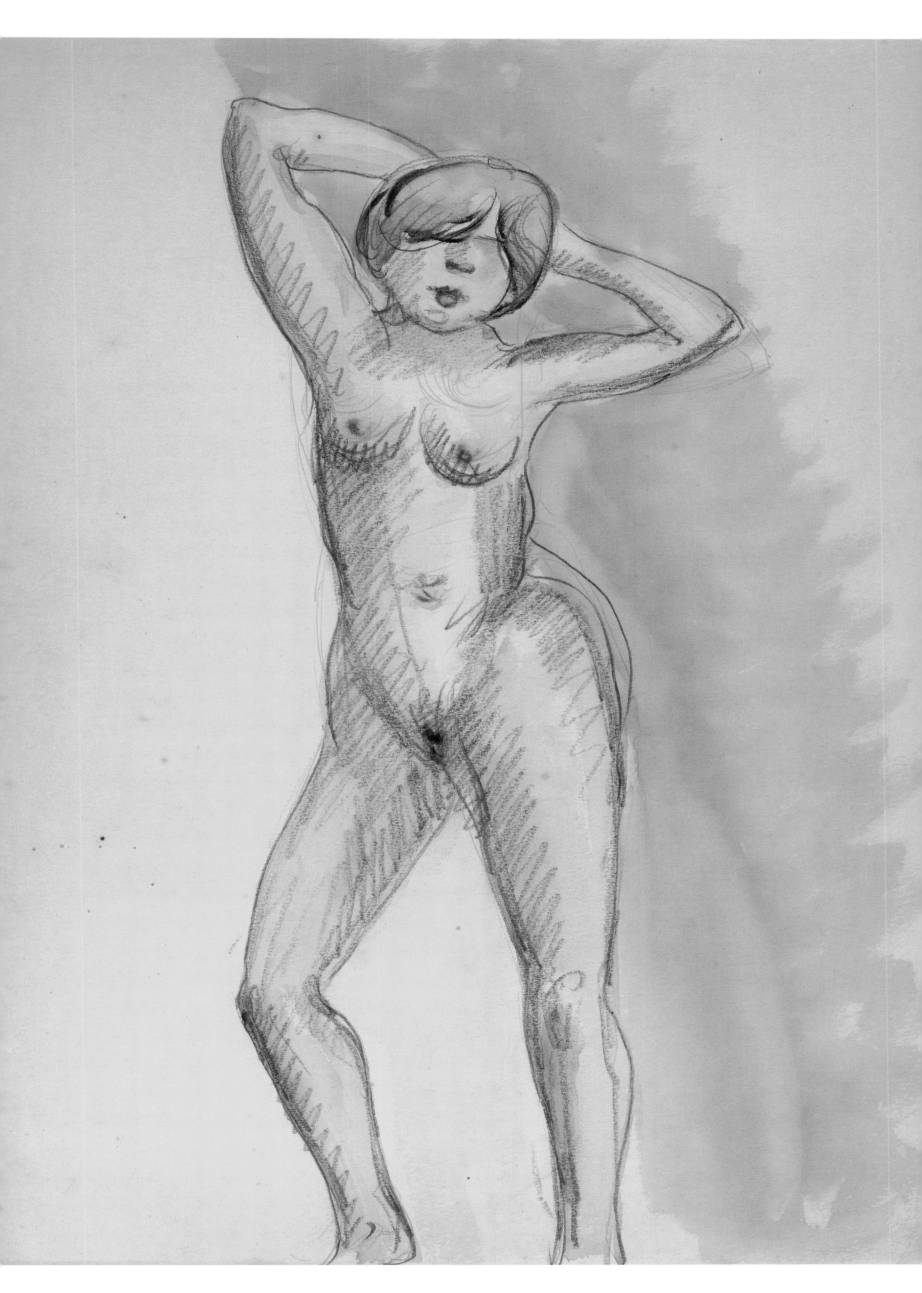

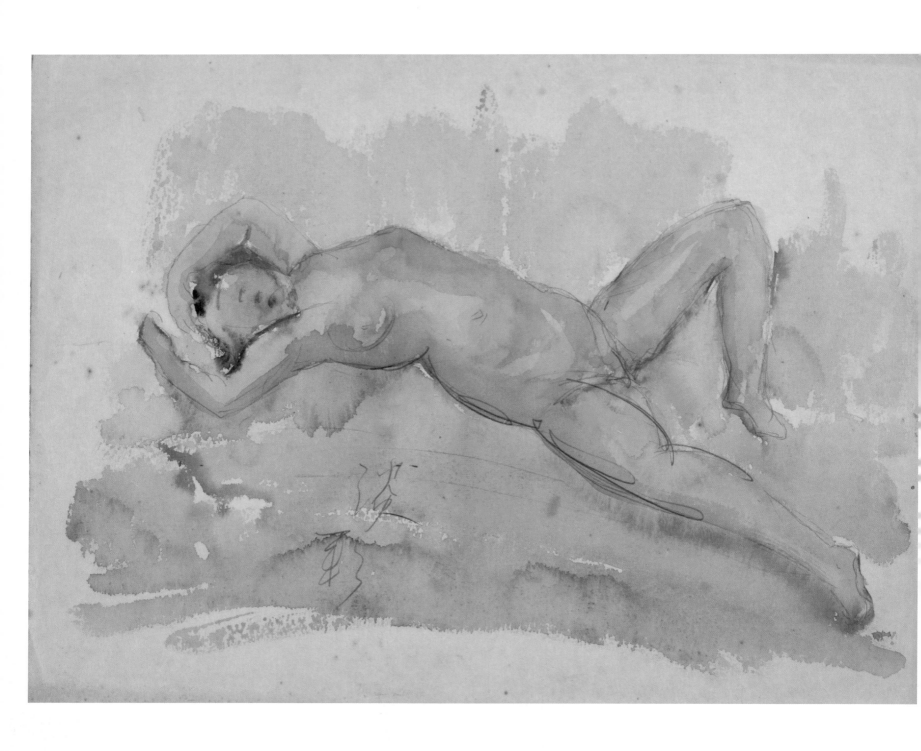

臥姿裸女（75）Lying Nude (75)

年代不詳　紙本淡彩鉛筆　28.5×29.5cm

[右頁圖]

立姿裸女（60）Standing Nude (60)

年代不詳　紙本淡彩鉛筆　36.5×28.5cm

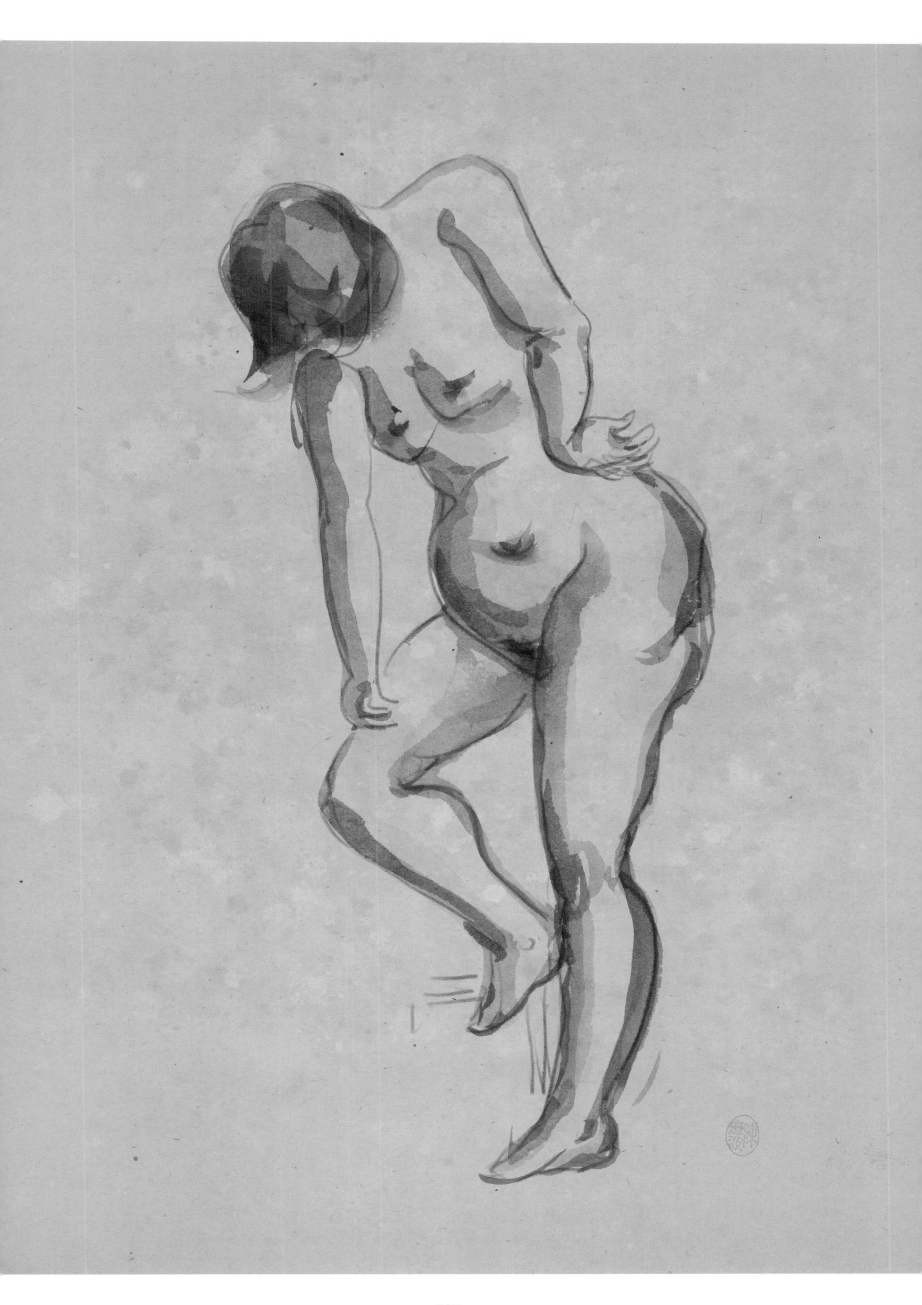

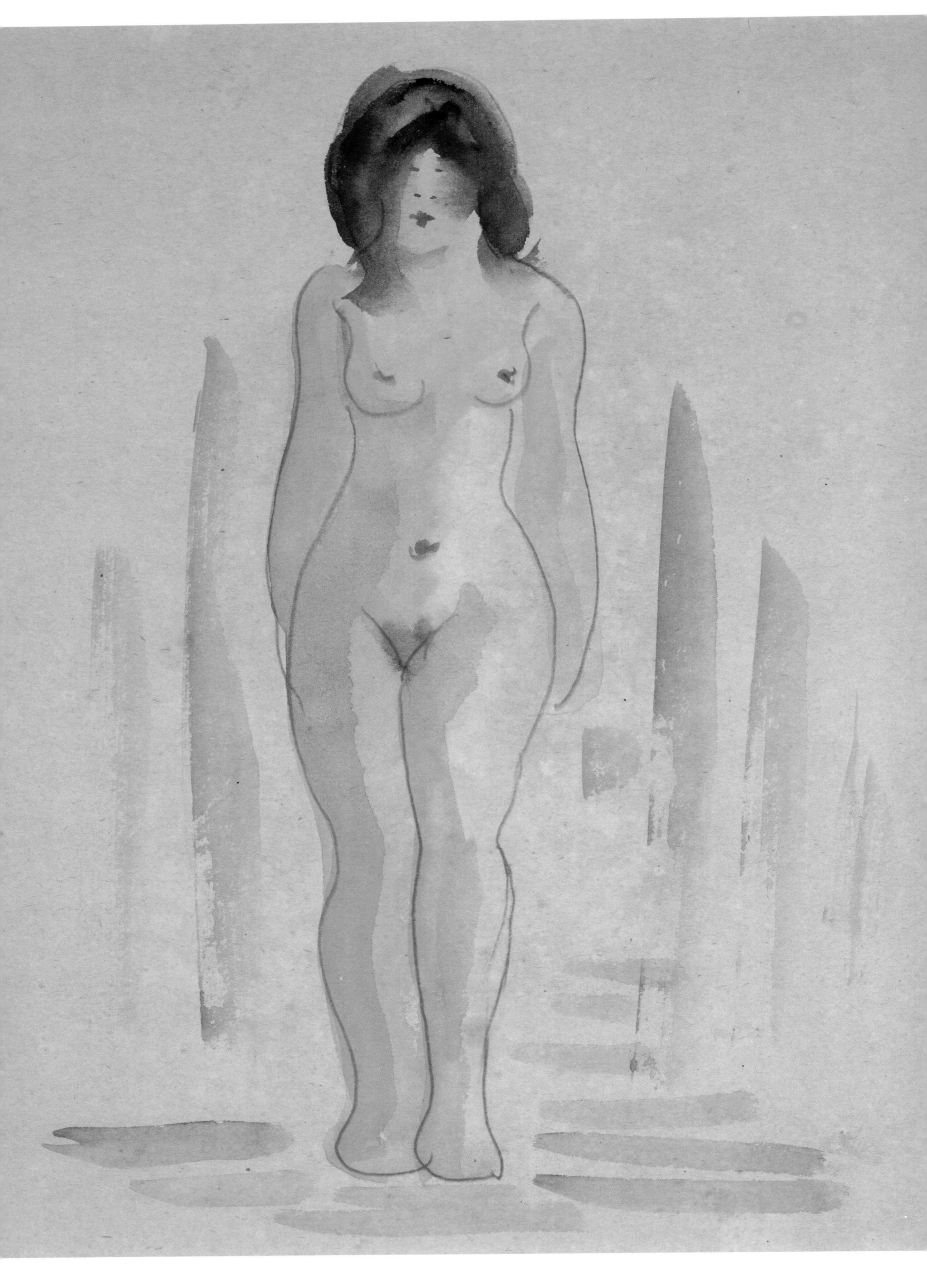

坐姿裸女（130） Seated Nude (130)

年代不詳　紙本淡彩鉛筆　22×31cm

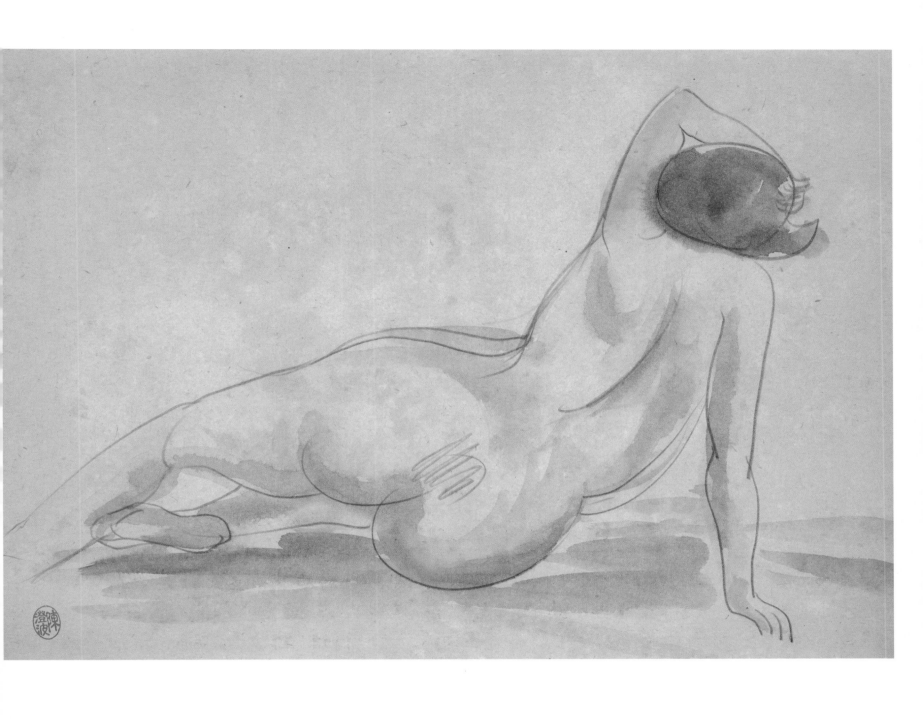

坐姿裸女（130） Seated Nude (130)

年代不詳　紙本淡彩鉛筆　22×31cm

[左頁圖]
立姿裸女（61） Standing Nude (61)

年代不詳　紙本淡彩鉛筆　36.5×28cm

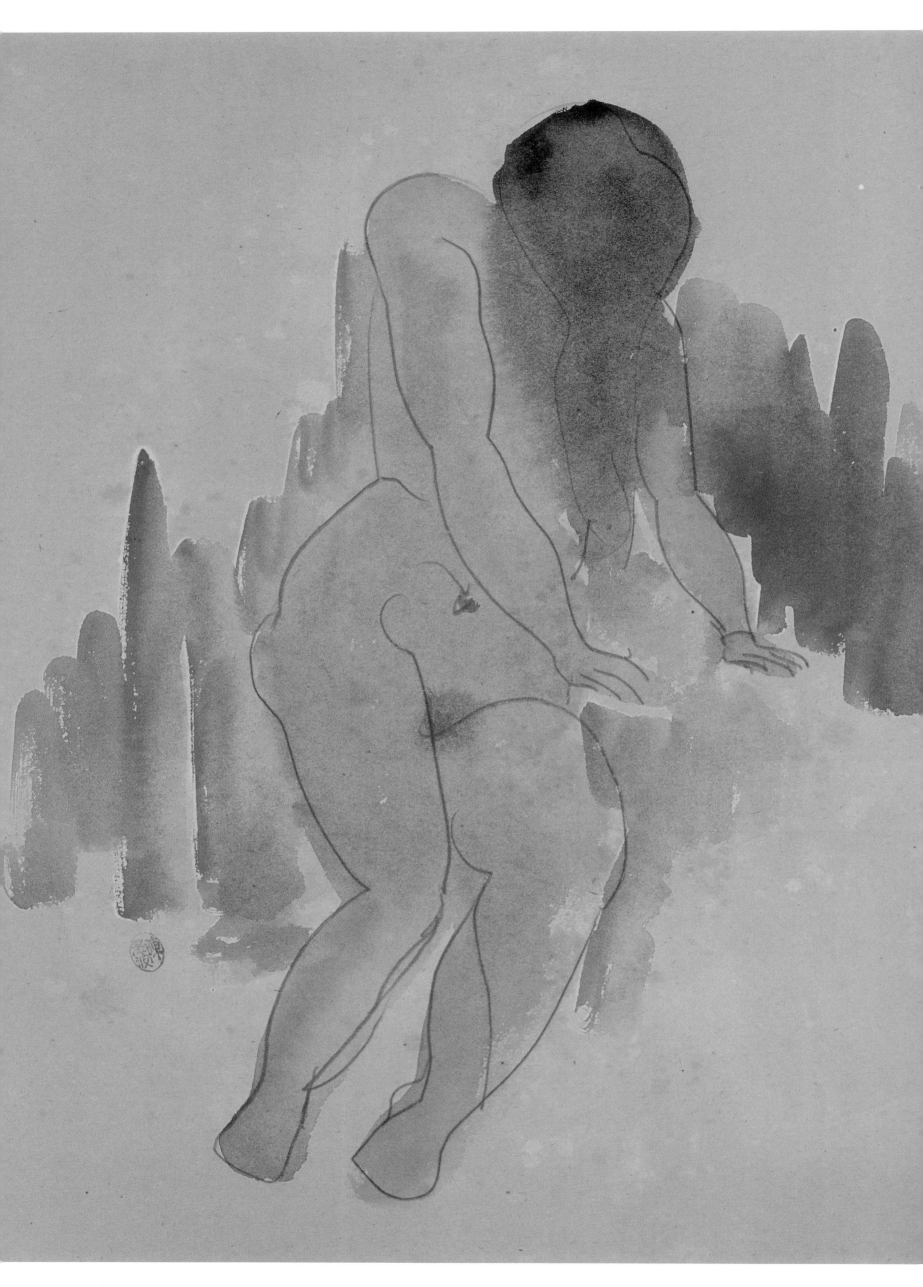

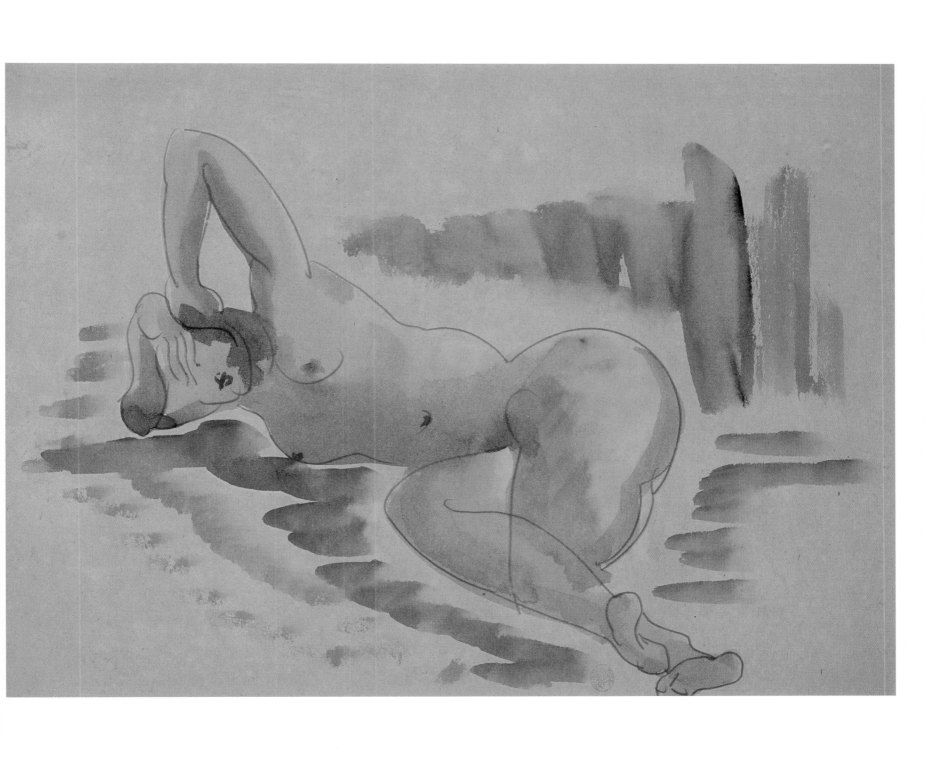

臥姿裸女（76）Lying Nude (76)

年代不詳　紙本淡彩鉛筆　27×37cm

[左頁圖]

坐姿裸女（131）Seated Nude (131)

年代不詳　紙本淡彩鉛筆　36.5×28cm

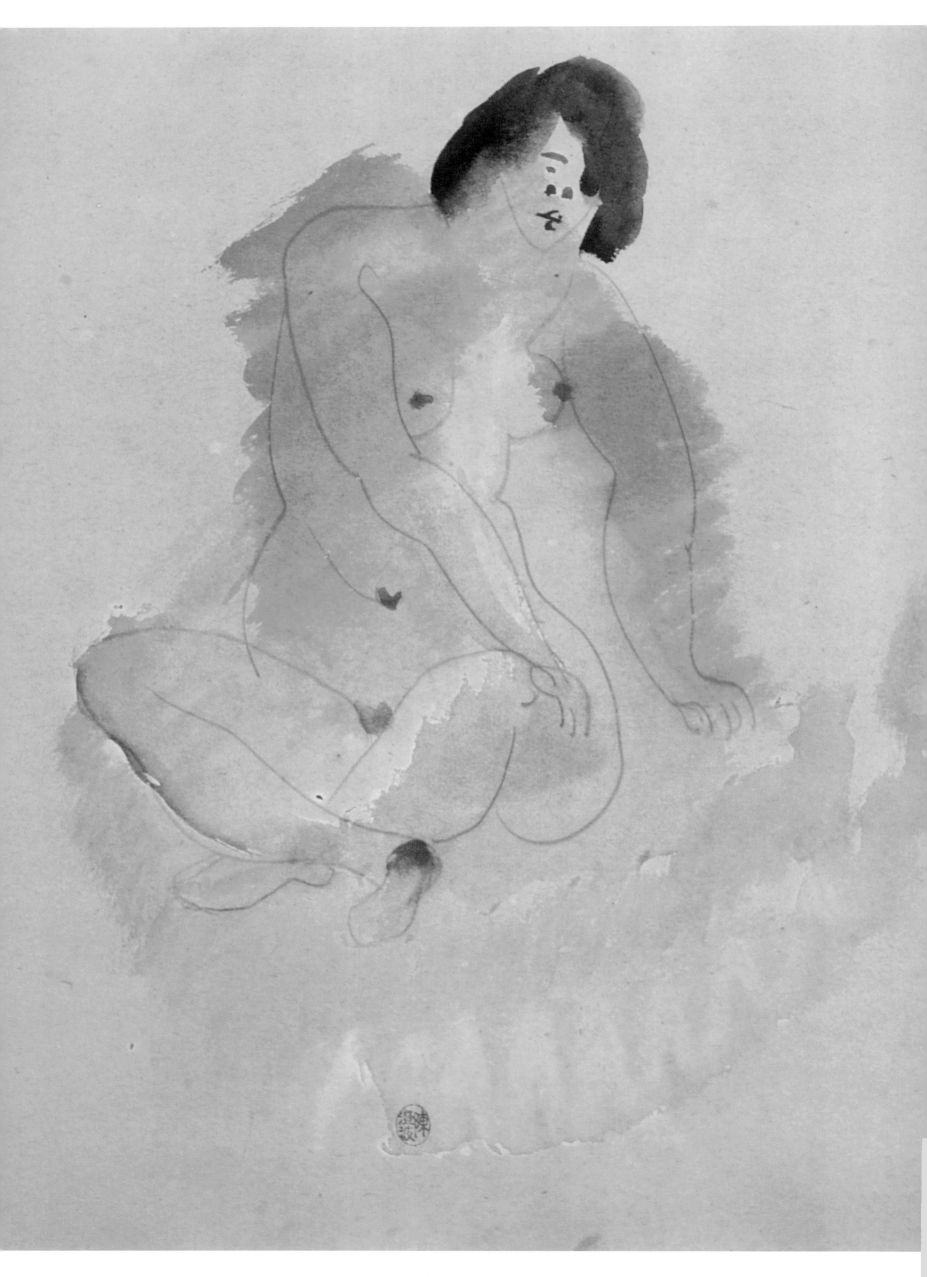

342

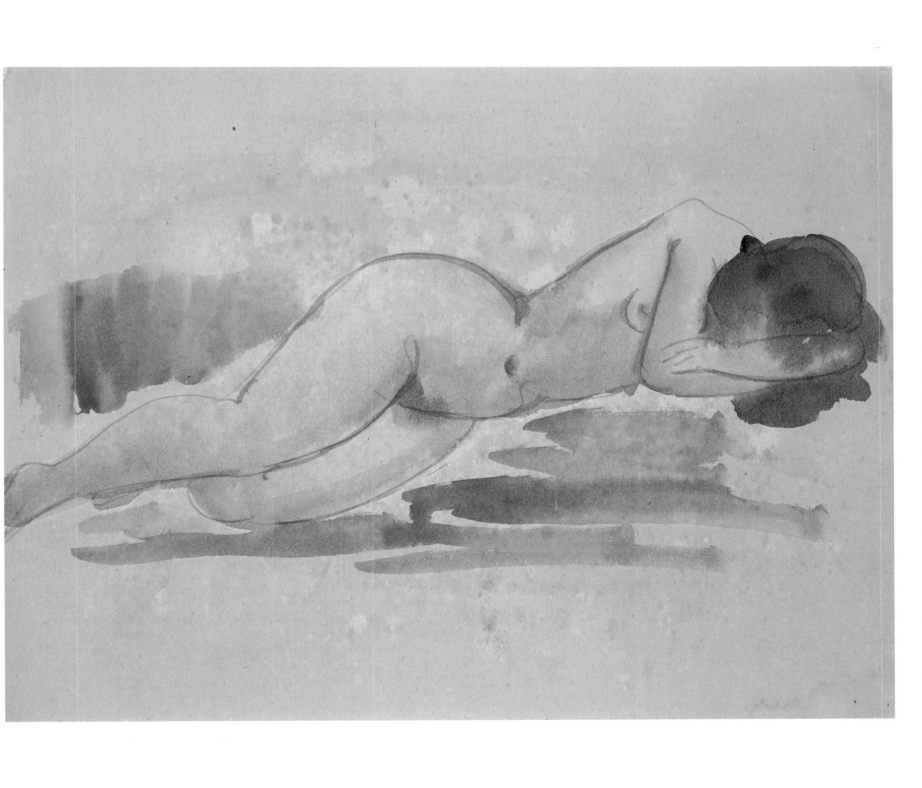

臥姿裸女（77） Lying Nude (77)

年代不詳　紙本淡彩鉛筆　28×37cm

[左頁圖]

坐姿裸女（132） Seated Nude (132)

年代不詳　紙本淡彩鉛筆　37.2×28.5cm

臥姿裸女（78）Lying Nude (78)

年代不詳　紙本淡彩鉛筆　27.5×36.5cm

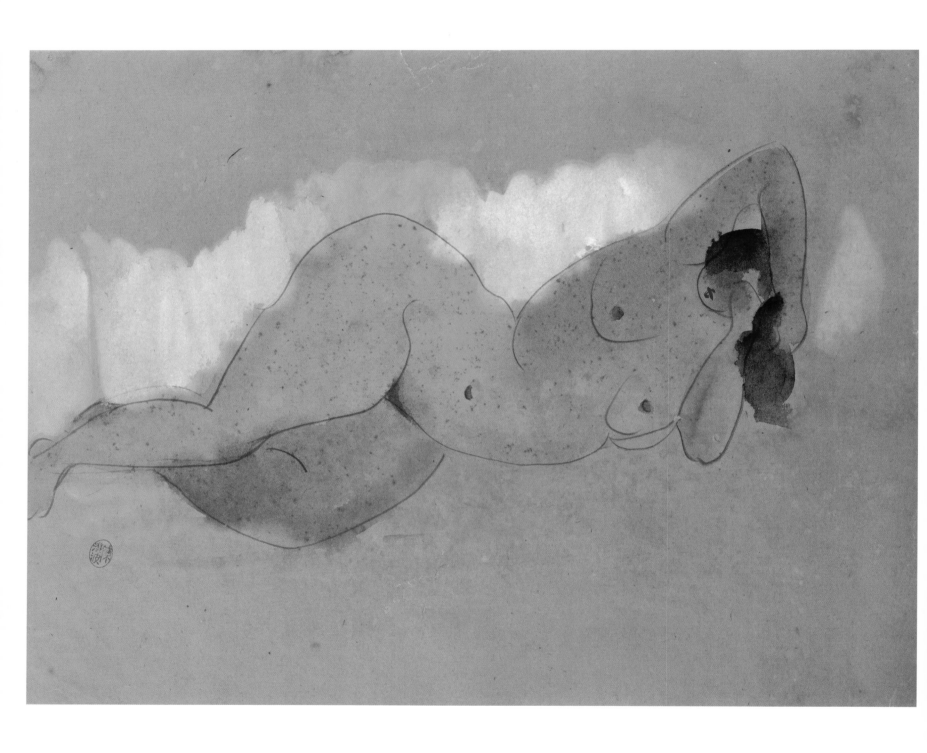

臥姿裸女（78）Lying Nude (78)

年代不詳　紙本淡彩鉛筆　27.5×36.5cm

[右頁圖]
立姿裸女（62）Standing Nude (62)

年代不詳　紙本淡彩鉛筆　37×28cm

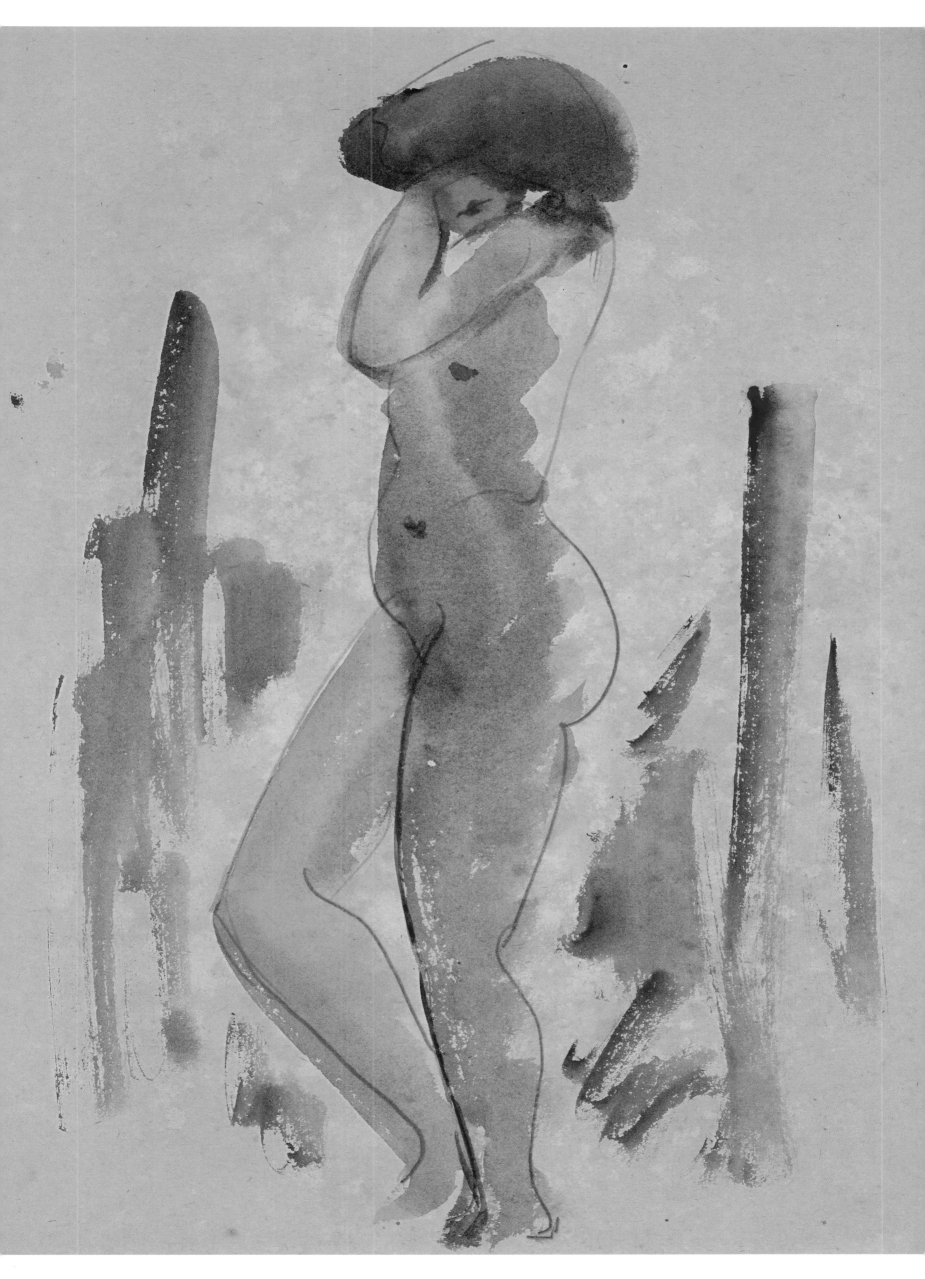

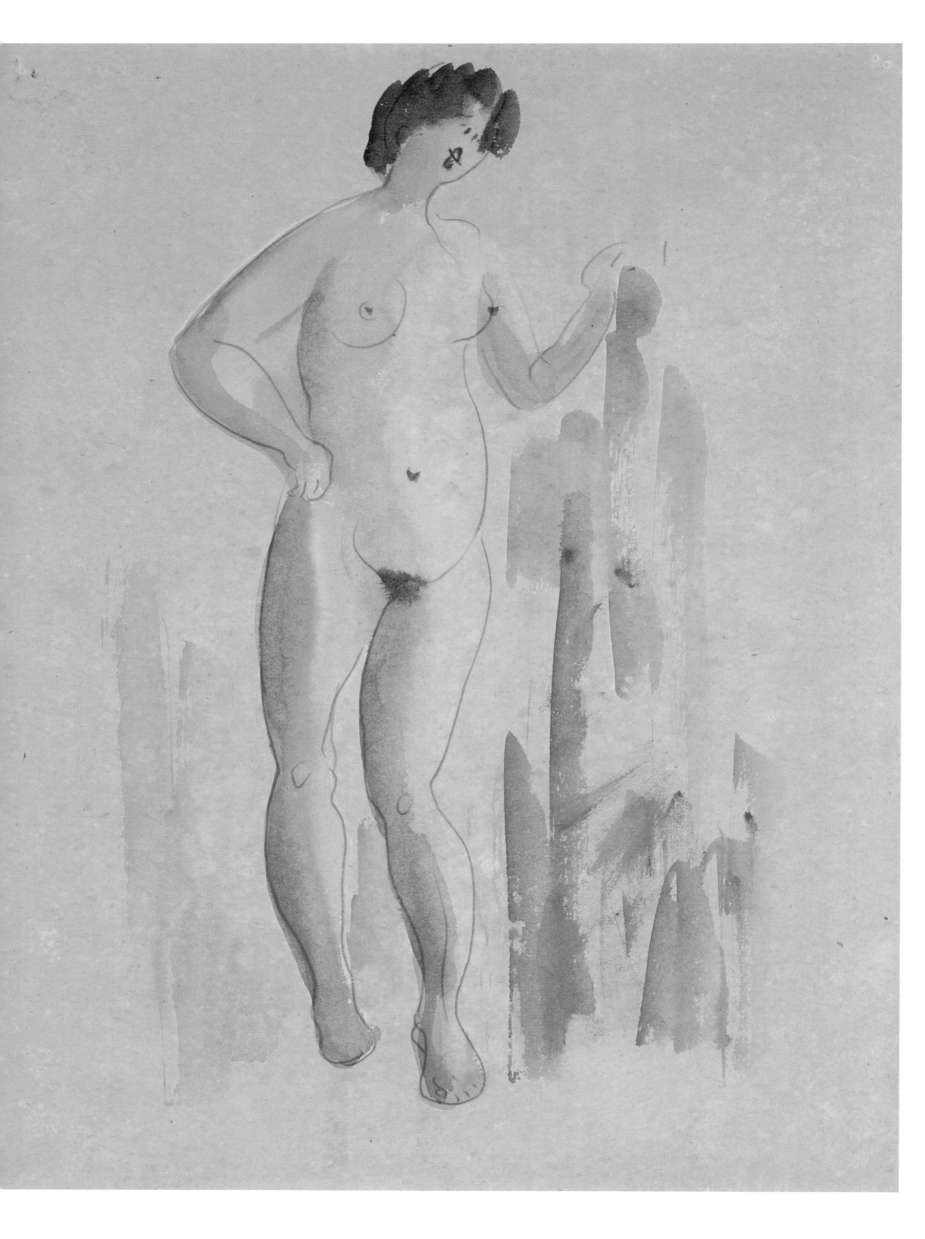

立姿裸女（63）Standing Nude (63)

年代不詳　紙本淡彩鉛筆　36.5×28.5cm

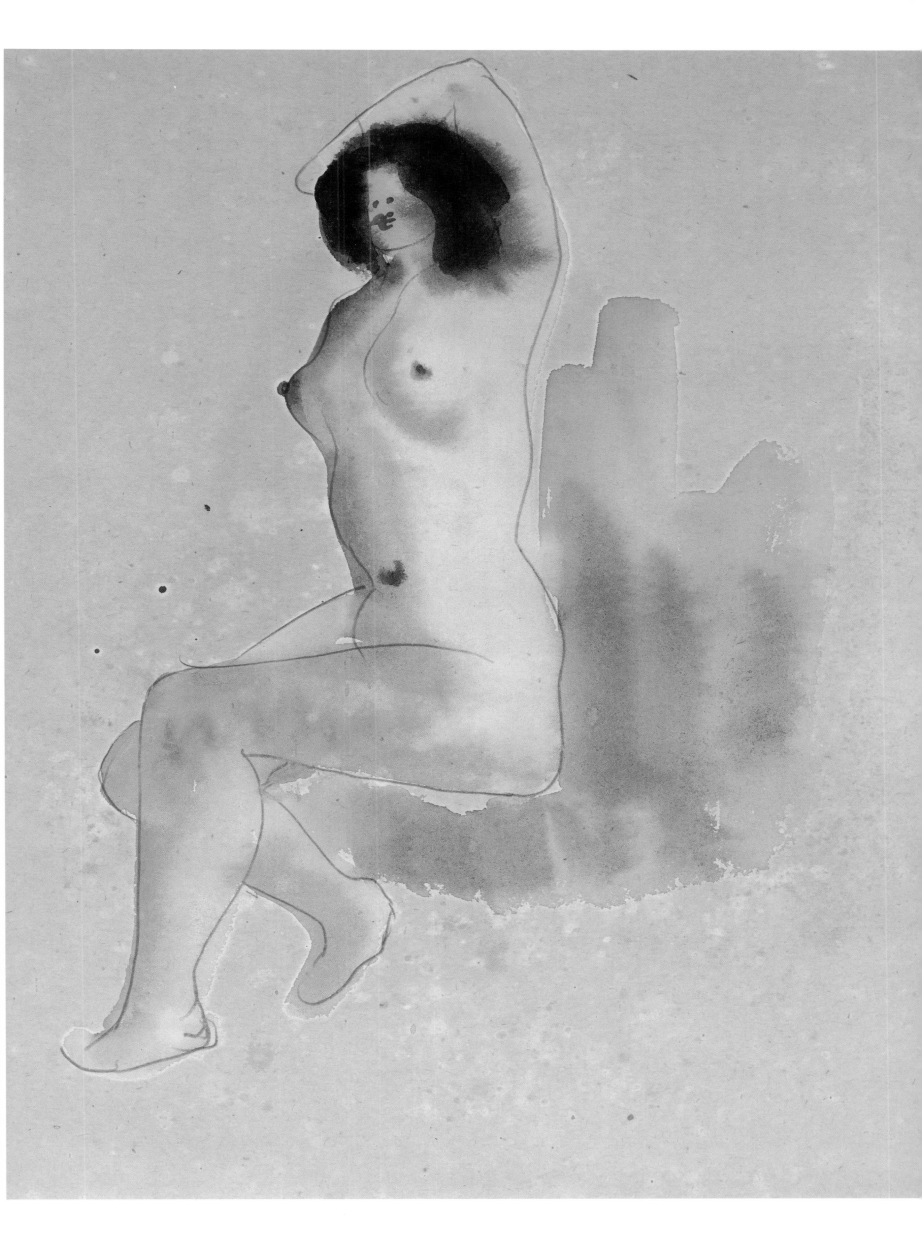

坐姿裸女（134）Seated Nude (134)

年代不詳　紙本淡彩鉛筆　36.5×28.5cm

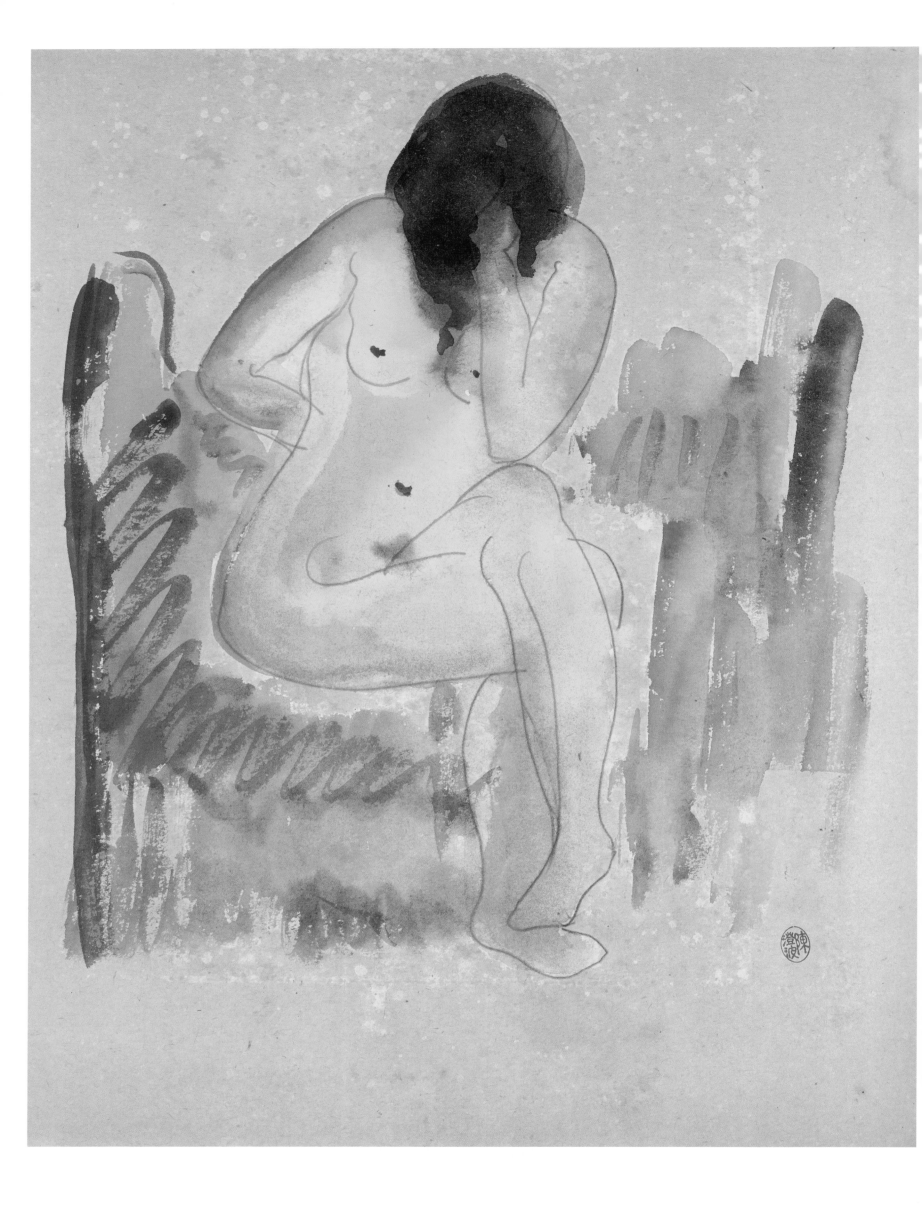

坐姿裸女（135）Seated Nude (135)

年代不詳　紙本淡彩鉛筆　37×28.5cm

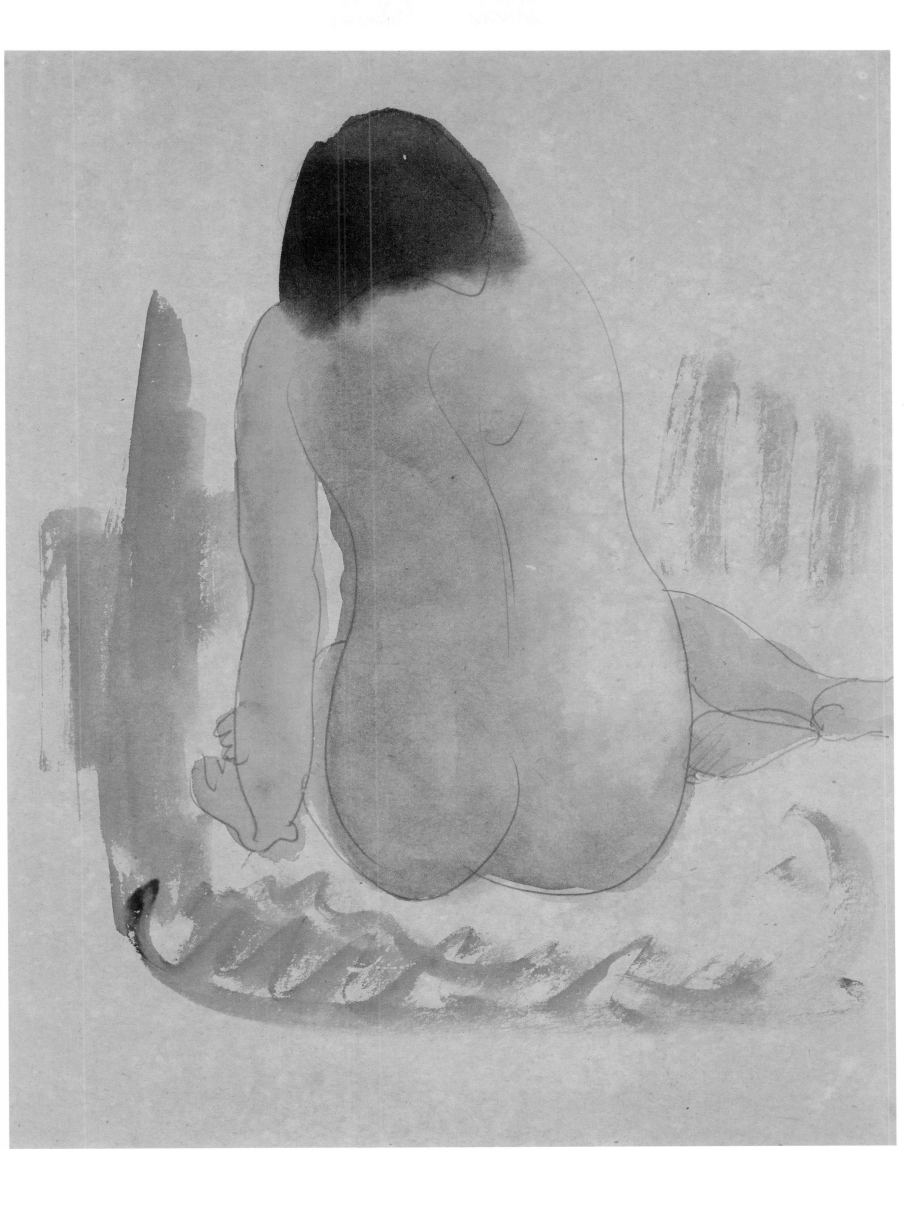

坐姿裸女（136） Seated Nude (136)

年代不詳　紙本淡彩鉛筆　37×28.5cm

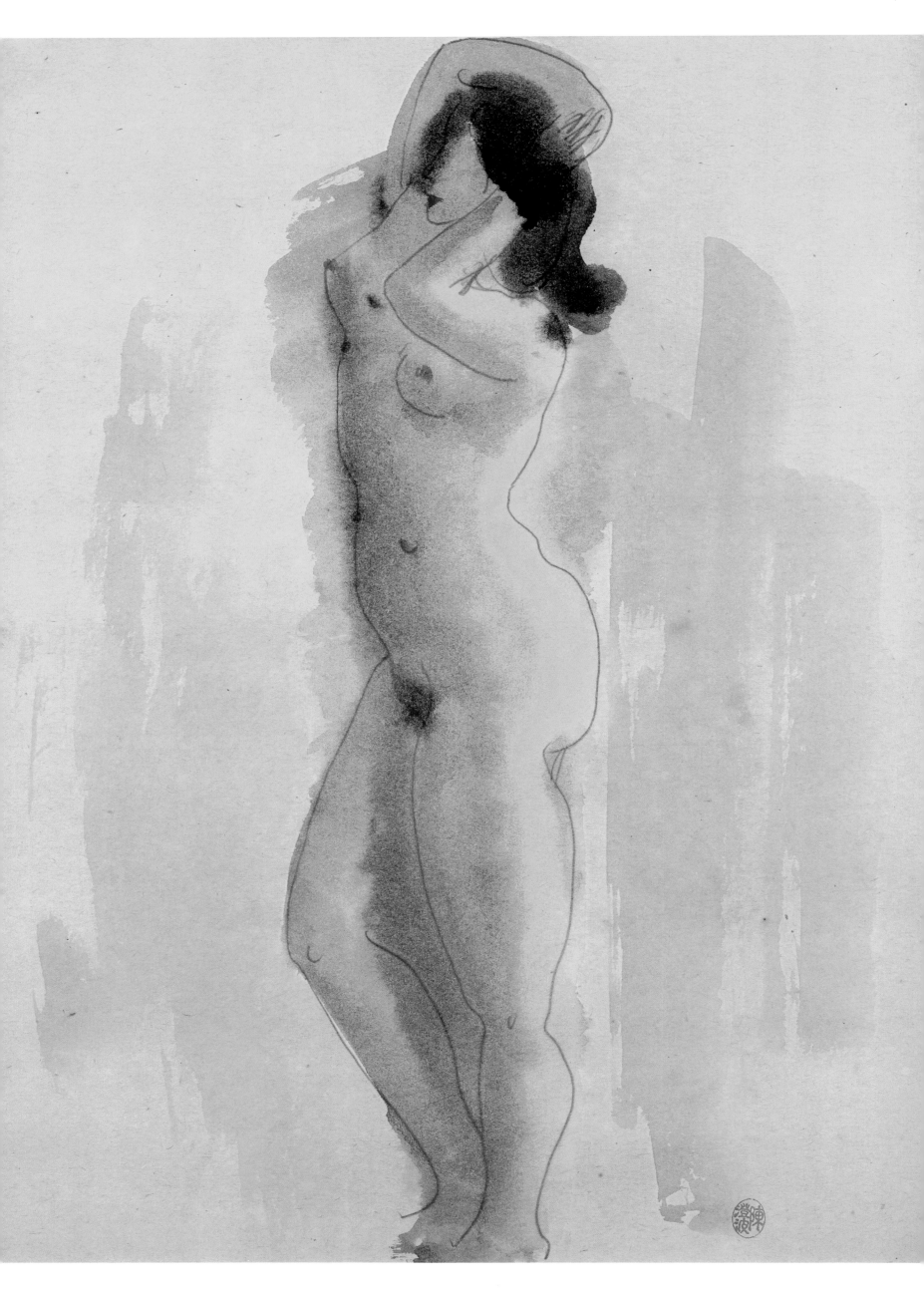

坐姿裸女（137） Seated Nude (137)
年代不詳　紙本淡彩鉛筆　28×37cm

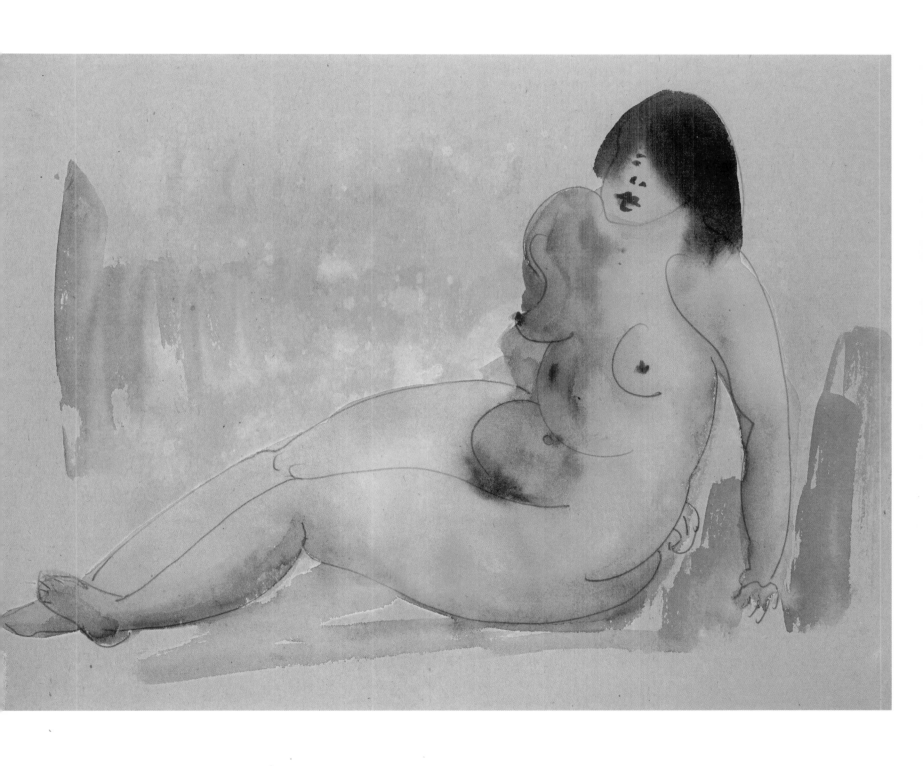

坐姿裸女（137） Seated Nude (137)
年代不詳　紙本淡彩鉛筆　28×37cm

[左頁圖]
立姿裸女（64） Standing Nude (64)
年代不詳　紙本淡彩鉛筆　37×29cm

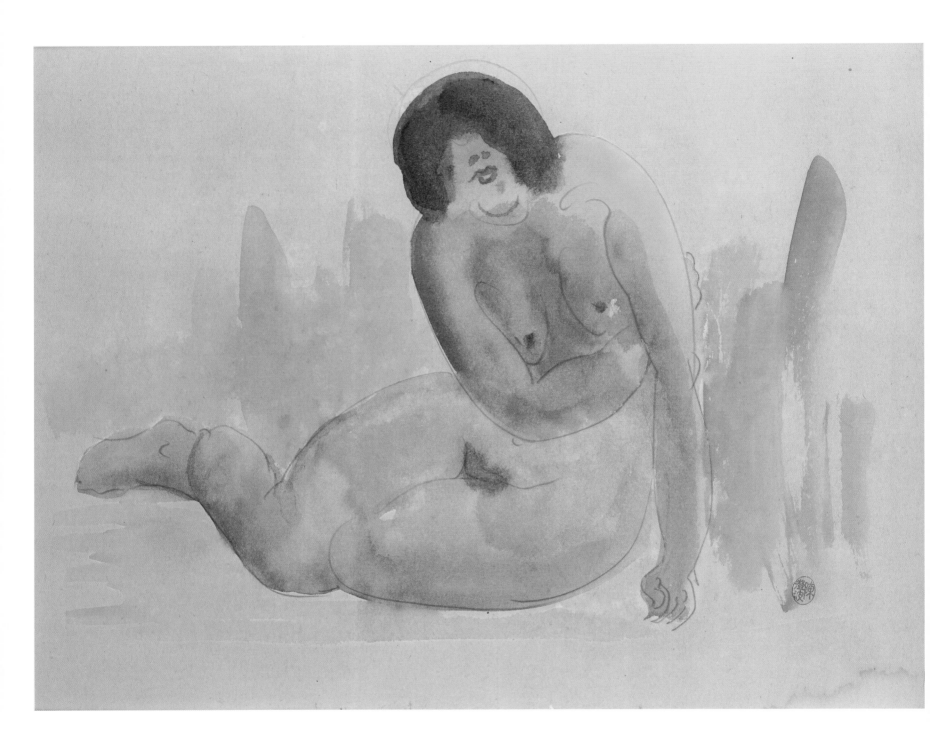

坐姿裸女（138）Seated Nude (138)

年代不詳　紙本淡彩鉛筆　29×37cm

[右頁圖]

立姿裸女（65）Standing Nude (65)

年代不詳　紙本淡彩鉛筆　37×29cm

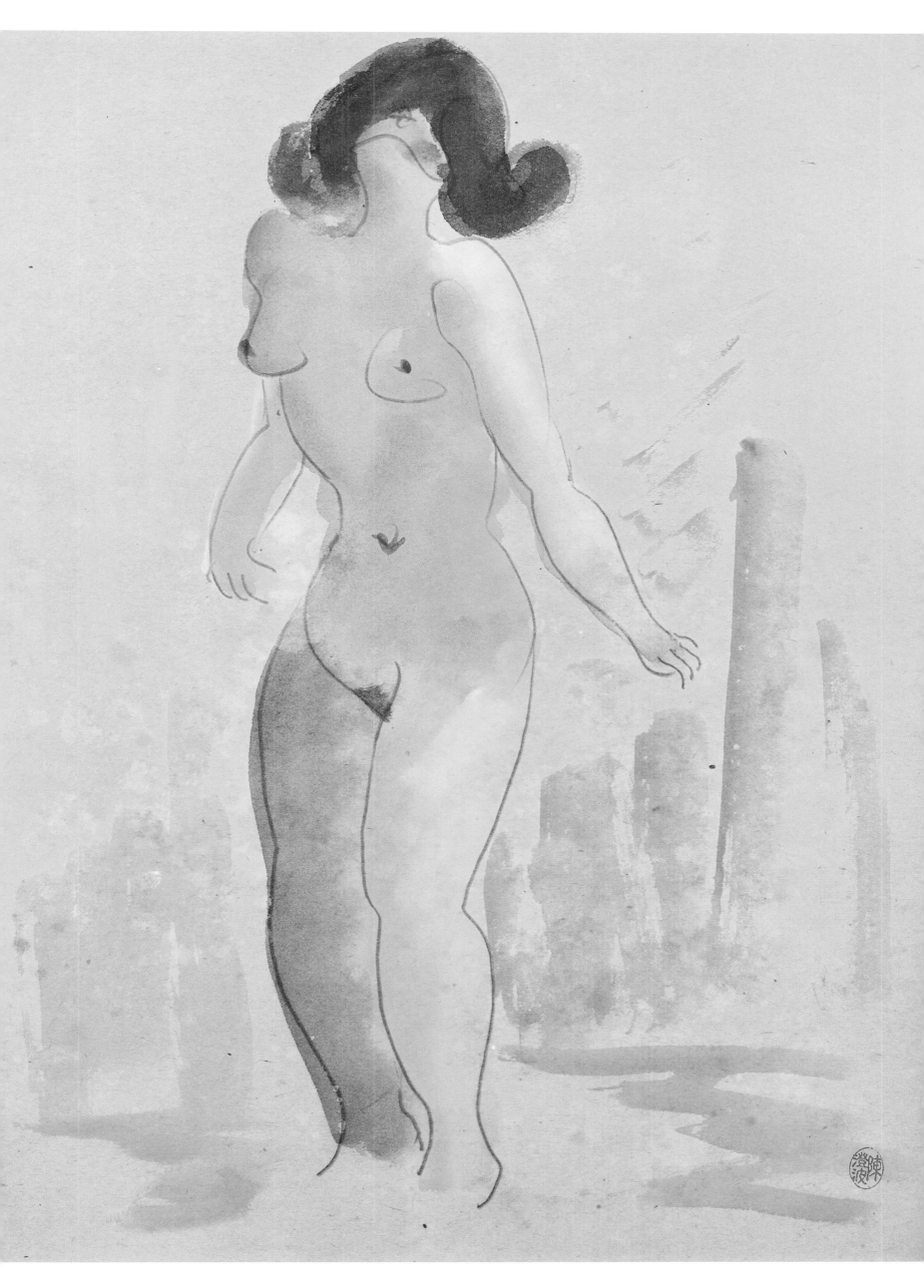

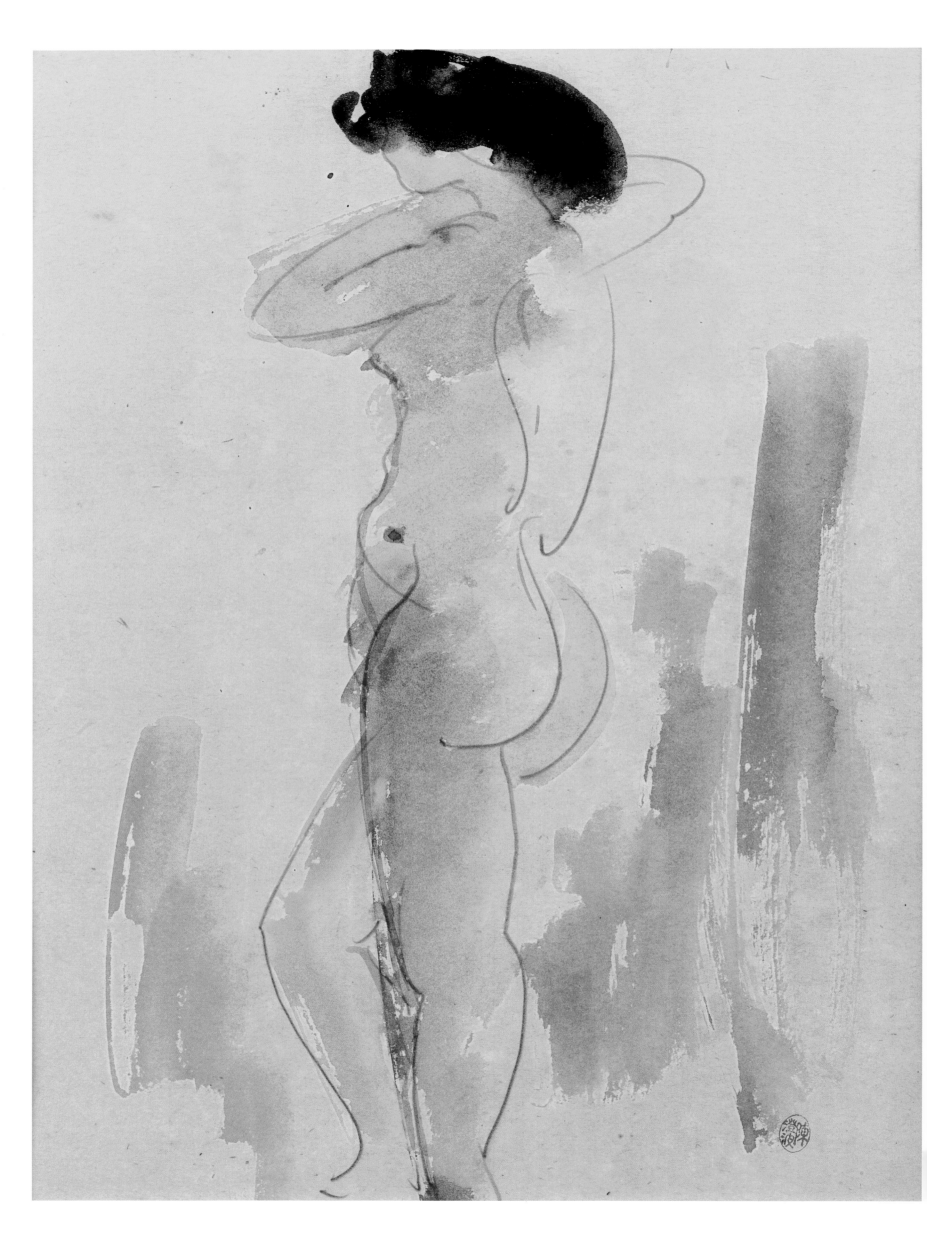

立姿裸女（66）Standing Nude (66)

年代不詳　紙本淡彩鉛筆　37.5×28.3cm

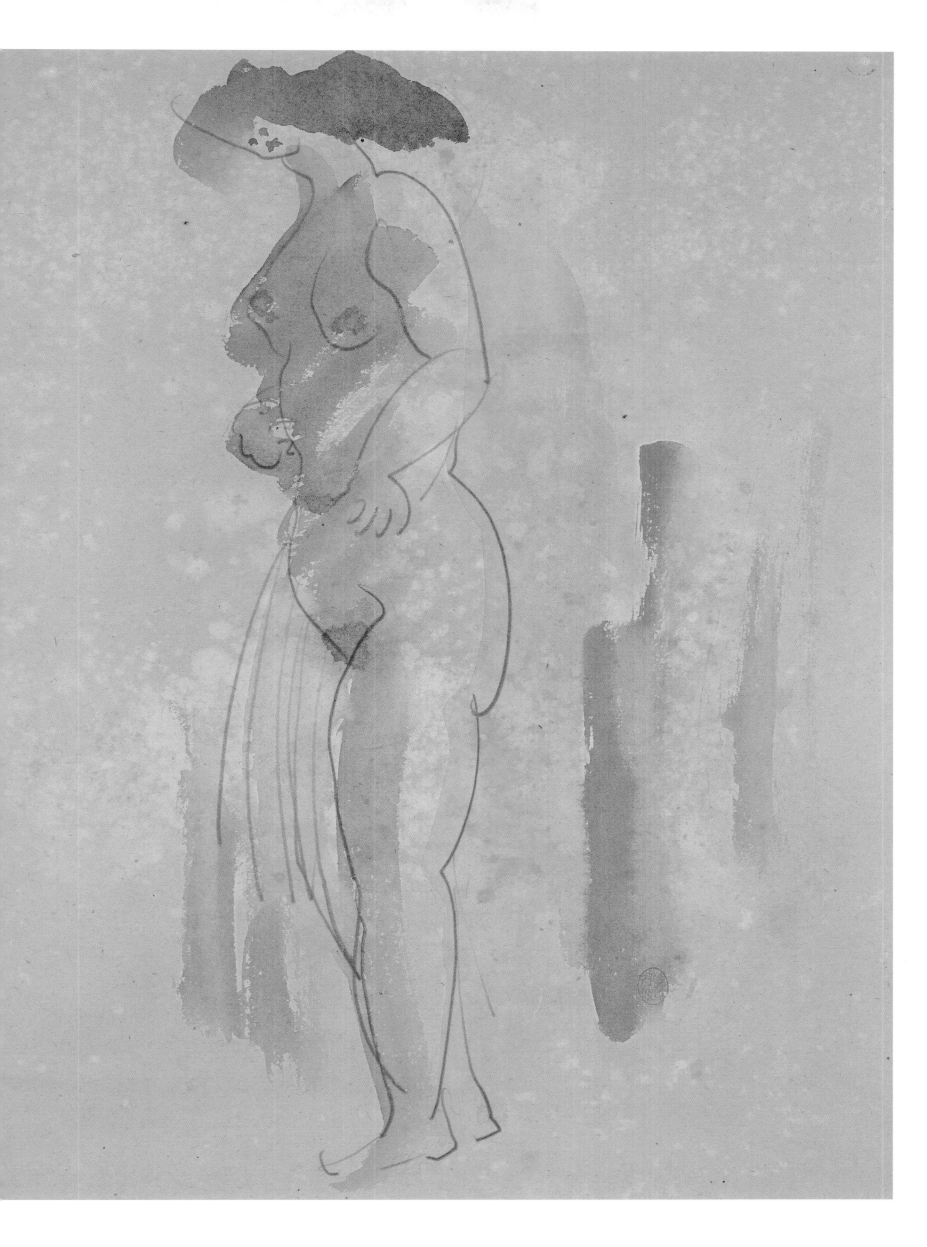

立姿裸女（67） Standing Nude (67)

年代不詳　紙本淡彩鉛筆　37×28cm

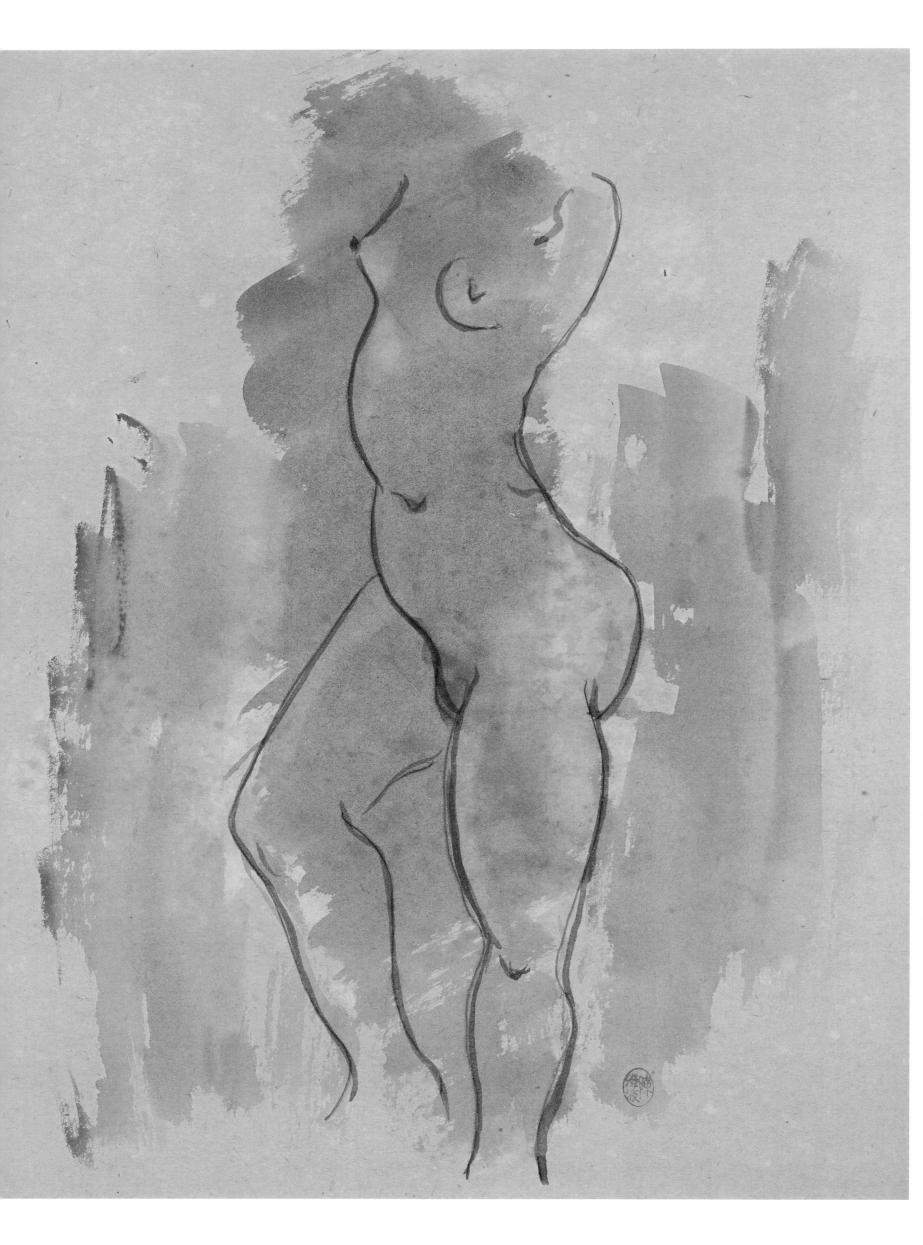

立姿裸女（68）Standing Nude (68)

年代不詳　紙本淡彩鉛筆　36.5×28.5cm

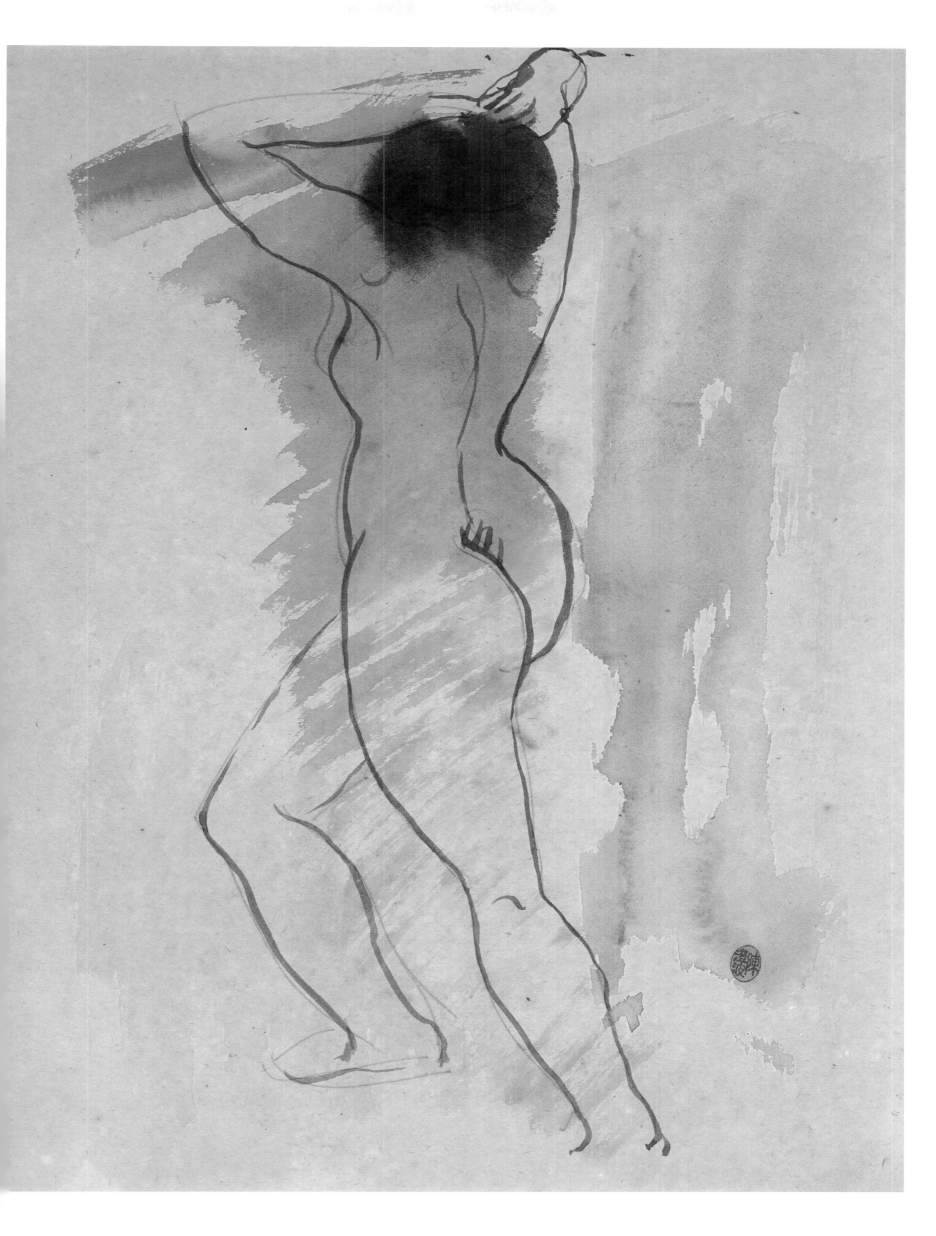

立姿裸女（69） Standing Nude (69)

年代不詳　紙本淡彩鉛筆　36.5×28.5cm

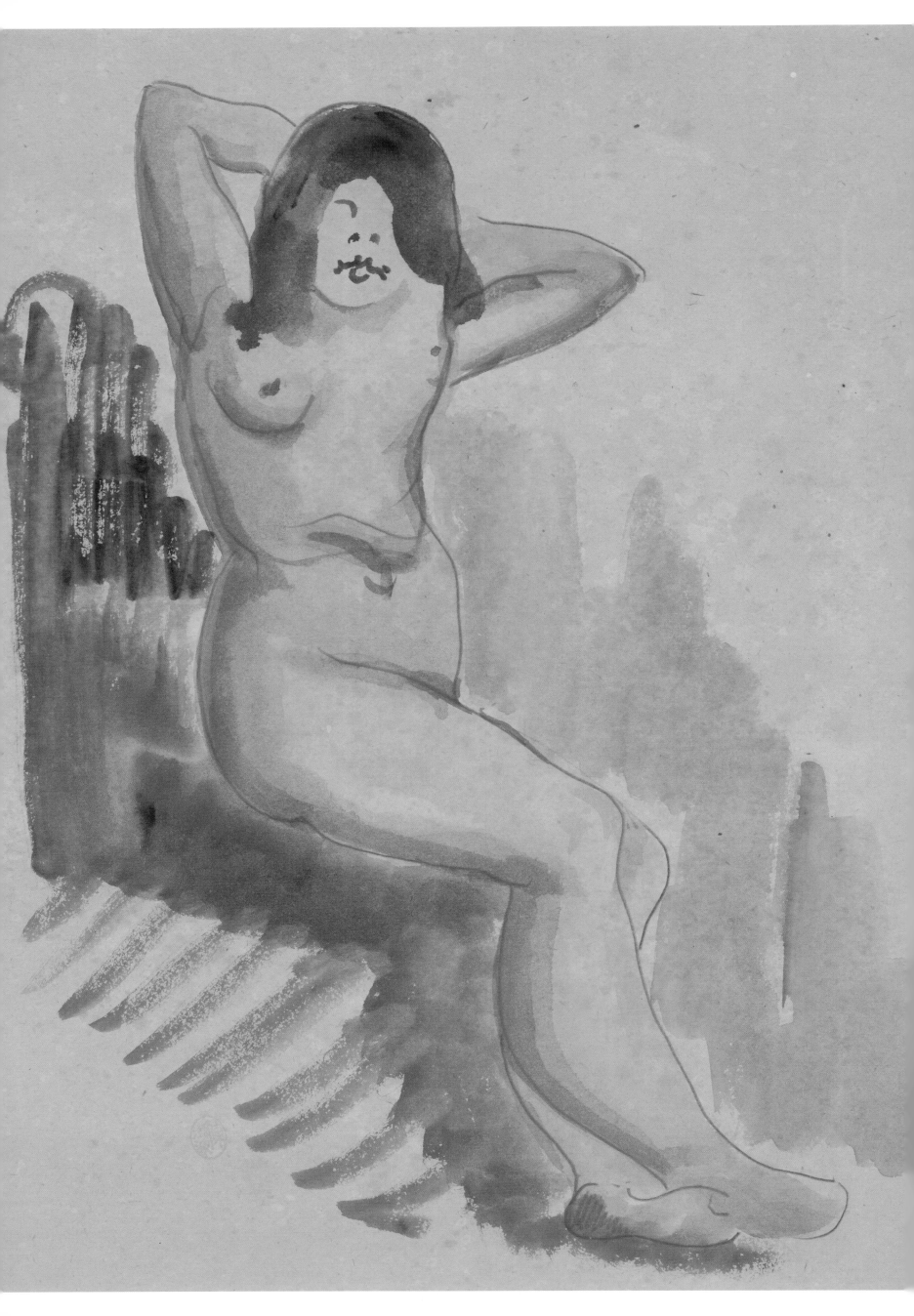

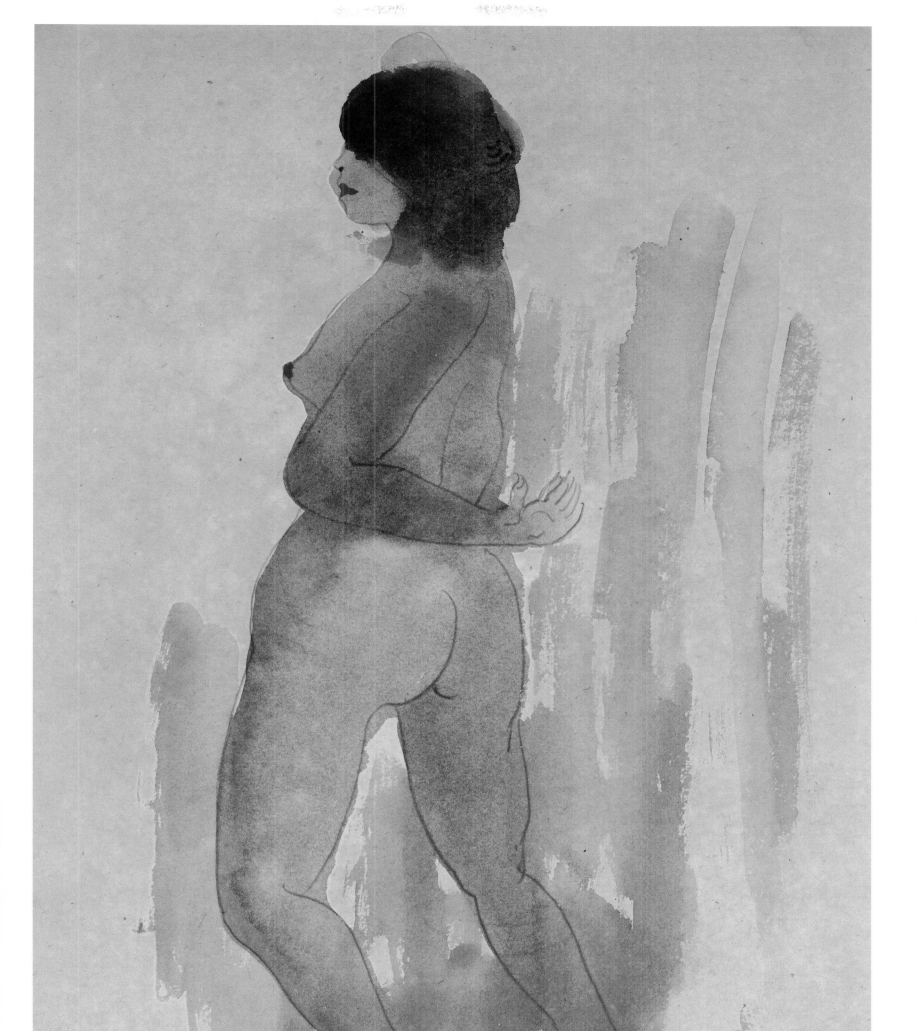

立姿裸女（71） Standing Nude (71)

年代不詳　紙本淡彩鉛筆　37×28.5cm

[左頁圖]

坐姿裸女（139） Seated Nude (139)

年代不詳　紙本淡彩鉛筆　原寸（35.5×25cm）

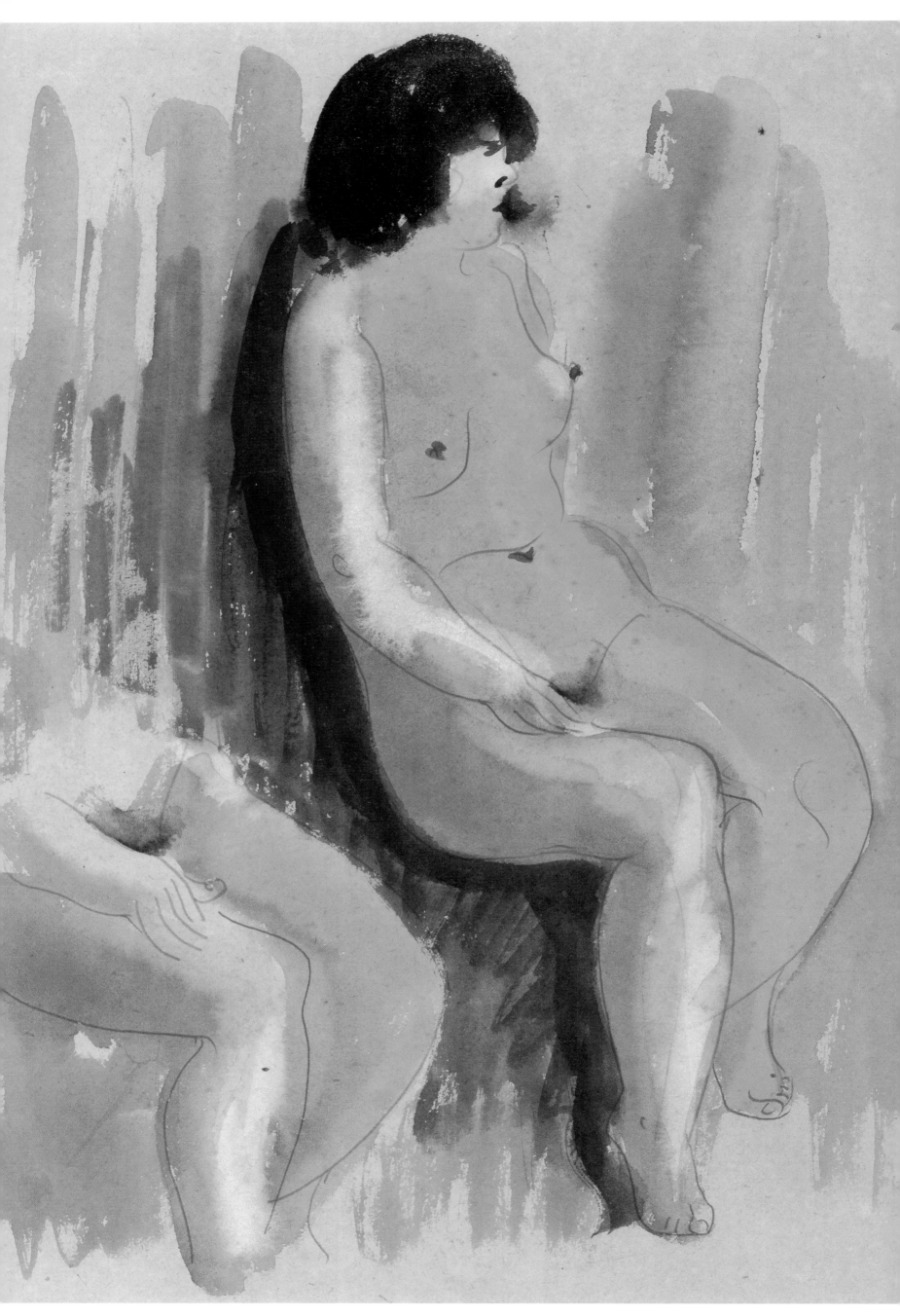

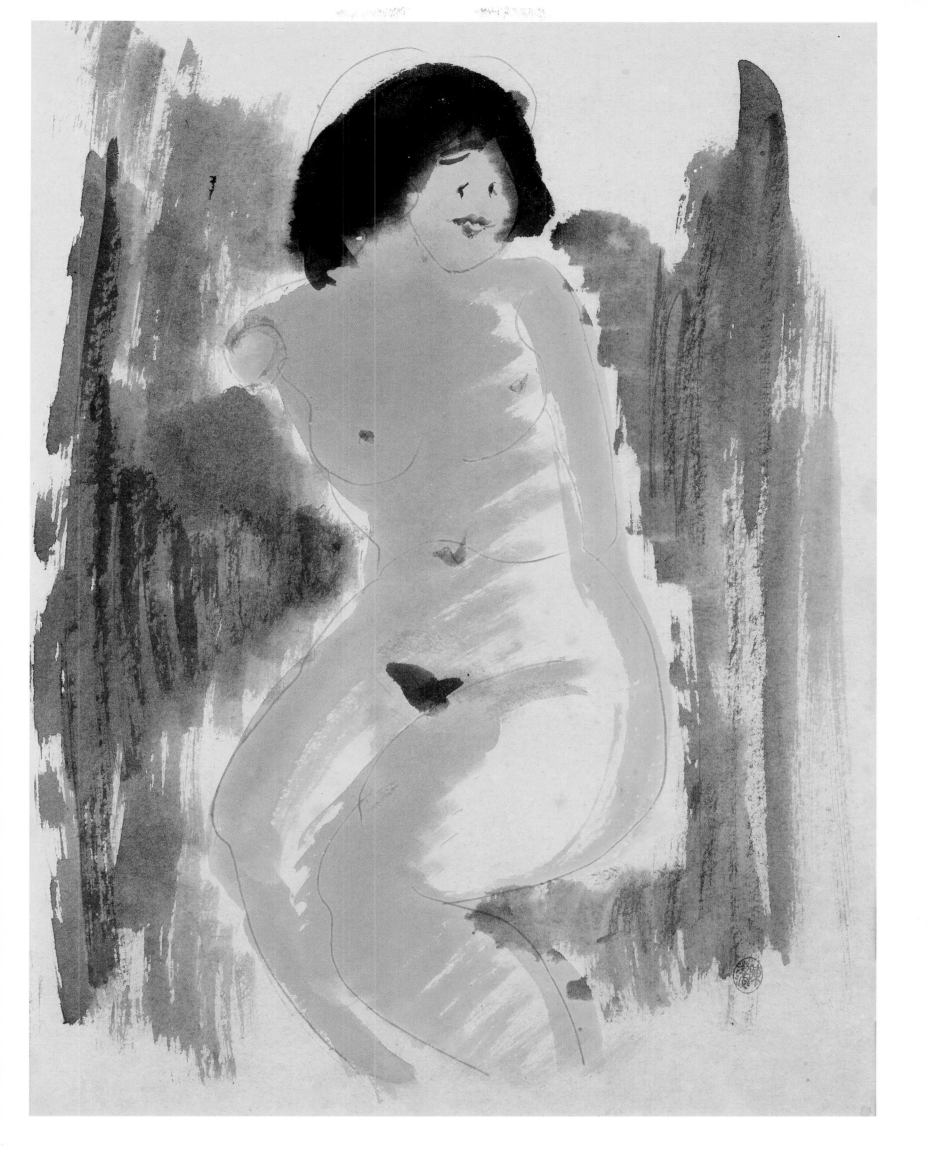

坐姿裸女（141）Seated Nude (141)

年代不詳　紙本淡彩鉛筆　36.7×27.4cm

[左頁圖]

坐姿裸女（140）Seated Nude (140)

年代不詳　紙本淡彩鉛筆　36.3×26.5cm

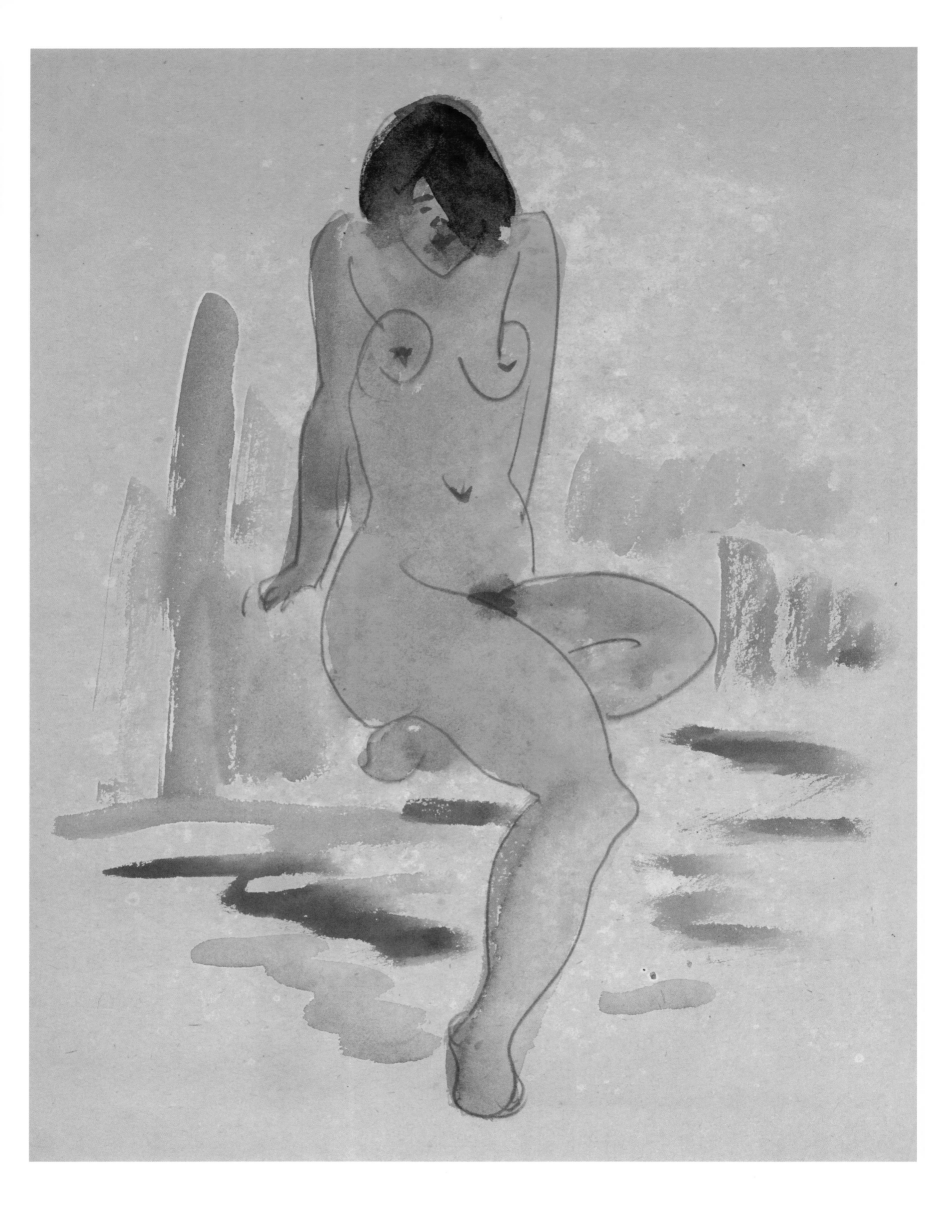

坐姿裸女（142）Seated Nude (142)

年代不詳　紙本淡彩鉛筆　36.5×28cm

362

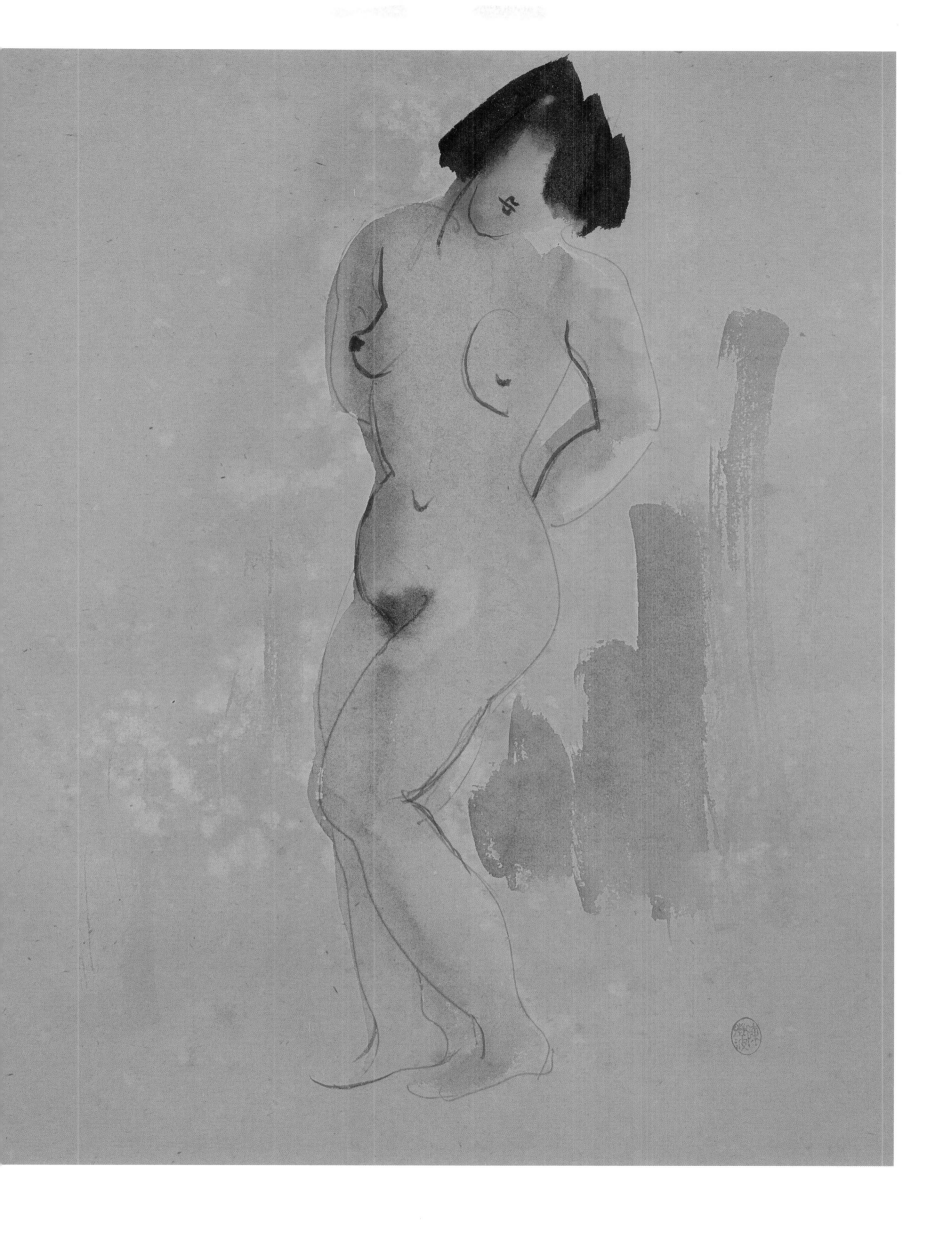

立姿裸女（72）Standing Nude (72)

年代不詳　紙本淡彩鉛筆　37×27cm

363

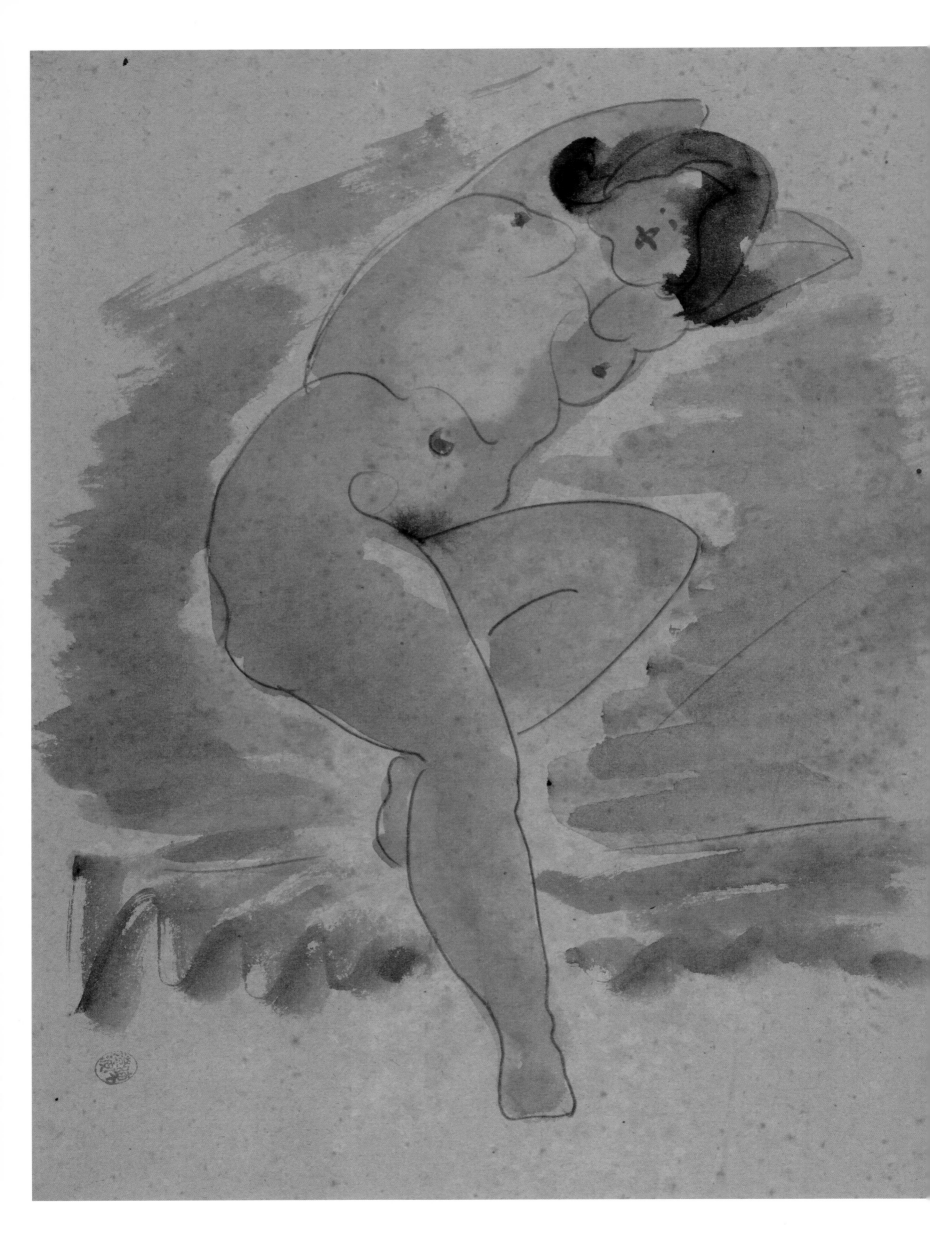

臥姿裸女（79） Lying Nude (79)

年代不詳　紙本淡彩鉛筆　35×26.5cm

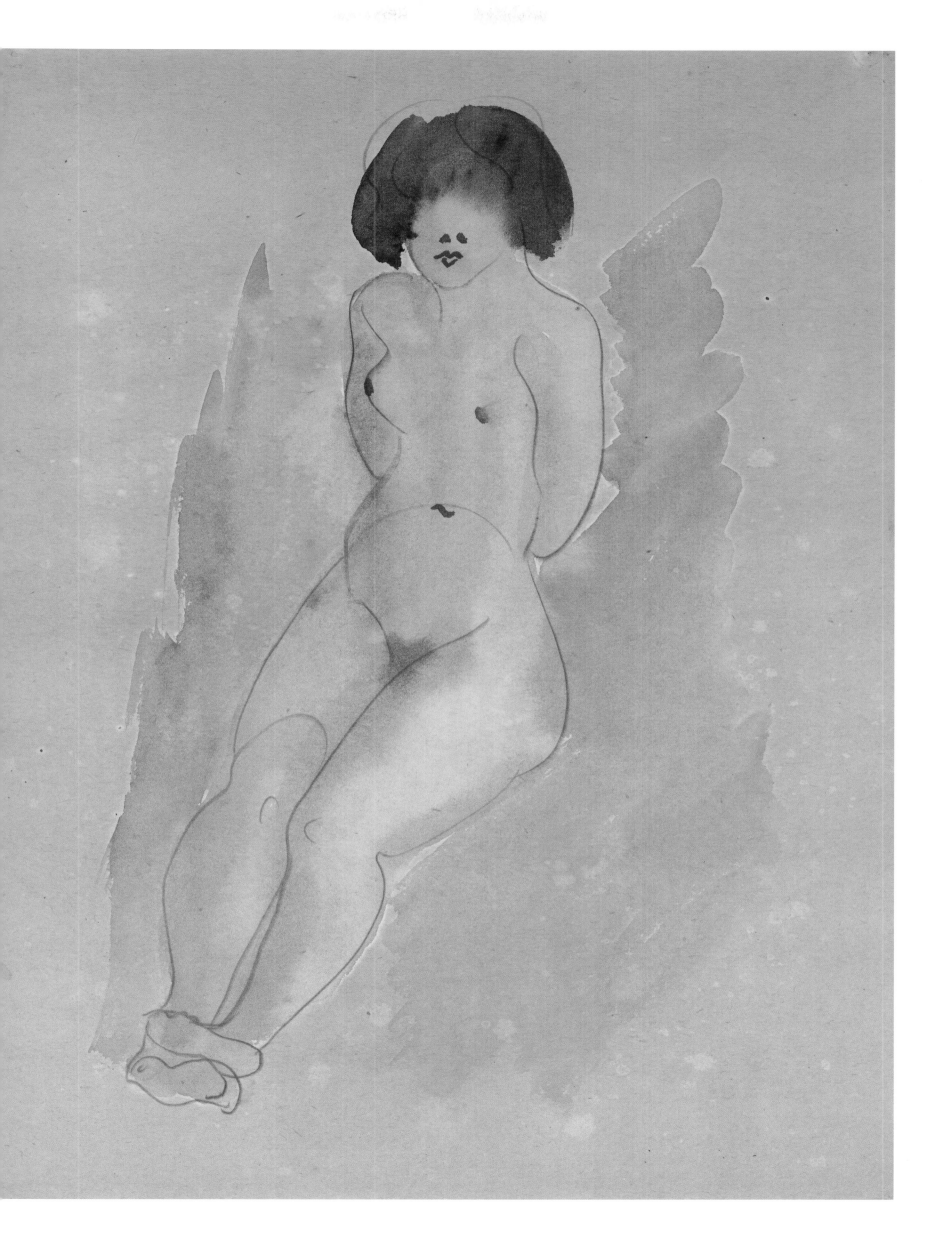

坐姿裸女（143）Seated Nude (143)

年代不詳　紙本淡彩鉛筆　36.5×28cm

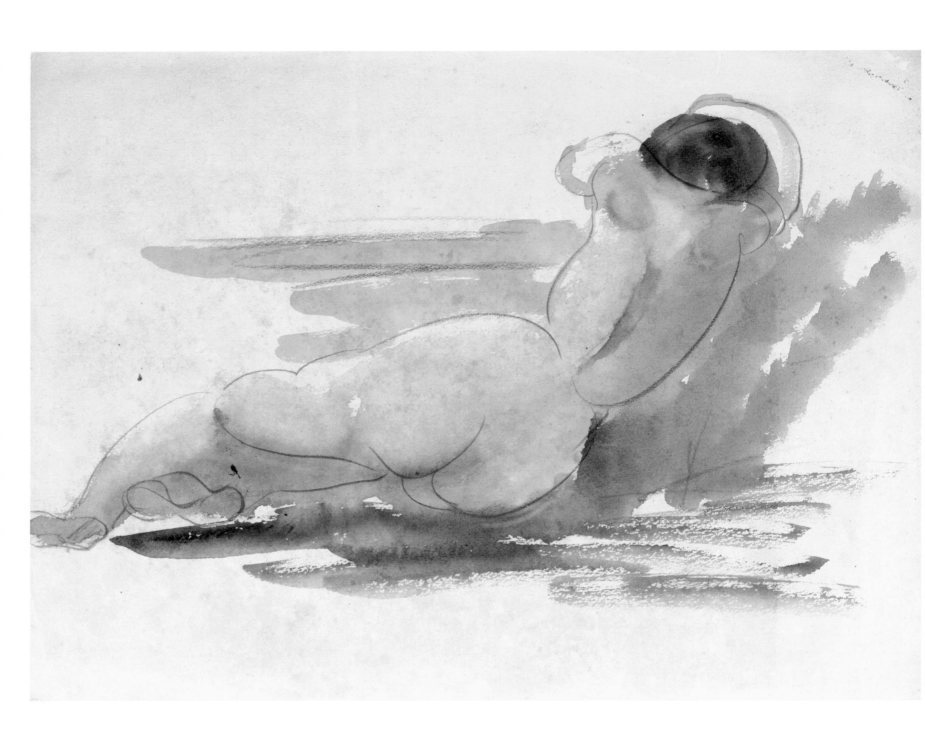

坐姿裸女（144）Seated Nude (144)

年代不詳　紙本淡彩鉛筆　28.5×37.5cm

[右頁圖]

立姿裸女（73）Standing Nude (73)

年代不詳　紙本淡彩鉛筆　36.5×28.5cm

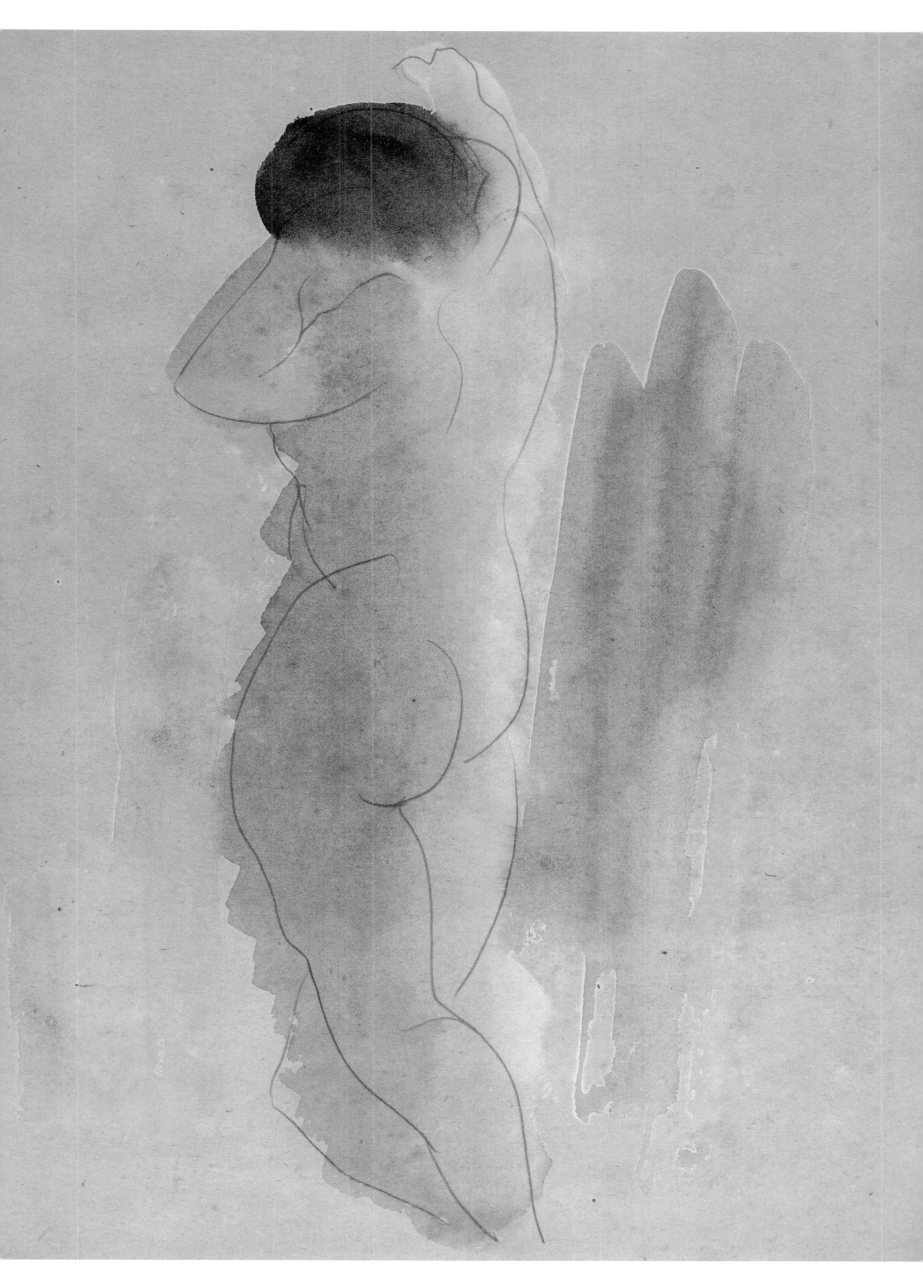

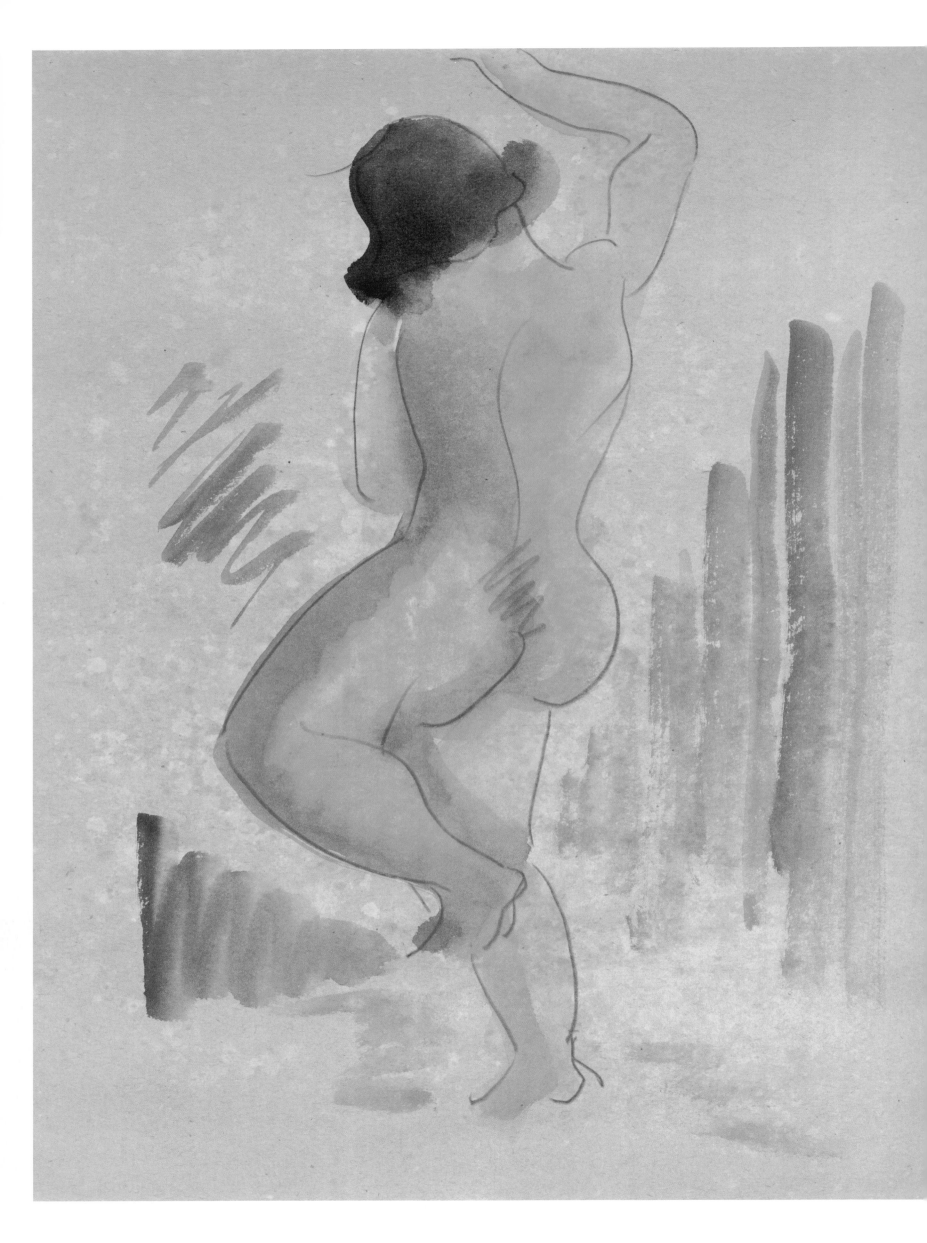

立姿裸女（74）Standing Nude (74)

年代不詳　紙本淡彩鉛筆　36.5×28cm

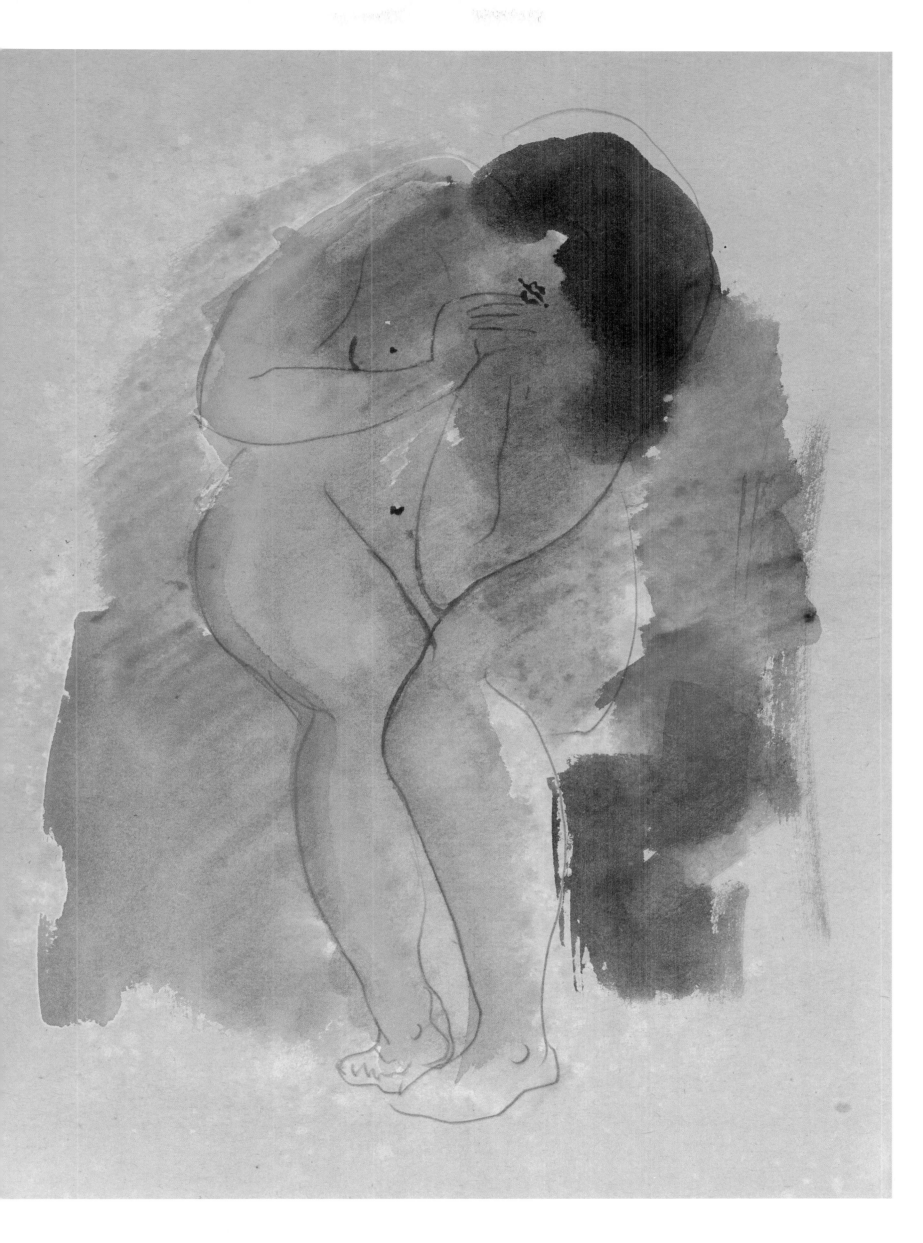

坐姿裸女（145） Seated Nude (145)

年代不詳　紙本淡彩鉛筆　36.5×28.5cm

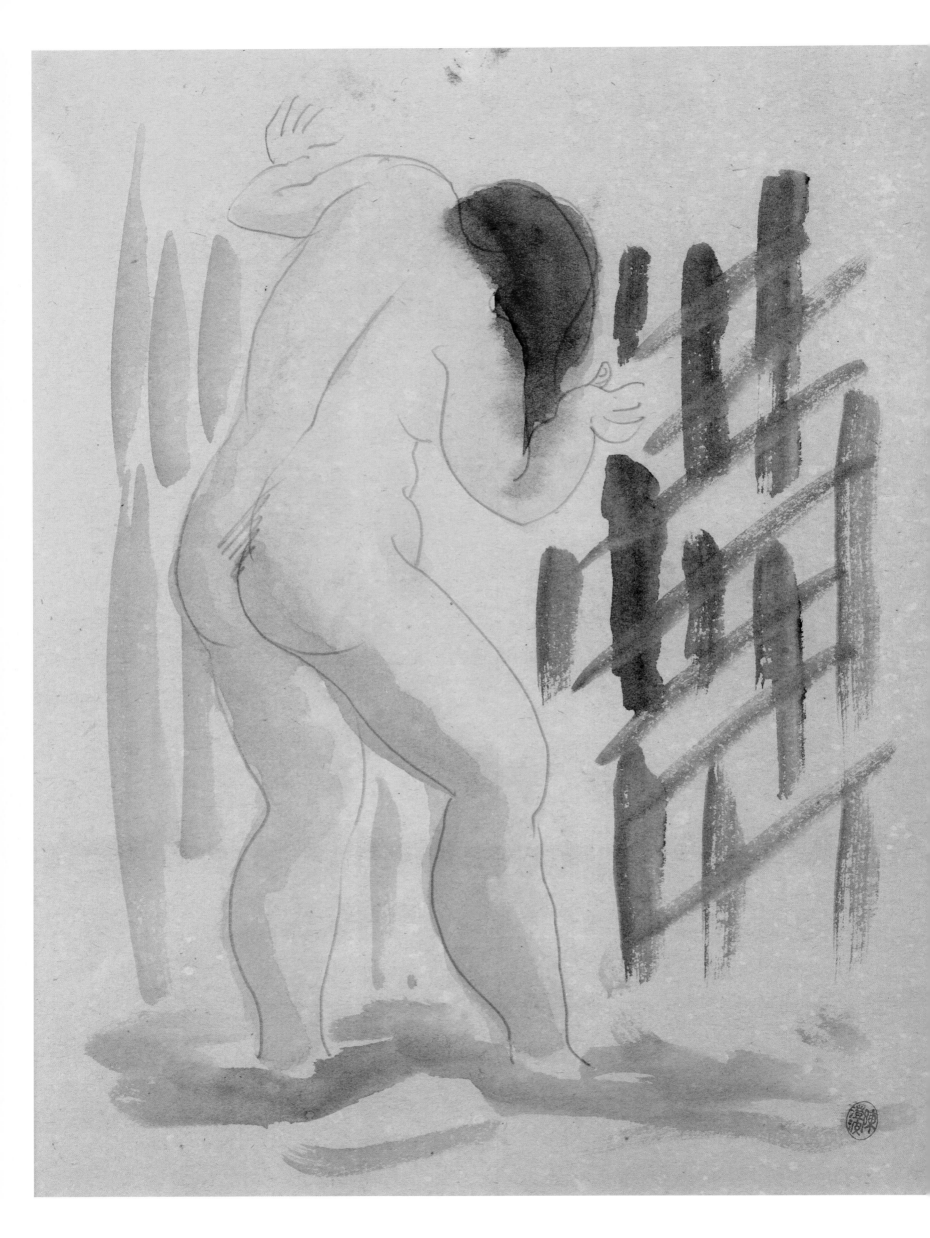

立姿裸女（75） Standing Nude (75)

年代不詳　紙本淡彩鉛筆　37×28.5cm

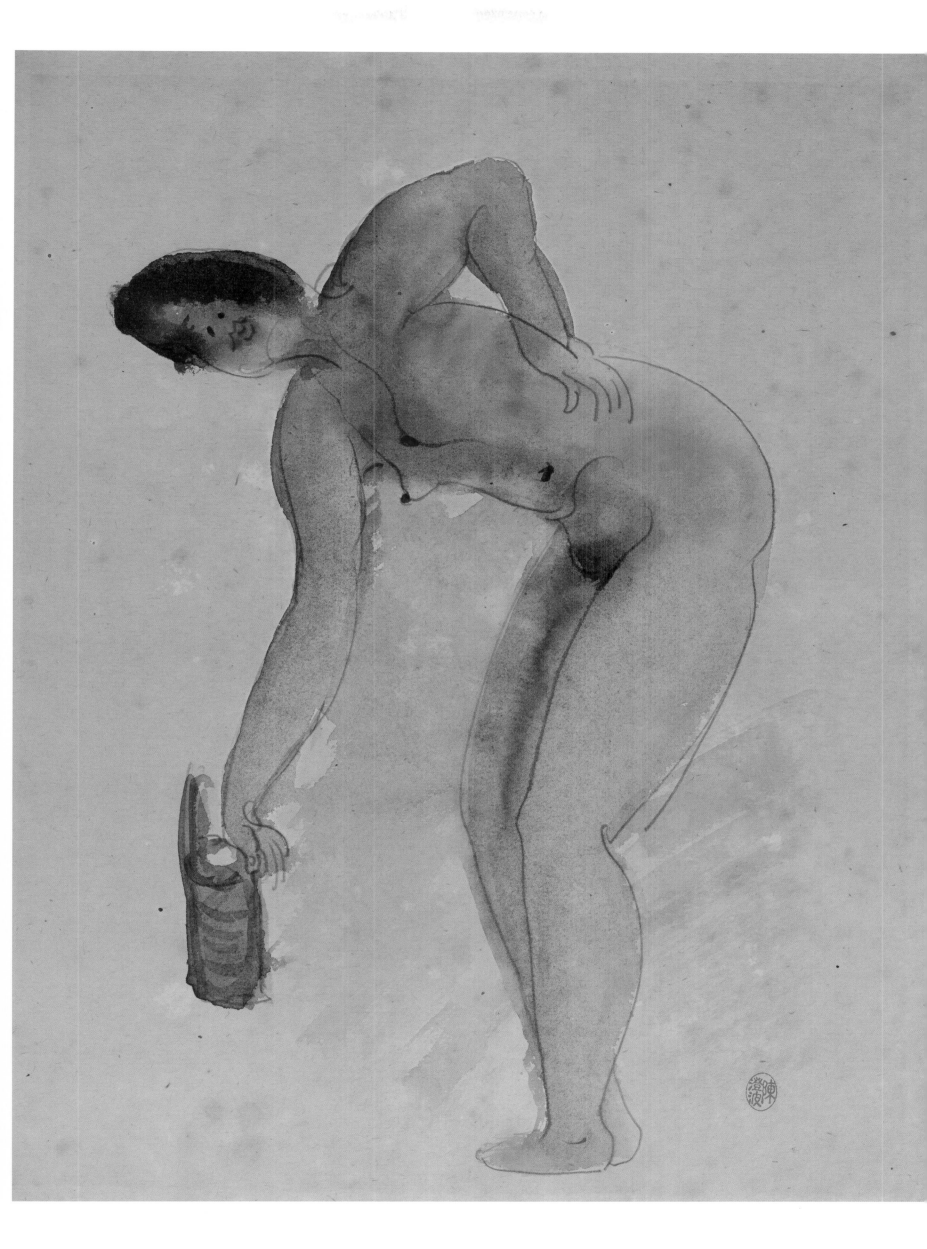

立姿裸女（76）Standing Nude (76)

年代不詳　紙本淡彩鉛筆　36.5×28.5cm

371

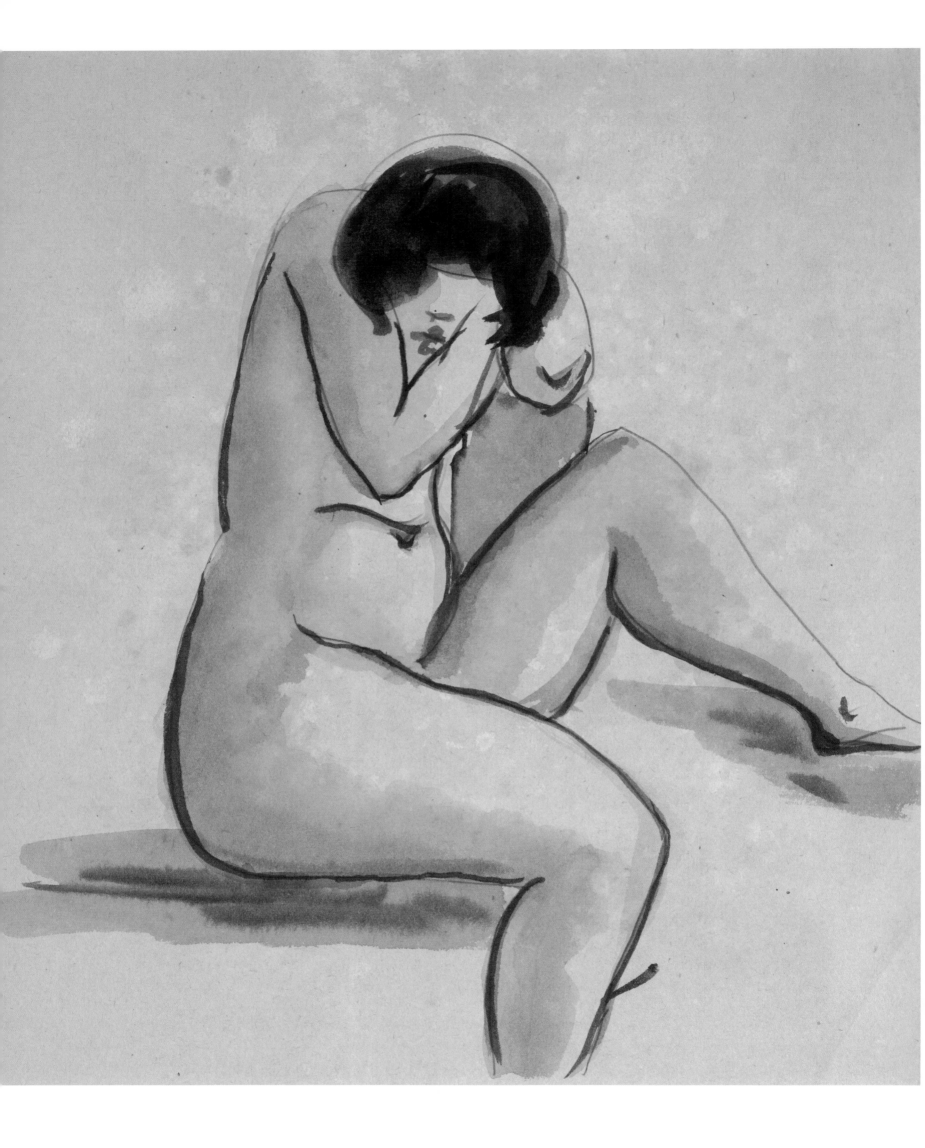

坐姿裸女（146）Seated Nude (146)

年代不詳　紙本淡彩鉛筆　31×27cm

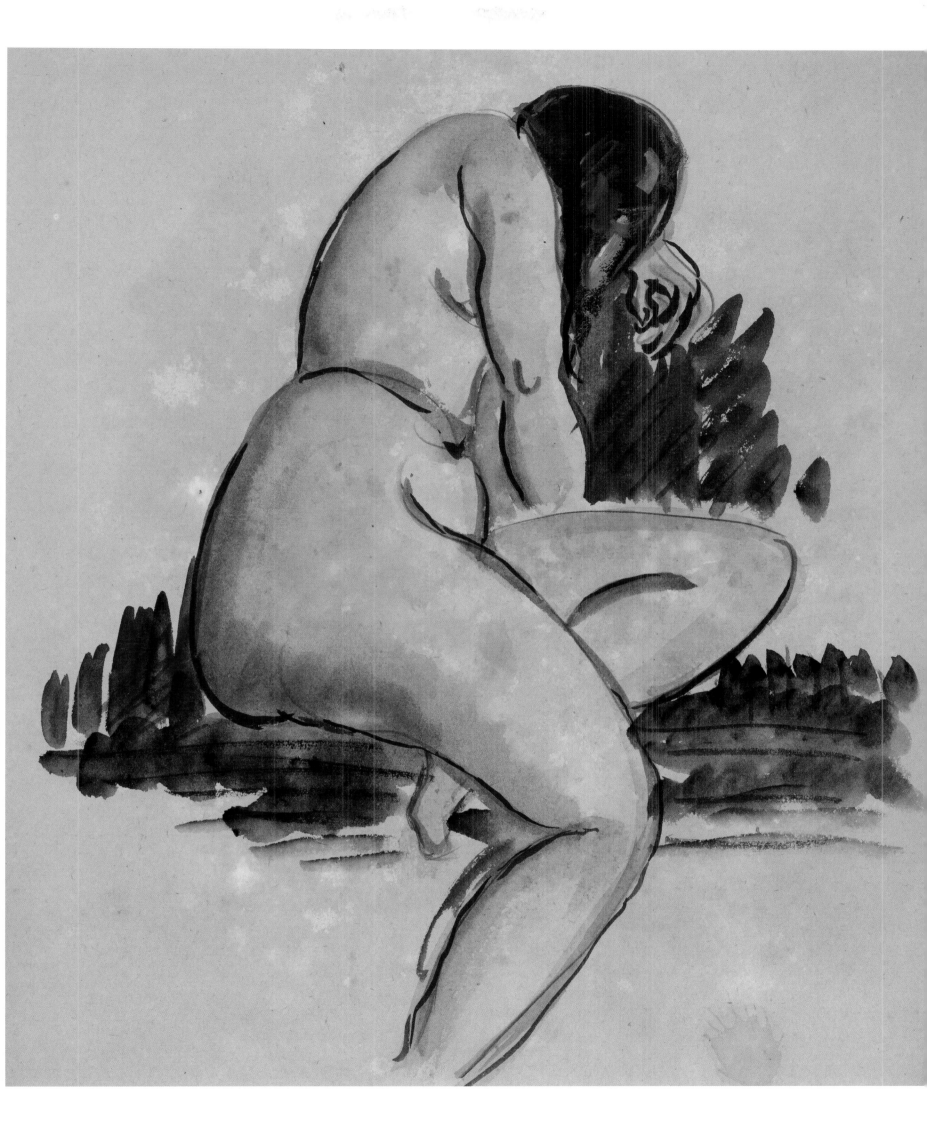

坐姿裸女（147）Seated Nude (147)

年代不詳　紙本淡彩鉛筆　31×27cm

臥姿裸女（80） Lying Nude (80)

年代不詳　紙本淡彩鉛筆　28.5×36.5cm

[右頁圖]
立姿裸女（77） Standing Nude (77)

年代不詳　紙本淡彩鉛筆　37×28.5cm

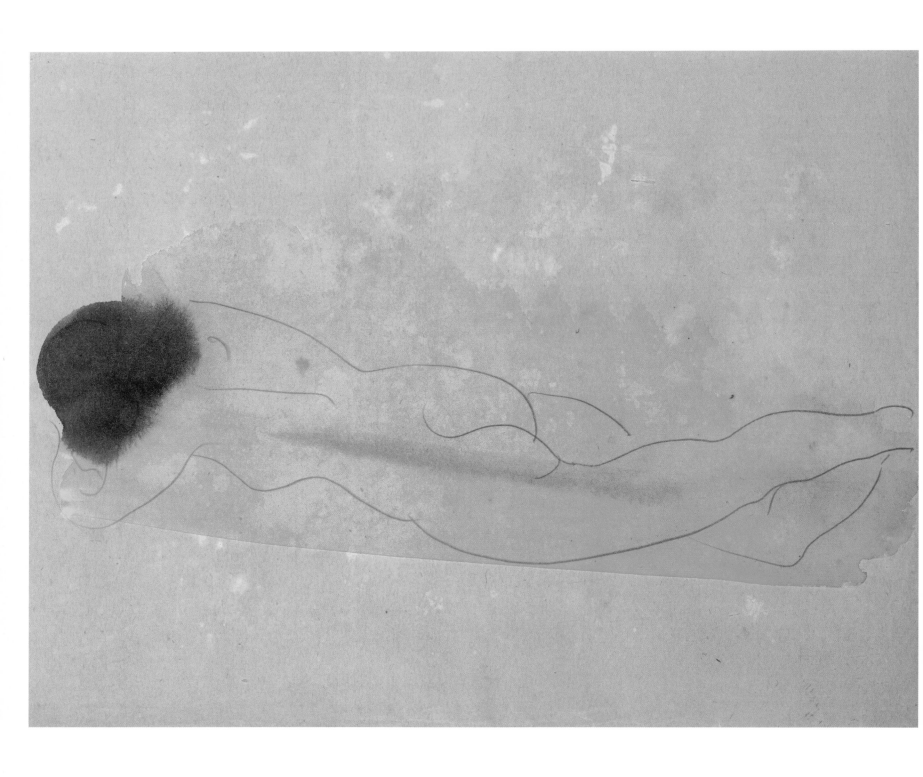

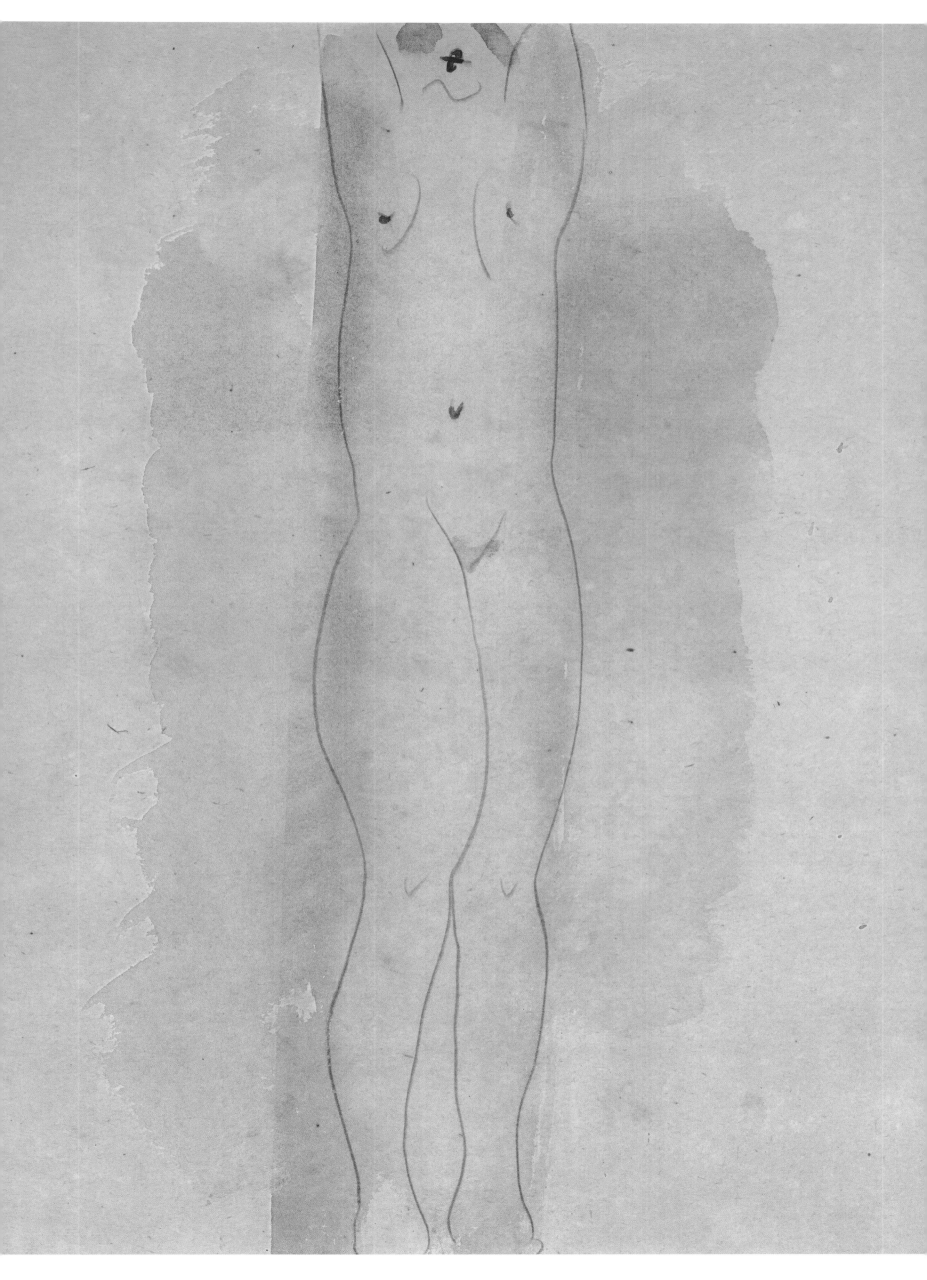

臥姿裸女（81） Lying Nude (81)

年代不詳　紙本淡彩鉛筆　26.5×36.5cm

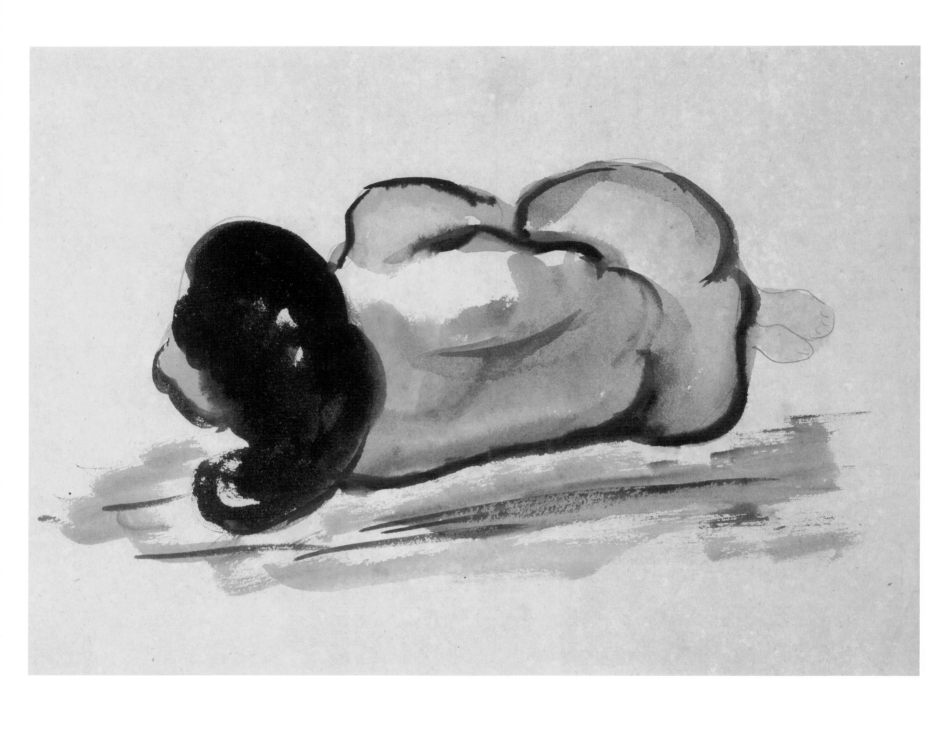

臥姿裸女（81） Lying Nude (81)

年代不詳　紙本淡彩鉛筆　26.5×36.5cm

[右頁圖]

臥姿裸女（82） Lying Nude (82)

年代不詳　紙本淡彩鉛筆　35.5×27cm

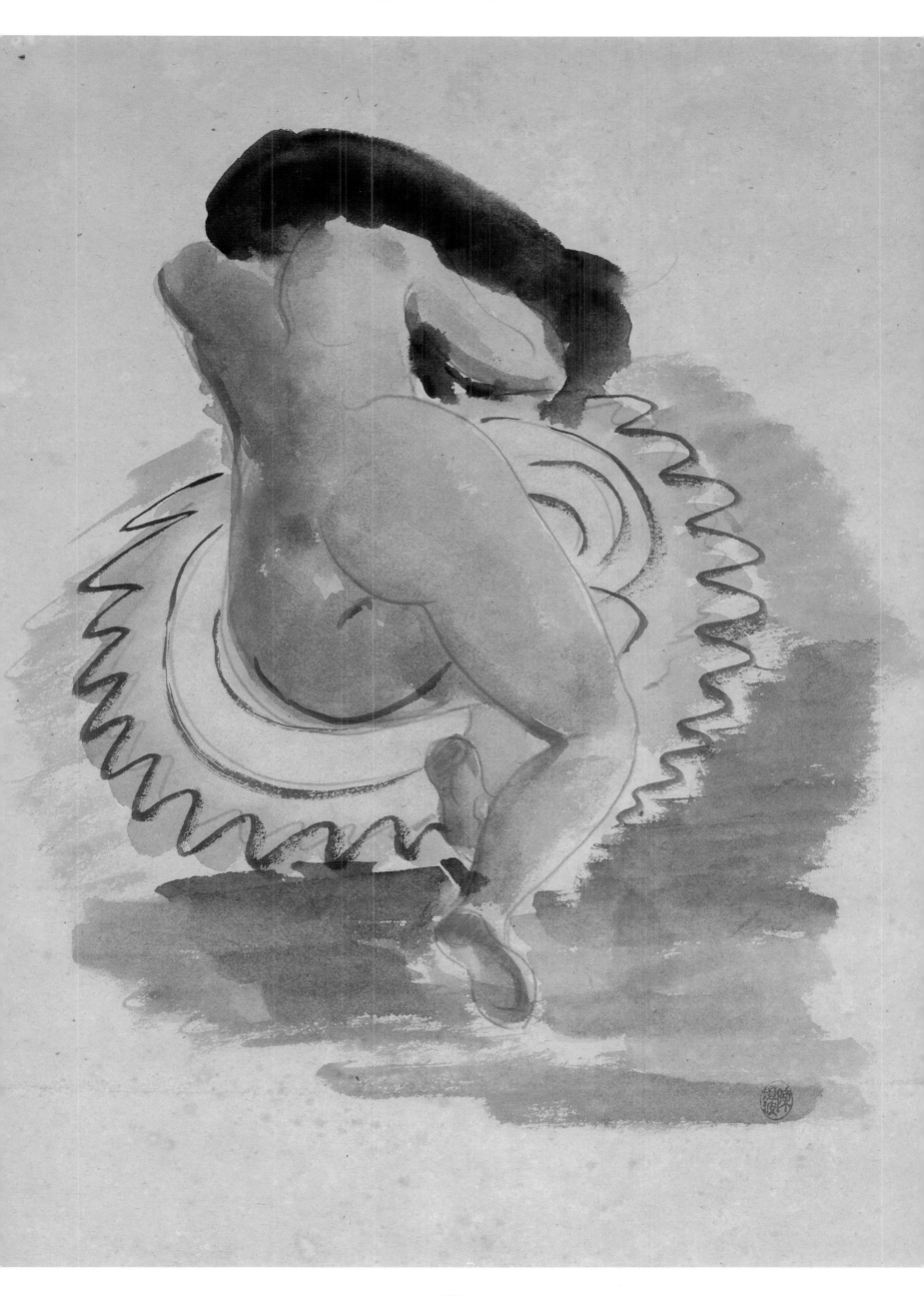

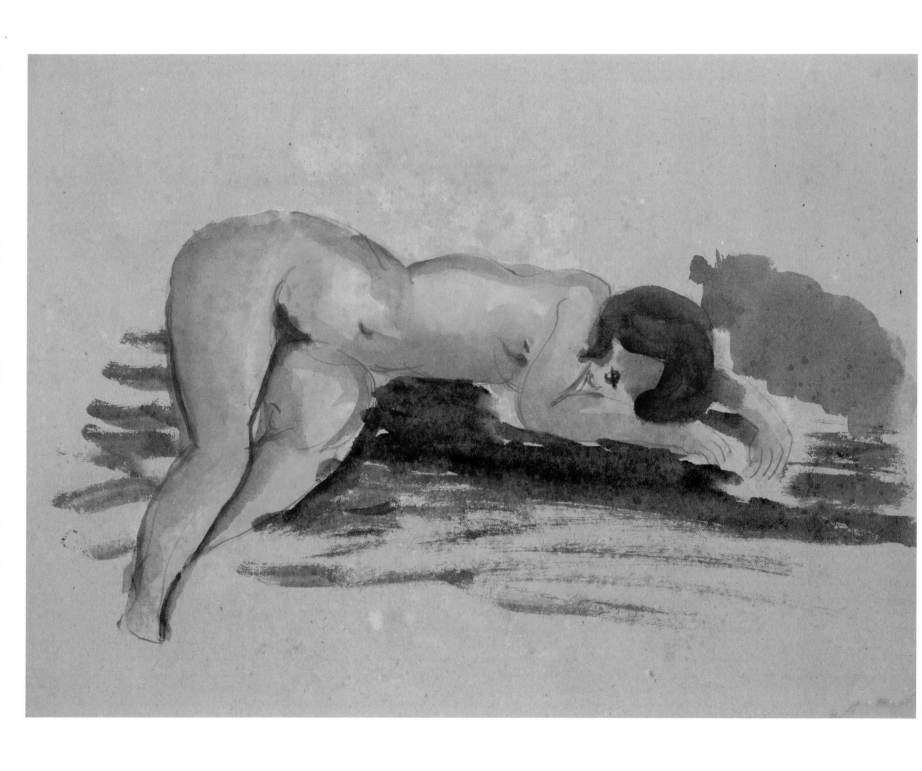

臥姿裸女（83） Lying Nude (83)

年代不詳　紙本淡彩鉛筆　28.5×36.5cm

[右頁圖]

坐姿裸女（149） Seated Nude (149)

年代不詳　紙本淡彩鉛筆　36.5×28.5cm

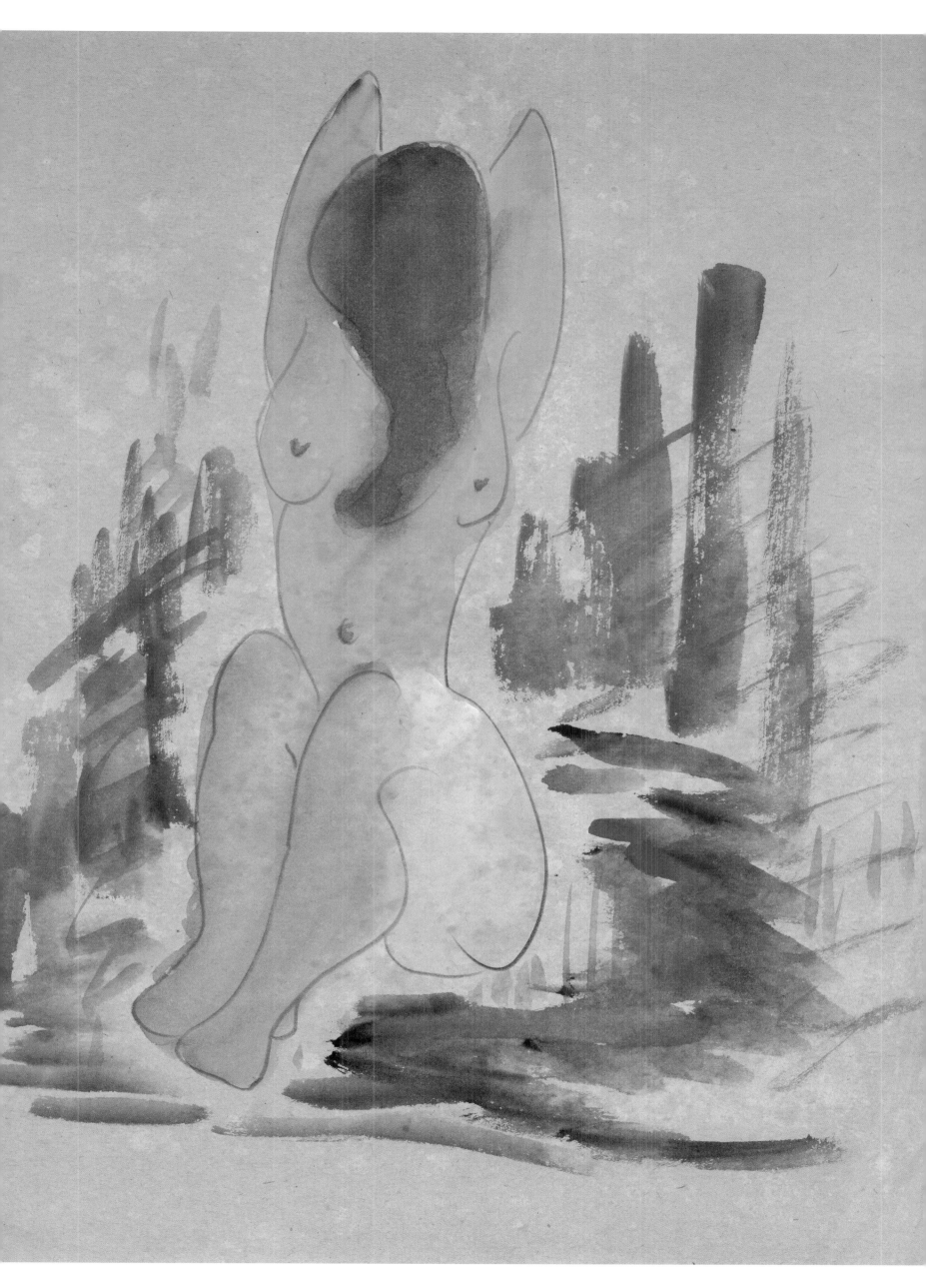

379

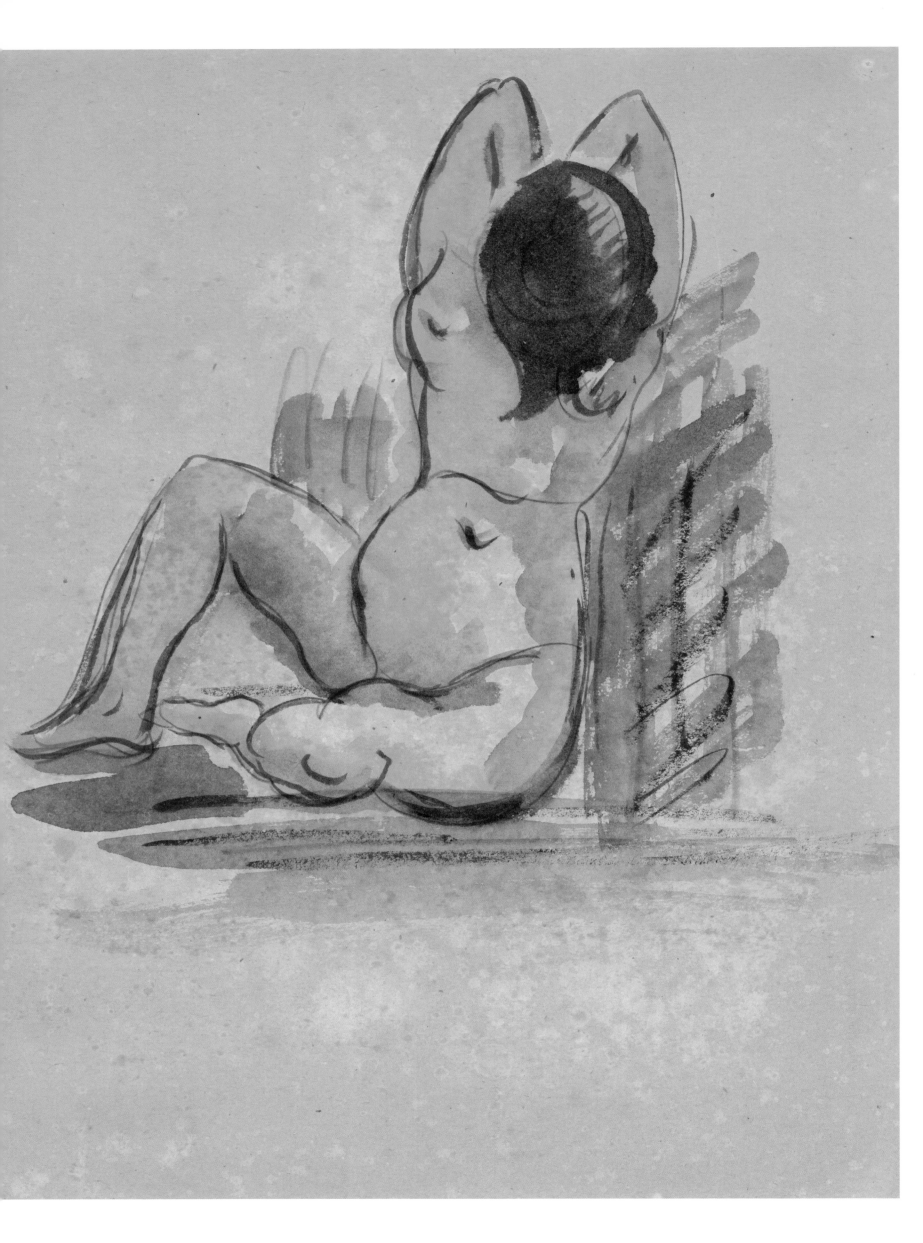

坐姿裸女（150） Seated Nude (150)

年代不詳　紙本淡彩鉛筆　36.5×28.5cm

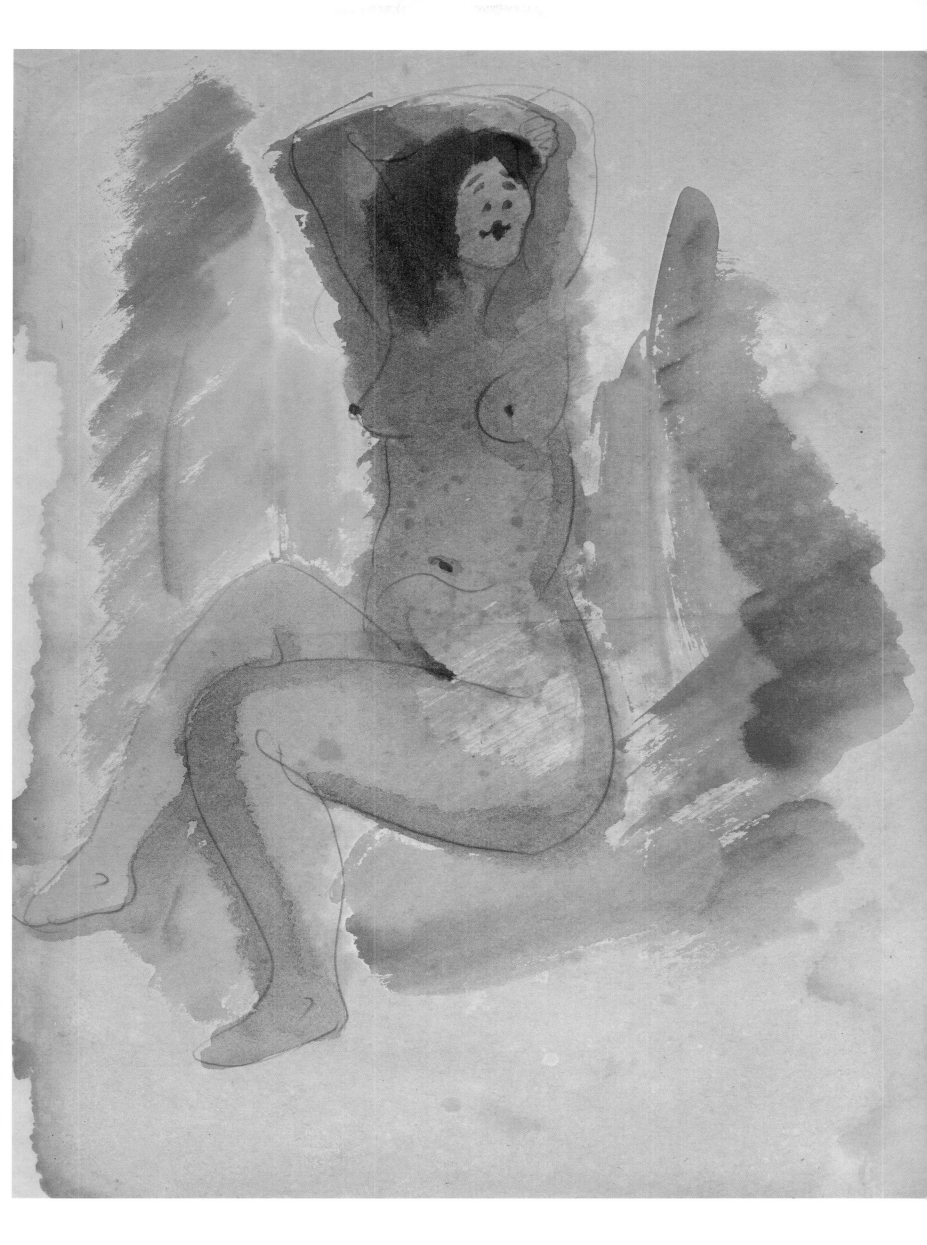

坐姿裸女（151）Seated Nude (151)

年代不詳　紙本淡彩鉛筆　36.5×28.5cm

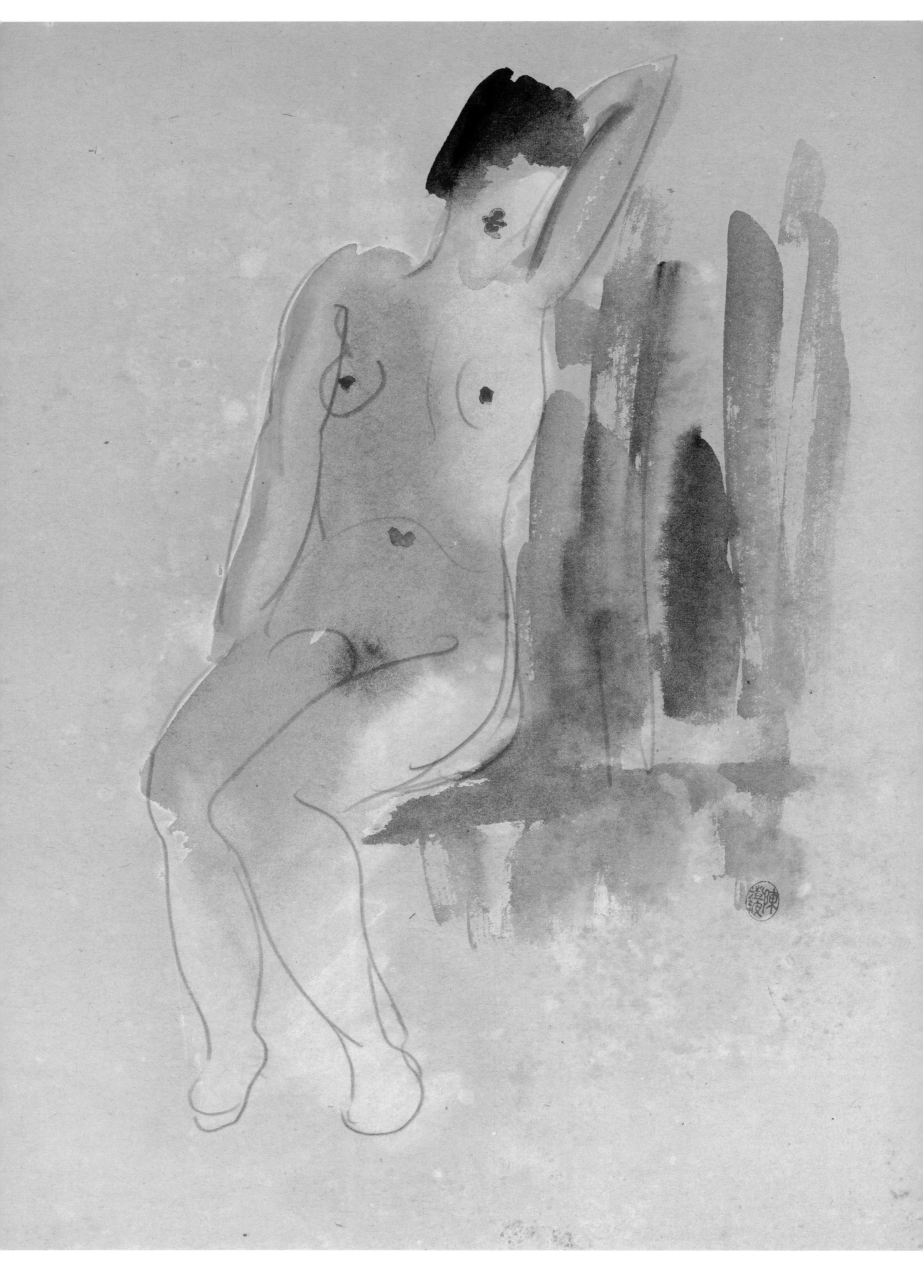

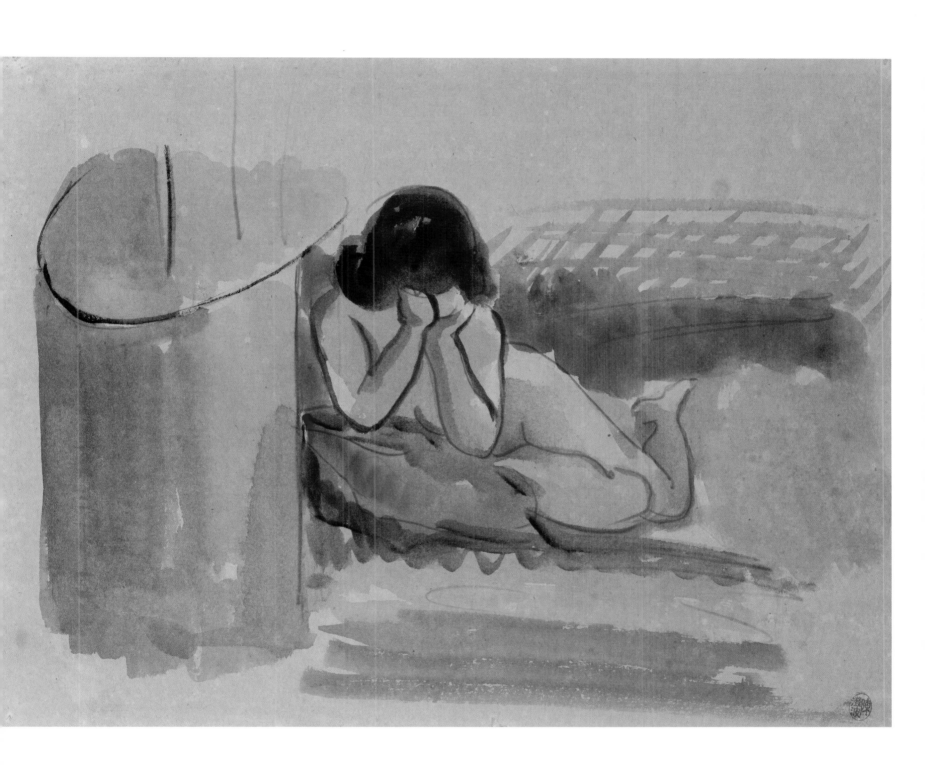

坐姿裸女（153） Seated Nude (153)

年代不詳　紙本淡彩鉛筆　28.5×36.5cm

[左頁圖]

坐姿裸女（152） Seated Nude (152)

年代不詳　紙本淡彩鉛筆　36×28cm

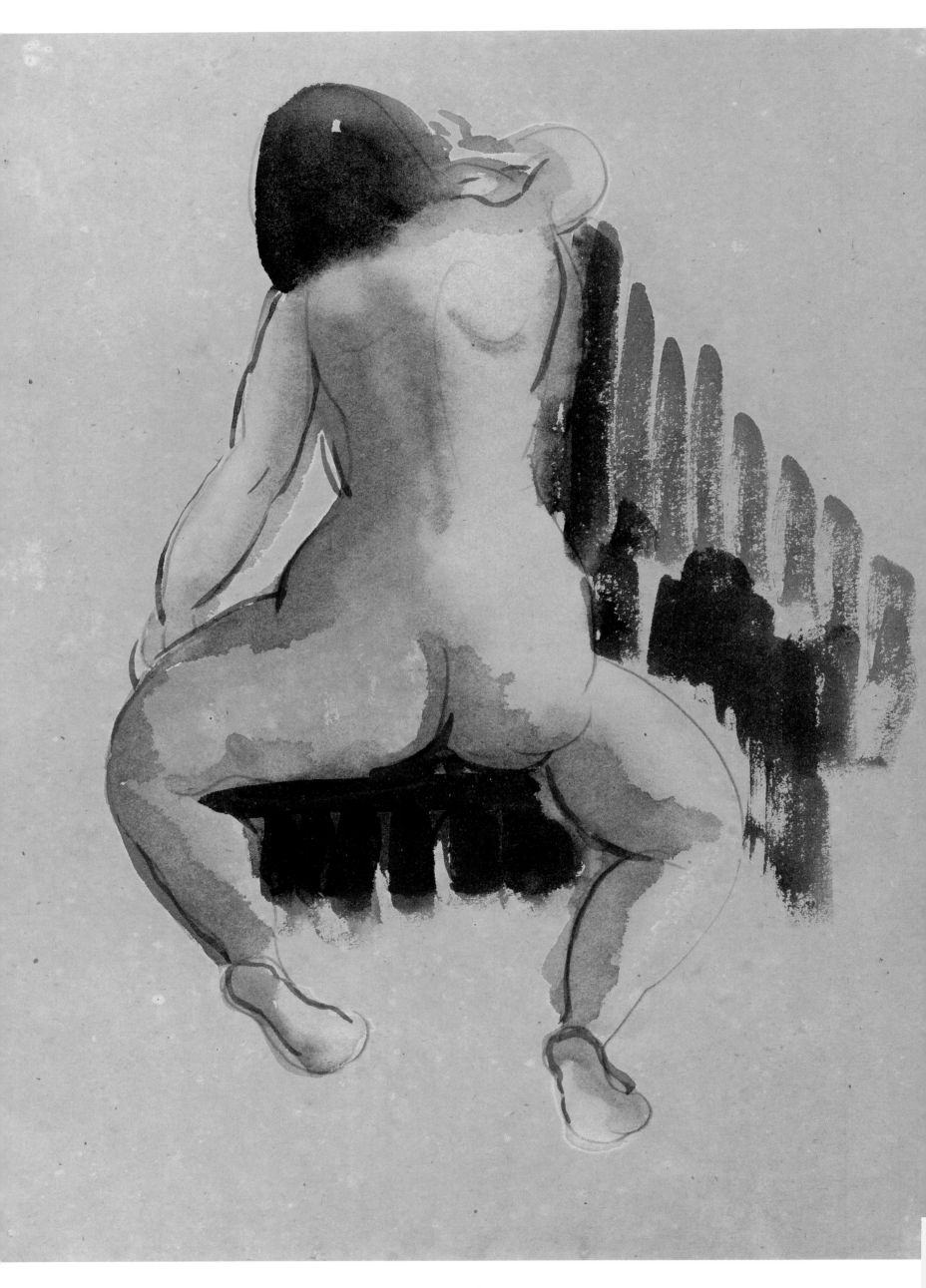

坐姿裸女（154）Seated Nude (154)
年代不詳　紙本淡彩鉛筆　28×36.5cm

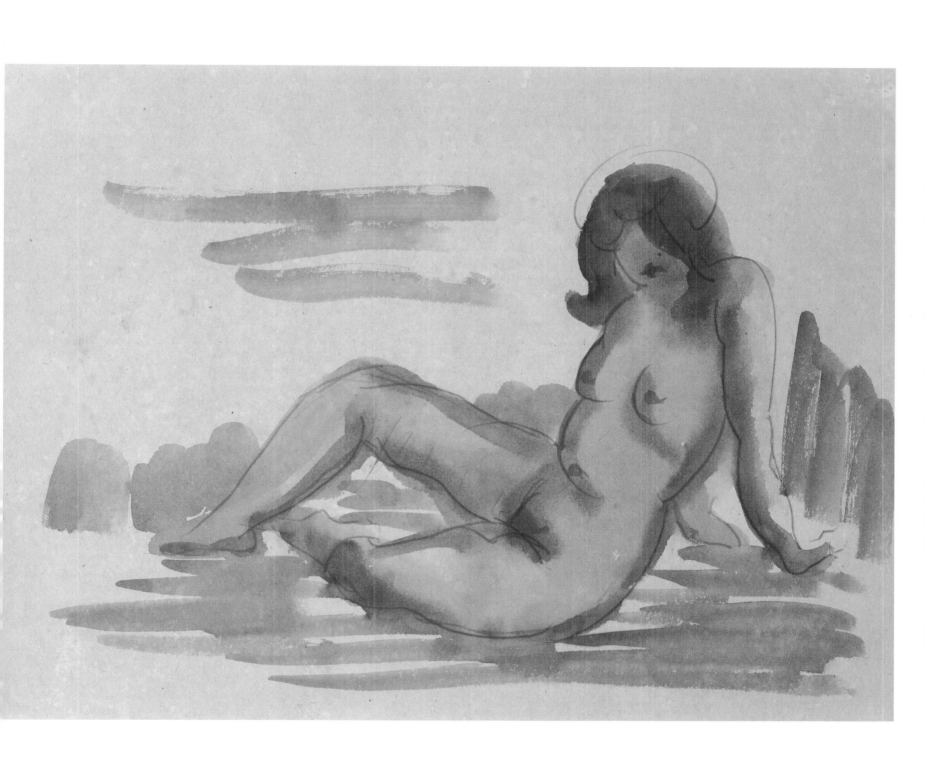

[左頁圖]
立姿裸女（78）Standing Nude (78)
年代不詳　紙本淡彩鉛筆　36×27.5cm

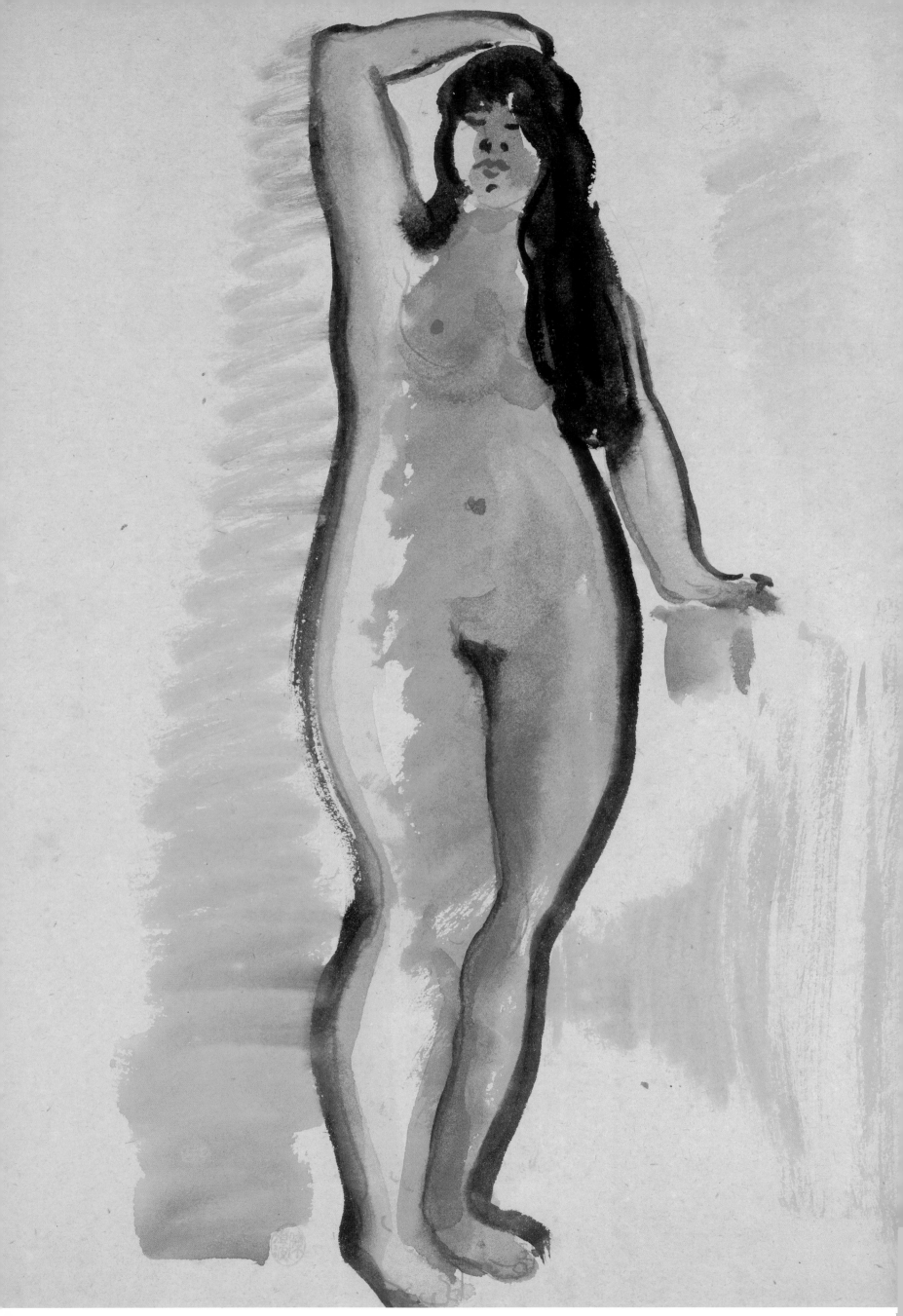

坐姿裸女（155）Seated Nude (155)

年代不詳　紙本淡彩鉛筆　28.5×37cm

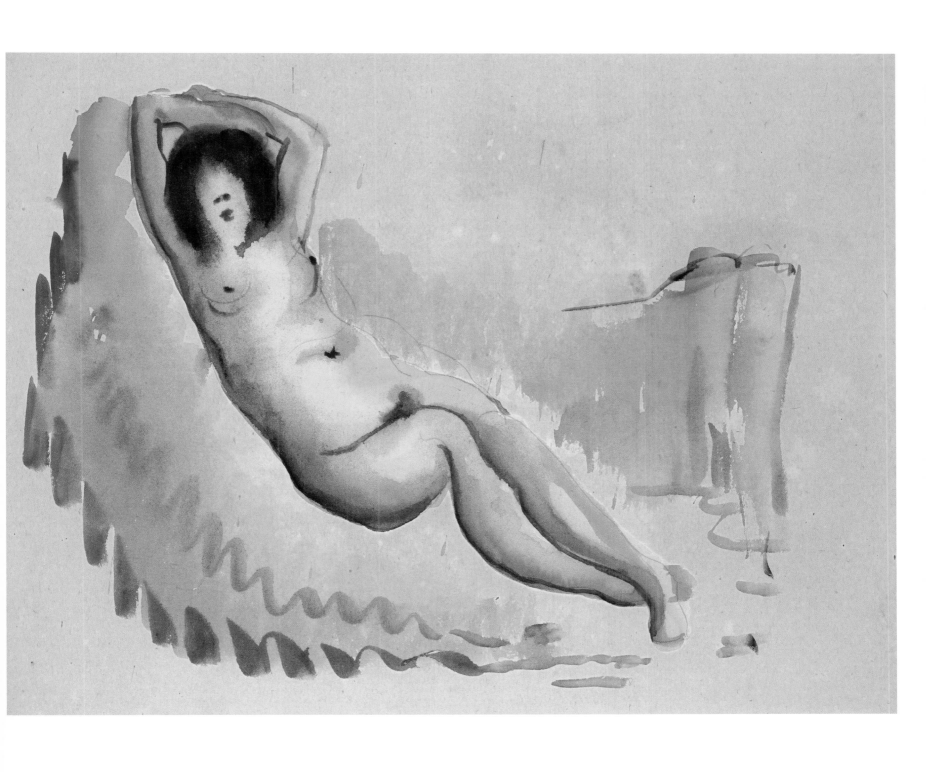

[左頁圖]

立姿裸女（79）Standing Nude (79)

年代不詳　紙本淡彩鉛筆　原寸（36.5×26.5cm）

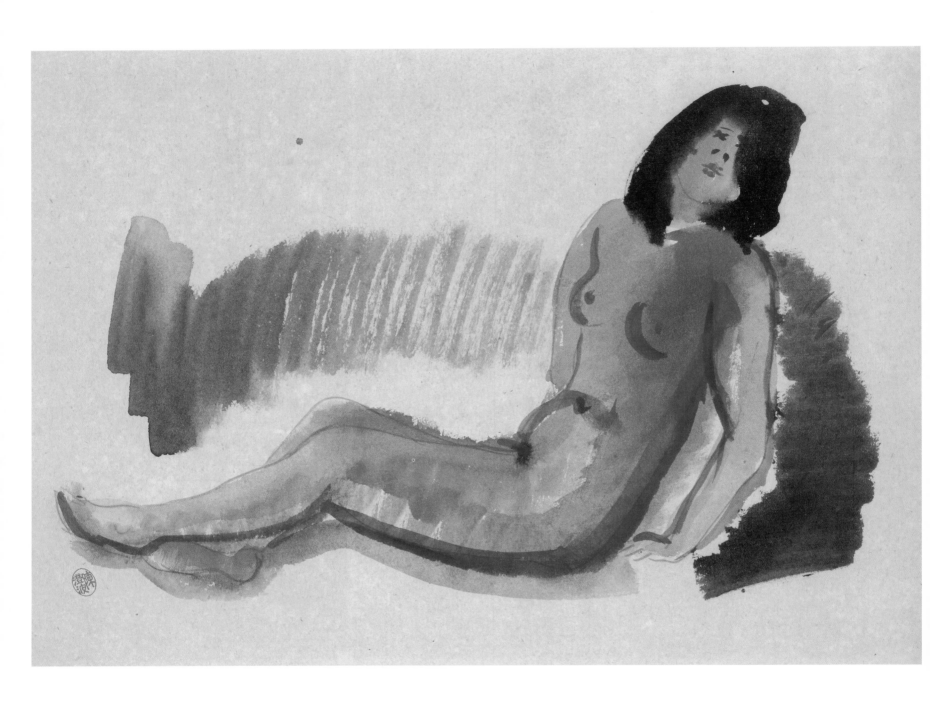

坐姿裸女（156） Seated Nude (156)
年代不詳　紙本淡彩鉛筆　26.5×36.5cm

[右頁圖]
立姿裸女（80） Standing Nude (80)
年代不詳　紙本淡彩鉛筆　原寸（36.5×26.5cm）

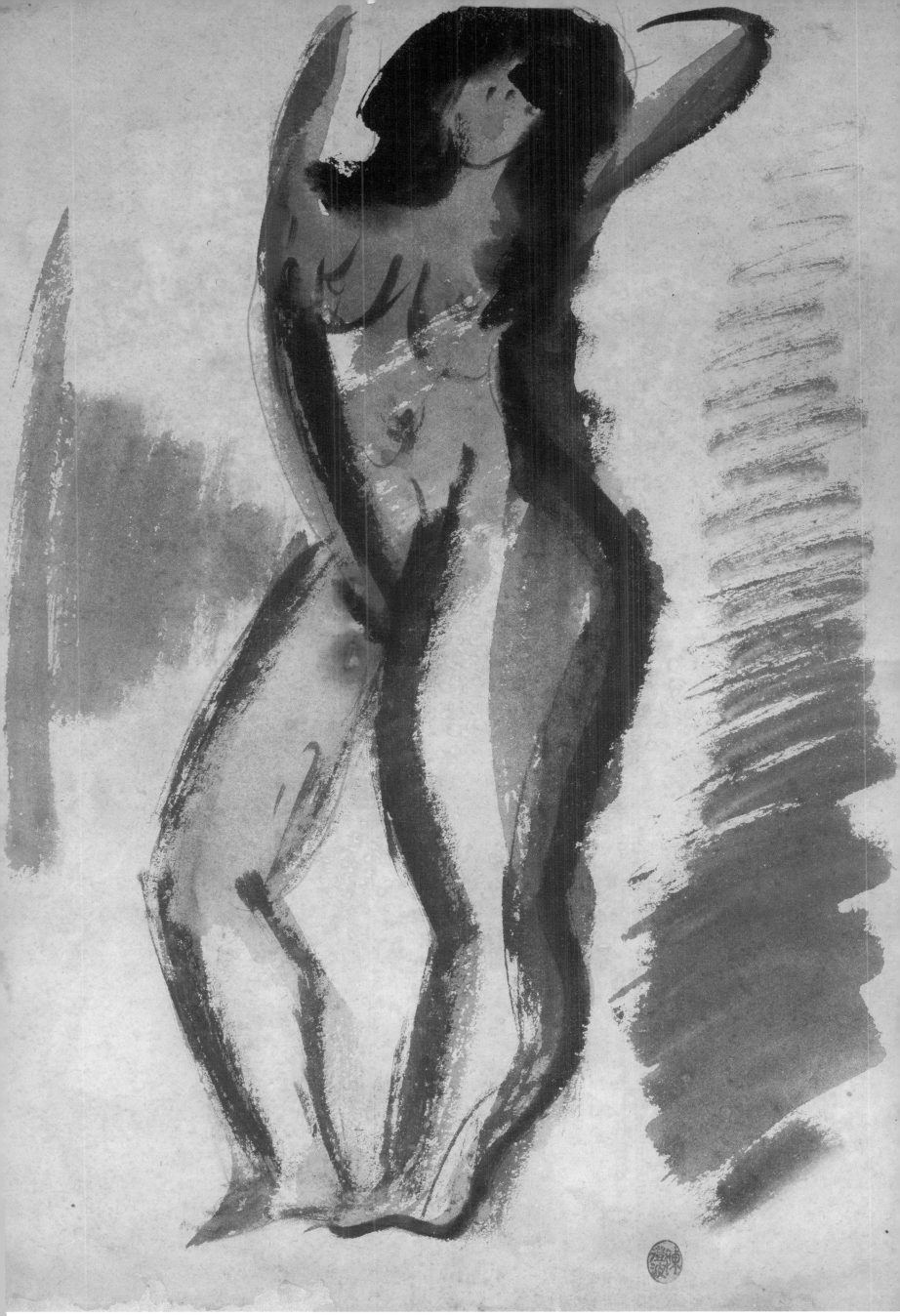

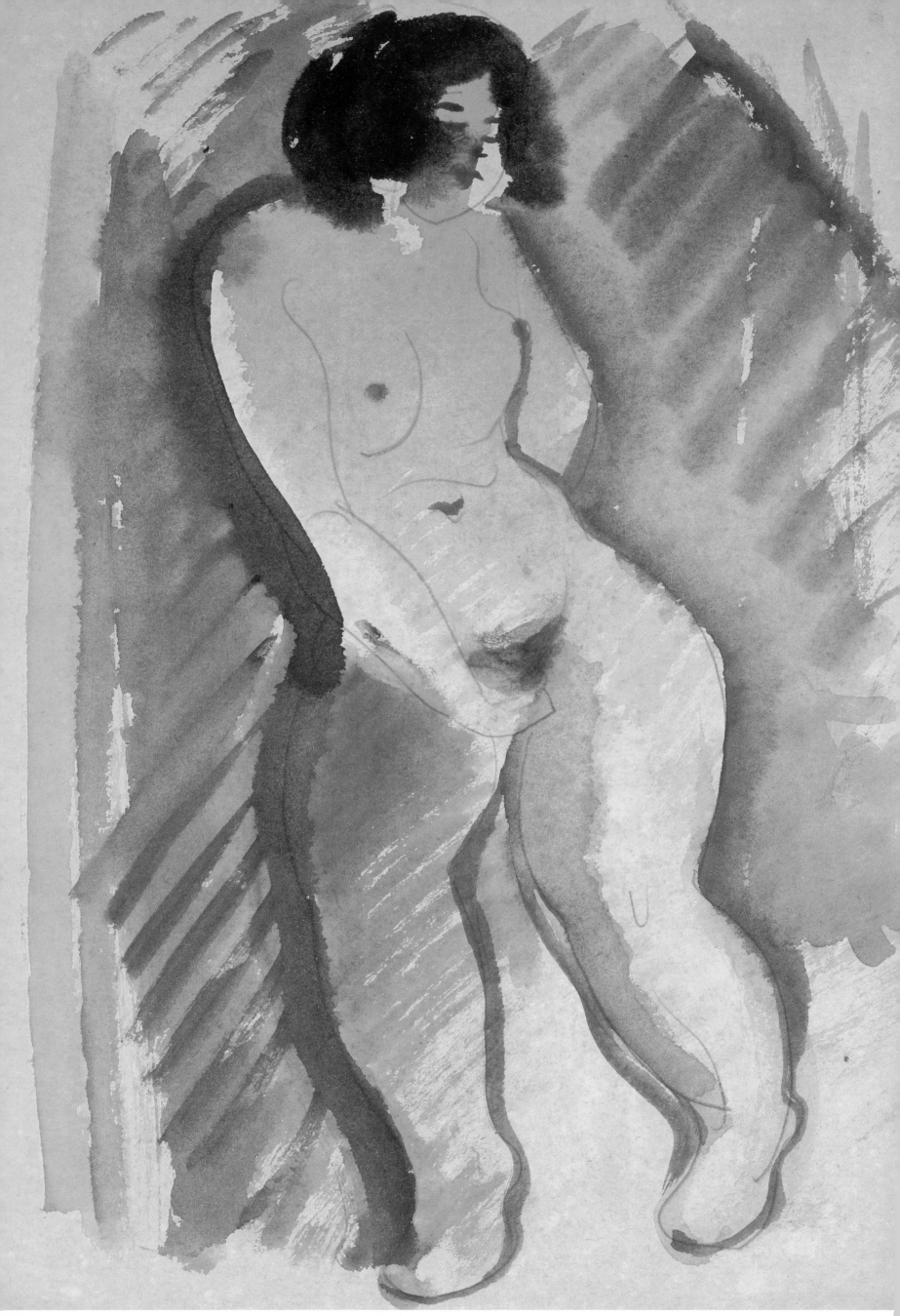

坐姿裸女（157）Seated Nude (157)

年代不詳　紙本淡彩鉛筆　26.5×36.5cm

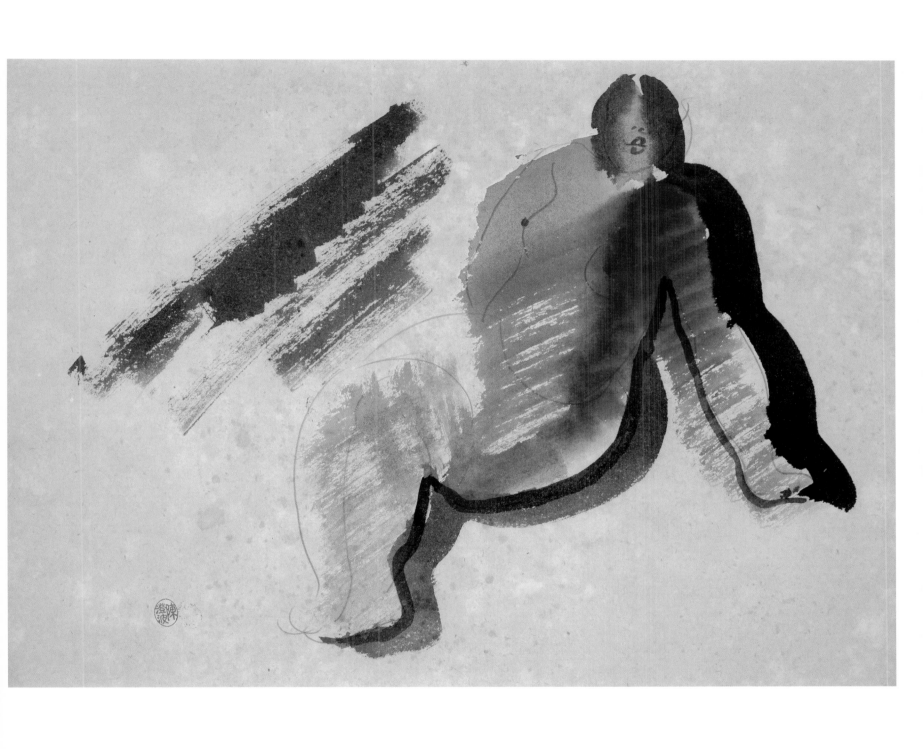

立姿裸女（81）Standing Nude (81)

年代不詳　紙本淡彩鉛筆　原寸（36.5×26.5cm）

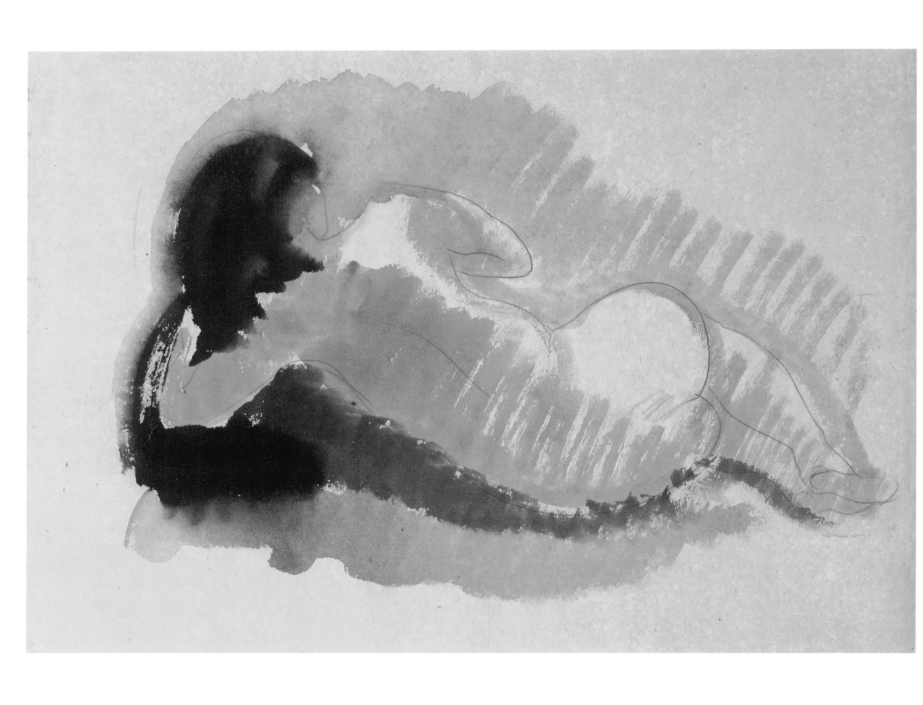

臥姿裸女（84） Lying Nude (84)

年代不詳　紙本淡彩鉛筆　26.5×38cm

392

坐姿裸女（158）Seated Nude (158)
年代不詳　紙本淡彩鉛筆　26.5×36.5cm

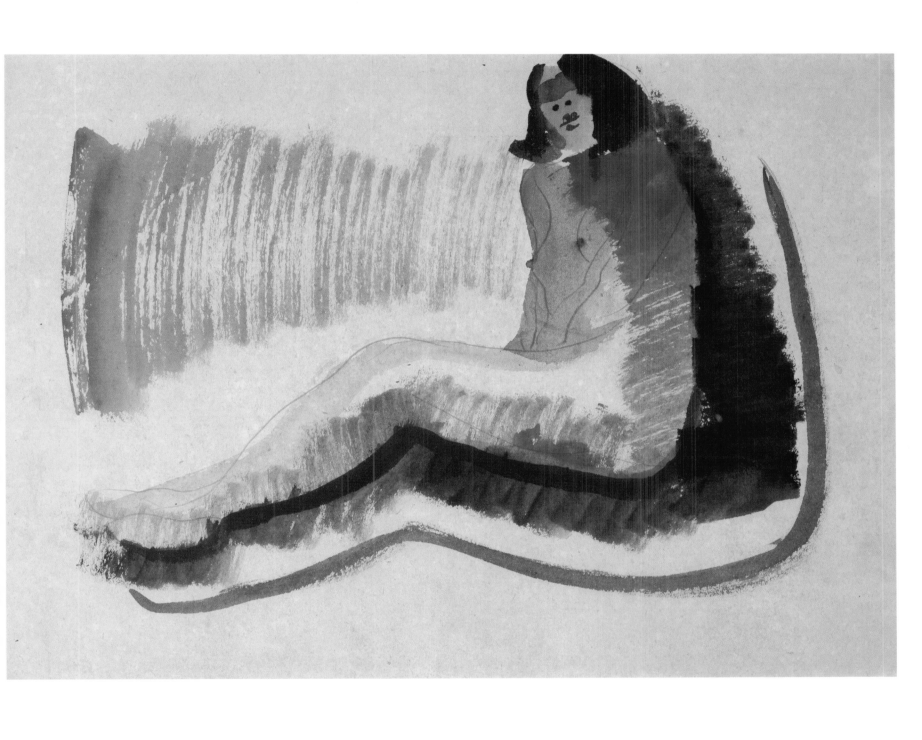

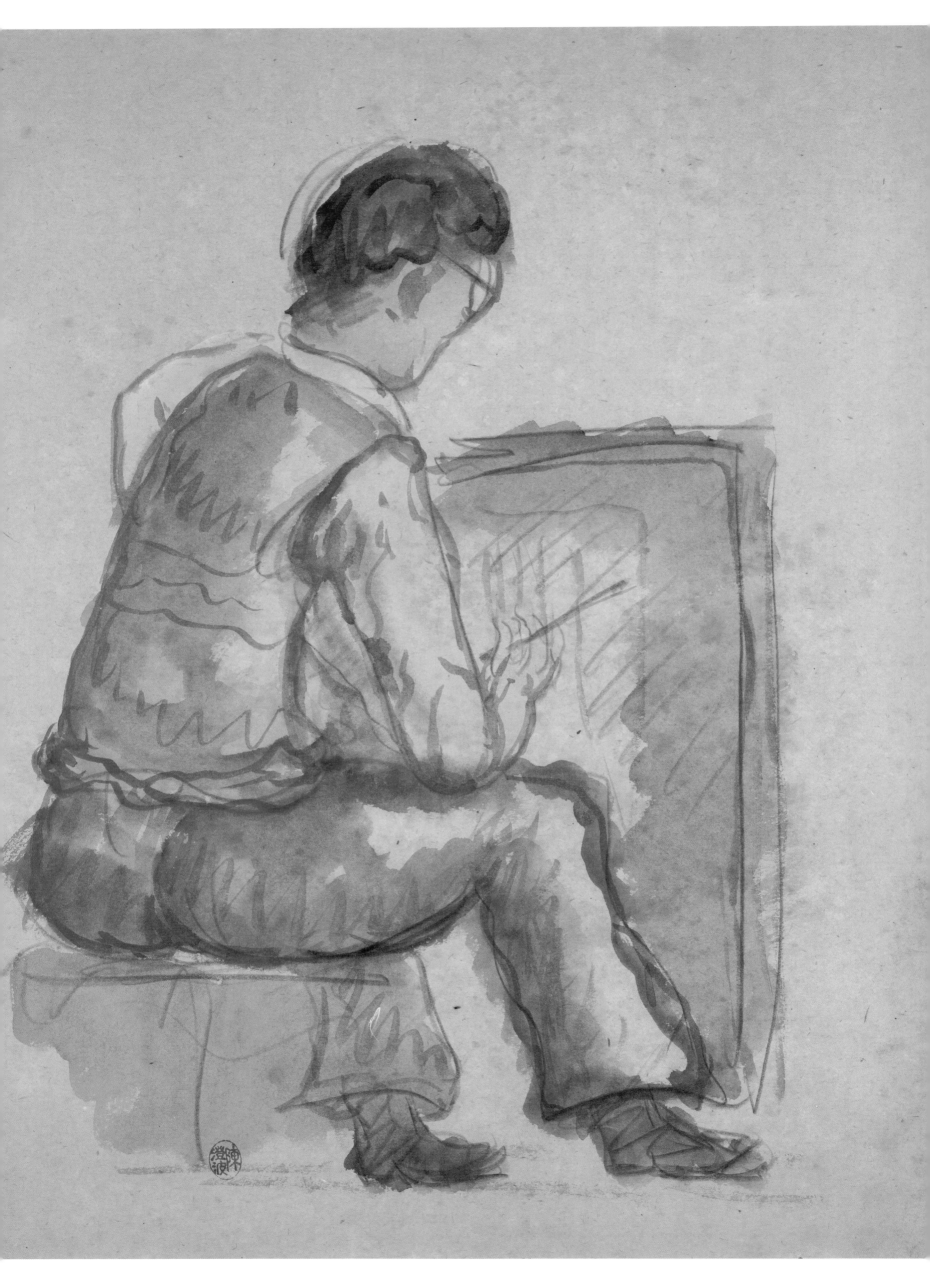

臥姿裸女（85） Lying Nude (85)

年代不詳　紙本淡彩　28×37.5cm

[左頁圖]
畫室（8） Studio (8)

年代不詳　紙本淡彩鉛筆　37×28.5cm

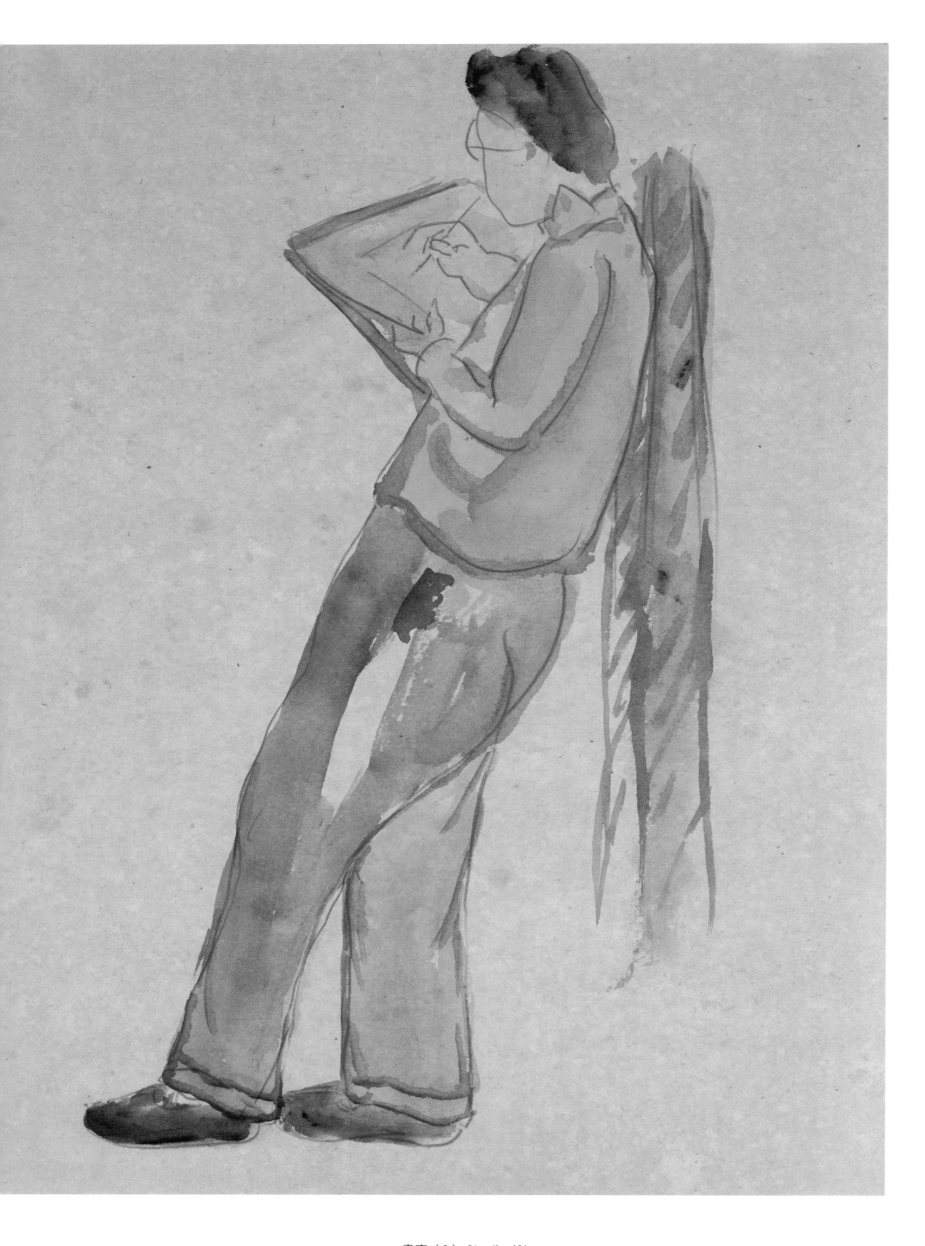

畫室（9）Studio (9)

年代不詳　紙本淡彩鉛筆　37×28.5cm

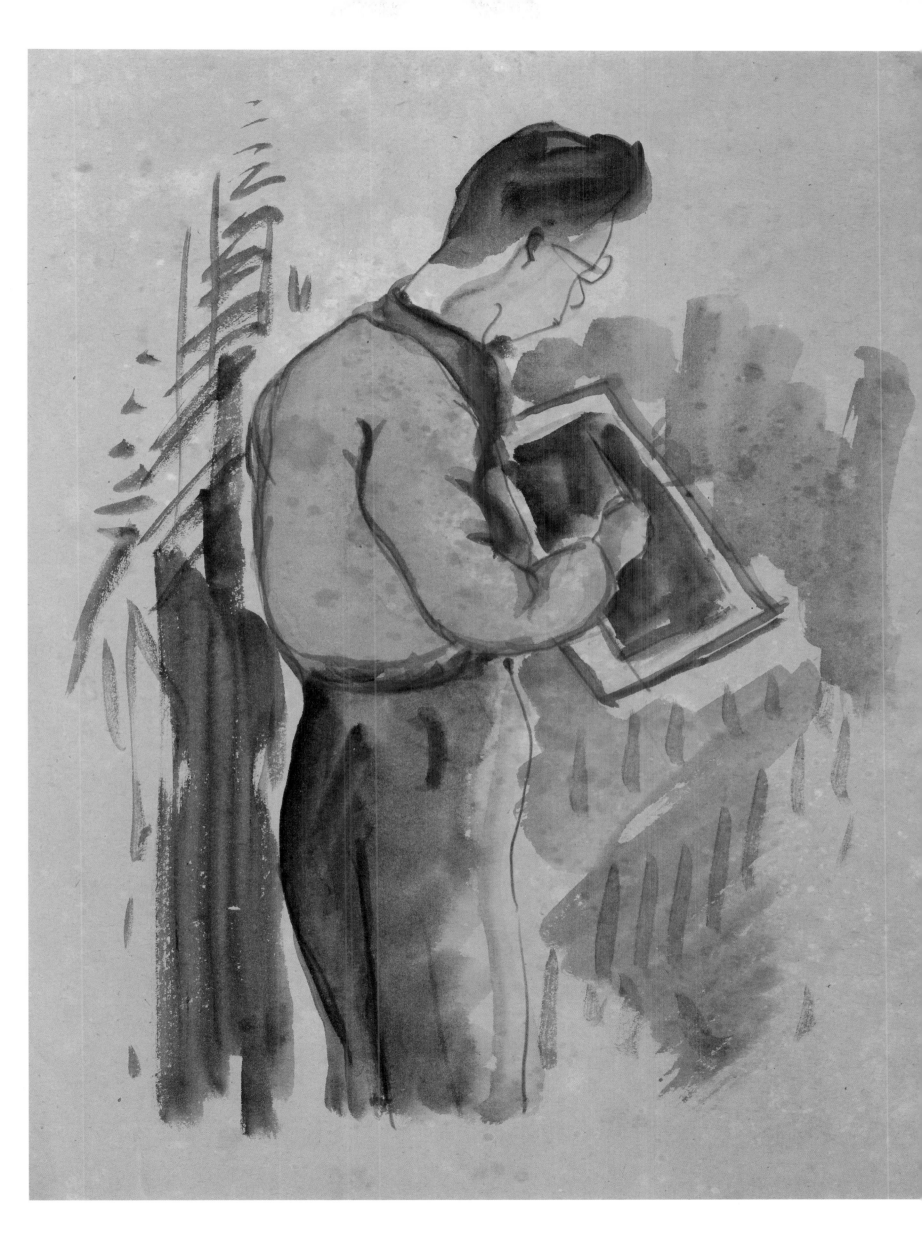

畫室（10） Studio (10)

年代不詳　紙本淡彩鉛筆　36×28cm

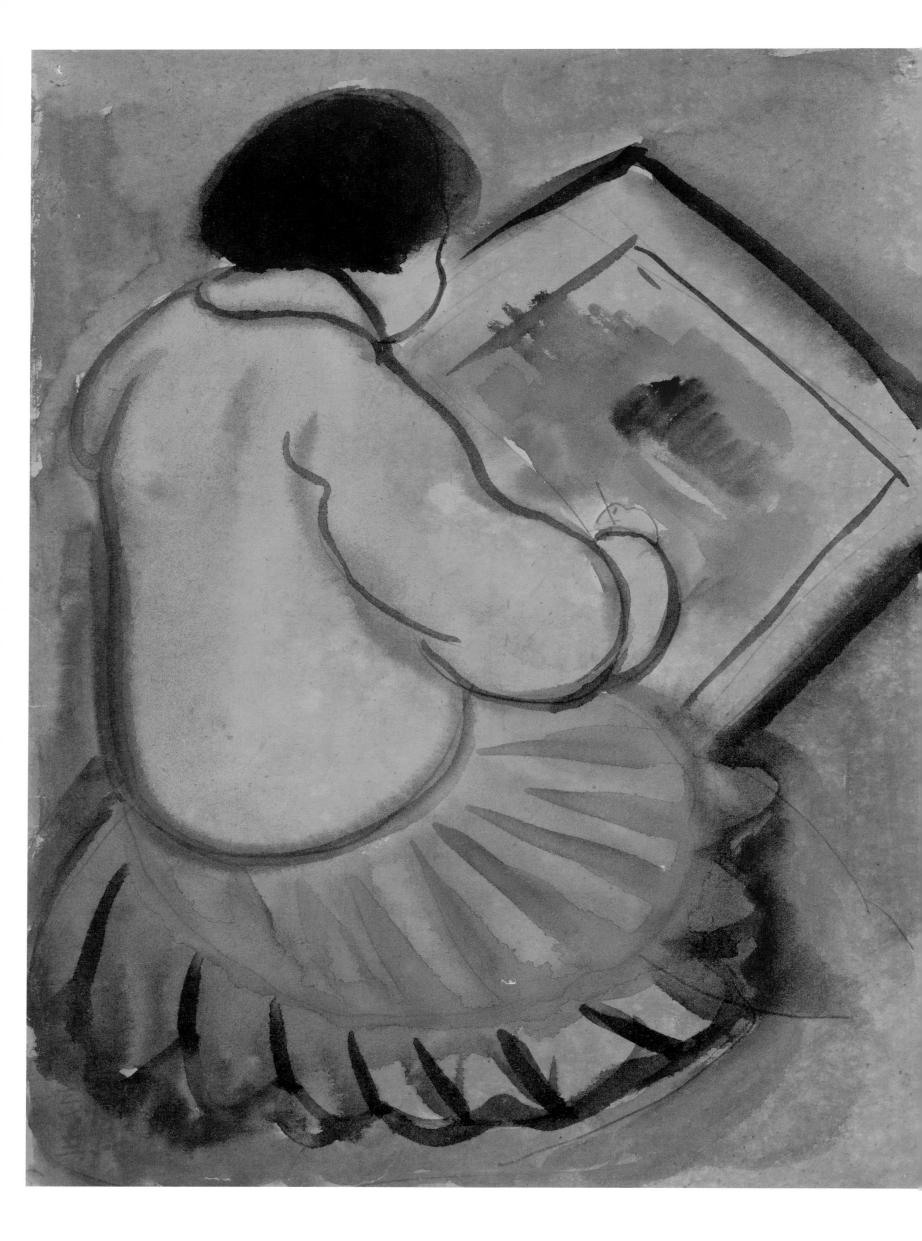

畫室（11）Studio (11)

年代不詳　紙本淡彩鉛筆　37×28cm

398

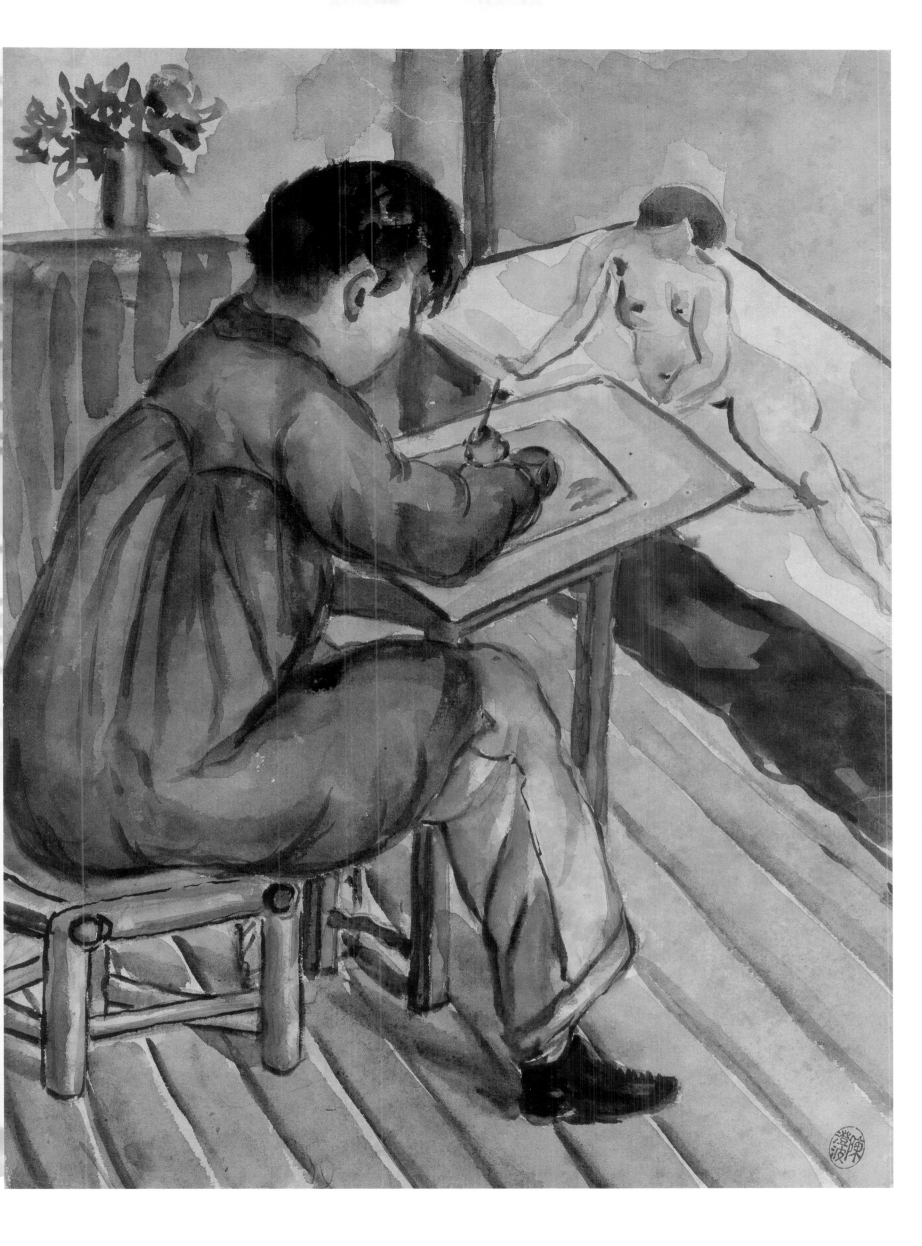

畫室（12）Studio (12)

年代不詳　紙本淡彩鉛筆　原寸（31×23.5cm）

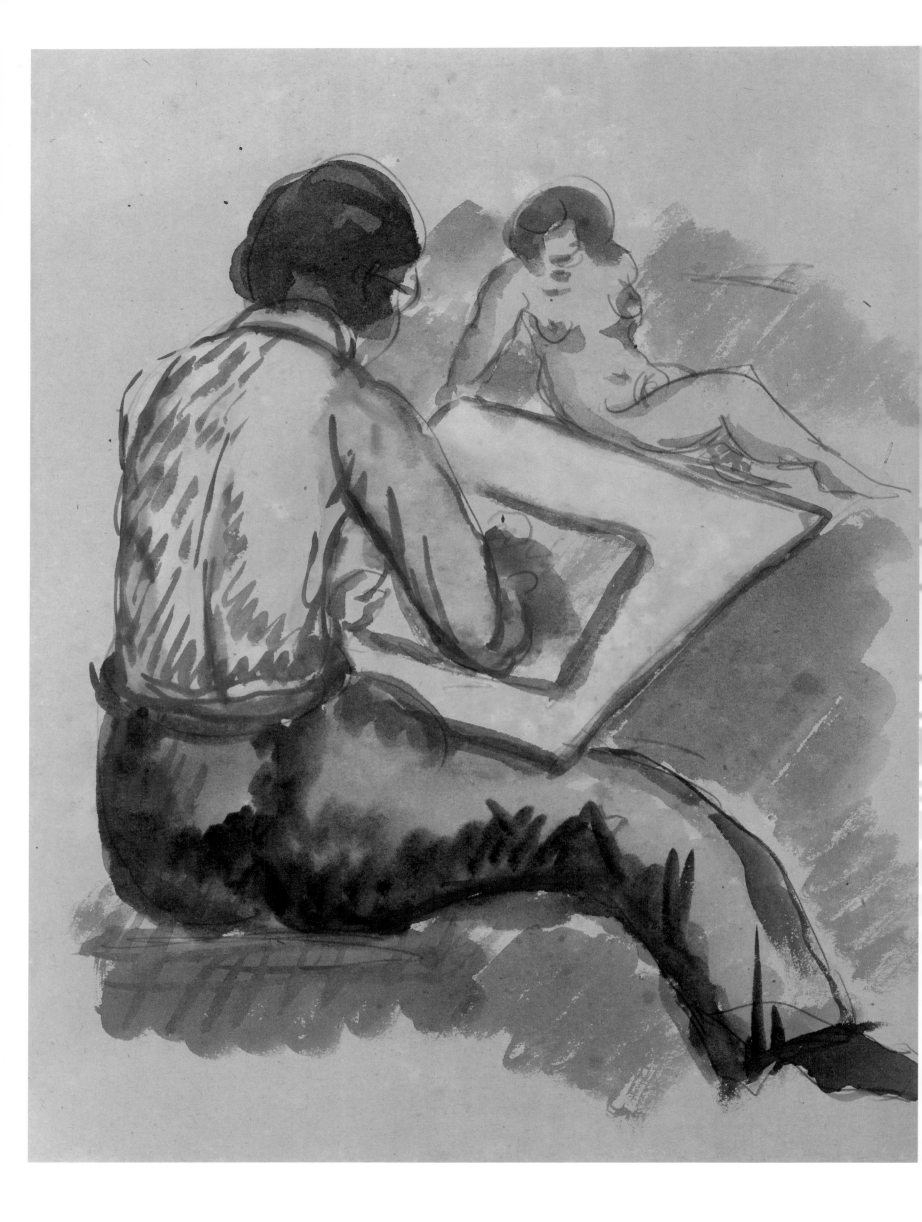

畫室（13）Studio (13)

年代不詳　紙本淡彩鉛筆　36.5×28cm

畫室（14）Studio (14)

年代不詳　紙本淡彩鉛筆　36.5×28cm

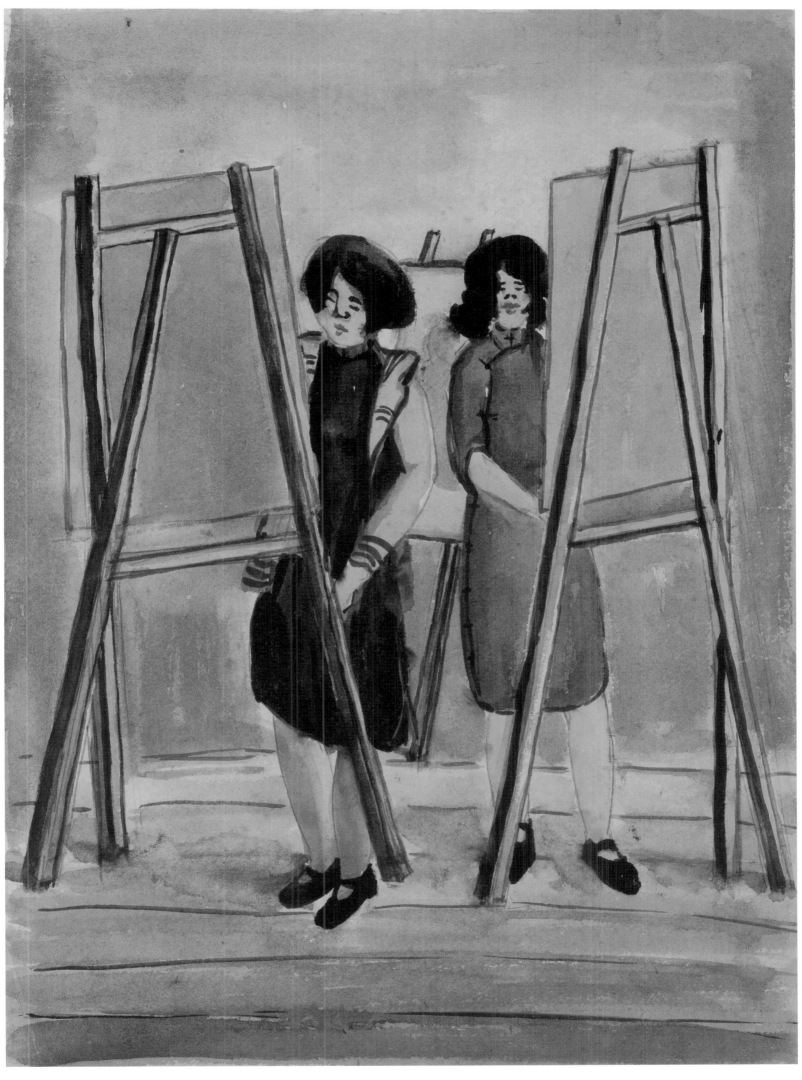

畫室（16）Studio (16)
年代不詳　紙本淡彩鉛筆　36×26.5cm

[左頁圖]
畫室（15）Studio (15)
年代不詳　紙本淡彩鉛　原寸（36.5×26cm）

畫室（17）Studio (17)

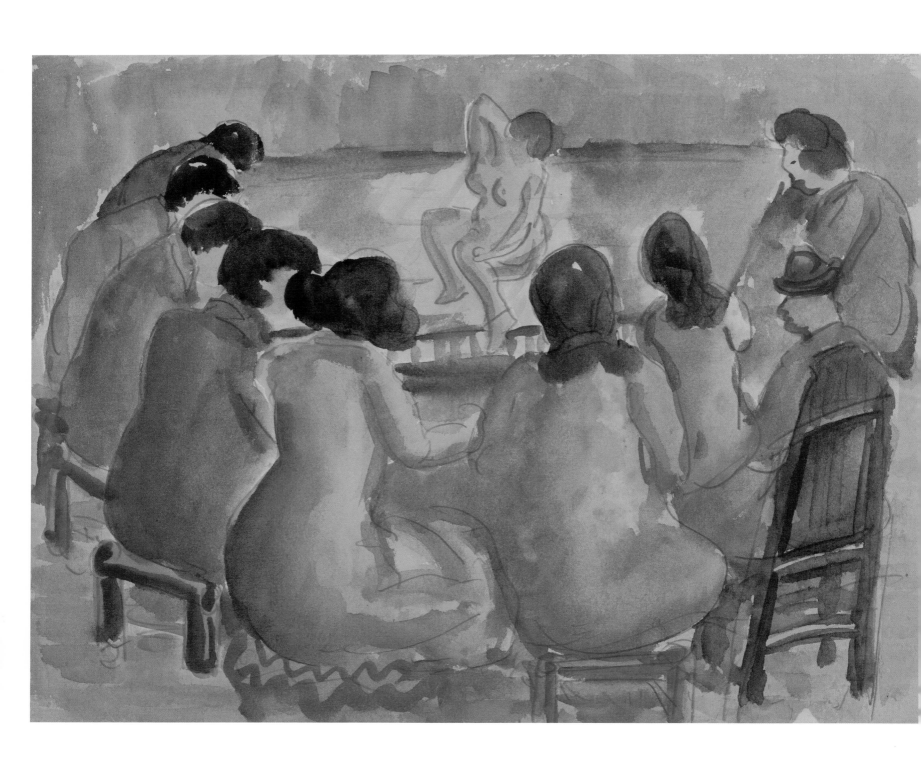

畫室（17）Studio (17)

年代不詳　紙本淡彩鉛筆　28×36.5cm

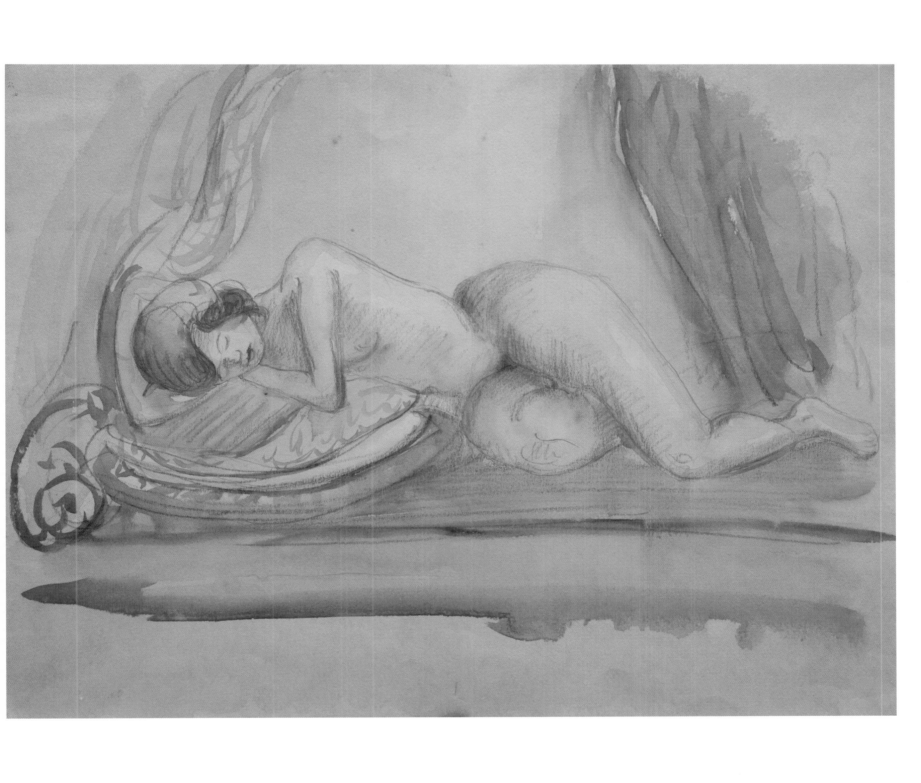

人物（20） Figure (20)

年代不詳　紙本淡彩鉛筆　29.5×38cm

人物（21）Figure (21)

年代不詳　紙本淡彩鉛筆　29.5×38cm

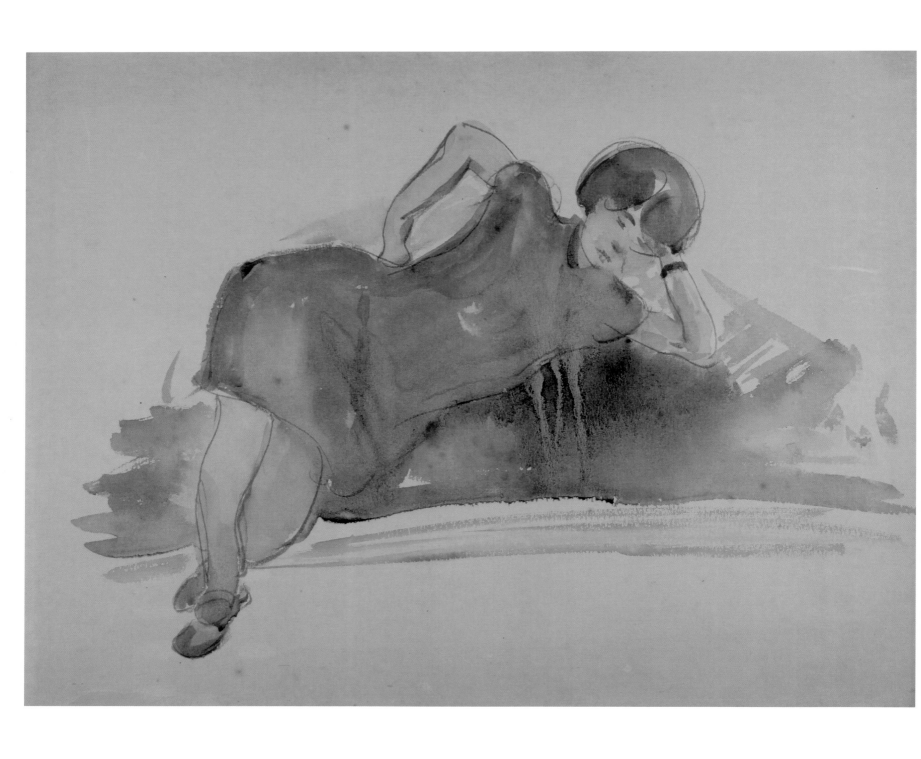

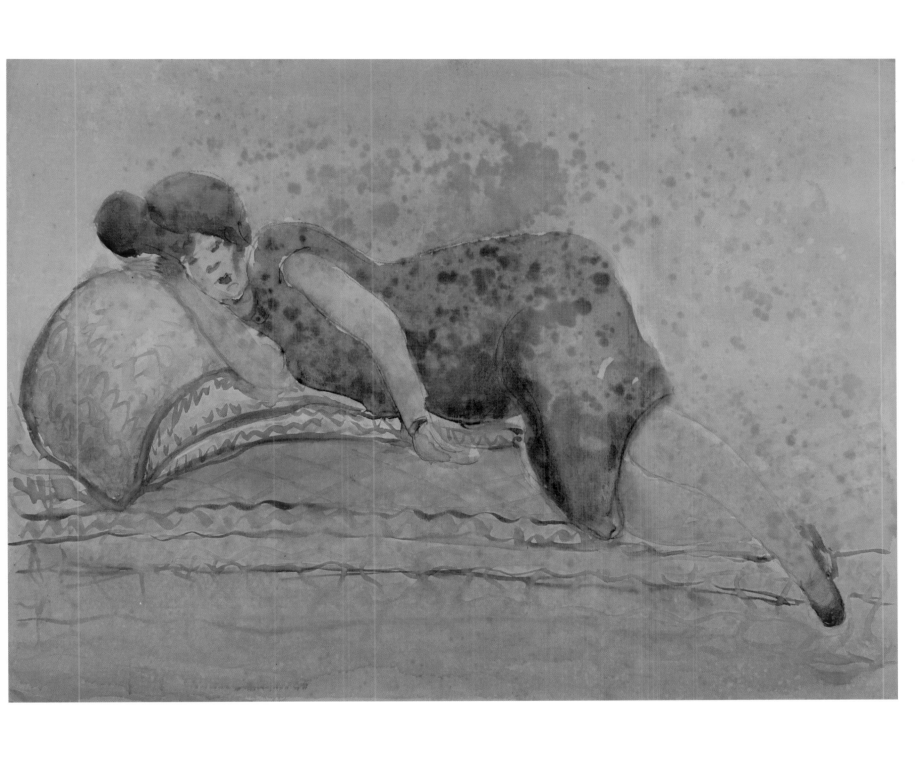

人物（22） Figure (22)

年代不詳　紙本淡彩鉛筆　29.5×38cm

407

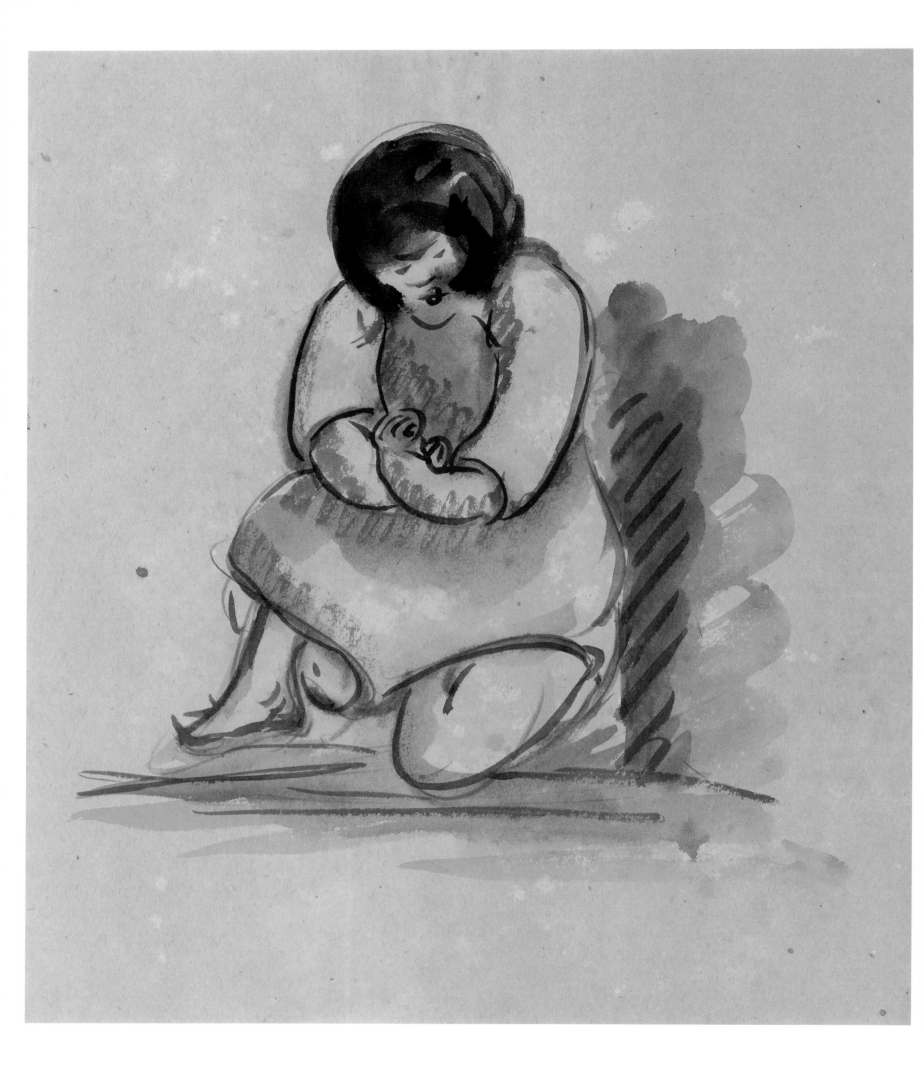

人物（24）Figure (24)

年代不詳　紙本淡彩鉛筆　30.5×27cm

[右頁圖]

人物（25）Figure (25)

年代不詳　紙本淡彩鉛筆　原寸（36.5×26cm）

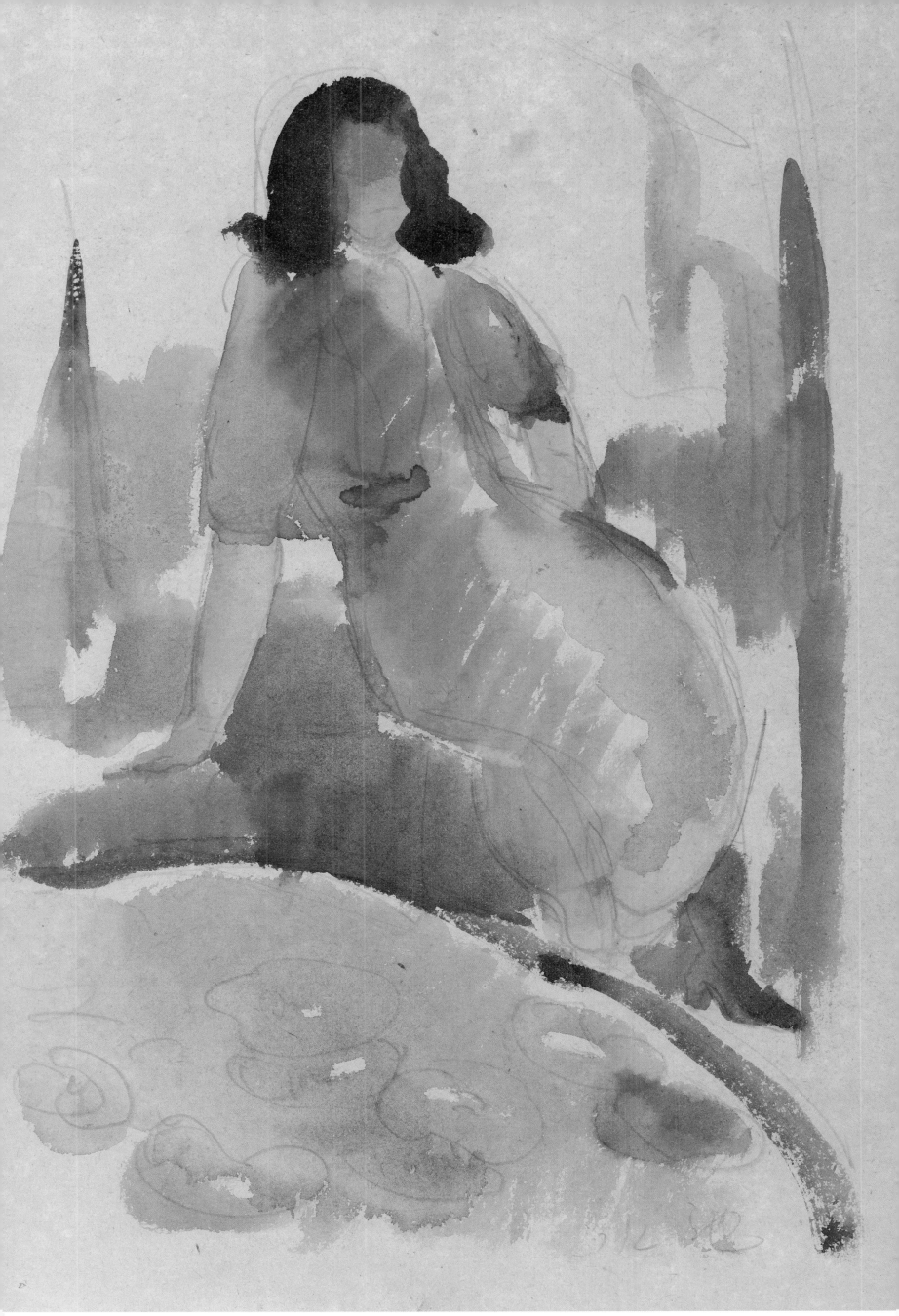

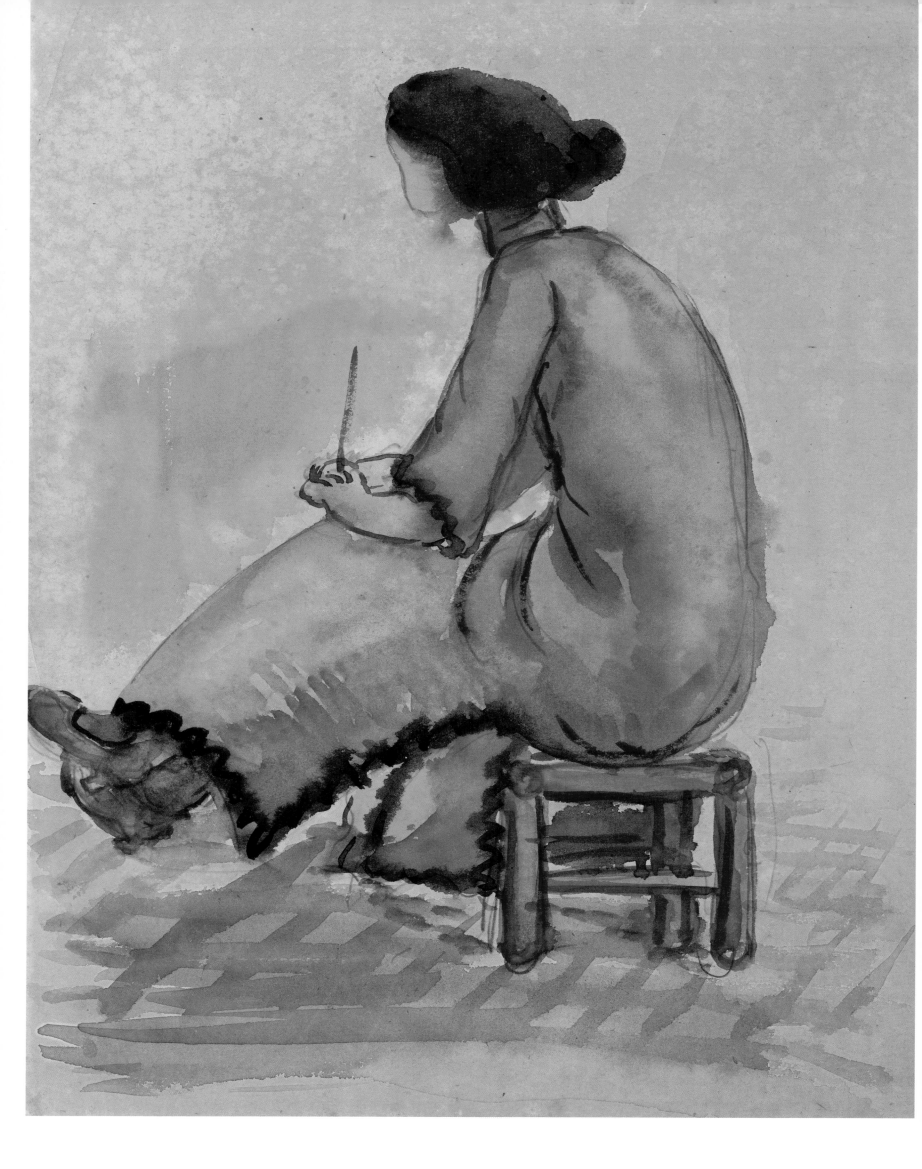

人物（27）Figure (27)

年代不詳　紙本淡彩鉛筆　36.5×28cm

[右頁圖]

人物（28）Figure (28)

年代不詳　紙本淡彩鉛筆　原寸（36.3×26.5cm）

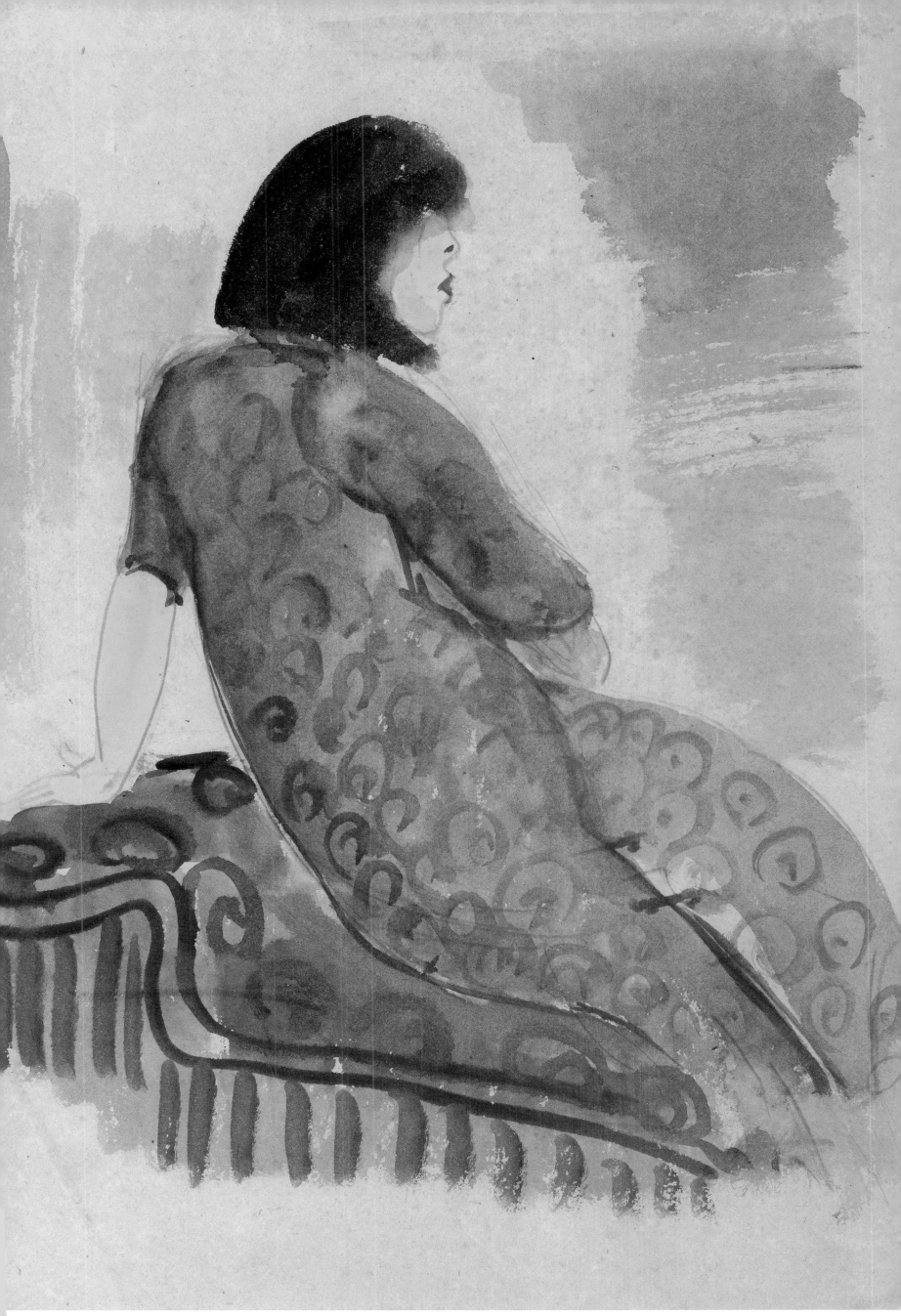

人物（29） Figure (29)

年代不詳　紙本淡彩鉛筆　36×28cm

人物（30） Figure (30)

年代不詳　紙本淡彩鉛筆　36.5×26.5cm

人物（31）Figure (31)

年代不詳　紙本淡彩鉛筆　36×26.5cm

[右頁圖]
人物（32）Figure (32)

年代不詳　紙本淡彩鉛筆　原寸（36.3×26.5cm）

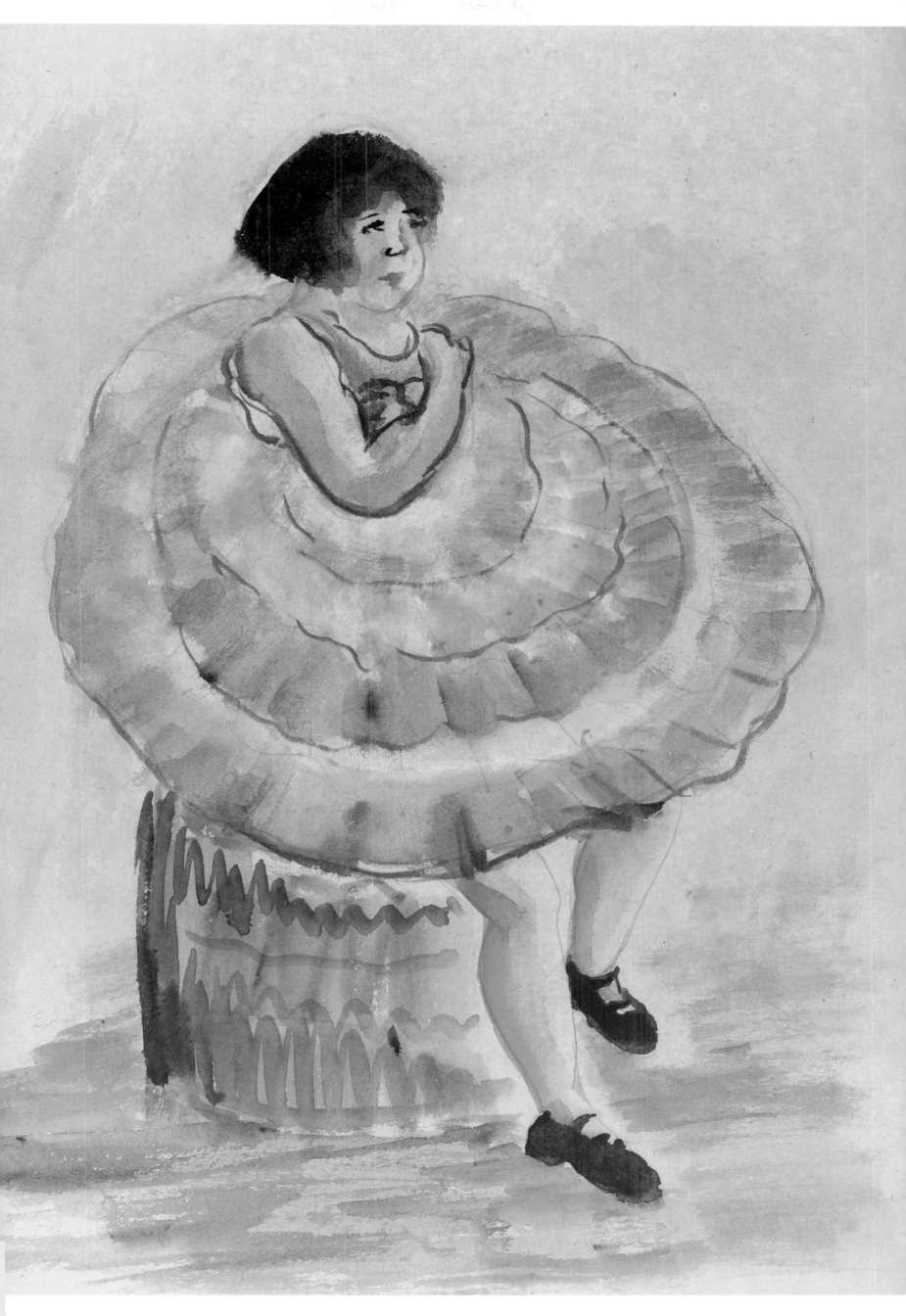

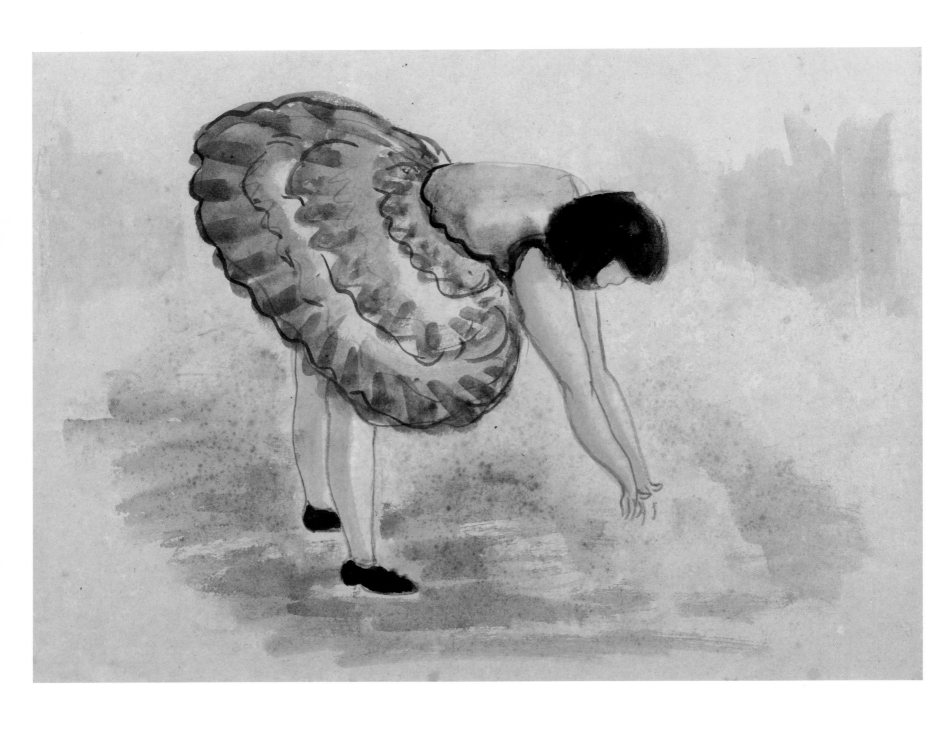

人物（33）Figure (33)

年代不詳　紙本淡彩鉛筆　26.5×36.3cm

人物（34）Figure (34)

年代不詳　紙本淡彩鉛筆　26.5×36.3cm

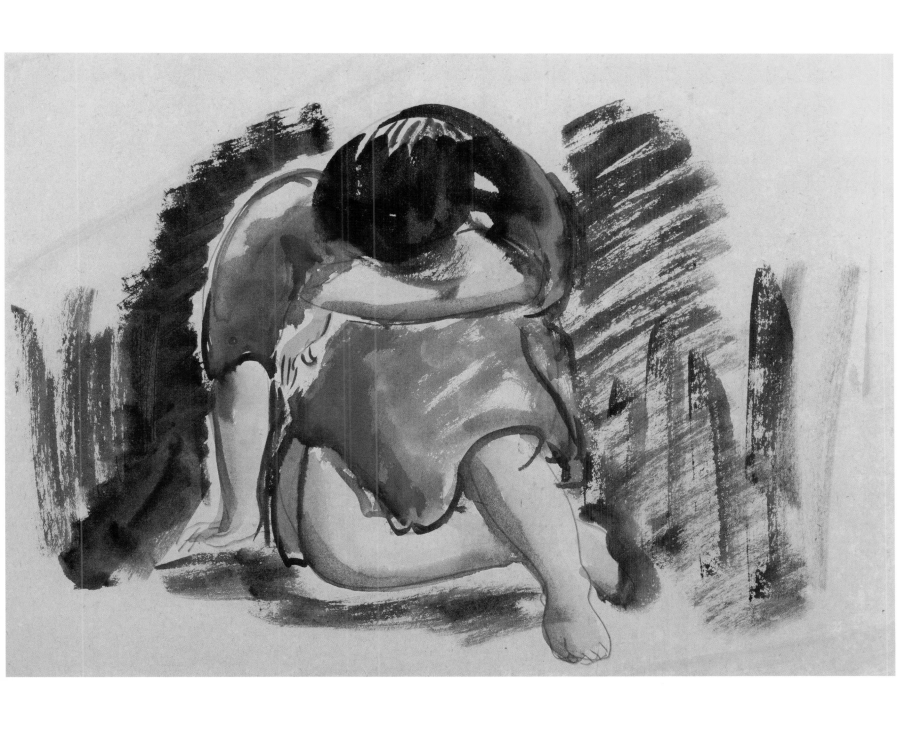

人物（35）Figure (35)

年代不詳　紙本淡彩鉛筆　37×27cm

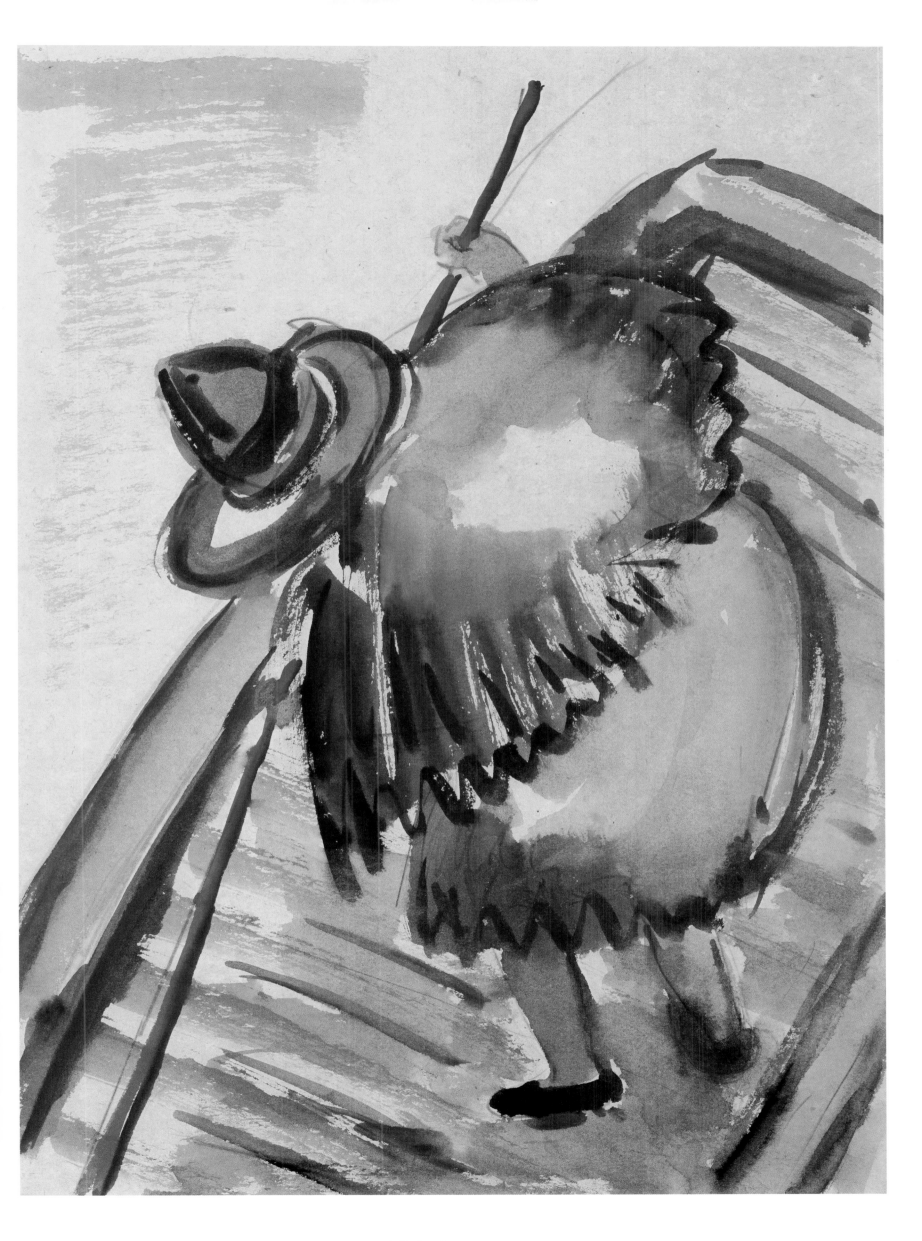

人物（36）Figure (36)

年代不詳　紙本淡彩鉛筆　36.5×26cm

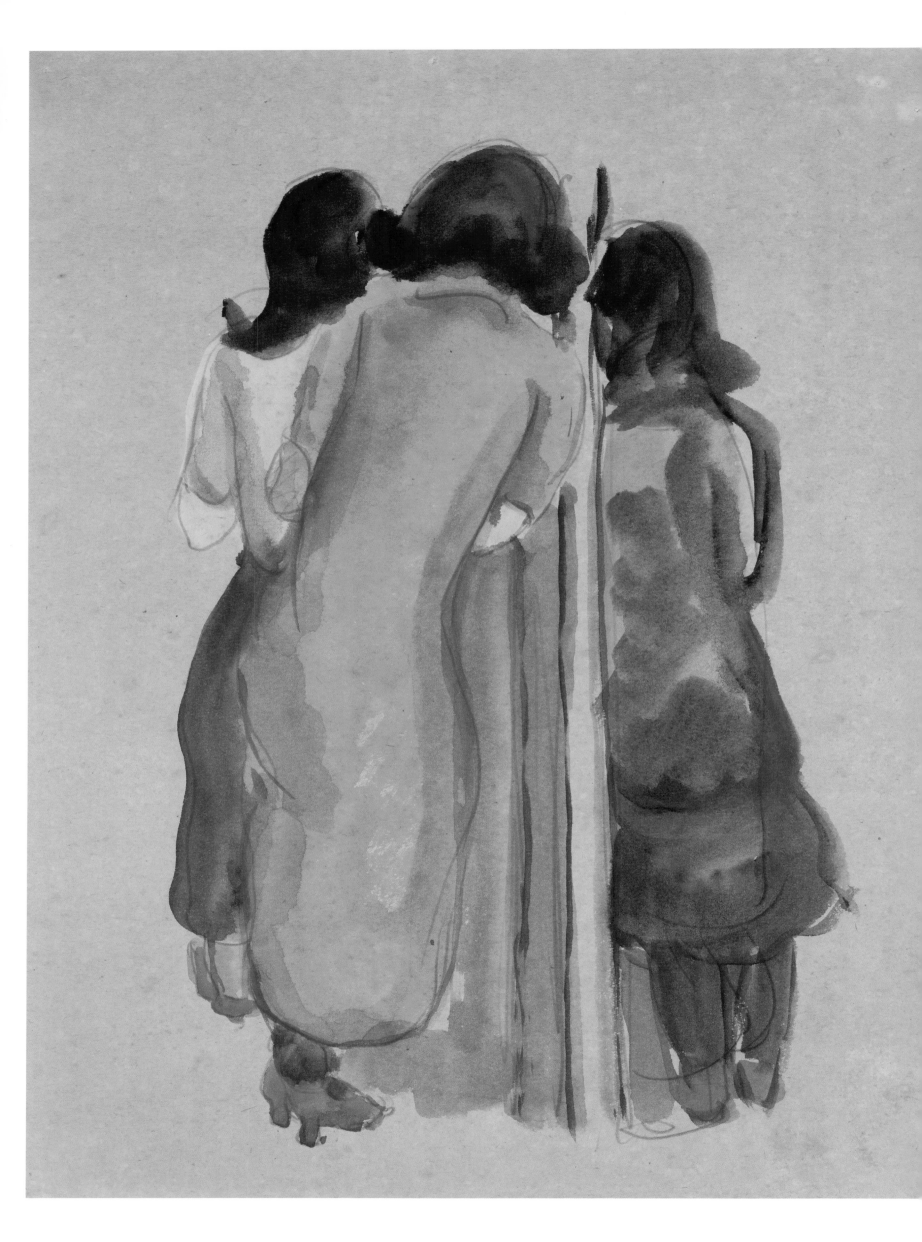

群像（7）Group Portrait (7)

年代不詳　紙本淡彩鉛筆　37×28cm

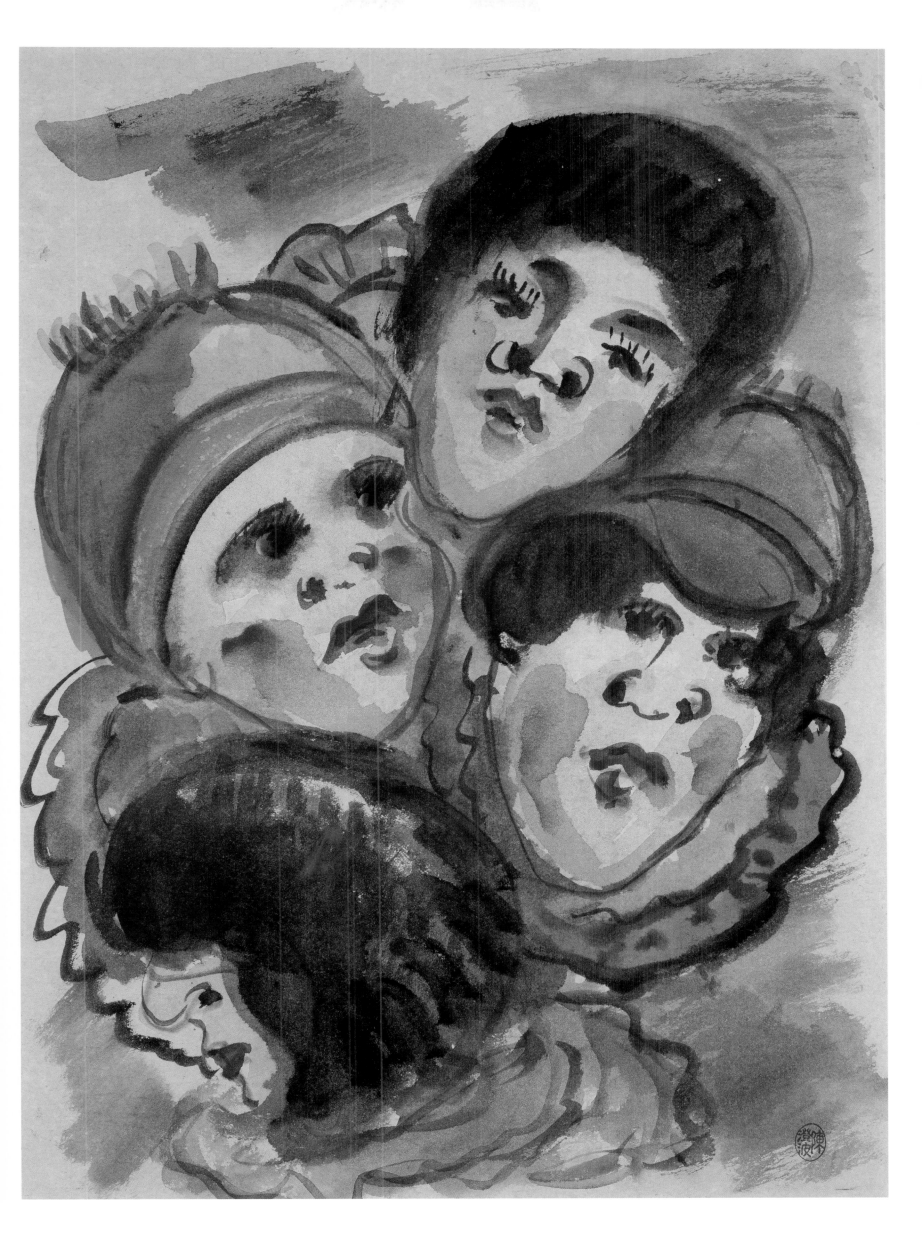

群像（8）Group Portrait (8)

年代不詳　紙本淡彩鉛筆　36.5×26.5cm

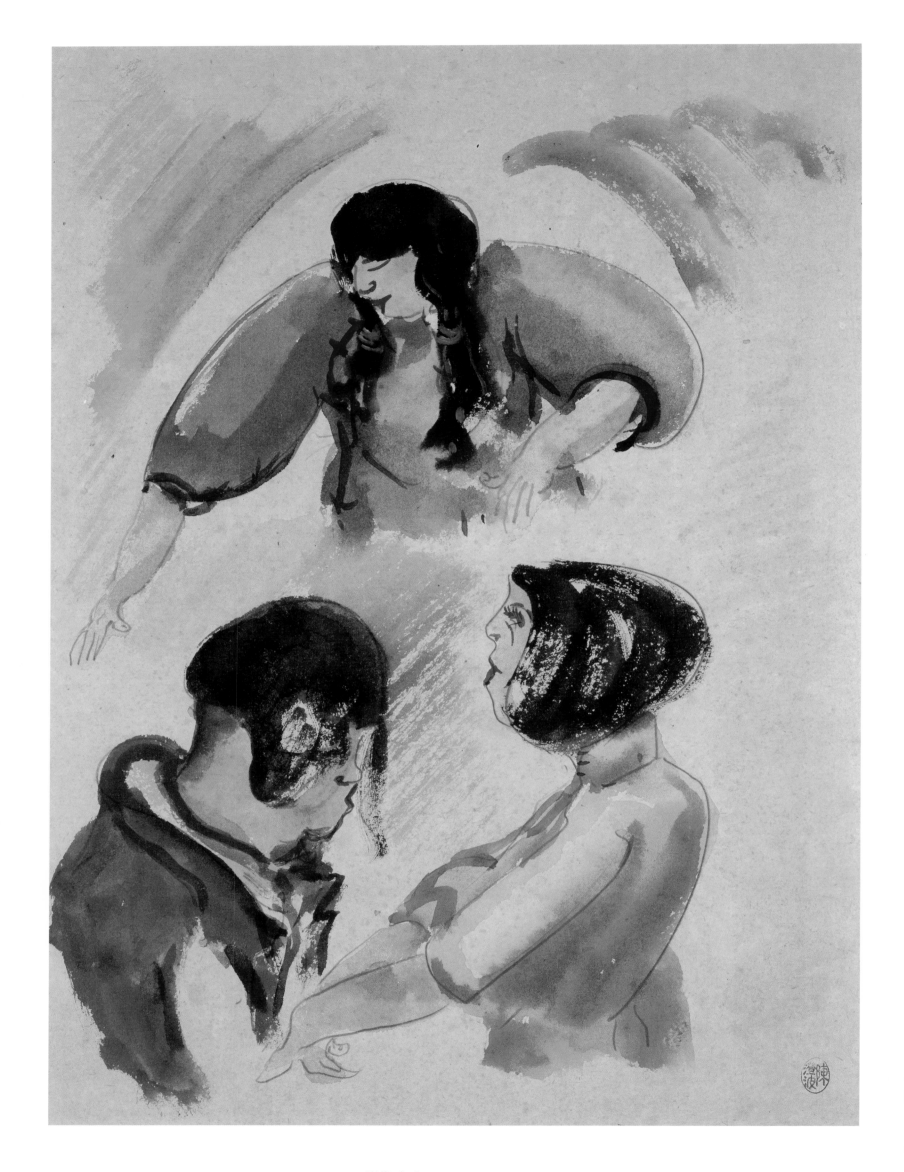

群像（9）Group Portrait (9)
年代不詳　紙本淡彩鉛筆　36.5×26.5cm

[右頁圖]
群像（10）Group Portrait (10)
年代不詳　紙本淡彩鉛筆　原寸（36×26.5cm）

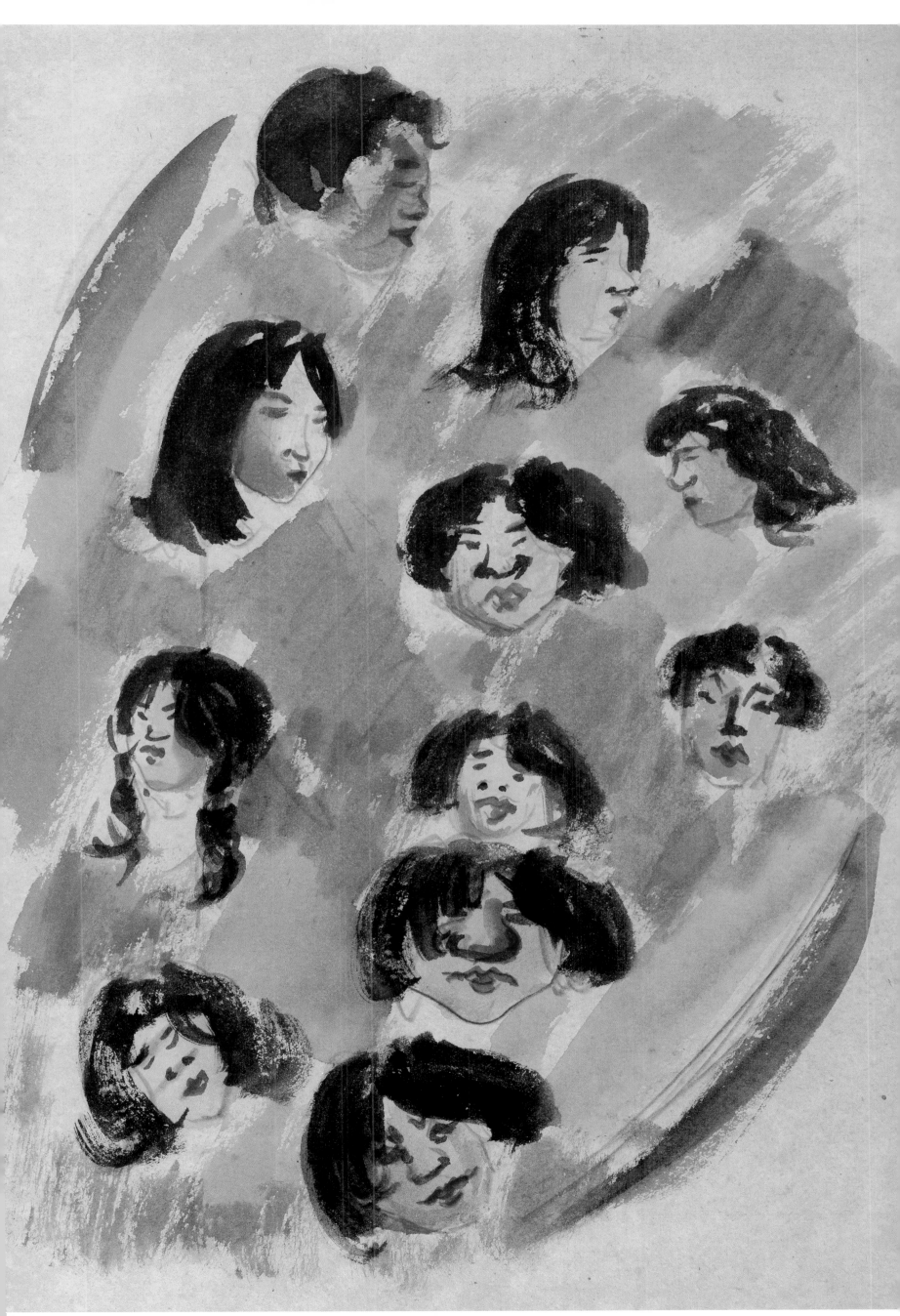

群像（11）Group Portrait (11)

年代不詳　紙本淡彩鉛筆　26.5×36cm

群像（12） Group Portrait (12)

年代不詳　紙本淡彩鉛筆　26.5×36.3cm

群像（13）Group Portrait (13)

年代不詳　紙本淡彩鉛筆　26.5×36cm

群像（14）Group Portrait (14)

年代不詳　紙本淡彩鉛筆　26.5×36.3cm

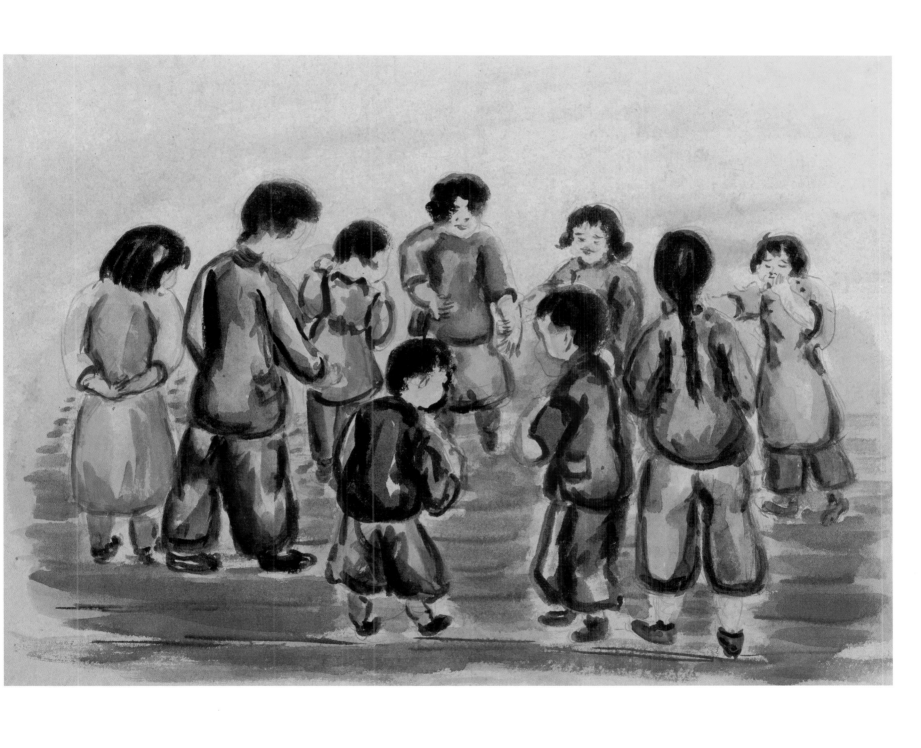

群像（15）Group Portrait (15)

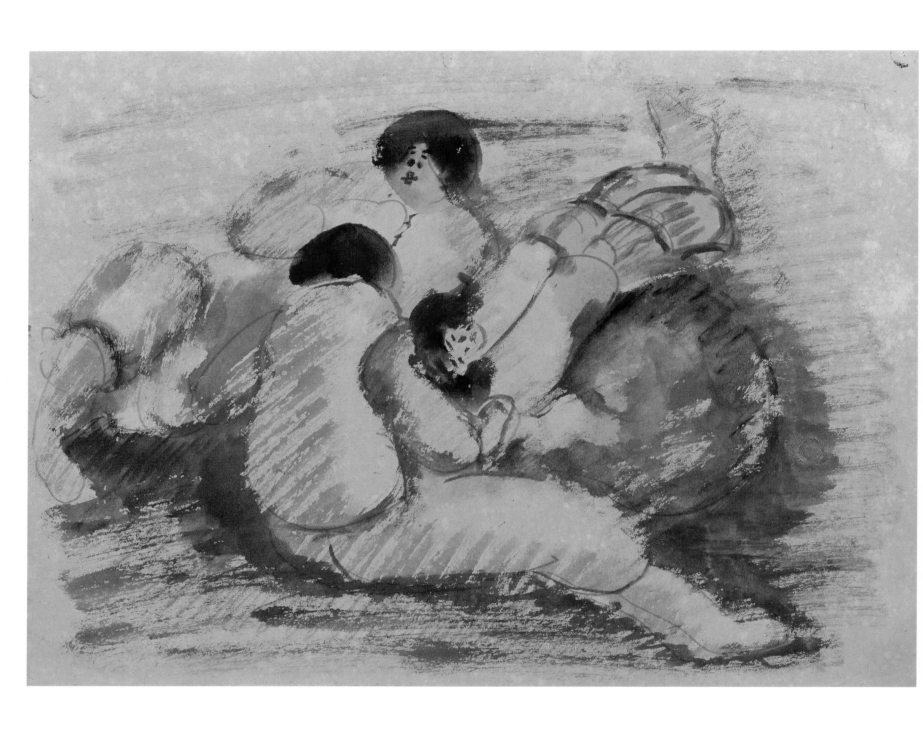

群像（15）Group Portrait (15)

年代不詳　紙本淡彩鉛筆　26.5×36cm

群像（16）Group Portrait (16)

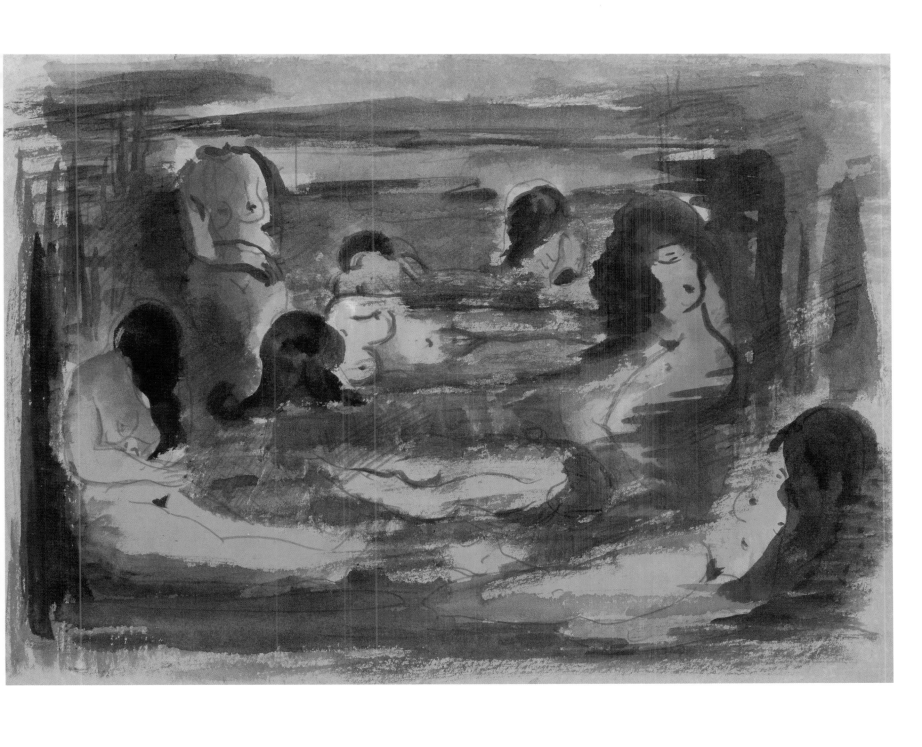

群像（16）Group Portrait (16)

年代不詳　紙本淡彩鉛筆　26×36cm

頭像（3）Portrait (3)

年代不詳　紙本淡彩鉛筆　30.5×27cm

[右頁圖]

頭像（4）Portrait (4)

年代不詳　紙本淡彩　原寸（36×26.5cm）

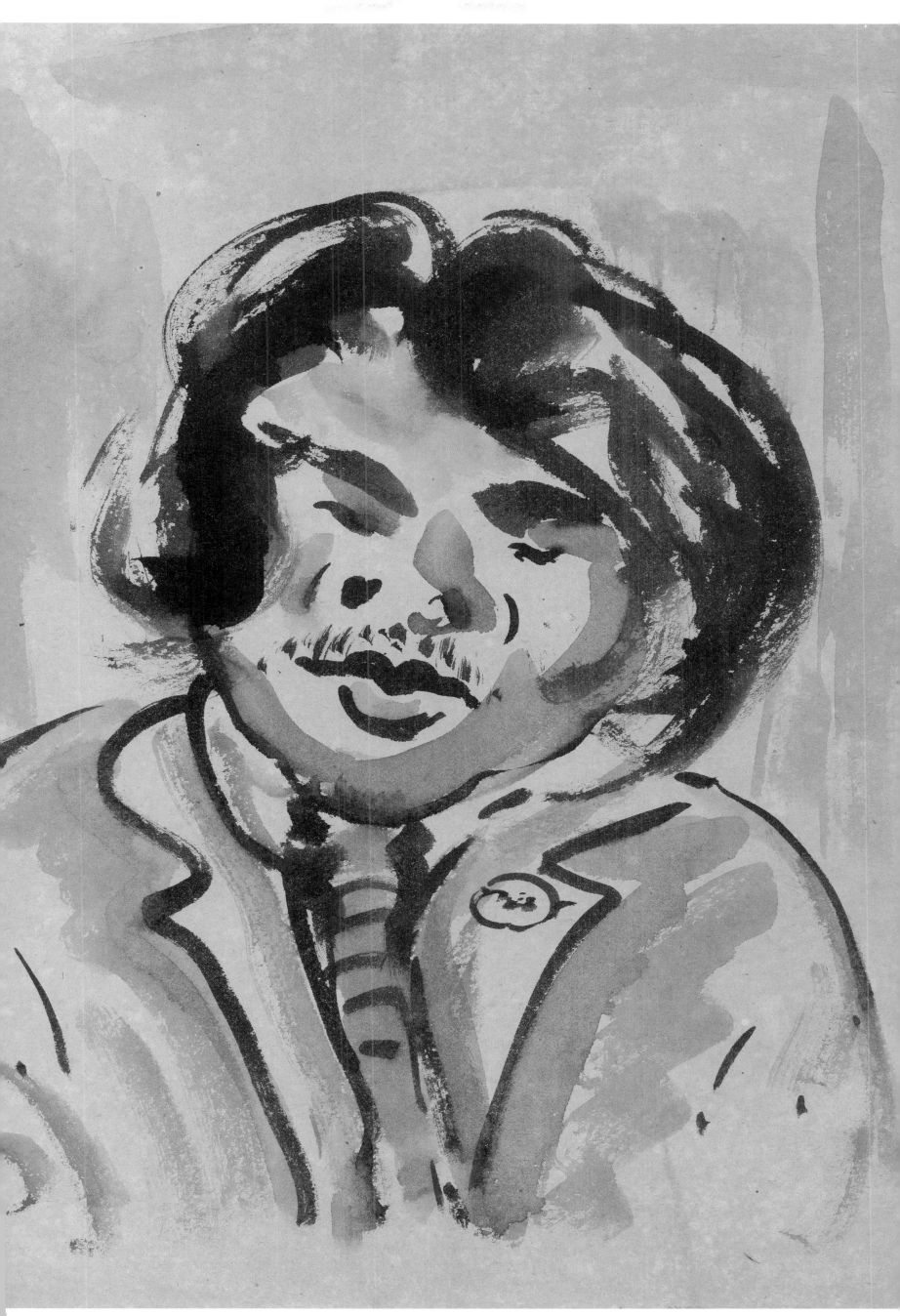

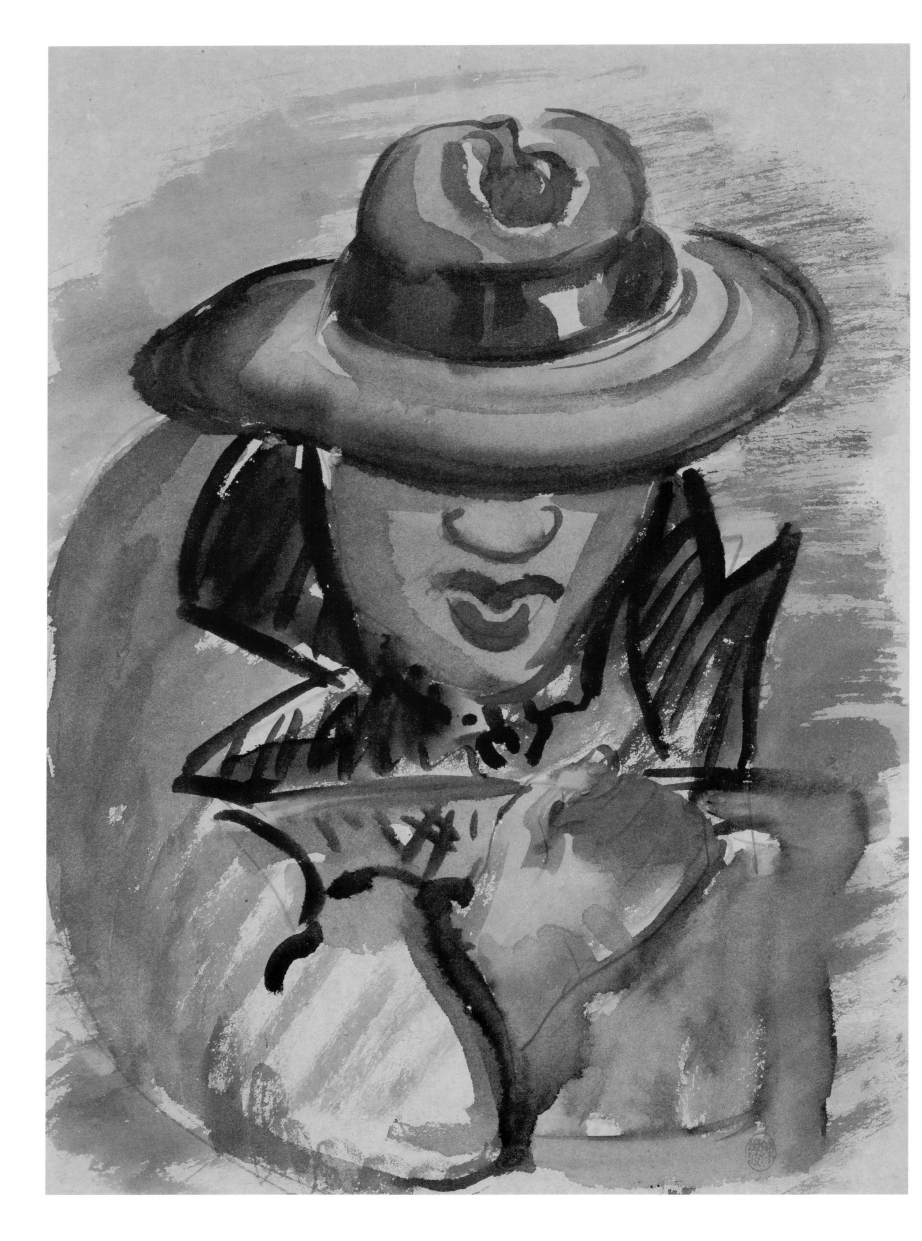

頭像（5）Portrait (5)

年代不詳　紙本淡彩鉛筆　36.5×26.5cm

432

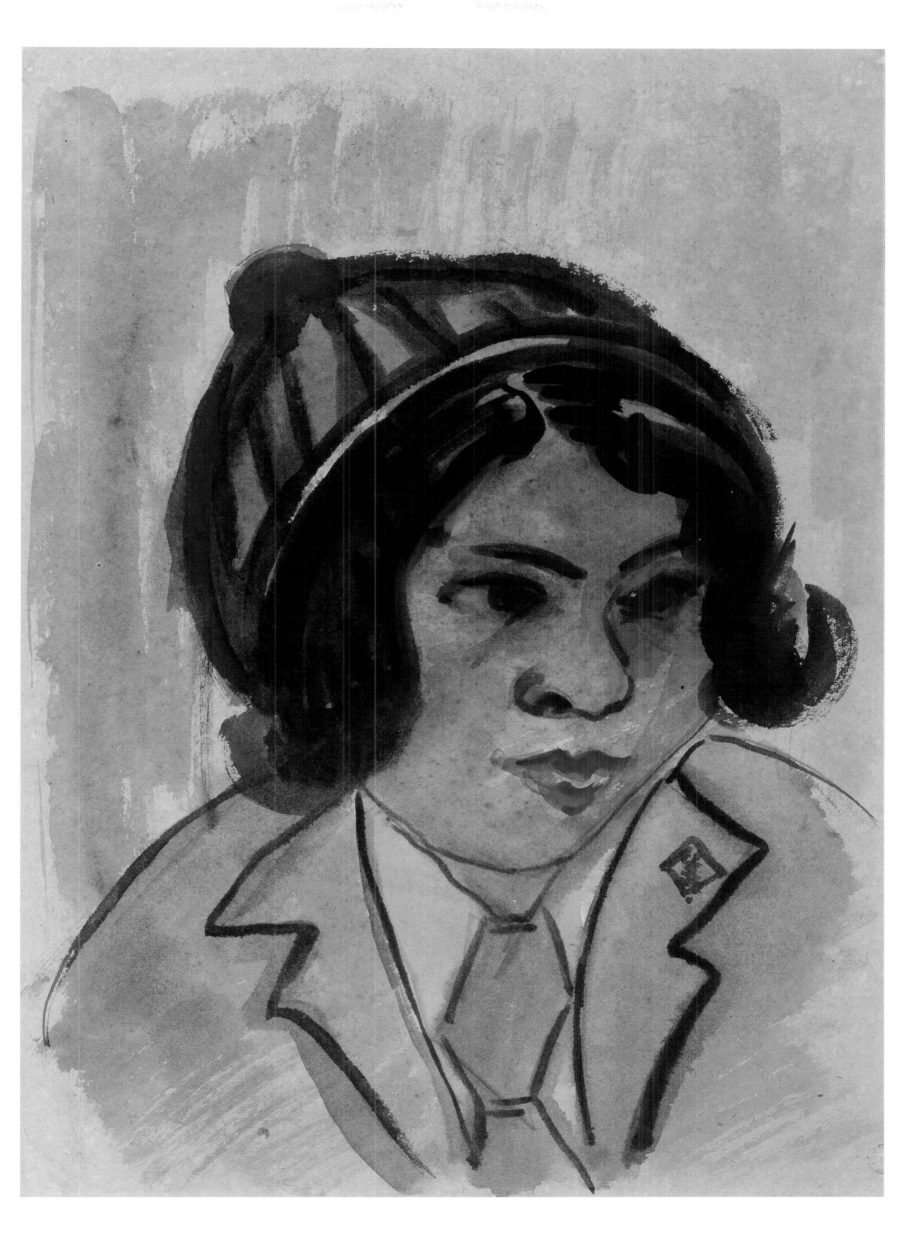

頭像（6）Portrait (6)

年代不詳　紙本淡彩鉛筆　原寸（36×26cm）

拖鞋　Slippers

5.3（年代不詳）　紙本淡彩鉛筆　26.5×36cm

[右頁圖]
掛在門板上的鍋子　Pot hanged on the door

年代不詳　紙本淡彩鉛筆　原寸（36×26.5cm）

兔子　Rabbit

年代不詳　紙本淡彩鉛筆　26.5×36cm

參考圖版
List of Illustration

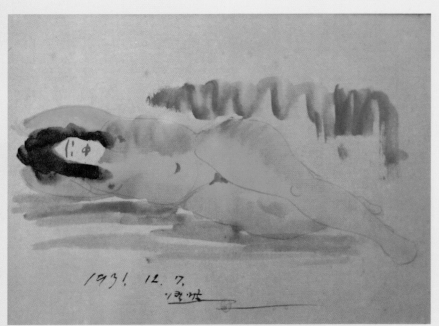

臥姿裸女-31.12.7（1）Lying Nude-31.12.7 (1) 1931 紙本淡彩鉛筆
尺寸不詳

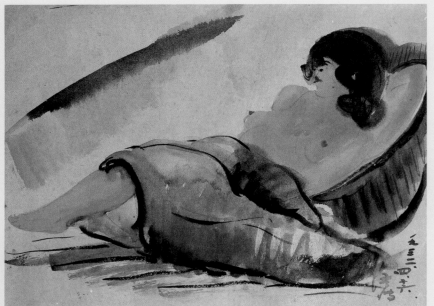

坐姿裸女-32.4.16（108）Seated Nude-32.4.16 (108) 1932 紙本淡彩鉛筆
28×37cm

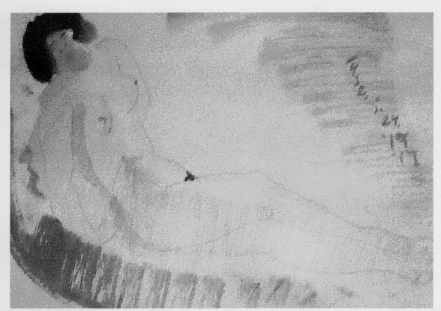

坐姿裸女-32.5.29（120）Seated Nude-32.5.29 (120) 1932 紙本淡彩鉛筆
尺寸不詳

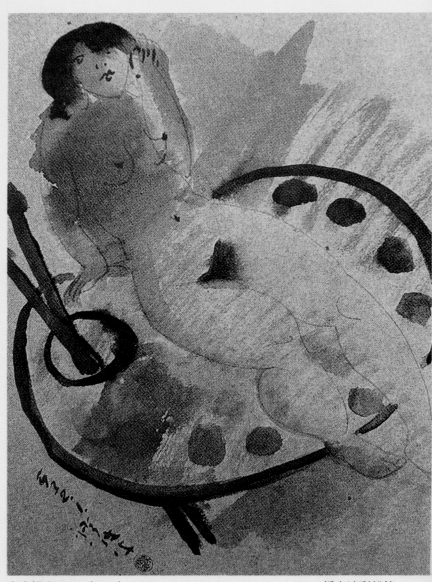

坐姿裸女-32.1（41）Seated Nude-32.1 (41) 1932 紙本淡彩鉛筆
36×27.5cm

坐姿裸女-32.1（105）Seated Nude-32.1 (105) 1932 紙本淡彩鉛筆
37.5×26.5cm

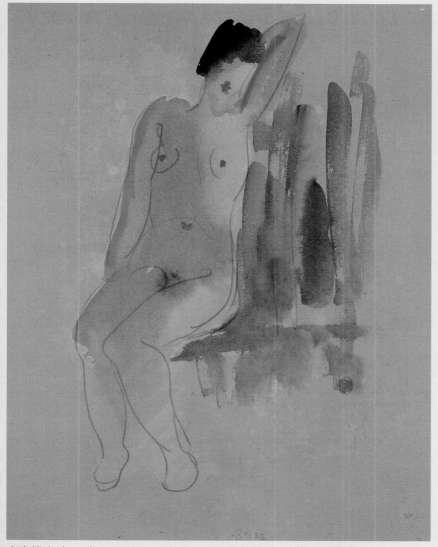

坐姿裸女（133）Seated Nude (133)　年代不詳　紙本淡彩鉛筆
36.5×28.5cm

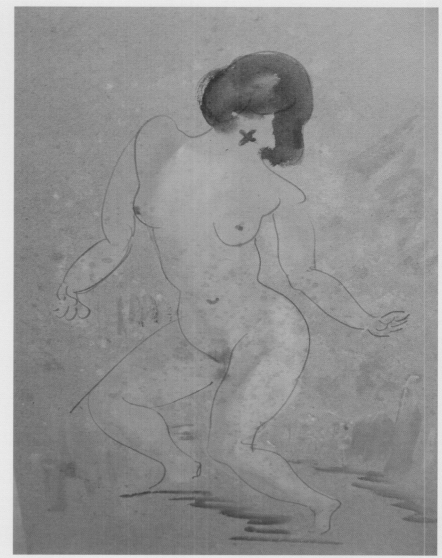

立姿裸女（70）Standing Nude (70)　年代不詳　紙本淡彩鉛筆
36.5×28.5cm

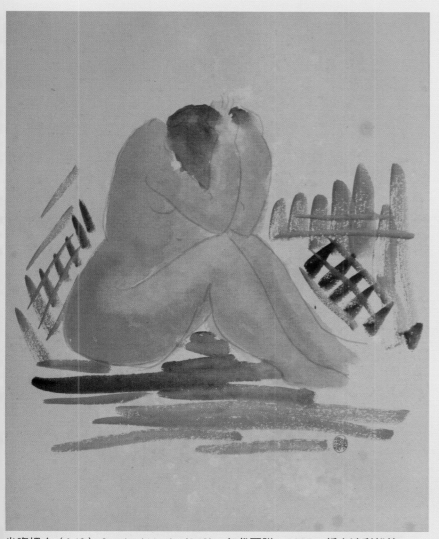

坐姿裸女（148）Seated Nude (148)　年代不詳　1932　紙本淡彩鉛筆
36×27.5cm

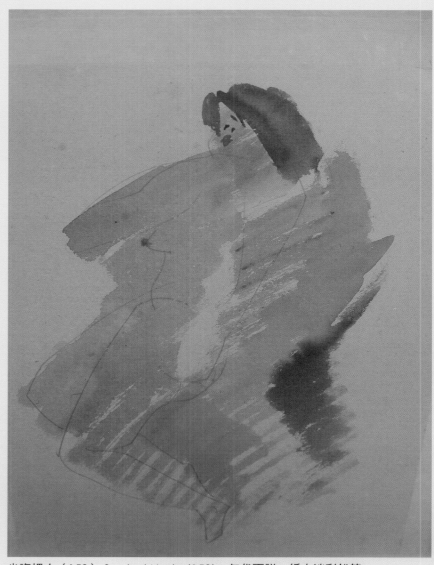

坐姿裸女（159）Seated Nude (159)　年代不詳　紙本淡彩鉛筆
36.5×28.5cm

人物（23）Figure (23)　年代不詳　紙本淡彩鉛筆　尺寸不詳

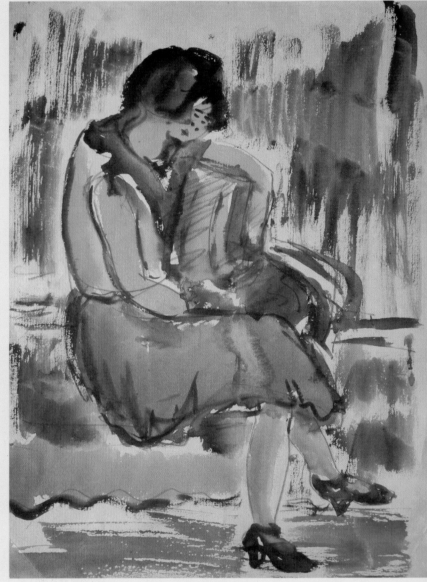

人物（26）Figure (26)　年代不詳　紙本淡彩鉛筆　30×21.5cm

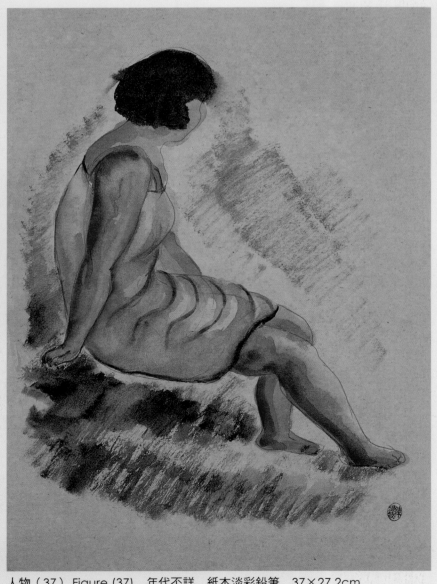

人物（37）Figure (37)　年代不詳　紙本淡彩鉛筆　37×27.2cm

圖版目錄
Catalogue

WS001　　　　　38
坐姿裸女-31.10.8（1）
Seated Nude-31.10.8 (1)

WS002　　　　　39
坐姿裸女-31.11.18（2）
Seated Nude-31.11.18 (2)

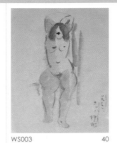

WS003　　　　　40
立姿裸女-31.11.18（1）
Standing Nude-31.11.18 (1)

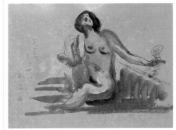

WS004　　　　　41
坐姿裸女-31.11.28（3）
Seated Nude-31.11.28 (3)

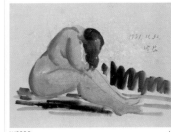

WS005　　　　　42
坐姿裸女-31.11.30（4）
Seated Nude-31.11.30 (4)

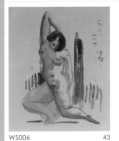

WS006　　　　　43
立姿裸女-31.11.30（2）
Standing Nude-31.11.30 (2)

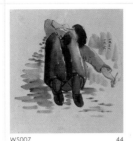

WS007　　　　　44
人物-31.12.6（1）
Figure-31.12.6 (1)

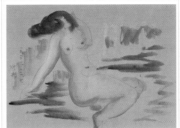

WS008　　　　　45
坐姿裸女-31.12.7（5）
Seated Nude-31.12.7 (5)

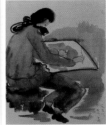

WS009　　　　　46
坐姿裸女-31.12.7（6）
Seated Nude-31.12.7 (6)

WS010　　　　　47
畫室-31.12.14（1）
Studio-31.12.14 (1)

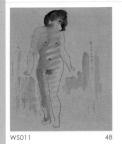

WS011　　　　　48
立姿裸女-31.12.18（3）
Standing Nude-31.12.18 (3)

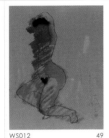

WS012　　　　　49
立姿裸女-31.12.28（4）
Standing Nude-31.12.28 (4)

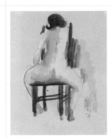

WS013　　　　　50
坐姿裸女-31.12（7）
Seated Nude-31.12(7)

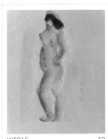

WS014　　　　　51
坐姿裸女-31.12（8）
Seated Nude-31.12(8)

WS015　　　　　52
立姿裸女-31.12（5）
Standing Nude-31.12(5)

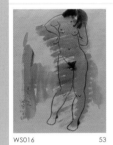

WS016　　　　　53
立姿裸女-31.12（6）
Standing Nude-31.12(6)

WS017　　　　　54
畫室-31.12（2）
Studio-31.12(2)

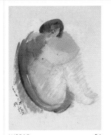

WS018　　　　　56
坐姿裸女-32.1.29（9）
Seated Nude-32.1.29 (9)

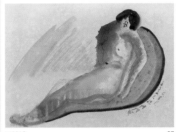

WS019　　　　　57
坐姿裸女-32.1.29（10）
Seated Nude-32.1.29 (10)

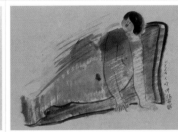

WS020　　　　　58
坐姿裸女-32.1.29（11）
Seated Nude-32.1.29 (11)

WS021　　　　　59
坐姿裸女-32.1.29（12）
Seated Nude-32.1.29

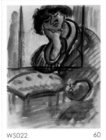

WS022　　　　　60
畫室-32.1.29（3）
Studio-31.1.29 (3)

WS023　　　　　61
坐姿裸女-32.1（13）
Seated Nude-32.1 (13)

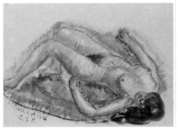

WS024　　　　　62
臥姿裸女-32.1（2）
Lying Nude-32.1 (2)

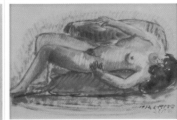

WS025　　　　　63
臥姿裸女-32.1（3）
Lying Nude-32.1 (3)

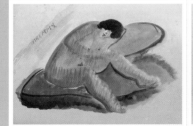

WS026　　　　　64
坐姿裸女-32.1（14）
Seated Nude-32.1 (14)

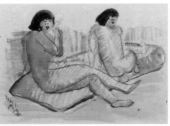

WS027　　　　　65
坐姿裸女-32.1（15）
Seated Nude-32.1 (15)

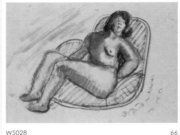

WS028　　　　　66
坐姿裸女-32.1（16）
Seated Nude-32.1 (16)

WS029　　　　　67
坐姿裸女-32.1（17）
Seated Nude-32.1 (17)

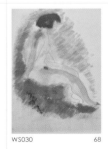

WS030　　　　　68
坐姿裸女-32.1（18）
Seated Nude-32.1 (18)

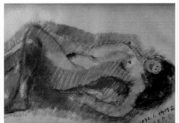

WS031　　　　　69
臥姿裸女-32.1（4）
Lying Nude-32.1 (4)

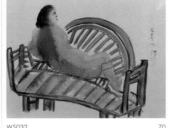

WS032　　　　　70
臥姿裸女-32.1（5）
Lying Nude-32.1 (5)

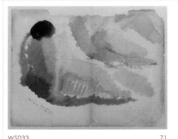

WS033　　　　　71
臥姿裸女-32.1（6）
Lying Nude-32.1 (6)

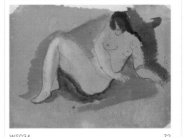

WS034　　　　　72
坐姿裸女-32.1（19）
Seated Nude-32.1 (19)

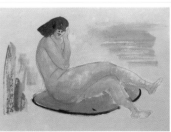

WS035　　　　　73
坐姿裸女-32.1（20）
Seated Nude-32.1 (20)

442

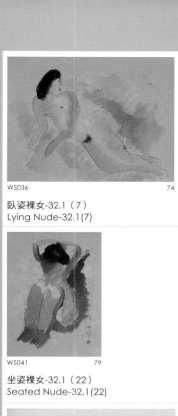
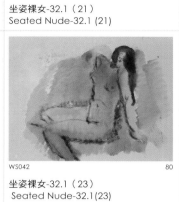
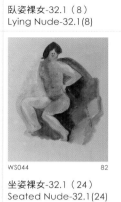
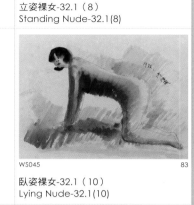

WS036　　74
臥姿裸女-32.1（7）
Lying Nude-32.1(7)

WS037　　75
坐姿裸女-32.1（21）
Seated Nude-32.1 (21)

WS038　　76
立姿裸女-32.1（7）
Standing Nude-32.1(7)

WS039　　77
臥姿裸女-32.1（8）
Lying Nude-32.1(8)

WS040　　78
立姿裸女-32.1（8）
Standing Nude-32.1(8)

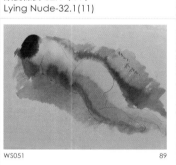
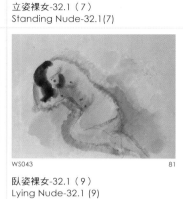
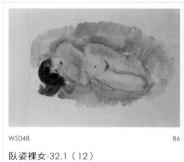
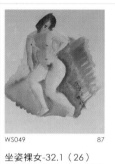
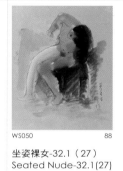

WS041　　79
坐姿裸女-32.1（22）
Seated Nude-32.1(22)

WS042　　80
坐姿裸女-32.1（23）
Seated Nude-32.1(23)

WS043　　81
臥姿裸女-32.1（9）
Lying Nude-32.1 (9)

WS044　　82
坐姿裸女-32.1（24）
Seated Nude-32.1(24)

WS045　　83
臥姿裸女-32.1（10）
Lying Nude-32.1(10)

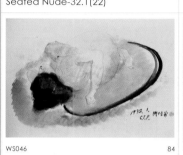
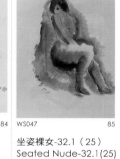
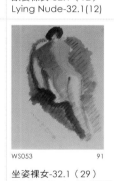
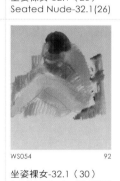
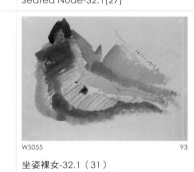

WS046　　84
臥姿裸女-32.1（11）
Lying Nude-32.1(11)

WS047　　85
坐姿裸女-32.1（25）
Seated Nude-32.1(25)

WS048　　86
臥姿裸女-32.1（12）
Lying Nude-32.1(12)

WS049　　87
坐姿裸女-32.1（26）
Seated Nude-32.1(26)

WS050　　88
坐姿裸女-32.1（27）
Seated Nude-32.1(27)

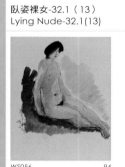
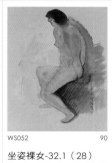
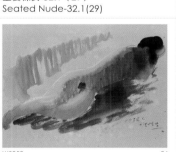
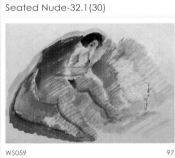

WS051　　89
臥姿裸女-32.1（13）
Lying Nude-32.1(13)

WS052　　90
坐姿裸女-32.1（28）
Seated Nude-32.1(28)

WS053　　91
坐姿裸女-32.1（29）
Seated Nude-32.1(29)

WS054　　92
坐姿裸女-32.1（30）
Seated Nude-32.1(30)

WS055　　93
坐姿裸女-32.1（31）
Seated Nude-32.1(31)

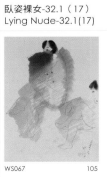
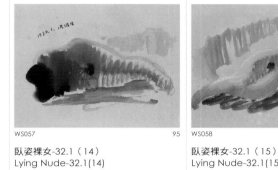

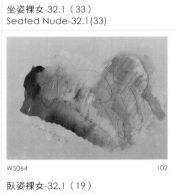
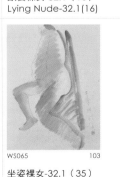

WS056　　94
坐姿裸女-32.1（32）（圖版提供：佳士得）
Seated Nude-32.1(32)

WS057　　95
臥姿裸女-32.1（14）
Lying Nude-32.1(14)

WS058　　96
臥姿裸女-32.1（15）
Lying Nude-32.1(15)

WS059　　97
坐姿裸女-32.1（33）
Seated Nude-32.1(33)

WS060　　98
臥姿裸女-32.1（16）
Lying Nude-32.1(16)

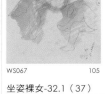
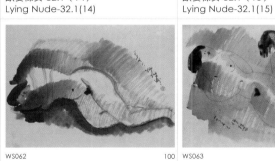

WS061　　99
坐姿裸女-32.1（34）
Seated Nude-32.1(34)

WS062　　100
臥姿裸女-32.1（17）
Lying Nude-32.1(17)

WS063　　101
臥姿裸女-32.1（18）
Lying Nude-32.1(18)

WS064　　102
臥姿裸女-32.1（19）
Lying Nude-32.1(19)

WS065　　103
坐姿裸女-32.1（35）
Seated Nude-32.1(35)

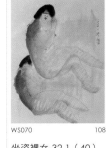

WS066　　104
坐姿裸女-32.1（36）
Seated Nude-32.1(36)

WS067　　105
坐姿裸女-32.1（37）
Seated Nude-32.1(37)

WS068　　106
坐姿裸女-32.1（38）
Seated Nude-32.1(38)

WS069　　107
坐姿裸女-32.1（39）
Seated Nude-32.1(39)

WS070　　108
坐姿裸女-32.1（40）
Seated Nude-32.1(40)

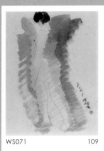
WS071 109
立姿裸女-32.1（9）
Standing Nude-32.1(9)

WS072 110
臥姿裸女-32.1（20）
Lying Nude-32.1(20)

WS073 111
臥姿裸女-32.1（21）
Lying Nude-32.1(21)

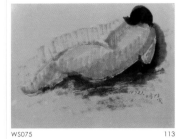
WS074 112
立姿裸女-32.1（10）
Standing Nude-32.1(10)

WS075 113
臥姿裸女-32.1（22）
Lying Nude-32.1(22)

WS076 114
坐姿裸女-32.1（42）
Seated Nude-32.1(42)

WS077 115
臥姿裸女-32.1（23）
Lying Nude-32.1(23)

WS078 116
臥姿裸女-32.1（24）
Lying Nude-32.1(24)

WS079 117
立姿裸女-32.1（11）
Standing Nude-32.1(11)

WS080 118
立姿裸女-32.1（12）
Standing Nude-32.1(12)

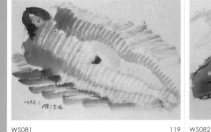
WS081 119
臥姿裸女-32.1（25）
Lying Nude-32.1(25)

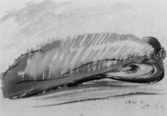
WS082 120
臥姿裸女-32.1（26）
Lying Nude-32.1(26)

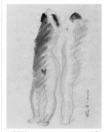
WS083 121
立姿裸女-32.1（13）
Standing Nude-32.1(13)

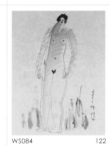
WS084 122
立姿裸女-32.1（14）
Standing Nude-32.1(14)

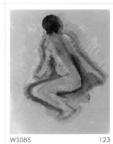
WS085 123
坐姿裸女-32.1（43）
Seated Nude-32.1(43)

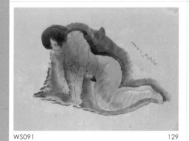
WS086 124
立姿裸女-32.1（15）
Standing Nude-32.1(15)

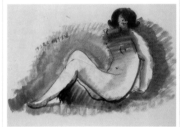
WS087 125
坐姿裸女-32.1（44）
Seated Nude-32.1(44)

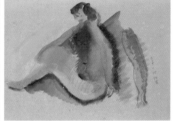
WS088 126
坐姿裸女-32.1（45）
Seated Nude-32.1(45)

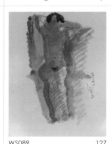
WS089 127
坐姿裸女-32.1（46）
Seated Nude-32.1(46)

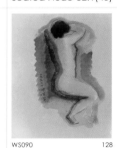
WS090 128
坐姿裸女-32.1（47）
Seated Nude-32.1(47)

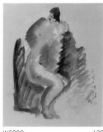
WS091 129
臥姿裸女-32.1（27）
Lying Nude-32.1(27)

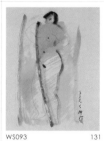
WS092 130
坐姿裸女-32.1（48）
Seated Nude-32.1(48)

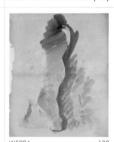
WS093 131
立姿裸女-32.1（16）
Standing Nude-32.1(16)

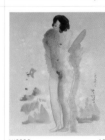
WS094 132
立姿裸女-32.1（17）
Standing Nude-32.1(17)

WS095 133
立姿裸女-32.1（18）
Standing Nude-32.1(18)

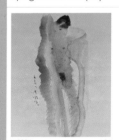
WS096 134
立姿裸女-32.1（19）
Standing Nude-32.1(19)

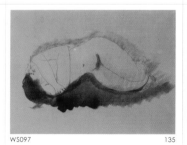
WS097 135
臥姿裸女-32.1（28）
Lying Nude-32.1(28)

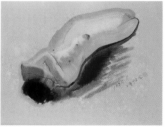
WS098 136
臥姿裸女-32.1（29）
Lying Nude-32.1(29)

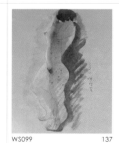
WS099 137
立姿裸女-32.1（20）
Standing Nude-32.1(20)

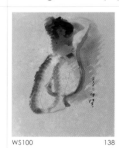
WS100 138
坐姿裸女-32.1（49）
Seated Nude-32.1(49)

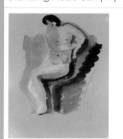
WS101 139
坐姿裸女-32.1（50）
Seated Nude-32.1(50)

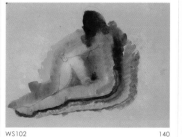
WS102 140
坐姿裸女-32.1（51）
Seated Nude-32.1(51)

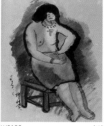
WS103 141
坐姿裸女-32.1（52）
Seated Nude-32.1(52)

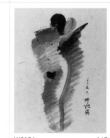
WS104 142
立姿裸女-32.1（21）
Standing Nude-32.1(21)

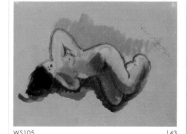
WS105 143
臥姿裸女-32.1（30）
Lying Nude-32.1(30)

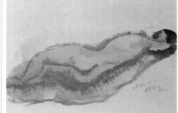

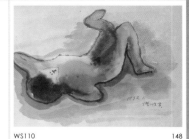

WS106　144
坐姿裸女-32.1（53）
Seated Nude-32.1(53)

WS107　145
臥姿裸女-32.1（31）
Lying Nude-32.1(31)

WS108　146
臥姿裸女-32.1（32）
Lying Nude-32.1(32)

WS109　147
坐姿裸女-32.1（54）
Seated Nude-32.1 (54)

WS110　148
臥姿裸女-32.1（33）
Lying Nude-32.1(33)

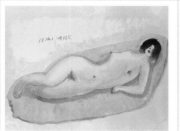

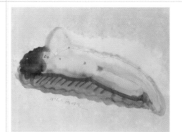
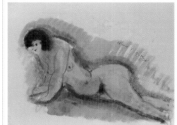
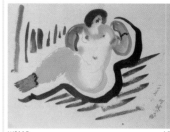

WS111　149
臥姿裸女-32.1（34）
Lying Nude-32.1(34)

WS112　150
立姿裸女-32.1（22）
Standing Nude-32.1(22)

WS113　151
臥姿裸女-32.1（35）
Lying Nude-32.1(35)

WS114　152
臥姿裸女-32.1（36）
Lying Nude-32.1(36)

WS115　153
坐姿裸女-32.1（55）
Seated Nude-32.1(55)

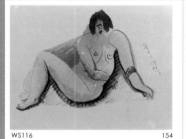
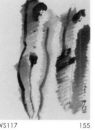
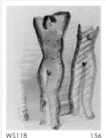
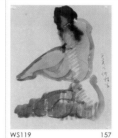
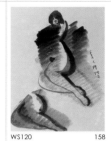

WS116　154
坐姿裸女-32.1（56）
Seated Nude-32.1(56)

WS117　155
立姿裸女-32.1（23）
Standing Nude-32.1(23)

WS118　156
立姿裸女-32.1（24）
Standing Nude-32.1(24)

WS119　157
坐姿裸女-32.1（57）
Seated Nude-32.1(57)

WS120　158
坐姿裸女-32.1（58）
Seated Nude-32.1(58)

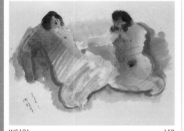
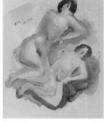

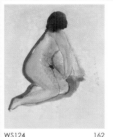
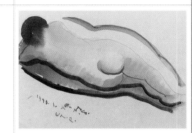

WS121　159
坐姿裸女-32.1（59）
Seated Nude-32.1(59)

WS122　160
臥姿裸女-32.1（37）
Lying Nude-32.1(37)

WS123　161
立姿裸女-32.1（25）
Standing Nude-32.1(25)

WS124　162
坐姿裸女-32.1（60）
Seated Nude-32.1(60)

WS125　163
臥姿裸女-32.1（38）
Lying Nude-32.1(38)

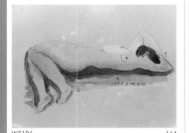
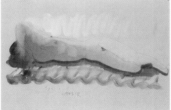
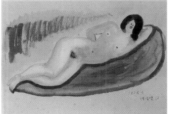
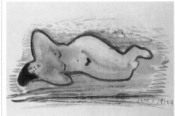
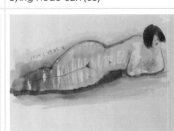

WS126　164
臥姿裸女-32.1（39）
Lying Nude-32.1(39)

WS127　165
臥姿裸女-32.1（40）
Lying Nude-32.1(40)

WS128　166
臥姿裸女-32.1（41）
Lying Nude-32.1(41)

WS129　167
臥姿裸女-32.1（42）
Lying Nude-32.1(42)

WS130　168
臥姿裸女-32.1（43）
Lying Nude-32.1(43)

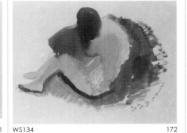

WS131　169
臥姿裸女-32.1（44）
Lying Nude-32.1(44)

WS132　170
臥姿裸女-32.1（45）
Lying Nude-32.1(45)

WS133　171
坐姿裸女-32.1（61）
Seated Nude-32.1(61)

WS134　172
坐姿裸女-32.1（62）
Seated Nude-32.1(62)

WS135　173
臥姿裸女-32.1（46）
Lying Nude-32.1(46)

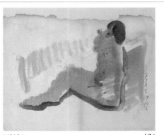
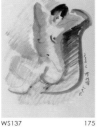
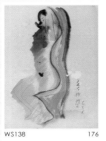
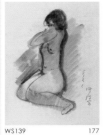
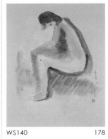

WS136　174
坐姿裸女-32.1（63）
Seated Nude-32.1(63)

WS137　175
坐姿裸女-32.1（64）
Seated Nude-32.1(64)

WS138　176
坐姿裸女-32.1（65）
Seated Nude-32.1(65)

WS139　177
坐姿裸女-32.1（66）
Seated Nude-32.1(66)

WS140　178
坐姿裸女-32.1（67）
Seated Nude-32.1(67)

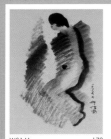 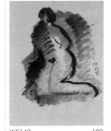 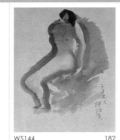 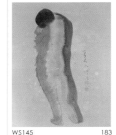

WS141 179	WS142 180	WS143 181	WS144 182	WS145 183
坐姿裸女-32.1（68） Seated Nude-32.1(68)	坐姿裸女-32.1（69） Seated Nude-32.1(69)	坐姿裸女-32.1（70） Seated Nude-32.1(70)	坐姿裸女-32.1（71） Seated Nude-32.1(71)	立姿裸女-32.1（26） Standing Nude-32.1(26)

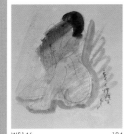 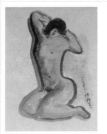 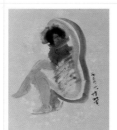

WS146 184	WS147 185	WS148 186	WS149 187	WS150 188
坐姿裸女-32.1（72） Seated Nude-32.1(72)	坐姿裸女-32.1（73） Seated Nude-32.1(73)	坐姿裸女-32.1（74） Seated Nude-32.1(74)	坐姿裸女-32.1（75） Seated Nude-32.1(75)	臥姿裸女-32.1（47） Lying Nude-32.1(47)

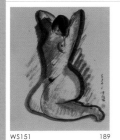 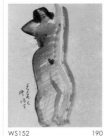 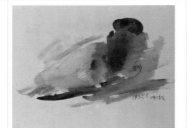 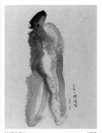 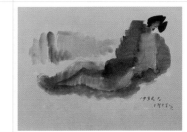

WS151 189	WS152 190	WS153 191	WS154 192	WS155 193
坐姿裸女-32.1（76） Seated Nude-32.1(76)	立姿裸女-32.1（27） Standing Nude-32.1(27)	臥姿裸女-32.1（48） Lying Nude-32.1(48)	立姿裸女-32.1（28） Standing Nude-32.1(28)	坐姿裸女-32.1（77） Seated Nude-32.1(77)

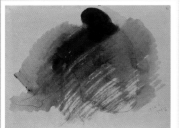 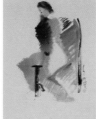 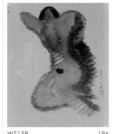 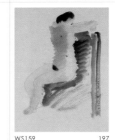 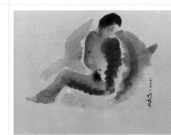

WS156 194	WS157 195	WS158 196	WS159 197	WS160 198
坐姿裸女-32.1（78） Seated Nude-32.1(78)	坐姿裸女-32.1（79） Seated Nude-32.1(79)	臥姿裸女-32.1（49） Lying Nude-32.1(49)	坐姿裸女-32.1（80） Seated Nude-32.1(80)	坐姿裸女-32.1（81） Seated Nude-32.1(81)

 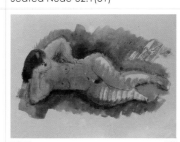

WS161 199	WS162 200	WS163 201	WS164 202	WS165 203
立姿裸女-32.1（29） Standing Nude-32.1(29)	坐姿裸女-32.1（82） Seated Nude-32.1(82)	立姿裸女-32.1（30） Standing Nude-32.1(30)	立姿裸女-32.1（31） Standing Nude-32.1(31)	臥姿裸女-32.1（50） Lying Nude-32.1(50)

 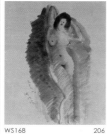

WS166 204	WS167 205	WS168 206	WS169 207	WS170 208
立姿裸女-32.1（32） Standing Nude-32.1(32)	立姿裸女-32.1（33） Standing Nude-32.1(33)	立姿裸女-32.1（34） Standing Nude-32.1(34)	立姿裸女-32.1（35） Standing Nude-32.1(35)	坐姿裸女-32.1（83） Seated Nude-32.1(83)

 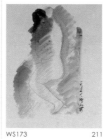 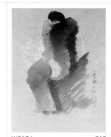

WS171 209	WS172 210	WS173 211	WS174 212	WS175 213
坐姿裸女-32.1（84） Seated Nude-32.1(84)	臥姿裸女-32.1（51） Lying Nude-32.1(51)	坐姿裸女-32.1（85） Seated Nude-32.1(85)	坐姿裸女-32.1（86） Seated Nude-32.1(86)	坐姿裸女-32.1（87） Seated Nude-32.1(87)

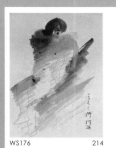 WS176 214
坐姿裸女-32.1（88）
Seated Nude-32.1(88)

 WS177 215
坐姿裸女-32.1（89）
Seated Nude-32.1(89)

 WS178 216
坐姿裸女-32.1（90）
Seated Nude-32.1(90)

 WS179 217
坐姿裸女-32.1（91）
Seated Nude-32.1(91)

 WS180 218
臥姿裸女-32.1（52）
Lying Nude-32.1(52)

 WS181 219
臥姿裸女-32.1（53）
Lying Nude-32.1(53)

 WS182 220
坐姿裸女-32.1（92）
Seated Nude-32.1(92)

 WS183 221
坐姿裸女-32.1（93）
Seated Nude-32.1(93)

 WS184 222
立姿裸女-32.1（36）
Standing Nude-32.1(36)

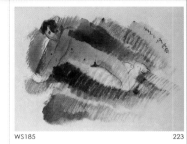 WS185 223
臥姿裸女-32.1（54）
Lying Nude-32.1(54)

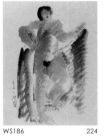 WS186 224
立姿裸女-32.1（37）
Standing Nude-32.1(37)

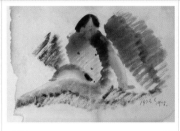 WS187 225
坐姿裸女-32.1（94）
Seated Nude-32.1(94)

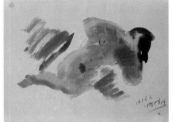 WS188 226
臥姿裸女-32.1（55）
Lying Nude-32.1(55)

 WS189 227
立姿裸女-32.1（38）
Standing Nude-32.1(38)

 WS190 228
立姿裸女-32.1（39）
Standing Nude-32.1(39)

 WS191 229
臥姿裸女-32.1（56）
Lying Nude-32.1(56)

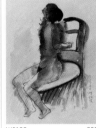 WS192 230
坐姿裸女-32.1（95）
Seated Nude-32.1 (95)

 WS193 231
坐姿裸女-32.1（96）
Seated Nude-32.1 (96)

 WS194 232
坐姿裸女-32.1（97）
Seated Nude-32.1 (97)

 WS195 233
坐姿裸女-32.1（98）
Seated Nude-32.1 (98)

 WS196 234
坐姿裸女-32.1（99）
Seated Nude-32.1(99)

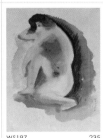 WS197 235
坐姿裸女-32.1（100）
Seated Nude-32.1(100)

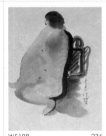 WS198 236
坐姿裸女-32.1（101）
Seated Nude-32.1(101)

 WS199 237
坐姿裸女-32.1（102）
Seated Nude-32.1(102)

 WS200 238
立姿裸女-32.1（40）
Standing Nude-32.1(40)

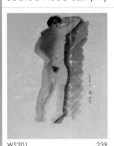 WS201 239
立姿裸女-32.1（41）
Standing Nude-32.1(41)

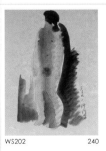 WS202 240
立姿裸女-32.1（42）
Standing Nude-32.1(42)

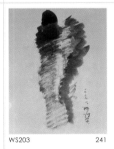 WS203 241
立姿裸女-32.1（43）
Standing Nude-32.1(43)

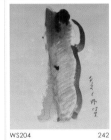 WS204 242
立姿裸女-32.1（44）
Standing Nude-32.1(44)

 WS205 243
立姿裸女-32.1（45）
Standing Nude-32.1(45)

 WS206 244
立姿裸女-32.1（46）
Standing Nude-32.1(46)

 WS207 245
立姿裸女-32.1（47）
Standing Nude-32.1(47)

 WS208 246
立姿裸女-32.1（48）
Standing Nude-32.1(48)

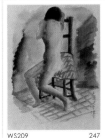 WS209 247
坐姿裸女-32.1（103）
Seated Nude-32.1(103)

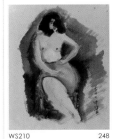 WS210 248
坐姿裸女-32.1（104）
Seated Nude-32.1(104)

 WS211 249
畫室-32.1（4）
Studio-32.1(4)

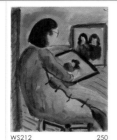 WS212 250
畫室-32.1（5）
Studio-32.1(5)

 WS213 251
畫室-32.1（6）
Studio-32.1(6)

 WS214 252
人物-32.1（2）
Figure-32.1(2)

 WS215 253
人物-32.1（3）
Figure-32.1(3)

 WS216 254
人物-32.1（4）
Figure-32.1(4)

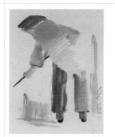 WS217 255
人物-32.1（5）
Figure-32.1(5)

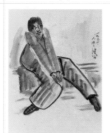 WS218 256
人物-32.1（6）
Figure-32.1(6)

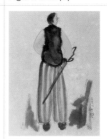 WS219 257
人物-32.1（7）
Figure-32.1(7)

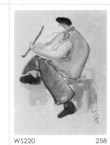 WS220 258
人物-32.1（8）
Figure-32.1(8)

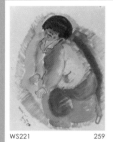 WS221 259
人物-32.1（9）
Figure-32.1(9)

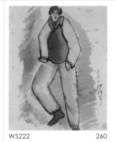 WS222 260
人物-32.1（10）
Figure-32.1(10)

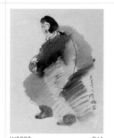 WS223 261
人物-32.1（11）
Figure-32.1(11)

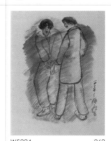 WS224 262
群像-32.1（1）
Group Portrait-32.1(1)

 WS225 263
群像-32.1（2）
Group Portrait-32.1(2)

 WS226 264
群像-32.1（3）
Group Portrait-32.1(3)

 WS227 265
貓-32.1
Cat-32.1

 WS228 266
畫室-32.3.22（7）
Studio-32.3.22(7)

 WS229 267
立姿裸女-32.2.14（49）
Standing Nude-32.2.14(49)

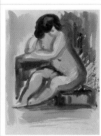 WS230 268
坐姿裸女-32.3.28（106）
Seated Nude-32.3.28(106)

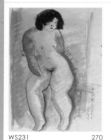 WS231 270
立姿裸女-32.4.1（50）
Standing Nude-32.4.1(50)

 WS232 271
頭像-32.4.1（1）
Portrait-32.4.1(1)

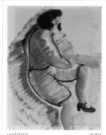 WS233 272
人物-32.4.9（12）
Figure-32.4.9(12)

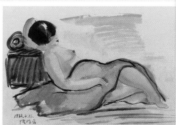 WS234 273
坐姿裸女-32.4.16（107）
Seated Nude-32.4.16(107)

 WS235 274
人物-32.4.22（13）
Figure-32.4.22(13)

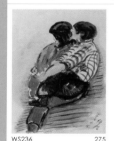 WS236 275
群像-32.4.16（4）
Group Portrait-32.4.16(4)

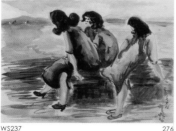 WS237 276
群像-32.4.16（5）
Group Portrait-32.4.16(5)

 WS238 277
花-32.4
Flower-32.4

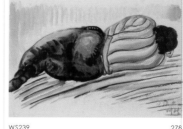 WS239 278
人物-32.4（14）
Figure-32.4(14)

 WS240 279
街景-32.4
Street-32.4

 WS241 280
人物-32.5.3（15）
Figure-32.5.3(15)

 WS242 281
人物-32.5.3（16）
Figure-32.5.3(16)

 WS243 282
立姿裸女-32.5.7（51）
Standing Nude-32.5.7(51)

 WS244 283
立姿裸女-32.5.7（52）
Standing Nude-32.5.7(52)

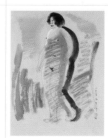 WS245 284
立姿裸女-32.5.7（53）
Standing Nude-32.5.7(53)

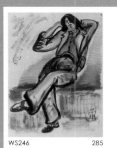

WS246 285

人物-32.5.7（17）
Figure-32.5.7(17)

WS247 286

群像-32.5.7（6）
Group Portrait-32.5.7(6)

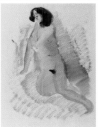

WS248 287

坐姿裸女-32.5.22（109）
Seated Nude-32.5.22(109)

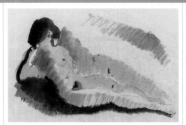

WS249 288

坐姿裸女-32.5.22（110）
Seated Nude-32.5.22(110)

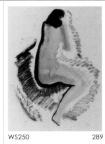

WS250 289

坐姿裸女-32.5.22（111）
Seated Nude-32.5.22(111)

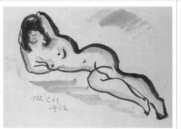

WS251 290

臥姿裸女-32.5.23（57）
Lying Nude-32.5.23(57)

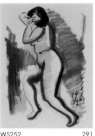

WS252 291

立姿裸女-32.5.23（54）
Standing Nude-32.5.23(54)

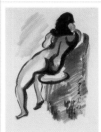

WS253 292

坐姿裸女-32.5.23（112）
Seated Nude-32.5.23 (112)

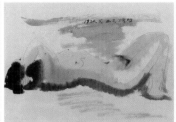

WS254 293

臥姿裸女-32.5.23（58）
Lying Nude-32.5.23(58)

WS255 294

臥姿裸女-32.5.23（59）
Lying Nude-32.5.23(59)

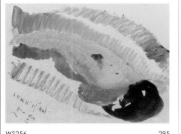

WS256 295

臥姿裸女-32.5.23（60）
Lying Nude-32.5.23(60)

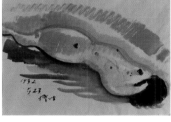

WS257 296

臥姿裸女-32.5.23（61）
Lying Nude-32.5.23(61)

WS258 297

人物-32.5.26（18）
Figure-32.5.26(18)

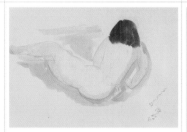

WS259 298

臥姿裸女-32.5.29（62）
Lying Nude-32.5.29(62)

WS260 299

坐姿裸女-32.5.29（113）
Seated Nude-32.5.29(113)

WS261 300

立姿裸女-32.5.29（55）
Standing Nude-32.5.29(55)

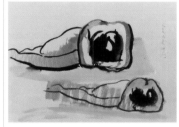

WS262 301

臥姿裸女-32.5.29（63）
Lying Nude-32.5.29(63)

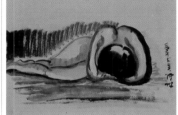

WS263 302

臥姿裸女-32.5.29（64）
Lying Nude-32.5.29(64)

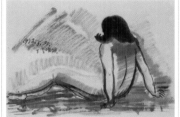

WS264 303

坐姿裸女-32.5.29（114）
Seated Nude-32.5.29(114)

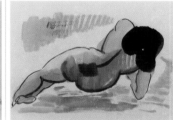

WS265 304

臥姿裸女-32.5.29（65）
Lying Nude-32.5.29(65)

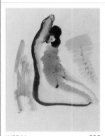

WS266 305

坐姿裸女-32.5.29（115）
Seated Nude-32.5.29(115)

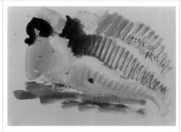

WS267 306

臥姿裸女-32.5.29（66）
Lying Nude-32.5.29(66)

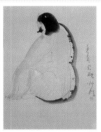

WS268 307

坐姿裸女-32.5.29（116）
Seated Nude-32.5.29(116)

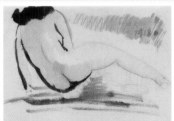

WS269 308

坐姿裸女-32.5.29（117）
Seated Nude-32.5.29(117)

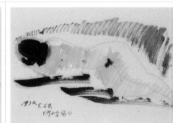

WS270 309

臥姿裸女-32.5.29（67）
Lying Nude-32.5.29(67)

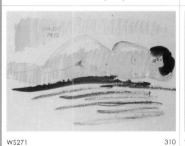

WS271 310

臥姿裸女-32.5.29（68）
Lying Nude-32.5.29(68)

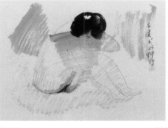

WS272 311

坐姿裸女-32.5.29（118）
Seated Nude-32.5.29(118)

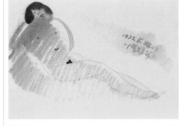

WS273 312

坐姿裸女-32.5.29（119）
Seated Nude-32.5.29(119)

WS274 313

人物-32.5.29（19）
Figure-32.5.29(19)

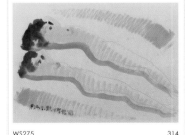

WS275 314

臥姿裸女-32.5.29（69）
Lying Nude-32.5.29(69)

WS276 315

臥姿裸女-32.5.29（70）
Lying Nude-32.5.29(70)

WS277 316

頭像-32.7（2）
Portrait-32.7(2)

WS278 317

坐姿裸女-32（121）
Seated Nude-32(121)

WS279 318

城隍祭典餘興-33.9.22
City God Festival Entertainment-33.9.22

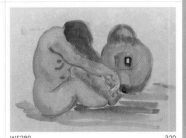

WS280 320

坐姿裸女（122）
Seated Nude(122)

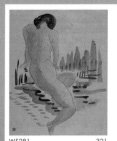
WS281 321
坐姿裸女（123）
Seated Nude(123)

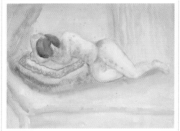
WS282 322
坐姿裸女（124）
Seated Nude(124)

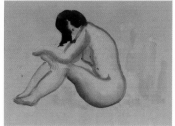
WS283 323
坐姿裸女（125）
Seated Nude(125)

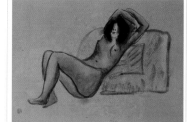
WS284 324
坐姿裸女（126）
Seated Nude(126)

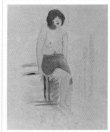
WS285 325
坐姿裸女（127）
Seated Nude(127)

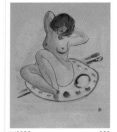
WS286 326
坐姿裸女（128）
Seated Nude(128)

WS287 327
臥姿裸女（71）
Lying Nude(71)

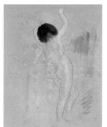
WS288 328
立姿裸女（56）
Standing Nude(56)

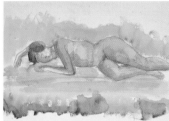
WS289 329
臥姿裸女（72）
Lying Nude(72)

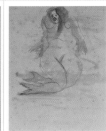
WS290 330
坐姿裸女（129）
Seated Nude(129)

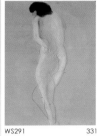
WS291 331
立姿裸女（57）
Standing Nude(57)

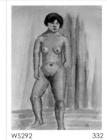
WS292 332
立姿裸女（58）
Standing Nude(58)

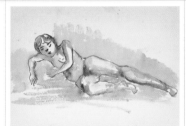
WS293 333
臥姿裸女（73）
Lying Nude(73)

WS294 334
臥姿裸女（74）
Lying Nude(74)

WS295 335
立姿裸女（59）
Standing Nude(59)

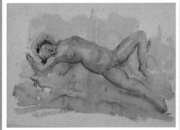
WS296 336
臥姿裸女（75）
Lying Nude(75)

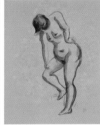
WS297 337
立姿裸女（60）
Standing Nude(60)

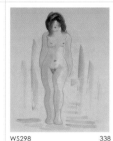
WS298 338
立姿裸女（61）
Standing Nude(61)

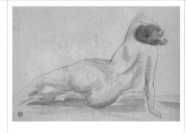
WS299 339
坐姿裸女（130）
Seated Nude(130)

WS300 340
坐姿裸女（131）
Seated Nude(131)

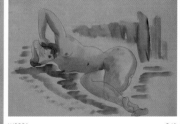
WS301 341
臥姿裸女（76）
Lying Nude(76)

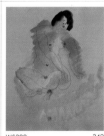
WS302 342
坐姿裸女（132）
Seated Nude(132)

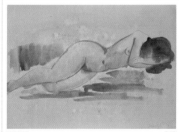
WS303 343
臥姿裸女（77）
Lying Nude(77)

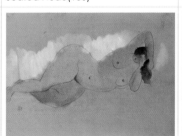
WS304 344
臥姿裸女（78）
Lying Nude(78)

WS305 345
立姿裸女（62）
Standing Nude(62)

WS306 346
立姿裸女（63）
Standing Nude(63)

WS307 347
坐姿裸女（134）
Seated Nude(134)

WS308 348
坐姿裸女（135）
Seated Nude(135)

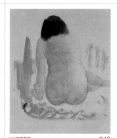
WS309 349
坐姿裸女（136）
Seated Nude(136)

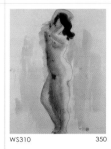
WS310 350
立姿裸女（64）
Standing Nude(64)

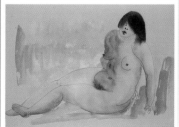
WS311 351
坐姿裸女（137）
Seated Nude(137)

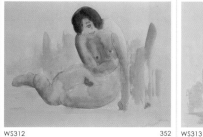
WS312 352
坐姿裸女（138）
Seated Nude(138)

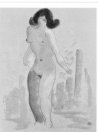
WS313 353
立姿裸女（65）
Standing Nude(65)

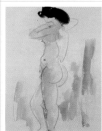
WS314 354
立姿裸女（66）
Standing Nude(66)

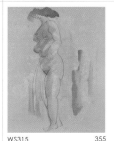
WS315 355
立姿裸女（67）
Standing Nude(67)

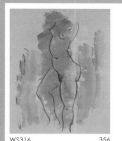

WS316 356

立姿裸女（68）
Standing Nude(68)

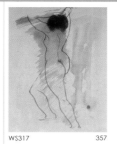

WS317 357

立姿裸女（69）
Standing Nude(69)

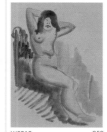

WS318 358

坐姿裸女（139）
Seated Nude(139)

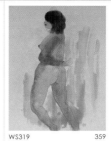

WS319 359

立姿裸女（71）
Standing Nude(71)

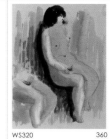

WS320 360

坐姿裸女（140）
Seated Nude(140)

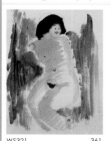

WS321 361

坐姿裸女（141）
Seated Nude(141)

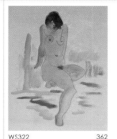

WS322 362

坐姿裸女（142）
Seated Nude(142)

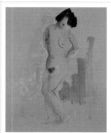

WS323 363

立姿裸女（72）
Standing Nude(72)

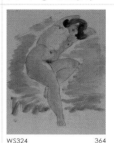

WS324 364

臥姿裸女（79）
Lying Nude(79)

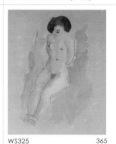

WS325 365

坐姿裸女（143）
Seated Nude(143)

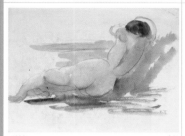

WS326 366

坐姿裸女（144）
Seated Nude(144)

WS327 367

立姿裸女（73）
Standing Nude(73)

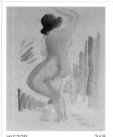

WS328 368

立姿裸女（74）
Standing Nude(74)

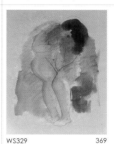

WS329 369

坐姿裸女（145）
Seated Nude(145)

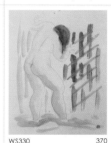

WS330 370

立姿裸女（75）
Standing Nude(75)

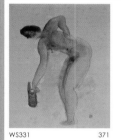

WS331 371

立姿裸女（76）
Standing Nude(76)

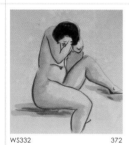

WS332 372

坐姿裸女（146）
Seated Nude(146)

WS333 373

坐姿裸女（147）
Seated Nude(147)

WS334 374

臥姿裸女（80）
Lying Nude(80)

WS335 375

立姿裸女（77）
Standing Nude(77)

WS336 376

臥姿裸女（81）
Lying Nude(81)

WS337 377

臥姿裸女（82）
Lying Nude(82)

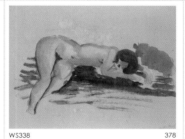

WS338 378

臥姿裸女（83）
Lying Nude(83)

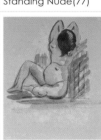

WS339 379

坐姿裸女（149）
Seated Nude(149)

WS340 380

坐姿裸女（150）
Seated Nude(150)

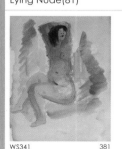

WS341 381

坐姿裸女（151）
Seated Nude(151)

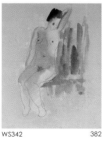

WS342 382

坐姿裸女（152）
Seated Nude(152)

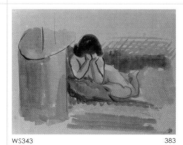

WS343 383

坐姿裸女（153）
Seated Nude(153)

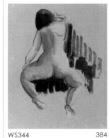

WS344 384

立姿裸女（78）
Standing Nude(78)

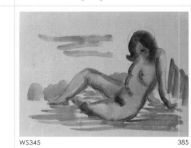

WS345 385

坐姿裸女（154）
Seated Nude(154)

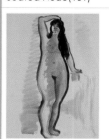

WS346 386

立姿裸女（79）
Standing Nude(79)

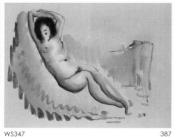

WS347 387

坐姿裸女（155）
Seated Nude(155)

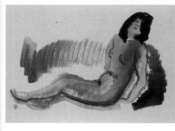

WS348 388

坐姿裸女（156）
Seated Nude(156)

WS349 389

立姿裸女（80）
Standing Nude(80)

WS350 390

立姿裸女（81）
Standing Nude(81)

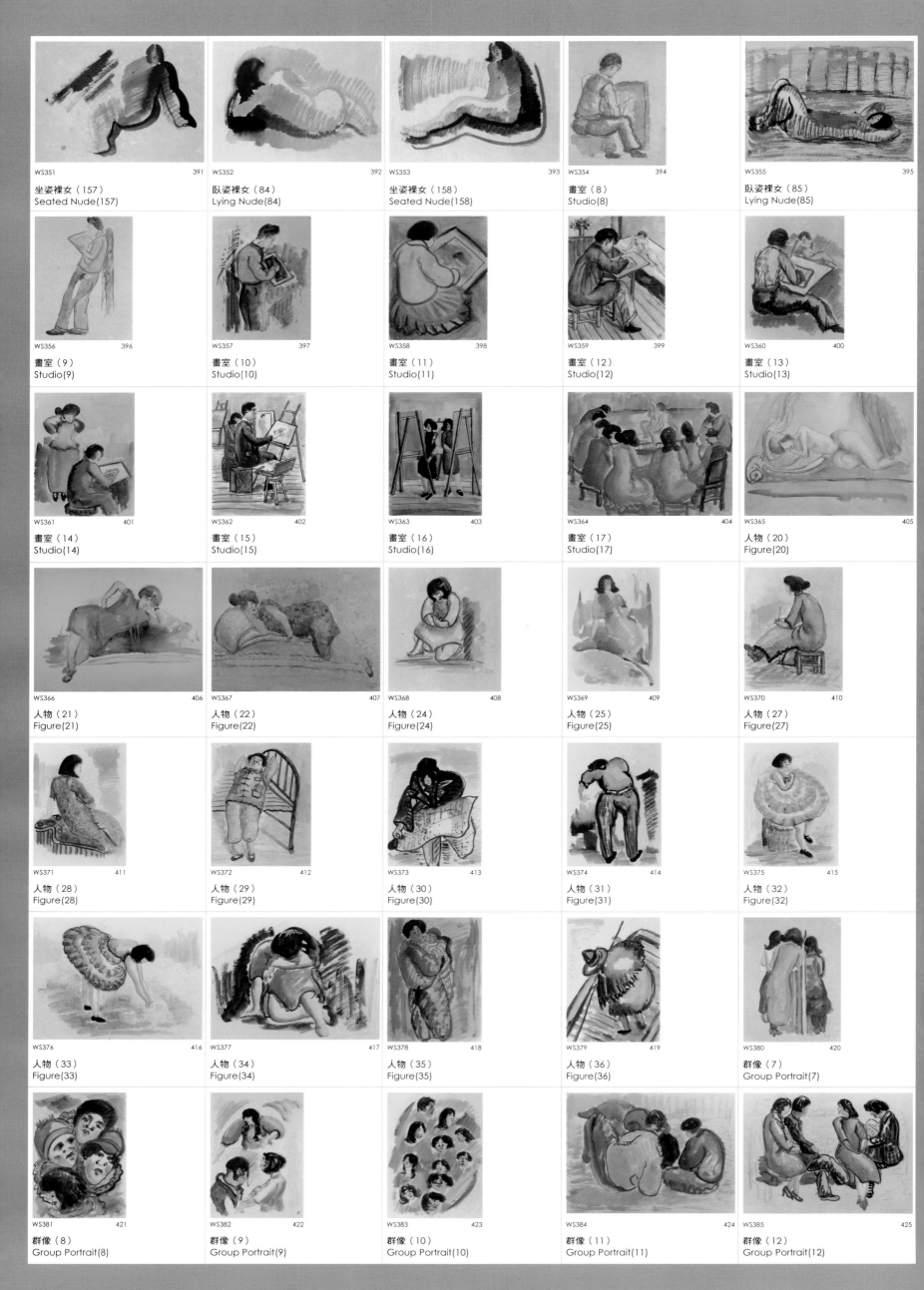

WS351 391
坐姿裸女（157）
Seated Nude(157)

WS352 392
臥姿裸女（84）
Lying Nude(84)

WS353 393
坐姿裸女（158）
Seated Nude(158)

WS354 394
畫室（8）
Studio(8)

WS355 395
臥姿裸女（85）
Lying Nude(85)

WS356 396
畫室（9）
Studio(9)

WS357 397
畫室（10）
Studio(10)

WS358 398
畫室（11）
Studio(11)

WS359 399
畫室（12）
Studio(12)

WS360 400
畫室（13）
Studio(13)

WS361 401
畫室（14）
Studio(14)

WS362 402
畫室（15）
Studio(15)

WS363 403
畫室（16）
Studio(16)

WS364 404
畫室（17）
Studio(17)

WS365 405
人物（20）
Figure(20)

WS366 406
人物（21）
Figure(21)

WS367 407
人物（22）
Figure(22)

WS368 408
人物（24）
Figure(24)

WS369 409
人物（25）
Figure(25)

WS370 410
人物（27）
Figure(27)

WS371 411
人物（28）
Figure(28)

WS372 412
人物（29）
Figure(29)

WS373 413
人物（30）
Figure(30)

WS374 414
人物（31）
Figure(31)

WS375 415
人物（32）
Figure(32)

WS376 416
人物（33）
Figure(33)

WS377 417
人物（34）
Figure(34)

WS378 418
人物（35）
Figure(35)

WS379 419
人物（36）
Figure(36)

WS380 420
群像（7）
Group Portrait(7)

WS381 421
群像（8）
Group Portrait(8)

WS382 422
群像（9）
Group Portrait(9)

WS383 423
群像（10）
Group Portrait(10)

WS384 424
群像（11）
Group Portrait(11)

WS385 425
群像（12）
Group Portrait(12)

WS386　　　　426
群像（13）
Group Portrait(13)

WS387　　　　427
群像（14）
Group Portrait(14)

WS388　　　　428
群像（15）
Group Portrait(15)

WS389　　　　429
群像（16）
Group Portrait(16)

WS390　　　　430
頭像（3）
Portrait(3)

WS391　　　　431
頭像（4）
Portrait(4)

WS392　　　　432
頭像（5）
Portrait(5)

WS393　　　　433
頭像（6）
Portrait(6)

WS394　　　　434
拖鞋
Slippers

WS395　　　　435
掛在門板上的鍋子
Pot hanged on the door

WS396　　　　436
兔子
Rabbit

WS397　　　　438
臥姿裸女-31.12.7（1）
Lying Nude-31.12.7(1)

WS398　　　　438
坐姿裸女-32.1（41）
Seated Nude-32.1(41)

WS399　　　　438
坐姿裸女-32.4.16（108）
Seated Nude-32.4.16(108)

WS400　　　　438
坐姿裸女-32.5.29（120）
Seated Nude-32.5.29(120)

WS401　　　　438
坐姿裸女-32.1（105）
Seated Nude-32.1(105)

WS402　　　　439
坐姿裸女（133）
Seated Nude(133)

WS403　　　　439
立姿裸女（70）
Standing Nude(70)

WS404　　　　439
坐姿裸女（148）
Seated Nude(148)

WS405　　　　439
坐姿裸女（159）
Seated Nude(159)

WS406　　　　440
人物（23）
Figure(23)

WS407　　　　440
人物（37）
Figure(37)

WS408　　　　440
人物（26）
Figure(26)

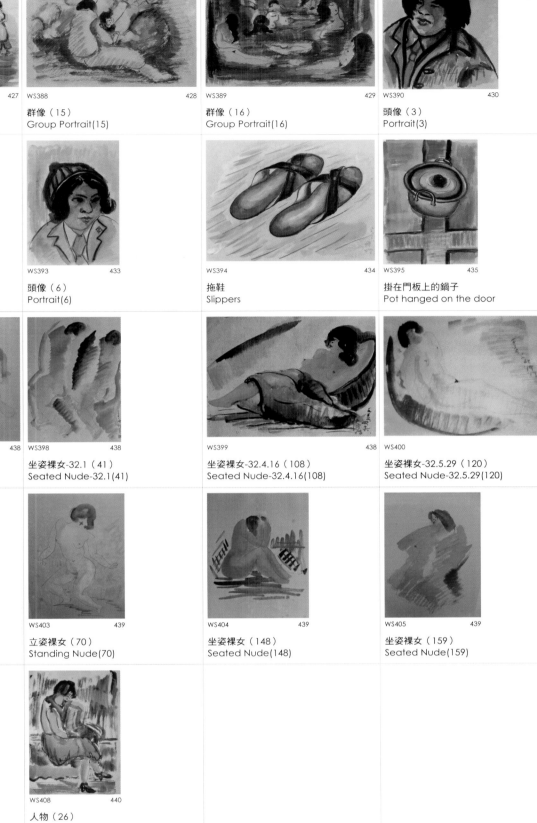
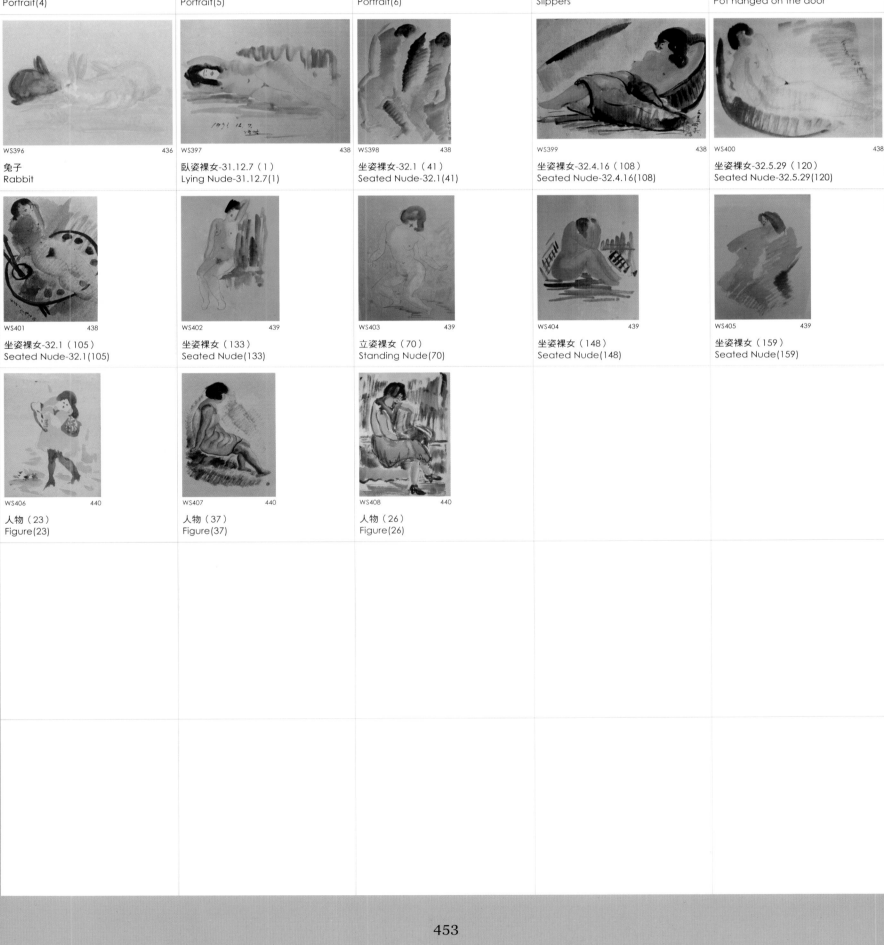

編後語

　　本卷為《陳澄波全集》第三卷「淡彩速寫」，收錄陳澄波淡彩作品408件，依據畫作內容，區分為：裸女、畫室、人物、群像、頭像，及其他等六大類型。其中，裸女類依姿態再分成：立姿裸女，坐姿裸女，與臥姿裸女等三小類。如作品中呈現作畫場景者，則歸類為畫室類。單一人物編入人物類；兩人以上者則為群像類。畫作聚焦於頭部描繪者歸於頭像類。動物、靜物、花等，則為其他類。在數量上，以裸女居首，占了淡彩作品的八成左右。

　　其次，全卷係依創作時間先後作為編輯軸線，再配合前述六大類型之順次，依序排列；惟年代不詳者置於最後。相同年代者，以畫作上明確標記年月日者為優先，僅年月者次之，又僅有年代者為第三順位。整體而言，全卷依此時間次序，可區分為四大時段：1931年、1932年1-3月、1932年4月-1933年及其他；如此的編排，將有利於作品的閱覽及搜尋，也較能完整呈顯陳澄波的創作脈絡與思維變遷。

　　為了容易日後的指認與論述，這批數量龐大的淡彩作品，除各幅均有流水編碼外，再依前述六大類型的分類名稱，後面加上畫作標示的年月日，同日者再給一流水號，以作為作品的名稱。

　　又為具體展現淡彩作品的真實感，在編輯上，大部分以畫作原寸大小呈現，讓閱讀者有彷彿端看原作之感；而少部分無法取得較好圖檔的作品，則放入參考圖版，以為存檔。

　　陳澄波一生創作繁多，蒐集到的作品雖已數以百計，但相信仍有許多作品未能完全囊括；還希望各方大家諒解，也期待日後的持續補正。

財團法人陳澄波文化基金會
研究專員　何冠儀

Editor's note

Ho, Kuan Yi

The third volume of the *Chen Cheng-po Corpus* focuses on watercolor sketches. 408 sketches are categorized into six sections: female nudes, studio, figures, group figures, portraits and miscellaneous. The female nudes section is additionally categorized into standing, sitting and lying positions. Sketches illustrated with a background are categorized in the studio section. Singular figure sketches are grouped in figures section, and sketches with more than one person in the group figures section. Sketches that focus on faces are sorted to the portraits section. Animals, still life and floral themes are classified in the miscellaneous section. The number of female nudes is most significant, occupying about eighty percent of his watercolor work.

Each section arranges artworks in chronological order. If the date is unknown, the sketch is placed at the end of each section. Conversely, accurate dating is prioritized. Artworks with clear given date and month are at the front. This volume displays four major periods: 1931, January to March 1932, April 1932 to 1933 and unspecified timing. This order is not only practical for reading and research, but also better shows Chen Cheng-po's creative vein and train of thought.

To make future reference and research easier, each work is given a serial reference number. The captions for each artwork are derived from the abbreviated characters of the above mentioned six major sections, date and serial number.

Each reproduction is realistically shown in its original size to give viewers an idea of how the original work looked like. In the case that high-quality images were unattainable, the works were added to the appendix for reference.

Chen Cheng-po left a huge body of outstanding work to us. Although we have collected hundreds, there might be others not included in this volume. We appreciate your understanding and envision future improvement.

Researcher,
Judicial Person Chen Cheng-Po Cultural Foundation
Ho Kuan-Yi *Ho, Kuan Yi*

陳澄波全集. 第三卷, 淡彩速寫 / 蕭瓊瑞總主編.
-- 初版. -- 臺北市：藝術家出版；嘉義市：陳澄波文化基金
會；[臺北市]：中研院臺史所發行, 2012.03.25
　　面 ; 37×26公分
　ISBN 978-986-282-060-5（精裝）

1.水彩畫 2.素描 3.畫冊

948.4　　　　　　　　　　　101003617

陳澄波全集
CHEN CHENG-PO　CORPUS
第三卷・淡彩速寫
Volume 3・Watercolor Sketch

發　　行：財團法人陳澄波文化基金會
　　　　　中央研究院台灣史研究所
出　　版：藝術家出版社
發 行 人：陳重光、翁啟惠、何政廣
策　　劃：財團法人陳澄波文化基金會
總 策 劃：陳立栢
總 主 編：蕭瓊瑞
編輯顧問：王秀雄、吉田千鶴子、李鴻禧、李賢文、林柏亭、林保堯、林釗、張義雄
　　　　　張炎憲、陳重光、黃才郎、黃光男、潘元石、謝里法、謝國興、顏娟英
編輯委員：文貞姬、白適銘、林育淳、邱函妮、陳麗涓、陳水財、張元鳳、張炎憲
　　　　　黃冬富、黃姍姍、廖瑾瑗、蔡獻友、蔣伯欣、謝慧玲、蕭瓊瑞
執行編輯：賴鈴如、何冠儀
校　　色：徐令軍
美術編輯：柯美麗
翻　　譯：日文／潘襎・英文／陳彥名、許恬瑛、Lauren Swartz

出 版 者：藝術家出版社
　　　　　台北市重慶南路一段147號6樓
　　　　　TEL：（02）2371-9692～3
　　　　　FAX：（02）2331-7096
　　　　　郵政劃撥：01044798 藝術家雜誌社帳戶

總 經 銷：時報文化出版企業股份有限公司
　　　　　新北市中和區連城路134巷16號
　　　　　TEL：（02）2306-6842
南區代理：台南市西門路一段223巷10弄26號
　　　　　TEL：（06）261-7268
　　　　　FAX：（06）263-7698

製版印刷：欣佑彩色製版印刷股份有限公司
初　　版：2012年3月25日
定　　價：新臺幣2600元

ISBN　978-986-282-060-5（精裝）